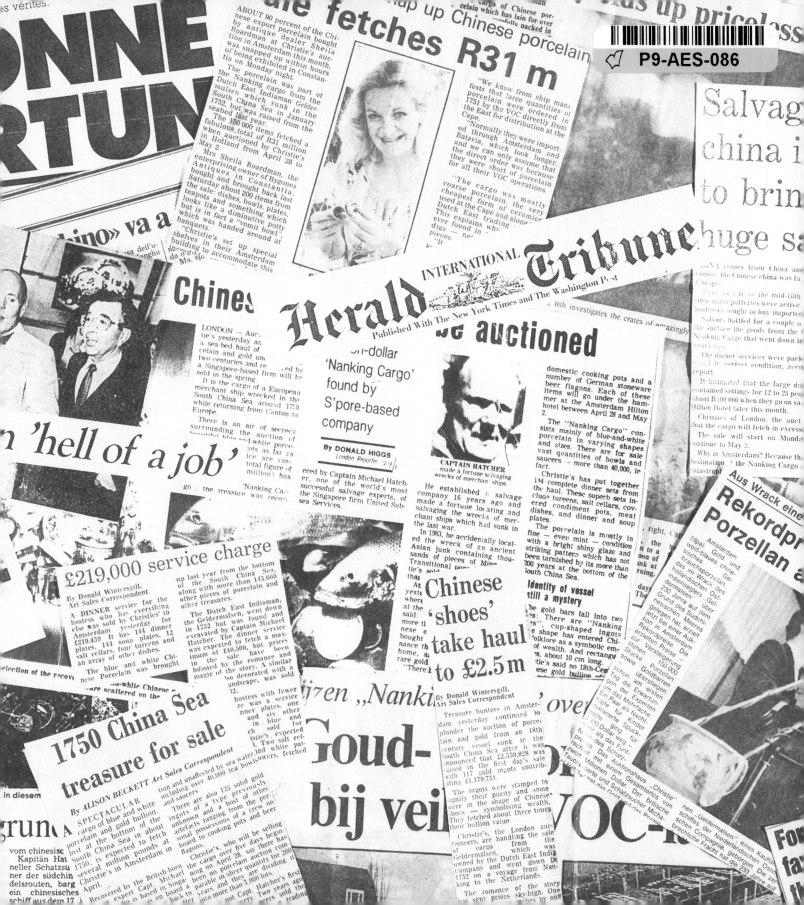

CHRISTIE'S

Review of the Season 1986

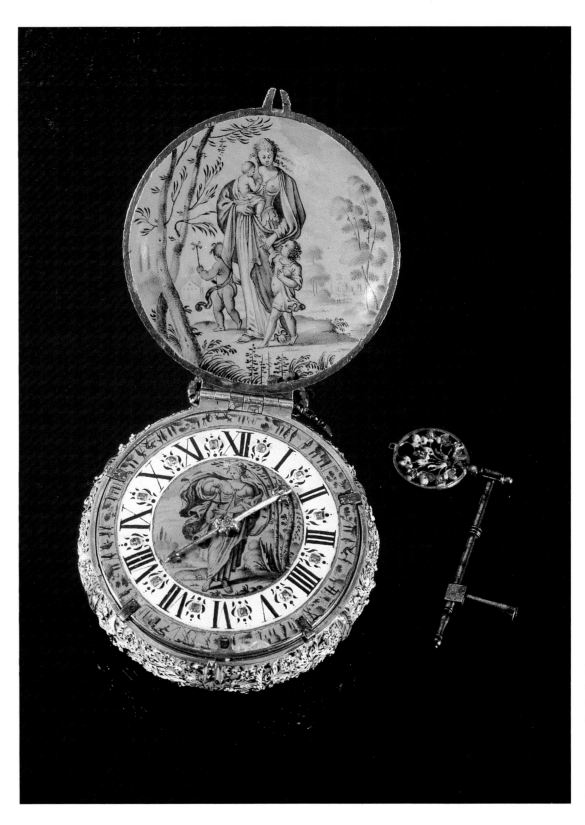

French gold, enamel and
diamond-set watch
Signed *Jehan Cremsdorff à Paris*
c. 1650
2⅜ in. (6 cm.) diameter
Sold 13.5.86 in Geneva for
Sw.fr.1,870,000 (£670,250)
Record auction price for a
watch

CHRISTIE'S

Review of the Season 1986

Edited by Mark Wrey

PHAIDON · CHRISTIE'S
OXFORD

Distribution through Phaidon · Christie's Ltd., Littlegate House, St. Ebbe's Street, Oxford OX1 1SQ

British Library Cataloguing in Publication Data
Christie's review of the season. – 1986
 1. Art – Periodicals
 705 N1
 ISBN 0-7148-8032-9

Distribution in USA and dependencies by Salem House, 99 Main Street, Salem, NH 03079

Design and layout by Norman Ball, Logos Design, Datchet, Berkshire

Phototypeset in Compugraphic Baskerville by J & K Hybert, Maidenhead, Berkshire

Printed and bound in The Netherlands by Drukkerij Onkenhout b.v., Hilversum

Endpapers: A collage of international press-cuttings relating to the Nanking Cargo, which sold 28 April to 2 May 1986 for a total of D.fl.37,372,919 (£10,100,789)

All prices include the buyer's premium where applicable. The currency equivalents given throughout the book are based on the rate of exchange ruling at the time of the sale.

Contents

Foreword

PAUL WHITFIELD

'How many things by season season'd are...'
(Portia: *Merchant of Venice*)

Clients and commentators alike are often baffled by the term 'The Auction Season', and it is not hard to see why: a year which consists of some 40 weeks rather than the customary 52; which starts officially in August, but in practice sometime in late September; which straddles the calendar and financial years respected by most of the world with a proud insouciance. What sort of chronological beast is it?

An autumnal start to the year is the tradition – in Western Europe at least – of many centuries. Whether the starting point is taken as Michaelmas, the immemorial start of the legal term, or as the time of harvest, or the advance payment in kind of servants, or the autumn equinox itself, the old year used to begin at the end of September. January 1st is an upstart, and in any case of no traditional interest to most of the world east of Vienna. And so, odd as it may seem today, an autumn start to a year of trading was always perfectly normal – as normal as those of the academic and legal years, which still remain the auctioneer's calendar companions.

As to its ending, the fashionable London Season, starting with the Royal Academy Exhibition in May, traditionally finishes with Goodwood Races at the end of July, after which Cowes and grouse present out-of-town distractions. No one, in theory, remains in Town. Any auctioneer who held sales in a theoretically 'empty' metropolis would generally be thought foolhardy, even though at Christie's South Kensington the trend, as so often, has firmly been bucked. And so, with clients on the beach, the grouse-moor or the yacht, the logic and the tradition continue. In New York, of course, it all happens a bit faster, and things finish a month earlier; nevertheless, in that city of modernity, sales still take place on Saturday mornings – something that has not happened in London since before the last war.

The auctioneer, poor fellow, therefore lives a somewhat schizoid life, inhabiting two years at once. In the late summer, the dead season between Goodwood in England and Labour Day in the United States, refreshed from his own holiday, he looks forward to planning his autumn and winter sales, only to be frustrated by his clients' continuing absence in Cap Ferrat, the Hamptons or Scotland. And so he is driven to reflection on the Season just finished, hoping that by close inspection of its entrails he will be able to look ahead to what his particular New Year – beginning in late September – may hold in store.

Each Season has its own character, a bouquet of memories which remain, so to speak, on the palate, as our esteemed Michael Broadbent would say, in a definite and special way. 1985/86 was no exception: it was indeed (to sustain the vinous metaphor) a great year, not perhaps the best, with a lot of fruit, showed well, some acidity, and a strong, firm finish.

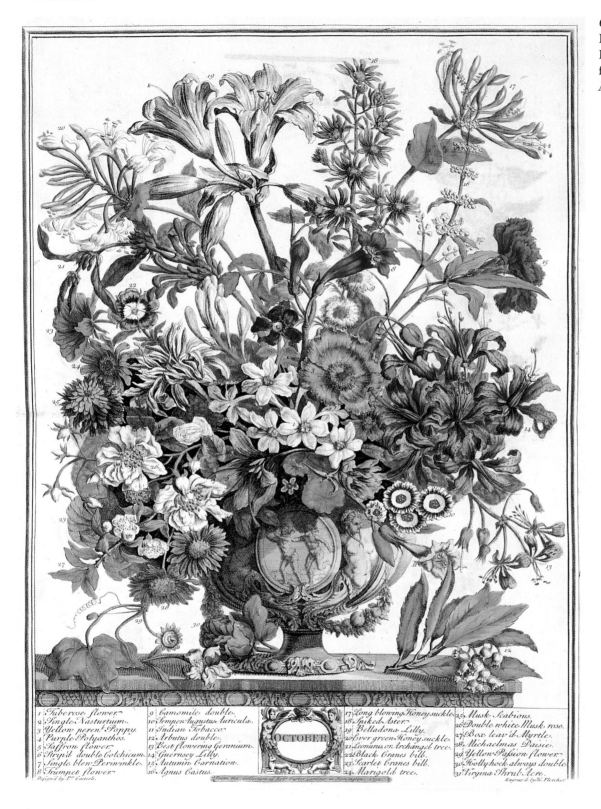

October
Hand-coloured engraving by
H. Fletcher after P. Casteels,
from Robert Furber's *Twelve
Months of Flowers*, 1730

As to colour, it was certainly a blue and white year. The 'Nanking Cargo', which sold – 235 years later than it might have done – in Amsterdam in May, was a truly global success. What auctioneer could have hoped for anything better: 18,000 people to the view, a stratospheric total, and the accolade, from the *International Herald Tribune*, of 'the most sophisticated publicity campaign in auction house history'.

It was a year in which distinguished and specialized collections, always the goal of the auctioneer, were particularly prominent: the Hans Bühler Collection of works by Theodore Géricault, followed closely by Old Master Prints from Chatsworth in December at King Street; the Jay Family Collection of Historical American Portraits in January in New York, and the Harrison Whittemore Impressionists in the same saleroom. Sir Charles Clore's collections dominated the scene both in Geneva in November and at our memorable début in Monaco in December. Ray Livingston Murphy's collection of drawings and pictures, offered in New York and London, had been formed in the 1940s and early 1950s and hidden from view since then; not so the Library of James Gilvarry, which was well known before its dispersal in New York in February. The European Porcelain Department had four noteworthy successes with the collections of Sir Charles Clore, Ambassador Weitnauer, the Meinertzhagens and Nyfellers. Marble sculpture, not always an easy market (perhaps because of memories of endless galleries and cemeteries?), had a most distinguished showing when a large group from Wentworth Woodhouse, as well as Rysbrack's handsome Shakespeare from Alscot Park, were sold in July in London.

Another 'difficult' subject, German Expressionist painting, has become a particular feature of the London market, as we saw in a hugely successful sale in June. As the following pages will show, it has also been a particularly good season for Modern Prints, English Furniture, Wine and Coins.

House sales always provide touches of poignancy which are remembered: for example, the extraordinary assemblage of pictures and objects at West Dean, the collections of Edward James and his parents: a mind, and a society, stripped bare before our gaze and discussed, from two different points of view, later in this book. And for poignant objects which have become universal symbols in the 20th century, who can better the battered bowler hat and springy cane of Charlie Chaplin, sold for an astonishing price at South Kensington? The medals of the explorer Stanley were a reminder both of imperial pride and early media 'hype', when they came under the hammer in London in July.

All of this amazing range of activity adds up to an *average* of £1 million a day in a year, or comfortably past the magic half-billion dollar mark. Overall, Christie's increased their sales by more than 8 per cent, and within this lie some very remarkable achievements, such as a rise of 63 per cent in Europe, sales up by nearly double in Rome and by a third in Scotland.

As we look forward to another autumn equinox, Michaelmas, fall or autumn, we hope that readers will enjoy the delights that follow in this *Review* and join us in our salerooms or offices round the world to participate in another New Season.

Negotiated Sales

HUGH ROBERTS

1986 has been something of an *annus mirabilis* for negotiated sales to the nation, for in this year the futures of three of our greatest English country houses and their collections – Kedleston Hall, Nostell Priory and Weston Park – have been secured and the prospect of three catastrophic dispersals averted. None but the most irresponsible could have wished to hear any other news; and certainly at King Street where, as professional advisers on chattels to all three houses, every sinew has been stretched to achieve this result, the pleasure in these three successes has been immense.

Much has been written in the press and elsewhere about all three houses; suffice it to say now that eighteen months ago the picture looked very bleak indeed with the ceiling on acceptance of works of art in lieu of tax drastically reduced and the National Heritage Memorial Fund, recent saviour of Belton House and Calke Abbey, seriously depleted. Equally it was clear that very considerable endowments would be necessary to keep any of these houses going in the event of acceptance by the National Trust. The picture changed unexpectedly and dramatically in February 1985 with the announcement that the government was prepared to make a special grant of £25 million to the Heritage Fund towards the cost of saving the three houses with their contents. This imaginative and greatly welcomed move, certainly due in part to energetic public discussion by the various heritage groups as well as to discreet behind the scenes lobbying, provided the key to the solution, though for the three owners and their advisers the most intricate and time-consuming negotiations still lay ahead.

Each house presented a different problem: at Kedleston, the first of the houses to fall under threat (on the death of the 2nd Viscount Scarsdale in 1977) the problems of capital tax were compounded by a complicated family trust. Difficult though this latter aspect was to overcome, it was crystal clear to all those involved in providing advice that the survival of Robert Adam's great masterpiece with its spectacular contents and Arcadian setting was of absolutely paramount importance and if the overworked term 'heritage' was to mean anything at all a solution had to be found. In the event the solution has been three-pronged: the Heritage Fund has agreed to purchase the greater part of the historic contents of the State Apartments and to provide a significant part of the endowment fund necessary for upkeep, a total of £13.5 million; the National Trust (as ultimate recipient) has launched a public appeal for £2 million to purchase a number of other important chattels and also to contribute towards necessary repairs and maintenance. The Hall, together with its amenity land, and further chattels of £1 million, will be the subject of a generous gift to the National Trust by Lord Scarsdale, who has consistently worked for a National Trust solution since he inherited Kedleston nine years ago.

Nostell Priory was given to the National Trust in 1954 by the late Lord St. Oswald, but the contents remained the property of the Winn family and therefore on the death of the Lord St. Oswald in December 1984, his successors were faced with the prospect of a daunting capital tax bill. As with Kedleston, the integrity of house and contents at Nostell was a cardinal con-

Kedleston Hall, Derbyshire:
the south front

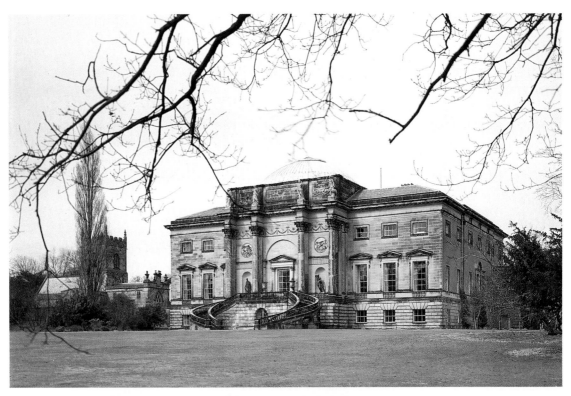

Weston Park, Shropshire

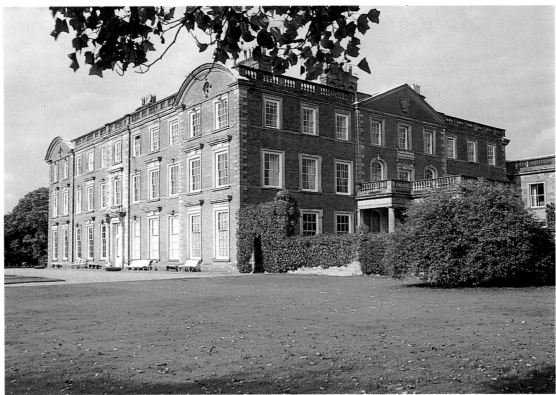

sideration. Very little of importance had changed in the state rooms since Robert Adam was employed to complete the unfinished interiors of the house in 1765 and Thomas Chippendale to furnish them. Chippendale's bills and correspondence survive in the house and from these as from the researches of his modern biographer Mr Christopher Gilbert, it was clear that Nostell is one of the most perfect and least altered of all 18th century schemes of decoration and furnishing to survive. The purchase by the Heritage Fund of a carefully selected package of the Chippendale furniture with its original bills and some other important items for retention in the house under the care of the National Trust was the happy outcome of months of negotiations and was largely achieved by the determination and generosity of the present Lord St. Oswald, together with that of the Heritage Fund and the National Trust.

At Weston Park, an oppressive tax bill also faced the present Earl of Bradford on his inheritance following the death of his father in 1981. Partial settlement of the tax debt was effected in 1983 by the private treaty sale, negotiated through Christie's, of a magnificent Bassano *Christ on the Road to Calvary* to the National Gallery (who had National Heritage Memorial Fund assistance with the purchase), but even then the outstanding sum looked likely to prejudice the continued survival of this historic Shropshire house with its magnificent Van Dycks, including the portrait of Sir Thomas Hanmer recently lent to the Treasure Houses exhibition in Washington; splendid French and English furniture; and one of only a handful of rooms to survive with dazzling pink ground Gobelins tapestries still *in situ*. However, thanks to the very substantial help of the Heritage Fund, detailed negotiations will result in the establishment of an endowment fund to support a private charitable trust which will own the principal contents, thus ensuring the future of Weston indefinitely.

Lawyers, accountants, politicians, heritage lobbyists, dealers, treasury officials, Christie's, the National Trust and above all the Heritage Fund have all contributed in varying degrees to this happy outcome for Kedleston, Nostell and Weston, but in all three of these great houses, it has been the willingness of the owners themselves to soldier on – often in the face of great odds – and to compromise generously when necessary that has given real impetus to the solution of these problems and has ensured that every member of the public with an interest in the nation's artistic heritage will be the ultimate beneficiary.

CHRISTOPHER PONTER, LL.B.

While the past year has seen renewed discussion over the need to coordinate the various procedures designed to encourage private owners to consider private treaty 'heritage' solutions, it is encouraging to record that through the persistent efforts of the families and their experienced advisers, solutions have been found to the problems at Nostell, Kedleston and Weston Park.

In addition, Christie's have also negotiated the sale or transfer to public bodies in this country of a number of major works of art. Towards the end of 1985, the magnificent portrait of

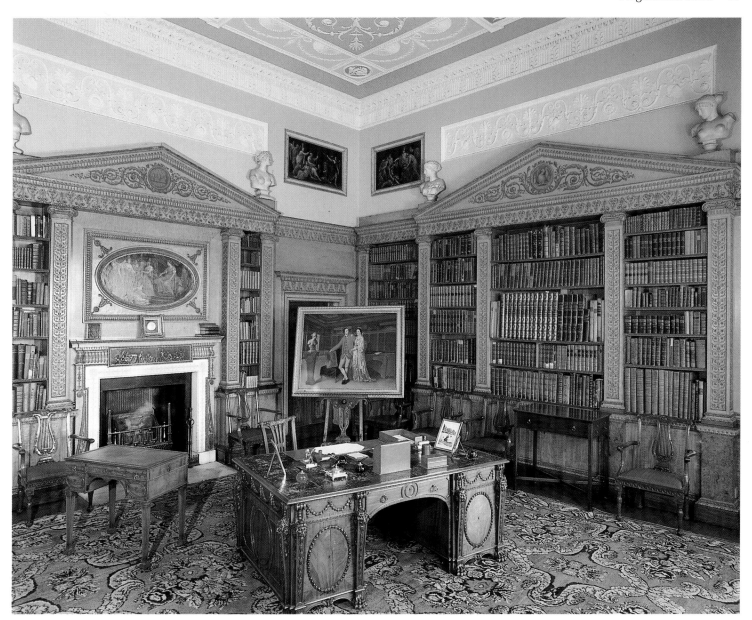

View of the Library at Nostell furnished by Thomas Chippendale in 1767–8

The Balbi Children was sold by private treaty to the National Gallery in London. One of the finest portraits by Anthony Van Dyck during his period in Genoa (1621–27), this painting was the first major picture to be purchased with the aid of a contribution from the Endowment Fund created in 1985 by Mr J. Paul Getty Jnr. During his Genoese period, Van Dyck developed the full repertory of his later years, and favoured large canvases on which he could capture the atmosphere of the sombre Genoese *palazzi* in which his patrons lived. This portrait reveals Van Dyck's exceptional ability as a painter of children, and is particularly effective in its representation of the individuality of each of the children and the vitality of their expressions.

Early in 1986, Christie's were instructed by the Cathedral Chapter of St. Nicholas, Newcastle upon Tyne to negotiate the sale of an important painting by Tintoretto entitled *Christ Washing the Disciples' Feet* (oil on canvas, 84¾ × 210 in., 215.5 × 533.3 cm.). As the Cathedral has owned this painting since 1818 when it was presented by a member of the Ridley family, the Chapter authorities were most anxious that it should remain in the North East, and thanks to significant contributions by the Heritage Fund and the National Art-Collections Fund, the painting was eventually acquired by the Tyne & Wear County Council.

One of the most extensive and highly important archives in this country is the collection of papers of the Bentinck family of the 17th/19th centuries with substantial collections of the Harley, Holles and Cavendish family papers built up by successive Dukes of Portland, and which has been on loan to the British Library, the Bodleian, Nottingham University Library and Hampshire Record Office for many years. To meet part of the heavy tax liability following the death of her mother, the Duchess of Portland, Lady Anne Bentinck surrendered these papers in lieu of tax, and this was the first major transaction utilizing the new arrangement, announced in July 1985, whereby the A.I.L. Fund can be supplemented from the Public Expenditure Reserve Fund.

Another first, for the Trustees of the National Museums & Galleries on Merseyside, was the acquisition by private treaty of the painting *Spring (Apple Blossoms)* of 1857/9 by the pre-Raphaelite artist John Everett Millais, which formerly belonged to Viscount Leverhulme, whose grandfather purchased it in 1920. It last appeared in Christie's on 2nd April 1892 when it realized 693 gns. First exhibited at the Royal Academy in 1859, *Spring* represented a new stage in the artist's career and depicts in glowing colours young girls resting in an orchard. The models include the sisters of the artist's wife Effie Gray, and also Georgiana (kneeling in the centre), daughter of Sir Thomas Moncrieffe of the Ilk, who became the famous beauty Lady Dudley.

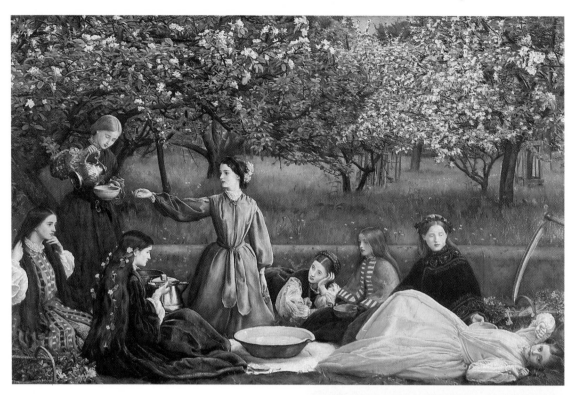

SIR JOHN EVERETT MILLAIS, BT., P.R.A.
British 1829–96
Spring (Apple Blossoms)
Signed with monogram and dated 1859
Oil on canvas
43½ × 68 in. (110.5 × 172.7 cm.)
Now in the Walker Art Gallery, Liverpool

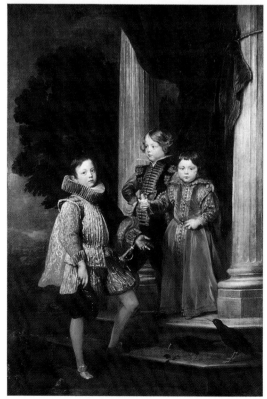

SIR ANTHONY VAN DYCK
Flemish 1599–1641
The Balbi Children
Painted *c.*1626
Oil on canvas
86½ × 59½ in. (219 × 151 cm.)
Now in the National Gallery, London
A masterpiece of Van Dyck's Genoese period

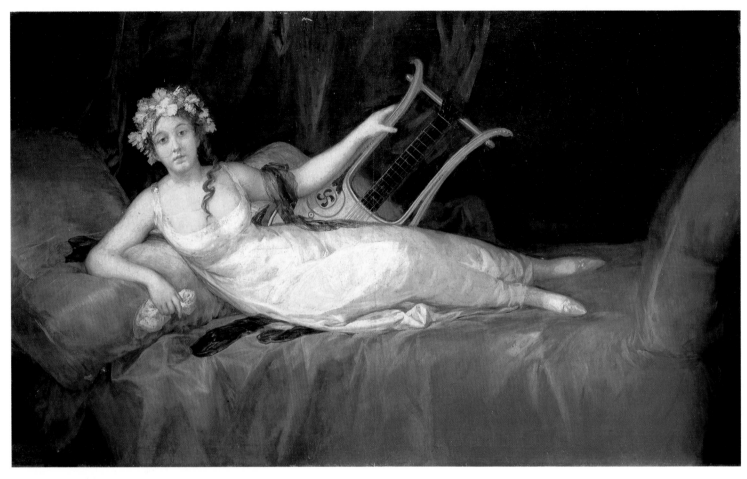

FRANCISCO JOSÉ DE GOYA Y LUCIENTES
Spanish 1746–1828
Portrait of Joaquina, née Téllez Girón y Alfonso Pimental, 10th Marquesa de Santa Cruz, reclining full length on a lit de repos, wearing a white satin dress, her head adorned with grapes and vine leaves, holding a lyre-guitar
Signed, inscribed with the sitter's name and dated 1805
49¼ × 81¾ in. (125 × 207 cm.)
Sold by private treaty to the Museo del Prado, Madrid, 1986

The sitter was the second daughter of Goya's early patrons, the 9th Duque de Osuna and his wife, Condessa de Benavente.

In January 1986 it was announced that Goya's portrait of the Marquesa de Santa Cruz was to be sold at auction in the Spring. From that moment onwards, the suggestive yet somewhat vulnerable features of the young beauty, painted in 1805 in a classical pose reminiscent of both Velasquez and Ingres, became as well known around the world as the newest Hollywood *ingénue*. Perhaps the subject herself, with a reputation in her time for being somewhat 'fast' would have enjoyed the enormous publicity.

Christie's were instructed to act on behalf of the owners, one of Lord Wimborne's family trusts, following a history of inconclusive negotiations with the Spanish authorities. Controversy arose in the run-up to the sale concerning the precise circumstances under which the picture had been allowed to leave Spain some years earlier. As agents for the owners, Christie's were satisfied as to the *bona fides* of the transaction and took the unusual step of inviting prospective purchasers, to inspect the relevant documents. In the event, however, a private sale was agreed shortly before the auction on 11 April. Payment of $6 million (£4 million) was agreed, and the picture returned to Spain. It now hangs in pride of place in the Prado Gallery near the famous *Maja Desnuda*.

In the final analysis, honour all round had been satisfied: the owners of the picture had received suitable recompense, Spain rejoiced in the return of one of its national treasures and the skills and resources of the London art market were again vindicated.

Pictures

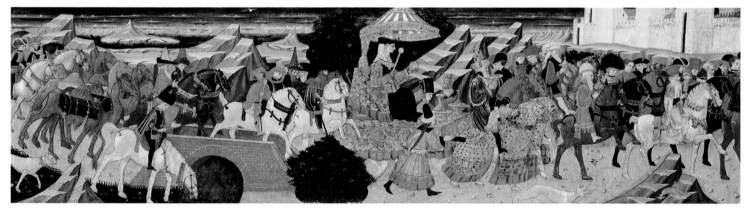

WORKSHOP OF APOLLONIO DI GIOVANNI AND MARCO DEL BUONO
Italian mid-15th century·
The Journey of the Queen of Sheba
Cassone panel
$16\frac{1}{4} \times 57\frac{1}{2}$ in. (41.3 × 146 cm.)
Sold 11.4.86 in London for £91,800 ($135,268)
Previously sold at Christie's 23.4.36 for 570 gns.
According to the 1936 sale catalogue, the end panels of the cassone in which the present lot was then
sold bore the arms of the Circhi and Rinaldeschi families

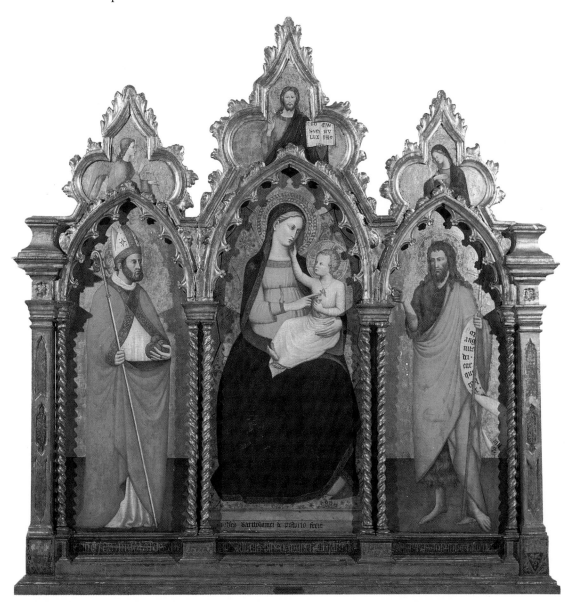

GIOVANNI DI BARTOLOMEO CRISTIANI
Italian 1340–98
The Madonna and Child with Saint Nicholas of Bari and Saint John the Baptist (Christ, the Angel of the Annunciation and the Virgin Annunciate in the pinnacles above)
Signed and dated 1390
On panel, in the original frame
73¾ × 72½ in. (187 × 184 cm.)
Sold 20.3.86 in Rome for L.575,000,000 (£250,000)
The picture was sold subject to Italian export restrictions
Purchased by the Bank of Pistoia
This signed tryptych, formerly in the Oratorio dei Nesli in the Castello di Montemurlo near Pistoia, is one of the key works upon which attributions to the artist depend

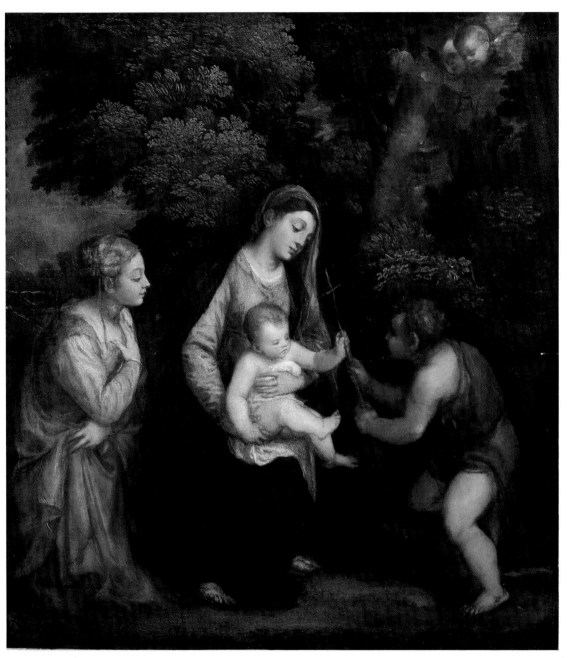

TIZIANO VECELLIO, CALLED TITIAN
Italian 1477–1576
The Madonna and Child with Saint Catherine, and the Infant Saint John the Baptist
Oil on canvas
37½ × 34¼ in. (95 × 87 cm.)
Sold 16.5.86 in Rome for L.575,000,000 (£250,000)
The picture was sold subject to Italian export restrictions

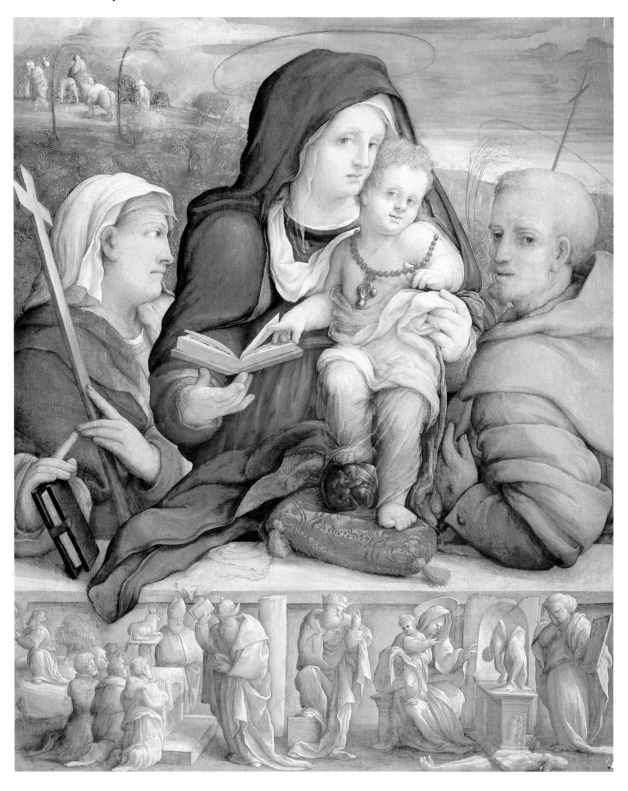

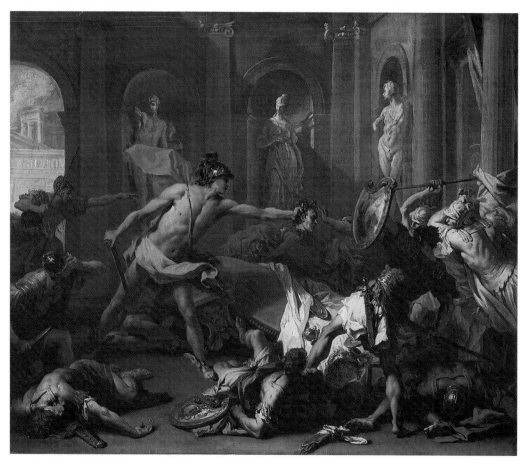

SEBASTIANO RICCI
Italian 1659–1734
Perseus with the Head of Medusa
Oil on canvas
$25\frac{1}{2} \times 30\frac{3}{4}$ in. (64.8 × 79 cm.)
Sold 15.1.86 in New York for $110,000 (£77,887)
From the collection of Ray Livingston Murphy

Opposite:
AMICO ASPERTINI
Italian *c.*1475–1552
The Madonna and Child with Saints Helen and Francis, the Flight into Egypt beyond
Oil on panel
$33\frac{5}{8} \times 28$ in.
(85.5 × 71.1 cm.)
Sold 11.4.86 in London for £345,600 ($508,032)
Now in the National Museum of Wales, Cardiff
Attributed to Ghirlandaio by the pioneering collector of Italian primitives William Roscoe, the picture was purchased at his sale in 1816 for 110 gns. by the 1st Earl of Leicester

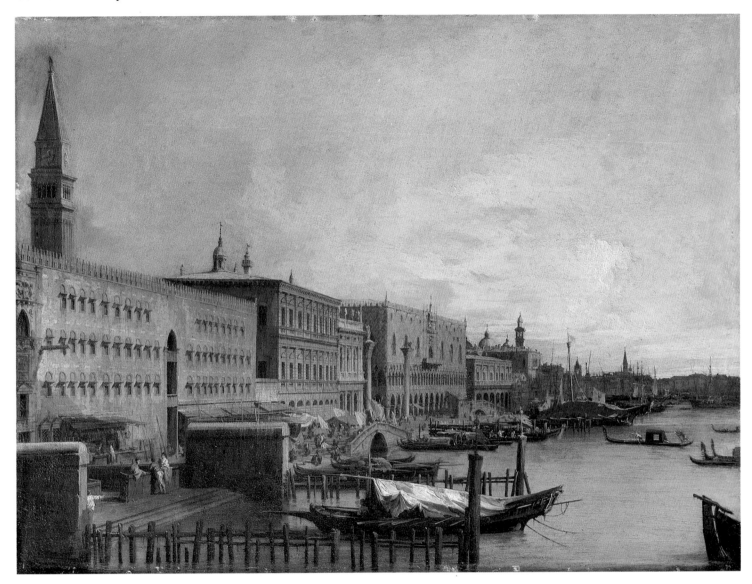

GIOVANNI ANTONIO CANAL, IL CANALETTO
Italian 1697–1768
The Riva degli Schiavoni, Venice, looking East, with the Granai, the Campanile, the Zecca, the Libreria and the Doge's Palace, the Church of San Giorgio dei Greci beyond (one of a pair)
Oil on copper
$17\frac{1}{2} \times 23\frac{1}{2}$ in. (44.5 × 59.7 cm.)
See opposite

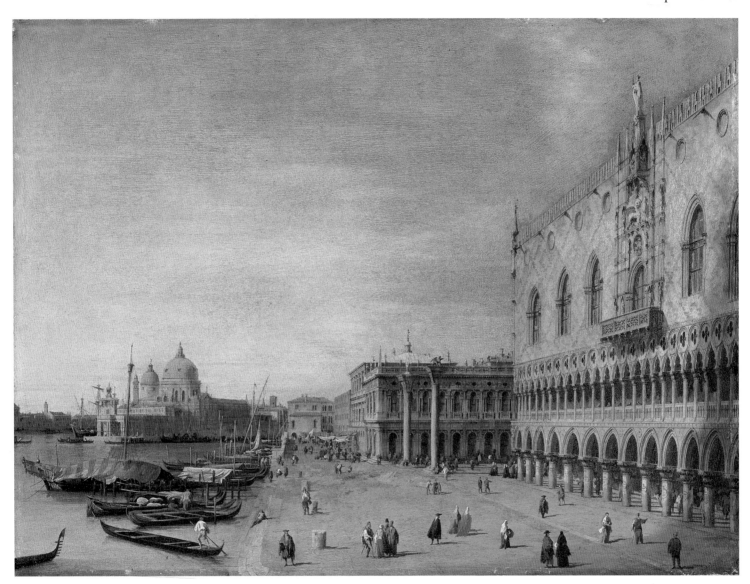

GIOVANNI ANTONIO CANAL, IL CANALETTO
Italian 1697–1768
The Molo, Venice, looking West, with the Doge's Palace, the Piazzetta and the Libreria, the Dogana, the Church of Santa Maria della Salute and the mouth of the Grand Canal beyond (one of a pair)
Oil on copper
$17\frac{1}{2} \times 23\frac{1}{2}$ in. (44.5 × 59.7 cm.)
The pair sold 4.7.86 in London for £594,000 ($891,000)
Canaletto executed nine such views on copper for English patrons in the late 1720s. The others are at Chatsworth, at Goodwood, at Holkham and in a French private collection. This pair was bought by Sir William Morrice, Bt., and was subsequently at Ashburnham Place. They were sold in 1953 for £2,800 and £3,000 respectively.

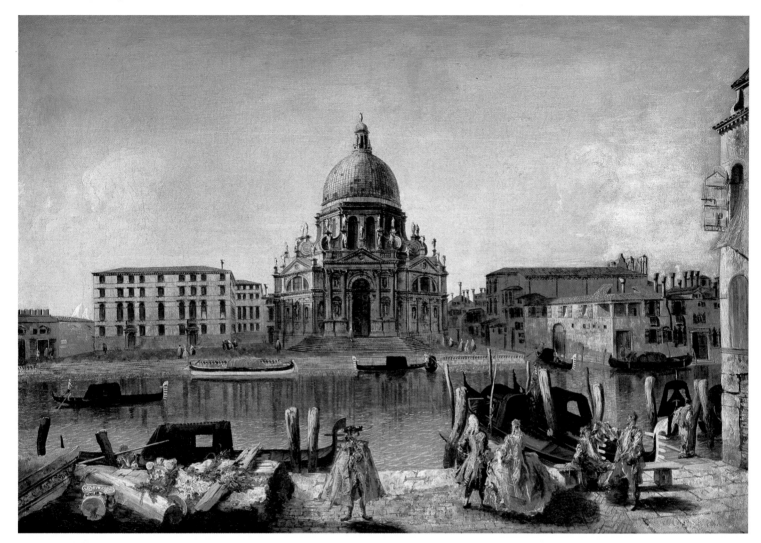

MICHELE MARIESCHI AND ANTONIO GUARDI
Italian 1696–1743, 1698–1760
Santa Maria della Salute from the Rio di San Moisé, Venice
Oil on canvas
$23\frac{1}{4} \times 33\frac{1}{2}$ in. (59 × 85 cm.)
Sold 13.12.85 in London for £162,000 ($232,389)
Previously sold at Christie's 12.7.57 for 2,100 gns.
The figures are by Antonio Guardi, who collaborated with Marieschi in a number of views of this kind

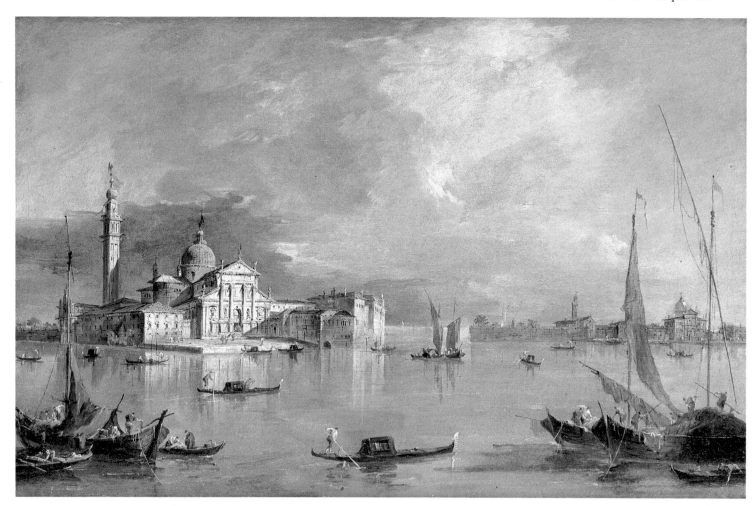

FRANCESCO GUARDI
Italian 1712–93
San Giorgio Maggiore, Venice, with the Giudecca and the Zitelle
Oil on canvas
13³⁄₈ × 20⁷⁄₈ in. (34 × 53 cm.)
Sold 13.12.85 in London for £194,400 ($278,867)
A related picture is in the Wallace Collection

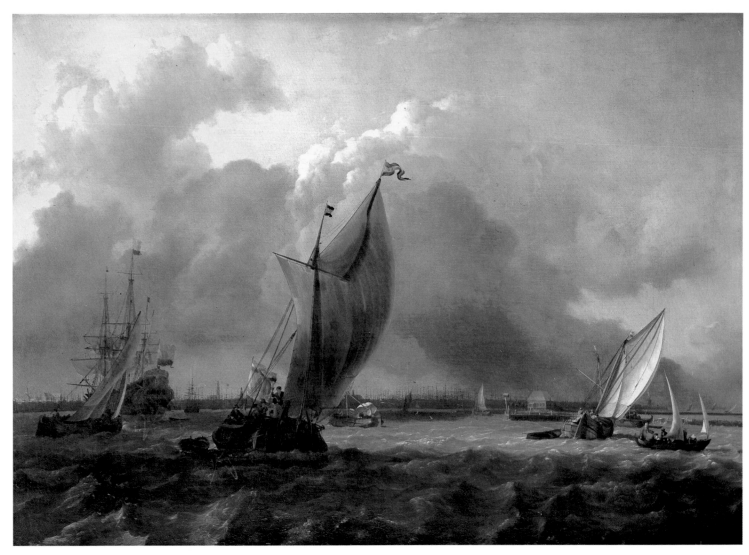

LUDOLF BACKHUYZEN
Dutch 1631–1708
The River IJ at Amsterdam with a Storm approaching
Signed (?) and dated 1666
Oil on canvas
30½ × 42¾ in. (77.5 × 108.5 cm.)
Sold 11.4.86 in London for £183,600 ($270,535)
Previously sold at Christie's 28.4.1806 for 60 gns.

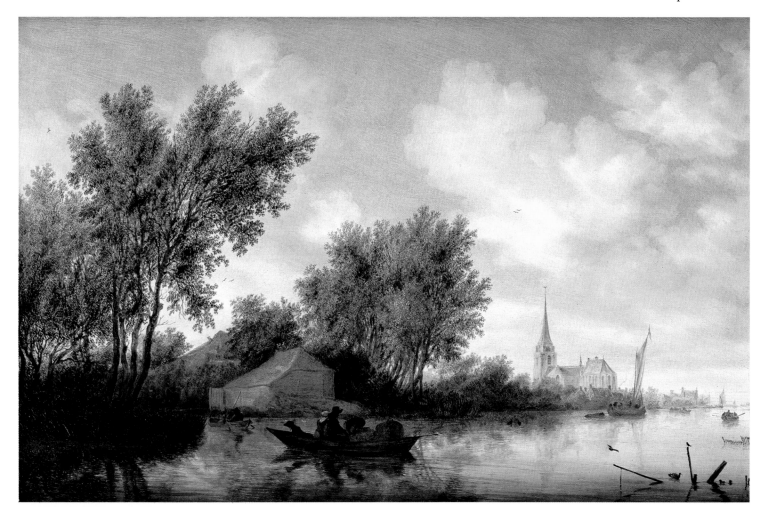

SALOMON JACOBSZ. VAN RUYSDAEL
Dutch 1630–81
A wooded River Landscape
Signed in monogram
Oil on panel
21¼ × 32¾ in. (54 × 83.2 cm.)
Sold 13.12.85 in London for £248,400 ($356,330)
This picture was formerly dated 1644 and the same church is depicted in the landscape of 1644 in the Louvre

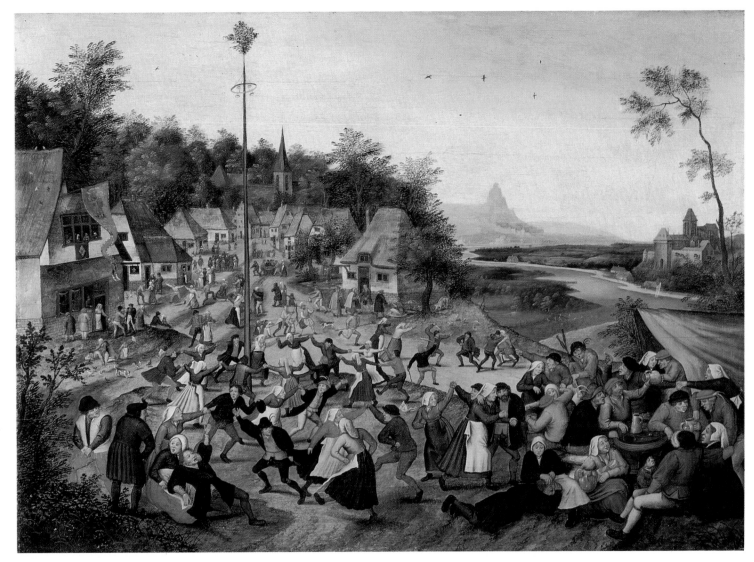

PIETER BRUEGHEL THE YOUNGER
Flemish 1564–1637
A Village 'Kermesse' with Peasants dancing around a Maypole
Indistinct signature
Oil on panel
22 × 30½ in. (55.5 × 77.5 cm.)
Sold 29.5.86 in Amsterdam for D.fl.788,800 (£202,257)

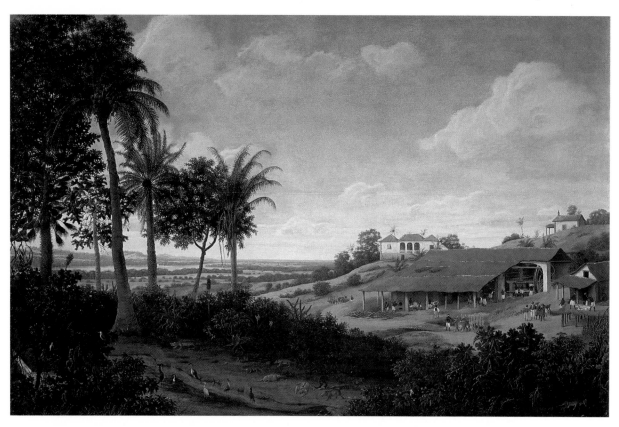

FRANZ POST
Dutch 1612–80
A Brazilian Landscape with a Sugar Mill
Oil on panel
27½ × 41¾ in. (69.8 × 106 cm.)
Sold 15.1.86 in New York for $440,000 (£306,941)

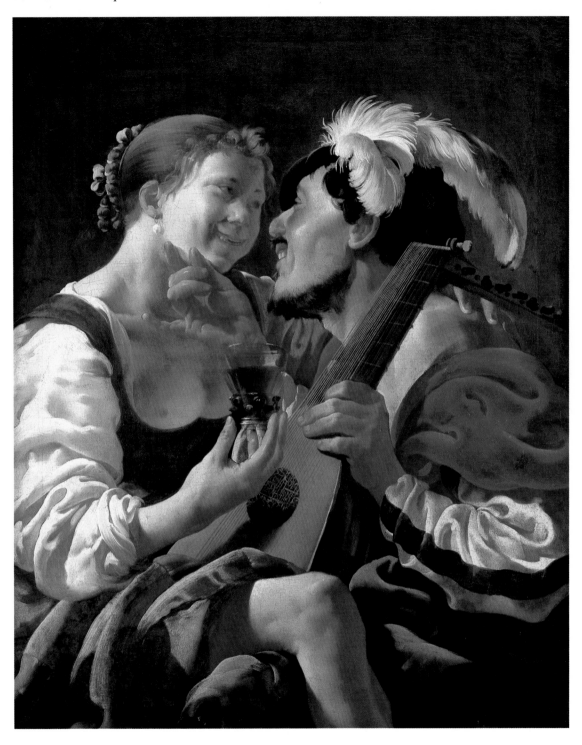

HENDRICK TERBRUGGHEN
Dutch 1587–1629
*A Luteplayer carousing with a
Young Woman*
Signed in monogram
Oil on canvas
41½ × 34 in.
(105.5 × 86.4 cm.)
Sold 13.12.85 in London for
£1,080,000 ($1,549,260)
Previously sold at Christie's
20.12.22 as by Jordaens for
17 gns.
Two other versions of the
composition are known, but
the pentiment in the shoulder
of the luteplayer,
Terbrugghen's monogram,
and the fluent brushwork and
vivid colours indicate the
primacy of the present work.
The picture is datable
1624–6.

Opposite:
GERARD DOU
Dutch 1603–75
*A Wine Cellar with a
Maidservant drawing Wine from
a Barrel by Candlelight*
Oil on panel
12 × 10 in. (30.5 × 25.4 cm.)
Sold 11.4.86 in London for
£129,600 ($190,966)

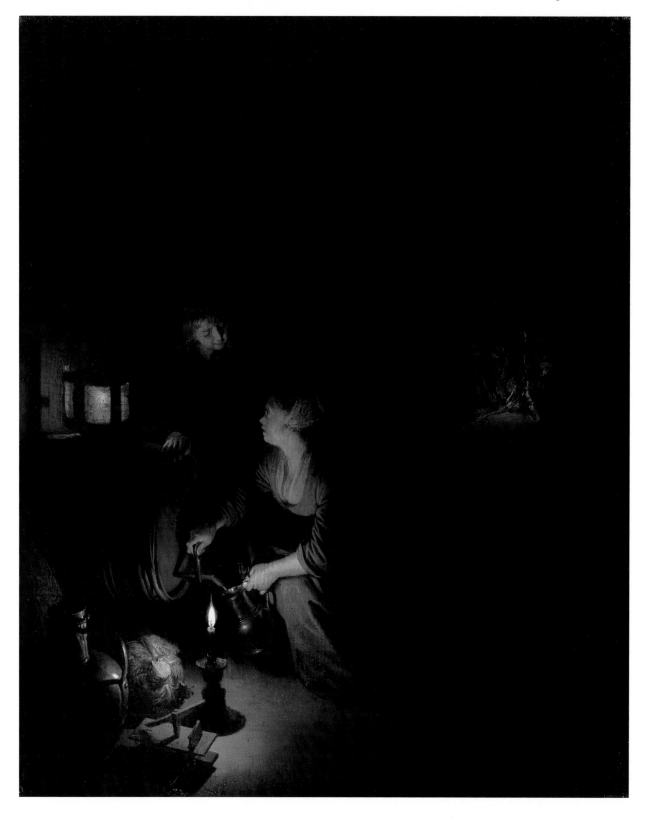

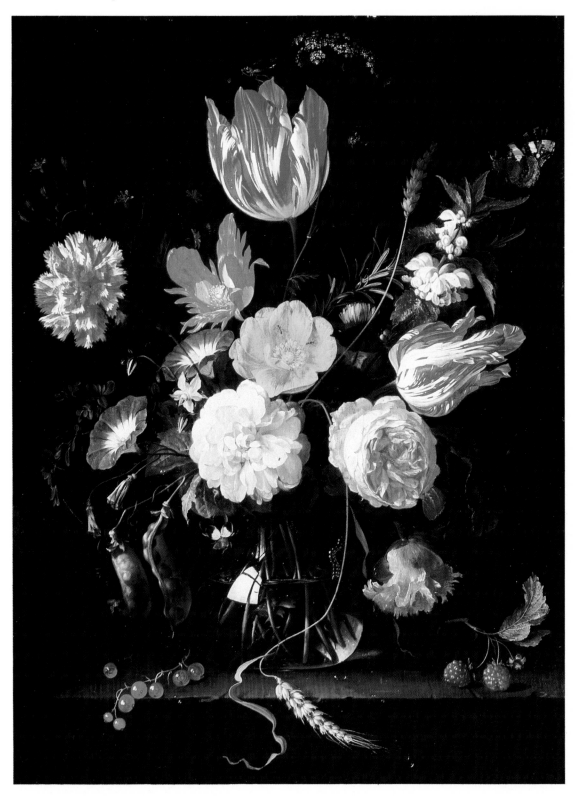

JAN DAVIDSZ. DE HEEM
Dutch 1606–84
A Still Life of Flowers
Signed
Oil on panel
18¾ × 14 in.
(47.5 × 35.8 cm.)
Sold 29.5.86 in Amsterdam
for D.fl.1,972,000 (£505,641)
Record auction price for any
work of art sold in The
Netherlands

Opposite:
CORNELIS DE HEEM
Dutch 1631–95
A Still Life of Fruit
Signed
Oil on canvas
28¼ × 21½ in.
(71.8 × 54.5 cm.)
Sold 13.12.85 in London for
£129,600 ($185,911)

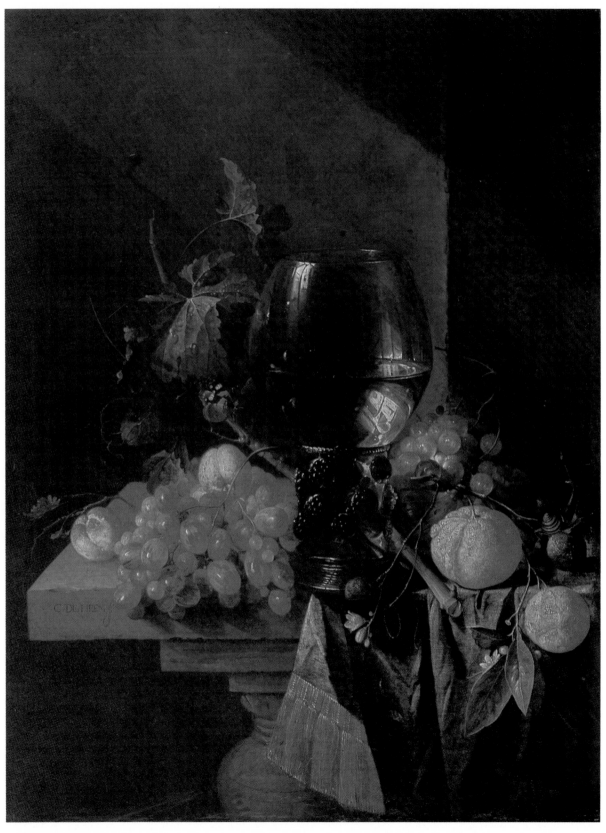

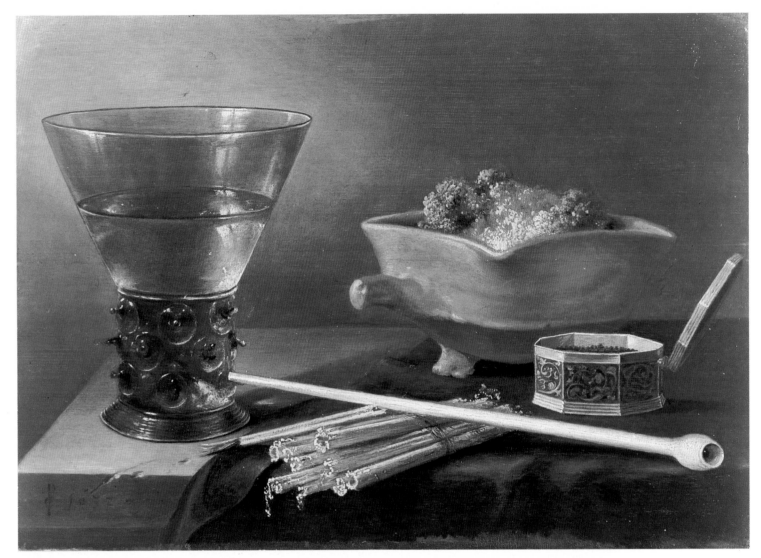

PIETER CLAESZ.
Dutch 1590–1661
A Vanitas Still Life
Signed with monogram and dated 1632
Oil on panel
10⅛ × 14¼ in. (25.7 × 36.2 cm.)
Sold 4.7.86 in London for £226,800 ($340,200)
Record auction price for a work by the artist
Previously sold at Christie's 15.5.53 for 600 gns.
The smoking requisites illustrate Psalm CII, 3, 'For my days are consumed like smoke…'

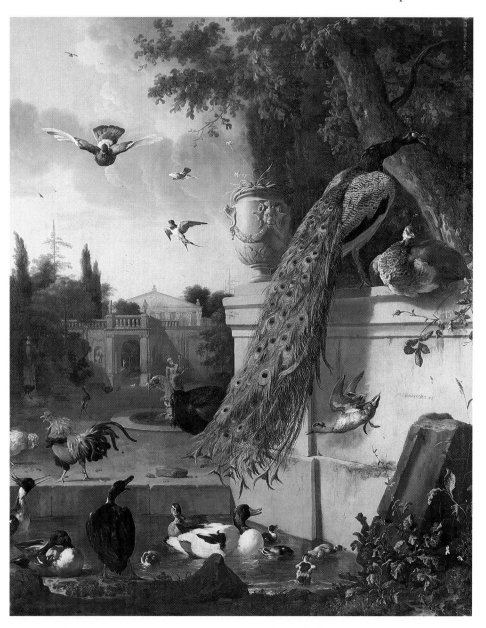

MELCHIOR DE HONDECOETER
Dutch 1636–95
A Peacock and other Birds in the Gardens of a Palace
Signed and dated 1677
Oil on canvas, unframed
97 × 75 in. (264.5 × 195 cm.)
Sold 15.1.86 in New York for $374,000 (£260,900)
Previously sold at Christie's 10.12.48 for 630 gns. and again 29.5.59 for 2,730 gns.

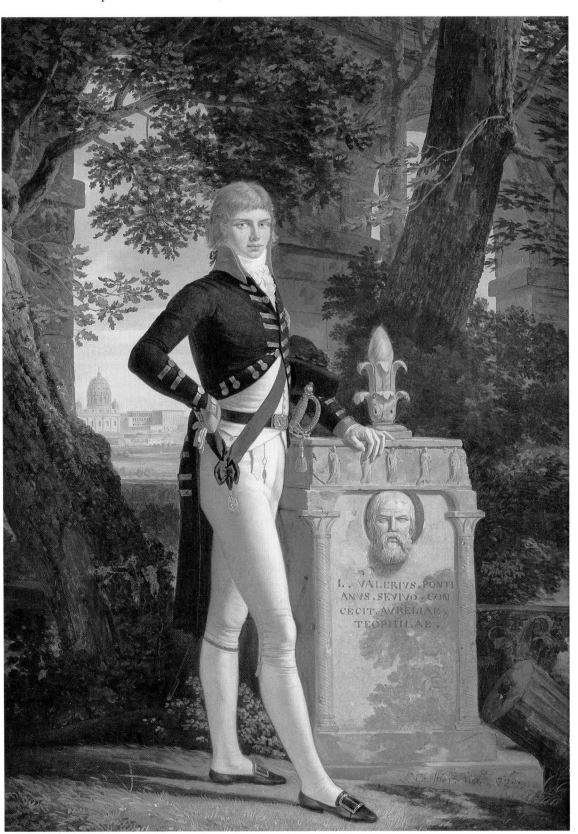

LOUIS GAUFFIER
French 1761–1801
Portrait of Prince Augustus Frederick, later Duke of Sussex, standing in Windsor Uniform, a ruined Aqueduct and the Vatican beyond
Signed, inscribed 'Flor.ce' and dated 1793
Oil on canvas
27 × 19¾ in. (68.5 × 50 cm.)
Sold 11.7.86 in London for £205,200 ($307,800)

Augustus Frederick, Duke of Sussex (1773–1843), was the 6th son of King George III and Queen Charlotte. During the winter of 1792, when in Rome, he met Lady Augusta Murray, 2nd daughter of the 4th Earl of Dunmore, whom he married on 4 April 1793 in Rome. The King declared the marriage void. In 1801 Prince Augustus was created Baron Arklow, Earl of Inverness and Duke of Sussex. He estranged himself from his father and the court because of his liberal views. After his death much of his collection was sold at Christie's.

JOHN WOOTTON
British 1682–1765
*A Huntsman on a Grey
Thoroughbred Stallion
with Hounds*
Signed
Oil on canvas
50 × 40 in.
(127 × 101.5 cm.)
Sold 19.9.85 in
Glasgow for £240,240
($318,919)
Record auction price
for any work of art
sold in Scotland

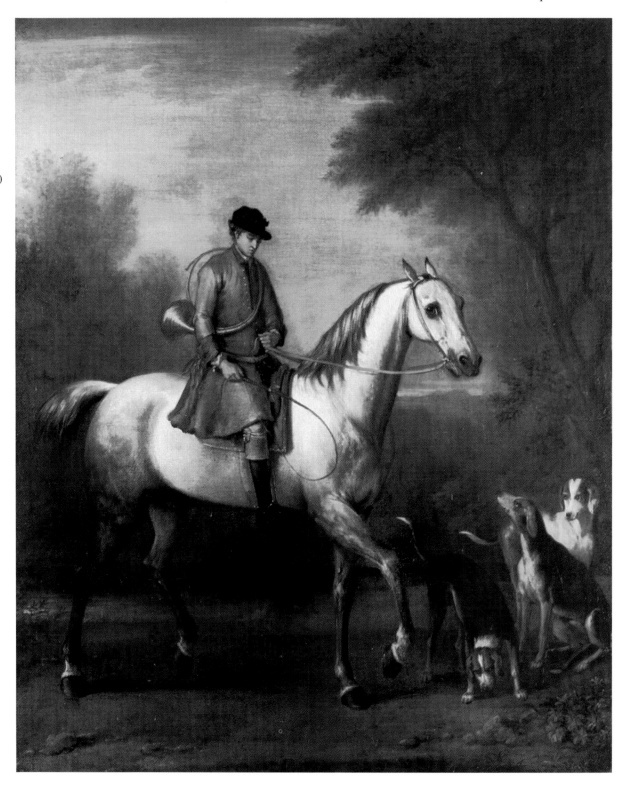

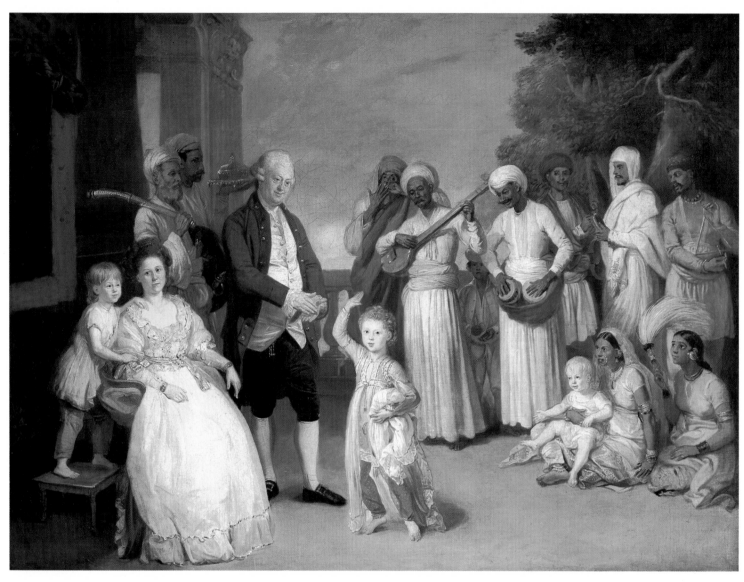

JOHANN ZOFFANY, R.A.
British 1733–1810
Group Portrait of Sir Elijah and Lady Impey with their three Children, Ayahs and Servants on the Terrace of a House
Oil on canvas
36 × 48 in. (91.5 × 122 cm.)
Sold 18.4.86 in London for £216,000 ($326,160)
Sir Elijah Impey (1732–1809) was appointed first Chief Justice of the Supreme Court of Justice at Calcutta in 1773. He was knighted in 1774 and sailed on the *Anson* for India the following year, arriving in October, and almost immediately he was involved in complex procedures brought before the court involving Warren Hastings, then the Governor-General, and an old school friend of Impey. Zoffany arrived in Calcutta in the autumn of 1783 and the picture must have been begun almost immediately, as Impey returned to England in the following December.

GILBERT STUART
American 1755–1828
Portrait of Master Day
Oil on canvas
66 × 38½ in. (167.6 × 97.8 cm.)
Sold 22.11.85 in London for £410,400
($590,976)
Record auction price for a work by the artist
Master Day was the son of Sir John Day, K.B.
(1738–1808), Advocate-General of the East
India Company in Bengal, and his wife
Benedetta, eldest daughter of Nicholas Ramus.
The picture was originally owned by his
godfather, Abraham Josiah Sluyske, Director of
Trade at Surat in the service of the Dutch East
India Company from 1765, and later Governor
of the Cape of Good Hope.

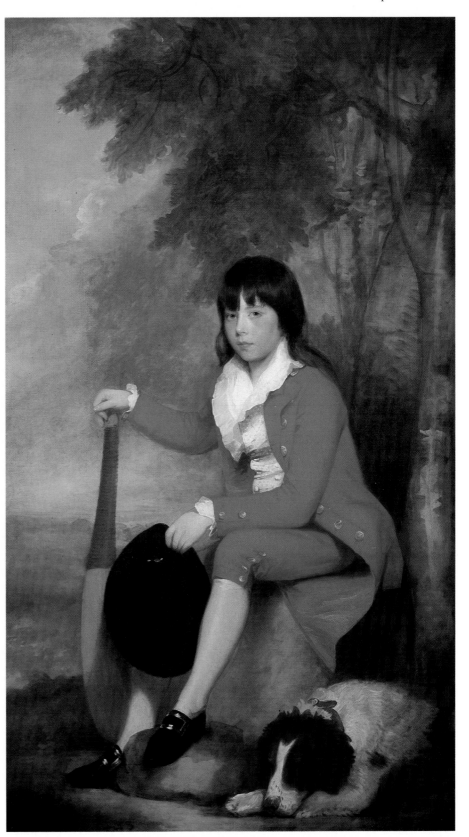

SIR HENRY RAEBURN, R.A.
British 1756–1823
Portrait of Lieutenant-Colonel Morrison of the 7th Dragoon Guards
Oil on canvas
35 × 27 in.
(89 × 68.5 cm.)
Sold 18.4.86 in London for £140,400 ($212,004)
William Mansfield Morrison was appointed Cornet, 13th Light Dragoons, on 10 July 1799. He became Captain in the 7th Dragoon Guards in 1804 and Lieutenant-Colonel of the 23rd Light Dragoons in 1830.

SIR THOMAS LAWRENCE,
P.R.A.
British 1769–1830
*Portrait of Lady Wallscourt
playing a Guitar*
Oil on canvas
$35\frac{1}{2} \times 27\frac{1}{2}$ in.
(90.1 × 69.8 cm.)
Sold 18.4.86 in London
for £151,200 ($228,312)
Elizabeth, Lady
Wallscourt (1805–77),
was daughter of William
Lock II of Norbury, and
married the 3rd Lord
Wallscourt in 1822

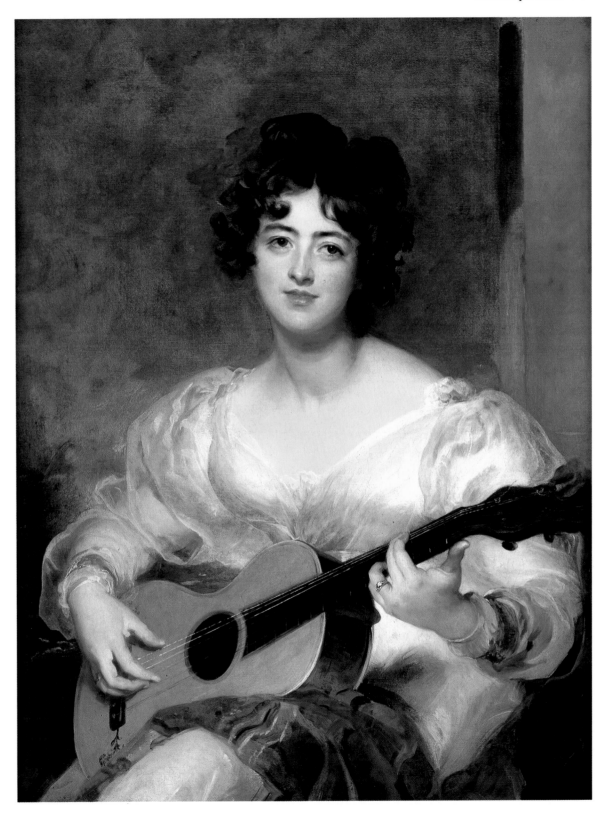

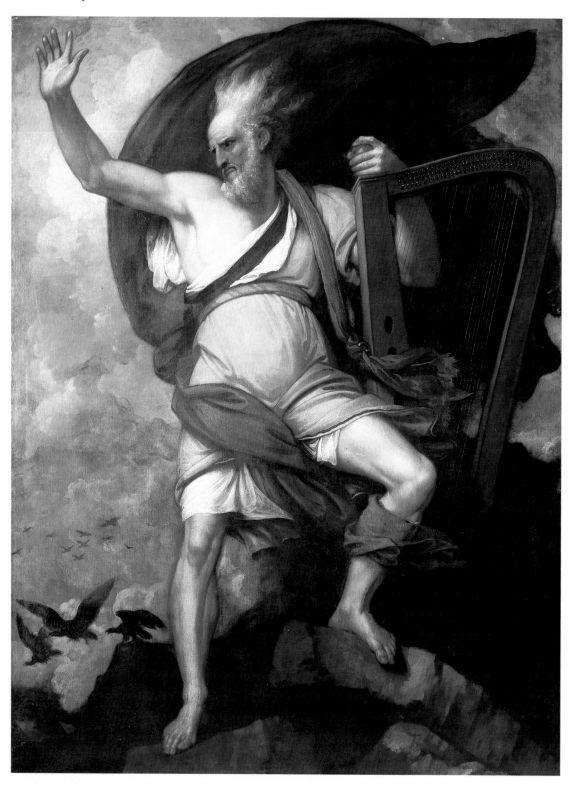

BENJAMIN WEST, P.R.A
British 1738–1820
The Bard
Signed and dated 1809
Oil on canvas
96 × 72 in.
(243.8 × 182.8 cm.)
Sold 11.7.86 in London for
£172,800 ($259,200)
Previously sold at Christie's
11.5.1867 for 69 gns.
The subject is taken from
Thomas Gray's poem, *The
Bard*, which was in turn
inspired by the Welsh legend
that King Edward I, after
conquering Wales, ordered
that all the Bards captured
should be put to death. Many
artists painted the subject and
West first worked on this as
early as 1778.

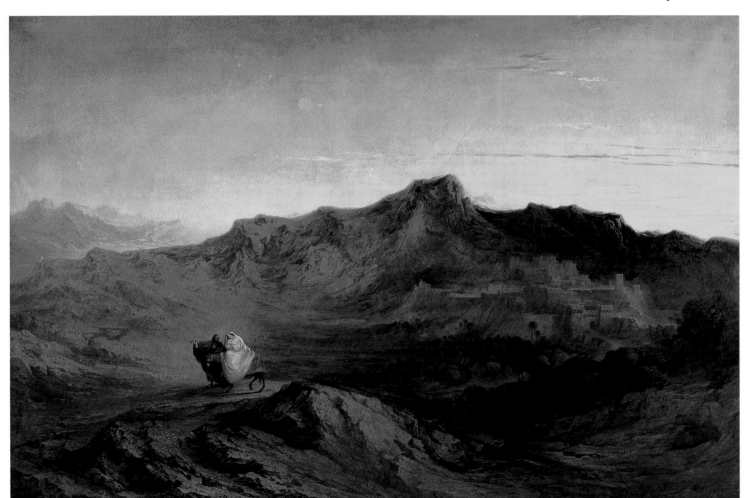

JOHN MARTIN
British 1789–1854
The Flight into Egypt: 'When he arose, he took the young child and his mother by night, and departed into Egypt' (Matthew II, 14)
Signed and dated 1842
Oil on canvas
55 × 83 in. (139.6 × 210.7 cm.)
Sold 22.11.85 in London for £194,400 ($279,936)
Record auction price for a work by the artist
Previously sold at Christie's 20.10.50 for 46 gns.

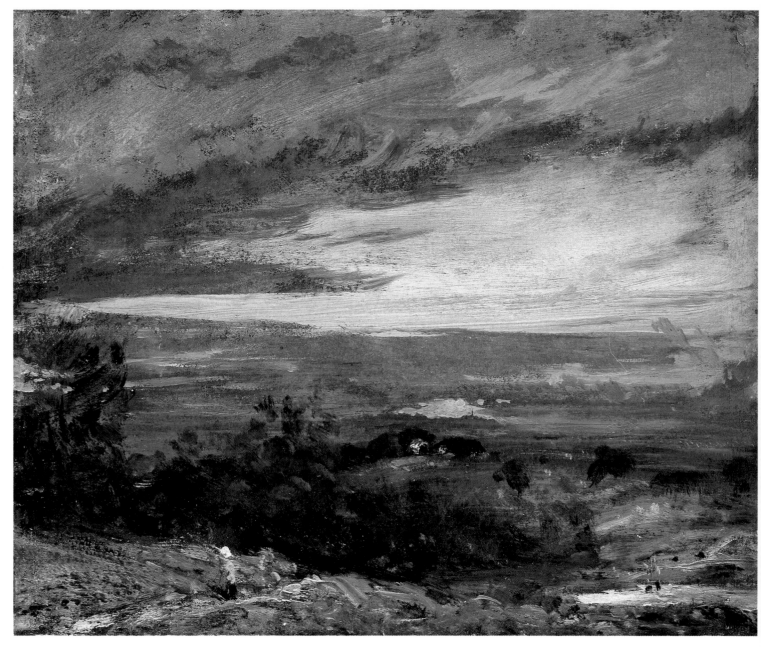

JOHN CONSTABLE, R.A.
British 1776–1837
Sunset study of Hampstead, looking towards Harrow
Inscribed on the reverse 'Sepr. 12. 1821. Sun setting over Harrow. This appearance of the Evening was (aft) just after a very heavy rain in the night and very light wind which continued all the day following – (the 13th) while making this sketch observed the Moon rising very beautifully (in the) due East over the heavy clouds from which the late showers had fallen., and Wind gentle…increasing from the North west. rather'
Paper laid down on panel
$9\frac{1}{2} \times 11\frac{1}{2}$ in. (24.1 × 29.2 cm.)
Sold 22.11.85 in London for £345,600 ($497,664)
Record auction price for a work by the artist; previously sold at Christie's 2.11.34 for 245 gns.

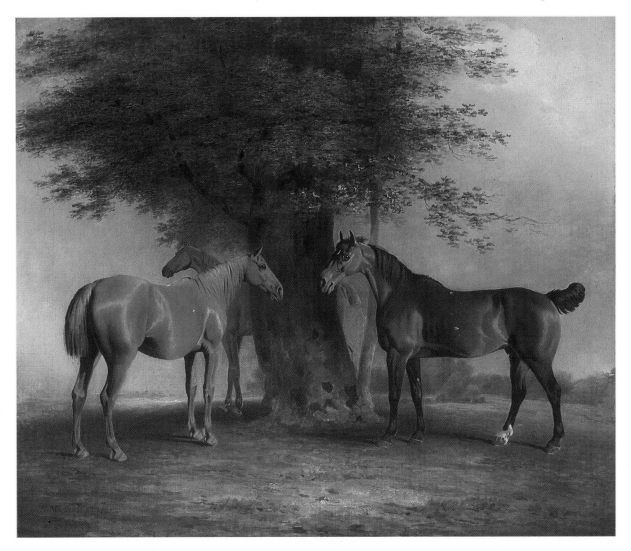

BEN MARSHALL
British 1767–1835
Hunters at Grass
Signed and dated 1801
Oil on canvas
33¼ × 39½ in. (84.5 × 100.3 cm.)
Sold 6.6.86 in New York for $198,000 (£132,000)
From the estate of Lucia Chase Ewing; previously in the collection of Alexander Smith Cochran

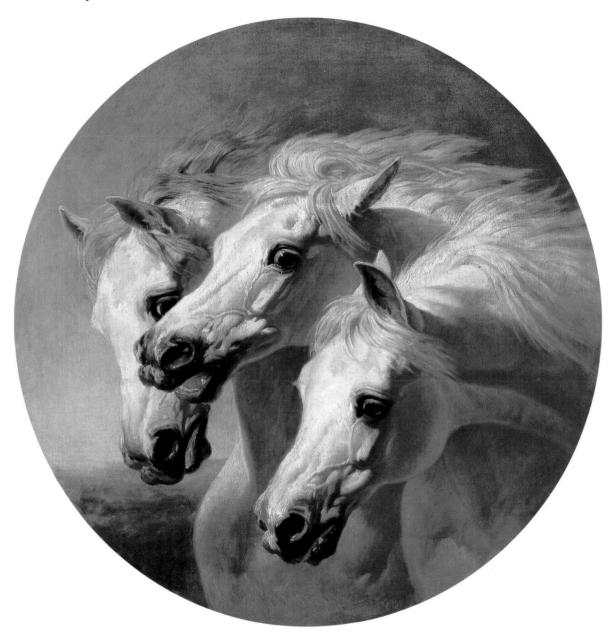

JOHN FREDERICK HERRING, SEN.
British 1795–1865
Pharoah's Horses
Signed and dated 1848; indistinctly inscribed on the reverse
Oil on canvas
31 in. (78.8 cm.) diameter
Sold 11.7.86 in London for £297,000 ($445,500)
By order of the L.A. Mayer Memorial Foundation from the
collection of Sir David Salomons

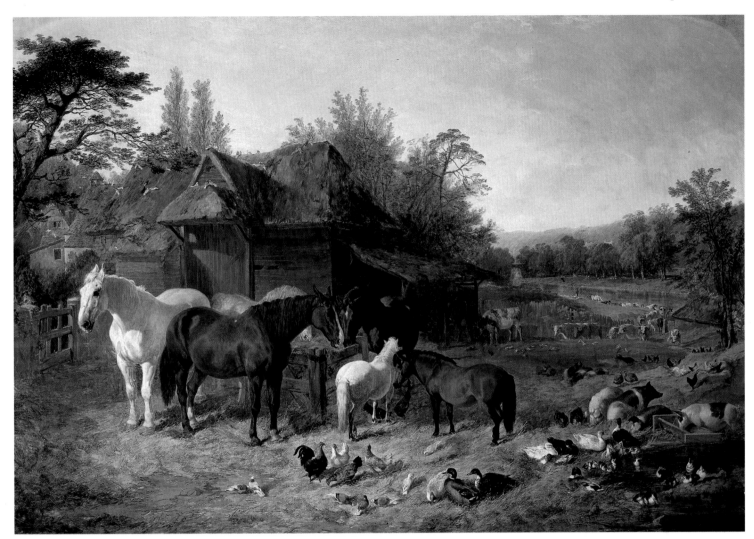

JOHN FREDERICK HERRING, SEN.
British 1795–1865
A Farmyard with Horses and Ponies, Berkshire Saddlebacks, Alderney Shorthorn Cattle, Bantams, Mallard and Guinea Fowl
Signed and dated 1853
Oil on canvas
48 × 70 in. (121.9 × 177.8 cm.)
Sold 18.4.86 in London for £237,600 ($358,776)
Painted for William Taylor Copeland (1797–1868) of the Copeland and Spode Company, a major patron of the artist

The Hans E. Bühler Collection of Works by Géricault

PHILIP HOOK

The finest collection of works by the great French Romantic painter Théodore Géricault to be offered for sale in recent times surpassed all expectations in London on 15 November 1985 when it realized nearly £5 million ($7.2 million). Buyers from all over the world, and especially from the United States, converged to compete for the many rare and beautiful examples.

Hans Bühler (1893–1967), the Swiss collector responsible for assembling the group on offer, was himself a man of many parts, Olympic equestrian, cavalry officer, and artist. It is not difficult to imagine him being drawn to Géricault, whose love of horses and romantic temperament matched his own. The collection was formed from 1920 onwards, so that Bühler had to chart a course through changing critical seas. Pictures accepted as unquestionably autograph before the war have since been generally rejected; even today leading critics are divided over the status of others. Under the circumstances, Bühler managed to gather together a good proportion of fine examples, including about 10 masterpieces.

The star oil painting was the *Buste de nègre* possibly connected with the *Raft of the Medusa*, which sold for £1,458,000 ($2,070,360). If indeed it is merely a rejected study for Géricault's *chef-d'oeuvre*, as has been suggested, then it is further evidence of the time, energy and passion devoted to that project, for here is a hauntingly beautiful portrait which was only its by-product. The second most expensive painting was also a study, unfinished, measuring only $8 \times 11\frac{1}{2}$ in. (20 × 29 cm.) for *La Course de chevaux libres*. This subject was the major preoccupation of Géricault's year in Rome (1816–17). Several versions exist, although, typically, Géricault never produced one fully finished to his satisfaction. This study shows Géricault at an interesting stage in the composition's development, breaking the processional effect of earlier sketches and experimenting with new angles of light. A painting of such compressed power and delicacy is a rare commodity indeed, and it was no surprise that it was acquired on behalf of the Getty Museum for £540,000 ($766,800), where it will join the *Buste de nègre*.

The sale was widely perceived as the best opportunity likely to occur for some time to acquire major works by Géricault, an artist whose output was limited by his lifespan of 33 years, and competition was fierce. The top watercolour was the magnificent Orientalist *La Giaour*, an illustration to a poem by Byron. As such it united two of the great forces of Romanticism – the restless artist interpreting the passionate poet, both of whom died young – and it is hard to imagine a more desirable icon of the movement. It fetched £356,400 ($516,780). Just as the negro's head was the world record price for an oil painting by the artist, this was the highest price ever paid for a watercolour by him, and it was gratifying to achieve the world record for a Géricault print in the same sale when the lithograph *Boxeurs* made £45,360 ($64,411).

Two most unusual drawings of landscapes illustrated the breadth of material available in the sale. One, in pencil, pen, ink and watercolour, depicted Tivoli, and with its hatching technique and washes seems to have been executed in conscious emulation of the Old Masters. The other (ironically earlier in date than the drawing of Tivoli) was much more forward-looking in its free handling, and showed Montmartre, where the artist lived from 1813. Each in its way had a unique appeal, and in the event Tivoli sold for £145,800 ($207,036) and Montmartre for £91,800 ($130,356). Another very beautiful equestrian watercolour of a charging cavalry officer made an outstanding £237,600 ($337,390).

Géricault visited England in 1821–2, and became a keen admirer of English sporting painters like James Ward and Ben Marshall. Despite this early connection, he has remained relatively unknown as a painter on the English side of the Channel in the years since. The opportunity to view so many outstanding examples of his work together in London was taken by many people before the sale. Indeed, there had never been a Géricault exhibition of comparable scale or quality in this country, so Christie's were delighted to be able to provide it, at least for two weeks. As it turned out, the response of the buying public was a measure of the collection's desirability and the deep impression it made.

THÉODORE GÉRICAULT
French 1791–1824
Buste de nègre
Oil on canvas
18¼ × 15 in.
(46.5 × 38 cm.)
Sold 15.11.85
in London for
£1,458,000
($2,070,360)
Record auction
price for a
work by the artist

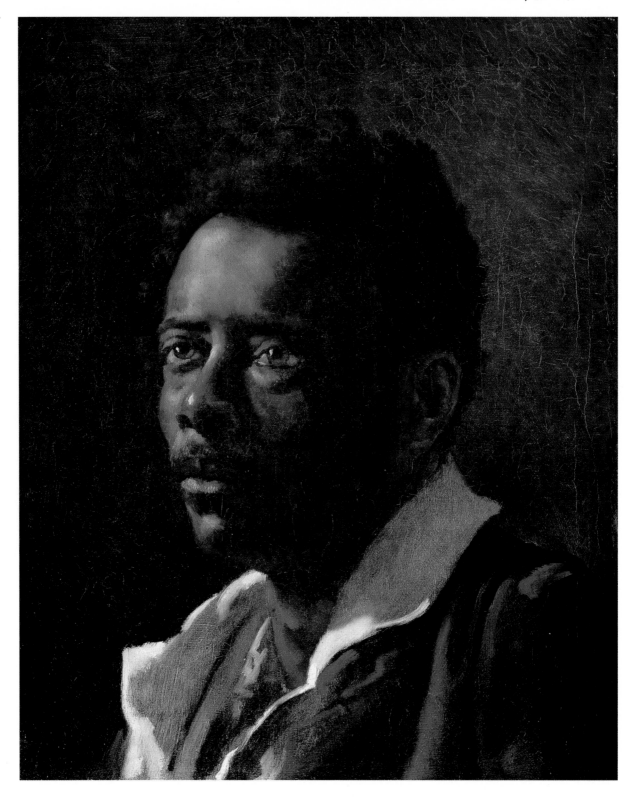

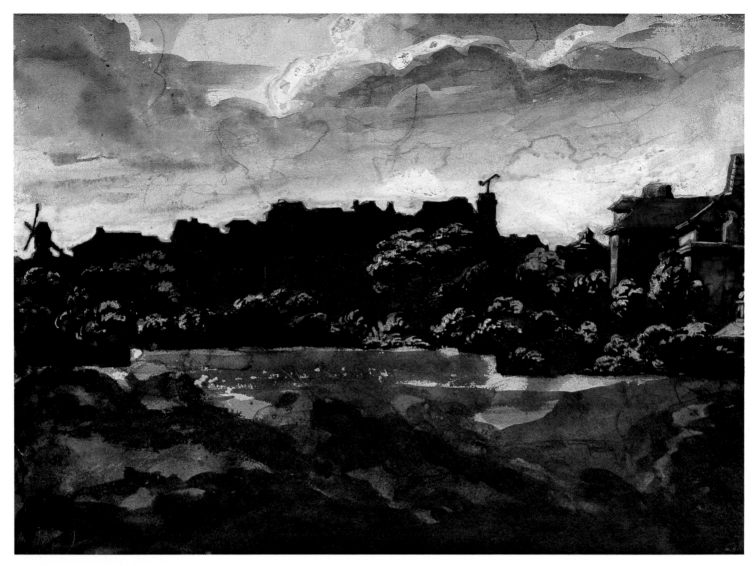

THÉODORE GÉRICAULT
French 1791–1824
Vue des collines de Montmartre
Watercolour and bodycolour
$7\frac{3}{4} \times 10\frac{3}{4}$ in. (18.7 × 26.4 cm.)
Sold 15.11.85 in London for £91,800 ($130,356)

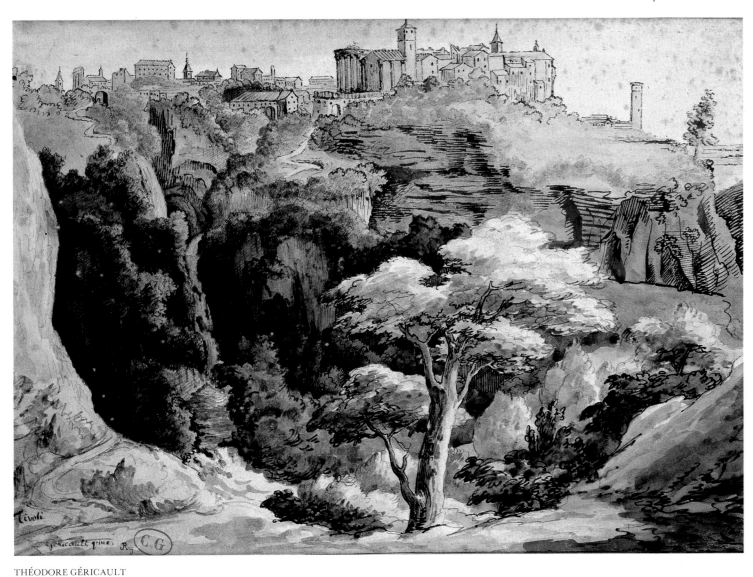

THÉODORE GÉRICAULT
French 1791–1824
Vue de Tivoli
Signed and inscribed 'Tivoli'
Pencil, pen and brown ink, and watercolour
$8\,^{13}/_{16} \times 15\,^{11}/_{16}$ in. (22.4 × 41.5 cm.)
Sold 15.11.85 in London for £145,800 ($207,036)

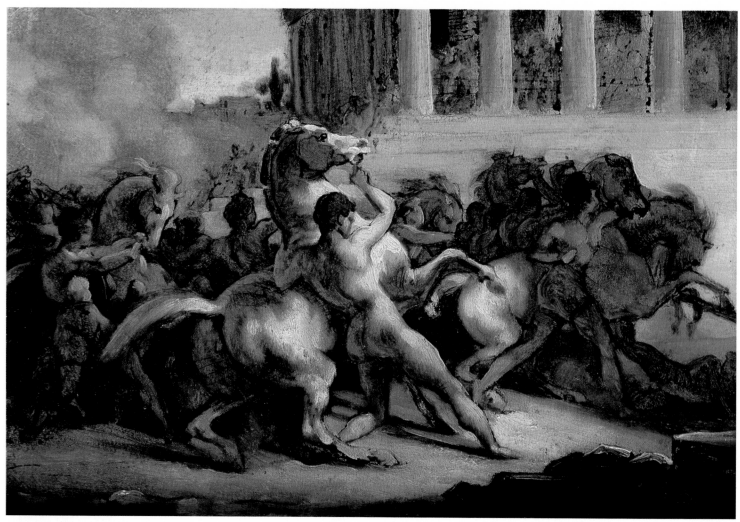

THÉODORE GÉRICAULT
French 1791–1824
La Course de chevaux libres
Oil on paper laid on canvas
8 × 11½ in. (20 × 29 cm.)
Sold 15.11.85 in London for £540,000 ($766,800)

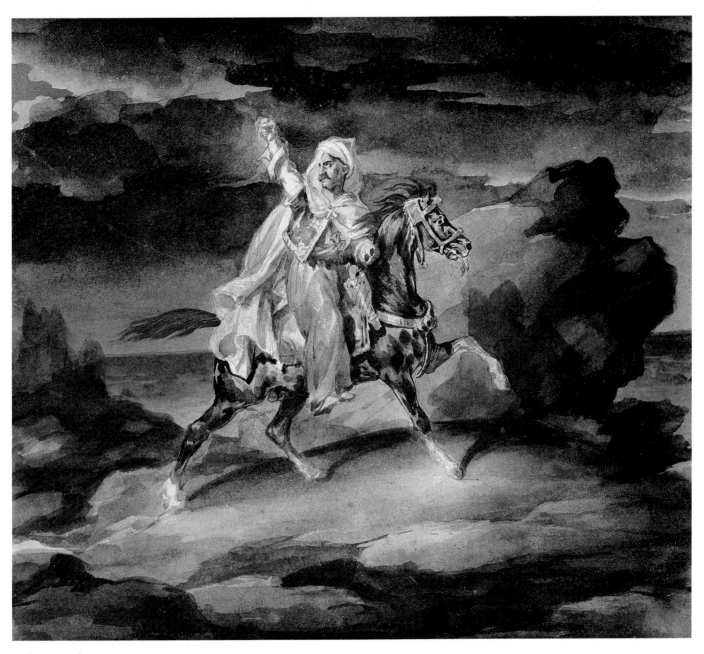

THÉODORE GÉRICAULT
French 1791–1824
Le Giaour
Watercolour
8¼ × 9½ in. (21 × 24 cm.)
Sold 15.11.85 in London for £356,400 ($516,780)
Record auction price for a drawing by the artist

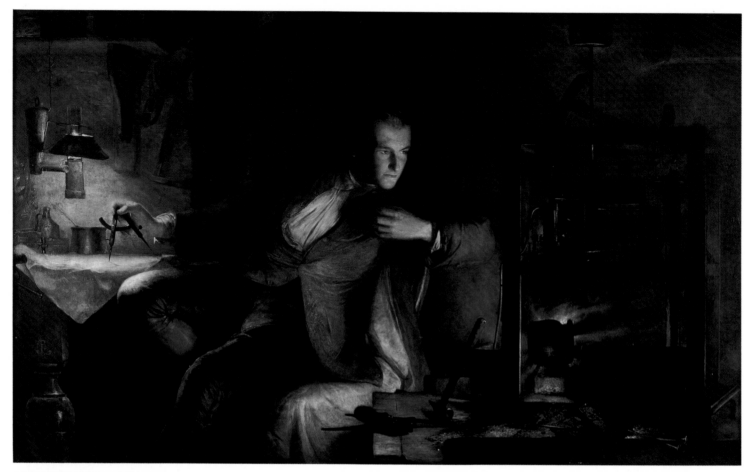

JAMES ECKFORD LAUDER, R.S.A.
British 1811–69
James Watt and the Steam Engine
Signed twice with monogram
Oil on canvas
58 × 94 in. (147.3 × 238.8 cm.)
Sold 30.4.86 in Glasgow for £41,490 ($63,895)
Record auction price for a work by the artist
From the collection of Mrs Dorothy Henry
Now in the National Gallery, Scotland

James Watt was born in Greenock on 19 January 1736, the son of a shipwright and nautical instrument maker. At the age of 21 he was appointed scientific instrument maker to the University of Glasgow. It was here, in 1764, that he repaired the University's model of a Newcomen steam engine. The inefficiency of this model directed Watt's attention to improving the design of the steam engine, which had remained almost unchanged for half a century, from 1720 to 1769, when Watt's first patent was taken out. His invention of a separate steam condenser was the major factor behind Britain's industrial expansion at the end of the 18th Century. In recognition of this and many other inventions, Watt was made a Fellow of the Royal Society of Edinburgh in 1784, of the Royal Society of London in 1785, and a Doctor of Law of Glasgow in 1806. He died at Aston Hall, Warwickshire, on 2nd June 1819. The picture sold shows Watt working on the model Newcomen steam engine which is in the possession of the Glasgow Hunterian Museum. The influence of the work of Joseph Wright of Derby shows very strongly in this painting, especially Wright's three major scientific paintings, *A Philosopher by Lamplight*, *Experiment on a Bird in the Air Pump*, and *The Alchemist*.

JEAN FRANÇOIS MILLET
French 1814–79
Portrait of Madame J.F. Millet (Catherine Lemaire)
Signed with initials
Oil on canvas
21¾ × 19 in.
(55.3 × 48.2 cm.)
Sold 21.5.86 in New York for $77,000 (£50,327)
This painting is a portrait of Millet's second wife, Catherine Lemaire. She served as a model for several of his genre drawings, usually in the role of peasant mother or housekeeper. The only other known portrait of her exists in a drawing in The Boston Museum of Fine Arts. The painting may have been executed in 1844.

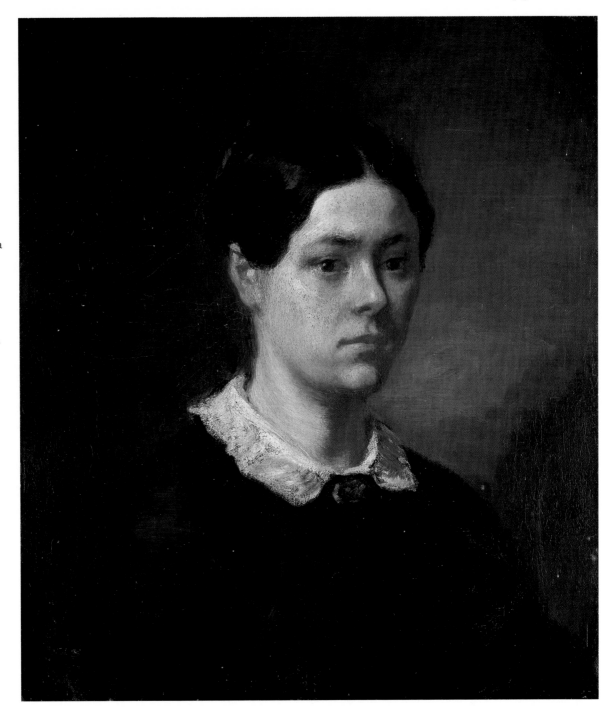

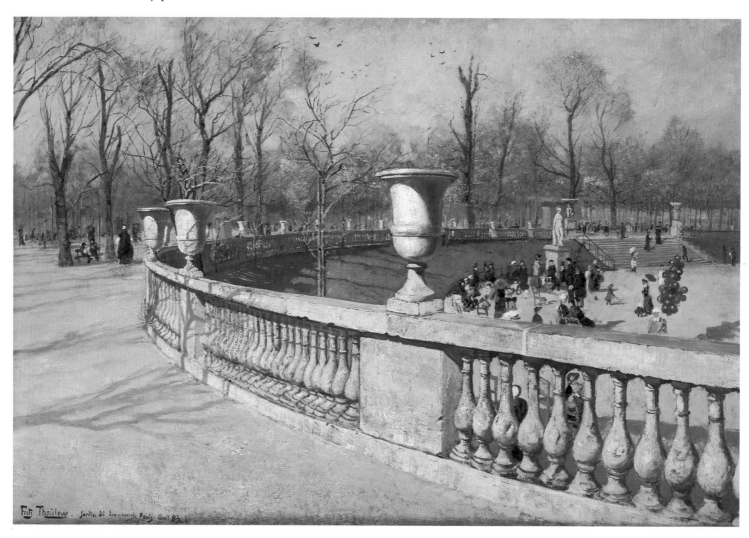

FRITS THAULOW
Norwegian 1847–1906
Jardin du Luxembourg
Signed, inscribed and dated 'Paris Avril 83'
Oil on panel
26 × 38¹/₂ in. (66.5 × 97.8 cm.)
Sold 29.11.85 in London for £140,400 ($206,388)

CARL LARSSON
Swedish 1853–1919
In the Hawthorn Hedge
(I hagtornshacken)
Signed with initials
Pen, ink, bodycolour and
watercolour, on paper laid on
canvas
37 × 24 in. (94 × 61 cm.)
Sold 29.11.85 in London for
£129,600 ($190,512)
The painter's daughter Suzanne is
seen in the garden of the family
house, now the Carl Larsson
Museum

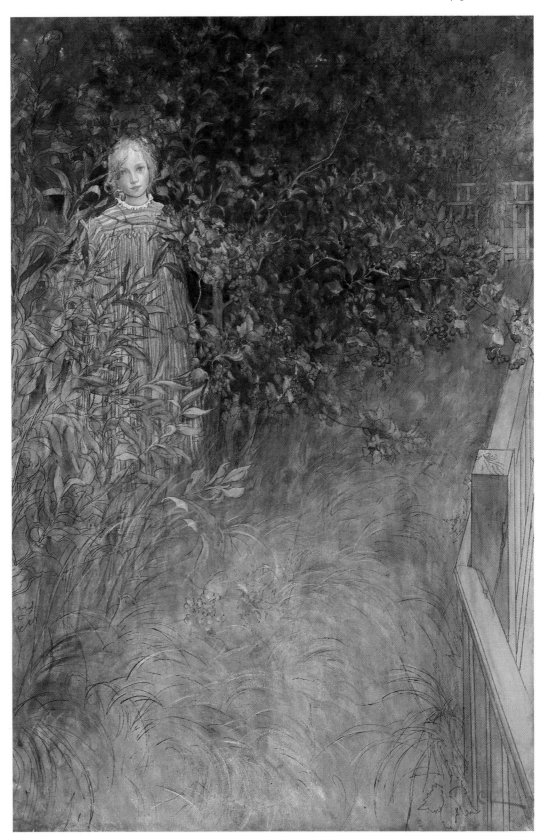

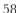

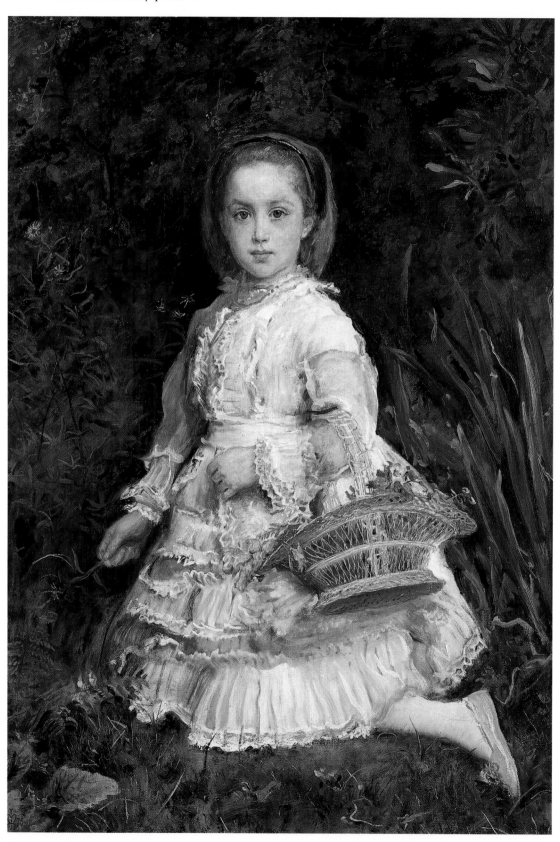

SIR JOHN EVERETT MILLAIS, BT.,
P.R.A.
British 1829–96
*Portrait of Gracia, daughter of
Evans Lees, picking Wild Flowers*
Signed with monogram and
dated 1875
Oil on canvas
$42\frac{1}{4} \times 29\frac{1}{2}$ in.
(107.2 × 75 cm.)
Sold 20.6.86 in London for
£129,600 ($195,178)

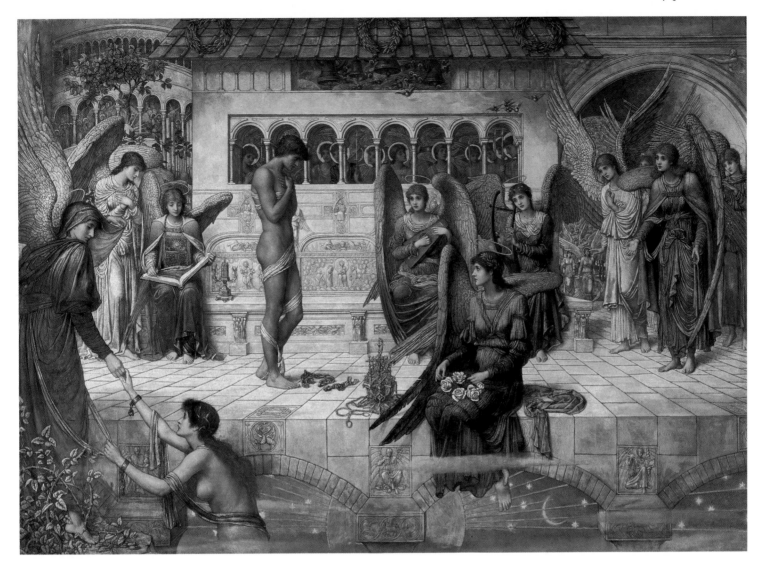

JOHN MELHUISH STRUDWICK
British 1849–1937
The Ramparts of God's House
Oil on canvas
24 × 33½ in. (61 × 85.1 cm.)
Sold 27.11.85 in London for £194,400 ($285,768)
Previously sold at Christie's on 28 June 1907 for 105 gns.
George Bernard Shaw describes the picture as follows: 'A man stands on the threshold of heaven, with his earthly shackles newly broken, lying where they have just dropped, at his feet. The subject of the picture is not the incident of the man's arrival, but the emotion with which he is welcomed by the angels. The foremost of the two stepping out from the gate to meet him is indeed angelic in her ineffable tenderness and loveliness; the expression of this group, heightened by its relation to the man, is so vivid, so intense, so beautiful, that one wonders how this sordid nineteenth century of ours could have such dreams, and realise them in its art. Transcendent expressiveness is the moving quality in all Strudwick's works; and persons who are fully sensitive to it will take almost as a matter of course the charm of the architecture, the bits of landscape, the elaborately beautiful foliage, the ornamental accessories of all sorts, which would distinguish them even in a gallery of early Italian paintings.'

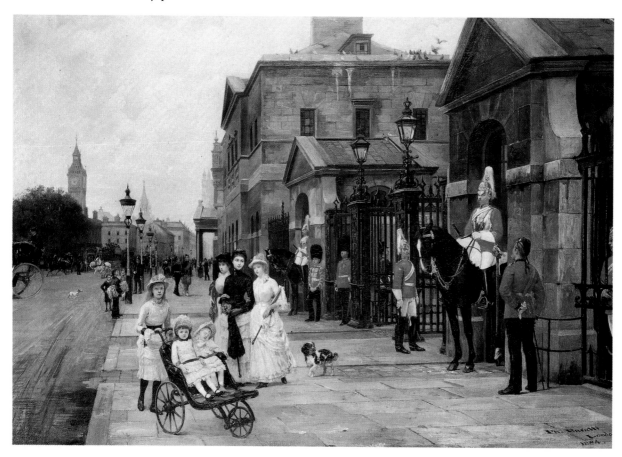

FILIPPO BARATTI
Italian 19/20th century
Whitehall
Signed and dated London 1884
Oil on canvas
27 × 39 in. (68.5 × 99 cm.)
Sold 20.6.86 in London for £48,600 ($73,192)
The artist, who was best known for his orientalist
and historical scenes, worked in London in the
mid-1880s

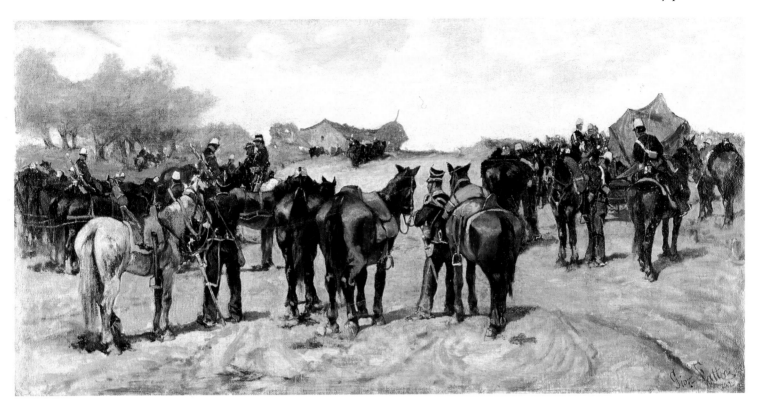

GIOVANNI FATTORI
Italian 1825–1908
Cavalry halted on a Road
Signed and dated 1882
Oil on canvas
12 × 23½ in. (30.5 × 59.6 cm.)
Sold 21.3.86 in London for £59,400 ($88,506)

The Jay Family Collection of American Portraits

JAY E. CANTOR

As icons of American history, portraits of the founding fathers have an interest far beyond the limited enthusiasm for portraits in general. For nearly a century prior to World War II, historical portraits occupied centre stage in the collecting arena of American painting. Prized for their antiquarian interest and compatibility with antique furniture, such portrait collections readily found homes in the scores of historical societies and art museums established in America during this period.

Rarely has such a distinguished group of portraits appeared in the market in recent times as those sent for sale by the descendants of John Jay. The paintings were particularly notable for having been commissioned by one of the principal architects of the American nation as a pantheon of fellow nation-makers. Included among the collection were images of John Jay, the first secretary of state and first chief justice of the Supreme Court, by Gilbert Stuart, and portraits of the first president and vice-president, George Washington and John Adams, by John Trumbull, who served during the revolution as an aide-de-camp of Washington and later as Jay's secretary during negotiations with Britain. A companion portrait by Trumbull of Alexander Hamilton had previously left family hands and is now in the National Gallery, Washington.

Jay also distinguished himself in New York state politics after his national career, and souvenirs of that career survived in portraits of Stephen Van Rensselaer, lieutenant-governor when Jay was governor of New York State, and Egbert Benson, a distinguished state jurist and lifelong friend and colleague of Jay. Two political rivals of Jay also joined the family collection during the 1840s when Jay's son, William, acquired portraits of Thomas Jefferson and James Madison by Ezra Ames after originals by Gilbert Stuart. Together these portraits hung in Katonah, the New York farm house that Jay enlarged to serve as his home in retirement and which survives as a museum.

Until these paintings were catalogued for sale, the precise relationship of the artists and the sitters was not fully understood. The major three-quarter length portrait of Jay was apparently the product of a commission given Stuart when Jay was in London recovering his health after difficult negotiations in Paris in 1783. The painting was acquired at the sale by the Diplomatic Reception Rooms at the Department of State in Washington, D.C., for $990,000 (£707,143), a record sale price for the artist. Jay introduced Stuart to George Washington, resulting in the extended series of likenesses of the first president. Jay sat again for Stuart a decade later, posing in academic gowns. During the same period he asked his friend and associate John Trumbull to memorialize Washington, Adams and Hamilton. Long thought to be later replicas, these portraits have now been recognized to be the originals. The portrait of John Adams possibly served as the model for later replicas. With both the Stuart and Trumbull portraits, the artists had first-hand encounters with the subjects, endowing the paintings with a lively intimacy often lost in the glorifying fabrications of later copyists.

The vitality and unique history of these paintings established auction records for all the artists, and pushed the sale total for the seven works to over $1.88 million (£1.25 million), more than double the pre-sale high estimate. While this does not necessarily betoken a broad-based renewal of interest in historical American portraits, it did reveal lively competition between private collectors and public institutions. Several of the Jay portraits were acquired by buyers who will exhibit the paintings publicly. The Adams likeness, which at $286,000 (£204,286) far surpassed the previous Trumbull record of $37,500 (£23,000) set in 1982, promises to appear in a prominent public place. The Stephen Van Rensselaer portrait was acquired for $132,000 (£94,286) for the Albany Institute of History and Art, where this important descendant of the Dutch patron Killian Van Rensselaer is represented by a major suite of furniture. The Egbert Benson will return to the Jay homestead as a memorial of a lifelong friendship, and the portrait of Madison was purchased for $99,000 (£70,715) by the Samuel Freeman Charitable Trust as a gift for Madison's Virginia home, Montpelier. This price, and the $55,000 (£39,286) paid for the Ames portrait of Jefferson, far exceeded the previous record of $2,000 for an Ames portrait!

GILBERT STUART
American 1755–1828
John Jay (1745–1829)
Oil on canvas
$50\frac{1}{4} \times 41\frac{5}{8}$ in.
(127.8×105.7 cm.)
Sold 25.1.86 in New
York for $990,000
(£712,743)
From the Jay Family
Collection of American
Portraits

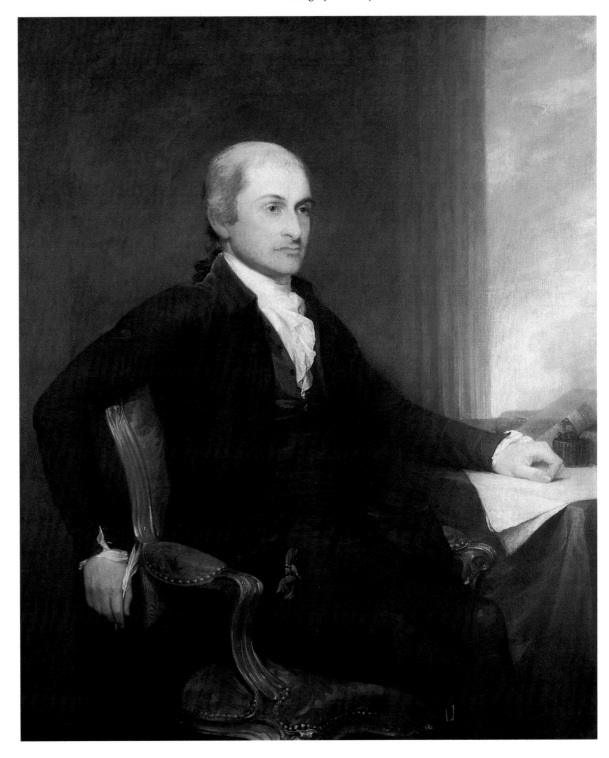

JOHN FREDERICK KENSETT
American 1818–72
Long Island Sound at Darien
Oil on canvas
15¼ × 30¾ in.
(39.5 × 78 cm.)
Sold 6.12.85 in New
York for $110,000
(£74,174)

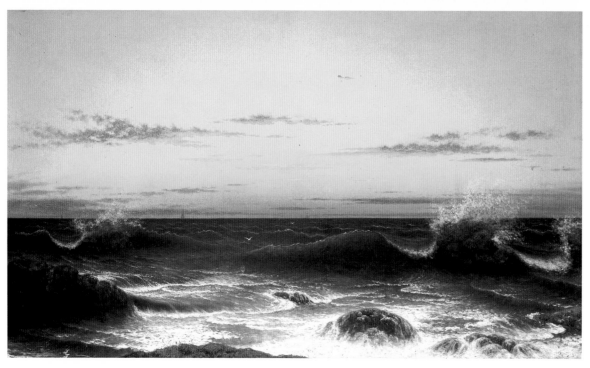

MARTIN JOHNSON HEADE
American 1819–1904
Seascape: Sunset
Signed and dated 1861
Oil on canvas
26 × 44 in.
(66.2 × 111.8 cm.)
Sold 30.5.86 in New
York for $330,000
(£221,032)
From the collection of
The Shelburne Museum

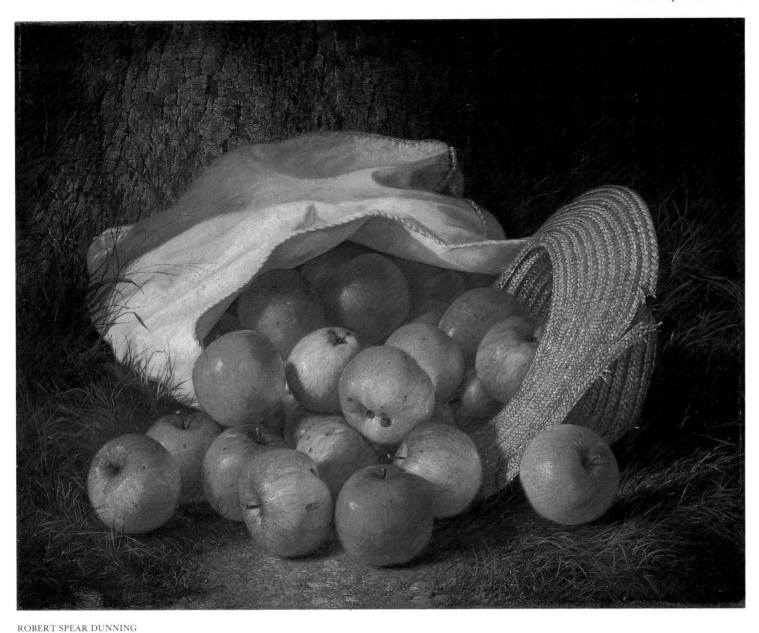

ROBERT SPEAR DUNNING
American 1829–1905
Autumn's Bounty
Signed and dated 1869
Oil on canvas
$19\frac{5}{8} \times 25\frac{1}{4}$ in. (50 × 64.3 cm.)
Sold 6.12.85 in New York for $286,000 (£192,853)

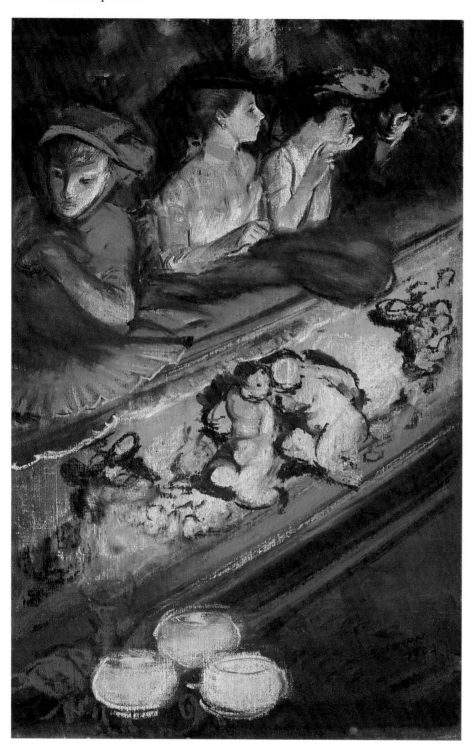

EVERETT SHINN
American 1876–1953
In the Loge
Signed and dated 1903
Oil and pastel on canvas laid down on board
$25\frac{1}{2} \times 17\frac{1}{8}$ in. (64.8 × 43.3 cm.)
Sold 6.12.85 in New York for $242,000
(£163,183)

JAMES ABBOTT MCNEILL WHISTLER
American 1834–1903
Green and Gold: The Dancer
Watercolour on board
$10\frac{7}{8} \times 7\frac{1}{4}$ in. (27.5 × 18.2 cm.)
Sold 6.12.85 in New York for $154,000
(£103,844)

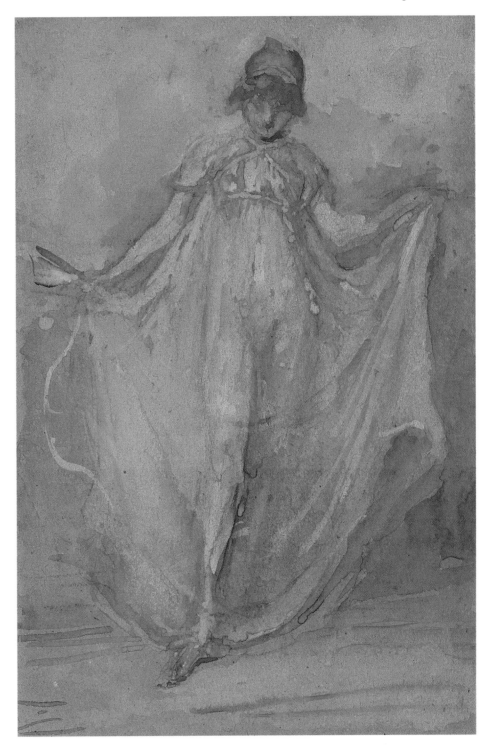

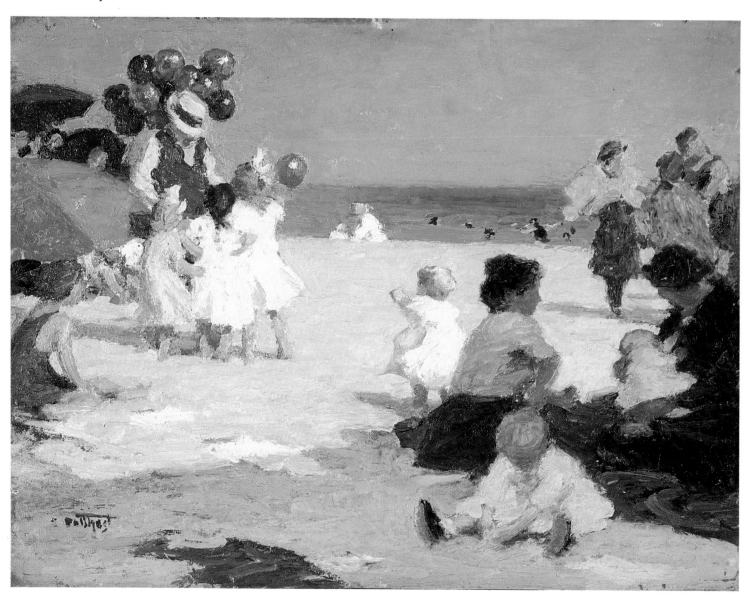

EDWARD HENRY POTTHAST
American 1857–1927
On the Beach
Signed
Oil on panel
12 × 16 in. (30.4 × 40.6 cm.)
Sold 30.5.86 in New York for $198,000 (£132,619)
From the collection of Gloria Vanderbilt

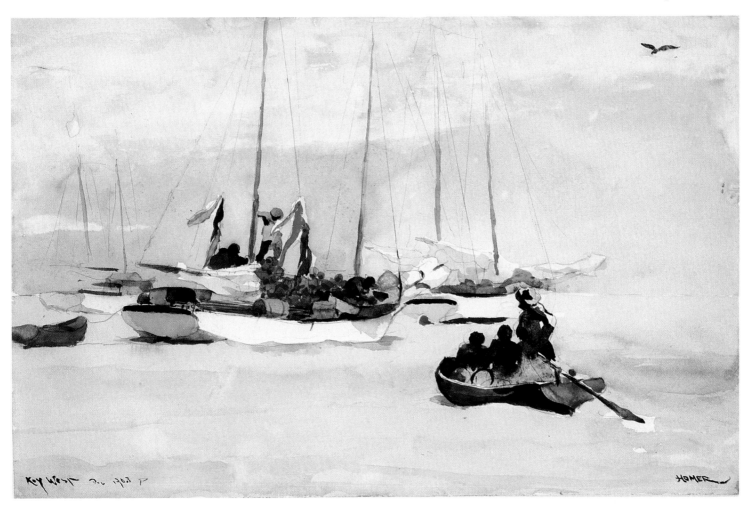

WINSLOW HOMER
American 1836–1910
Schooner at Anchor, Key West
Signed, inscribed 'Key West' and dated Dec. 1903
Watercolour and pencil on paper
14 × 21¾ in. (35.4 × 55.3 cm.)
Sold 30.5.86 in New York for $440,000 (£294,709)

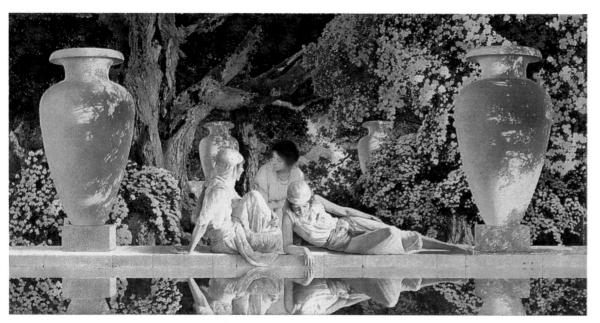

MAXFIELD PARRISH
American 1870–1966
Garden of Allah
Signed with initials
Oil on paper laid down
on panel
15½ × 30⅜ in.
(39.3 × 77.2 cm.)
Sold 6.12.85 in New
York for $220,000
(£148,348)
This painting was
commissioned as the
decoration for 1918 gift
boxes of Crane's
Chocolates

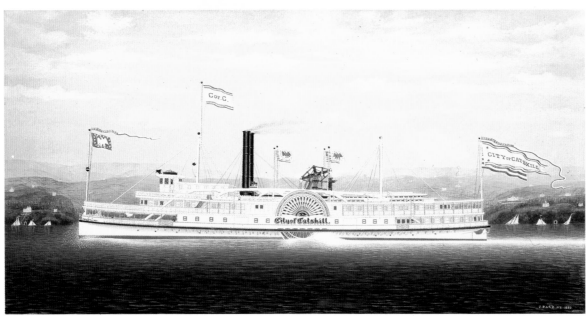

JAMES BARD
American 1815–97
Paddle Steamboat 'City of Catskill'
Signed and dated N.Y. 1880
Watercolour, gouache, pencil and pen and black ink on paper laid down on canvas
25⅞ × 51 in. (65.5 × 129 cm.)
Sold 30.5.86 in New York for $88,000 (£58,942)
The *City of Catskill* was an American wooden paddle wheel steamboat built in 1880 by Van Loan and
Magee in Athens, New York. She served the area between New York and Catskill from 1882 to 1883,
when she burned at dock in Rondout, New York.

JOHN HENRY TWACHTMAN
American 1853–1902
Gloucester
Signed
Oil on canvas
25 × 30 in. (63.5 × 76.3 cm.)
Sold 30.5.86 in New York for $187,000
(£125,252)

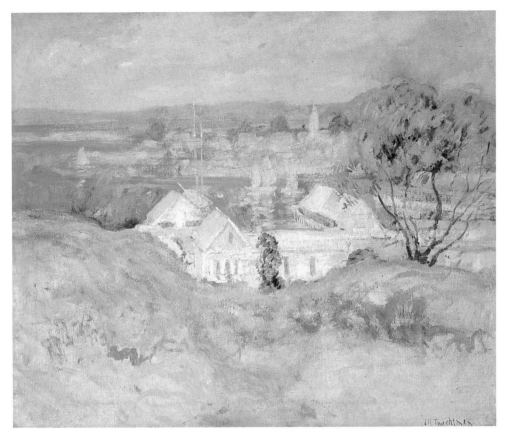

BEN SHAHN
American 1898–1969
Self-Portrait among Churchgoers
Signed
Tempera on masonite
Painted in 1939
20 × 29½ in. (51 × 75 cm.)
Sold 6.12.85 in New York for $121,000
(£81,592)
From the collection of the
Edward and Betty Marcus Foundation,
Dallas, Texas

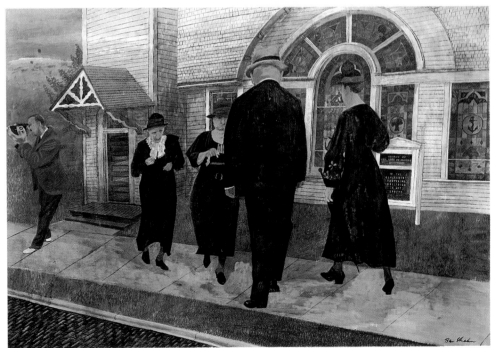

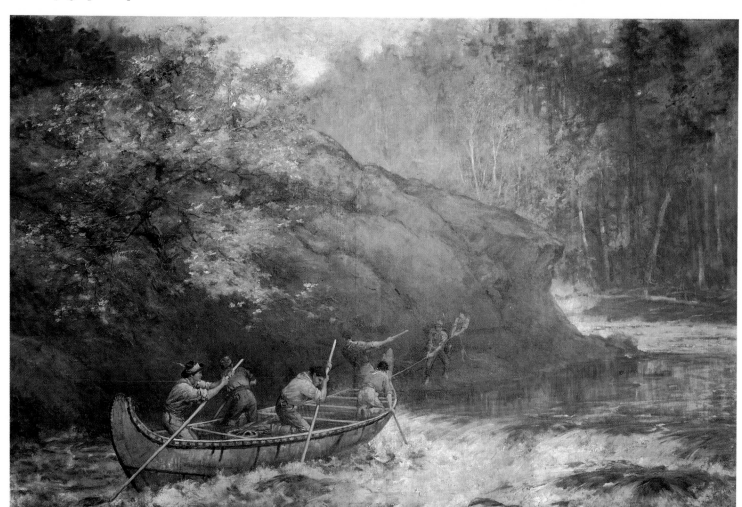

FRANCES ANNE HOPKINS
British 1838–1918
Mounting a Rapid: Autumn, Canada
Signed with initials
Oil on canvas
36½ × 53½ in. (92.7 × 135.9 cm.)
Sold 10.6.86 in London at Christie's South Kensington for £75,000 ($112,725)
Record auction price for a work by the artist

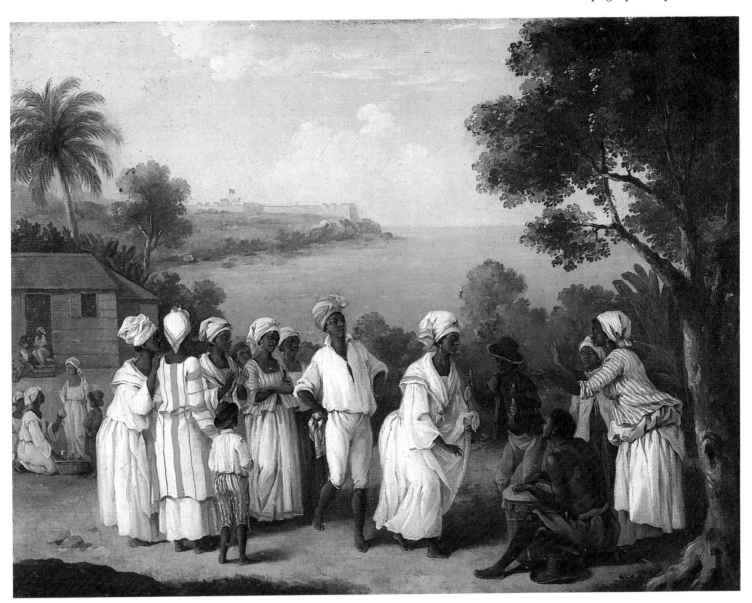

AUGUSTIN BRUNAIS
British, active 1752–79
A Dance in the Island of Dominica, Fort Young beyond
Oil on canvas
19¼ × 25½ in. (48.9 × 64.8 cm.)
Sold 19.11.85 in London at Christie's South Kensington for £22,000 ($31,361)

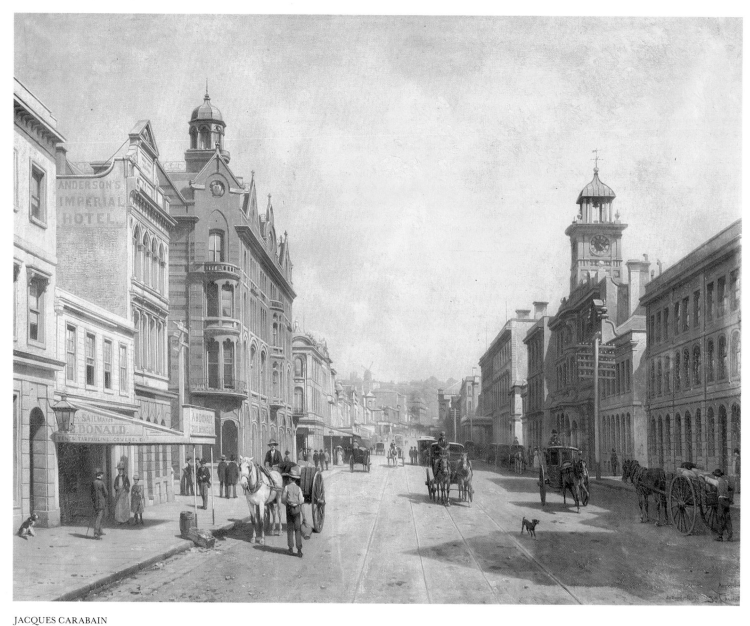

JACQUES CARABAIN
Belgian 1834–92
Queen Street, Auckland
Signed, inscribed and dated 20 December 1889
Oil on canvas
37½ × 49 in. (95.2 × 124.4 cm.)
Sold 19.11.85 in London at Christie's South Kensington for £50,000 ($71,110)

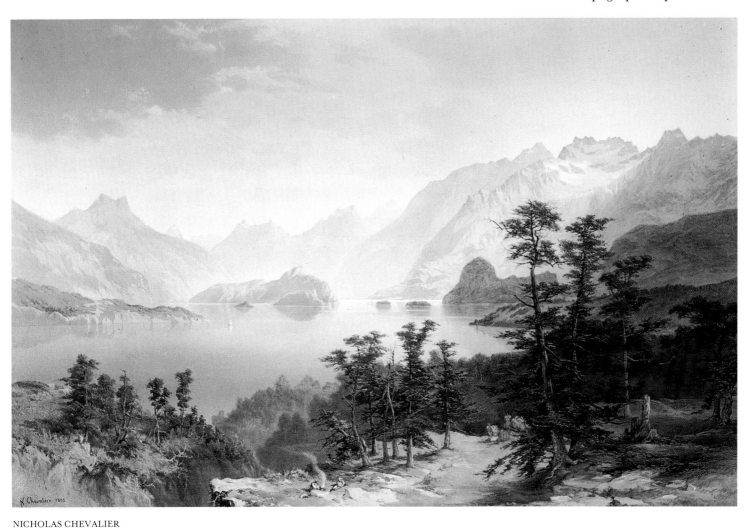

NICHOLAS CHEVALIER
Australian 1828–1902
Lake Manapouri, South Island, New Zealand
Signed and dated 1882
Watercolour
19¾ × 29½ in. (50.2 × 74.9 cm.)
Sold 10.6.86 in London at Christie's South Kensington for £42,000 ($63,000)
Record auction price for a watercolour by the artist

Repetition in Georgian Theatre Painting and the Decorative Arts

GEOFFREY ASHTON

The sale at Christie's last year of one of at least three versions of Zoffany's scene from *Love in a Village* prompted questions of patronage, precedence, quality and authenticity. The enormous price of £345,600 ($435,456) not only suggested that the last two questions had been quickly answered but also served to emphasize the dearth of information on the first two. Given the great variety of the 18th century theatrical repertory and his own spirit and inventiveness, why did Zoffany paint as many as four almost identical versions of his theatre scenes in the 1760s? There was a precedent, of course, in Hogarth's well-known scene from the 1728 production of *The Beggar's Opera*; the Hever Castle version appeared at Christie's recently. There are at least half a dozen versions of this picture, although it is evident that the artist was developing and elaborating his composition rather than replicating the initial idea.

Hogarth had the advantage of the effective publicity machine of John Rich, the man who produced *The Beggar's Opera* and, as a consequence, was able to build the first Covent Garden Theatre in 1732. Zoffany had a much more potent advantage in David Garrick, manager of Drury Lane, the finest actor of his generation and the greatest self-publicist of the 18th century. Both managers had a healthy theatrical belief in squeezing the last drop of publicity out of a good idea. A lasting visual image of a successful or even an unsuccessful production came high on the list of good ideas and Garrick, especially, encouraged artists, engravers, enamellers and potters to perpetuate the image.

One of the earliest multi-purpose theatrical images was provided by Thomas Worlidge when he painted a full-length life-size portrait of David Garrick as Tancred in *Tancred and Sigismunda* by James Thomson. This picture, signed and dated 1752, has been in the Garrick Club since 1940. A reduced full-length version was sold at Christie's in 1980 and a life-size head and shoulders is in the Dyce Collection at the Victoria and Albert Museum, on loan to the Theatre Museum. Garrick created the role of Tancred at Drury Lane on 18 March 1745 and played the part 23 times over the next few years, with a flurry of performances in the spring of 1752 evidently commemorated by the Worlidge portrait.

Worlidge produced an etching of the picture, probably in 1752, and various versions showing the figure facing in the same direction as in the painting as well as in reverse had a long active life in the print shops. An example in the Harvard Theatre Collection is printed on paper watermarked 1794 and another seems to be one of the several prints of Garrick republished by T. Purland in the early 1850s. Editions of the play published in the late 18th century were given portrait frontispieces adapted from Worlidge's portrait, by Wenman and James Roberts for instance, even though Garrick stopped playing Tancred in 1762.

An oval Liverpool enamel transfer-printed portrait plaque of about 1778 also post-dates Garrick's last appearance in the role. The enamel, an example was sold at Christie's in 1983 and another is in the Wolverhampton Art Gallery, shows a half-length figure and reverses Worlidge's picture. However, Garrick was still playing the part when his portrait was translated into a

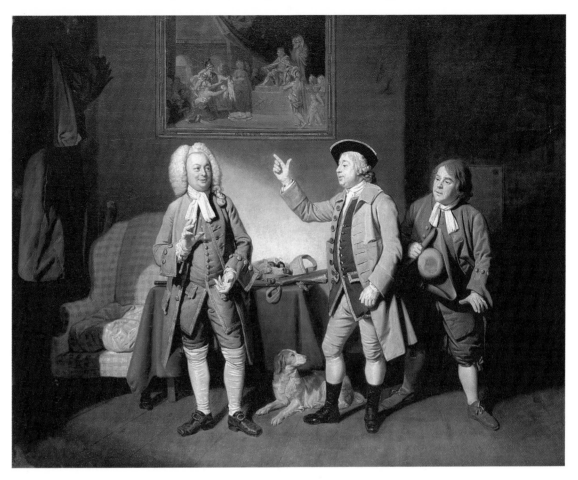

JOHAN ZOFFANY R.A.
British 1733–1810
A Scene from 'Love in a Village' by Isaac Bickerstaffe, Act 1, Scene 2, with Edward Shuter as Justice Woodcock, John Beard as Hawthorn, and John Dunstall as Hodge
*c.*1767
Oil on canvas
$51\frac{1}{4} \times 65$ in. (130.2 × 165.1 cm.)
Sold 26.4.85 in London for £345,600 ($435,456)

Derby figure in *c.*1760 by William Duesbury & Co.; an example sold at Christie's in 1981. For practical reasons the modeller has dispensed with the spear held in the outstretched right hand, bringing the right arm down across the actor's chest.

Worlidge's *Tancred* is perhaps an extreme example of a theatrical icon being done to death. The fact that neither the play nor Garrick's part in it were particularly popular does not seem to have affected the proliferation of the image and Garrick's Hussar costume, dripping with gold braid and tassels, might have been the major attraction.

Unlike *Tancred and Sigismunda*, Isaac Bickerstaffe's *Love in a Village* was extremely popular in the 18th century and after its first performance at Covent Garden on 8 December 1762 was second only to *The Beggar's Opera* in its universal appeal. Perhaps it is not surprising, therefore, that Zoffany should have produced three versions of a scene from this play. One version of the picture was shown at the Society of Artists in 1767 and again at the special exhibition in 1768 when John Finlayson's mezzotint of the picture was also shown (it had already been shown at the exhibition earlier in 1768). The mezzotint follows one of two versions, either the one sold at Christie's in 1985, now in the British Art Center at Yale, or another in the Detroit Institute of Fine Arts, both of which show the protagonists spouting in front of a table behind which hangs an early 18th century North Italian *Judgement of Solomon*. To a limited extent the actors echo the poses in the picture behind them.

In the version of the picture in the Somerset Maugham Collection in the National Theatre there is no connection between the actors and the picture on the wall, which is a copy of the Van Dyck portrait of the three eldest children of Charles I at Windsor. Zoffany also painted a single figure of Beard as Hawthorn and all three figures were copied by Jean Louis Fesch and engraved in 1769 for John Smith and Robert Sayer's *Dramatic Characters*.

With the scene from *Love in a Village* there is no obvious solution to the problem of precedence. The Yale picture is large for a Zoffany theatrical conversation piece, $51\frac{1}{4} \times 65$ in. (130.2 × 165.1 cm.) rather than the usual 40×50 in. (101.6 × 127 cm.), and may have been ordered for a particular position after the success of the engraved Detroit version. The Yale and Detroit versions are of a higher quality than that in the National Theatre but I see no reason to doubt the authenticity of any of them. The provenance of the Yale and Detroit versions has been confused in the past but does not go back far enough to establish what happened in the late 1760s.

It is only with the theatrical conversation pieces painted for David Garrick that we are given any insight into at least the initial stages of duplication. Garrick rescued Zoffany from the studio of Benjamin Wilson some time during the winter of 1761–2 and commissioned the first of the theatrical conversation pieces, a scene from *The Farmer's Return* shown at the Society of Artists in 1762. This play, a curtain-raiser by David Garrick, was first performed at Drury Lane on 20 March 1762 with Garrick and Mrs Bradshaw playing the farmer and his wife. The picture hung in Garrick's house in the Adelphi and remained with his widow. It was sold by Christie's at the Garrick sale over 60 years later (23 June 1823), when it was bought for the future Earl of Durham, with whose family it remains. The picture was engraved in mezzotint by J.G. Haid in 1766 and there are at least three subsequent versions of the picture, one of which appeared at Christie's in 1981. There are minor compositional variations between the pictures, suggesting that the same artist is varying his work to avoid boredom, but there is no doubt that the original Garrick version is crisper and fresher than the others.

The story is the same with Zoffany's second theatrical work. It depicts David Garrick and Mrs Cibber as Jaffier and Belvidera in Thomas Otway's *Venice Preserv'd*. Commissioned by Garrick

RICHARD WESTALL
British 1765–1836
Scene from 'The Father's Revenge'
Oil on canvas
$78\frac{1}{2} \times 60\frac{1}{2}$ in.
(199 × 153.6 cm.)
Sold 3.5.86 in London for
£7,344 ($11,083)

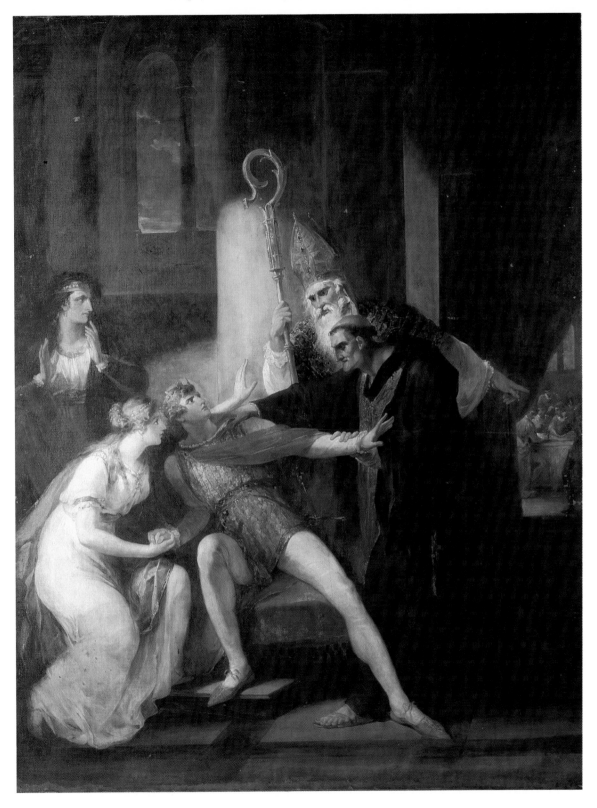

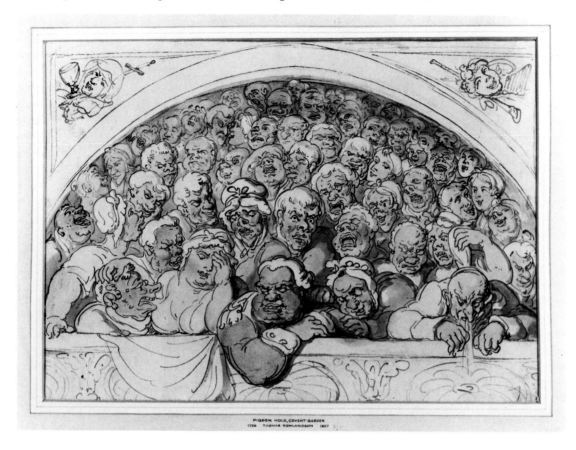

THOMAS ROWLANDSON
British 1756–1827
Pigeon Hole, Covent Garden
Pen and brown ink and
watercolour
$8\frac{3}{4} \times 12\frac{7}{8}$ in. (22 × 33 cm.)
Sold 9.7.85 in London for
£1,900 ($2,470)

and painted whilst Zoffany was staying in the Garrick villa at Hampton, it was shown at the Society of Artists in 1763. It hung next to the scene from *The Farmer's Return* in the Adelphi and was also bought for the future Earl of Durham in 1823. John McArdell's mezzotint was published in 1764 and again there are at least three subsequent versions, all inferior to the Garrick picture. However, although the differences between the pictures are less obvious than those in the earlier group the quality of the *Venice Preserv'd* pictures, including those in the Garrick Club and the National Theatre, is high and Zoffany, I think, is largely reponsible for all of them.

It seems likely that the publication of the mezzotint marks the dividing line between the original picture and subsequent versions. Two of Zoffany's most remarkable theatrical conversation pieces are known only in one version. The scene from *The Alchymist* was shown at the Royal Academy in 1770 and engraved by John Dixon in a mezzotint that was shown at the Society of Artists in 1771, and the scene from *The Clandestine Marriage* in the Garrick Club was apparently painted in late 1769 and engraved in mezzotint by Richard Earlom in 1772.

Zoffany left for the Continent in 1772 and presumably did not have time to fulfil the orders generated by the publication of the mezzotints. Nor, one imagines, did he have the inclination to persist with such theatrical drudgery, as Queen Charlotte's commission for *The Tribuna* implied an elevation beyond the tinsel of Drury Lane and the popular market place. On the other

JOHAN ZOFFANY
British 1733–1810
*A Scene from 'The Farmer's
Return' by David Garrick, David
Garrick as the Farmer and Mrs
Bradshaw as the Farmer's Wife*
*c.*1766 (?)
Oil on canvas
40 × 50 in. (101.6 × 127 cm.)
Sold 17.11.81 in London for
£13,000 ($26,000)

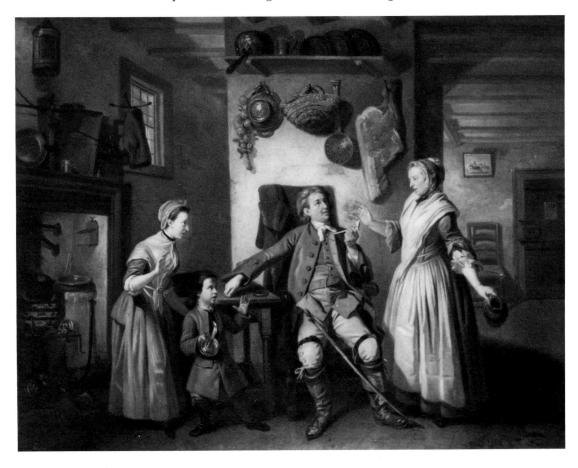

hand, Zoffany did paint two versions of the dagger scene from *Macbeth* in the late 1760s and
Valentine Green's mezzotint did not appear until 1776.

Jean Louis Fesch's use of Zoffany's theatrical figures has already been mentioned. He pro-
duced the 24 plates for John Smith and Robert Sayer's *Dramatic Characters, or Different Portraits
from the English Stage*, published in 1770, and a further 13 plates for a second edition published
three years later. Many of Fesch's little watercolours on vellum show David Garrick in various
roles, some copied from the work of other artists and some original, and he seems to have been
invited over to England after sending Garrick a letter of self-recommendation worthy of Leonardo.
The watercolours proliferate wherever 18th century theatre is collected and there are several
versions of each engraved figure as well as many that were not engraved.

They are important because they started a craze for small, inexpensive theatrical portraits
that really got under way with the publications of John Bell. They were also widely used in
the decorative arts; for instance, Babette Craven has traced nine pieces of a Worcester tea-
service decorated with figures from *Dramatic Characters* and a remarkable silver tea-caddy was
sold this season at Christie's, the four sides pierced and chased with four figures from the same
work. There are similar examples in the Theatre Museum and in the Bristol City Art Gallery.

Several Fesch figures also appear amongst the well-known series of Liverpool theatrical tiles

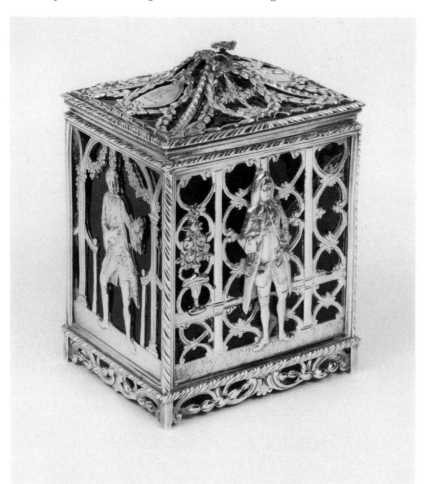

Silver tea-caddy, the sides pierced and chased with theatrical figures taken from the illustrations by Jean Louis Fesch to John Smith and Robert Sayer's *Dramatic Characters, or Different Portraits from the English Stage*; the figures are David Garrick as Hamlet and as Macbeth, Edward Shuter as Justice Woodcock and Mrs Bellamy as Clarinda
*c.*1775
Unmarked
Sold 27.11.85 in London for £3,240 ($4,745)

of *c.*1779–82. Thirty-six figures have been identified and all are printed in black and in red. The majority of the figures are taken from the first editions of Bell's *Shakespeare*, 1772–4, and Bell's *British Theatre*, 1776–81 (102 plays), although some are taken from the more sophisticated Lowndes' *New English Theatre*, 1776–89 (70 plays, with 60 published by 1777). Some of the figures appear on other pottery wares and others will no doubt turn up.

Theatrical portraiture had become a truly popular art by the early years of the 19th century and the Penny Plain portraits and popular Bloor Derby figures of John Liston of the 1820s were within the pocket of any theatre enthusiast. Not so the painted versions of Zoffany's theatrical scenes or even the relatively expensive mezzotints of the 1760s. However, they were among the first examples of theatrical repetition, which was gradually accepted as a useful and convenient means of publicly promoting the art of the stage. The high public profile enjoyed by so many of today's stars of screen and stage owes a great deal to David Garrick's conceit and patronage and Zoffany's ability and industry.

Modern Pictures and Sculpture

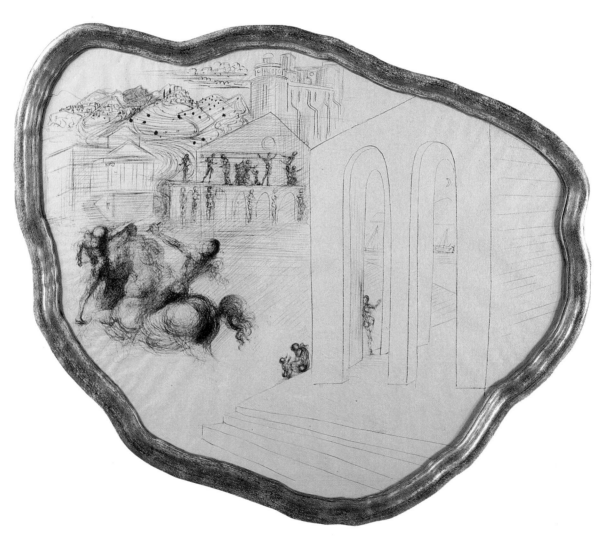

SALVADOR DALI
Spanish b.1904
Messenger in a Palladian Landscape
Pen and ink on pink paper, in shaped gilt frame possibly inspired by Magritte
Drawn *c.*1936
$20\frac{1}{2} \times 25\frac{3}{4}$ in. (52×65.5 cm.)
Sold 5.6.86 at West Dean for £28,080 ($42,120)
From the Edward James Collection

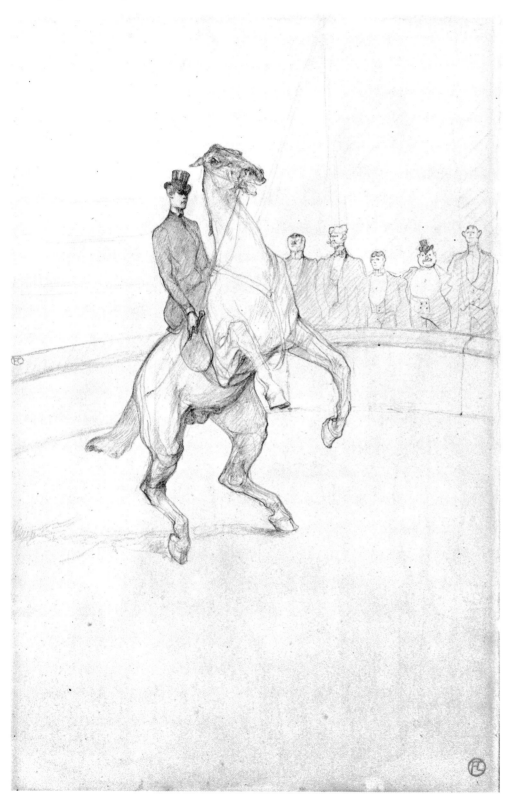

HENRI DE TOULOUSE-LAUTREC
French 1864–1901
Au Cirque, écuyère de haute école –
Le Pointage
Signed and stamped with monogram
Pencil
19¾ × 12⅞ in. (50.2 × 32.7 cm.)
Sold 12.11.85 in New York for
$286,000 (£200,000)
From the collection of
Juan Alvarez de Toledo

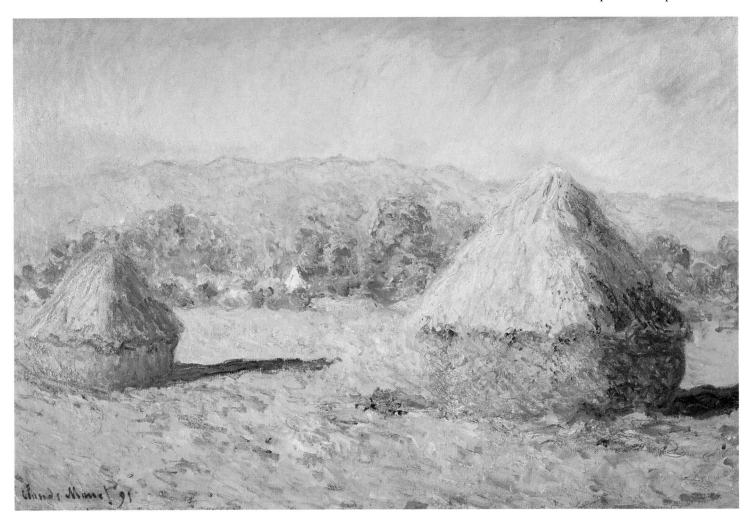

CLAUDE MONET
French 1840–1926
Les Meules au soleil, effet du matin
Signed and dated 91
Oil on canvas
25 5/8 × 39 1/2 in. (65 × 100.5 cm.)
Sold 12.11.85 in New York for $2,090,000 (£1,461,538)
From the collection of Harris Whittemore

Although almost universally known in English as the 'Haystacks' series, *Les Meules* are not in fact haystacks but bound sheaves of
wheat or oats thatched with straw, which formed an essential feature of the autumn and winter landscape.

Monet had first painted haystacks in 1884 and 1885 but it was in the autumn of 1890 and the winter and spring of 1891 that he
painted this *Meules* series, which was exhibited to great acclaim at Galerie Durand Ruel in May 1891. The *Meules* were situated in a
field near Monet's house in Giverny called Le Clos Morin. As with all his series pictures, he worked on several canvases at the
same time, concentrating on the immediate effects of light at a particular time of day and changing canvas when the light changed.
His stepdaughter Blanche Hoschedé would run to and from the house with canvases for him. He described his manner of painting
to the Duc de Trévise: 'Elle me l'apporte, mais peu après, c'est encore différent; une autre, encore une autre! Et je ne travaillais à
chacune que quand j'avais mon effet, voilà tout.'

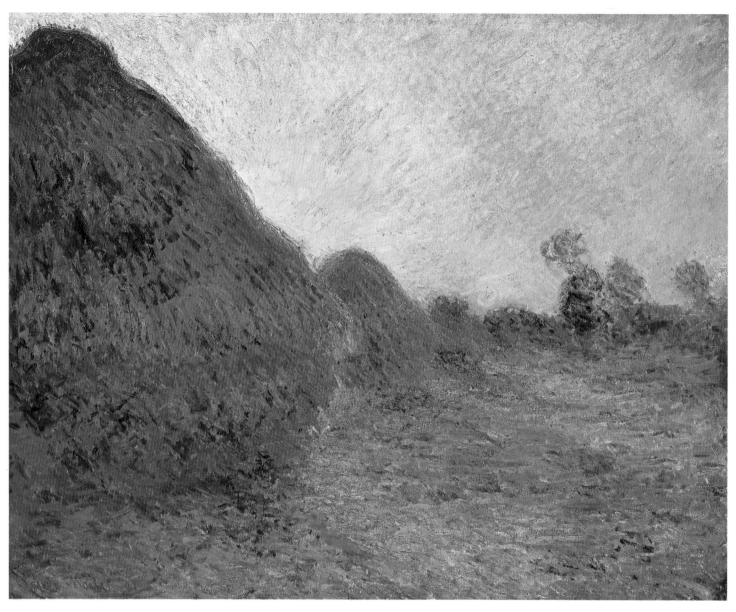

CLAUDE MONET
French 1845–1926
Meules
Signed and dated 91
Oil on canvas
Painted in 1890
28¾ × 36½ in. (73 × 92.5 cm.)
Sold 14.5.86 in New York for $2,530,000 (£1,611,465)

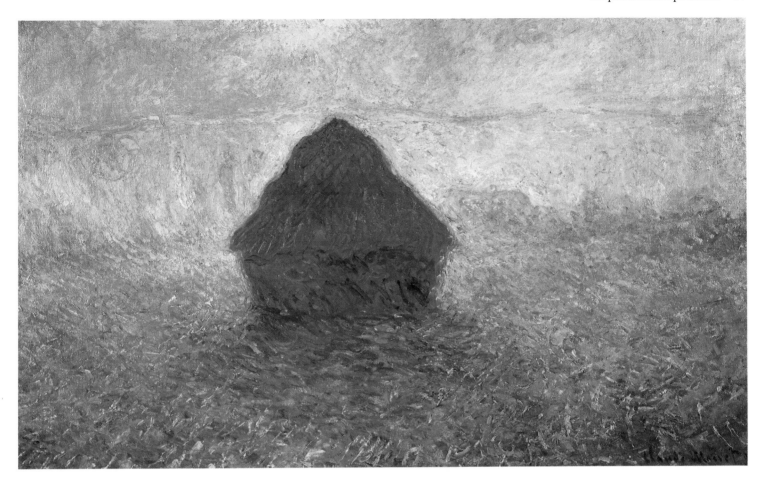

CLAUDE MONET
French 1845–1926
Meule, soleil dans la brume
Signed and dated 91
Oil on canvas
$23\frac{5}{8} \times 39\frac{1}{2}$ in. (60 × 100.5 cm.)
Sold 12.11.85 in New York for $2,200,000 (£1,538,461)
From the collection of Harris Whittemore

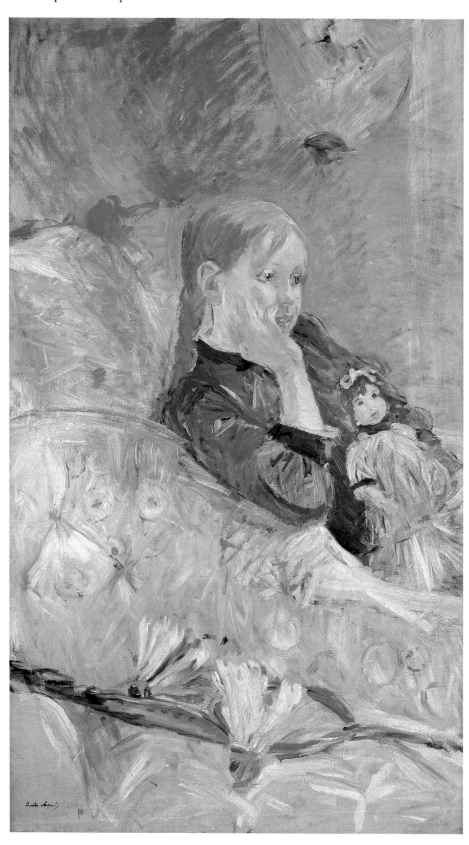

BERTHE MORISOT
French 1841–95
Fillette à la poupée
Stamped signature
Oil on canvas
Painted in 1886
$38\frac{3}{8} \times 22\frac{3}{4}$ in. (97 × 58 cm.)
Sold 23.6.86 in London for £205,200
($318,060)
By order of the Executors of the late
Mrs Neville Blond, O.B.E.
The sitter is Jeannie Gobillard (Mme Paul
Valéry), daughter of the artist's elder sister
Yves

Opposite:
CLAUDE MONET
French 1840–1926
Point de rochers à Port-Goulphar
Signed and dated 86
Oil on canvas
$32\frac{1}{8} \times 25\frac{5}{8}$ in. (81.5 × 65 cm.)
Sold 12.11.85 in New York for $650,000
(£454,545)
Now in the Cincinnati Art Museum

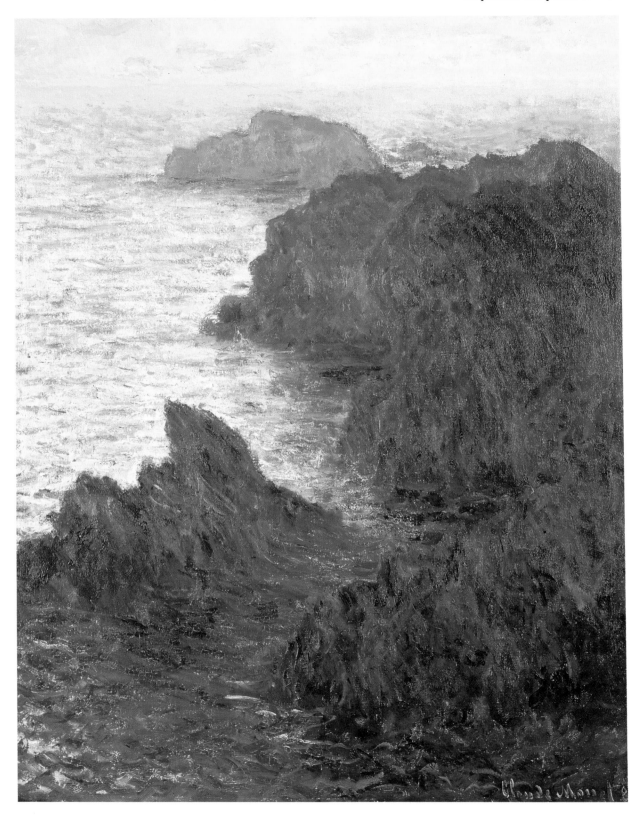

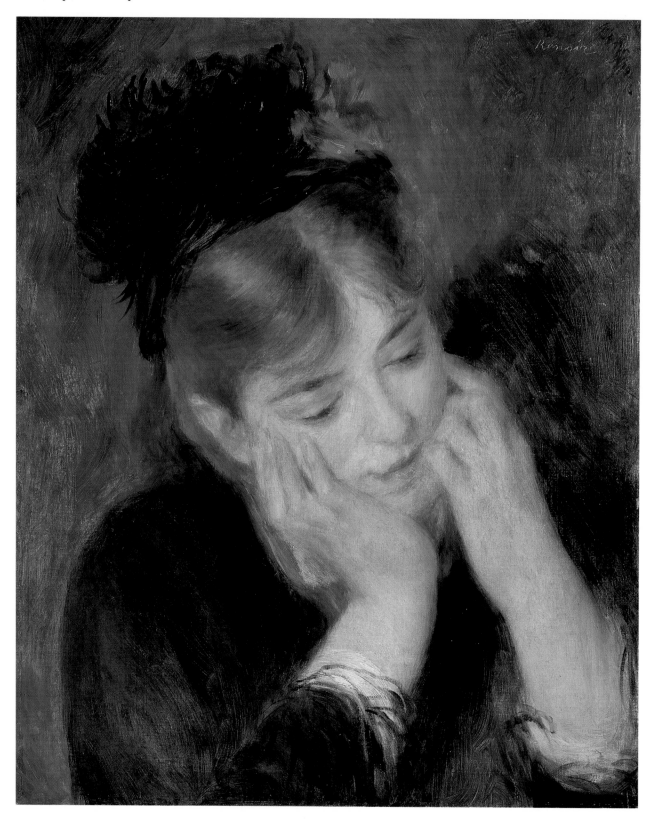

PIERRE AUGUSTE RENOIR
French 1841–1919
Baigneuse
Signed
Oil on canvas
Painted in 1887
32⅛ × 20⅞ in. (81.5 × 53 cm.)
Sold 14.5.86 in New York for
$1,430,000 (£910,828)

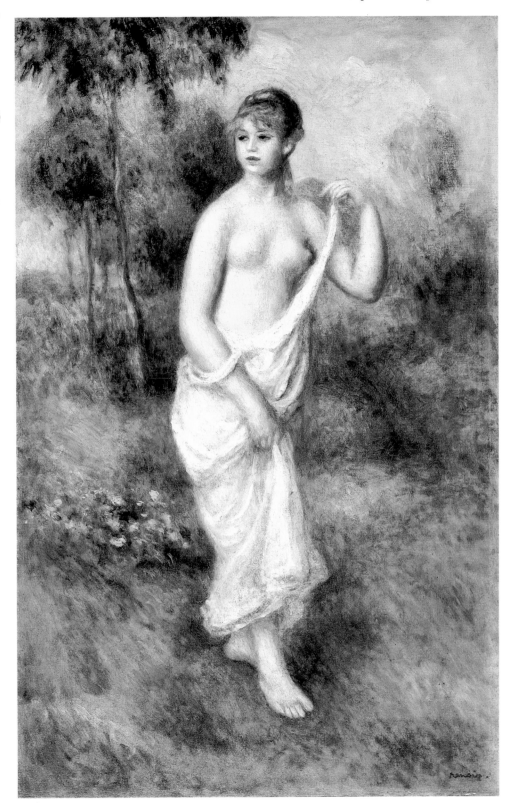

Opposite:
PIERRE-AUGUSTE RENOIR
French 1841–1919
Reflexion
Signed
Oil on canvas
Painted in 1877
18⅛ × 15 in. (46 × 38.1 cm.)
Sold 12.11.85 in New York for
$1,430,000 (£1,000,000)
From the collection of Juan
Alvarez de Toledo
Previously sold at Christie's New
York 13.5.80 for $660,000

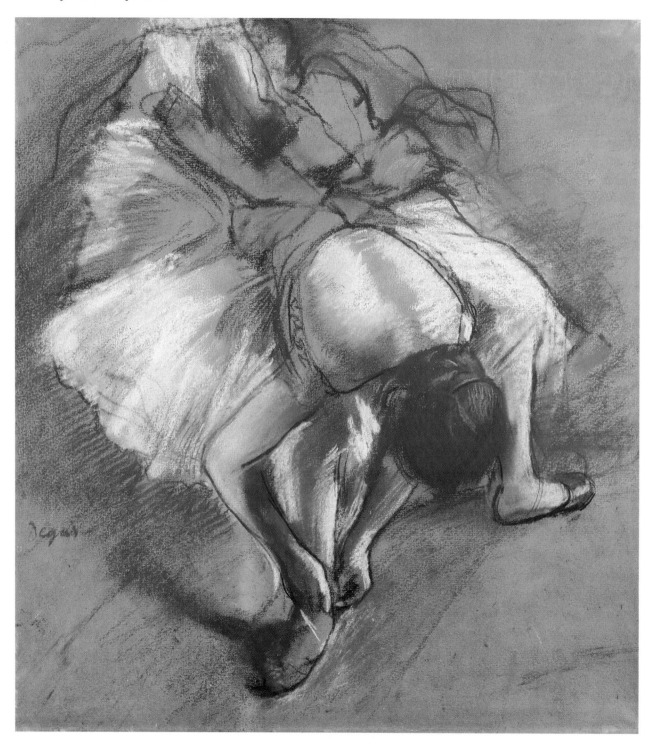

ODILON REDON
French 1840–1916
Bouquet de fleurs dans un vase
Signed
Oil on board laid down on
cradled panel
$27\frac{1}{2} \times 21\frac{1}{8}$ in.
(68.5 × 53.5 cm.)
Sold 23.6.86 in London for
£270,000 ($418,500)

Opposite:
EDGAR DEGAS
French 1834–1917
Danseuse attachant son chausson
Signed
Pastel and black chalk
Executed *c.*1880–5
$18\frac{5}{8} \times 16\frac{7}{8}$ in.
(47.2 × 43 cm.)
Sold 12.11.85 in New York
for $1,045,000 (£730,769)
From the collection of
Juan Alvarez de Toledo

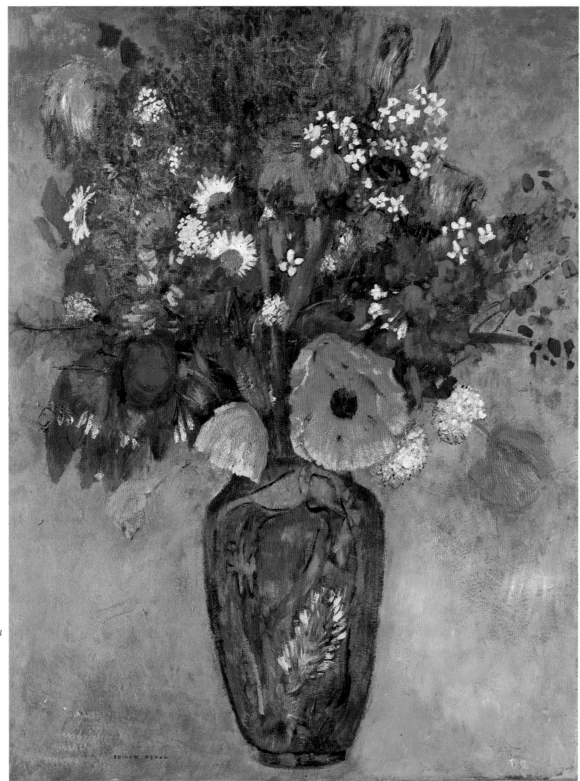

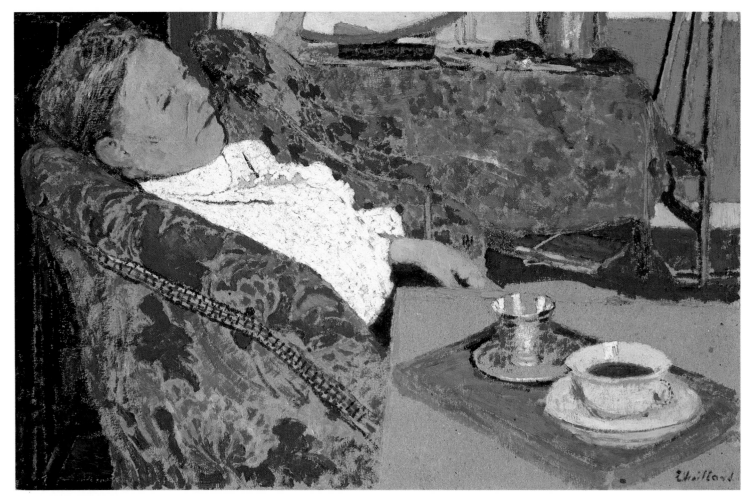

EDOUARD VUILLARD
French 1868–1940
La Mère de l'artiste se reposant
Signed
Oil on board laid down on cradled panel
Painted *c.* 1897
14 × 22 in. (35.5 × 55.9 cm.)
Sold 12.11.85 in New York for $418,000 (£292,307)
From the collection of Juan Alvarez de Toledo

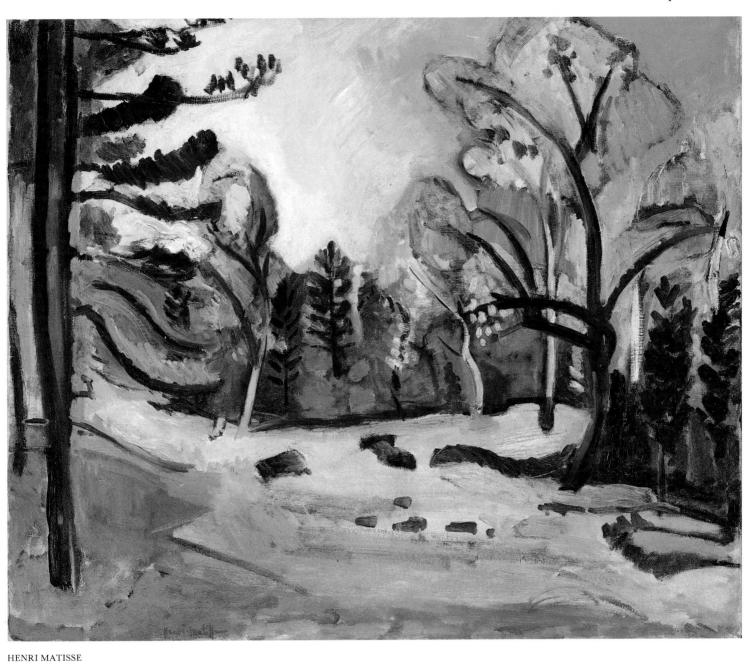

HENRI MATISSE
French 1869–1954
Forêt de Fontainebleau
Signed
Oil on canvas
Painted near Barbizon, 1909
23⅝ × 29 in. (60 × 73.5 cm.)
Sold 2.12.85 in London for £420,000 ($622,860)

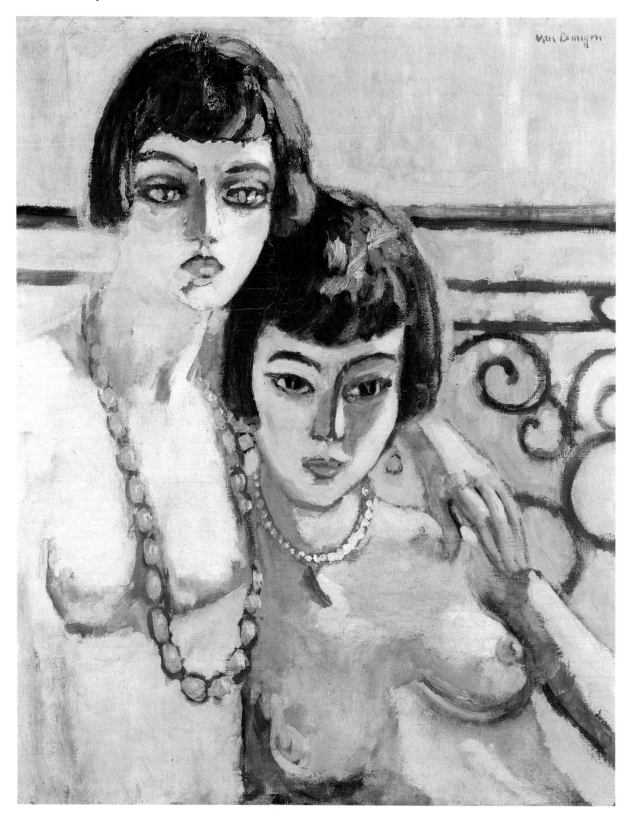

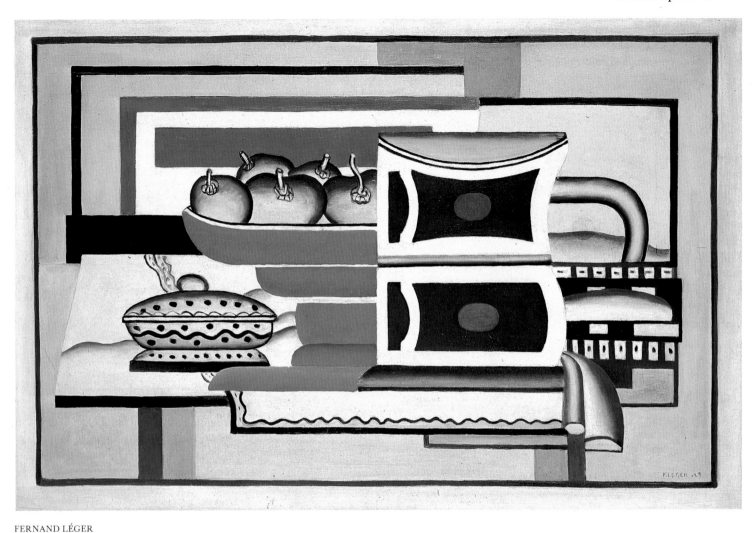

FERNAND LÉGER
French 1881–1955
Le Compotier rouge
Signed and dated 25
Oil on canvas
$23\frac{3}{4} \times 36\frac{1}{2}$ in. (60 × 92.5 cm.)
Sold 14.5.86 in New York for $638,000 (£406,369)

Opposite:
KEES VAN DONGEN
Dutch/French 1877–1968
Les Amies
Signed
Oil on canvas
$29 \times 23\frac{1}{4}$ in. (74 × 59 cm.)
Sold 23.6.86 in London for £270,000 ($418,500)

AMEDEO MODIGLIANI
Italian 1884–1920
Jeanne Hébuterne (au foulard)
Signed
Oil on canvas
Painted in Nice, 1919
36¼ × 21¼ in. (92 × 54 cm.)
Sold 23.6.86 in London for £1,944,000
($3,013,200)
Jeanne Hébuterne was only 19 when she met Modigliani in July 1917. She was attracted not only by his exceptionally good looks but also by the dissolute Bohemian life that he led. In spite of the drink and drugs (which she did not share) and his frequent infidelities, she remained fanatically devoted to him until her own suicide two days after Modigliani's death in January 1920. She bore him a child, Jeanne, in November 1918 and was nine months pregnant with another when she died.

Opposite:
ALEXANDER ARCHIPENKO
Russian 1887–1964
Woman with Hat
Signed
Oil, metal, papier mâché and gauze on wood in a wood frame constructed by the artist
Executed in Paris, 1916
14 × 10½ in. (35.5 × 26.5 cm.)
Sold 12.11.85 in New York for $209,000
(£146,154)

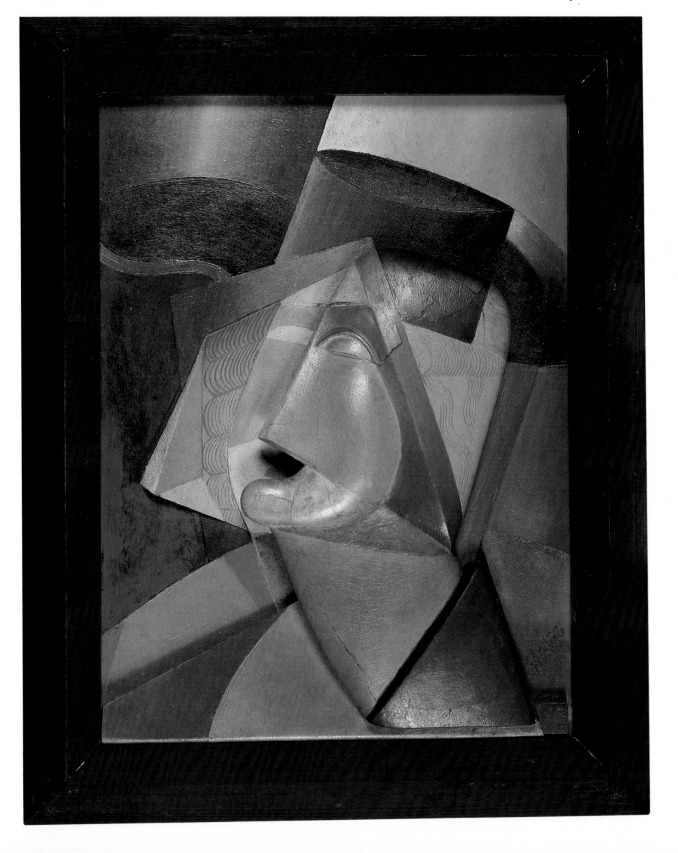

German Expressionists

GUY JENNINGS

In the last season Christie's London has developed still further its strength in the field of German 20th century painting. The December sales in 1985 saw new records for Campendonk, Dix and Pechstein, which were all broken again this summer. Prices continued to be consistently good for Emil Nolde, although the record still remains at £345,600 ($442,368) for *Sonnenblumengarten* which was reached in our Rooms in June 1985.

The best of the works can be seen on the following pages, but they are only the tip of the iceberg. In four days in June 1986 we sold almost £4 million ($6 million) worth of German pictures; ranging widely in date and style, from the impressionistic work of Max Liebermann through to the 1960s and the work of Georg Baselitz.

'Modern' German painting begins at the end of the 19th century when the artists began to be influenced by French Impressionism. The leading 'German' Impressionists were Max Slevogt, Max Liebermann and Lovis Corinth, all of whom continued to paint well into the 20th century. French neo-Impressionism or Pointillism also influenced German artists and the most important of these were Paul Baum and Carl Schmitz-Pleis. More significant, however, were the home grown German movements of the pre-war years. The two main groups were *Die Brucke* and *Die Blaue Reiter*, movements which are loosely known as Expressionist.

Max Pechstein, Erich Heckel and Ernst Ludvig Kirchner were the most important and earliest members of this group and all their best work was painted before 1920. Emil Nolde was another leading painter of *Die Brucke* but interestingly much of his best work was not executed until the 1930s. Their choice of colours were vivid and strong, not unlike their French *'fauve'* contemporaries, but stylistically they were much harsher. *Die Blaue Reiter*, based in Munich around Wassily Kandinsky and Franz Marc in the years 1910–14, used similar colours but their images were less harsh and their subject matter drawn from much more pastoral and mythological themes.

After the First World War new groups developed and in the 1920s *Neue Sachlichkeit* or new realism emerged from the suffering and horror of war-ravaged Germany. Otto Dix's *Der Salon I* is a superb example of *Neue Sachlichkeit* painting; other leading artists were George Grosz and Conrad Felixmuller. For the latter's *Der Tod des Dichters Walter Rheiner*, we achieved the very high price of £145,800 ($232,960) as long ago as 1982.

The coming of Hitler to power in 1934 signalled the demise of Expressionist painting which, along with many modern foreign schools, was condemned as *'entartete kunst'* or degenerate art. It was only after the Second World War that German art slowly began to re-establish itself with Willi Baumeister and Ernst Wilhelm Nay.

London, or more particularly Christie's London, is now firmly established as the leading centre for German 20th century art at auction, selling work by all these artists. Pictures have come to us for sale from Argentina, Venezuela, Canada, the United States and England, as well as Germany, and have departed to as wide a variety of destinations. Consistently high prices have been maintained for all the leading artists and a new record for a 20th century German painting was reached when *Der Salon I* by Otto Dix was sold for £561,600 ($870,480) on 23 June.

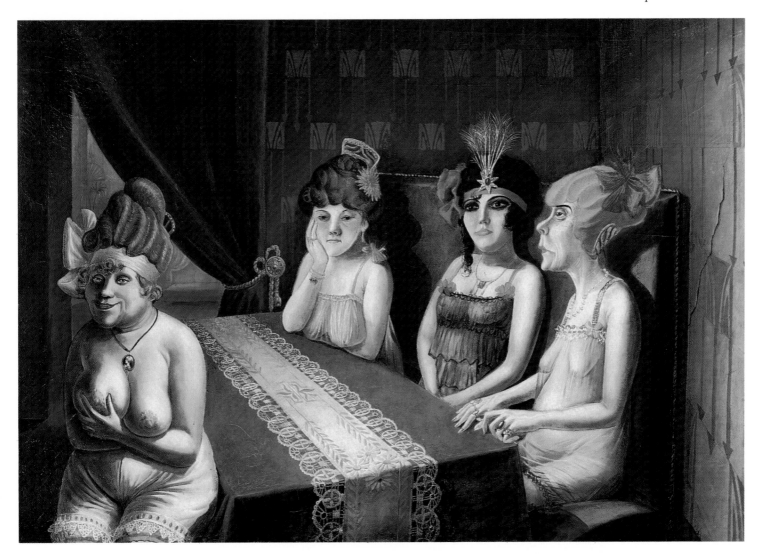

OTTO DIX
German 1891–1969
Der Salon I
Signed and dated 1921
Oil on canvas
33¾ × 47½ in. (86 × 120.5 cm.)
Sold 23.6.86 in London for £561,600 ($870,480)
Record auction price for any 20th century German picture
Now in the Galerie der Stadt Stuttgart

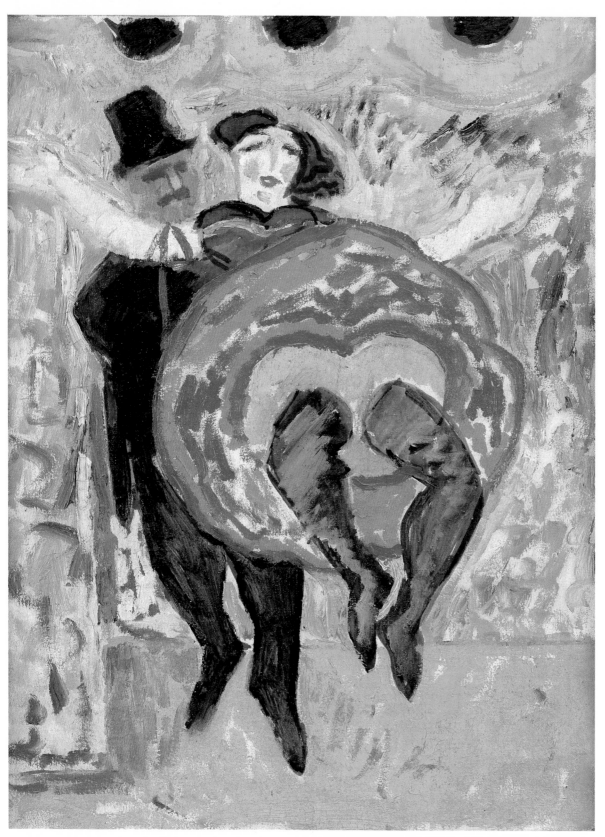

MAX PECHSTEIN
German 1881–1955
Tänzerin (Tänzerpaar)
Oil on canvas
Painted *c.*1909
25½ × 19½ in.
(65 × 49.5 cm.)
Sold 23.6.86 in London
for £162,000 ($243,486)
Record auction price
for a work by the artist

ERNST LUDWIG KIRCHNER
German 1880–1938
Gut Staberhof, III
Oil on canvas
Painted on the Island of
Fehmarn, summer 1913
$32\frac{1}{4} \times 35\frac{3}{4}$ in. (82 × 91 cm.)
Sold 23.6.86 in London for
£205,200 ($318,060)

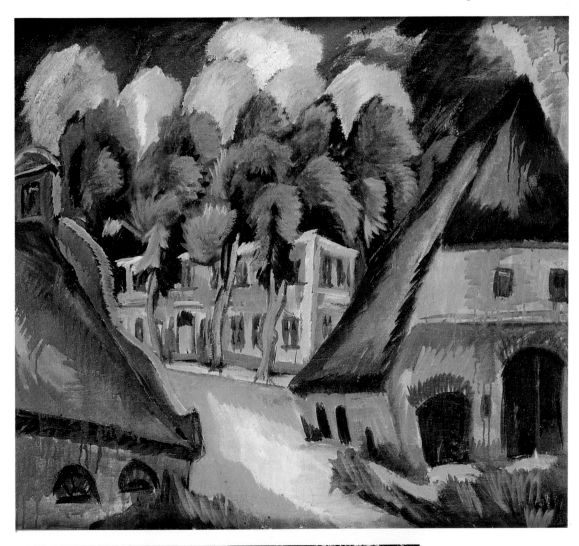

Present-day view of
Gut Staberhof

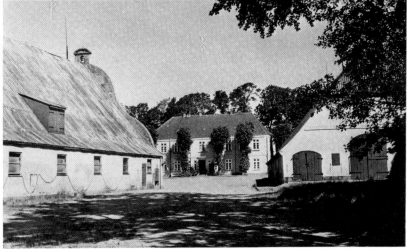

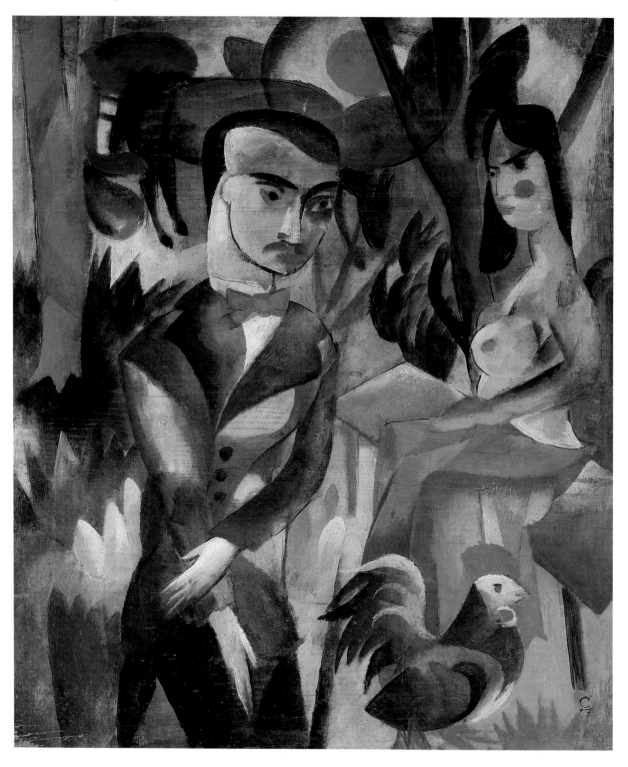

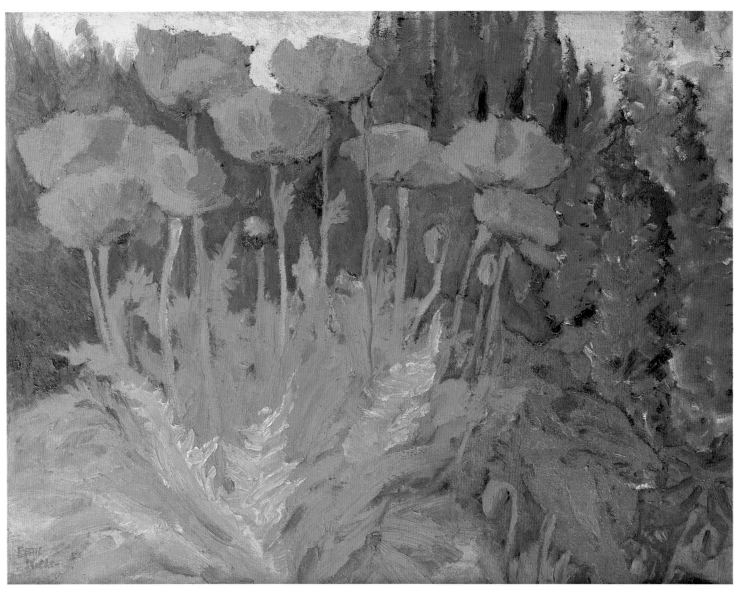

Opposite:
HEINRICH CAMPENDONK
German 1889–1975
Paar mit Hahn
Signed and dated 17
Oil on panel
23¼ × 19½ in. (58.7 × 50 cm.)
Sold 23.6.86 in London for £129,600 ($193,752)
Record auction price for a work by the artist

EMIL NOLDE
German 1867–1956
Grosser Mohn
Signed
Oil on canvas
Painted in 1930
26¾ × 34¾ in. (67 × 88.5 cm.)
Sold 23.6.86 in London for £324,000 ($502,200)

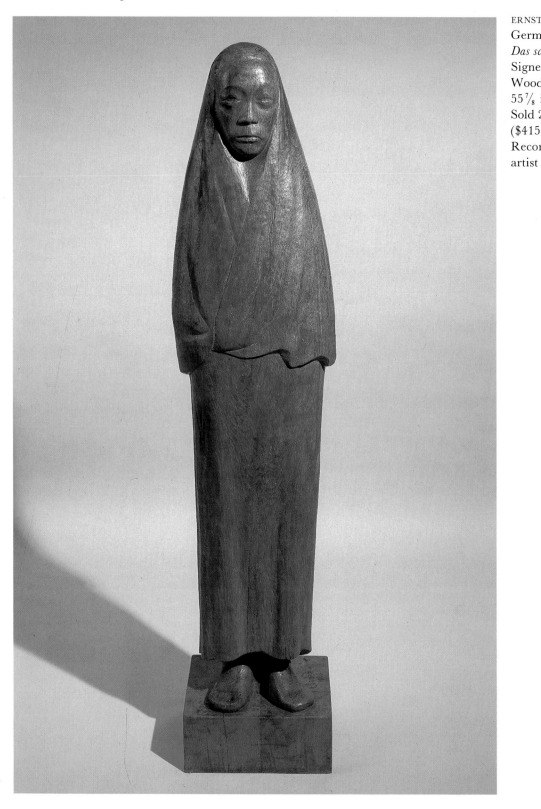

ERNST BARLACH
German 1870–1938
Das schlimme Jahr 1937
Signed and dated 1936
Wood
55 7/8 in. (142 cm.) high, including base
Sold 2.12.85 in London for £280,000
($415,240)
Record auction price for a work by the
artist

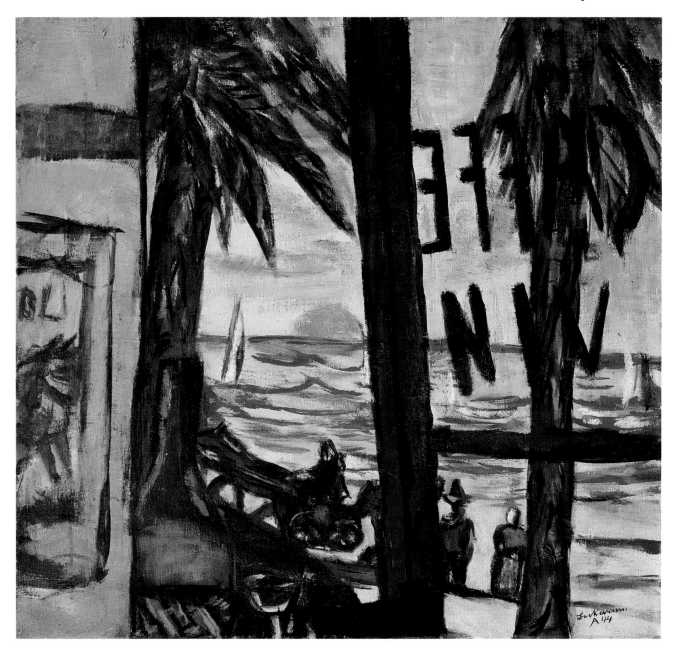

MAX BECKMANN
German 1884–1950
Café Bandol
Signed and dated 44
Oil on canvas
Painted in Amsterdam, 1944
25⅞ × 27¾ in. (66 × 70.5 cm.)
Sold 23.6.86 in London for £194,400 ($301,320)
From the collection of Mrs Margie Wolcott May, St Louis

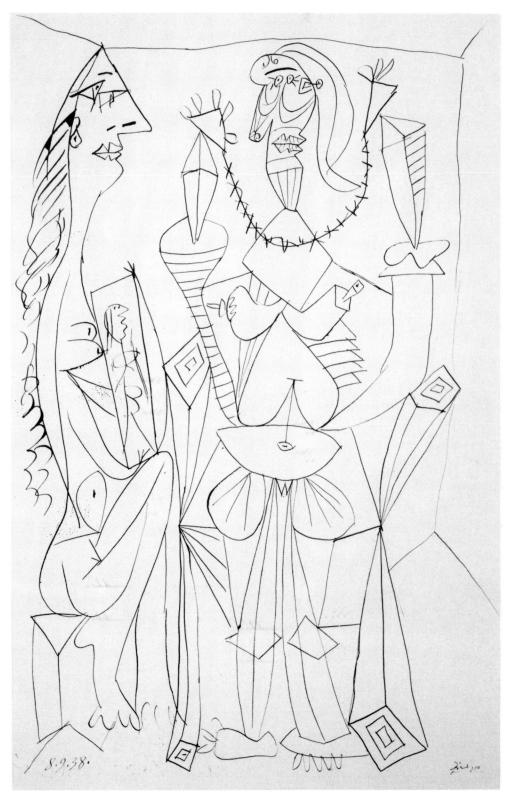

PABLO PICASSO
Spanish/French 1881–1974
Deux Femmes assises (Le Collier)
Signed and dated 8.9.38
Pen and India ink
$26\frac{5}{8} \times 17\frac{1}{2}$ in. (67.6 × 44.4 cm.)
Sold 15.5.86 in New York for
$176,000 (£112,820)
From the collection of
John R. Gaines, Lexington,
Kentucky

JOAN MIRO
Spanish 1893–1983
Le Corps de ma brune…
Signed and dated 1925
Oil on canvas
51⅛ × 37¾ in.
(130 × 96 cm.)
Sold 12.11.85 in New York
for $770,000 (£538,461)

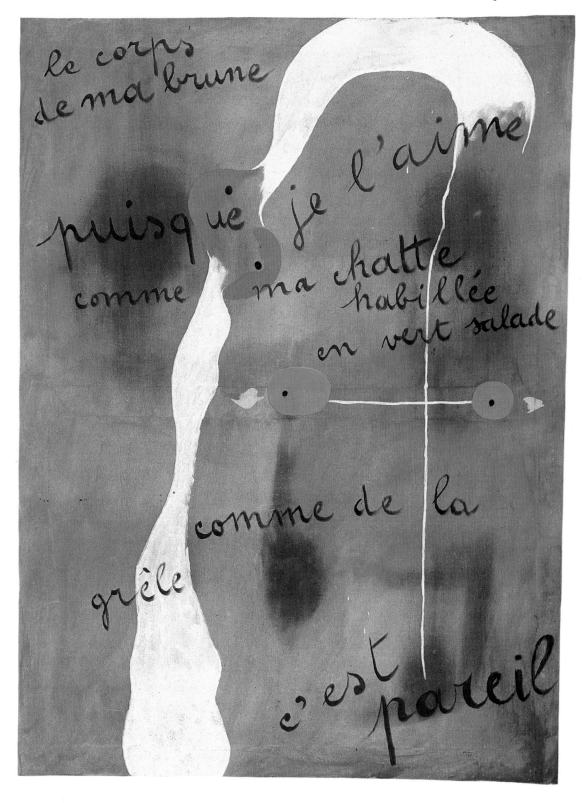

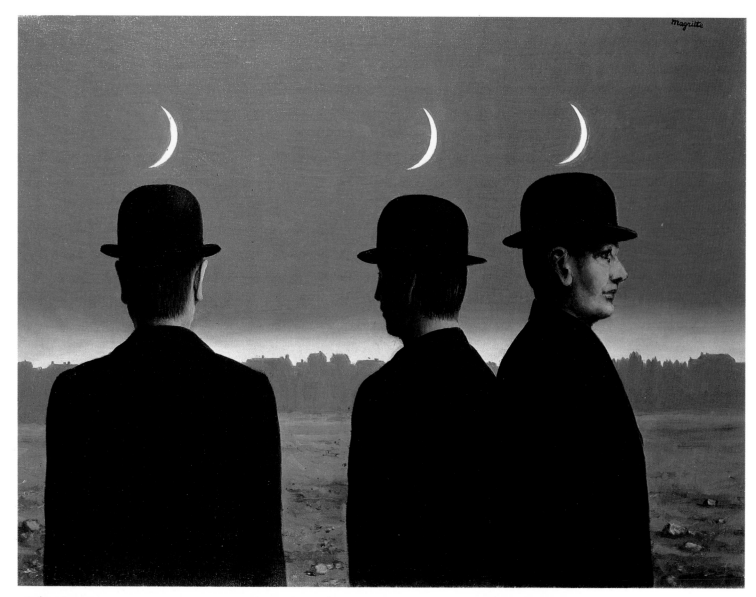

RENÉ MAGRITTE
Belgian 1898–1967
Le Chef d'oeuvre ou les mystères de l'horizon
Signed
Oil on canvas
Painted in 1955
$22\frac{3}{4} \times 26\frac{1}{2}$ in. (48 × 73 cm.)
Sold 14.5.86 in New York for $352,000 (£227,390)
By order of the estate of L. Arnold Weissberger

Opposite:
MARIE LAURENCIN
French 1885–1956
Deux Femmes
Signed and dated 1929
Oil on canvas
$32 \times 25\frac{3}{4}$ in. (81.3 × 65.4 cm.)
Sold 15.5.86 in New York for $264,000 (£169,231)
By order of the Heirs of Winifred Dodge Seyburn
Record auction price for a work by the artist

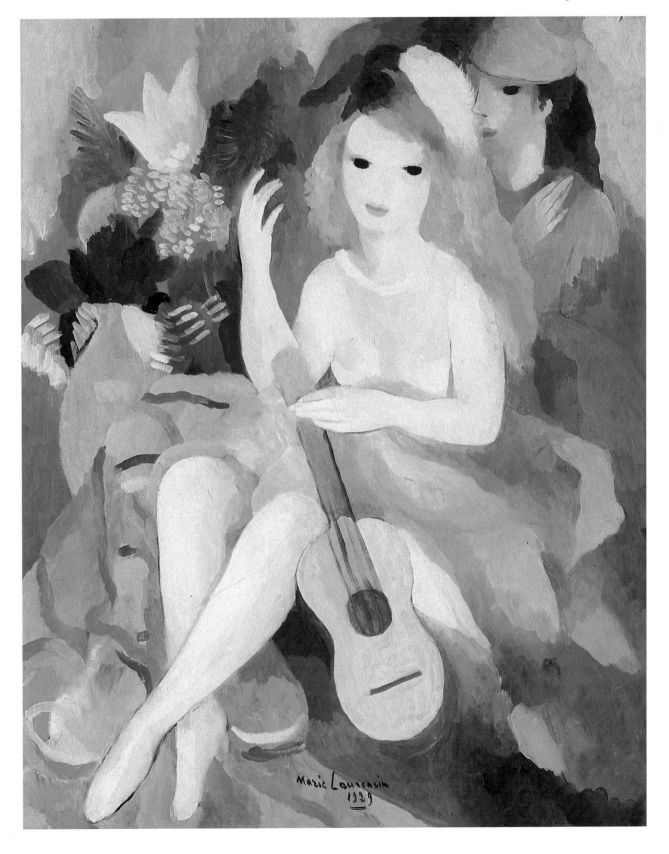

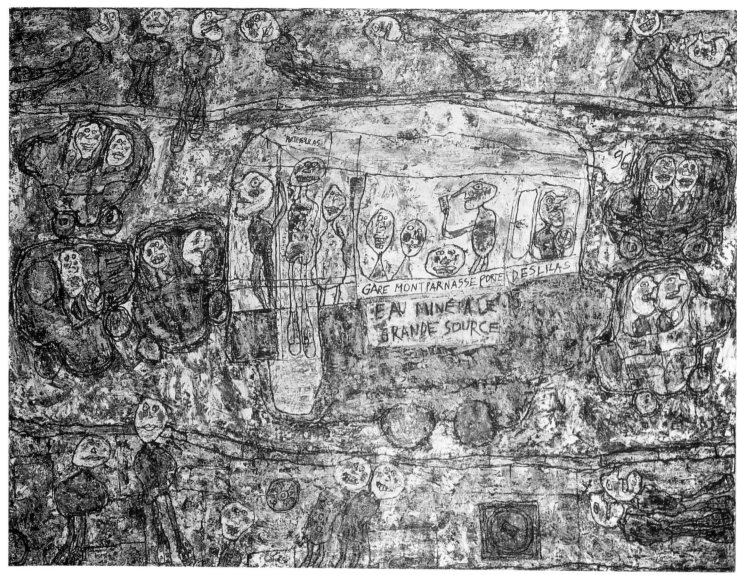

JEAN DUBUFFET
French 1901–85
Paris – Montparnasse
Signed and dated 61
Oil on canvas
65 × 86¾ in. (165 × 220.5 cm.)
Sold 12.11.85 in New York for $770,000 (£538,461)
Record auction price for a work by the artist

Opposite:
HENRY MOORE, O.M., C.H.
British 1898–1986
Seated Woman
Bronze with green patina on a copper-covered base
Cast in 1956–7, edition of six
63 in. (160 cm.) high; 56 in. (142 cm.) long
Sold 14.5.86 in New York for $990,000 (£630,573)
By order of the Trustees of the Hirshhorn Museum and
Sculpture Garden
Record auction price for a bronze by the artist

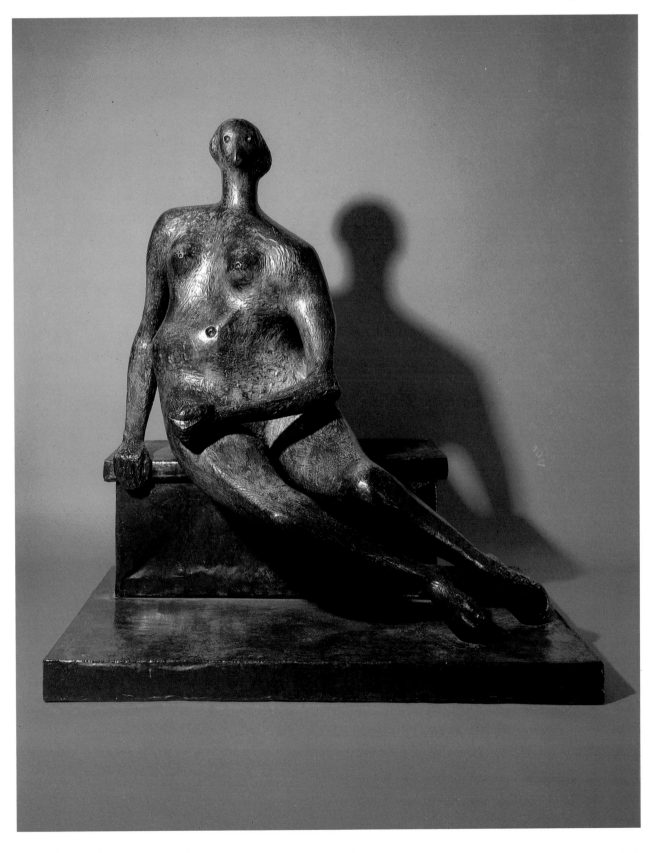

The Visual Diary of Edward James

DESMOND MORRIS

Edward James was a rich, eccentric and socially rebellious art patron whose recent death led to one of the strangest sales of 1986. Wandering around the assembled works of art in the huge marquee erected on the front lawn of his family mansion of West Dean, one thing soon became clear: this was not a collection in the usual sense of the word. A true collection has some kind of system behind it. It has a structure, clearly defined limits, and easily specifiable aims. The brain behind it is that of a hunter, seeking out his prey and then carrying home each new trophy to place with the other treasures already assembled. The prey in question may be snuff-boxes, early Impressionists or vintage cars, but the goal is always the same – to make the very best collection possible in the chosen category. In that sense Edward James was not a collector at all. Systematic behaviour of any kind seemed alien to his strange personality.

The best way to describe the art works gathered together by Edward James is not as a collection but as a 'visual diary'. Each object reflects a passing whim. There is no grand design or lifetime search. His progress through life was wayward and meandering and it is no accident that many of the artists he admired and whose work he bought were themselves wayward, rebellious and often obscure in their choice of subject matter. In fact, traditional subjects are conspicuous by their absence. There is hardly any straightforward, representational art to be seen – none of the usual sporting scenes, landscapes, portraits, nudes or still-life pictures that we expect to find adorning the walls of great British mansions.

In his obsession for the surreal, the bizarre and the dramatically romantic, Edward James seems to have been fired not only by a positive personal eccentricity but also by a deep-seated disdain for traditional art values. And yet there is a contradiction even in this, for although he turned his back on traditional subjects, he could not bring himself to abandon traditional craftsmanship. The result is a narrowing down in his range of favoured painters to those who used meticulous technique to perpetrate their acts of visual outrage. There are no blank canvases here, no minimalist shocks, no splashes and trickles, no Dadaist snook-cocking, no childlike squiggles. No experimental techniques at all. Technically everything is highly respectable. It is only when one looks closer at what is being portrayed that the rebellion becomes clear.

The great master of outrageous content dressed in refined technique is, of course, the Spanish surrealist Salvador Dali, and it was his haunted brain that fascinated Edward James to such an extent that he took the unusual step of virtually 'renting' the artist for a whole year. The arrangement was that whatever Dali painted went to James and to nobody else. In exchange for this exclusivity, James agreed to pay Dali for everything he produced. Of the total Dali output James then kept some and sold others, but the essential point was that Dali was for a while financially secure and it was this that James gave as his primary objective. He claimed that his motive was to free Dali from the necessity of producing hack work to pay for his extravagant lifestyle and to encourage him to produce great works worthy of his talent. He saw himself, not as a collector of Dali pictures, but as a beneficent patron of Dali's work, exclaiming: 'All honour to me, all profit to Dali.'

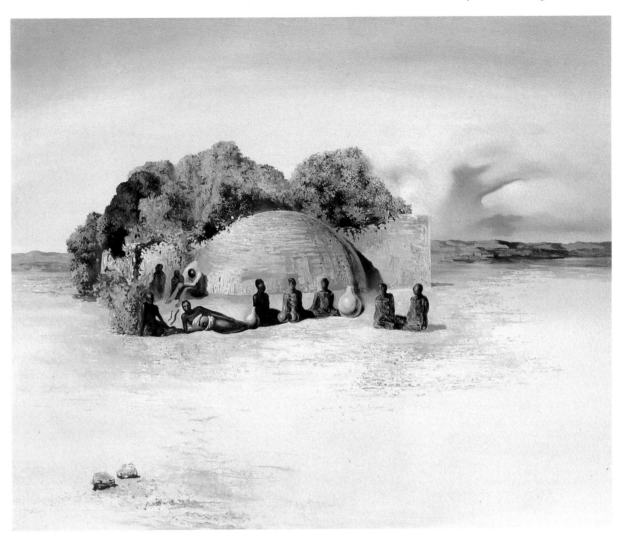

SALVADOR DALI
Spanish b.1904
Paranoiac Face
Oil on panel
Painted in 1935
$7\frac{1}{2} \times 9$ in. (19 × 23 cm.)
Sold 5.6.86 at West Dean for £205,200 ($307,800)
From the Edward James Collection

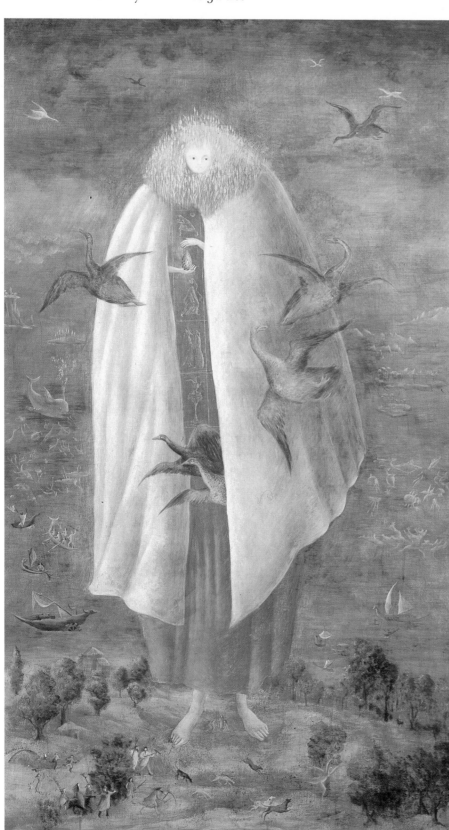

LEONORA CARRINGTON
British/Mexican b.1917
The Guardian of the Egg
Oil on board
46¼ × 27 in. (117.5 × 68.5 cm.)
Sold 5.6.86 at West Dean for £43,200 ($64,800)
From the Edward James Collection
Record auction price for a work by the artist

It is easy today to scoff at the way James behaved, to call his patronage merely patronizing and his sponsorship of Dali no more than rent-a-genius tomfoolery by a rich eccentric, but this would be grossly unfair. The 'contract' with Dali dates from half a century ago when Surrealism was still widely reviled, Dali was considered by most people to be a dangerous and obscene madman and his paintings were certainly not the major financial investments they are today. Now that he is looked upon almost as an 'Old Master', it is easy to forget what a courageous act of rebellion against the stuffy art establishment of the day was being performed by the remarkable Edward James.

Like Dali, Magritte uses traditional techniques to make highly un-traditional comments and he too became a favourite of James's. Like Dali he also became a personal friend and visited James in England. It was friendships with artists that were the basis of James's picture-buying, and it is this that made his assembly of works of art so much more a visual diary than a formal collection. Through his involvement with the theatre and in particular the ballet, he became attached to the works of the set designers – such artists as Tchelitchew, Berman and Berard, and again his closeness to them triggered off bursts of buying, both of their sketches and their paintings.

After the Second World War, he became fascinated by two women Surrealists, Leonor Fini and Leonora Carrington. Yet again, his friendship was sealed with many purchases. Two small portraits can be classed among Fini's best work, each called *Young Girl in Armour*, with their sombre colours and their careful technique, these two little pictures repeat the James preference for the outrageous posing as the traditional. Close inspection reveals that the young girls in question have been dressed by the artist in tight corsets made of metal – a typical piece of restrained Fini eroticism.

The same contradiction appears in the works of Edward's other Leo – Leonora Carrington. He also assembled an important group of her major works and their detail is fascinating. Her picture called *The Gaming Cabinet*, for example, at first sight looks like a simple scene in the games room of a country house, where two slim young women are playing ping-pong. At a distance, the subject matter looks almost tame enough to hang happily on the wall of any other country mansion. But, as always with Edward James, appearances are deceptive. Closer scrutiny reveals that the ping-pong table is hexagonal and has six nets instead of one; that the ping-pong balls are brightly coloured birds, one of which lies dead beneath the table; that one of the players sprouts hairy wings while her partner's body is covered in either fur or tiny, downy feathers; and that they are both wearing bizarre headgear.

This love of traditionally painted shock-images reaches its peak, however, in the famous double-painting by Dali called *Paranoiac Face*. Here, what appears to be a rather insipid 'traveller's scene' showing a group of natives sitting around a mud hut becomes dramatically converted into a striking portrait head when the picture is rotated through 90 degrees. Under Dali's magic brush, the bushes become hair, the hut becomes a rounded cheek, the figures become facial features and the large water jug becomes a chin. In a way, this painting sums up Edward James perfectly. Viewed in the staid perspective of his highly respectable upbringing, with the King as his godfather, education at Eton and Oxford, and a vast fortune inherited at the age of 25, one might have expected the young man to grow up as a typical country gentleman with a taste for hunting scenes, a box at Ascot, and the usual rural preoccupations of the landed gentry of the early 20th century. Instead, by rotating him through 90 degrees, one finds an unexpected and remarkable personage. A man who kept exotic parrots rather than racehorses, who

built weird architectural follies deep in the Mexican jungle, who painted his country house purple to anger the neighbours, and who adorned it with bamboo-shaped drain pipes and life-size artificial palm trees.

Those who visited the sale at West Dean in June of 1986 and who purchased one of his belongings will have bought themselves a small piece of the life of one of the last great eccentrics. He was not, as some have claimed, a rich poseur – a millionaire cultivating and exaggerating his idiosyncracies for effect – but a genuine and intriguing oddity. Nor would he be insulted by such a description. In his final public statement, at the end of a television programme about his capricious lifestyle, he said: 'I have tried to conform as much as possible, but something in my nature obliges me to be eccentric . . . I am an eccentric entirely against my own will . . . it is just something one is born with, like having green hair . . .'

When he died, in 1984, there was a concerted move to keep all his belongings together inside his favourite house, Monkton, near the great mansion of West Dean, converting it into a Surrealist mausoleum. Instead they have been sold and carried off in a hundred different directions, to come to rest in a hundred different settings, where they will be enjoyed by their new owners. Somehow I think James himself would have preferred this. The concept of a museum is alien to the true spirit of Surrealism. Given the choice between having the ashes of his perverse psyche scattered to the winds in a great sale of his effects, and having then entombed forever in a tourist-infested Monkton, I suspect that Edward James would have opted for the scattering every time.

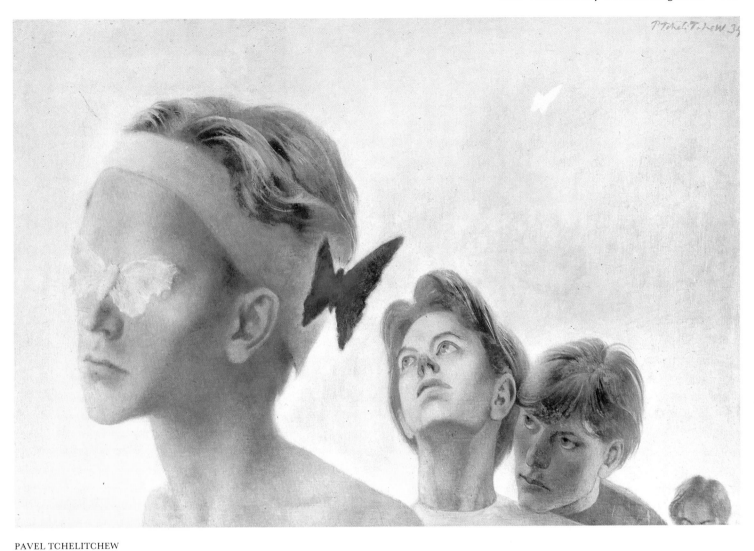
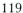

PAVEL TCHELITCHEW
Russian/American 1898–1957
Excelsior
Signed and dated 34
Oil on canvas
31 × 45 in. (79 × 114.5 cm.)
Sold 5.6.86 at West Dean for £28,080 ($42,120)
From the Edward James Collection
Record auction price for a work by the artist

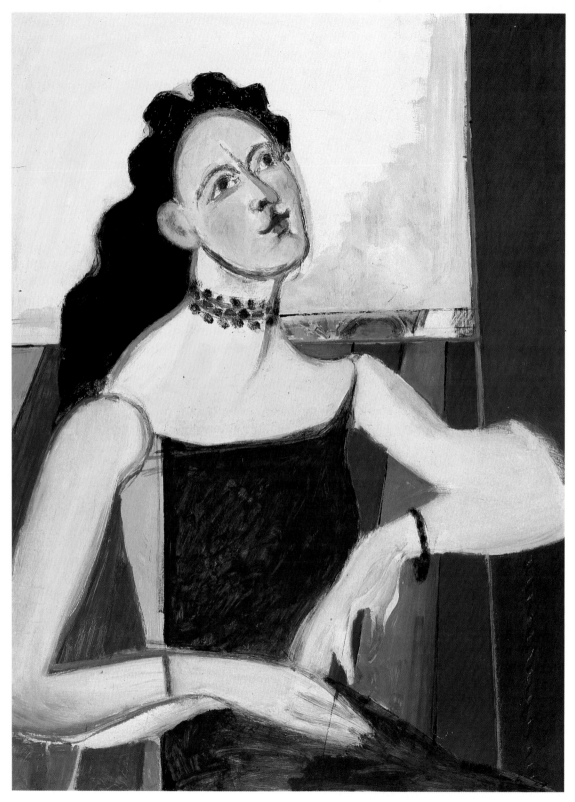

JOHN GRAHAM
American 1881–1961
Untitled (Portrait of a Woman)
Oil on panel
Painted *c*.1942
48 × 35½ in.
(121.9 × 90.2 cm.)
Sold 6.11.85 in New York for
$275,000 (£191,771)
Record auction price for a
work by the artist

WILLEM DE KOONING
Dutch/American
b.1904
Woman
Signed
Oil and charcoal on
board
Painted *c.*1951
25¾ × 19¾ in.
(65.4 × 50.2 cm.)
Sold 6.11.85 in New
York for $385,000
(£268,480)
From the collection of
Vincent Melzac

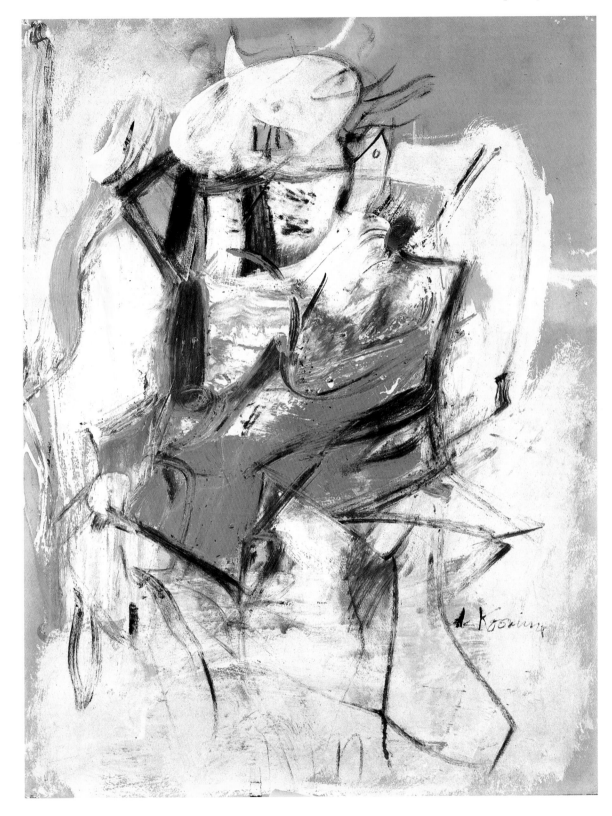

RICHARD DIEBENKORN
American b.1922
Ocean Park #121
Signed with initials and dated 80; also signed, inscribed with title and dated 1980 on the reverse
Oil on canvas
78 × 78 in. (198.2 × 198.2 cm.)
Sold 6.5.86 in New York for $374,000 (£243,490)
From the collection of Max Palevsky

ADOLPH GOTTLIEB
American b.1923
Deep over Pale
Signed, inscribed with title and
dated 1964 on the reverse
Oil on canvas
90 × 60¼ in. (228.6 × 153 cm.)
Sold 6.5.86 in New York for
$308,000 (£203,974)
Record auction price for a work
by the artist
From the collection of
Mr and Mrs Gilbert H. Kinney

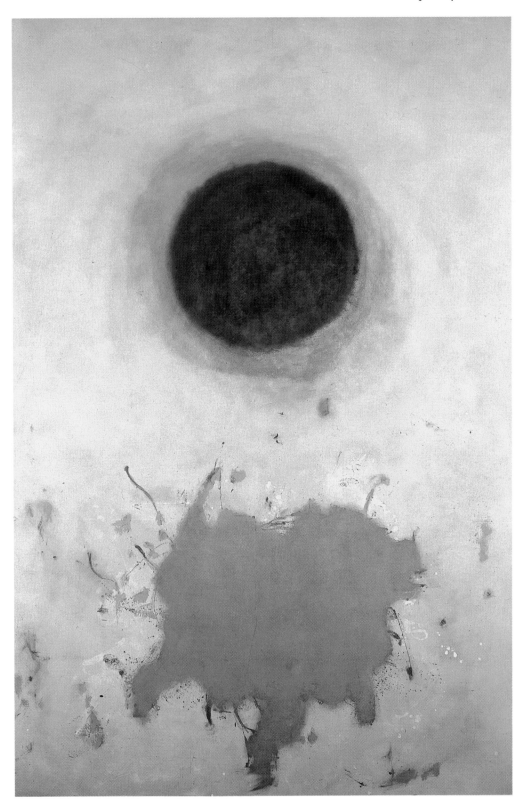

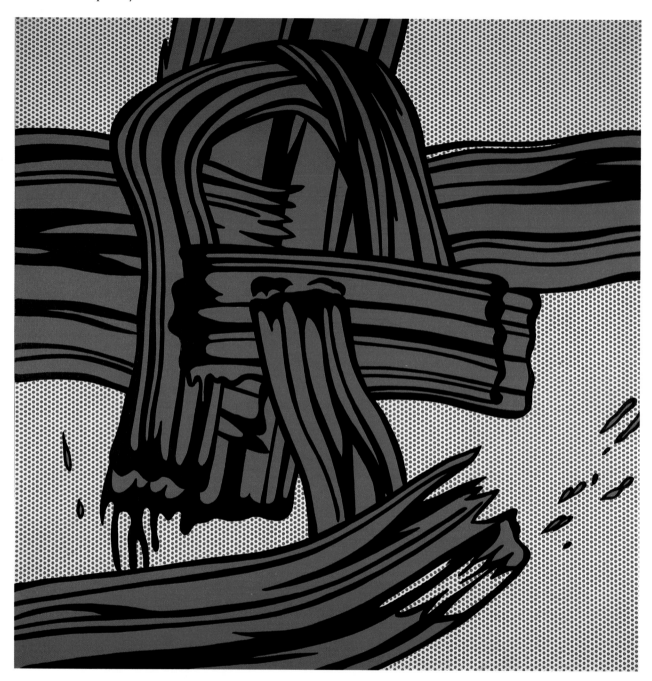

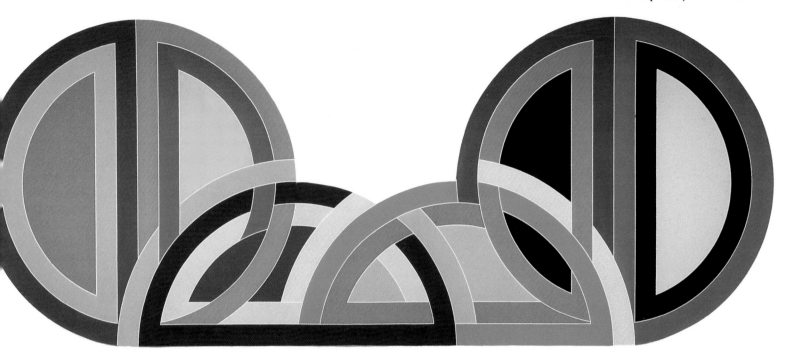

FRANK STELLA
American b.1935
Madinat As-salam I
Polymer and fluorescent polymer paint on shaped canvas; unframed
Painted in 1970
118 × 300 in. (300 × 760 cm.)
Sold 6.11.85 in New York for $297,000 (£207,113)

Opposite:
ROY LICHTENSTEIN
American b.1923
Red Painting
Signed and dated 65 on the reverse
Oil and magna on canvas
60 × 60 in. (152.4 × 152.4 cm.)
Sold 6.5.86 in New York for $440,000 (£306,407)
The 'Brushstroke' paintings from the mid-1960s set in contrast the expressionist stroke of paint to the flattened, precisely-dotted surface of the canvas. Contrary to what is presumed, these paintings are not tongue-in-cheek comments on Abstract Expressionism but representations of the artist's fascination with the 'brushstroke' as 'romantic, classic, expressionist'. Lichtenstein returned to regularly using the image of 'brushstrokes', but only as part of the subject matter, in paintings from 1980 onwards.

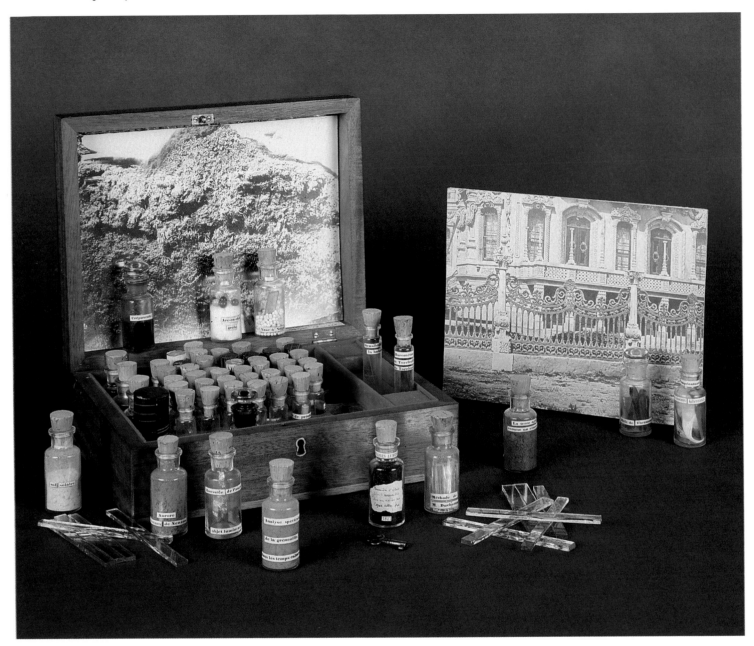

JOSEPH CORNELL
American 1903–73
Object, Cabinet of Natural History
Signed by the artist and typed 'Object (1936–1940)' on a paper label
Open: $9\frac{1}{4} \times 9\frac{1}{4} \times 7\frac{1}{4}$ in. ($23.5 \times 23.5 \times 18.5$ cm.)
Closed: $3\frac{1}{4} \times 9\frac{1}{4} \times 7\frac{1}{4}$ in. ($8.3 \times 23.5 \times 18.5$ cm.)
Sold 6.5.86 in New York for $181,560 (£118,164)
Record auction price for a work by the artist
From the Edward James Collection

DAVID SMITH
American 1906–65
V.B. XXIII
Signed, inscribed with title
and dated 'Mar 14–63' on
the base
Welded steel
$69\frac{1}{2} \times 28\frac{5}{8} \times 24$ in.
$(176.5 \times 72.8 \times 61$ cm.)
Sold 6.5.86 in New York for
\$1,320,000 (£859,375)
Record auction price for a
work by the artist and for any
contemporary sculpture
From the collection of
Sarah Dora Greenberg

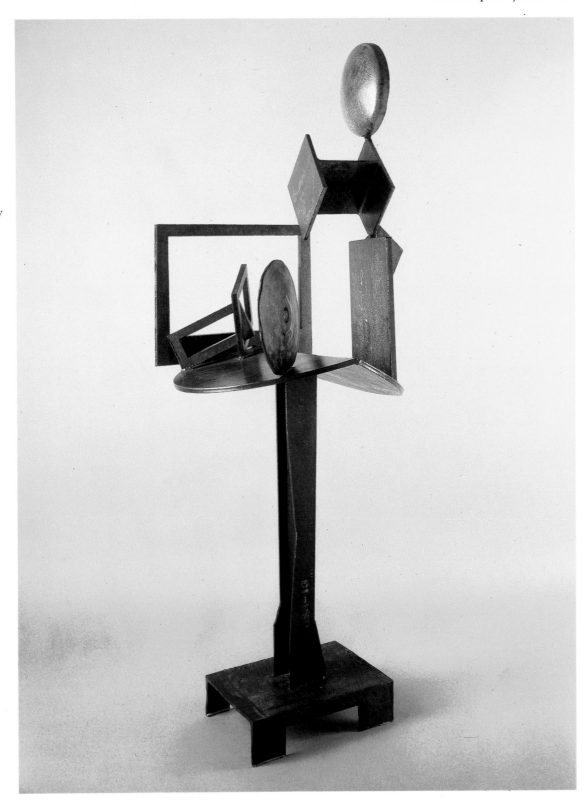

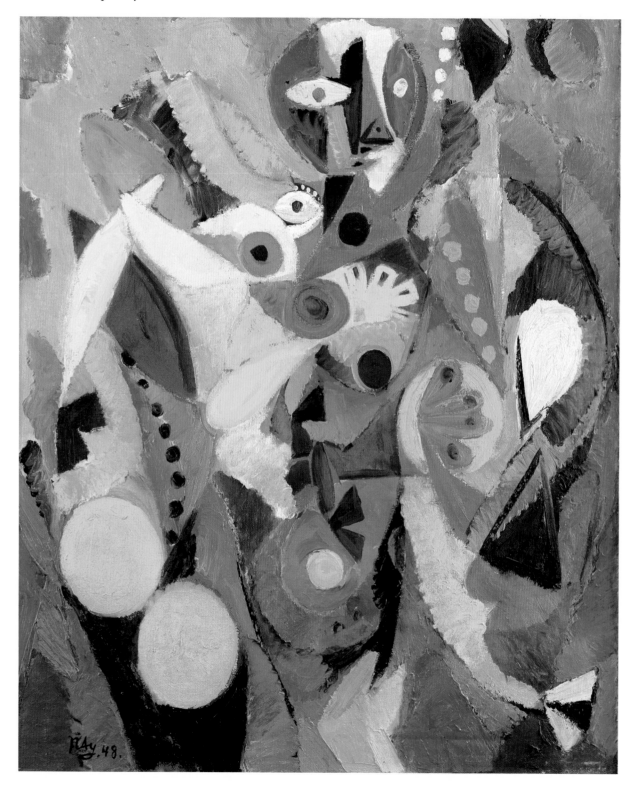

GERHARD RICHTER
German b.1932
Stadtbild PL
Signed, inscribed with title and
dated 1970 on the reverse
Oil on canvas
67 × 67 in. (170.2 × 170.2 cm.)
Sold 6.12.85 in London for £23,760
($34,928)
Record auction price for a work by
the artist

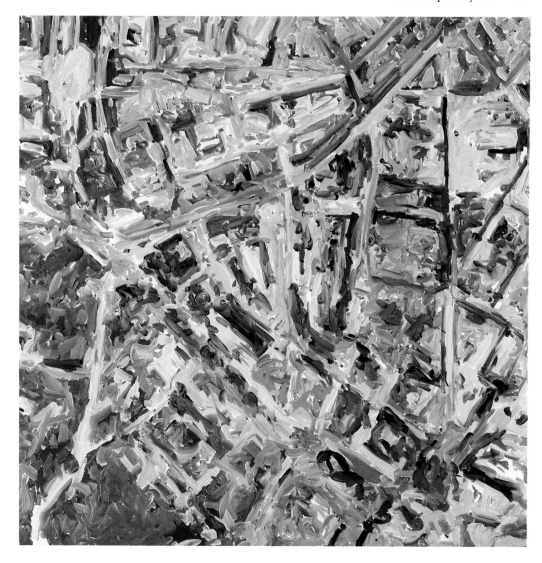

Opposite:
ERNST WILHELM NAY
German 1902–68
Der Hirte III
Signed and dated 48; also signed,
inscribed with title and dated 1948
on the reverse
Oil on canvas
35 ⁷⁄₈ × 29 ³⁄₄ in. (91 × 75.5 cm.)
Sold 26.6.86 in London for £59,400
($89,100)
From the collection of the St. Louis
Art Museum

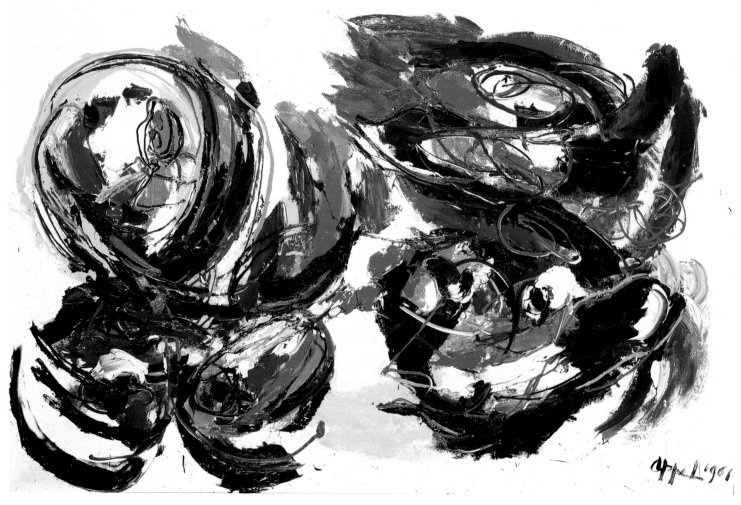

KAREL APPEL
Dutch b.1921
Un Matin
Signed and dated 1961; also signed, inscribed with title and dated 1961 on the reverse
Oil on canvas
78¾ × 118 in. (200 × 300 cm.)
Sold 6.12.85 in London for £51,840 ($76,205)
Record auction price for a work by the artist

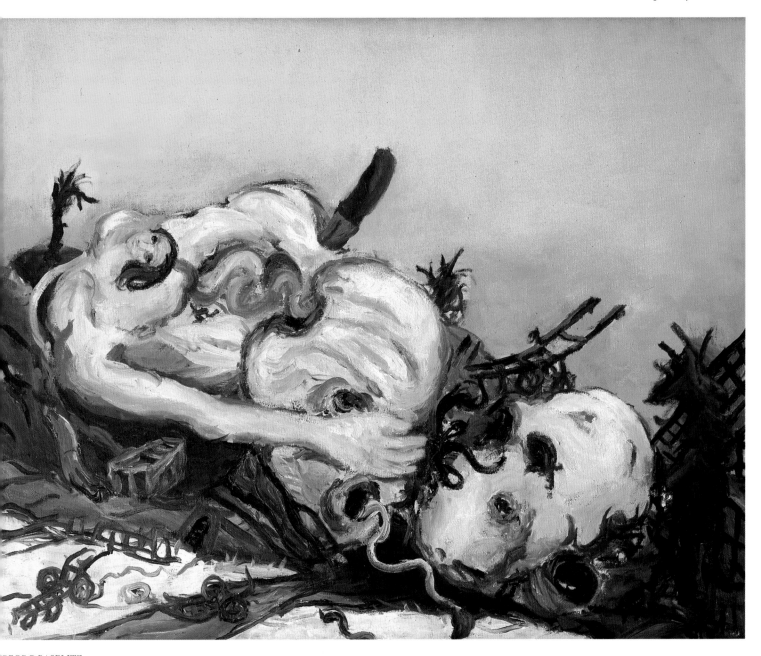

GEORG BASELITZ
German b.1938
Landschaft Für Väter
Signed with initials; also signed, inscribed with title and dated 1965 on the reverse
Oil on canvas
51 1/8 × 63 3/4 in. (130 × 162 cm.)
Sold 26.6.86 in London for £108,000 ($162,000)
Record auction price for a work by the artist

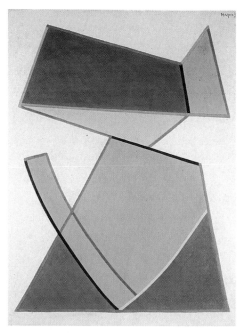 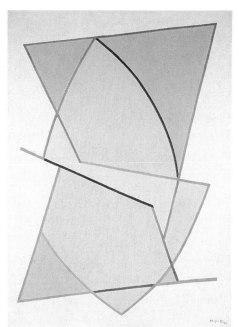 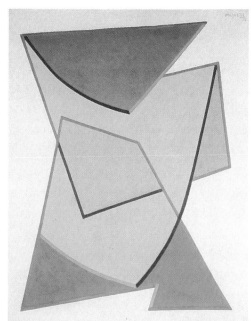

ALBERTO MAGNELLI
Italian 1888–1971
Triptyque
Signed
Oil on canvas
Painted in 1956
No. 1: 36 × 29 in. (92 × 73 cm.)
No. 2: 51 × 37 in. (130 × 95 cm.)
No. 3: 36 × 29 in. (92 × 73 cm.)
Sold 8.5.86 in Rome for L.138,000,000 (£60,000)
Record auction price for a work by the artist

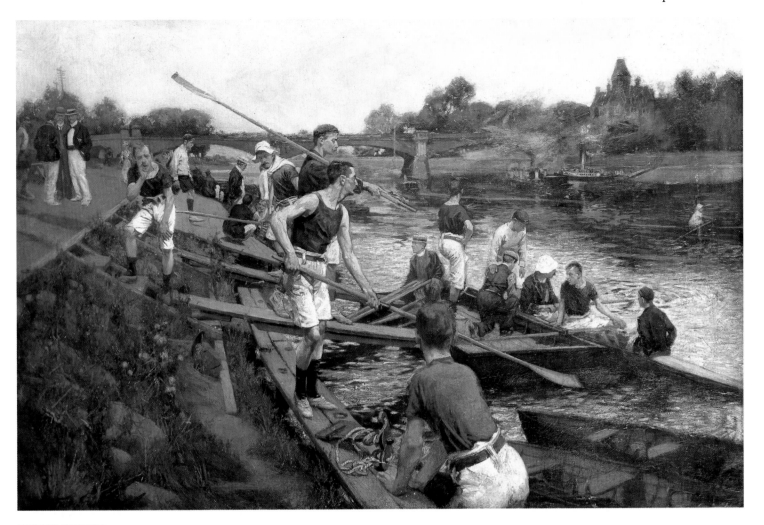

ARTHUR SPOONER
British, active 1920–55
The Nottingham Boat Club, 1894
Signed
Oil on canvas
39½ × 59½ in. (100 × 151 cm.)
Sold 6.3.86 in London for £91,800 ($132,513)
Record auction price for a work by the artist

The Nottingham Boat Club was founded in 1894 by a breakaway group from the Nottingham Rowing Club. At that time, it was a rule that the Boat House should not be opened on Sundays. There was a crew in training that resented this discipline; they rebelled, broke the rule and refused to apologize to the committee. Their membership was suspended until they made a promise not to repeat the offence. This they refused to do, so they decided to leave the Rowing Club and form a club of their own. The founders were Alderman Alfred Page (afterwards Lord Mayor of Nottingham) and his three sons, and Ross Browne, W.T. Crofts, F. Harrison, L. Kirk, T. Danls, Albert Smith and Ben Hardstaff. All these men are represented in the above painting, commissioned to commemorate the formation of the club and the start of Sunday rowing.

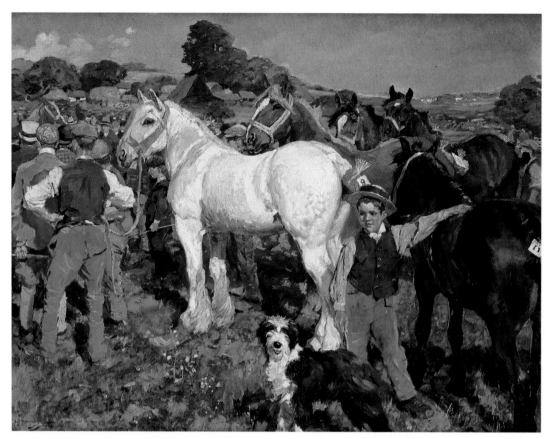

SIR ALFRED J. MUNNINGS, P.R.A.
British 1878–1959
A Michaelmas Sale on a Suffolk Farm
Signed and dated 1900
Oil on canvas
28 × 36 in. (71 × 91.5 cm.)
Sold 6.3.86 in London for £118,800 ($171,488)

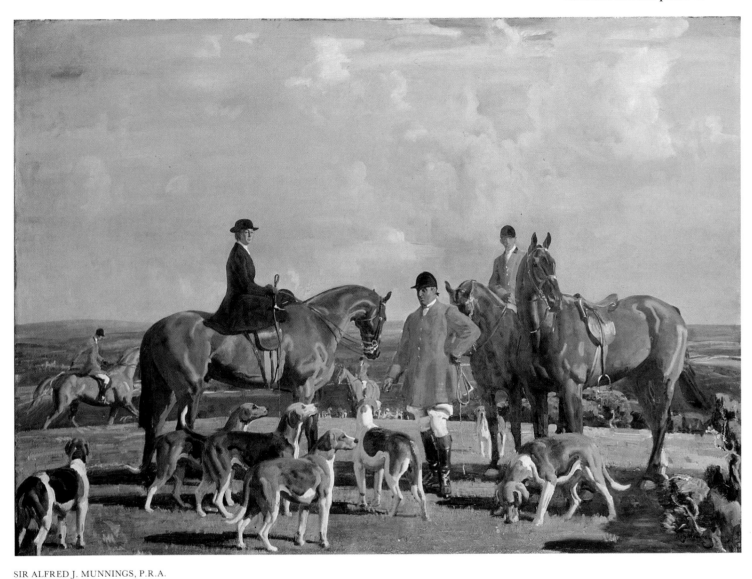

SIR ALFRED J. MUNNINGS, P.R.A.
British 1878–1959
John J. Moubray, Master of Fox Hounds, with his Wife
and the Bedale Hounds
Signed and dated 1920
Oil on canvas
48 × 68 in. (122 × 173 cm.)
Sold 12.6.86 in London for £324,000 ($486,000)
Record auction price for a work by the artist

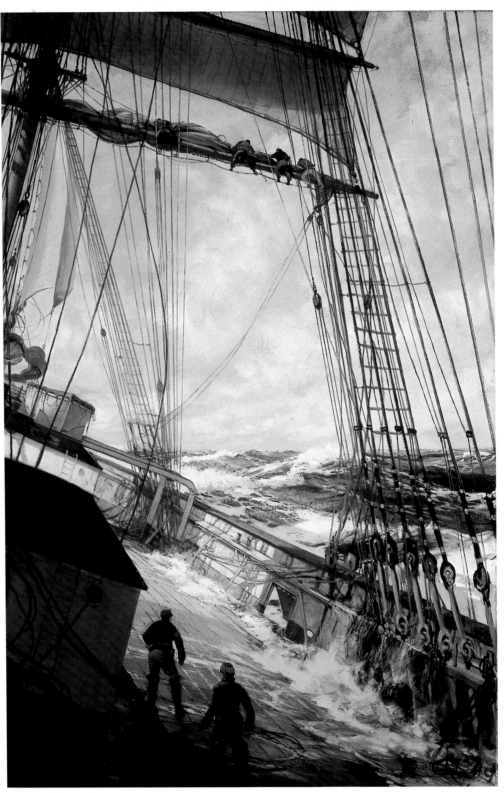

MONTAGUE DAWSON
British 1895–1973
Up Aloft
Signed
Oil on canvas
42 × 28 in. (106.6 × 71 cm.)
Sold 26.2.86 in New York for $74,800
(£50,473)

Opposite:
FRANK O. SALISBURY
British 1874–1962
Portrait of the Rt. Hon. Sir Winston Churchill
Signed and dated 24 October 1944; also signed and inscribed on the reverse
Oil on canvas
30 × 25 in. (76 × 63.5 cm.)
Sold 25.9.85 in London for £21,600 ($30,834)
From the Frank O. Salisbury studio sale
In 1944 the sitter was conferred with the honorary Freedom of the City of London by the Lord Mayor, Sir Samuel Joseph, in the Guildhall, and Salisbury was commissioned to commemorate the event with a painting

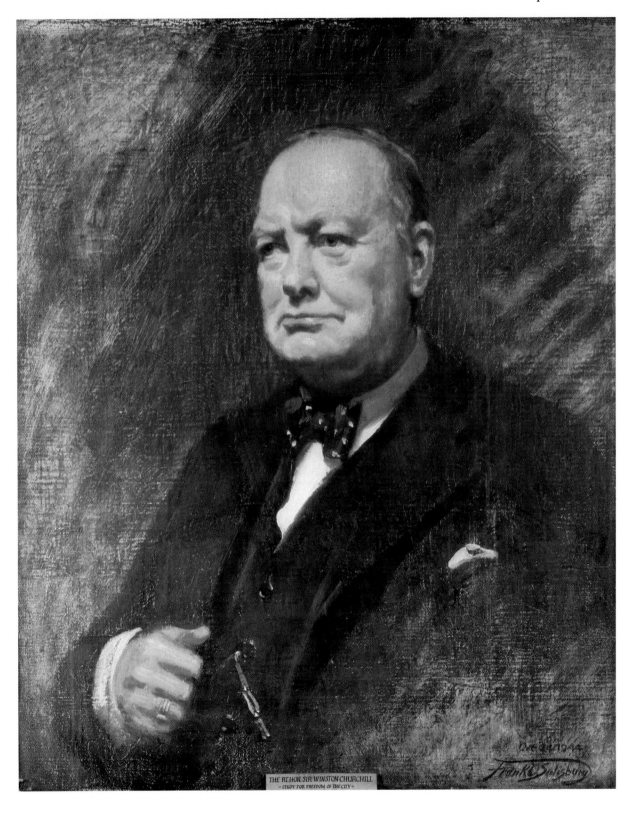

THE RT. HON. SIR WINSTON CHURCHILL
~ STUDY FOR FREEDOM OF THE CITY ~

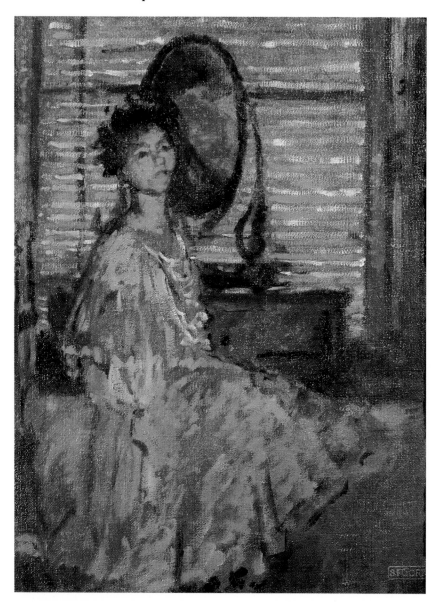

SPENCER FREDERICK GORE
British 1878–1914
Behind the Blind
With studio stamp
Oil on canvas
Painted *c.* 1906
19½ × 15⅜ in. (49.5 × 39 cm.)
Sold 7.3.86 in London for £28,080 ($40,576)

JOSEPH EDWARD SOUTHALL
British 1861–1944
The Nut Brown Maid
Signed with monogram and dated
'JES 1902–3–4'; also signed and
inscribed on a label on the reverse
Tempera on canvas
39 × 25½ in. (99 × 64.8 cm.)
Sold 6.3.86 in London for £75,600
($109,129)

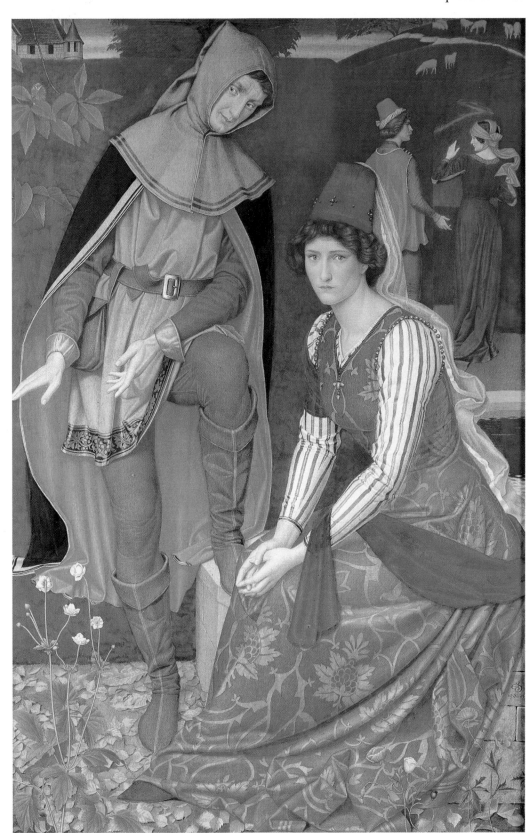

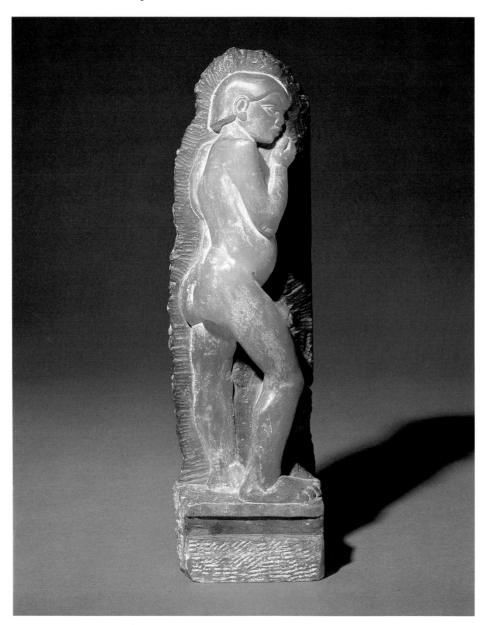

HENRI GAUDIER-BRZESKA
French 1891–1915
Amour
Alabaster
Executed *c.*1912–13
18 in. (45.7 cm.) high
Sold 7/8.11.85 in London for £20,520 ($29,272)

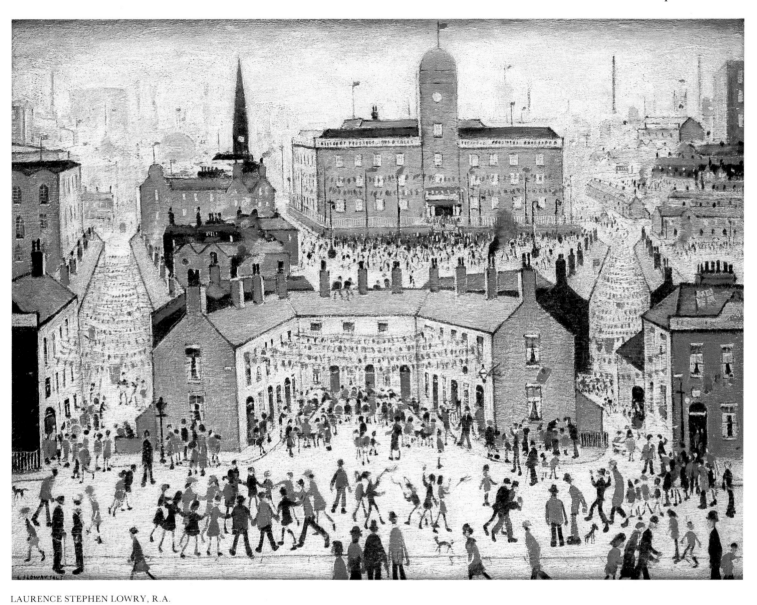

LAURENCE STEPHEN LOWRY, R.A.
British 1887–1976
VJ Day
Signed and dated 1945
Oil on panel
20 × 27 in. (50.8 × 68.5 cm.)
Sold 7/8.11.85 in London for £45,360 ($64,707)

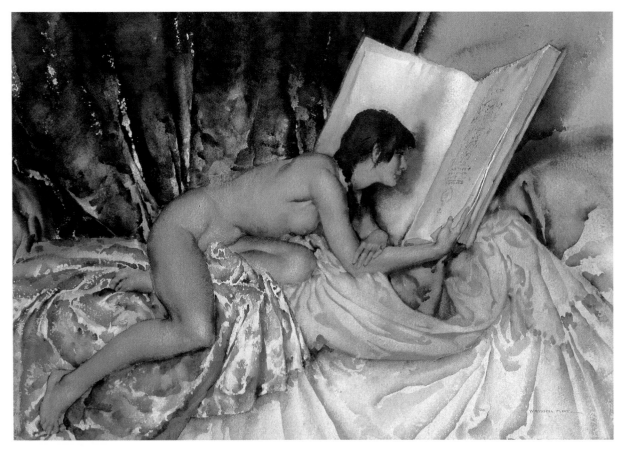

SIR WILLIAM RUSSELL FLINT, R.A.
British 1880–1969
Janelle and the Volume of Treasures
Signed; signed again and inscribed with title on the backboard
Watercolour
$14\frac{1}{2} \times 20\frac{1}{2}$ in. (36.8×52 cm.)
Sold 12.6.86 in London for £21,600 ($32,400)

SAMUEL JOHN PEPLOE,
R.S.A.
British 1871–1935
Roses in a Japanese Vase
Signed
Oil on board
Painted *c.*1923
20 × 16 in.
(50.8 × 40.7 cm.)
Sold 30.4.86 in Glasgow
for £34,820 ($53,623)

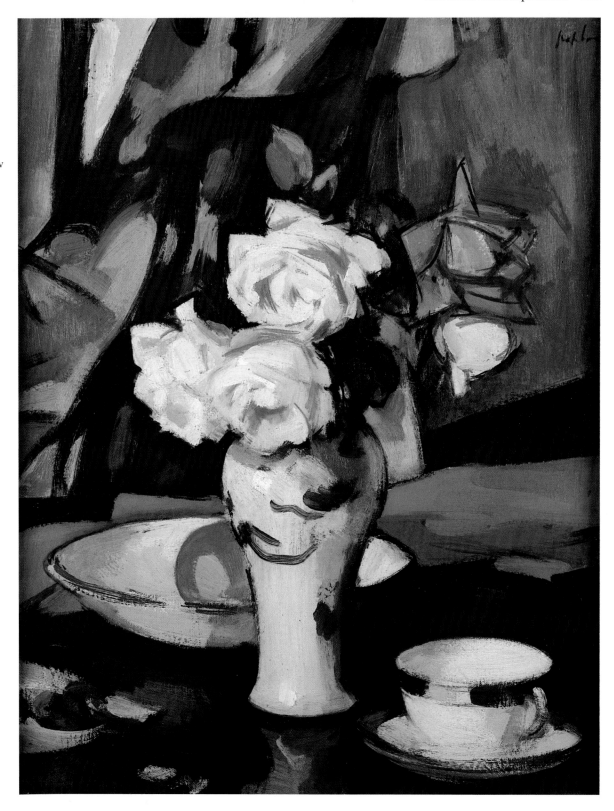

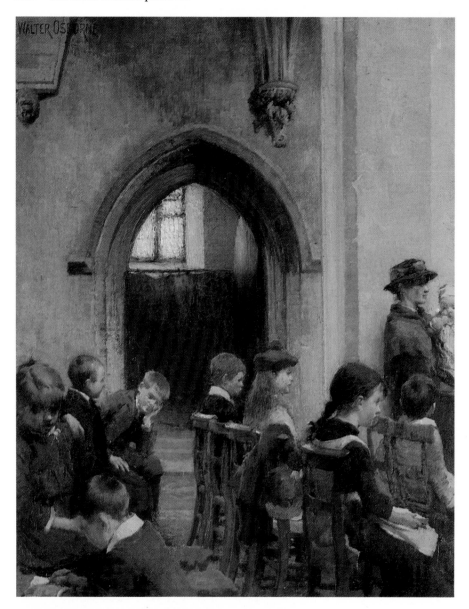

WALTER FREDERICK OSBORNE, R.H.A., R.O.I.
Irish 1859–1903
Children in Church
Signed
Oil on panel
16 × 12¾ in. (40.6 × 32.5 cm.)
Sold 10.2.86 at Carrickmines, Dublin for IR£54,920 (£48,818)

JACK BUTLER YEATS, R.H.A.
Irish 1871–1957
The Circus Proprietor
Signed
Oil on canvas
18 × 24 in. (45.7 × 60.9 cm.)
Sold 10.2.86 at Carrickmines, Dublin
for IR£37,346 (£33,197)
Record auction price for a work by the
artist

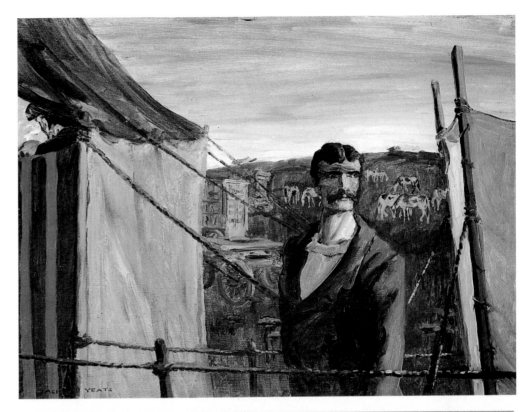

RODERIC O'CONOR
Irish 1860–1940
Red Rocks, Brittany
Oil on board
18 × 24 in. (45.7 × 60.9 cm.)
Sold 13.6.86 in London for £18,360
($27,540)

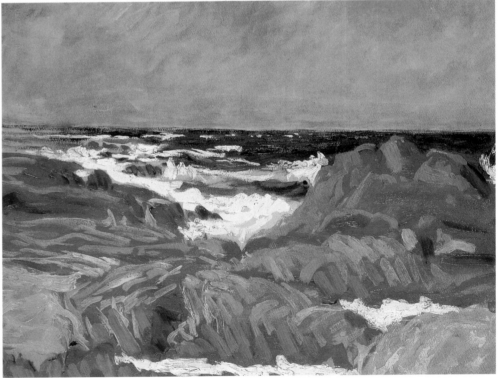

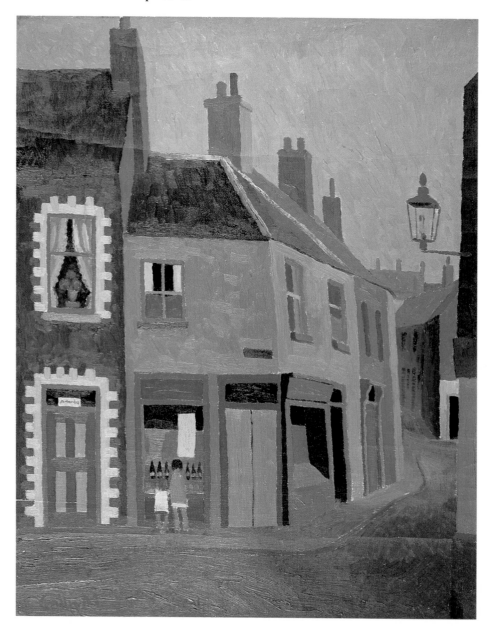

COLIN MIDDLETON, R.H.A.
Irish 1910–83
Street Corner Shop
Signed and dated 39
Oil on canvas
20 × 15¾ in. (50.8 × 40 cm.)
Sold 4.10.85 in London for £5,184 ($7,390)
From the Colin Middleton studio sale

Drawings, Watercolours and Prints

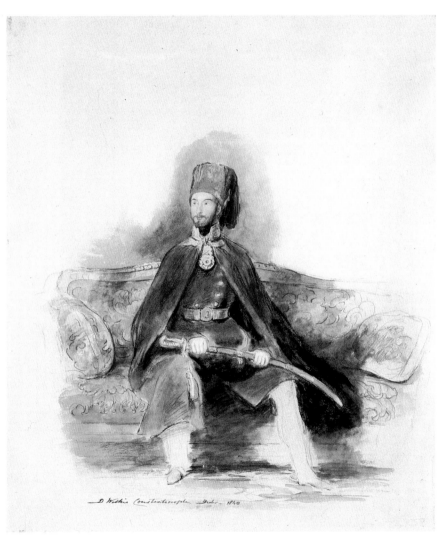

SIR DAVID WILKIE, R.A.
British 1785–1841
Portrait of Abd-Ul-Mejid, Sultan of Turkey
Signed, inscribed 'Constantinople' and dated 'Decbr. 1840'
Pencil, black and red chalk and watercolour heightened with white and gold
bodycolour on stone-coloured paper
15⅛ × 13 in. (38.2 × 33 cm.)
Sold 8.7.86 in London for £16,200 ($25,110)

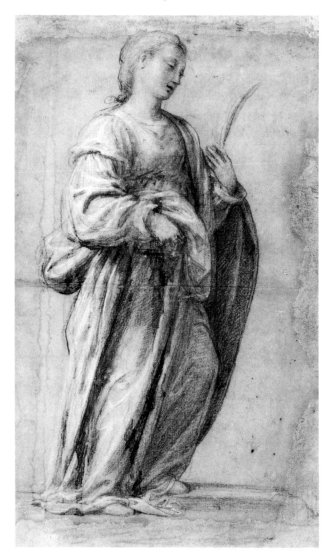

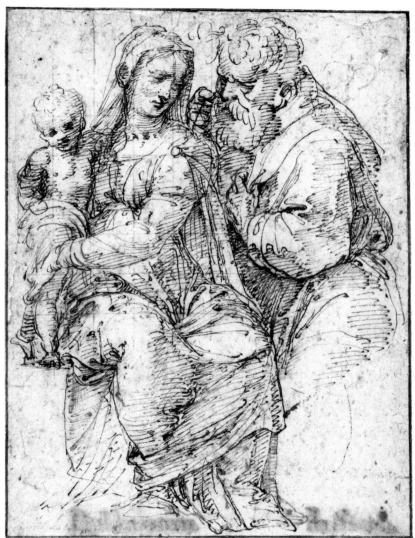

FRA PAOLINO DA PISTOIA
Italian 1490–1547
Saint Lucy
Black and white chalk on buff paper, watermark circle
below a cross
16 × 10¾ in. (40.9 × 27.0 cm.)
Sold 1.7.86 in London for £41,040 ($64,433)
A study for an altarpiece in the Church of San
Domenico, Pistoia

BALDASSARE PERUZZI
Italian 1481–1536
The Holy Family
Inscribed 'Baldassare da Siena' and attributed to 'Baltassar da Sienna' on
the mount
Pen and brown ink, the upper left section lightly squared in black chalk
9½ × 7½ in. (23.9 × 19 cm.)
Sold 14.1.86 in New York for $66,000 (£44,000)
From the collection of Mr and Mrs Fred Kline
This hitherto unpublished drawing is evidently of not long after 1510,
when the Siennese master was established in Rome

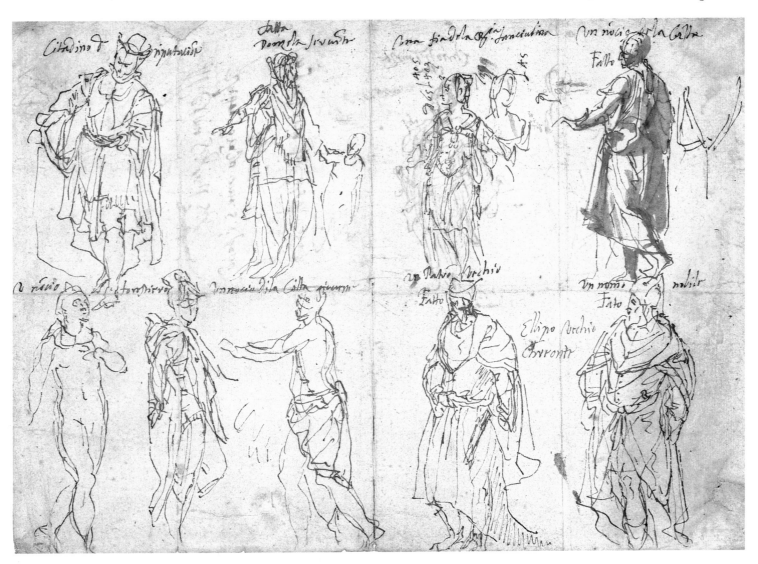

PAOLO CALIARI, IL VERONESE

Italian 1528–88

Costume Studies for the 'Oedipus Tyrannus' of Sophocles (recto and verso)

Extensively inscribed

Pen and brown ink, the recto with brown wash, watermark encircled man below small cross

8¼ × 12 in. (21.3 × 30.3 cm.)

Sold 1.7.86 in London for £70,200 ($107,406)

This was drawn for the inaugural performance of Sophocles' *Oedipus Tyrannus* at the Teatro Olimpico, Vicenza, on 3 March 1585. The decision to stage Orsatto Giustiniani's translation of the play was made by May 1584 and on 6 May committees to supervise the production were set up under Leonardo Valmarana. The costumes are known to have been designed by Alessandro Maganza, but two drawings establish that he consulted Veronese, who had enjoyed a long association with Palladio, the architect of the theatre. Three studies by Maganza based on the present sheet are recorded.

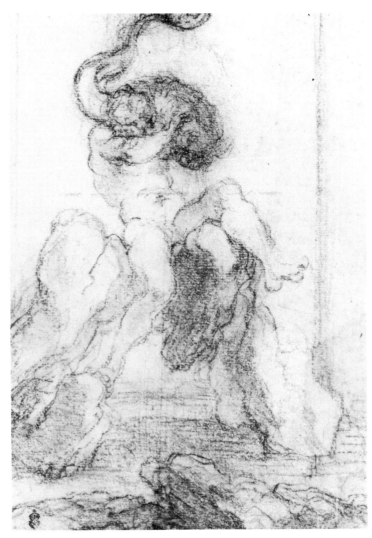

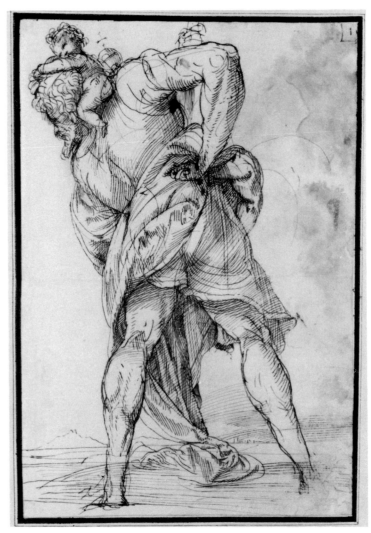

GIAN LORENZO BERNINI
Italian 1598–1680
A Marine God with a Dolphin
Inscribed 'Bernini' on the verso
Black chalk on rough light grey paper, watermark crown in a
cartouche
14 × 9½ in. (35.2 × 24 cm.)
Sold 15.6.86 in Monaco for F.fr.1,221,000 (£115,188)
This is a study for a fountain in the courtyard of Palazzo degli
Estense at Sassuolo, near Modena, which Bernini designed for
Francesco I d'Este, Duke of Modena in 1652–3. Bernini's schemes
were executed in stucco by Antonio Raggi, with the assistance of
local craftsmen. Drawings for the two companion fountains are at
Windsor.

ATTRIBUTED TO TIZIANO VECELLIO, CALLED TITIAN
Italian 1477–1576
Saint Christopher
Pen and brown ink
13 × 9 in. (33.2 × 23 cm.)
Sold 11.12.85 in London for £86,400 ($123,250)
From the Stenman Collection, Stockholm
First published by Hans Tietze in 1950 as by Titian, the drawing
has also been considered to be the work of Domenico Campagnola

GIOVANNI BATTISTA
PIAZZETTA
Italian 1682–1754
A Boy holding a Lemon
Black and white chalk
on light blue paper
15½ × 12 in.
(39 × 30.8 cm.)
Sold 12.12.85 in
London for £162,000
($228,420)
No other autograph
version exists, but the
boy's right arm and
hand are found in the
picture *Boy with a
Lemon* in the
Wadsworth Athenaeum
at Hartford. In this
the model is in profile
but is dressed in
similar clothes to those
in the present sheet.

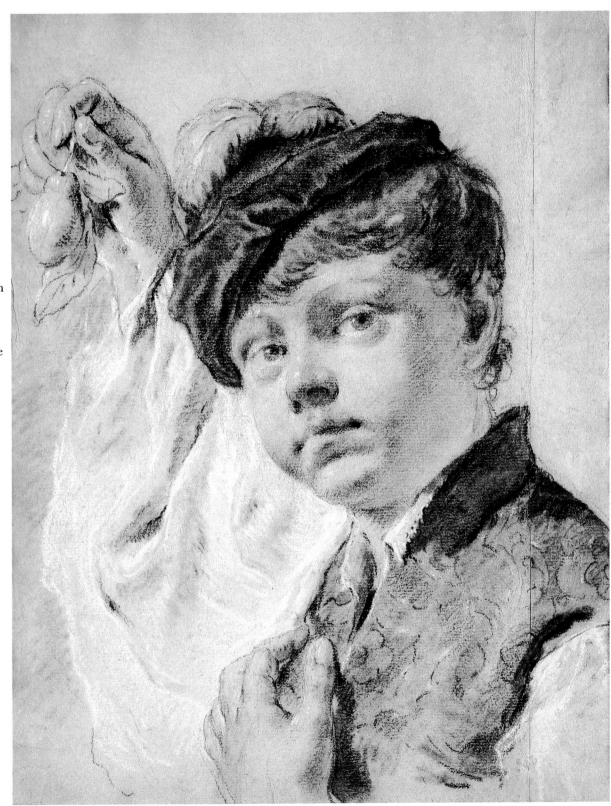

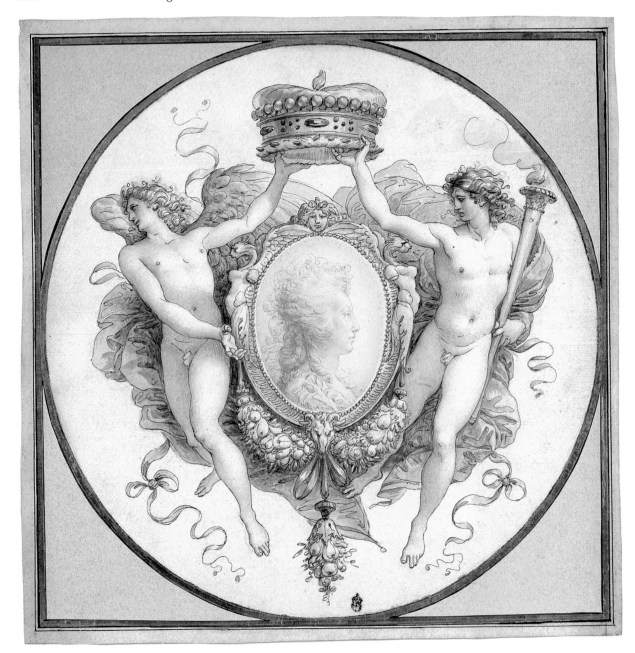

GIUSEPPE CADES
Italian 1750–99
An oval Portrait of a Woman aged 30, in profile with a decorative border of Grotesques and Swags, with flanking allegorical
Figures of Fame and Victory holding a Coronet
Inscribed and dated 1785
The portrait in red and black chalk, the surround in red and black chalk, pen and black ink, blue, yellow, red
and green and brown wash; circular
14¼ in. (36 cm.) diameter
Sold 12.12.85 in London for £45,360 ($63,958)

JEAN AUGUSTE DOMINIQUE INGRES
French 1780–1867
Portrait of the Hon. Mrs Fleetwood Pellew, later Lady Pellew
Signed 'Ingres. Del. Rome 1817'
$11\frac{1}{2} \times 8\frac{3}{4}$ in.
(29.7 × 22.2 cm.)
Sold 12.12.85 in London for £226,800 ($319,788)
Record auction price for a work by the artist
Harriet Webster (1793–1861), who married Captain the Hon. Fleetwood Pellew, 2nd son of the 1st Viscount Exmouth, on 5 June 1816, was the daughter of Sir Godfrey Webster, 4th Bt. of Battle Abbey, and his wife Elizabeth Vassall, later Lady Holland. In 1796, when Lady Webster finally decided to break with her husband, her devotion to the infant was such that she pretended that Harriet had died. The deception was concealed until 1799, when she was returned to the custody of her father, who died in 1800. Captain Fleetwood Pellew (1789–1861) followed his father into the Navy. He rose quickly in the service, finally attaining the rank of Admiral of the Blue in 1858, and was knighted in 1836.

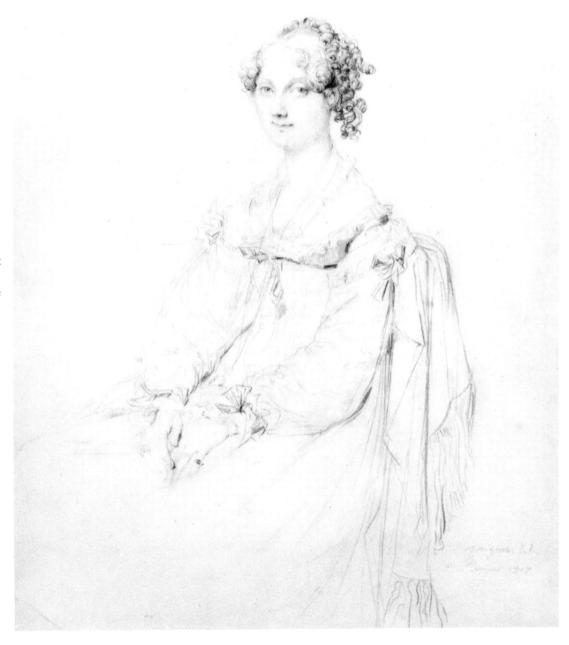

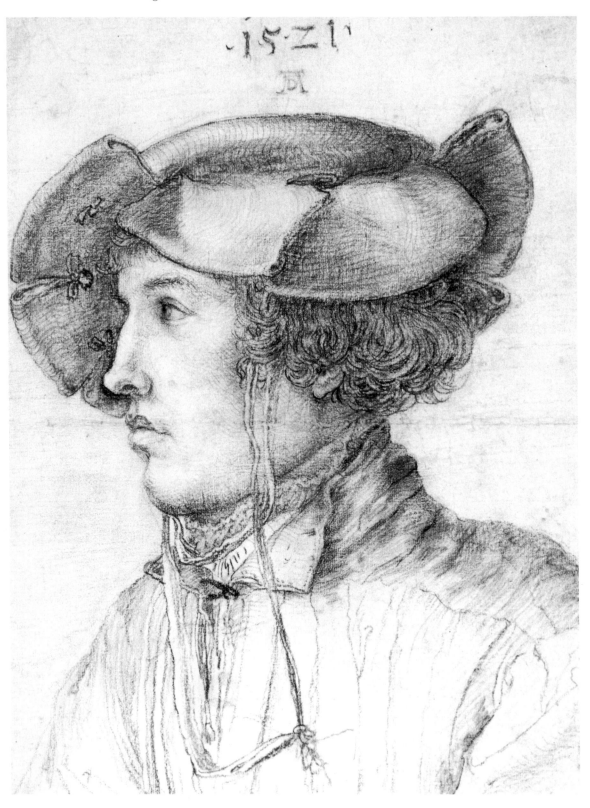

SWISS SCHOOL
*Portrait of a young Man
wearing a Hat, in profile*
Dated 1521, and with
later monogram 'AD'
Black chalk, watermark
bear (Bern)
15 × 11¼ in.
(38 × 28.7 cm.)
Sold 12.12.85 in London
for £70,200 ($98,982)
A similar hat, the flaps
upturned, is shown in a
drawing of the same year
by Niklaus Manuel
Deutsch at Basel. The
same numerical forms
appear in the signed and
dated portrait of 1523 of
Jacob van Roverea, Herr
von Crest by the
monogramist HF,
evidently a close associate
of Deutsch, at Bern.

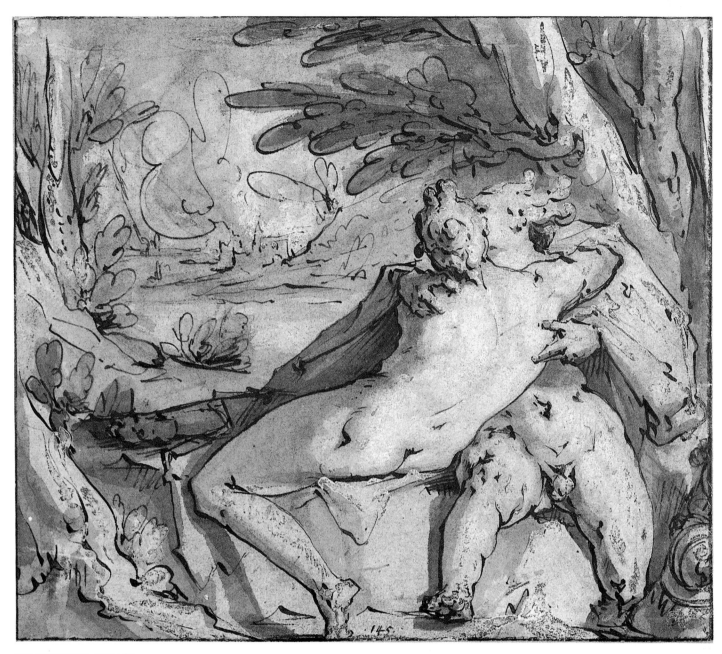

JAN HARMENSZ. MULLER
Dutch 1571–1628
A nude Couple seated embracing by a Tree, in the distance burning Buildings
With a number '145'
Black chalk, pen and brown ink, brown wash heightened with white on light brown paper
7¼ × 8½ in. (18.7 × 21.8 cm.)
Sold 18.11.85 in Amsterdam for D.fl.162,400 (£38,667)
Ascribed with other drawings to the period 1588–*c.*1594, when Muller was most strongly under the influence of Spranger

The Collection of Ray Livingston Murphy (1923–53)

Ray Murphy lived less than 30 years, yet the range and number of his accomplishments would do credit to a life twice that length. He was brought up in New York, the younger of two brothers. His father, a North Carolinian by birth, was a successful physician and medical researcher. His mother, Ray Slater Murphy, after whom he was named, was a Bostonian and the granddaughter of the artist and collector, William Morris Hunt. His mother's considerable fortune descended from her great grandfather, Samuel Slater, 'Father of the Industrial Revolution in America'. Mrs Murphy had been educated in Europe and was a linguist, an inveterate traveller and an amateur archaeologist. She frequently left her young family for several months at a time to join archaeological digs in remote spots or to accompany Alan Priest, curator of Far Eastern Art at the Metropolitan Museum, on collecting expeditions to China. Possibly her younger son began developing his taste for collecting when as a child he welcomed his mother home from these trips and examined the artifacts, curiosities and some occasional real treasures with which she returned. Mrs Murphy was also a patron of the arts and often invited artists into her home. At different times, both J.P. Marquand and Geoffrey Scott lived and worked at the Murphys' house on Park Avenue.

Young Ray was early perceived as extraordinary: he had black hair and dark blue, 'violet' eyes, and he grew to be 6 ft. 6 in. tall, a throwback, his parents said, to a Murphy ancestor of tremendous stature who had fought with Sam Houston's raiders in Texas a century before. A child of enormous vitality, he was precocious, erratic, difficult and fascinating. Quite predictably, he did not fit into the conventional educational system. After a brief and disastrous stay at an American preparatory school, he was taken by his mother to Edinburgh, where, aged 14, he took courses at the University. For the following two years he studied and travelled in Europe and during this time, directed to some extent by his mother, he began to collect books and paintings. While in Edinburgh he attended the book auction at which he acquired the foundation of the Beckford collection (mostly given to Yale University after his death).

Returning to America in 1940, Murphy entered the University of Virginia as special student – he was still only 16. He eventually received his baccalaureate degree from Yale University after the war. His studies were interrupted when he joined the war effort as a foreign correspondent and a member of the Operations Analysis Department of the U.S. Army Air Force. While in the Pacific theatre he met Lord Louis Mountbatten and determined to write his biography. Thus at the end of the war he returned to London to pursue this project, which was published in 1948 as *The Last Viceroy*. Also during these two years in London, Murphy began collecting on a larger scale. He met Paul Oppé, who became his friend and mentor. His early acquisitions were 18th and 19th century paintings; from there he moved on to English watercolours. He also continued to collect rare books. His final great interest was Old Master drawings.

Pictures of endless vistas fascinated Murphy. He was an admirer and collector of Edward Lear's oils and watercolours, and they so intrigued him that he edited Lear's *Indian Journal* (Jarrolds, 1953).

Murphy's sudden death at the age of 29, the result of a fluke accident, cut short the career of a versatile and talented collector. His mother, overcome with grief, moved into the house in New York that he filled with his collection and lived as a recluse among her son's belongings until her death.

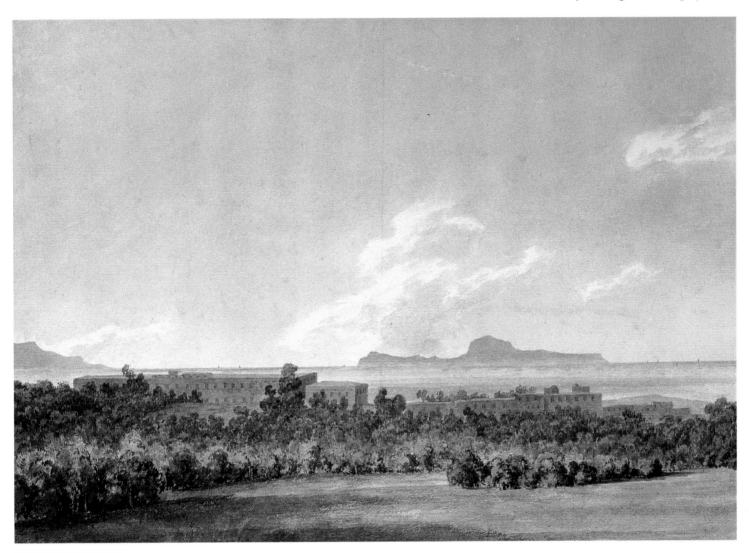

JOHN ROBERT COZENS
British 1752–97
View from Sir William Hamilton's Villa at Portici, showing the Promontory of Miseno, the King's Palace and the Isle of Capri
Pencil and watercolour
10⅜ × 14¾ in. (26.5 × 37 cm.)
Sold 19.11.85 in London for £41,040 ($58,503)
From the estate of Ray Livingston Murphy, New York City

JOSEPH MALLORD WILLIAM TURNER, R.A.
British 1775–1851
Margate
Watercolour and bodycolour on light brown paper
8¾ × 11½ in. (22 × 29.2 cm.)
Sold 19.11.85 in London for £59,400 ($84,675)
From the estate of Ray Livingston Murphy, New York City

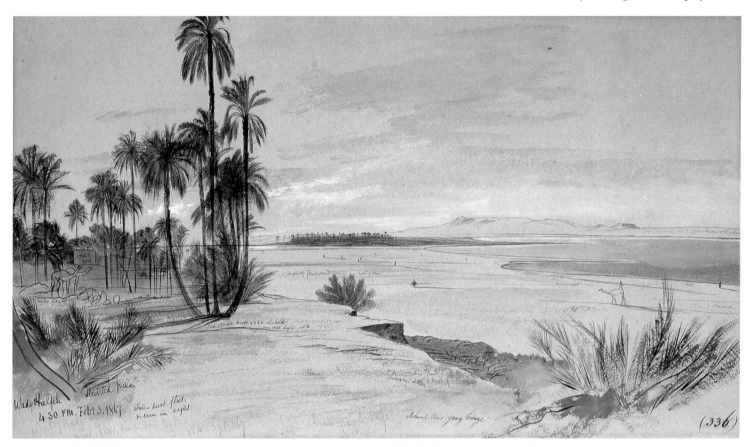

EDWARD LEAR
British 1812–88
Wady Halfeh
Inscribed '4.30. P.M. Feby. 3. 1867., wind – dust. Flies, & sun in eyes.', with colour notes and numbered (336)
Pencil, pen and brown ink and watercolour heightened with white on stone-coloured paper
11¾ × 21⅛ in. (29.5 × 53.5 cm.)
Sold 19.11.85 in London for £21,600 ($30,791)
Record auction price for a watercolour by the artist
From the estate of Ray Livingston Murphy, New York City

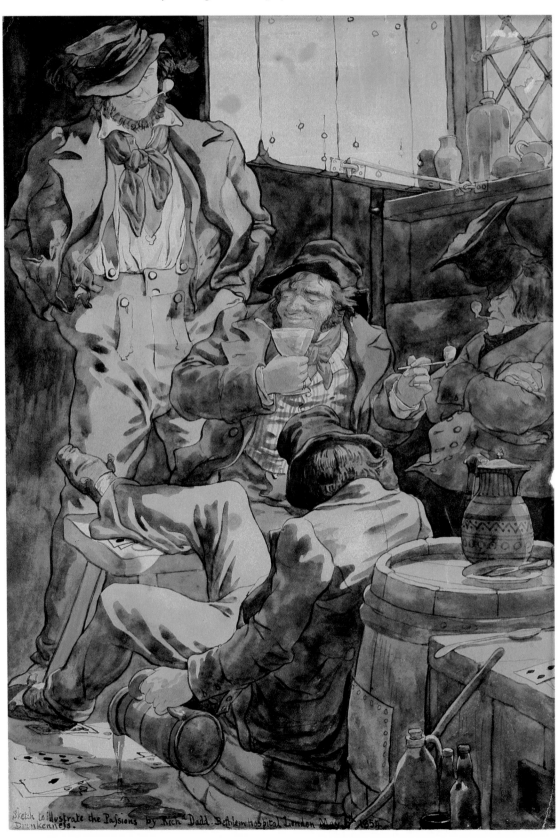

RICHARD DADD
British 1819–87
Sketch to illustrate the
Passions – Drunkenness
Inscribed as title and 'by
Richd. Dadd. Bethlem
Hospital London May 6th
1854'
Pencil, pen and grey ink and
watercolour
$14\frac{1}{2} \times 10\frac{1}{4}$ in. (36.8 × 26 cm.)
Sold 19.11.85 in London for
£19,440 ($27,712)
From the estate of Ray
Livingston Murphy, New
York City

DAVID COX
British 1783–1859
Beached Shipping near Flint
Inscribed 'Coast Nr. Flint'
Pencil and watercolour
$7\frac{3}{8} \times 10\frac{3}{4}$ in. (19 × 27 cm.)
Sold 18.3.86 in London for
£14,040 ($20,498)

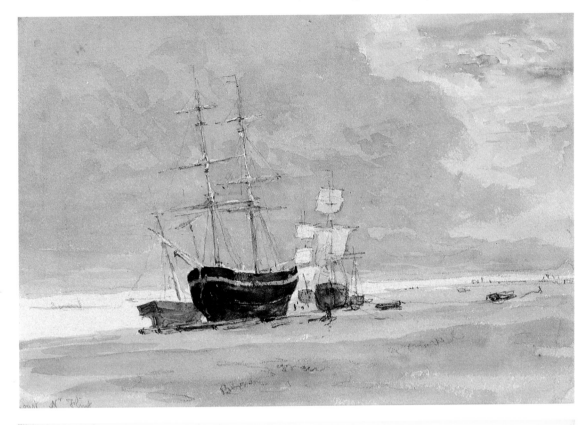

WILLIAM CALLOW
British 1812–1908
Edinburgh from Salisbury Crags
Signed and dated 1844
Pencil and watercolour
heightened with white
$29\frac{7}{8} \times 45$ in.
(76 × 114.3 cm.)
Sold 8.7.86 in London for
£32,400 ($48,600)
Record auction price for a
watercolour by the artist

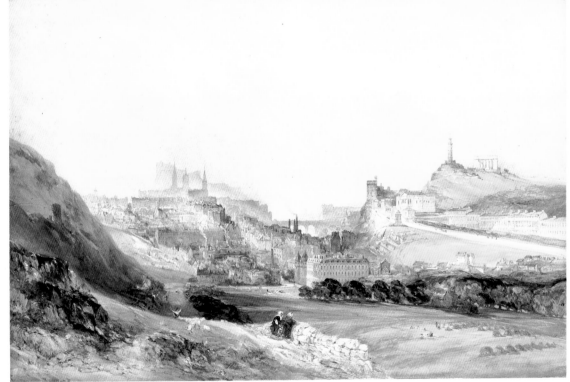

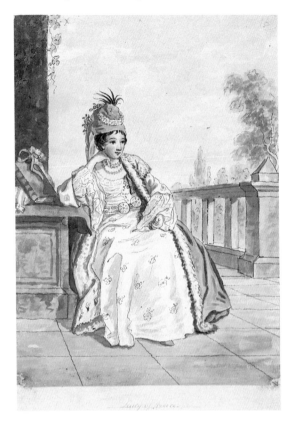

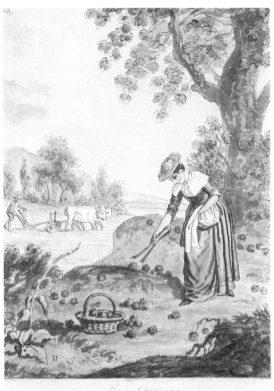

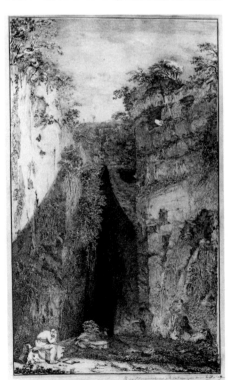

Above:
DAVID ALLAN
British 1744–96
An Album entitled 'A Collection of Dresses by Da Allan mostly from Nature 1776'
Inscribed on the pages of the album with the title, list of contents and description of each subject, the majority of the watercolours numbered
Pencil, pen and grey ink and watercolour, some of the album pages watermarked J. Whatman or Strasburg lily
The watercolours averaging 9 × 7¼ in. (22.9 × 18.5 cm.); the album 13 x 10¼ in. (33 × 26 cm.) overall
Sold 8.7.86 in London for £15,120 ($23,436)
From the collection assembled by the Scottish banker and connoisseur, Sir William Forbes, 7th Bt., of Pitsligo (1773–1828)

JOHN BROWN
British 1752–87
The Cave of Dionysius, Syracuse
Signed, inscribed and dated 'July ye 10th 1772 – John Brown Fecit pr. W Young E–' on the mount
Pencil, pen and brown ink, watermark Strasburg bend and lily
18⅛ × 10¾ in. (45.8 × 26.5 cm.)
Sold 8.7.86 in London for £23,760 ($35,640)
From the collection assembled by Sir William Forbes

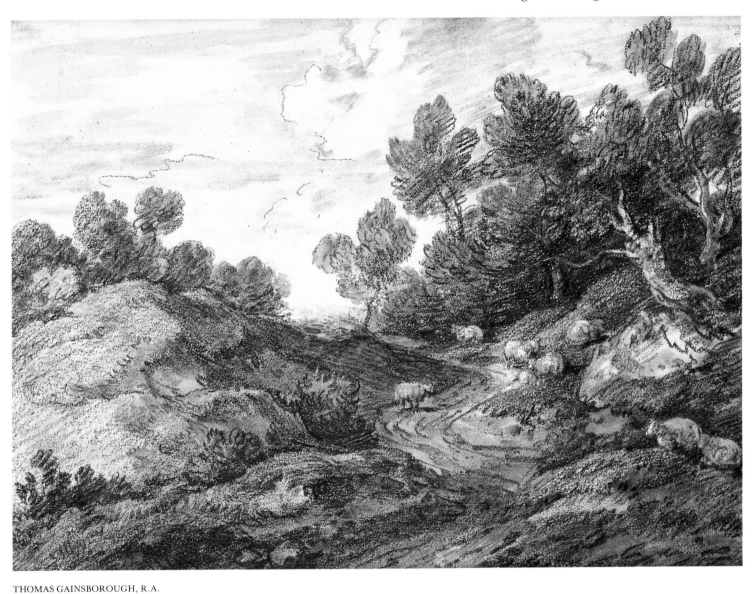

THOMAS GAINSBOROUGH, R.A.
British 1727–88
A wooded Landscape with Sheep by a winding Track
Black chalk and stump and watercolour heightened with white
$10^{3}/_{4} \times 14^{3}/_{4}$ in. (27×37.5 cm.)
Sold 8.7.86 in London for £21,600 ($33,480)

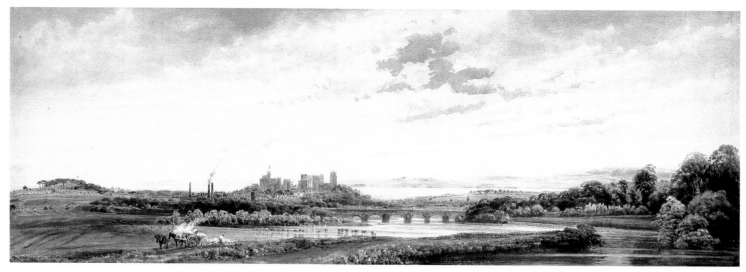

Above:

PETER DE WINT
British 1784–1849
*Panoramic View of Lancaster,
looking towards Morecambe
Bay, the River Lune in the
foreground*
Pencil and watercolour
$12\frac{1}{4} \times 36$ in.
(31 × 91.5 cm.)
Sold 18.3.86 in London for
£19,440 ($28,382)

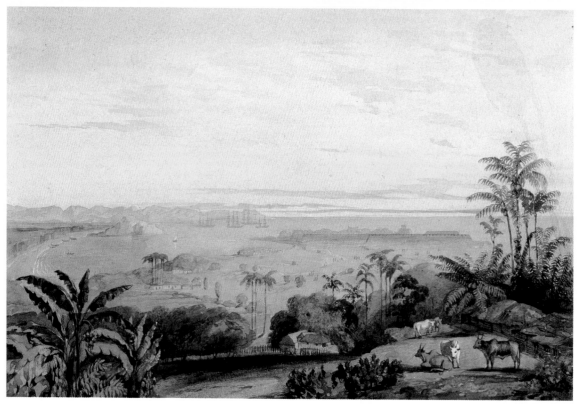

ATTRIBUTED TO HENRY FITZCOOK
British 1824–?
The Route of the Overland Mail to India – An Album of 31 Watercolours recording the Diorama of 1850
Pencil and watercolour heightened with white
The watercolours $8\frac{1}{2} \times 12\frac{5}{8}$ in. (21.5 × 32 cm.); the album 23 × 20 in. (58.4 × 50.8 cm.) overall
Sold 8.7.86 in London for £23,760 ($36,828)
From the estate of Ray Livingston Murphy, New York City

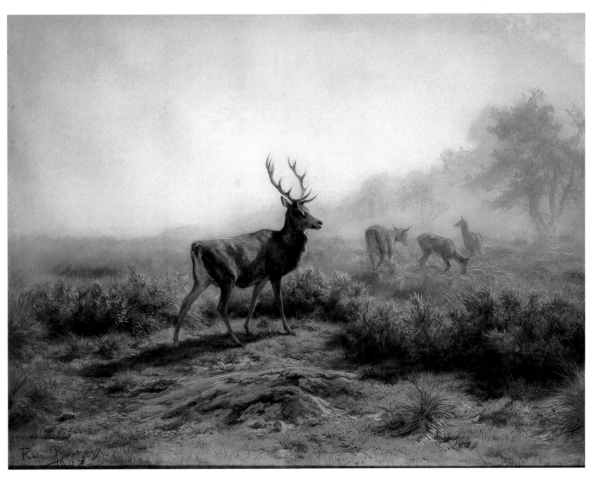

ROSA BONHEUR
French 1822–99
A Stag and three Doe in a misty mountainous Landscape
Signed and dated 1897
Pastel on stretched canvas
59 × 76 in. (150 × 193 cm.)
Sold 30.10.85 in New York for $24,200 (£16,864)
Record auction price for a pastel by the artist

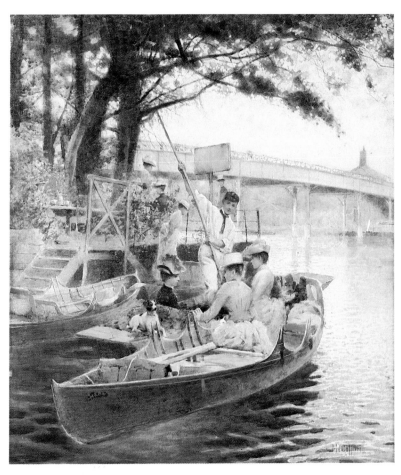

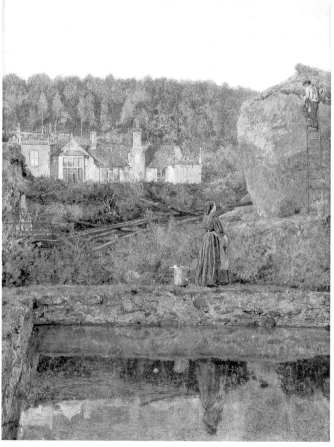

HECTOR CAFFIERI
British 1847–1932
Cookham: The Boating Party
Signed
Watercolour heightened with white
22⅛ × 19¾ in. (55.9 × 50 cm.)
Sold 29.4.86 in London for £17,280 ($26,663)
Record auction price for a watercolour by the artist

JOHN WILLIAM NORTH, A.R.A.
British 1842–1924
The Haystack: Halsway Manor Farm, Somerset
Indistinctly signed and dated 64
Watercolour and bodycolour
10⅛ × 7½ in. (25.5 × 19 cm.)
Sold 29.10.85 in London for £30,240 ($43,062)
Record auction price for a watercolour by the artist

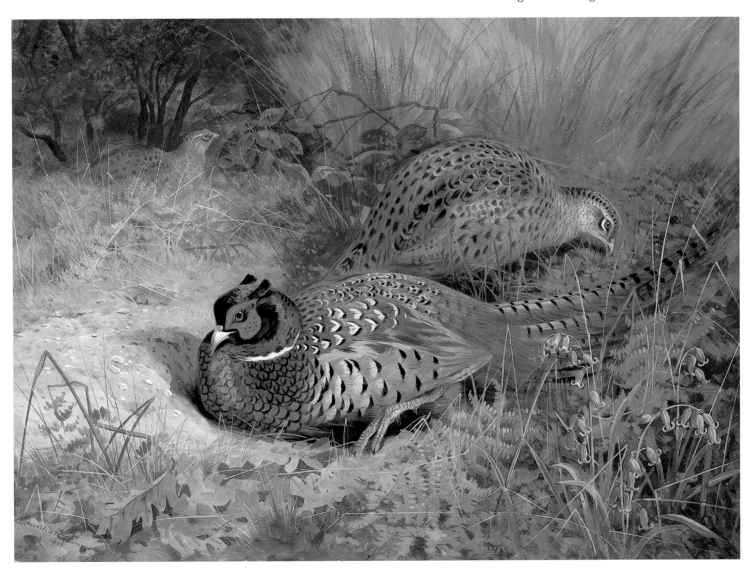

ARCHIBALD THORBURN
British 1860–1935
A Cock and two Hen Pheasants
Signed and dated 1902
Watercolour and bodycolour
$21^5/_8 \times 30$ in. (54.7 × 76.2 cm.)
Sold 29.4.86 in London for £23,760 ($36,709)
Record auction price for a work by the artist

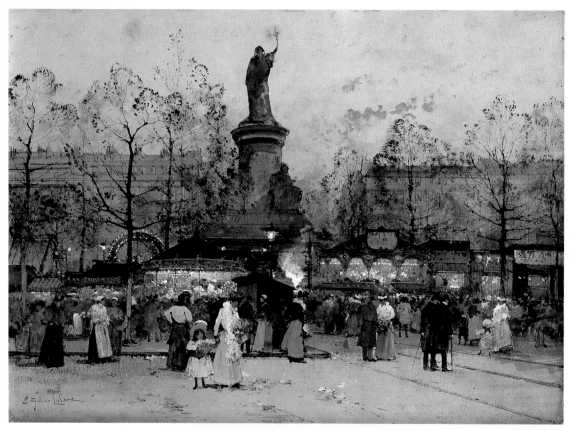

EUGENE GALIEN-LALOUE
French 1854–1954
Place de la Republique
Signed
Gouache with pencil
15⅜ × 20⅛ in.
(39 × 53.8 cm.)
Sold 30.10.85 in New York
for $17,600 (£12,265)
Record auction price for a
work on paper by the artist

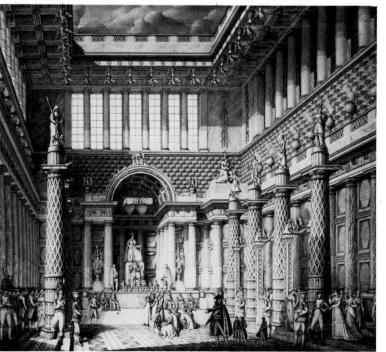

JEAN JACQUES LE QUEU
French 1757–*c.*1825
*Napoleon receiving the Persian
Ambassadors*
Signed and dated 1809
Watercolour, pen and black
ink
18⅞ × 21⅝ in. (48 × 55 cm.)
Sold 30.10.85 in New York
for $30,800 (£21,464)

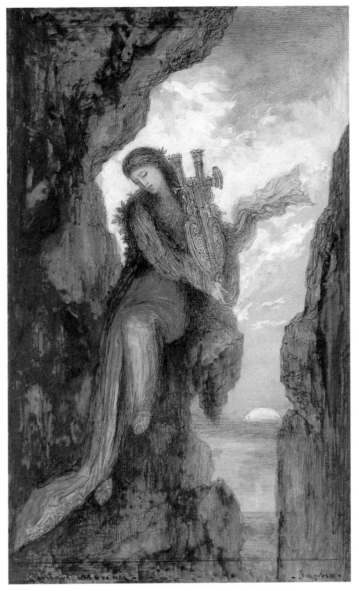

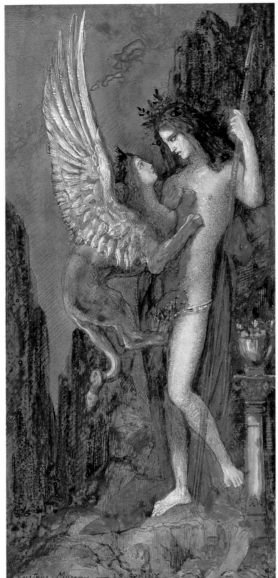

GUSTAVE MOREAU
French 1826–98
Sappho on the Cliff
Signed and inscribed
Pencil and watercolour heightened with white on tinted paper
Painted *c.*1872
11¾ × 7⁷⁄₁₆ in. (30 × 19 cm.)
Sold 19.6.86 in London for £75,600 ($113,400)

GUSTAVE MOREAU
French 1826–98
The Sphinx
Signed and inscribed
Pen and black ink and watercolour heightened with white on yellow paper
Painted *c.*1864
10¾ × 5⁵⁄₁₆ in. (27.5 × 13.6 cm.)
Sold 19.6.86 in London for £91,800 ($138,251)

Old Master Prints from Chatsworth

DAVID LLEWELLYN

Christie's had advertised the sale of Old Master Prints from Chatsworth as the most outstanding sale of this type to be held since the 1920s. The fact that the sale contained the finest examples of many Old Master prints from artists as diverse as Mantegna and Piranesi, and that the prices paid established over 65 new auction records and contributed to a total of £3,614,533 ($5,385,655), persuaded many that in the field of Old Master prints it was indeed the sale of the century.

Little is known about the formation of the print collection at Chatsworth, but it is probable that it was assembled for the most part by the 2nd Duke of Devonshire between about 1690 and 1735. Its strength lies mainly in the Italian School and in particular in those extremely rare prints by Mantegna and his followers dating from the second half of the 15th century. The prices paid for Mantegna's two masterpieces, *A Bacchanal with a Wine-Press* at £275,400 ($410,346) and *The Entombment* at £221,400 ($329,886), were a recognition of their iconographic importance in the history of Renaissance art and a testament to the rare excellence of these particular impressions. The unknown engravers from the School of Mantegna commanded their own considerable interest. *The Adoration of the Magi*, based on the Uffizi triptych, realized £48,600 ($72,414) and a brilliant, black impression of *Hercules and the Hydra* made £64,800 ($96,552). Other notable early Italian engravings included one of only four recorded first-state impressions of the large and forceful engraving of *Hercules and the Giants* by an unknown artist based on a drawing by Pollaiuolo, which realized an astonishing £108,000 ($160,920), and the hauntingly enigmatic *An Allegory: Triumph of the Moon* by the Master PP, which made £45,360 ($67,587).

The sale contained a wide cross-section of Italian printmaking from the 16th and 17th centuries, with works by D. Campagnola, A. Veneziano, J. Caraglio, G. Bonasone, G.B. Franco, G. Ghisi, F. Barocci, the Carracci, G. Reni, S. Cantarini and others. Auction records for most of these artists were established (or 'tumbled like ninepins' as one commentator remarked) and highlights included Domenico Beccafumi's powerful etching of *Three Nude Men in a Landscape* at £59,400 ($88,506), the large woodcut from nine blocks of *The Destruction of Pharaoh in the Red Sea* from the School of Titian at £43,200 ($64,368) and the unique early set of four *Grotteschi* by Piranesi, which realized £49,680 ($74,023). However, it was the monotype of *The Creation of Adam* by Giovanni Benedetto Castiglione which seemed, among the Italian prints at least, to have captured the greatest deal of attention of the many people who viewed and attended the sale. Perhaps the first extant example of this printing technique, which in this case seems to create light out of darkness so appropriate to the subject involved, this dramatic composition realized £345,600 ($514,944). Another monotype by Castiglione, *Theseus finding his Father's Arms*, was one of two prints (the other being *The Widow Saint Francesca* by Cristofano Robetta) that were chosen and purchased by the British Museum from a special group of Old Master prints offered to that institution by the Trustees of the Chatsworth Settlement in a separate but related transaction negotiated by Christie's.

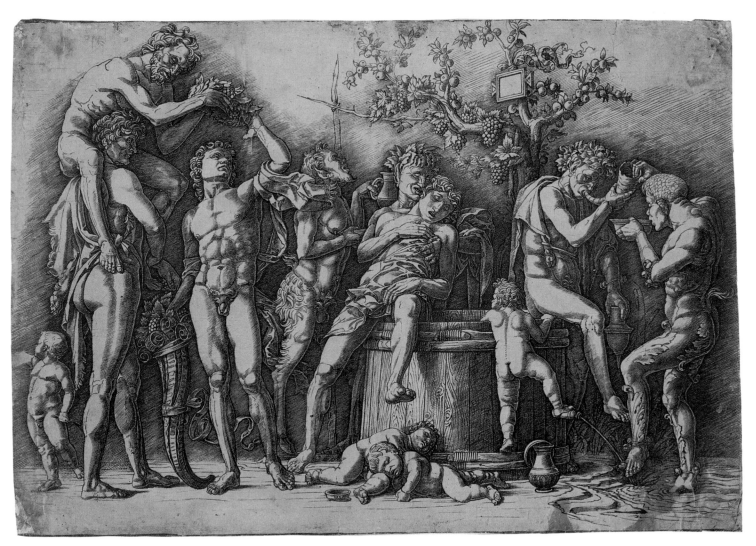

ANDREA MANTEGNA
Italian 1431–1506
A Bacchanal with a Wine-Press
(Bartsch 19)
Engraving, a superb
impression
S. 11¾ × 17¼ in.
(29.9 × 43.7 cm.)
Sold 5.12.85 in London for
£275,400 ($410,346)

The early German printmakers were headed quite naturally by Albrecht Dürer. The previous auction record for a print by the master had been the £65,880 ($90,256) paid for his engraving of a *Coat of Arms with a Skull* at Christie's on 27 June 1984. This price was comfortably exceeded by superb impressions of two of his most famous compositions, *Knight, Death and the Devil* at £183,600 ($273,564) and *Saint Eustace* at £205,200 ($305,748). After the group of Dürers came two exquisite, detailed landscapes in the form of a woodcut of *Saint George and the Dragon* by Wolf Huber at £37,800 ($56,322) and an etching of *Landscape with two Pine Trees* by Albrecht Altdorfer at £81,000 ($120,690), the latter print being one of the earliest pure landscapes in the history of Western graphic art.

The Low Countries were represented by artists from the 15th to 17th centuries. The first lot in the sale was the Master WA's *Interior of a Gothic Church*, whose quiet and elegant charm coupled with an extraordinary rarity stimulated a price of £45,360 ($67,587). This enchanting piece was followed by the Master FVB's *Saint George*, which made £32,400 ($48,276). The Gothic tradition was found further in the superb impression of Lucas van Leyden's arresting portrait

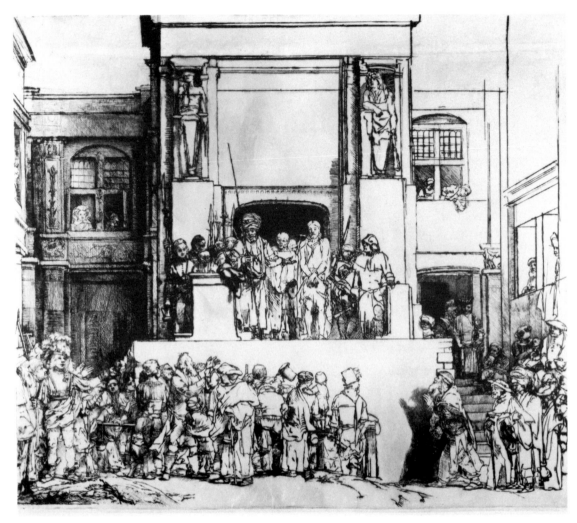

REMBRANDT HARMENSZ. VAN
RIJN
Dutch 1606–69
Christ presented to the People
(Bartsch 76)
Drypoint, second state (of
eight), a superb, majestic
impression
P. 15 × 17½ in.
(38.3 × 44.7 cm.)
Sold 5.12.85 in London for
£561,600 ($836,784)
Record auction price for any
print

of *The Emperor Maximilian* dating from 1520, which made £70,200 ($104,598). The later Dutch Mannerist printmakers were well represented by Bartholomeus Spranger's *Saint Sebastian*, which made £24,840 ($37,012), and an astonishingly fresh and brilliant impression of Goltzius's chiaroscuro woodcut of *Hercules and Cacus*, printed in vibrant colours, which made £59,400 ($88,506).

It was Rembrandt who brought the proceedings to a close. A small group of the master's etchings culminated in his magnificent *Christ presented to the People*. One of only 17 recorded impressions of the full composition, the Chatsworth example, printed on Japanese paper, has qualities of great beauty and presence. A saleroom packed with collectors, museum curators and dealers from all over the world stayed to the end of an exciting and dynamic sale to see a new auction record for a print established at £561,600 ($836,784).

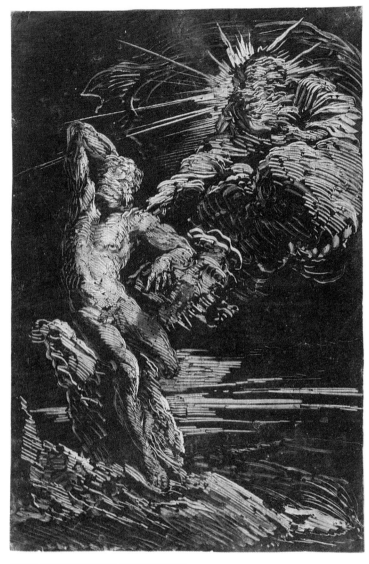

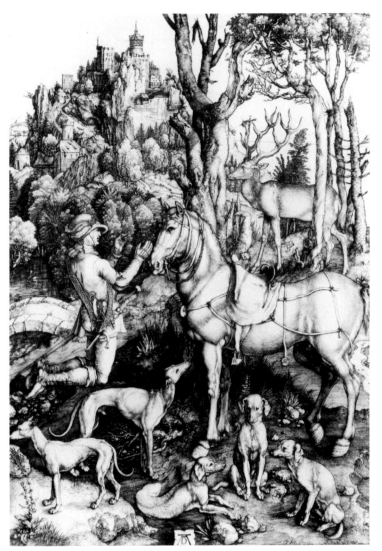

GIOVANNI BENEDETTO CASTIGLIONE
Italian *c.*1616–70
The Creation of Adam
(Calabi 14)
Monotype, printed in a rich black ink, displaying excellent and
dramatic contrast
L. 12 × 8 in. (30.2 × 20.4 cm.)
Sold 5.12.85 in London for £345,600 ($514,944)

ALBRECHT DÜRER
German 1471–1528
Saint Eustace
(Bartsch 57)
Engraving, a superb Meder b impression
P. 14 × 10¼ in. (35.8 × 26.1 cm.)
Sold 5.12.85 in London for £205,200 ($305,748)

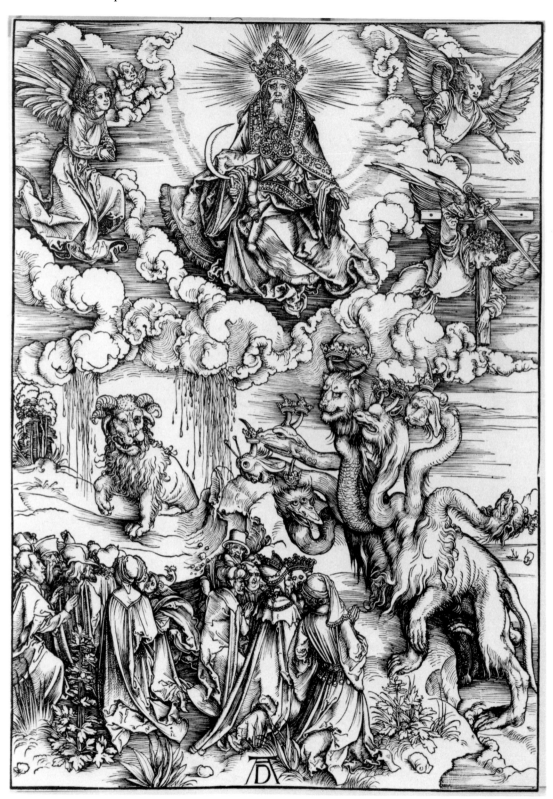

ALBRECHT DÜRER
German 1471–1528
The Beast with two Horns like a Lamb
From *The Apocalypse*
(Bartsch 74)
Woodcut, a brilliant proof impression
L. 15¼ × 11 in.
(38.9 × 28 cm.)
Sold 26.6.86 in London for £34,560 ($54,605)

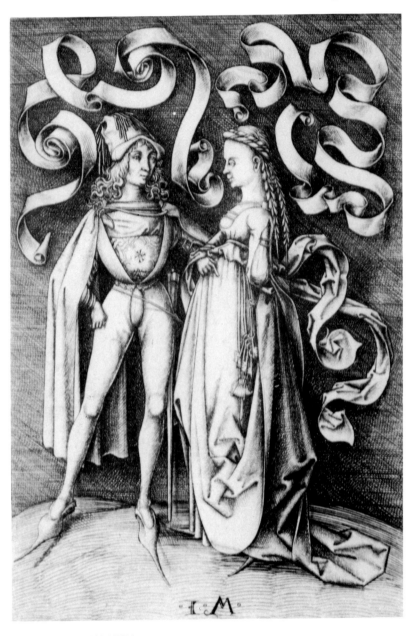

ISRAHEL VAN MECKENEM
German *c.*1445–1503
Der Ritter und seine Schöne
(Bartsch 182)
Engraving, a very good impression of this rare print
S. 6¼ × 4½ in. (16.2 × 11.2 cm.)
Sold 6.12.85 in London for £23,220 ($34,133)

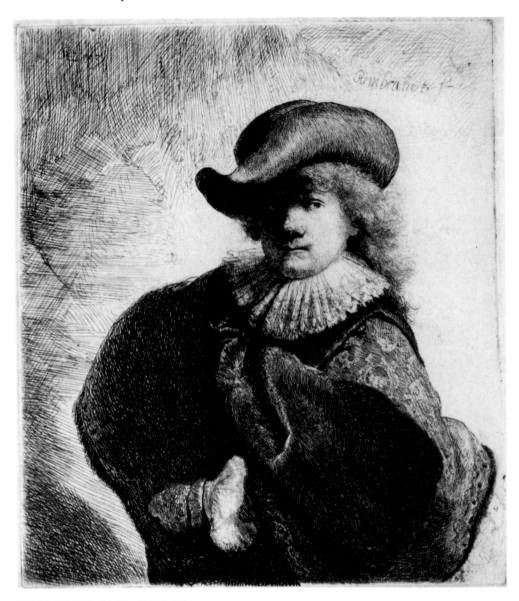

REMBRANDT HARMENSZ. VAN RIJN
Dutch 1606–69
Self Portrait in a soft Hat and embroidered Cloak
(Bartsch 7)
Etching, 10th state (of 11), a very good, clear impression of this very rare print
P. 6 × 5¼ in. (14.9 × 13.3 cm.)
Sold 26.6.86 in London for £27,000 ($42,660)

REMBRANDT HARMENSZ.
VAN RIJN
Dutch 1606–69
The Entombment
(Bartsch 86)
Etching with drypoint
and engraving, fourth
(final) state, a very fine
impression with much
burr, printed with a
strong, warm tone
P. $8\frac{1}{2} \times 6\frac{1}{2}$ in.
(21.3 × 16.2 cm.)
Sold 6.12.85 in London
for £34,560 ($50,803)
Formerly in the collection
of Edward Vernon
Utterson and sold at
Christie's on 17 February
1848 for 8s.

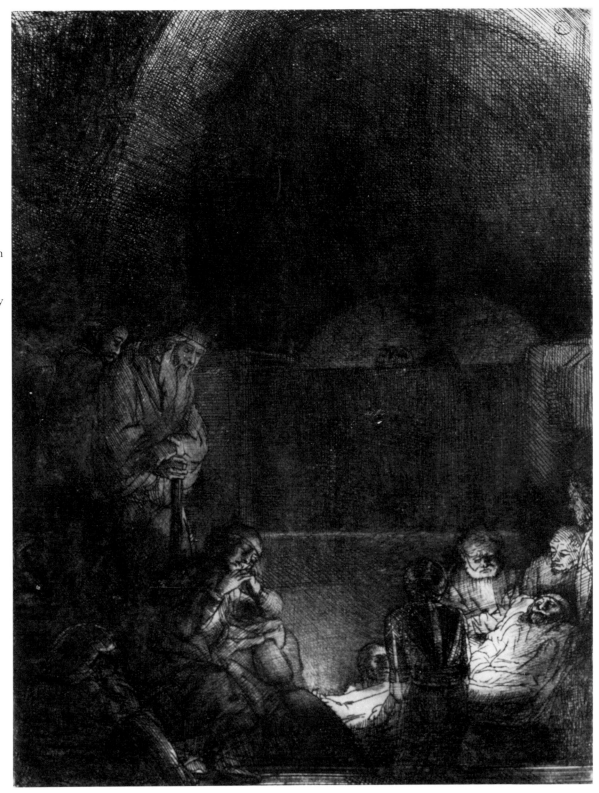

GIOVANNI BATTISTA BRACELLI
Italian, active 1624–49
Bizarie
Etchings from the set of 50, dedication, frontispiece
and 34 plates, very good impressions of these
extremely rare prints
P. 3½ × 4 in. (8.6 × 10.8 cm.)
Sold 26.6.86 in London for £36,720 ($58,018)
From the estate of Ray Livingstone Murphy of
New York City

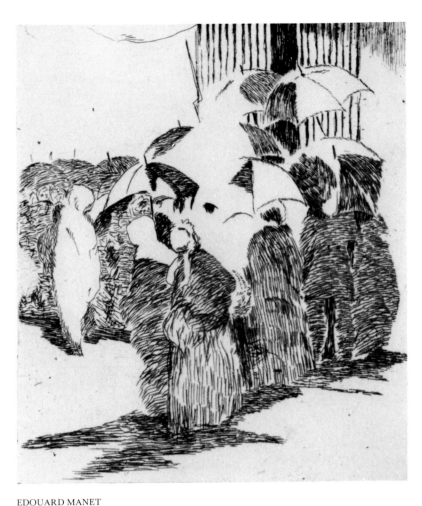

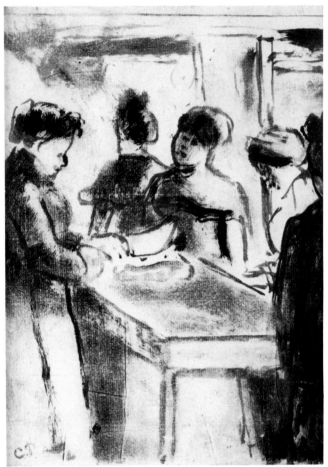

EDOUARD MANET
French 1832–83
Manet trente eaux-fortes originales
Etchings, some with aquatint, folding title wrapper with photogravure
of Manet after Fantin-Latour, introduction by Theodore Duret, index
and set of 30 plates, from the edition of 100 printed for A. Strölin,
published by Ernst Arnold Kunsthandlung, 1905, in original portfolio
Overall S. $22\frac{1}{4} \times 15$ in. (56.2 × 38.5 cm.)
Sold 25.6.86 in London for £19,440 ($30,716)

CAMILLE PISARRO
French 1830–1903
Monotype (Marchande et clientele dans un magasin)
Monotype with heightening in black ink, *c.*1894–5, with the
artist's monogram stamp (L. 613c)
S. $8\frac{1}{4} \times 6$ in. (21 × 15.3 cm.)
Sold 20.11.85 in New York for $17,600 (£11,973)

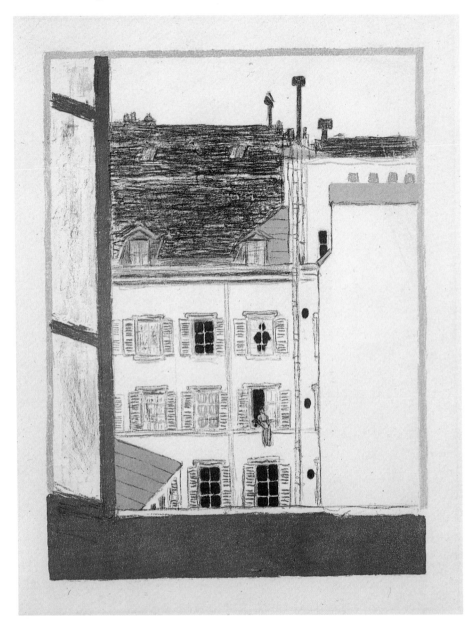

PIERRE BONNARD
French 1867–1947
Maison dans la cour
Plate III from *Quelques aspects de la vie de Paris*
(Bouvet 61)
Lithograph printed in colours, 1899, from the edition of 100 printed by A. Clot for
A. Vollard
L. $13\frac{3}{4} \times 10\frac{1}{4}$ in. (34.7 × 25.9 cm.)
Sold 25.6.86 in London for £9,180 ($14,505)

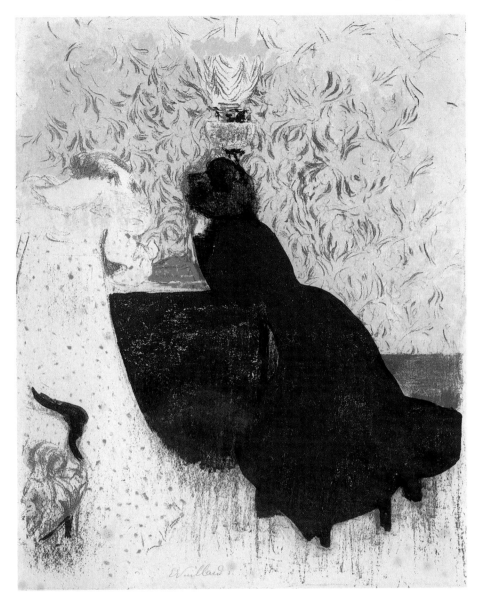

EDOUARD VUILLARD
French 1868–1940
Les Deux Belles-soeurs
From *Paysages et intérieurs*
(Roger-Marx 43)
Lithograph printed in colours, 1899, third (final) state, signed in pencil,
from the edition of 100 printed by A. Clot for A. Vollard
S. 14½ × 12 in. (36.9 × 30.1 cm.)
Sold 6.12.85 in London for £12,420 ($18,257)

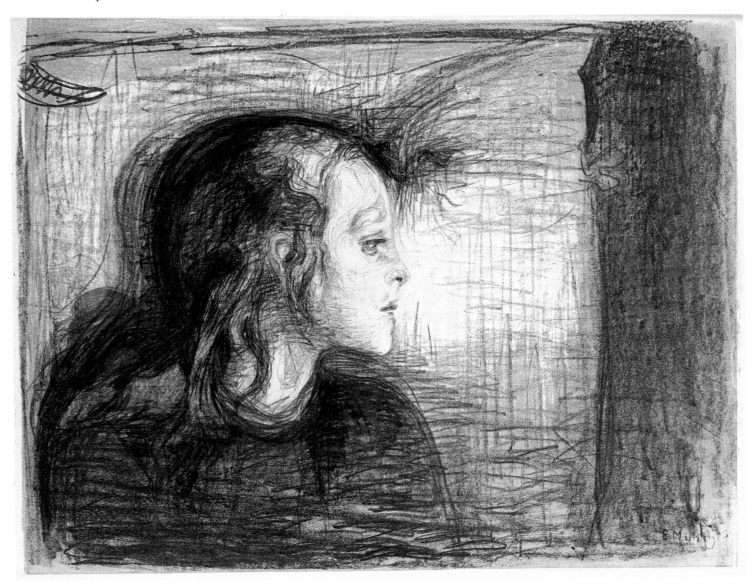

EDVARD MUNCH
Norwegian 1863–1944
Das Kranke Mädchen
(Schiefler 59)
Lithograph printed in black, dark red, pale lemon yellow and grey, 1896, the drawing stone in the second state (of three), with the printed signature but before the date, signed in pale orange crayon, numbered in blue crayon 'No. 5', a superb impression
L. 16½ × 22¼ in. (42 × 56.6 cm.)
Sold 25.6.86 in London for £75,600 ($119,448)
Record auction price for this particular Munch print
Das Kranke Mädchen was Munch's first colour lithograph and later he was to remark, 'I consider this lithograph my most important print' (I. Langaard, *Edvard Munchs Modningsar*, 1960, p. 452). The print exists in several different colour variations, most of which seem to have been done in relatively small, sometimes numbered editions.

ERNST LUDWIG KIRCHNER
German 1880–1938
Melancholishes Mädchen
(Schiefler 460)
Woodcut printed in black, purple and red from one
block, 1922, apparently an intermediary state
between Dube's first and second state, signed and
inscribed in pencil 'Handdruck', a superb and
brilliantly fresh impression, one of only a few
impressions pulled of this rare print, probably
printed by the artist
L. $27\frac{1}{2} \times 16$ in. $(70.4 \times 40.4$ cm.$)$
Sold 6.12.85 in London for £43,200 ($63,504)
This self-portrait with his companion, Erna
Schilling, whom he first met in 1912, is among the
finest and most dramatic of Kirchner's woodcut
portraits. It was printed from a single block, to
which the colours were applied with a brush by
hand, rather than by an inking roller, a technique
peculiar to Kirchner among the Brücke artists and
an example of his particularly inventive and
experimental approach to printmaking. The effect
is inevitably close to that of a monotype and known
impressions of this print vary considerably in both
the shade and intensity of colour used.

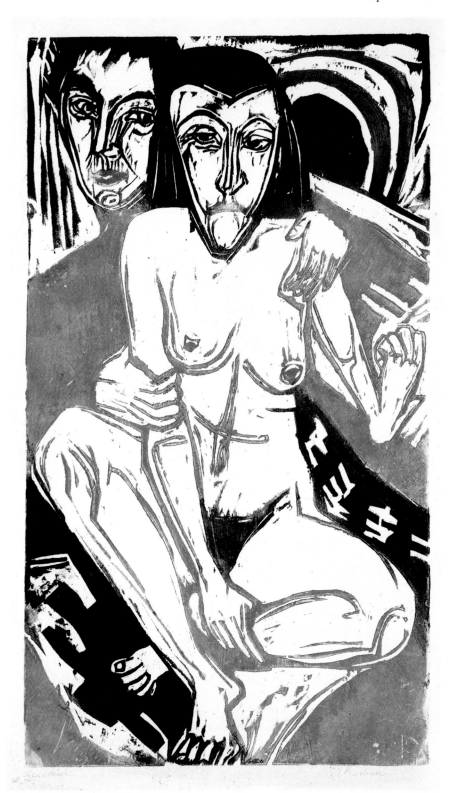

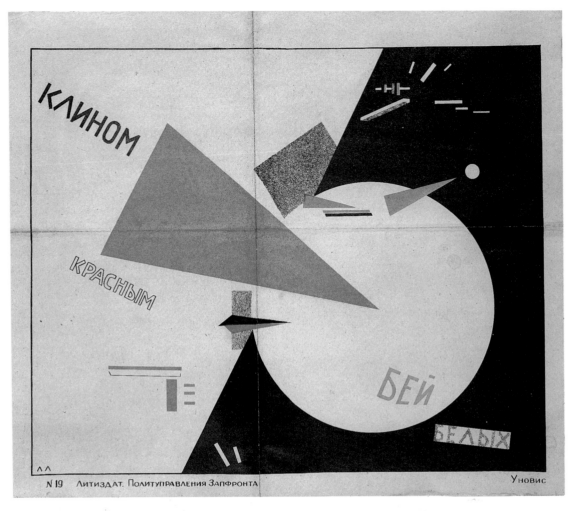

EL LISSITZKY
Russian 1890–1941
Beat the Whites with the Red Wedge (The Red Wedge Poster)
(Lissitzky-Kuppers 40)
Lithograph printed in red and black, 1919, extremely rare, printed and published in Vitebsk, 1919
L. 18 × 22 in. (46 × 55.7 cm.)
Sold 25.6.86 in London for £34,560 ($54,605)

The Red Wedge is the most famous Revolutionary Poster to have been created by a Russian avant-garde artist, its dynamic forms and simple message combining to create a work of rare power. The avant-garde artists were vital to the Revolution in disseminating political ideas through easily intelligible images to the then vast, illiterate populace of Russia. Lissitzky sought to show the coming victory of the Red Bolsheviks over Kerenski's Whites. Boris Brodsky in *The Avant Garde in Russia* (Exh. cat. 1980, p. 92) observed, 'the phonic script sounded as an incantation while the inevitability of the red triangle breaking the white circle seemed to be a magic sign denoting the destruction of the enemy'. The poster was executed for the Politupravleniya and was pasted up in the streets as well as on agit-prop trains which travelled across the country distributing Bolshevik propaganda. Very few examples of this poster survive, no doubt resulting from the rather ephemeral use to which it was put on the streets of Moscow and on the agit-prop trains. The present impression may be one of only two or three impressions in existence outside the Soviet Union.

WASSILY KANDINSKY
Russian 1866–1944
Kleine Welten
(Roethel 164–75)
Lithographs, woodcuts and
drypoints, six plates printed
in colours, 1922, the set of
12 from the total edition of
230, published by
Propyläen Verlag, Berlin, in
original portfolio
S. 18 × 33½ in.
(46 × 85 cm.)
Sold 20.11.85 in New York
for $104,500 (£73,230)

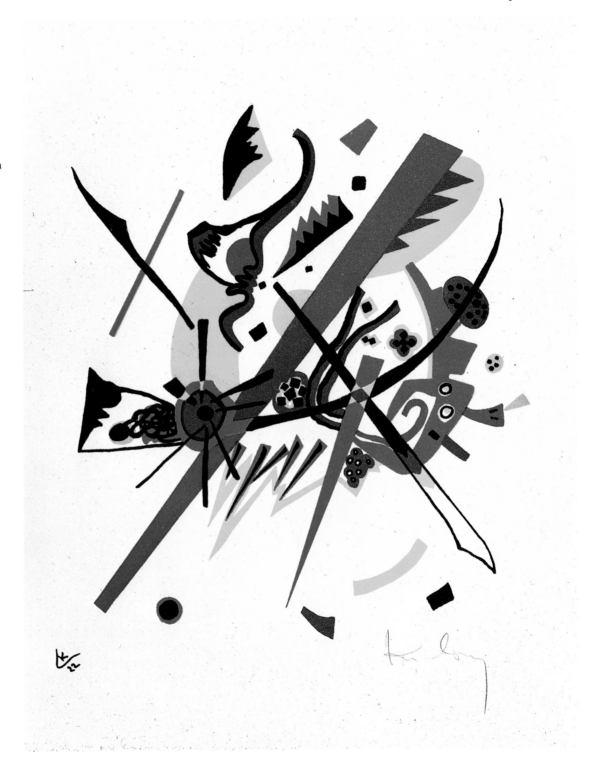

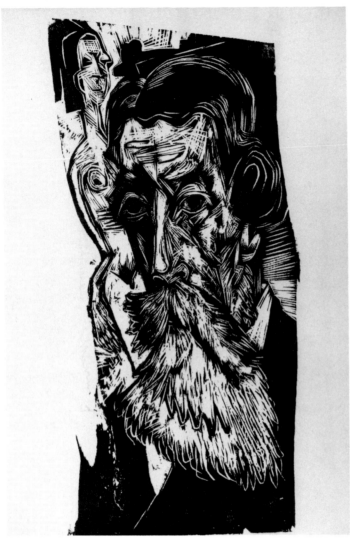

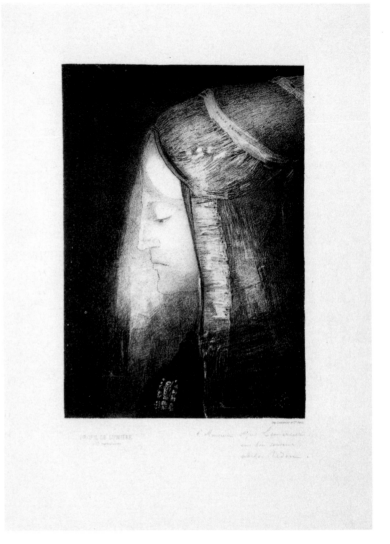

ERNST LUDWIG KIRCHNER

German 1880–1938

Kopf Ludwig Schames

(Schiefler 281)

Woodcut, 1918, probably first state (of three), a very good, strong impression with excellent contrasts, signed and inscribed 'Handdruck' in pencil

L. 22½ × 10 in. (57 × 25.6 cm.)

Sold 25.6.86 in London for £37,800 ($59,724)

Ludwig Schames (1852–1922) was introduced to Kirchner by Professor Botho Gräf in 1916. In the same year he organized an exhibition of Kirchner's work at his gallery in Frankfurt. As Kirchner's dealer Schames organized eight such exhibitions between 1916 and 1922, probably providing Kirchner's main source of income in these difficult years. On Schames's death Kirchner wrote, 'Das var der Kunsthandler Ludwig Schames, der feine uneigennützige Freund der Kunst und der Kunstler'.

ODILON REDON

French 1840–1916

Profil de Lumière

(Mellerio 61)

Lithograph, 1886, signed in capital letters in pencil on the hat band, inscribed 'à Monsieur Alfred Lemercier en bon souvenir' and signed again with the full cursive signature, from the edition of 50

L. 13⅜ × 9½ in. (34.1 × 24.2 cm.)

Sold 20.11.85 in New York for $38,500 (£26,980)

From the estate of Ray Livingstone Murphy of New York City

Another impression of this print was sold 25.6.86 in London for £25,920 ($40,954)

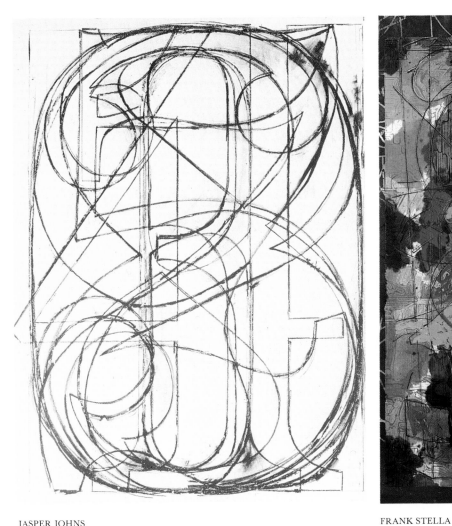

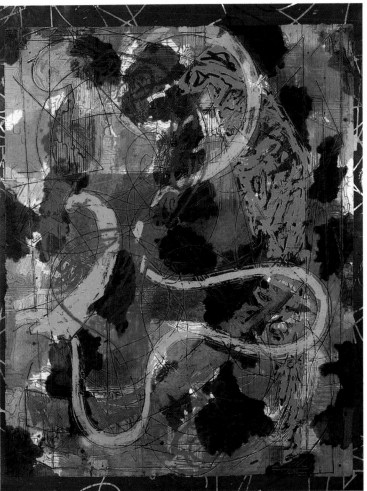

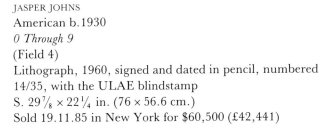

JASPER JOHNS
American b.1930
0 Through 9
(Field 4)
Lithograph, 1960, signed and dated in pencil, numbered
14/35, with the ULAE blindstamp
S. $29\frac{7}{8} \times 22\frac{1}{4}$ in. (76 × 56.6 cm.)
Sold 19.11.85 in New York for $60,500 (£42,441)

FRANK STELLA
American b.1936
Estoril Five II
(Axsom 141)
Etching and relief print in colours, 1982, signed and dated in
pencil, numbered 18/30 with the Tyler Graphics, Ltd.
blindstamp
S. $66\frac{1}{4} \times 51\frac{1}{2}$ in. (168.3 × 130.8 cm.)
Sold 22.4.86 in New York for $24,200 (£15,984)

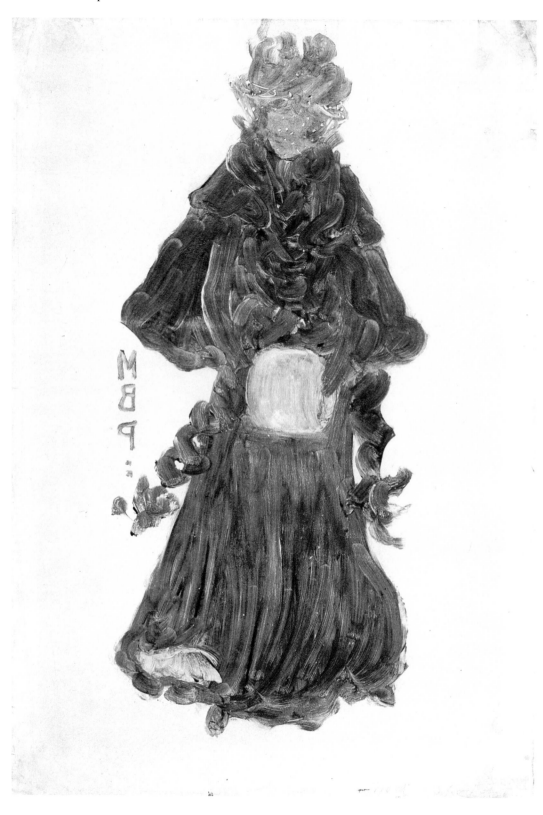

MAURICE BRAZIL PRENDERGAST
American 1859–1924
The Red Cape
Monotype in colours, *c.*1900,
signed with initials
S. 15¾ × 11 in. (40 × 27.9 cm.)
Sold 13.5.86 in New York for
$77,000 (£50,367)

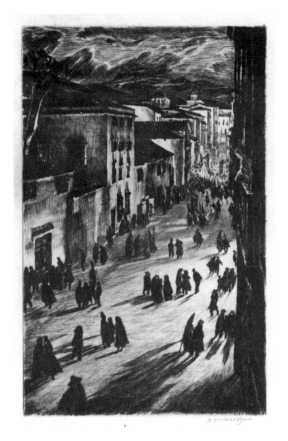

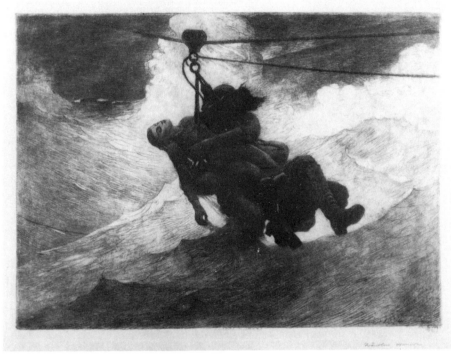

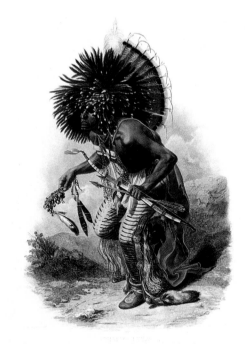

Above:
SIR MUIRHEAD BONE
British 1876–1953
A Spanish Good Friday
(Dodgson 412)
Drypoint, 1925, 16th state (of 29), signed in
pencil, from the edition of 31 in this state
P. 12½ × 8 in. (32 × 20.5 cm.)
Sold 23.4.86 in London for £1,404 ($2,120)

Right:
AFTER KARL BODMER
German 1809–93
*Pehriska-Ruhpa (Moennitarri Warrior in the Costume
of the Dog Dance)*
By R. Rollet, Plate 28 from *Travels in the Interior
of North America* (Abbey, *Travel II*, 615, no. 57),
coloured etching with aquatint and roulette
work, published by Ackermann & Co., London,
1844
P. 21¼ × 15⅝ in. (54 × 39.1 cm.)
Sold 11.9.85 in New York for $9,350 (£6,555)

Above:
WINSLOW HOMER
American 1836–1910
The Life Line
(Goodrich 91)
Etching printed in dark green,
1884, with Klackner's publication
line and a remarque of an anchor
between two dials, signed in
pencil
P. 13 × 17¾ in. (33 × 45.1 cm.)
Sold 5.5.86 in New York for
$22,000 (£14,666)

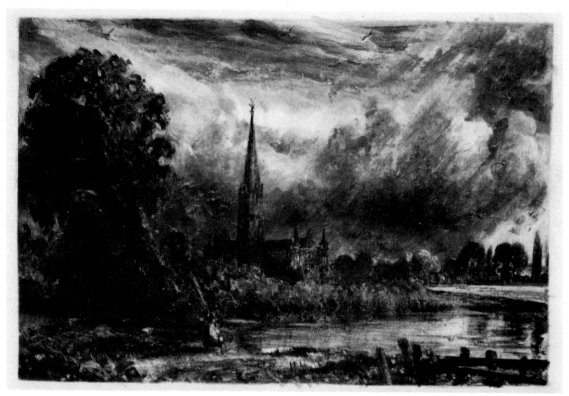

AFTER JOHN CONSTABLE
British 1776–1837
Salisbury Cathedral
(Wedmore 40)
By D. Lucas, mezzotint,
progress proof d or e (of m)
extensively worked by the
artist with white and grey
washes, chalk and pen and
ink over most of the image,
with an indistinct pencil title
and date 'Jany. 13 1832'
P. 7 × 10 in. (17.7 × 25.2 cm.)
Sold 5.11.85 in London for
£10,260 ($14,728)
Record auction price for a
print after the artist

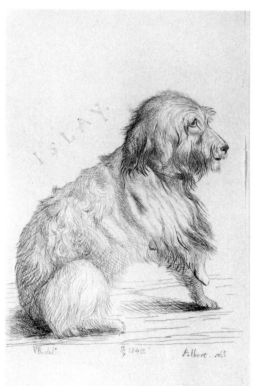

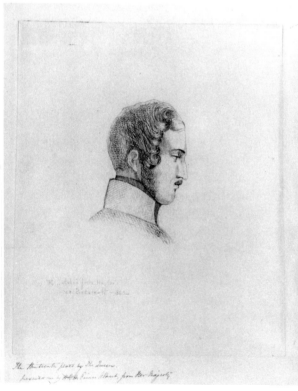

QUEEN VICTORIA AND PRINCE
ALBERT
British 1819–1901, 1819–61
*Etchings presented to Sir George
Hayter*
An album of etchings,
including many proof
impressions annotated in
pencil by Sir George Hayter
and with pen and ink
additions by Hayter,
consisting of 25 plates by
Queen Victoria, 23 plates by
Prince Albert and 2 by
Hayter
Overall S. 18½ × 12½ in.
(47 × 32 cm.)
Sold 13.5.86 in London for
£21,600 ($33,005)

Books and Manuscripts

Selection of illustrated French books formerly in the library of
Sir David Salomons (1851–1925)
Sold 25.6.86 in London for a total of £705,770 ($1,058,655)
By order of the L.A. Mayer Memorial Foundation

Modern Literature: The James Gilvarry Library

BART AUERBACH

An extensive selection of modern literary books, letters and manuscripts from the library of the late James Gilvarry, a noted American collector and bibliophile, was auctioned (with all lots sold) for a total of $1,160,104 (£833,109) by Christie's in New York on 7 February 1986. Competition was international, bidding was intense, and the total splendidly exceeded the pre-sale estimate. The Gilvarry Collection of Paul Klee watercolours had been sold with equal success by Christie's New York in November 1984.

The Gilvarry library, comprising 565 lots in two sessions, included the most important assembly of modern Irish literature to appear at auction since the John Quinn sale of 1923–4, and the finest gathering of Henry James material to come on to the market in recent memory. Of the triad of writers forming the foundation of the library – James Joyce, William Butler Yeats, and Henry James – the Joyce items (in 59 lots) totalled the most ($458,293/£329,116) and accounted for nearly 40 per cent of the sale total in just over 10 per cent of its lots. The highest price in the sale, was for *The Mookse and The Gripes* episode which eventually formed part of *Finnegans Wake*, comprising 24 printed pages from its first appearance in *Transition* magazine in 1927–8, heavily revised by Joyce for publication by the Black Sun Press in the book *Tales Told of Shem and Shaun* (1929). This sold to John Fleming of New York for $132,000 (£94,794), against the $525 Mr Gilvarry paid for it at auction in 1954. The earliest extant manuscript of *Chamber Music* (1907), Joyce's first book, containing 33 of the 36 poems in the work, fetched the next highest price: $99,000 (£71,096) to J. Howard Woolmer of Revere, Pa. A wonderful presentation copy of the first edition of *Ulysses* (Copy No. 3 of 100 on Dutch handmade paper) inscribed by Joyce to Margaret Anderson of *The Little Review*, was purchased for $38,500 (£25,667), by Glen Horowitz of New York – a record for a 20th century literary book.

The largest part (103 lots) of the auction was devoted to W.B. Yeats. This rich assemblage of first editions, presentation and association copies, letters and manuscripts totalled $156,794 (£112,599), the leading price being the $36,300 (£24,200), John Fleming paid for *Mosada* (Dublin, 1886), Yeats's very rare first book, a pamphlet privately printed for him by his father, John Butler Yeats, in an edition of about 100 copies. This marked the second time in about two years that Christie's New York auctioned a copy of this *rara avis*: the Frederic Dannay copy, enhanced with a Yeats presentation inscription, sold for $33,000 (£23,699) in December 1983.

Henry James material – an abundance of first editions, presentation and association copies, and letters – formed the second largest segment, 92 lots totalling $209,181 (£150,220). A first edition of *The Golden Bowl* (New York, 1904) inscribed to Walter Berry and with an inserted postcard from James and Edith Wharton made $17,600 (£13,239), a record for any James item at auction.

The remaining 311 lots made $291,142 (£209,079). Of these, one of the more surprising (and pleasing) results was the sale for $7,150 (£5,377) of Evelyn Waugh's rare first book, *P.R.B., An Essay on the Pre-Raphaelite Brotherhood* (London, 1926), inscribed to a favourite master at his public school, Lancing: the winning bid came all the way from Peking, China.

Right:
JAMES JOYCE
24 pages of 'The Mookse and The Gripes' episode (later part of *Finnegans Wake*) from *Transition* magazine (1927–8), heavily revised by Joyce for publication in *Tales Told of Shem and Shaun* (Paris, Black Sun Press, 1929)
Sold 7.2.82 in New York for $132,000 (£94,794)
Modern Literature from the Library of James Gilvarry

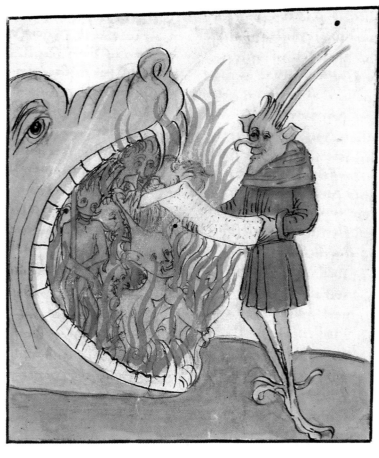

Above:

JACOBUS DE THERAMO
Belial
In German, Swabian dialect, manuscript with 20 fine coloured
illustrations
Southern Germany, 1460–70
Sold 25.6.86 in London for £24,000 ($38,880)

Above left:

ISAAC BEN SOLOMON IBN ABI SAHSULA
Meshal ha-Kadmoni
Brescia, Gershon, Soncino 1491
Sold 22.5.86 in New York for $176,000 (£115,790)
Record auction price for a Hebrew printed book
Sold on behalf of the Jewish Theological Seminary of America
The first illustrated Hebrew printed book, a collection of fables
and allegories

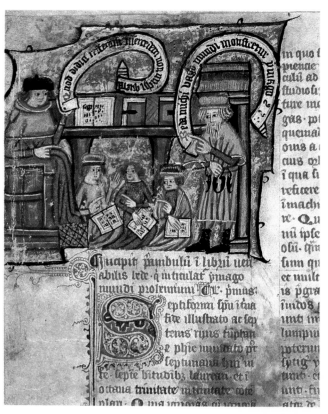

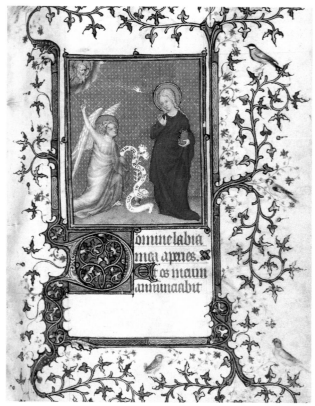

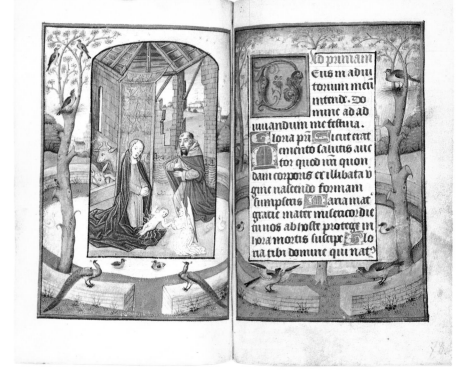

Above:
Book of Hours in Latin
Illuminated manuscript on
vellum, 35 large miniatures,
Paris, *c.*1390
Sold 27.11.85 in London for
£97,200 ($142,350)
From the collection of the late
Sir Charles Clore

Above left:
English Chronicles
Illuminated manuscript on
vellum, 13 miniatures,
1349–1400
Sold 25.6.86 in London for
£16,200 ($25,596)

Left:
Book of Hours in Latin
Illuminated manuscript on
vellum, 17 large miniatures
Ghent or Bruges, 15th century
Sold 25.6.86 in London for
£38,880 ($61,431)

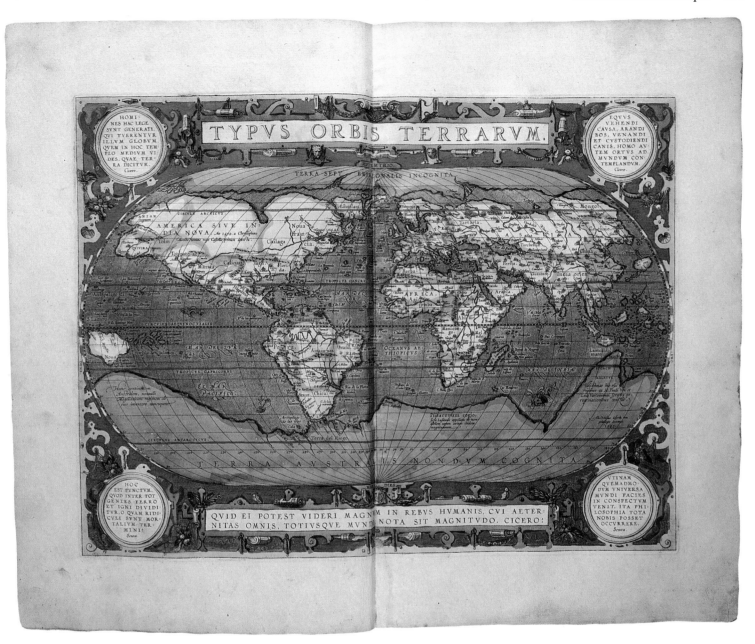

ORTELIUS
Theatrum Orbis Terrarum…The Theatre of the Whole World
156 coloured maps, bound for Henry Percy, 9th Earl of Northumberland, the 'Wizard' Earl, London, John Norton, 1606
Sold 22.11.85 in New York for $66,000 (£45,672)

HORACE
Opera
The first illustrated edition of
The Works, folio
Strassburg, Johannes
Grüninger, 1498
Sold 30.5.86 in London for
£5,400 ($8,063)

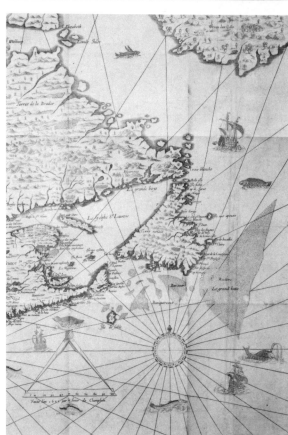

Far left:
STEPHAN FRIDOLIN
*Schatzbehalter oder Schrein der
wahren Reichtümer des Heils*
96 woodcut illustrations by
Wolgemuth, Nuremberg,
Anton Koberger, 1495
Sold 25.6.86 in London for
£22,680 ($35,835)

Left:
SAMUEL DE CHAMPLAIN
*Les Voyages de la Nouvelle France
Occidentale, dicte Canada*
Second edition of
Champlain's *Voyages*, 4to
Paris, 1632
Sold 22.11.85 in New York
for $20,900 (£14,463)

Collection of 28 aquatint views of
Switzerland
Oblong folio
Basle, Birmann & Fils, *c.* 1825
Sold 16/17.4.86 in London for £18,360
($27,357)

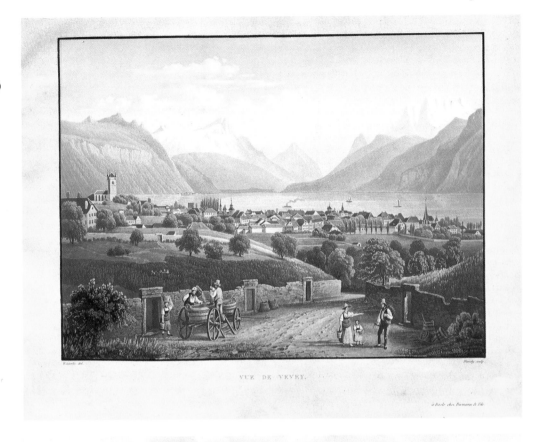

JOHN GOULD
The Mammals of Australia
Three volumes, folio
1845–63
Sold 31.10.85 in London for £38,880
($55,968)

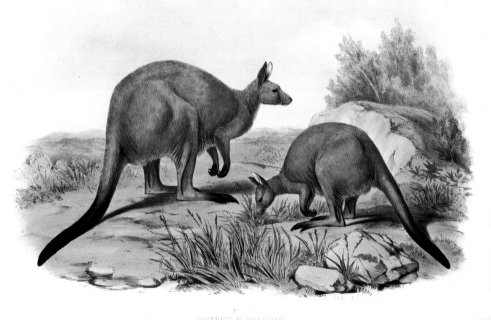

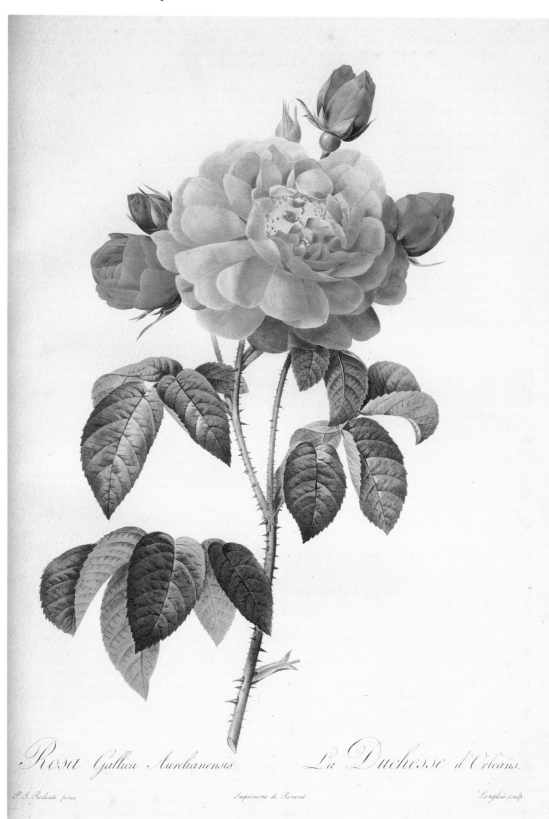

Rosa Gallica Aurelianensis *La Duchesse d'Orléans.*

P.J. Redouté pinx. Imprimerie de Remond Langlois sculp.

P.J. REDOUTÉ
Les Roses
Three volumes, 169 plates,
each in two states, first
edition
Paris, 1817–24
Sold 31.10.85 in London for
£59,400 ($88,714)

Opposite:
GEORGE BROOKSHAW
*Pomona Britannica, or a collection
of the most esteemed fruits at
present cultivated in this country*
90 coloured aquatint plates,
folio
London, 1812
Sold 30/31.10.85 in London
for £48,600 ($69,960)

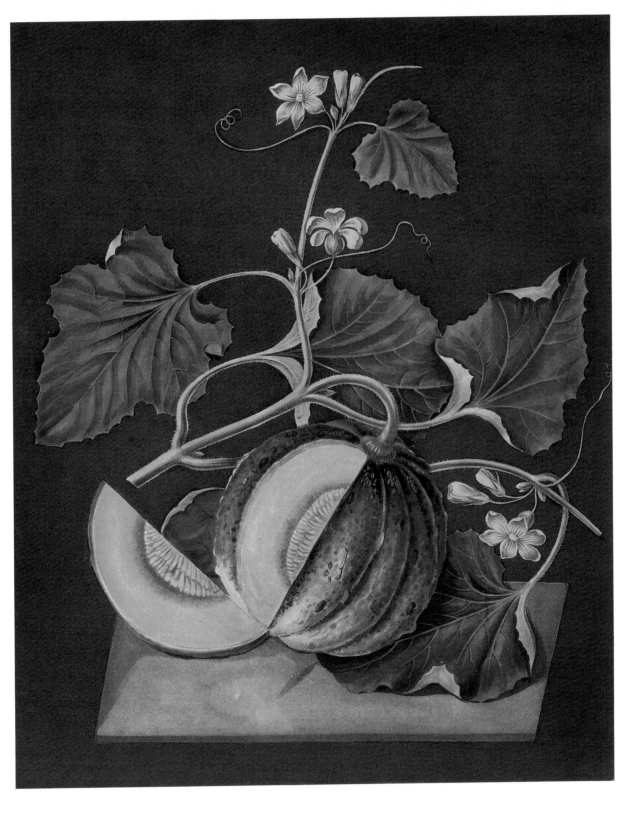

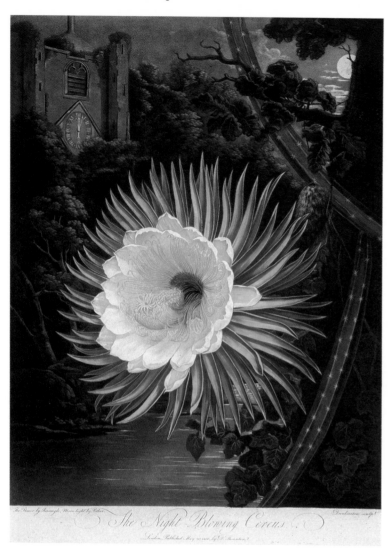

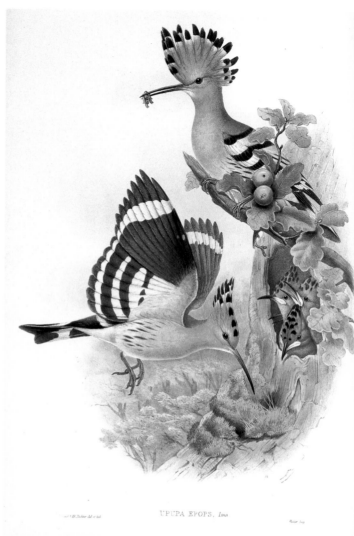

R.J. THORNTON
The Temple of Flora or Garden of Nature
31 coloured plates, folio
London, 1807
Sold 16/17.4.86 in London for £43,200 ($64,368)

JOHN GOULD
The Birds of Great Britain
Five volumes, 367 coloured lithographed plates, folio
London, 1862–73
Sold 16/17.4.86 in London for £32,400 ($48,276)

BALTHAZAR DE BEAUJOYEULX
Balet comique de la Royne
Paris, 1582
Sold 25.6.86 in London for
£27,000 ($42,660)
The first known attempt to stage
a musical opera in Europe

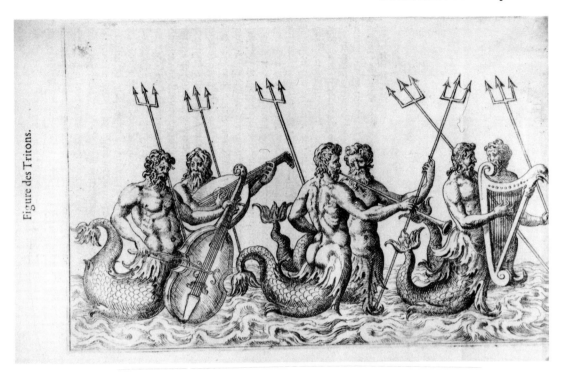

WOLFGANG AMADEUS MOZART
Autograph manuscript, signed,
of the song *Als Luise die Briefe
ihres ungetreuen Liebhabers
verbrannte*, K.520 in C minor,
$1\frac{2}{3}$ pp.
26 May 1787
Sold 16.10.85 in London for
£51,840 ($72,939)

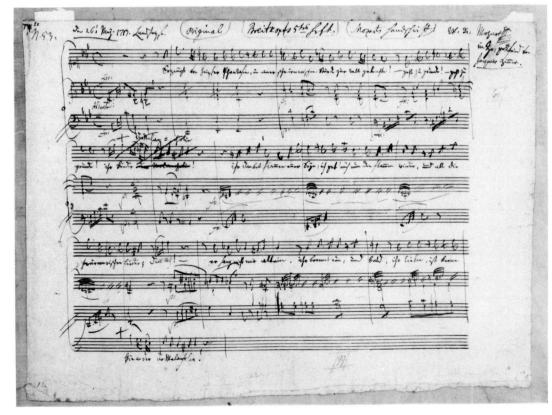

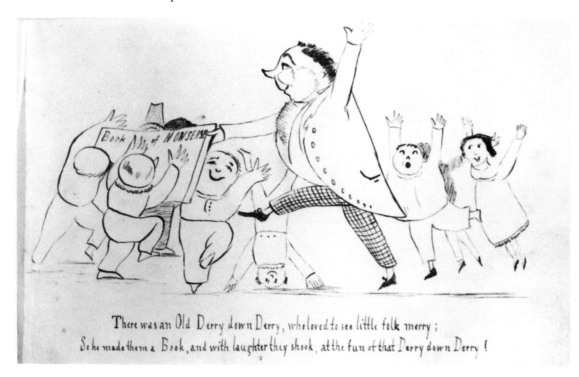

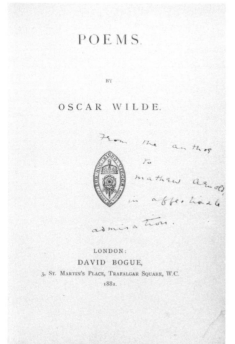

EDWARD LEAR
A Book of Nonsense
Autograph manuscript, 36
pen-and-ink drawings after
the third edition
*c.*1861
Sold 29.5.86 in London for
£47,520 ($71,280)

Far left:
OSCAR WILDE
Poems
First edition, inscribed to
Matthew Arnold, with
accompanying letter
London, 1881
Sold 22.11.85 in New York
for $44,200 (£30,586)

Left:
W.S. MAUGHAM
Autograph manuscript,
signed, of *The Casuarina Tree*,
319 pages
1926
Sold 22.11.85 in New York
for $52,800 (£36,537)

MAURICE VLAMINCK
Haute Folie (1964)
Bound in brown and green morocco
with geometric decoration by G. de
Coster and H. Dumas, 1966
Sold 10.11.85 in Geneva for
Sw.fr.187,000 (£61,513)

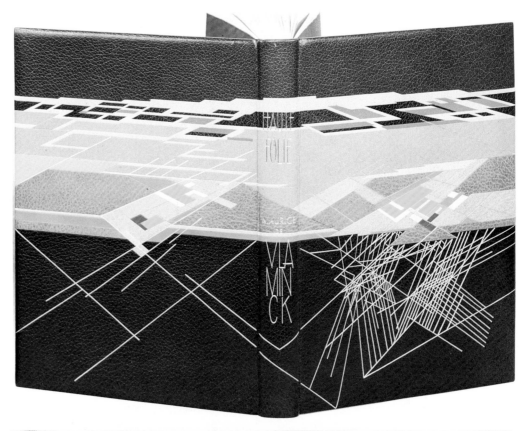

PABLO PICASSO
La Tauromaquia
One of 220 copies, bound in red and
green morocco, with multicoloured
onlays, by Henri Mercher
Barcelona, 1959
Sold 22.11.85 in New York for $28,600
(£19,791)

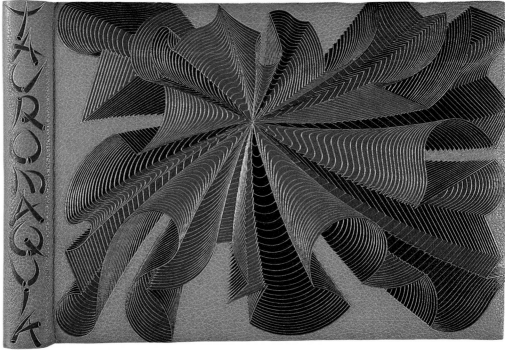

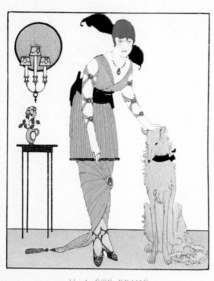

IL A ÉTÉ PRIMÉ

Robe du soir

Gazette du Bon Ton. — N° 3 Mars 1914. — Pl. 31

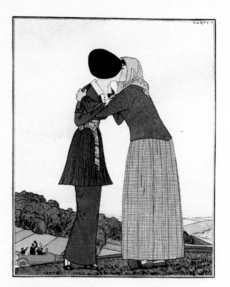

LES SŒURS DE LAIT

Robe d'après-midi de Dœuillet

Gazette du Bon Ton. — N° 2 Février 1914. — Pl. 17

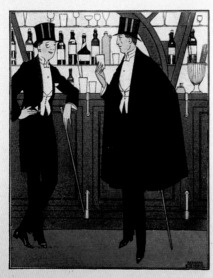

LA CAPE NOIRE

Habit et Pèlerine de soirée

Gazette du Bon Ton. — N° 5 Mars 1913. — Pl. III

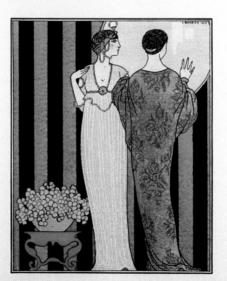

LE CONSEILLER DES DAMES

Robe et Manteau pour le Théâtre

Gazette du Bon Ton. — N° 5 Mars 1913. — Pl. I

Gazette du Bon Ton, Art, Modes et Frivolités
69 issues, 575 plates, 4to
Paris, 1912–25
Sold 10.11.85
in Geneva for
Sw.fr.440,000
(£144,736)
Record auction price
for a 20th century
book

Furniture

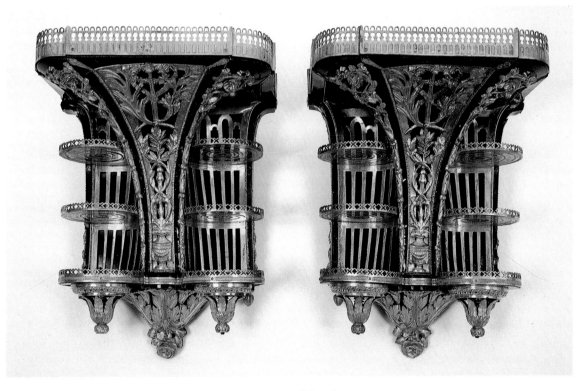

Pair of Louis XVI tortoiseshell, ebony and Ormolu wall-brackets
17$\frac{1}{4}$ in. (44 cm.) wide
Sold 7.12.85 in Monaco for F.fr.288,600 (£25,360)

A Memoir of Edward James and the Creation of Monkton

NORRIS WAKEFIELD

Part of the fascination and the sheer enjoyment of the creative side of interior design and decorating are the extreme demands made on one's imagination. For me, these have included a private circus and other parties, film and stage sets and of course, in the case of Edward James, Monkton House, the ultimate in the presentation of Surrealism. I suppose the climate of the age has great bearing on this; Monkton perhaps reflects the words of Oscar Wilde, 'The first duty of life is to be as artificial as possible', or perhaps, 'Art for Art's sake'. Monkton House seemed to me to show the serious adaptation of imagination and the dreams of a period, combined with certain practical techniques and workmanship.

Perhaps because I was in my early twenties, it is only now that I realize how fortunate I was to have the opportunity to share in the decoration of Monkton. Edward James was also young, only 27 years old, and totally unknown to me, until out of the blue he came to Mrs Mann's shop in Arlington Street to ask me to make two cushions – quite straightforward work. Having delivered these in the stipulated time, I received a telephone call a week later to ask 'whether the young man who had made his two cushions would consider undertaking some interior decoration at a small house near Chichester'. On the following Saturday, rather late in the morning I remember (which resulted in a quick luncheon at the Ritz Hotel), I was whisked to Sussex. It must have been towards the end of the year because my first glimpse of the Lutyens house, built by James's father as a quiet retreat away from the family estate at West Dean, was a view, after five miles of private road, of a small house on the top of the Downs, cut in half by low cloud. A fantasy, one might say; a Surrealist dream from the start.

From then on I was to spend four years working on the house, involving weekly trips to Monkton. The work was greatly assisted by the fact that James made only periodic visits to England, having a house in Italy and travelling frequently abroad. At one time he owned an aeroplane, and piloted by Cathgate Jones made a complete aerial tour of Spain. The original maps of this journey are used as a wall decoration for the 'Map Bedroom' at Monkton.

To begin with, James said he would like a new roof in black and green Dutch tiles, and a new curved staircase to replace the traditional Lutyens double-entry staircase. Mrs Dolly Mann suggested that we avail ourselves of the services of the young architects Christopher Nicholson and Hugh Casson, who subsequently designed the new staircase at Monkton.

The (rather sad for me) sale by Christie's of the contents of Monkton House and West Dean also included some pieces from one of Edward James's London houses in Upper Wimpole Street, in which I did some interesting work in the early thirties. This included a Drawing Room with special Matisse panel paintings, which James decided might be a little offensive to the contemporary eye, and which were therefore to be hidden behind a special part-silvered mirror. The paintings were viewed, if desired, by special lighting which could be switched on behind the mirror plate. Salvador Dali, from whom James bought so much, also executed murals there.

Right:
Monkton House

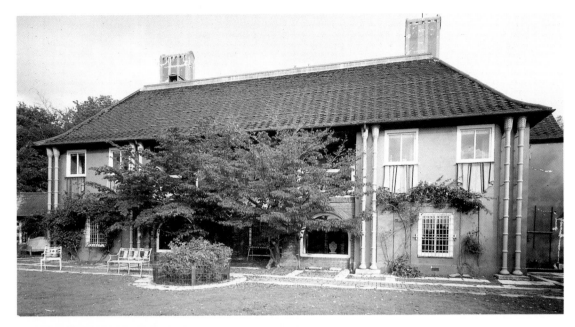

Right:
Drawing Room at Monkton

Far right:
A reconstruction of the 'Blue Serge Sitting Room' at Monkton House in Christie's marquee prior to the sale

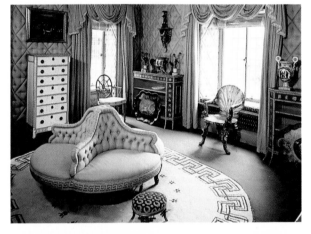

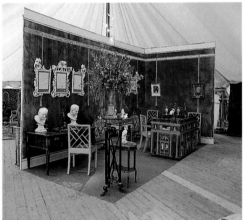

Right:
Dining Room at Monkton

Far right:
A reconstruction of the Hall of Monkton House in Christie's marquee prior to the sale, showing the 'wolfhound footprint carpet'

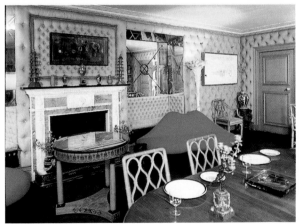

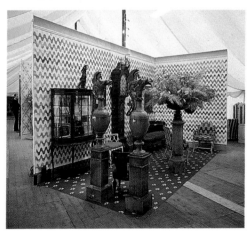

To continue with Monkton, before even the major incidental works were completed James started to enlarge on his ideas for the interior. Fortunately, with his periodic visits, I was able to prepare, if not always complete, these various and sometimes extreme Surrealist ideas over the years. One of them included the installation of a bedroom ceiling designed to instil the sensation of sleeping under the sky at night, complete with brilliant star constellations. James at one time asked me to fix a clock tower on the chimney stack of the house. I enquired what style of figures he would like for the hours, and was somewhat surprised when he answered, 'Not hours, Wakefield, days of the week!' On another occasion he asked for the sun and moon to show in his bathroom, on either side of the mirror, which was to be as the globe. His own bed was a specially-made carved four-poster, copied from Napoleon's funeral hearse, with palm tree end-posts and curtaining completely surrounding it.

The interior decoration evolved piece by piece, and this was ideally suited to the build up of the whole house. Each part evolved from the previous one: walls to be padded in grey linen, similar to Victorian button furniture, floors and curtains to be covered with actual billiard table felt, his own study walls and curtains to be treated using dark blue gentlemen's suiting. This was inspired by a suit he was wearing at the time, with a primrose in the button hole. Radiator cases from chain-mail, walls to be painted and then covered with net sprayed with silver and gold. In the bathroom a real fish tank alongside the bath with fish and anemones brought from Italy and electric fish-design fittings designed in Paris. A carver was also brought from Italy and housed for some years, during which time he spent his days carving designs, which included, amongst others, Rex Whistler's oval door at West Dean, the window dressings on the exterior of Monkton imitating bed blankets, such as one would see hanging for airing outside windows abroad, plus the bamboo and honeysuckle moulds to cover the drains and waterpipes on the outside (these were exact copies of those used in the decoration by the Adam brothers for the Adelphi, which, sadly, was being demolished at that time).

Furnishings included lamp-standards in the manner of champagne glasses one above the other, designed by Salvador Dali, as were settees in bright red in the shape of Mae West's lips, chairs with arms and hands for backs, and furniture carved to imitate tree branches. Covering the curved wall of the new staircase presented a problem, as it was to continue the scroll design of an Italian material covering the walls in the hall, gallery and corridor. This I had copied in wallpaper by Messrs Cole & Son so that it could be hung to follow the curved surface of the wall.

James one day said completely out of the blue, 'Wakefield, make me a carpet with my two wolfhound dogs' footprints.' I suspect the idea came about as he had already had a staircase carpet made at West Dean at some earlier time with the wet footprints of his then wife, Tilly Losh. I was perplexed to decide how best to get a true repeat of the paw marks, so I had the two dogs parade with their paws covered in ink on a large length of lining paper. This was faithfully reproduced by a Scottish carpet manufacturer. It is interesting how easily one can make errors with untried ideas. James asked later to have the same carpet laid on the stairs. I did not then realize that the continuous prints would show on the risers as well as on the steps of the staircase. It could be rectified quite easily with plain carpet added.

At that time, at Upper Wimpole Street, James asked me to make a bed for his wife, Tilly Losh, using the design of two 18th century chair backs with draperies. This was also sold recently, among other pieces made especially for him, at the West Dean sale.

Edward James adored Monkton House. I suppose it gave him and me such a foundation for our avant-garde ideas. I was most fortunate to be able to share in it, and it is a great sadness to me that this example of Surrealism has been lost as a permanent record of a very true patron. Speaking personally, I would like to have seen this house preserved intact, to take its place alongside the Pavilion at Brighton and other properties that have their own positions in history.

People ask, what was James like? I can say that, at my young age, he appeared to me a very interesting person, perhaps because of the unusual (to say the least) decoration he demanded which was so much out of the ordinary even during that period of hectic change. Perhaps a person older than myself would have put up certain barriers to the ideas, but his large staff at West Dean Park and the estate managers were so helpful at that time. I always found Edward James most kind and considerate. The last time I saw him was at Christie's, at the auction of a few of his large collection of Surrealist paintings, which were then so much sought after. He did invite me to Mexico to see the work there, but sadly I was unable to go. Amusing incidents come to mind: I remember him buying the latest Mercedes sports car with a rather loud and penetrating super-charger, which he used at very low speeds through quiet villages or towns at night. He thought it was great fun, and it amused me! He was always beautifully dressed, and well-mannered, giving no sign to me of the temperament for which he has been known. He was always full of enthusiasm and constructive ideas and suggestions.

Sometimes we hurried through ideas; perhaps it was all to the good to have to make quick decisions on apparently extreme works. One such occasion when James said, 'OK, let's do it', and immediately rushed off to Southampton to catch a boat for the United States, where he was arranging and financing a pavilion for the exhibition of Dali, which included a large lobster-shaped telephone. He loved animals, and Monkton was latterly a miniature zoo, with rare peacocks, doves, pheasants, and so on. I remember one of the last ideas James had was during dinner at West Dean with several American friends. Suddenly he said, 'Wakefield, I would like to have the dining room as if it was under the roots of a large tree.' I agreed that it was feasible, but he was at that time immersed in a fantasy in Mexico, and unfortunately we did not do it. It would have been a terribly interesting job.

When moths attacked the Mae West lips sofa, James amused himself by making up caterpillars in green baize to cover the holes. He was acutely fussy over details, but left much to the designer's imagination – in the dining room at Monkton he used the billiard table felt on the floor and curtains. I made the latter in wide stripes in various colours with Victorian-style black trellis and tassled pelmets, similar to ones on mantelpieces of the period. I would like to think he enjoyed the Strawberry Hill Regency and Empire periods with their detailing.

All in all, James lived his life according to his dreams of architectural fantasy and definitely not, as has been suggested, 'as a crazy eccentric with a taste of mad art'. His gifts and capabilities lifted him above general levels of eccentricity and he knew how he wanted to exist in the world of ideas and imagination and yet retain the love of nature he had inherited from his family.

Monkton remains, despite today's rounds of domesticity and more simple tastes, a testimony to the inspiration of one of the most interesting eras. I believe that Edward James will not easily be forgotten and as the term indicates, *avant garde* often points in the general direction of the future.

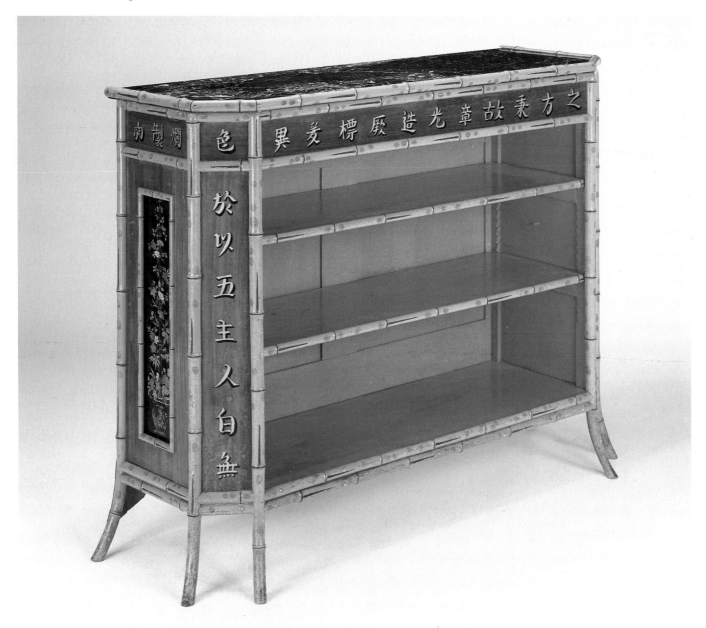

One of a pair of Regency simulated bamboo and mahogany dwarf bookcases in the Brighton Pavilion taste
48½ in. (123.5 cm.) wide; 38 in. (96.5 cm.) high; 16¾ in. (42.5 cm.) deep
Sold 2.6.86 at West Dean for £30,240 ($44,544)
From the Edward James Collection
When Edward James bought these cabinets they were thought to have been made for the Royal Pavilion, Brighton, and to have been given or left to Lady Jersey, wife of the 6th Earl. They are closely related to a number of pieces made for the Pavilion, particularly the set of simulated bamboo cabinets supplied by Marsh and Tatham in 1802 for the Corridor, possibly to the designs of Henry Holland. These appear in Augustus Pugin's series of watercolours painted before 1820 and *c.*1822–4 and are still *in situ.*

Regency ebonized and gilded
mirror with convex plate
56 × 42 in. (142 × 107 cm.)
Sold 2.6.86 at West Dean for
£51,840 ($76,360)
From the Edward James
Collection

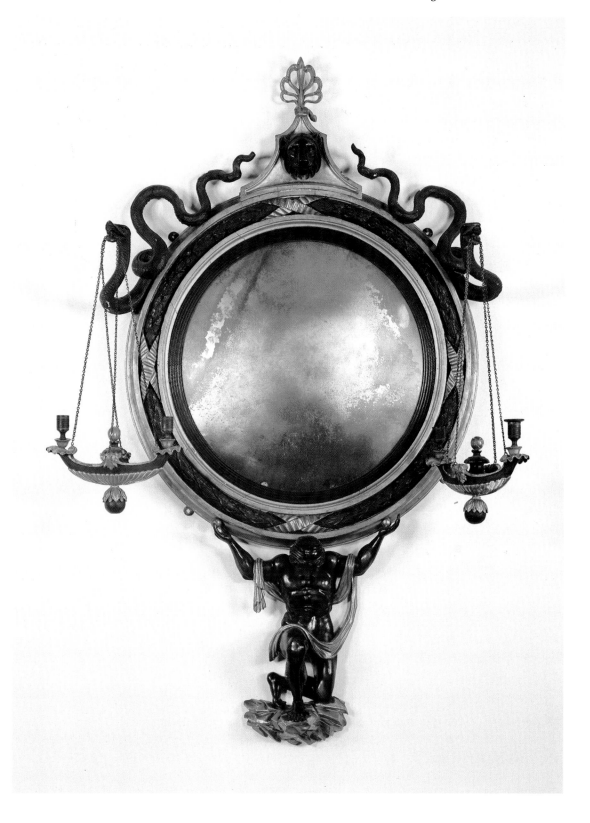

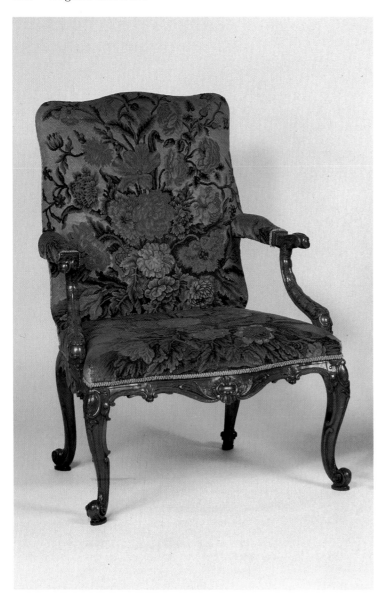

One from a set of four armchairs
29 in. (74 cm.) wide; 38½ in. (100 cm.) high
Sold 2.6.86 at West Dean for £129,600 ($190,900)
From the Edward James Collection

One of a pair of George II giltwood open armchairs
41½ in. (105 cm.) high; 28½ in. (72 cm.) wide
Sold 21.11.85 in London for £62,640 ($91,361)

Opposite:
One of a pair of early George III mahogany library armchairs
One armchair stamped WH five times
38 in. (96.5 cm.) high; 29½ in. (75 cm.) wide
Sold 21.11.85 in London for £75,600 ($110,263)

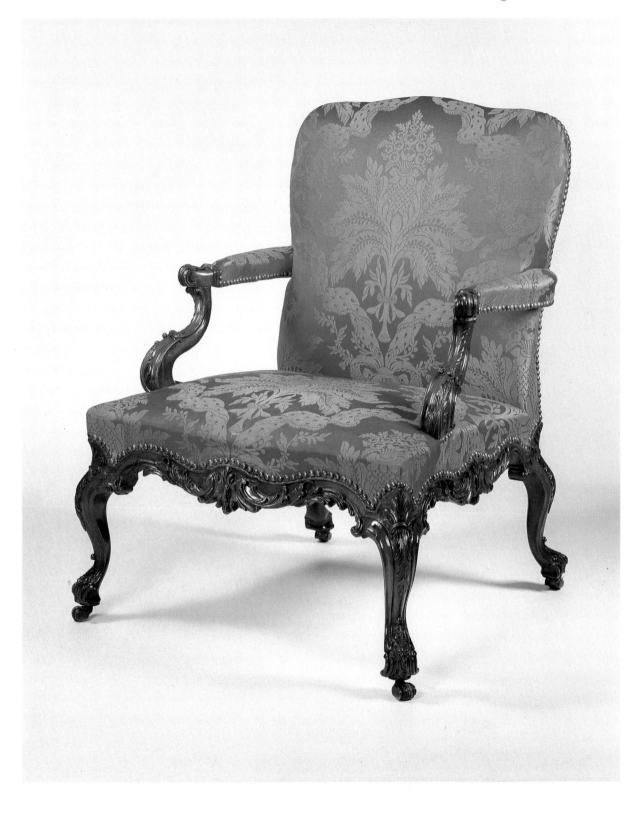

Right:
George I walnut stool
22 in. (56 cm.) wide; 17¾ in. (45 cm.) high;
17½ in. (44.5 cm.) deep
Sold 21.11.85 in London for £11,880 ($17,327)

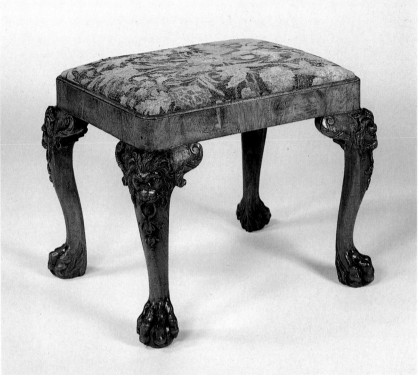

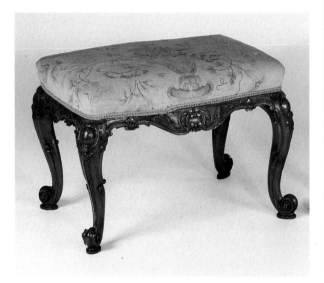

Above:
One of a pair of George II stools
23 in. (58.5 cm.) wide; 16 in. (41 cm.) high; 18½ in.
(47 cm.) deep
Sold 2.6.86 at West Dean for £37,800 ($55,680)
From the Edward James Collection

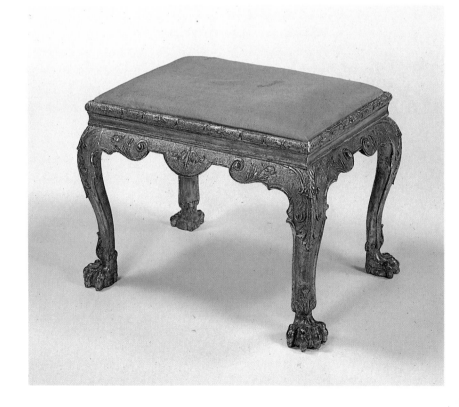

Right:
George I gilt-gesso stool
24½ in. (62 cm.) wide; 17½ in. (44.5 cm.) high;
18 in. (46 cm.) deep
Sold 21.11.85 in London for £22,680 ($33,079)

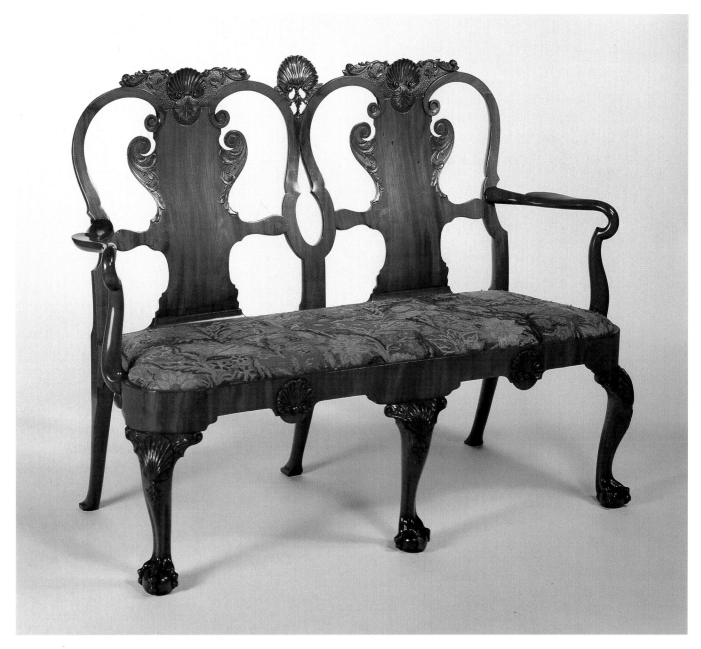

George I mahogany twin-back settee
42 in. (107 cm.) high; 55 in. (140 cm.) wide
Sold 21.11.85 in London for £28,080 ($40,955)

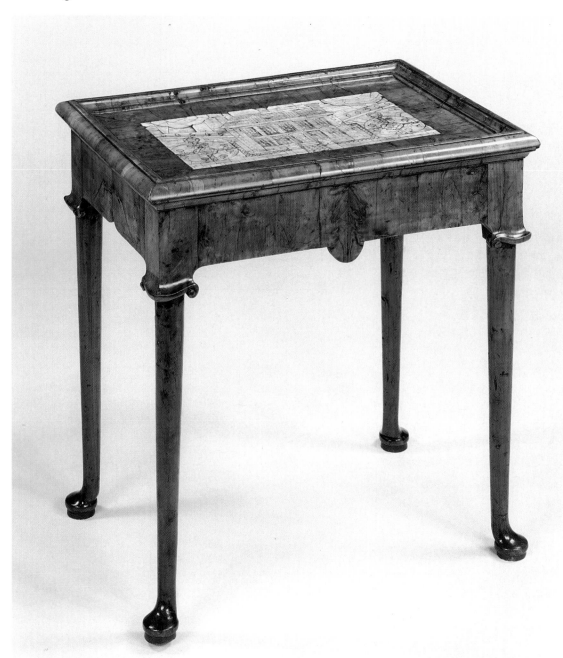

Queen Anne yew-wood centre table with inset marquetry ivory centre depicting a manor house with formal gardens, possibly Nether Lypiatt
27½ in. (70 cm.) wide;
27½ in. (70 cm.) high;
19½ in. (49.5 cm.) deep
Sold 26.6.86 in London for £29,160 ($46,073)
Nether Lypiatt in Gloucestershire was probably built *c.*1700–5 by an unknown architect for Judge John Coxe (d.1728). Judge Coxe was Clerk of the Patent Office and also represented Cirencester and Gloucester in Parliament. The house remained with his descendants until 1884.

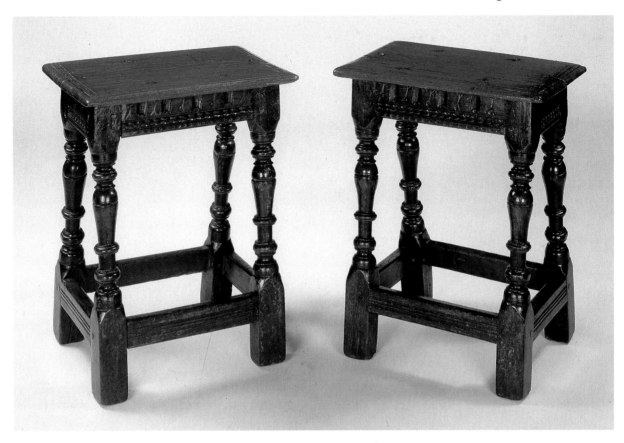

Two from a set of six oak joint stools
Early 17th century
18 in. (46 cm.) wide
Sold 21.11.85 in London for £25,920 ($37,312)

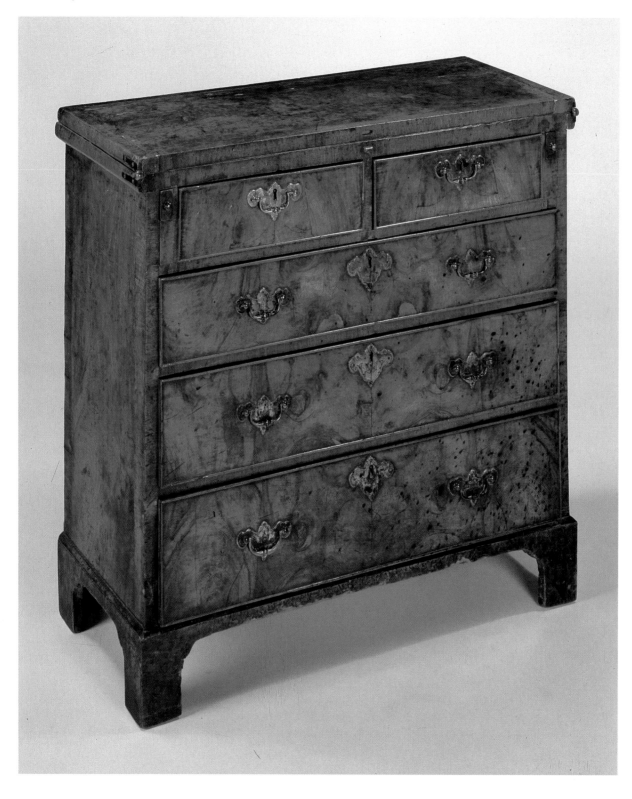

Queen Anne walnut bureau-cabinet
42½ in. (107 cm.) wide; 93 in. (236 cm.)
high; 21½ in. (55 cm.) deep
Sold 21.11.85 in London for £62,640
($91,361)

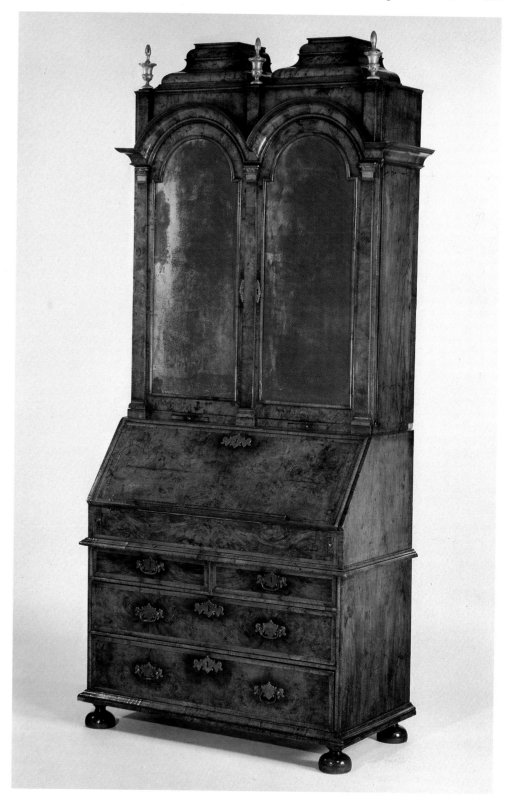

Opposite:
Queen Anne walnut bachelor's chest
29½ in. (75 cm.) wide
Sold 21.11.85 in London for £25,920
($37,312)

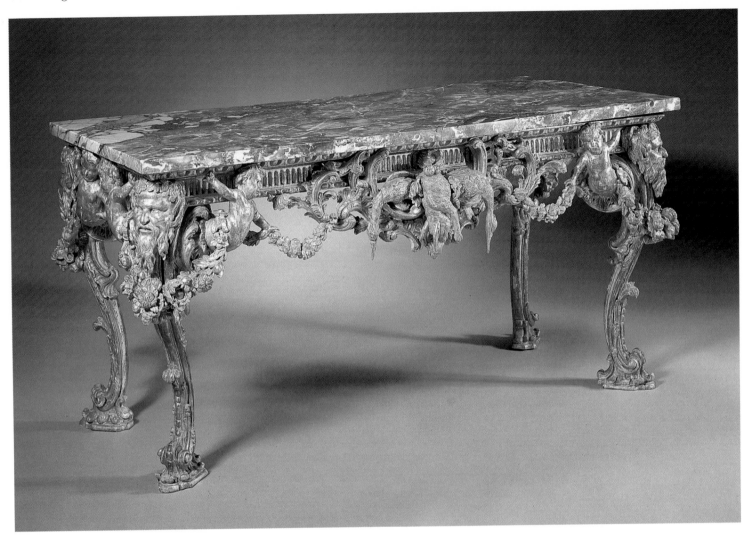

George II giltwood side table made for St. Giles's House, Dorset
Mid-18th century
68 in. (173 cm.) wide; 33½ in. (85 cm.) high; 31 in. (78.5 cm.) deep
Sold 19.4.86 in New York for $220,000 (£144,833)
This table, which was previously sold at Christie's in the St. Giles's sale in June 1980, is the outstanding example of virtuoso naturalistic carving among a spectacular group of carvers' work from St. Giles's. Matthias Lock, one of the most accomplished of rococo furniture designers, has been suggested as a possible author of these designs.

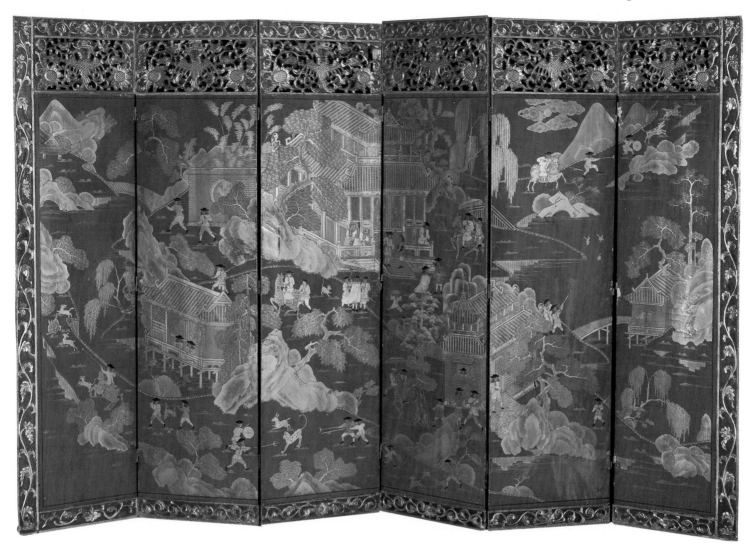

Chinese scarlet and gold lacquer six-leaf screen decorated with European figures and carved with Habsburg double-headed eagles
*c.*1700
79¼ in. (201 cm.) high; each leaf 21¼ in. (54 cm.) wide
Sold 26.6.86 in London for £91,800 ($145,044)
Presented by a Jesuit mission in China (together with a second screen now at Althorp, Northamptonshire) to the Archduke Leopold of Austria on his election as Holy Roman Emperor in 1700

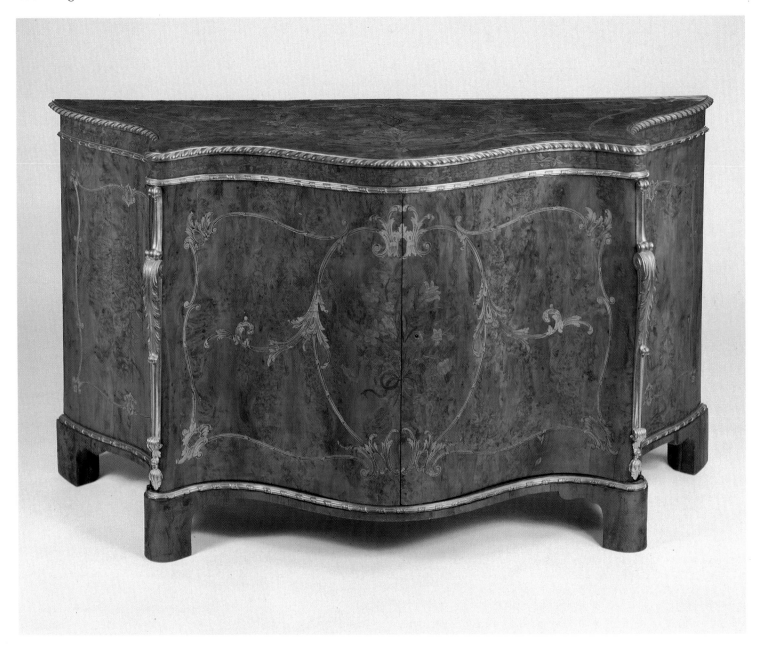

George III Ormolu-mounted yew-wood marquetry commode
Attributed to William Ince and John Mayhew
61½ in. (156 cm.) wide; 32¾ in. (83 cm.) high; 24½ in. (62 cm.) deep
Sold 21.10.85 at Hilborough Hall for £43,200 ($61,884)
From the collection of the late Mrs Charles Mills

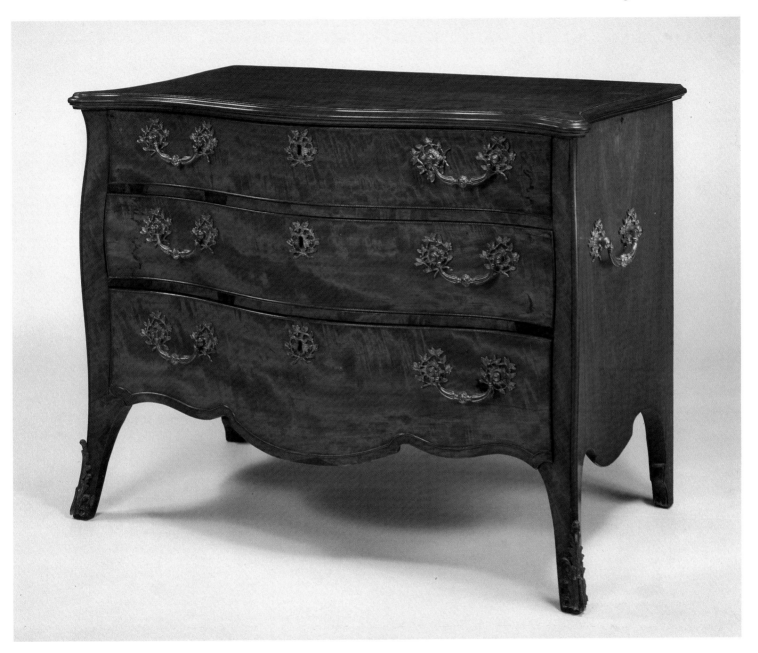

George III mahogany serpentine commode
Attributed to John Cobb
47¼ in. (120 cm.) wide; 34¾ in. (88.5 cm.) high; 26¼ in. (77 cm.) deep
Sold 26.6.86 in London for £66,960 ($105,797)
This commode is almost identical to that supplied by John Cobb in 1766 to James West of Alscot Park, Warwickshire. It was
invoiced as 'an extra fine wood Commode chest of drawers with large Handsome wrought furniture, good brass locks, etc....£16'.

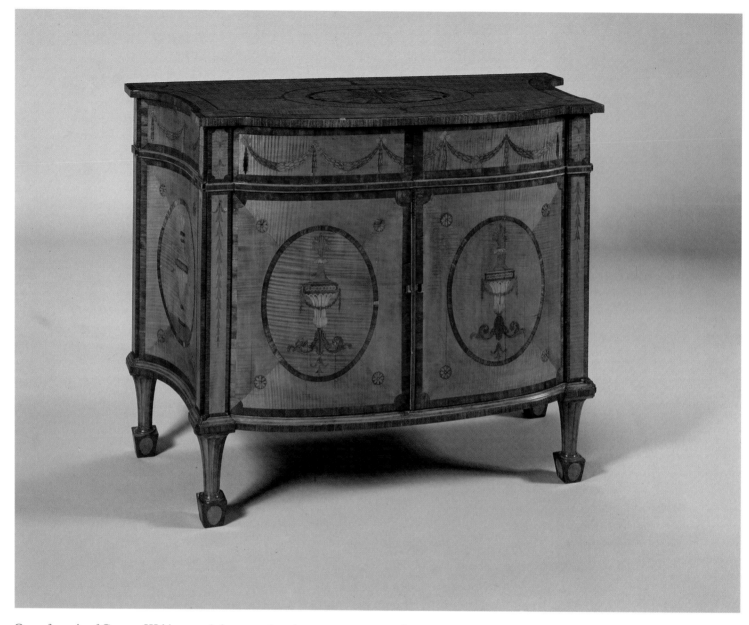

One of a pair of George III kingwood, harewood and marquetry commodes
By Thomas Chippendale, supplied in 1774 to William Constable at Mansfield Street, London
*c.*1774
36½ in. (92.7 cm.) high; 48 in. (122 cm.) wide; 23½ in. (59.7 cm.) deep
Sold 26.10.85 in New York for $242,000 (£170,183)
These commodes, one of the most interesting furniture rediscoveries in America in recent times, were identified partly on the basis of Chippendale's bill, where they are described as '2 Very neat commodes for the Piers [of the Mansfield Street Drawing Room] of Air, wood very neatly Inlaid...£58', and partly from the ink inscriptions on the drawers mentioning William Constable by name

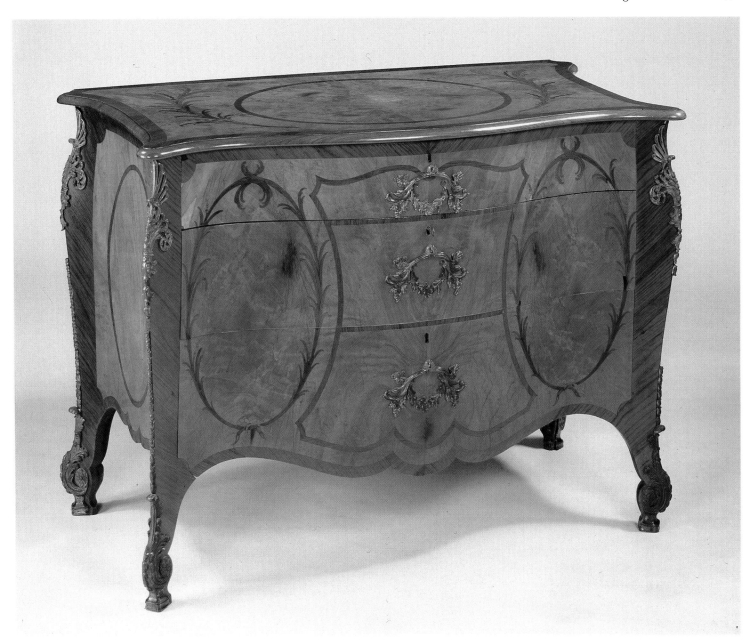

George III Ormolu-mounted satinwood and rosewood commode
50 in. (127 cm.) wide; 35½ in. (90 cm.) high; 26¼ in. (66.5 cm.) deep
Sold 26.6.86 in London for £70,200 ($110,916)
This commode was probably supplied by Chippendale's firm to Sir Richard Hoare, 1st Bt., of Barn Elms and was subsequently
inherited by his son, Charles Hoare of Luscombe Castle

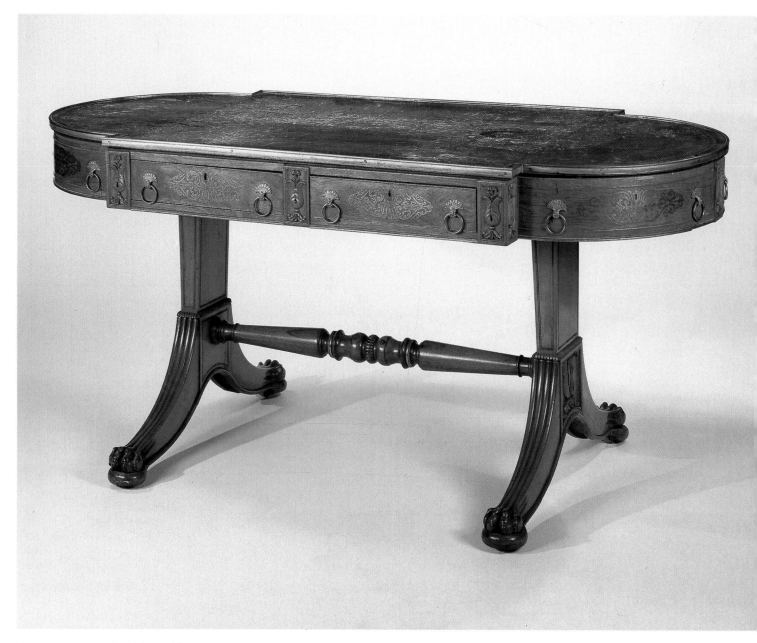

Regency rosewood writing-table
62½ in. (159 cm.) wide; 29¼ in. (74 cm.) high; 29¾ in. (75.5 cm.) deep
Sold 21.11.85 in London for £32,400 ($47,256)

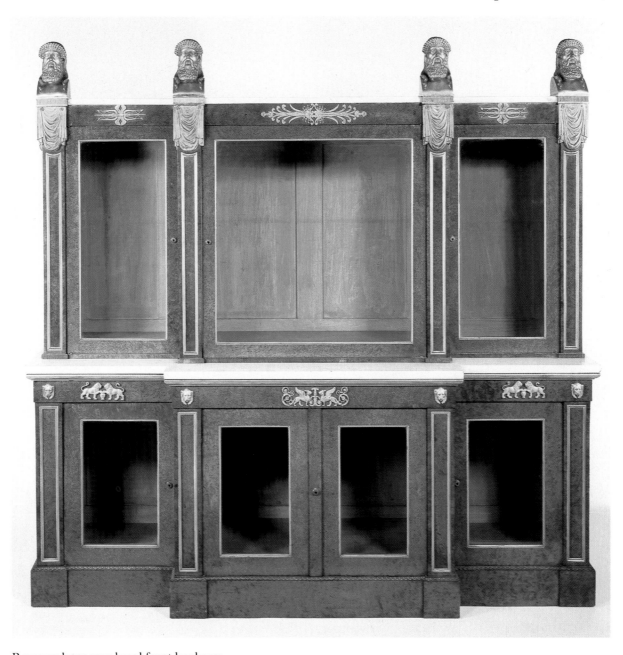

Regency burr-yew breakfront bookcase
Supplied by Marsh and Tatham to the Prince of Wales at Carlton House
73½ in. (187 cm.) wide; 71 in. (180.5 cm.) high; 20 in. (51 cm.) deep
Sold 21.11.85 in London for £145,800 ($212,650)
This seems to have been one of four similar bookcases supplied to the Prince of Wales (later George IV) for the Gothic Library in 1806 at a total cost of £680. The bookcases were later sent to Windsor and this one was recorded there in the York Tower in 1866.

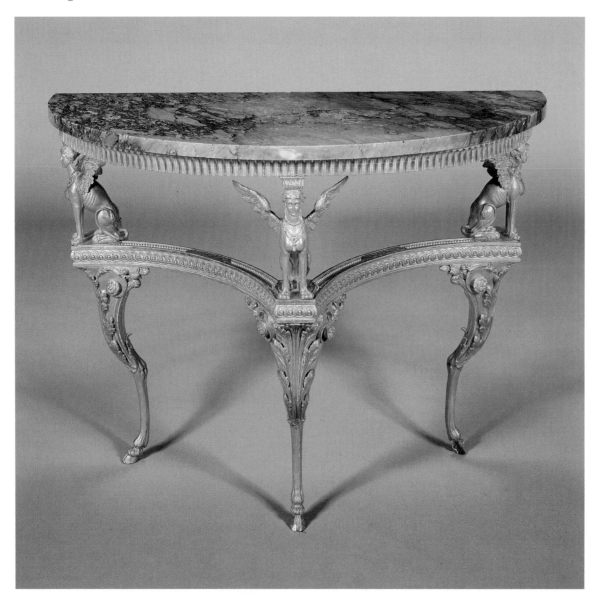

One of a pair of George III giltwood console tables
Late 18th century
32 in. (81.3 cm.) high; 45 in. (114.3 cm.) wide; 20¾ in. (52.7 cm.) deep
Sold 26.10.85 in New York for $77,000 (£54,149)

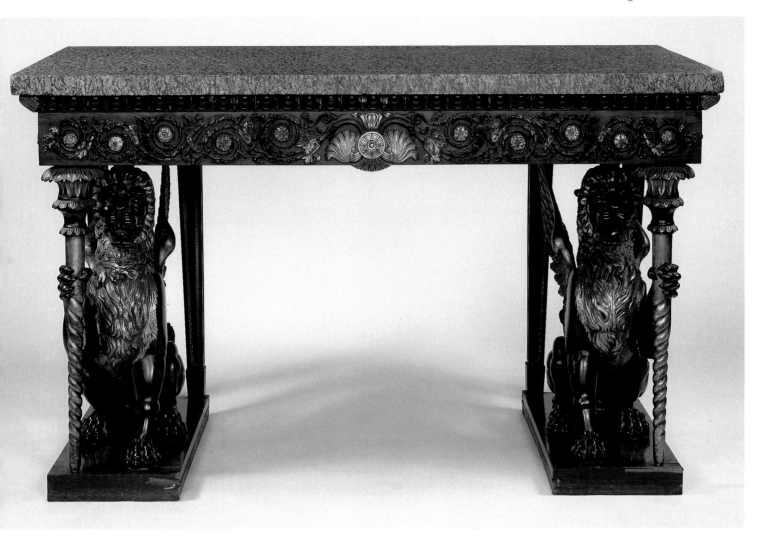

George IV rosewood and parcel-gilt pier-table
66 in. (168 cm.) wide; 40 in. (102 cm.) high; 33 in. (84 cm.) deep
Sold 26.6.86 in London for £41,040 ($64,844)

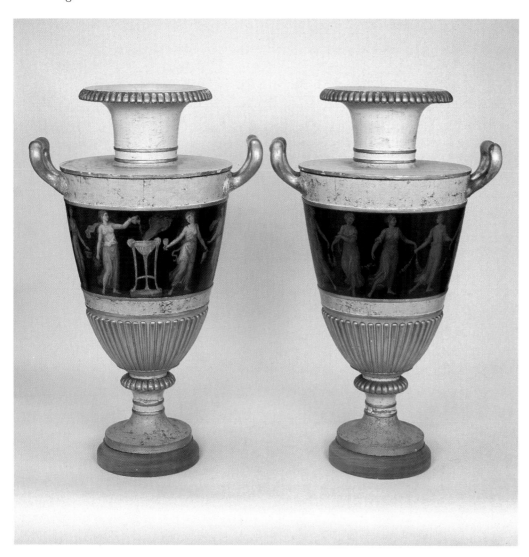

Pair of George III painted and gilded urns
28 in. (71 cm.) high; 18 in. (47 cm.) wide
Sold 21.11.85 in London for £21,600 ($31,093)
These urns may perhaps be from the dining room pedestals made (together with a sideboard and a wine-cooler) to a design by Robert Adam for Henry Frederick, Duke of Cumberland, for Cumberland House, Pall Mall. Until recently it had not been known whether this furniture had been executed but the Duke's sale at Christie's (25 February 1793 and eight days following) provides the evidence that it was. Lots 59–61 in this sale correspond to Adam's design, dated 28 October 1780; the wine-cooler was unrecorded until it recently reappeared and was sold in these Rooms, June 1985.

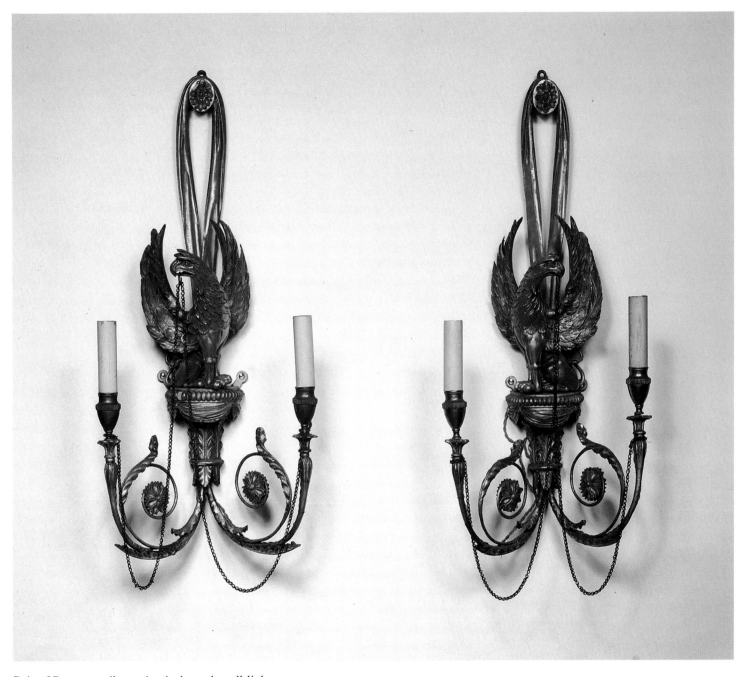

Pair of Regency giltwood twin-branch wall-lights
28½ in. (72 cm.) high
Sold 21.11.85 in London for £23,760 ($34,654)

The Bennison Sale

No one who walked along London's Pimlico Road at any time in the last 10 years could have failed to be struck by the windows of Geoffrey Bennison's shop. The heavy draperies, with their elaborate fringes and tassels, the unfashionable paintings, the variety of sculpture and furniture and the subtle night-lighting evoked the world of some rather grand, albeit slightly shabby, country house. The subsequent creation of interiors in a similar style for his clients was Geoffrey's *forte*, and, coupled with his sharp business acumen, was to lead to his becoming one of the first Englishmen to occupy a leading position in the world of interior decoration, both in Europe and the United States. His influence was enormous, and many younger English designers have freely admitted how much they owed to Geoffrey's originality and leadership.

His remarkable career started partly as a result of illness. In his affectionate appreciation of Geoffrey, John Richardson has told us of their days together as students at the Slade during the war, and what a marvellous gift for theatrical design Geoffrey showed. Then he fell gravely ill with tuberculosis, staying first in an English sanatorium and later, as soon as the war was over, in Davos. It was here that he was destined to become the close friend of a fellow patient and young Italian, Enrico Medioli, and this friendship was to alter his life. For Medioli belonged to the group of brilliant designers, script-writers and budding directors working with and around Luchino Visconti. It was their enthusiasm and example which encouraged Geoffrey to try his own luck in the world of antiques and decorating.

Now cured of his tuberculosis, he returned to London and set up a stall in the Portobello Road. From here he rapidly progressed to a shop in Islington, and finally to Pimlico Road where the success of his business meant the acquisition of an ever increasing amount of shop space and this allowed him to show off objects on a far larger scale: huge bookcases, full length Elizabethan portraits, views of mysterious country houses, landscapes with stallions and their jockeys, elaborate rugs and tapestries. As the business grew, Geoffrey took on more staff and turned his attention increasingly to interior decoration. Much of this work was for foreign clients and particularly members of the Rothschild family, for whom he carried out several remarkable installations. Happily for the rest of us, he was still to be found frequently at the back of the shop dispensing tea and gossip, or holding court in his attic flat in Golden Square, from whence he was to make his final move to Audley Square.

Following his sudden death, his executors asked Christie's to carry out a sale of the stock in trade and the contents of the flat in Audley Square. It had been their wish to try and find a buyer for the flat with all its contents intact, leaving it as a memorial to Geoffrey's unique taste and style. Sadly, after several near misses, this proved impossible and a sale became inevitable. Though many of the individual pictures and works of art were of themselves of unusual quality, it was as a collection and in the setting that Geoffrey had planned for them that they showed to their best advantage. It was with this in mind that it was decided to attempt to recreate, as accurately as possible, the two main rooms at Audley Square in Christie's. Helped by Stanley

Geoffrey Bennison's flat at
4 Audley Square, London
W1, re-created in Christie's
Great Rooms for viewing
prior to the sale

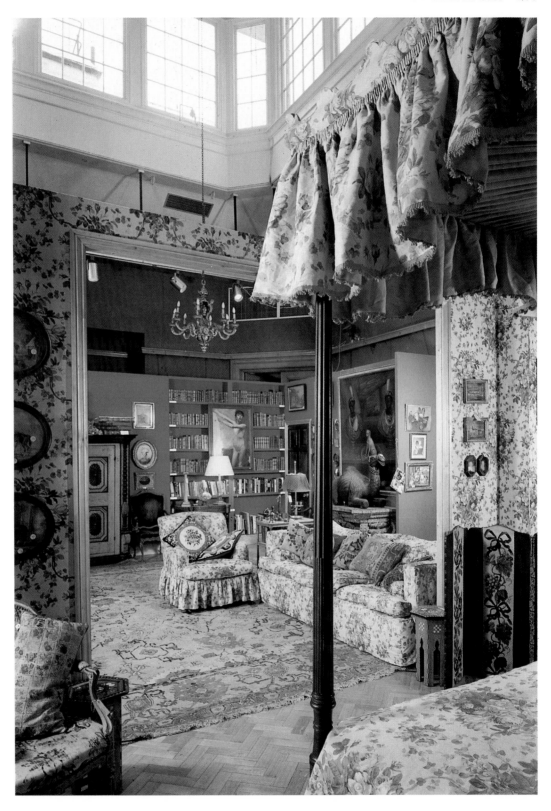

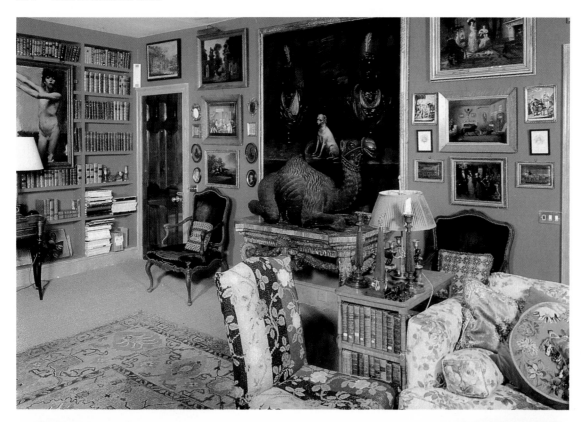

The Drawing Room of
4 Audley Square,
London W1

The Drawing Room of
Geoffrey Bennison's flat at
4 Audley Square, London
W1. The contents of the flat
sold for a total of £667,936
($962,496).

Falconer of Colefax & Fowler, an old friend and one of Geoffrey's executors, and by some excellent photographs of the flat taken by Jeremy Whittaker, the resulting re-creation met with the nostalgic approval of Geoffrey's many old friends, and intrigued and excited those who did not know his style.

The prices paid at the subsequent sale more than justified the effort and expense. Even things acquired by Geoffrey quite recently were sold at a handsome premium; for example an enchanting Orientalist painting by Francis John Wyburd illustrating Dryden's *Conquest of Granada* which had been bought in 1982 for £11,000 ($18,554) fetched £43,200 ($62,252); the same price was paid for an as yet unattributed picture of a dog and two blackamoor busts (previously sold at Christie's in 1966 for 1,600 gns.). In another sale in 1982, Geoffrey had paid £2,700 ($4,555) for a view of a Russian country house, presumably in the Crimea, by a little-known Russian painter called Sazhin – it changed hands for £20,520 ($29,570). Similarly, a tiny drawing by Ingres of the actor Brochard, which was sold at Christie's in 1968 at 900 gns., now realized £24,840 ($35,795).

Other typical Bennison pictures included a Charles Towne of an astonishingly elongated race horse which sold for £18,360 ($26,457); a strange scene of a pony, a terrier and a man with a fishing rod in an interior, possibly by R.B. Davis, which made £14,040 ($20,232); and a trio of rather severe ladies taking tea in a charming 18th century interior, watched through a door by a frightened girl, which sold for £9,180 ($13,220).

The sale naturally contained a great deal of furniture: a most unusual and eye-catching lot in this section consisted of a pair of Biedermeier bedside cupboards in the form of truncated Ionic columns, which made an astonishing £18,360 ($26,457), against a pre-sale estimate of £3,000–£4,000 ($4,323–$5,764); a fine Victorian pedestal desk, with its pigeon-holes labelled by Geoffrey for his office records and with a handy concealed bottle cupboard, made £9,160 ($13,200), against a pre-sale estimate of £1,000–£1,500 ($1,441–$2,162).

Geoffrey's eye for sculpture was well known and there were some intriguing items: a large genial seated camel in sculpted wood, probably French and of the early 19th century, realized £14,040 ($20,232); a magnificent marble bust of Laocöon after the antique, either by a Roman 17th century sculptor, or more probably by the English 18th century sculptor, Joseph Wilton, realized £7,560 ($10,894).

The most personal lots in the sale, among others of his sketches, were two albums of Geoffrey's designs for textiles, which made £118 ($170) each. The cheapest lot was a group of 19 bolsters and cushions which fell to some fortunate buyer for £5.40 ($7.79), and which made their tiny contribution to the final total of £667,936 ($962,496). Of one thing we can be certain: Geoffrey would have loved it all.

The Clore Collection

HUGH ROBERTS

The inaugural sale of French furniture and *objets d'art* in Monaco, built round a nucleus of spectacular objects from the collection of the late Sir Charles Clore, enjoyed to the full the *éclat* that in most people's minds is indelibly linked with life in the Principality. The Clore Collection – just over 50 lots ranging from the rarest Sèvres to the grandest Louis XVI . fetched a resounding F.fr.50,235,270 (£4,414,347), scoring fresh records on almost every front: certainly the most expensive lot of Sèvres porcelain ever sold (a pair of apparently unrecorded *vases oeufs*, with egg finials and 'straw' handles) at F.fr.1,998,000 (£175,571) and one of the most expensive items of French furniture ever sold (the magnificent commode by J.F. Leleu) at F.fr.12,210,000 (£1,072,934). This commode, one of 14 pieces bought by Sir Charles at the sale of the Wildenstein/Ojjeh collection six years previously, fetched nearly three times its 1979 price, a rare enough achievement for any recently sold item, but one which was nevertheless considerably exceeded in the case of a sumptuous pair of Boulle commodes which fetched F.fr.8,880,000 (£780,316) or four times their previous price. These enormous leaps in value no doubt reflect to some extent the general upwards spiral of prices fuelled by the comparative dearth of incontestably first-rate French furniture on the market in recent years. There are however indications that a change in taste in favour of neoclassical and Empire furniture has also had its effect: a pair of console tables by Jacob Desmalter of great distinction fetched F.fr.3,330,000 (£292,618), about four times their previous price and well above the level of prices previously seen for Empire furniture, and a huge and splendid *psyché* (cheval mirror) probably by the same maker fetched F.fr.721,500 (£63,401), also about four times the previous price.

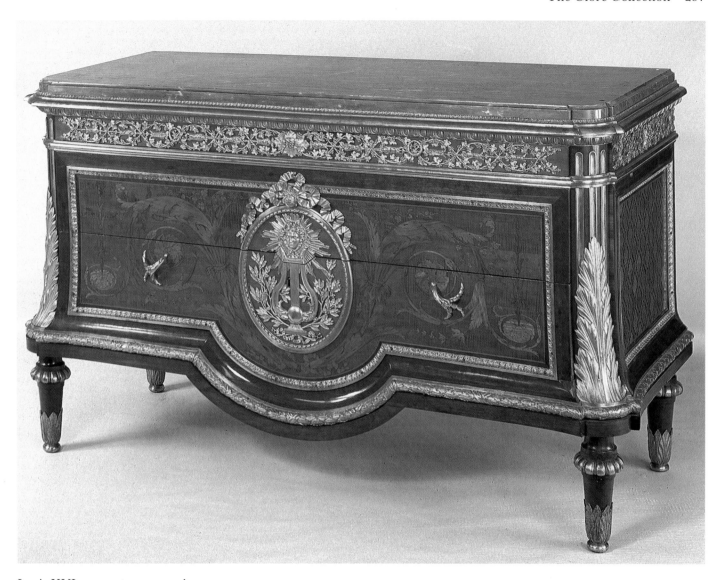

Louis XVI marquetry commode
By J.F. Leleu
Stamped J.F. Leleu and indistinctly inscribed in ink with the inventory number 24
57½ in. (146 cm.) wide; 24¾ in. (63 cm.) deep; 35½ in. (90 cm.) high
Sold 6.12.85 in Monaco for F.fr.12,210,000 (£1,072,934)
One of only two pieces of furniture ever to have been sold at auction for over £1 million
From the collection of the late Sir Charles Clore
Interestingly, this heroic piece of neoclassical furniture belonged to the formidable English collector George Watson Taylor and figured in his sale at Christie's in May 1825. On that occasion it was said to be 'from the Palace of Versailles', a claim which may yet be substantiated as Watson Taylor purchased a number of items of royal provenance at a time when such pieces were circulating in the aftermath of the Revolutionary sales.

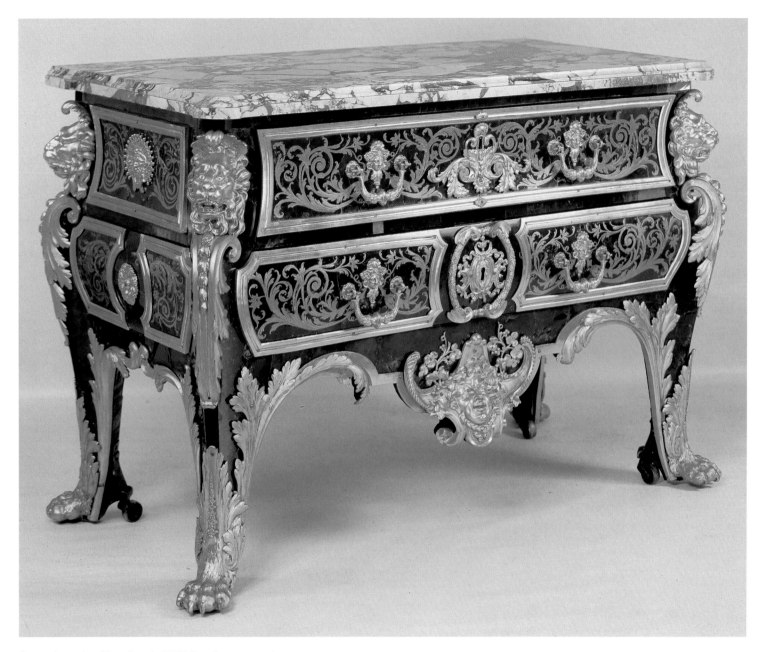

One of a pair of late Louis XIV Boulle commodes
Each stamped 'E Levasseur JME' twice (as restorer)
50¼ in. (128 cm.) wide; 27¼ in. (69 cm.) deep; 35 in. (89 cm.) high
Sold 6.12.85 in Monaco for F.fr.8,880,000 (£780,316)
From the collection of the late Sir Charles Clore
Levasseur trained in the Boulle workshop, probably with A.C. Boulle the Younger,
and specialized in the repair and restoration of Boulle furniture

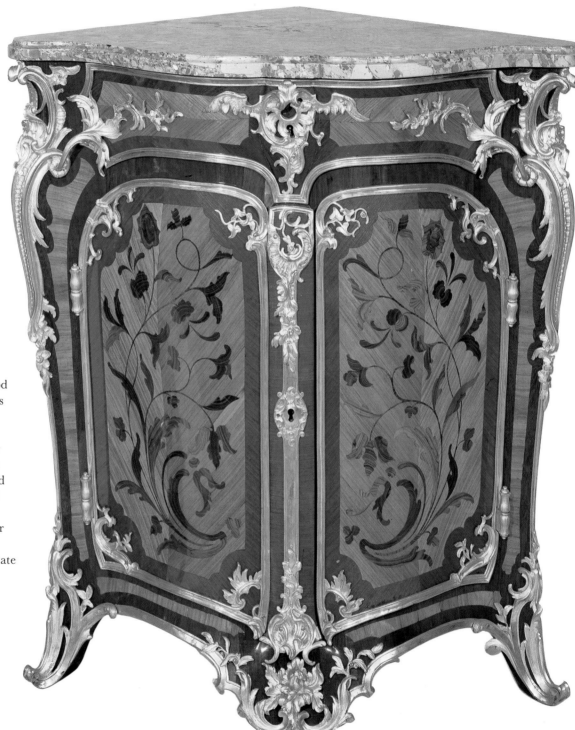

One of a pair of Louis XV
Ormolu-mounted tulipwood
and marquetry encoignures
By J.-P. Latz
Each stamped 'I.P. Latz'
twice and branded EU (for
the Château d'Eu) below a
closed crown; one stencilled
1597 No. 2, the other 1598
No. 1
Sold 6.12.85 in Monaco for
F.fr.4,995,000 (£438,928)
From the collection of the late
Sir Charles Clore

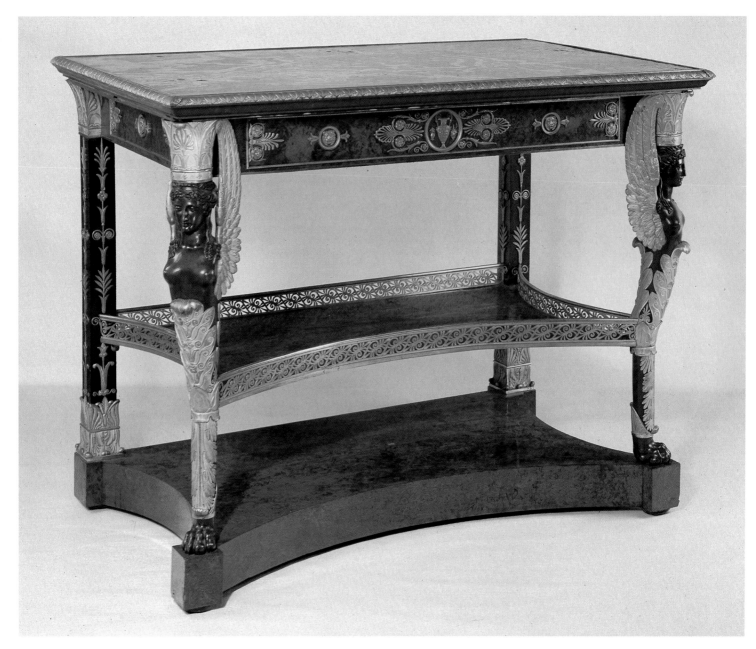

One of a pair of Empire Ormolu-mounted amboyna console tables
By Jacob Desmalter, after a design by Charles Percier
Stamped 'Jacob.D.R.Meslee'
51¼ in. (130 cm.) wide; 32½ in. (82.5 cm.) deep; 39¾ in. (101 cm.) high
Sold 6.12.85 in Monaco for F.fr.3,330,000 (£292,618)
From the collection of the late Sir Charles Clore
François-Honoré-Georges Jacob and Georges Jacob in partnership used this stamp between 1803 and 1813.
These tables are *en suite* with a very similar but smaller console now in the grand Cabinet de l'Empereur at the Grand Trianon,
made by Jacob Desmalter after a design by Percier and placed by Joachim Murat in the Elysée in 1806.

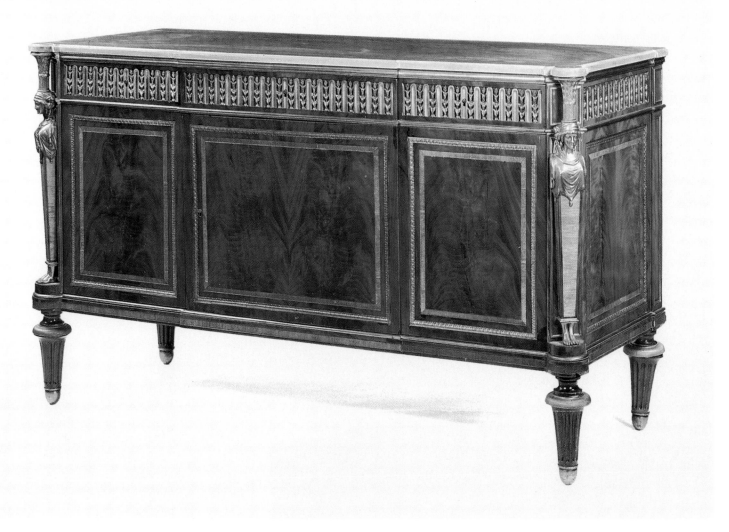

Louis XVI ormolu-mounted mahogany breakfront commode from the Palais des Tuileries
By Guillaume Beneman
Stamped four times G. BENEMAN
64¼ in. (163.5 cm.) wide; 38 in. (96.5 cm.) high; 24½ in. (62.5 cm.) deep
Sold 3.7.86 in London for £151,200 ($237,384)

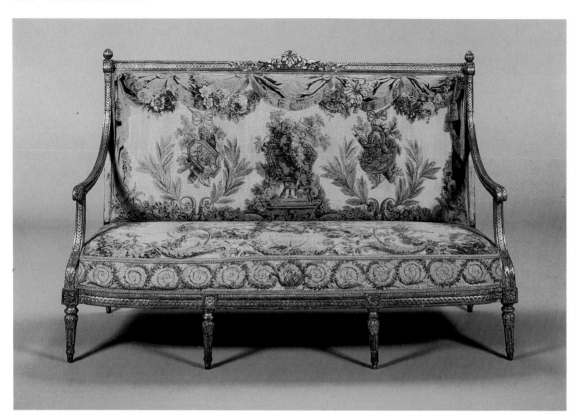

Canapé from a suite of Louis
XVI giltwood seat furniture
*c.*1785–90
Stamped 'G Iacob'
Sold 14.11.85 in New York
for $121,000 (£85,573)

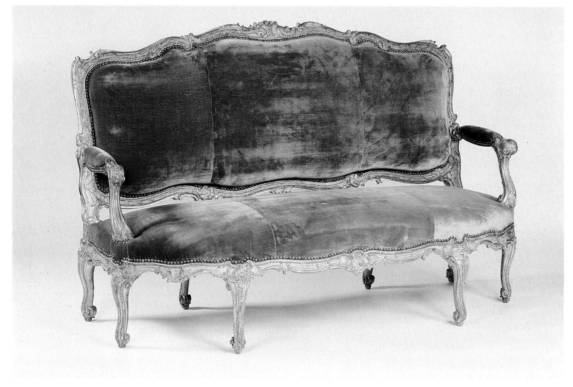

Louis XV giltwood canapé in
the manner of Nicolas
Heurtaut
66 in. (168 cm.) wide;
41½ in. (105 cm.) high;
27 in. (69 cm.) deep
Sold 3.7.86 in London for
£38,880 ($61,042)

Louis XIV giltwood sedan chair
34 in. (86 cm.) wide; approx. 80 in. (203 cm.) high; 39 in. (99 cm.) deep
Sold 2.6.86 at West Dean for £45,360 ($66,815)
From the Edward James Collection

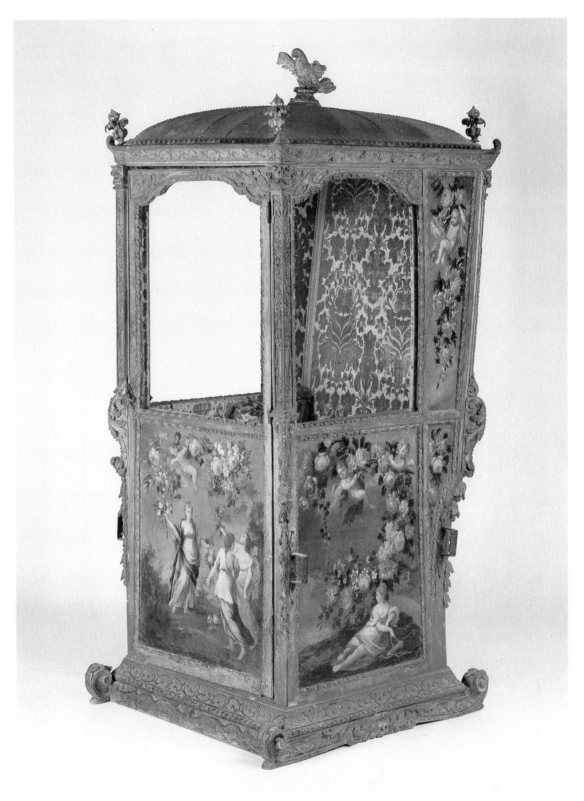

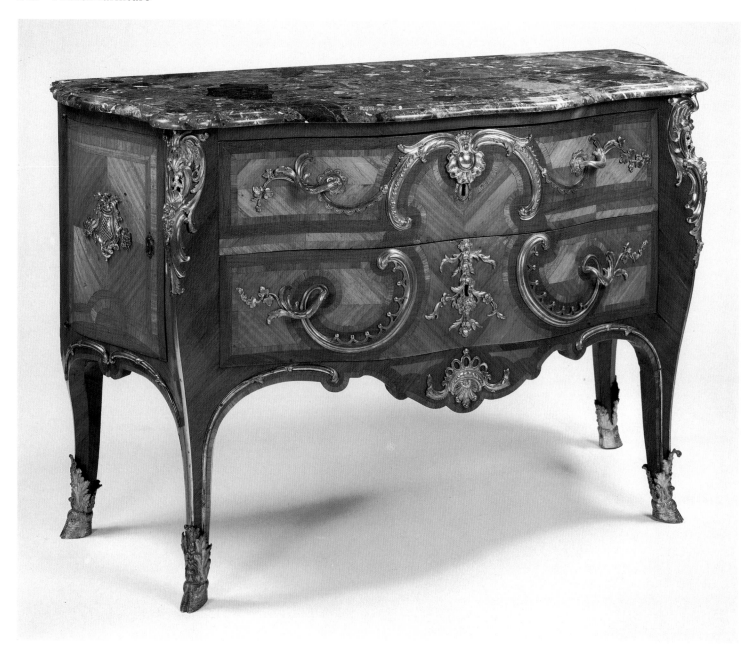

Louis XV kingwood commode in the style of Charles Cressent
55½ in. (141 cm.) wide; 25¾ in. (65.5 cm.) deep; 36 in. (91.5 cm.) high
Sold 3.7.86 in London for £124,200 ($194,994)
From the collection of the Duke of Buccleuch and Queensberry, K.T.

Louis XIV Ormolu-mounted Boulle
armoire
62 in. (157.5 cm.) wide; 110 in.
(279.5 cm.) high; 22 in. (56 cm.) deep
Sold 3.7.86 in London for £102,600
($161,082)

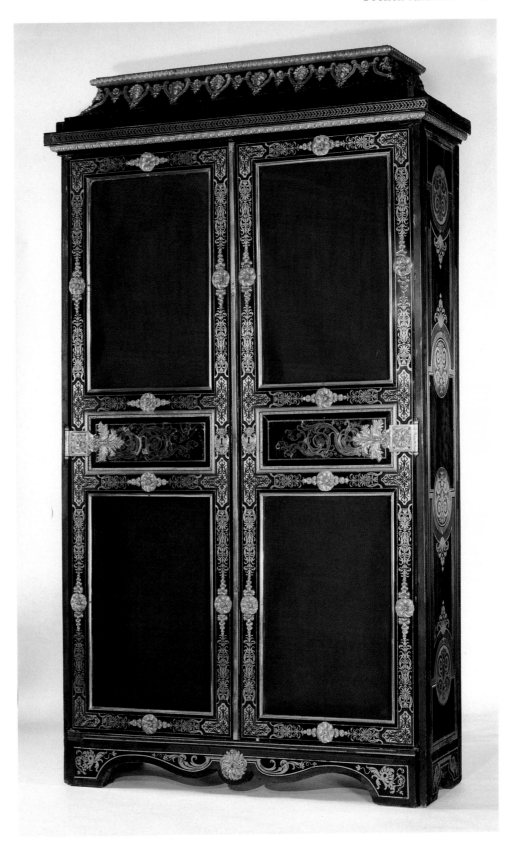

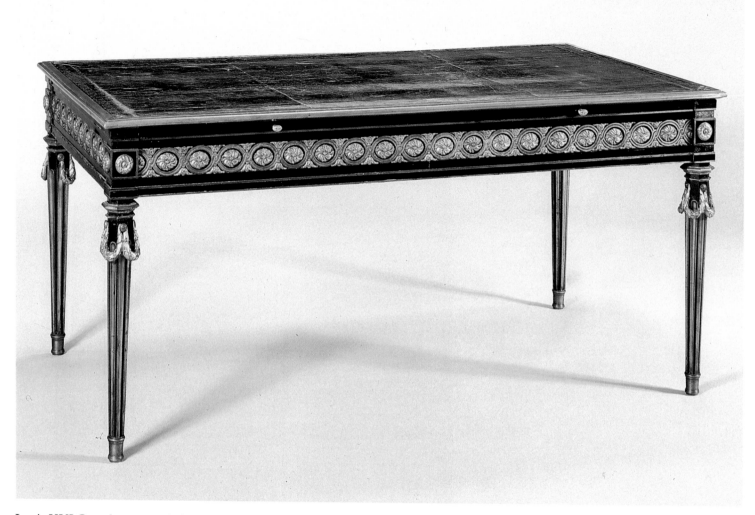

Louis XVI Ormolu-mounted ebony bureau plat
Stamped 'Montigny JME' three times
30 in. (75 cm.) high; 64 in. (160 cm.) wide; 34 in. (85 cm.) deep
Sold 30.4.86 in New York for $352,000 (£228,572)
From the estate of Marionne V. Norton

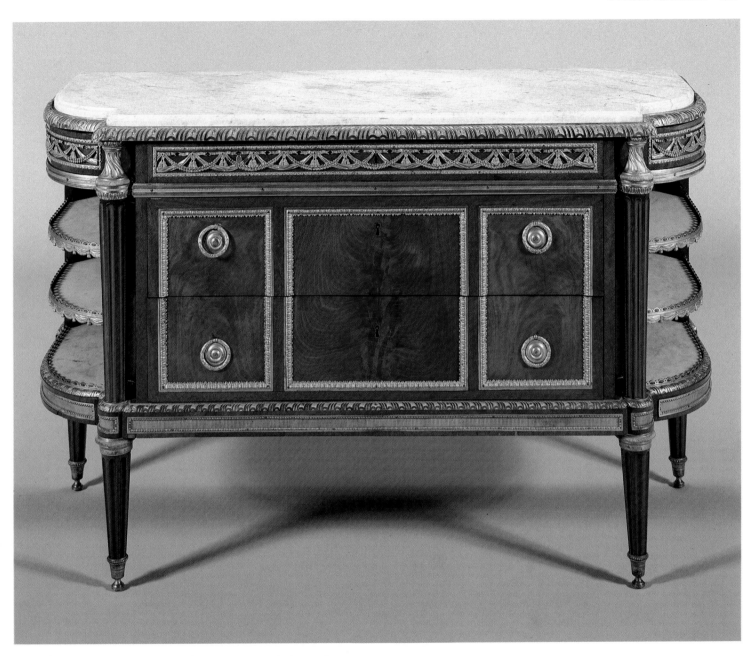

Louis XVI Ormolu-mounted mahogany commode à encoignures
Stamped J.H. Riesener twice, branded with SC within an oval for the Château de Saint Cloud and GM
36½ in. (91.5 cm.) high; 57¼ in. (145.4 cm.) wide; 22½ in. (57.1 cm.) deep
Sold 14.11.85 in New York for $198,000 (£140,029)
The inventory stamp is that of the Château de Saint Cloud and probably dates from the era of Louis Philippe, and is accompanied
by the monogram GM for the Garde-Meuble

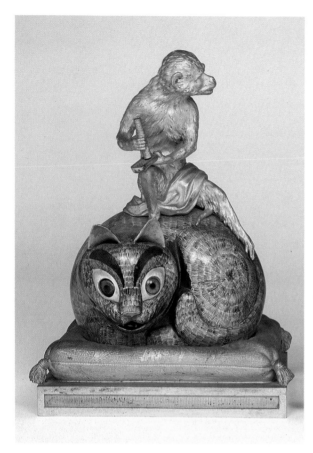

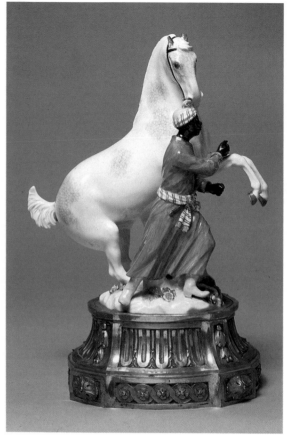

One of a pair of Louis
XV Ormolu-mounted
Meissen groups
Modelled by
J.J. Kändler
The porcelain *c.* 1750
13 in. (33 cm.) high
Sold 3.7.86 in London
for £32,240 ($47,477)

One of a pair of Louis XVI Ormolu and Chinese
porcelain ornaments
The porcelain Kangxi
8 in. (20 cm.) high
Sold 3.7.86 in London for £31,320 ($49,173)

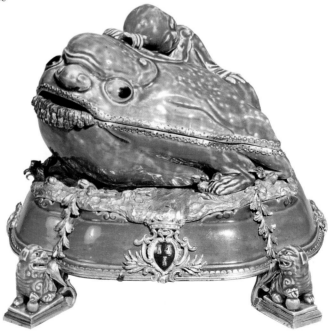

Louis XV Ormolu-mounted turquoise-glazed
Chinese porcelain brule parfum
10½ in. (27 cm.) wide; 7½ in. (19 cm.) high
Sold 3.7.86 in London for £24,840 ($38,999)

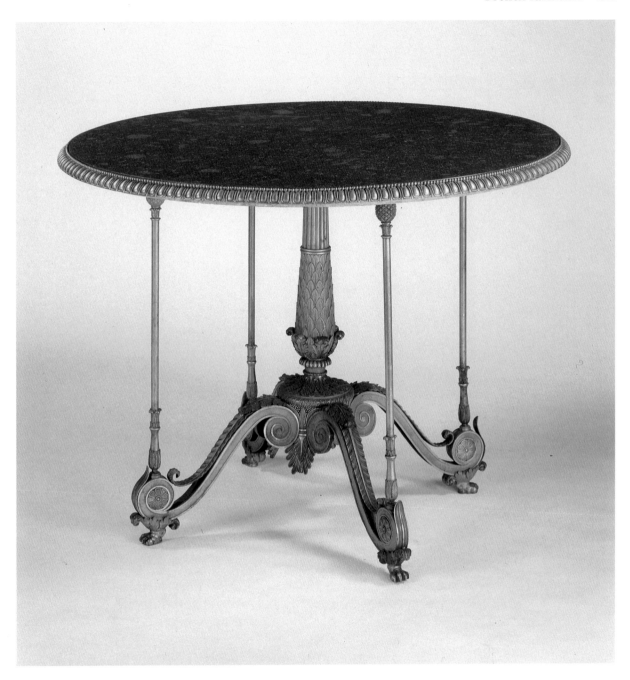

Louis XVIII Ormolu gueridon with inset circular porphyry top
45 in. (114 cm.) diameter; 31¾ in. (80.5 cm.) high
Sold 3.7.86 in London for £97,200 ($152,604)

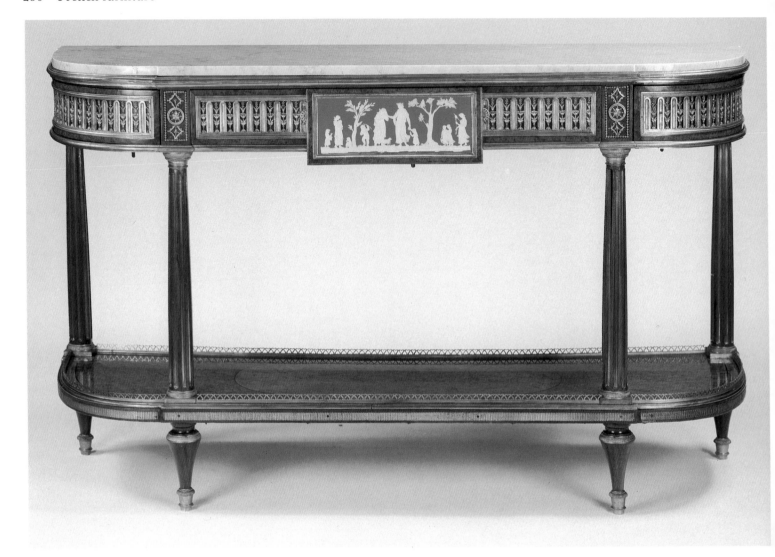

Louis XVI amboyna console desserte
Attributed to Adam Weisweiler
65½ in. (167 cm.) wide; 38 in. (96.5 cm.) high; 20¼ in. (51.5 cm.) deep
Sold 3.7.86 in London for £56,160 ($88,172)

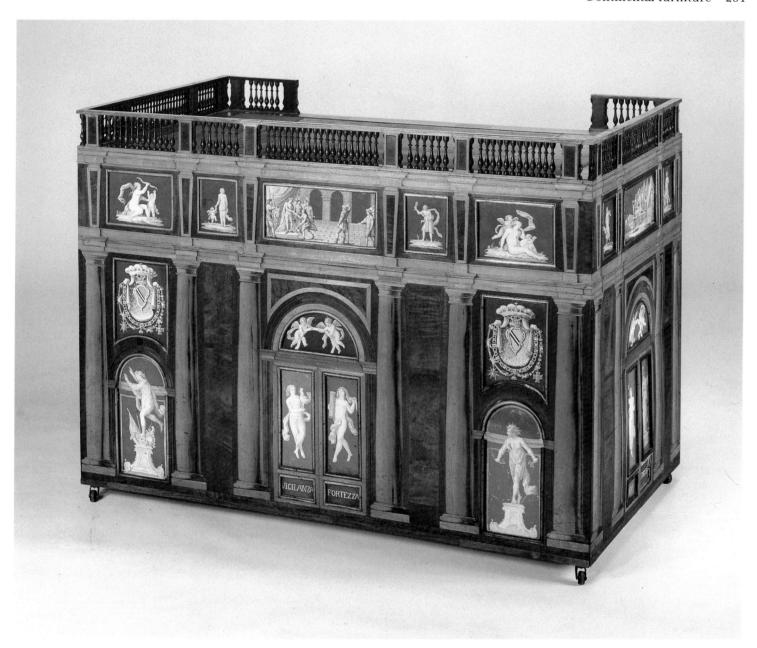

Italian walnut and marquetry kneehole desk
Late 18th or early 19th century
51½ in. (131 cm.) wide; 37¼ in. (95 cm.) high; 31 in. (78.5 cm.) deep
Sold 2.6.86 at West Dean for £48,600 ($71,588)
From the Edward James Collection
This unusual and distinctive desk appears in the photograph of Edward James with the composer Igor Markevitch at 35 Wimpole Street, taken by Norman Parkinson in 1936

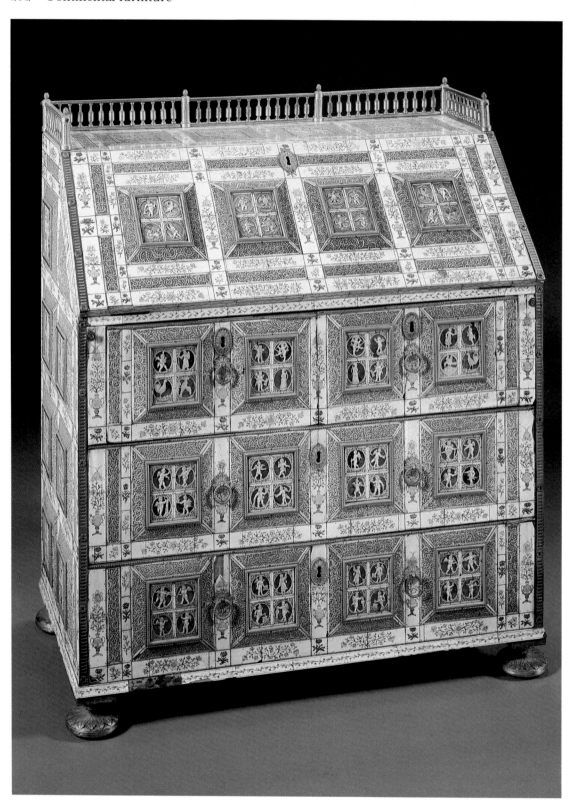

Pair of Russian
Ormolu-mounted and
engraved ivory bureaux
Late 18th century
40 in. (101.6 cm.) wide;
19 in. (49 cm.) deep
Sold 14.11.85 in New
York for $385,000
(£272,278)

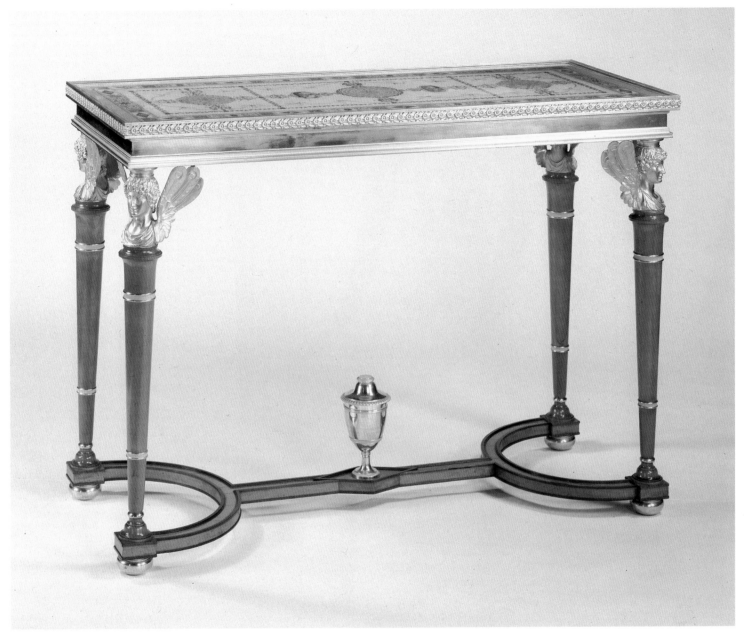

Russian ormolu-mounted mahogany and satinwood centre table
Attributed to Heinrich Gambs
Early 19th century
50 in. (127 cm.) wide; 34½ in. (87.5 cm.) high; 21 in. (53 cm.) deep
Sold 3.7.86 in London for £70,200 ($110,214)
Heinrich Gambs, born either in Baden-Baden or Stuttgart, went to work in Russia at the end of the 18th century, at first associated with the Roentgen workshop. From 1808–10 he provided all the furniture for the Archduchess Katharina Pavlovna and Prince George of Oldenburg.

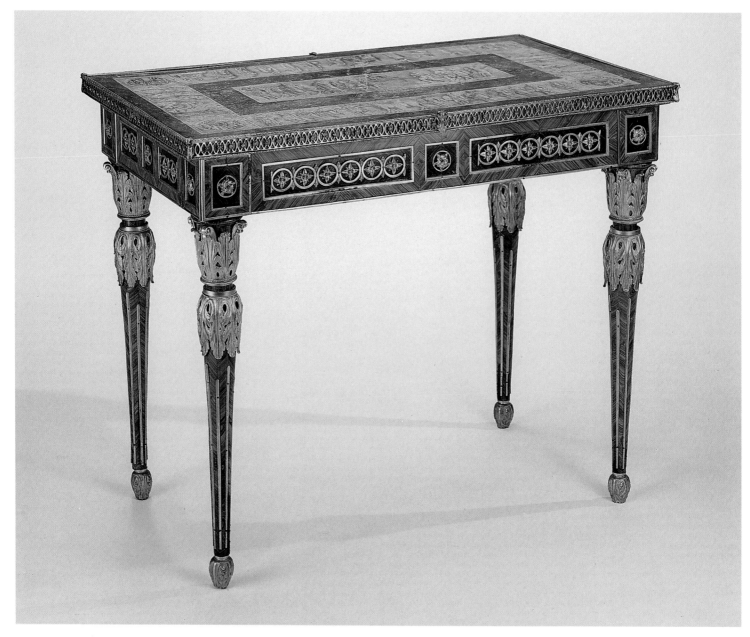

Ormolu-mounted kingwood table de milieu
Late 18th century, possibly Russian
36½ in. (93 cm.) wide; 22½ in. (57 cm.) deep; 30½ in. (77 cm.) high
Sold 7.12.85 in Monaco for F.fr.555,000 (£48,769)

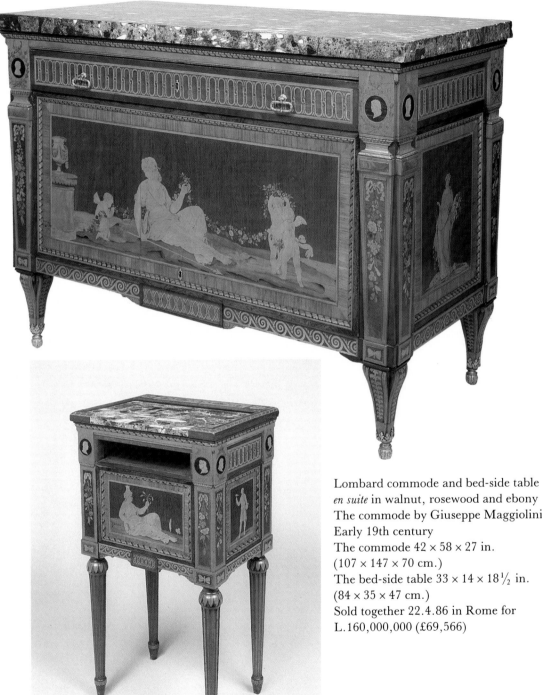

Lombard commode and bed-side table
en suite in walnut, rosewood and ebony
The commode by Giuseppe Maggiolini
Early 19th century
The commode 42 × 58 × 27 in.
(107 × 147 × 70 cm.)
The bed-side table 33 × 14 × 18½ in.
(84 × 35 × 47 cm.)
Sold together 22.4.86 in Rome for
L.160,000,000 (£69,566)

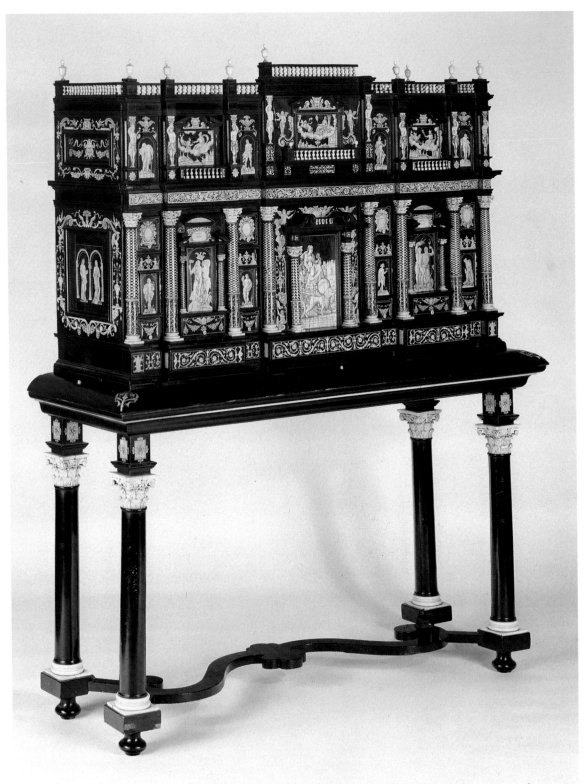

Italian ebony and ivory cabinet-on-stand
17th century
57 in. (145 cm.) wide;
68¼ in. (173.5 cm.) high; 19 in. (48 cm.) deep
Sold 2.6.86 at West Dean for £34,560 ($50,907)
From the Edward James Collection

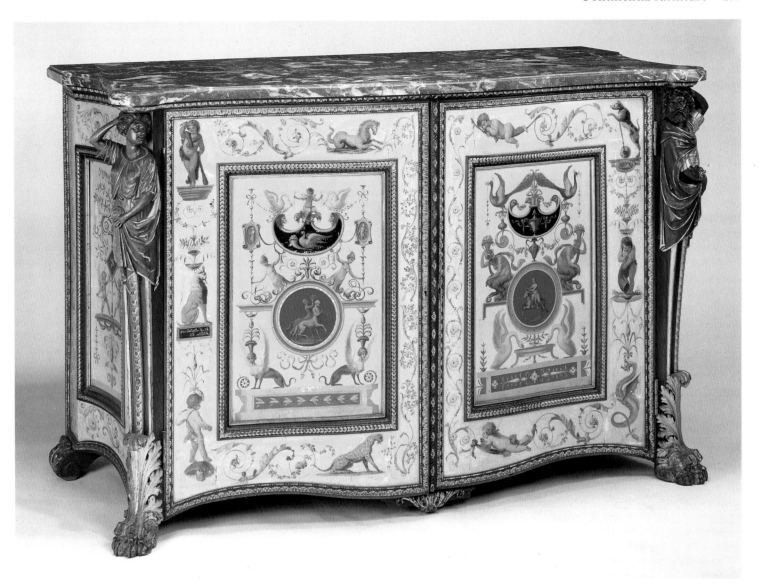

One of a pair of Italian parcel-gilt, walnut and painted commodes
Late 19th century
66½ in. (169 cm.) wide; 42 in. (107 cm.) high; 32¼ in. (82 cm.) deep
Sold 2.6.86 at West Dean for £25,920 ($38,180)
From the Edward James Collection
Willie James is thought to have had this pair of commodes made in Italy to incorporate panels from Neapolitan state carriages that he had acquired

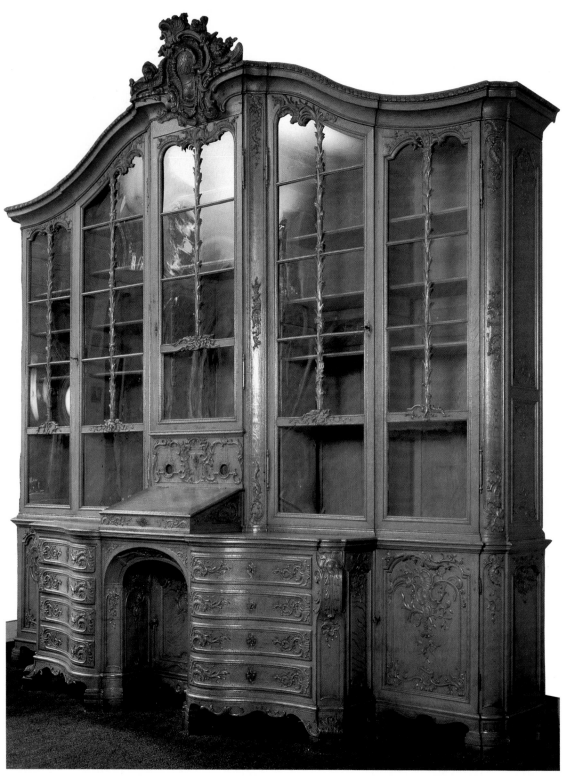

Liège Régence breakfront
bookcase
Signed on the inner rail
'Opus Lud Lejeune Anno
1744'
129 in. (327 cm.) high;
129 in. (327 cm.) wide;
35 in. (90 cm.) deep
Sold 20.12.85 in Amsterdam
for D.fl.301,600 (£72,675)

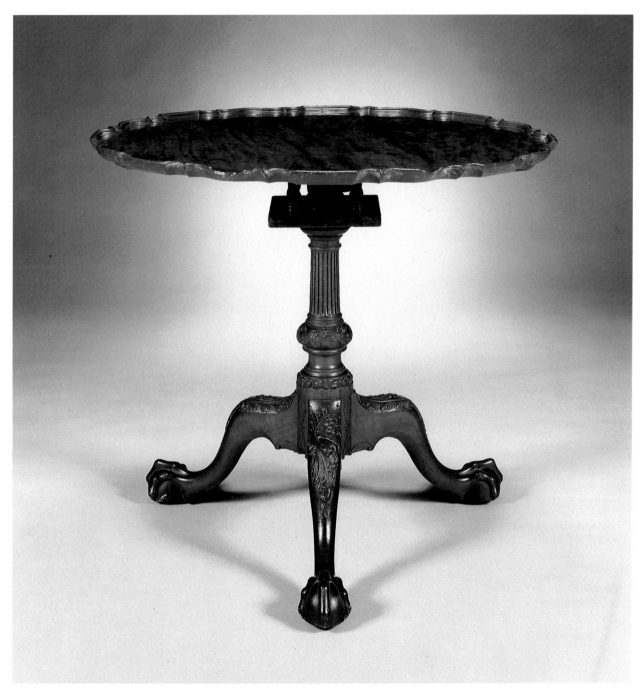

Chippendale carved mahogany tea-table
Philadelphia
1760–80
27½ in. (69.8 cm.) high; 32⅞ in. (83.8 cm.) diameter
Sold 26.1.86 in New York for $1,045,000 (£711,853)
Record auction price for a piece of American furniture

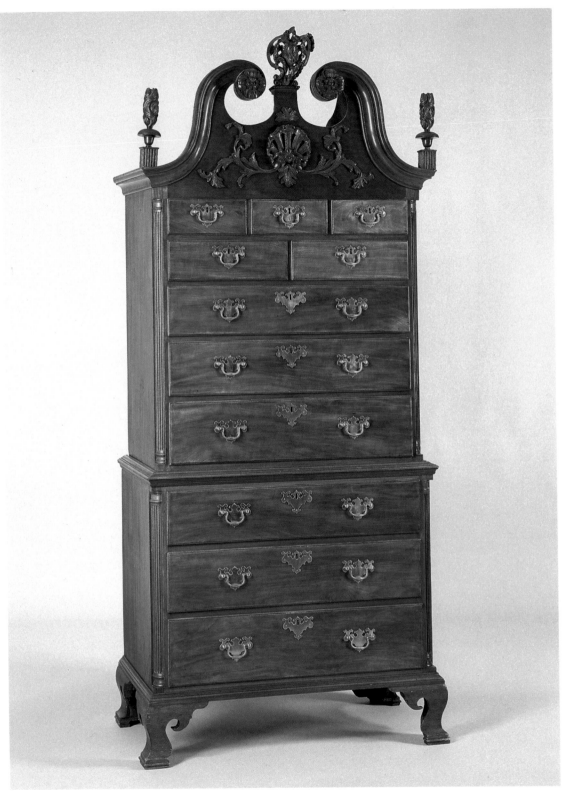

The James Bartram
Chippendale mahogany
chest-on-chest
Philadelphia
c. 1750–70
98¼ in. (249 cm.) high;
44½ in. (113 cm.) wide;
23¼ in. (59 cm.) diameter
Sold 19.10.85 in New York
for $110,000 (£77,465)
James Bartram was the
brother of the botanist John
Bartram, who painted
James's garden on the West
Bank of the Schuylkill River
in 1728

Chippendale mahogany block-front
chest-on-chest
Boston
1750–85
80 in. (203 cm.) high; 38 in.
(96.5 cm.) wide; 21¾ in. (55 cm.) deep
Sold 31.5.86 in New York for $297,000
(£198,000)

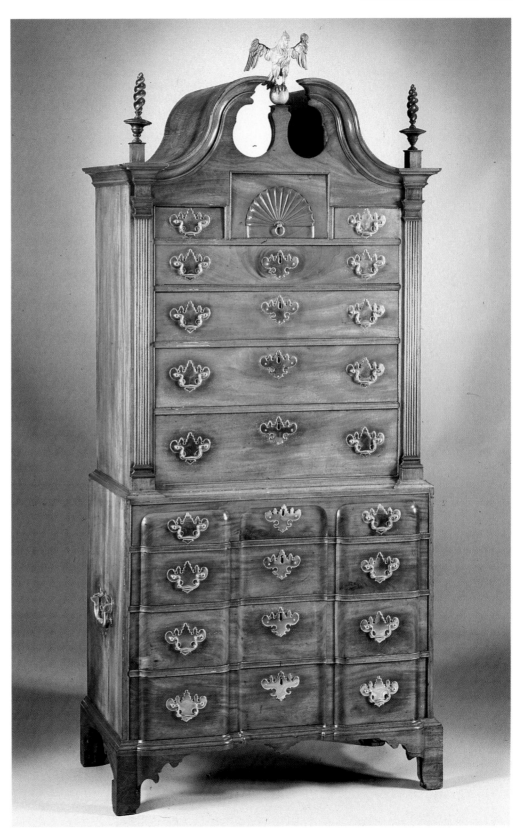

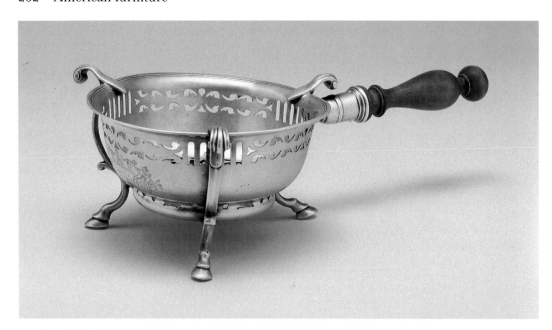

Silver chafing dish
By Jacob Hurd, Boston
1745
Marked 'Hurd' within a
cartouche
3⅝ in. (8.8 cm.) high; 12½ in.
(31.75 cm.) long
Sold 19.10.85 in New York for
$55,000 (£38,732)
The base is inscribed: 'The Gift
of Mr. Wm. Blair Townsend
Merct. to Capt. John Phillips in
Boston 1745'

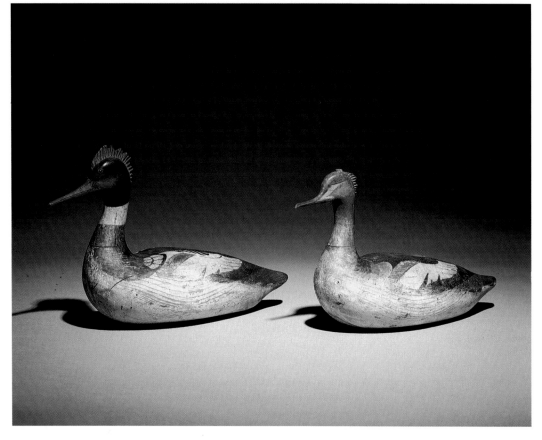

Pair of painted wooden American
Merganser decoys: a hen and
drake
By Lothrop T. Holmes,
Kingston, Massachusetts
c. 1855–65
The hen stamped 'HOLMES';
the drake stamped 'L.T.
HOLMES'
Sold 19.10.85 in New York for
$93,500 (£65,845)

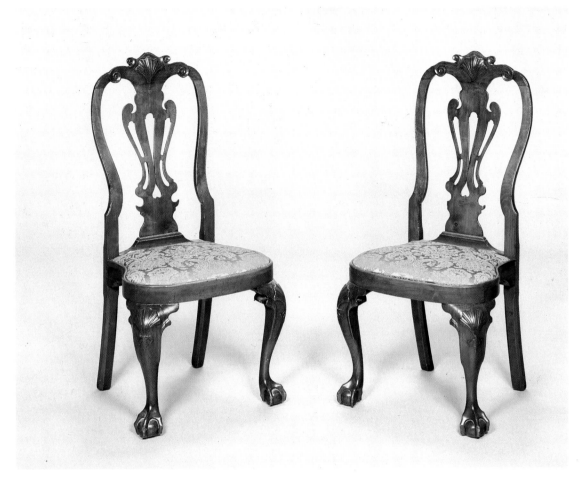

Pair of Queen Anne carved walnut side chairs
Philadelphia
1745–65
42$\frac{1}{4}$ in. (107 cm.) high; 20$\frac{1}{2}$ in. (52 cm.) wide
Sold 31.5.86 in New York for $110,000 (£73,333)

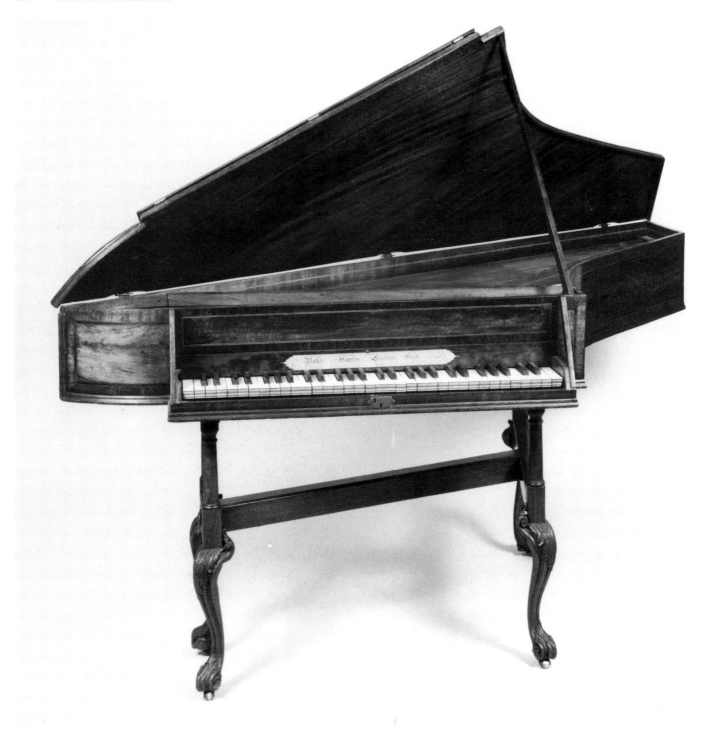

Ivory recorder, the body piqué in gilt nailheads
of scrolling flower-sprays, the gold mounts
chased with miniature hunting scenes including
birds and animals on matted grounds
By Thomas Stanesby Junior
Branded 'Stanesby/Junior/6'
12³⁄₁₆ in. (31 cm.) long
Sold 12.11.85 in London for £27,000 ($38,138)
Record auction price for any wind instrument

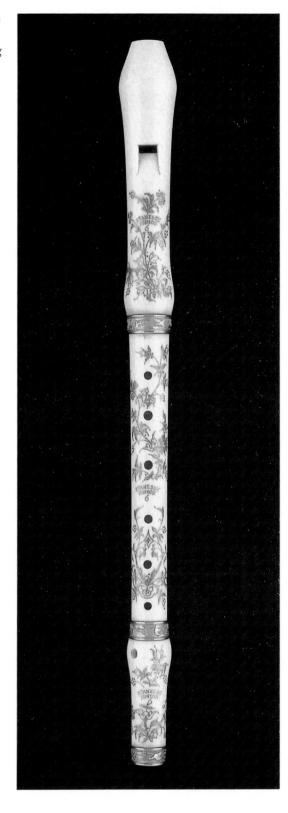

Opposite:
English spinet
By Baker Harris
The nameboard inscribed
'Baker Harris Londini Fecit
1766'
74 in. (188 cm.) wide
Sold 20.5.86 in London for
£12,960 ($19,868)

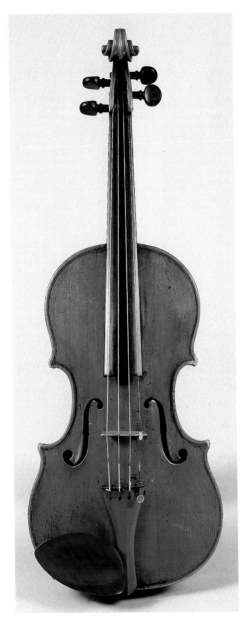

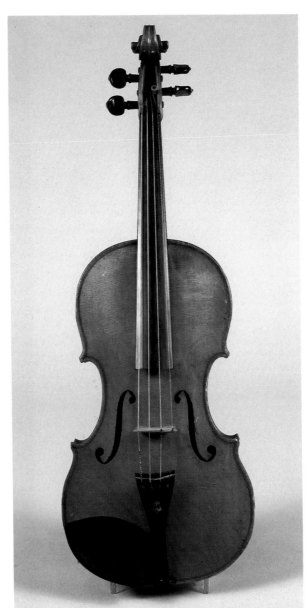

Italian violin
By Gennaro Gagliano
Labelled 'Januarius Gaglianus/Fecit
Neapoli 1765'
Length of back $13^{15}/_{16}$ in. (35.3 cm.)
Sold 12.11.85 in London for £21,600
($30,510)

French violin
By Jean-Baptiste Vuillaume
Labelled 'Jean-Baptiste Vuillaume à Paris/3 rue
Demours-Ternes 1865'
Length of back $14^{1}/_{16}$ in. (35.7 cm.)
Sold 18.3.86 in London for £19,440 ($28,383)

Italian violin
By Joseph Rocca
Labelled 'Joseph Rocca
fecit/Taurini anno
Domini 1850 IHS'
Length of back
13$^{15}\!/_{16}$ in. (35.3 cm.)
Sold 12.11.85 in
London for £28,080
($39,663)

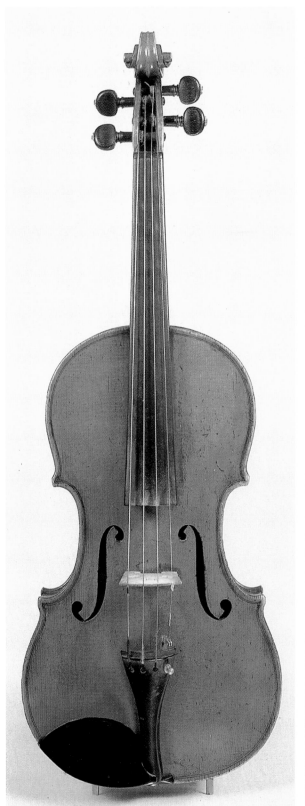

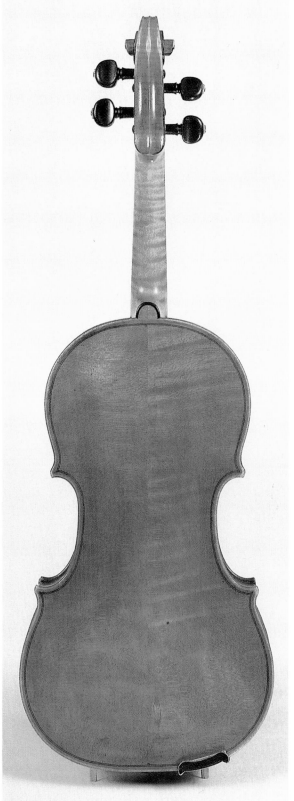

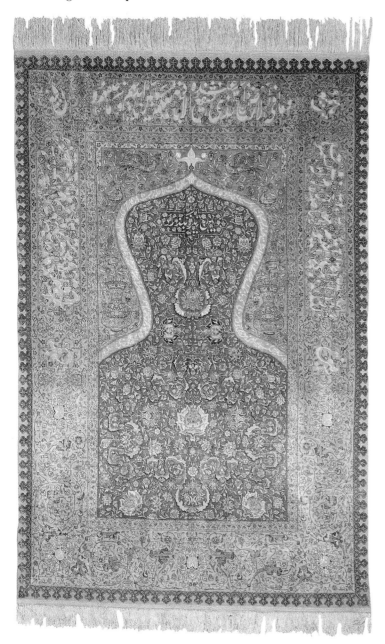

Silk and metal thread Koum Kapu prayer rug
Signed Zare Agha
6 ft. × 4 ft. (183 × 122 cm.)
Sold 17.10.85 in London for £59,400 ($83,665)

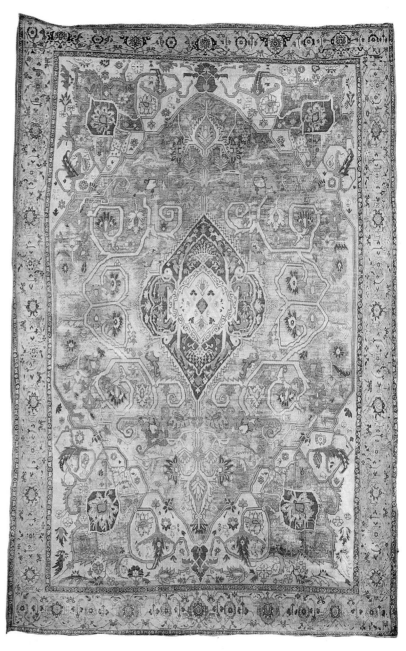

Silk and cotton Heriz carpet
19th century
16 ft. 11 in. × 11 ft. (516 × 335 cm.)
Sold 17.10.85 in London for £30,240 ($42,593)

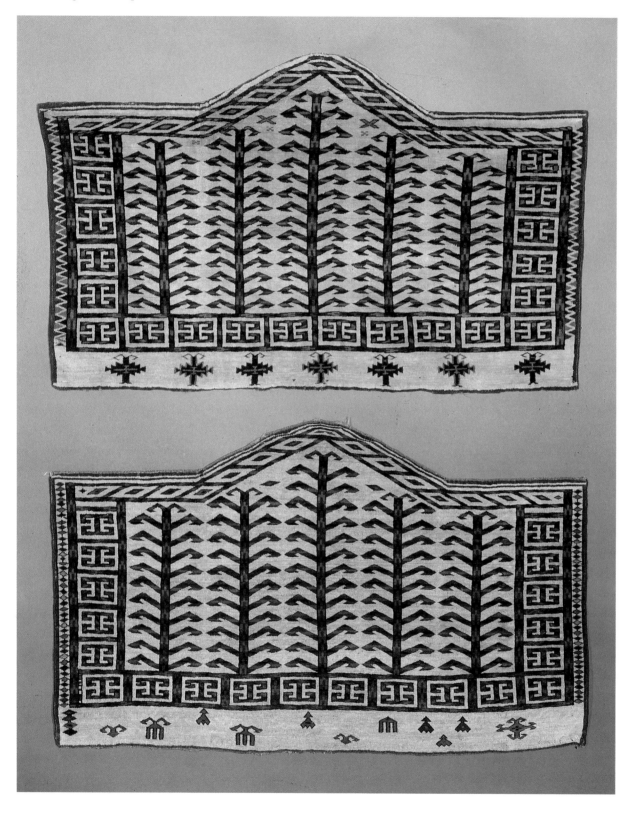

Fereghan rug
19th century
6 ft. 4 in. × 4 ft. 1 in. (193 × 125 cm.)
Sold 17.4.86 in London for £14,580 ($21,870)

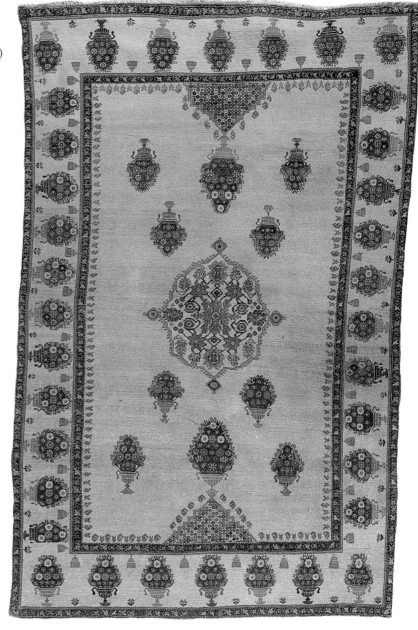

Opposite above:
Yomut Asmalyk
Late 18th or early 19th century
4 ft. 1 in. × 2 ft. 6 in. (125 × 76 cm.)
Sold 17.4.86 in London for £16,200
($24,300)

Opposite below:
Yomut Asmalyk
Late 18th or early 19th century
4 ft. 2 in. × 2 ft. 6 in. (126 × 76 cm.)
Sold 17.4.86 in London for £23,760
($35,640)

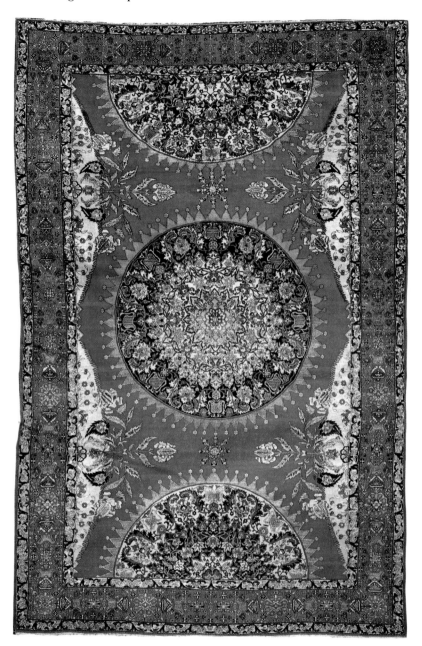

Antique part silk Isfahan carpet
10 ft. 4 in. × 6 ft. 10 in. (314 × 208 cm.)
Sold 17.10.85 in London for £24,840 ($34,987)

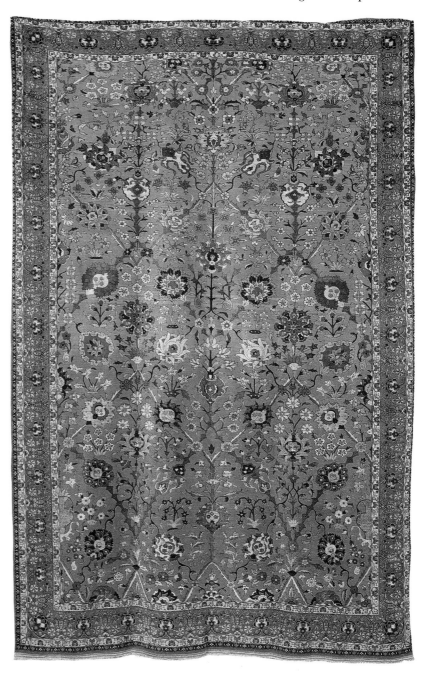

Tehran silk and wool carpet
9 ft. 11 in. × 6 ft. 8 in. (302.2 × 203.1 cm.)
Sold 19.11.85 in New York for $22,000 (£15,433)

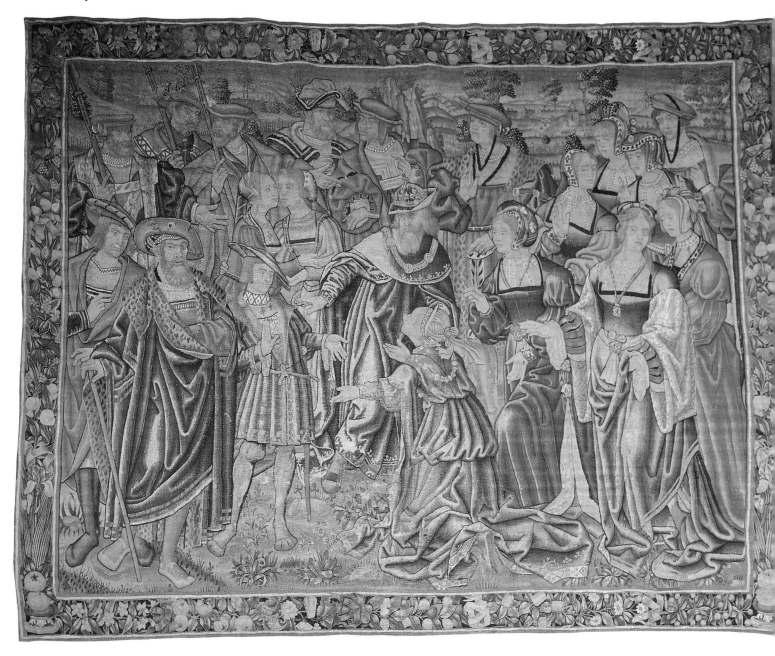

Brussels Gothic tapestry
Early 16th century
8 ft. 9 in. × 10 ft. 10 in. (266 × 330 cm.)
Sold 6.6.86 at West Dean for £54,000 ($81,918)
From the Edward James Collection

Tournai tapestry
16th century
10 ft. 9½ in. × 7 ft. 10 in.
(329 × 239 cm.)
Sold 12.12.85 in London
for £19,440 ($27,576)

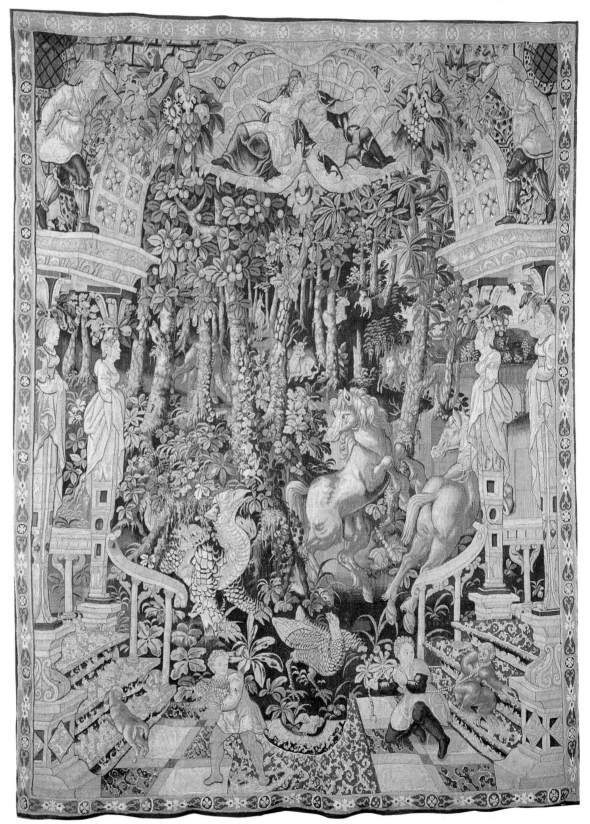

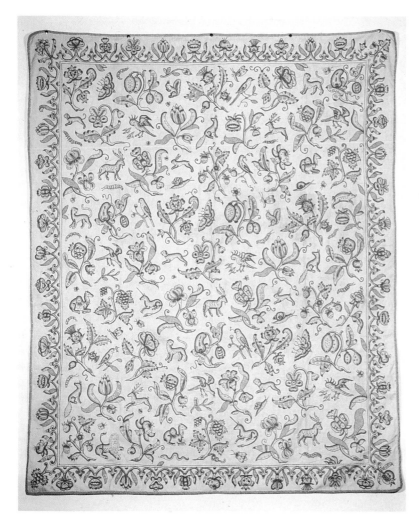

Embroidered coverlet
English
c. 1630
62 × 52 in. (157 × 132 cm.)
Sold 10.6.86 in London at Christie's South Kensington for
£6,800 ($10,200)

Embroidered coverlet
Continental, probably Portuguese
Early 18th century
100 × 80 in. (254 × 203 cm.)
Sold 10.6.86 in London at Christie's South Kensington for
£7,200 ($10,800)

Clocks and Watches

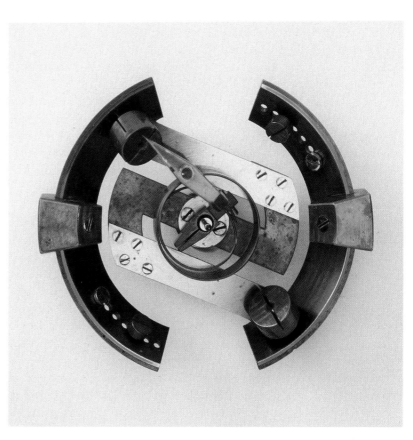

Victorian two-day marine chronometer with 'Hartnup's balance'
By Thos. Russell & Son, Liverpool, No. 6626
$4\frac{1}{8}$ in. (10.5 cm.) diameter of dial
Sold 5.3.86 in London for £4,104 ($6,000)

A Blois Enamelled Watch

RICHARD GARNIER

It is normal for the comparatively inefficient timepieces of the first three-quarters of the 17th century to have been modified in order to improve their timekeeping. Indeed, the magnificent gold, enamel and diamond-set watch by Johan (or Jehan) Cremsdorff of Paris, as a particularly prized possession, had sometime been modified on behalf of its owners through the provision of a later balance with hairspring. This refinement must have enabled the watch to keep pace with the increasingly accurate but less splendid watches of the later 17th and 18th centuries. Besides the sensible provision of a fusee-chain in place of the original catgut, this conversion to spring-balance was the watch's only material mechanical alteration and perhaps ensured the survival of a remarkable example of the Baroque goldsmith's art.

The extraordinary richness and variety of enamelling techniques employed in the construction of this watch would arguably confirm it as being amongst the most important examples to have surfaced in recent years. The only watches truly comparable in importance are the Edward East watch in the Victoria and Albert Museum in London (inv. 14-1888) for its use of a case entirely decorated in turquoise blue enamel, the 'Philip IV' watch in the Musée d'horlogerie, La Chaux-de-Fonds, and the watch by Goullons of Paris with a portrait of Louis XIV as Dauphin, formerly in the Hekscher Collection, both for their use of flowers in high relief.

On the Cremsdorff watch the techniques of *champlevé*, *en relief* and *peinture en camaieu* on enamel are combined. The basic technique remains obscure, but could employ a cast in gold with high relief or the covering of a thin gold case entirely with blue enamel then encrusted with additional gold in high relief, which is partly chased and partly enamelled with flowers in a technique known as *l'emaillage sur ronde-bosse d'or*. The cover is set with baguette-cut diamonds, which are also applied to the chapter-ring and the single steel hand. The interior is painted *en camaieu* in shades of blue-black against the blue ground.

The technique of painting in enamel on an enamel ground was reputed to have been the invention of Jean Toutin, a goldsmith in Châteaudun, *c.*1630. This information comes from a single publication, *Principes de l'architecture, de la sculpture, de la peinture et des autres arts qui en dépendant*, by Félibien and published in 1676, but it is now generally accepted that the process was known in Blois some years earlier. Very few of the artists signed their work and so it is not normally possible to attribute cases to a particular enameller. However, Dr Hans Boeckh of the Fond National Suisse pour les Recherches Historiques has suggested an attribution to Henry Toutin, son of Jean Toutin I, the reputed innovator. Henry Toutin was born at Châteaudun in 1614, and was established in Paris in 1636, where he died in 1683.

Dr Boeckh's researches also revealed that the figures of the theological virtues – Faith (represented as a mother with three children), Hope (with her anchor) and Temperance (pouring wine into a tazza) – are based on a series engraved by Abraham Bosse and published in 1635. Bosse, the son of a tailor, was born at Tours in 1602 and died in Paris in 1676, and was one of the most prolific 17th century Parisian engravers, some of whose designs were intended for or used by goldsmiths and jewellers.

Information about Cremsdorff is scanty. Tardy's list of makers published in Paris in 1971 baldly cites a Joachim or Malevict Cremstorff or Crenestorf as working 1663–83. The quality and elaboration of this watch indicate that it must have been executed for an important personage. Dr Boeckh saw similarities in the Cremsdorff watch case with the work of one of the court goldsmiths to Louis XIV. Further corroboration of the importance of Cremsdorff's clientele is suggested by the recent discovery of a night clock by Charles II's clockmaker, Edward East, bearing a plaque signed Cremsdorff, Paris.

This mid-17th century watch prefigures the finest *tabatières* of the 18th century onwards. When it sold in Geneva on 13 May 1986 it realized Sw.fr.1,870,000 (£670,250), a record for any watch, and indeed vastly exceeding the record of £435,028 for a gold box.

French gold, enamel and
diamond-set watch
Signed *Jehan Cremsdorff à Paris*
c.1650
$2^3/_8$ in. (6 cm.) diameter
Sold 13.5.86 in Geneva for
Sw.fr.1,870,000 (£670,250)
Record auction price for a
watch

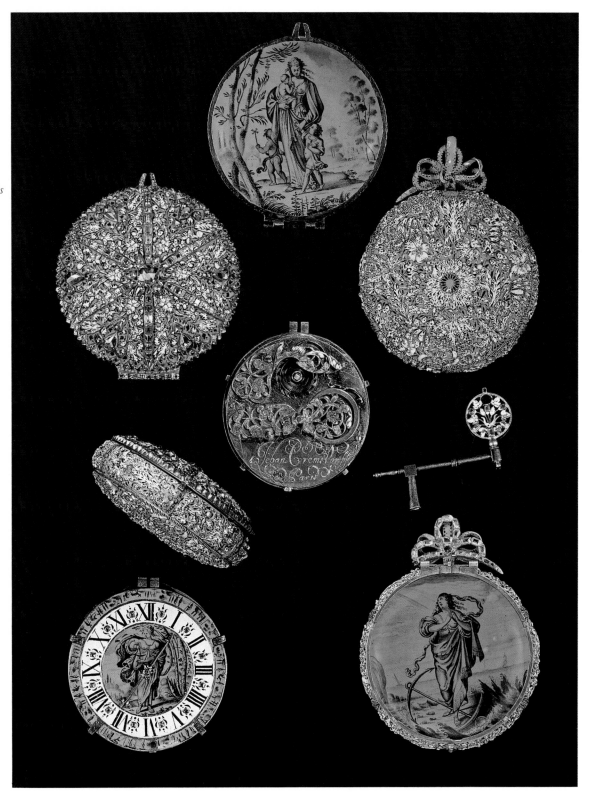

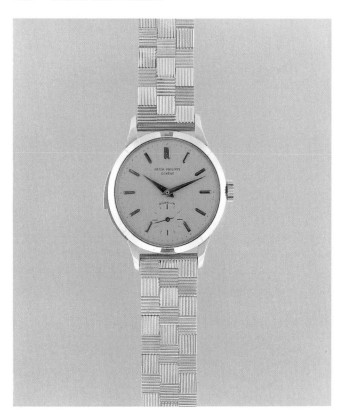

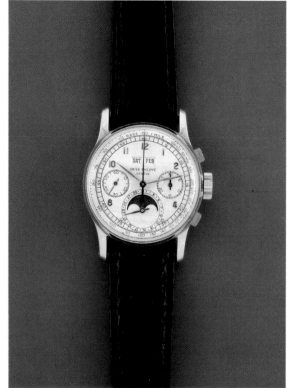

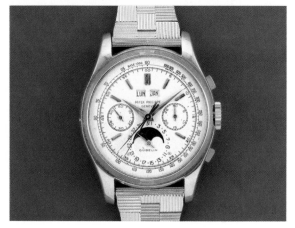

Above:
Gentleman's gold-cased minute-repeating bracelet watch
By Patek Philippe & Co., Geneva, No. 861245
Completed 1956
1³⁄₈ in. (3.4 cm.) diameter
Sold 13.5.86 in Geneva for Sw.fr.99,000 (£35,483)

Above right:
Gentleman's gold-cased perpetual calendar bracelet watch
By Patek Philippe & Co., Geneva, No. 867914
Completed 1950
1³⁄₈ in. (3.5 cm.) diameter
Sold 13.5.86 in Geneva for Sw.fr.88,000 (£31,541)

Gentleman's gold-cased perpetual calendar
bracelet watch
By Patek Philippe & Co., Geneva, No. 868331
Completed 1955
1¹⁄₂ in. (3.9 cm.) diameter
Sold 13.5.86 in Geneva for Sw.fr.286,000
(£102,500)
Record auction price for a wristwatch
Now in the Patek Philippe private museum

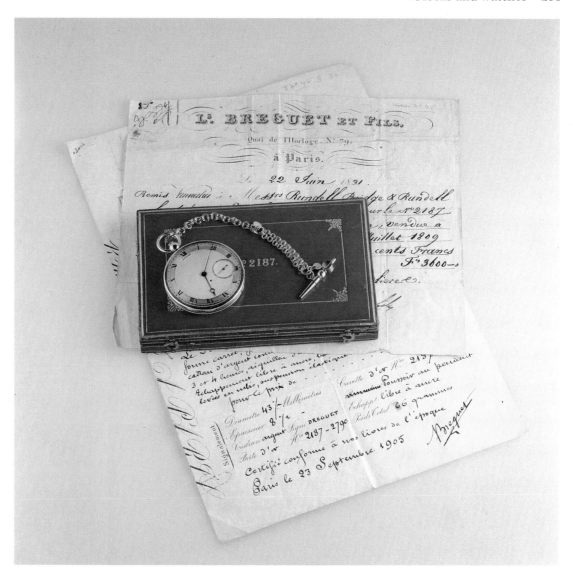

Gold-cased repeating watch with Robin escapement
By Breguet, No. 2187
Originally sold 22 June 1831
1 ¾ in. (4.4 cm.) diameter
Sold 13.11.85 in Geneva for Sw.fr.66,000 (£21,679)

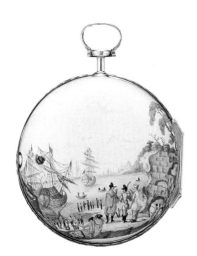

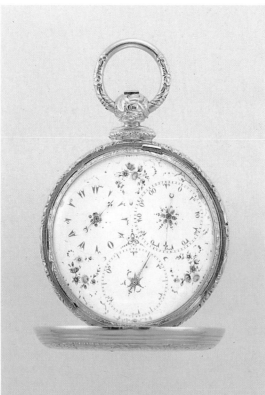

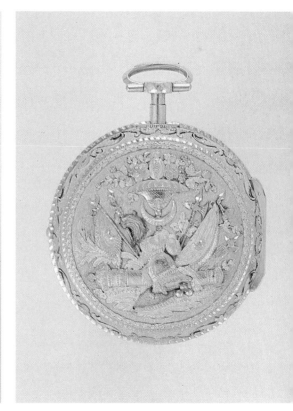

French gold and enamel
verge watch
Signed *LeRoy à Paris*, the
enamel case attributed to
Christian Friedrich Herold
c.1750
1⅞ in. (4.7 cm.) diameter
Sold 17.6.86 in New York
for $22,000 (£14,667)

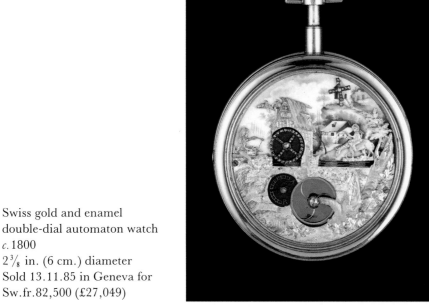

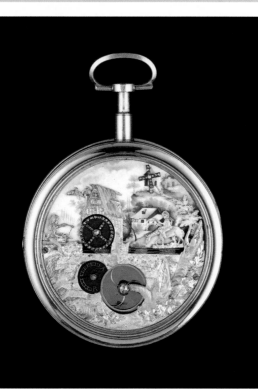

Above left:
Swiss gold hunter-cased one-minute
chronometer tourbillon watch
By F. William Dubois, Locle
c.1840
2 in. (5.2 cm.) diameter
Sold 13.11.85 in Geneva for Sw.fr.84,700
(£27,770)

Above:
Gold and diamond set clock-watch, for the
Turkish market
By Daniel de St. Leu, London
c.1790
2⅜ in. (6 cm.) diameter
Sold 13.11.85 in Geneva for Sw.fr.71,500
(£23,442)

Swiss gold and enamel
double-dial automaton watch
c.1800
2⅜ in. (6 cm.) diameter
Sold 13.11.85 in Geneva for
Sw.fr.82,500 (£27,049)

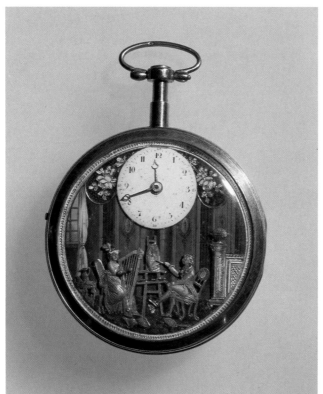

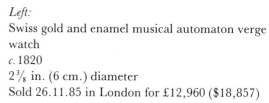

Left:
Swiss gold and enamel musical automaton verge
watch
*c.*1820
2⅜ in. (6 cm.) diameter
Sold 26.11.85 in London for £12,960 ($18,857)

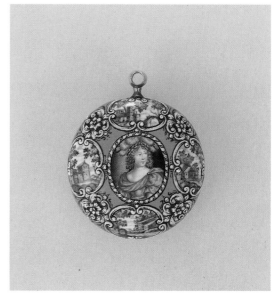

Above:
Swiss gold and enamel pendant watch
By Jean Rousseau, enamelled in the manner of
Peter Huaud le Pere
*c.*1660
1⅜ in. (3.5 cm.)
Sold 13.11.85 in Geneva for Sw.fr.82,500
(£27,049)

Left:
Historical two-day marine chronometer
By James Muirhead, Glasgow, No. 2169
4 in. (10 cm.) diameter of dial
Sold 16.10.85 in London for £5,400 ($7,598)
Now in the British Columbia Provincial
Museum, Canada
A 'military' marine chronometer associated
with the mid-19th century political and
cartographic history of Western Canada and
U.S.A., having been employed by the Oregon
Expedition, 1858–62, to determine the
delineation of the 49th Parallel between the
shore opposite Vancouver Island and the Rocky
Mountains

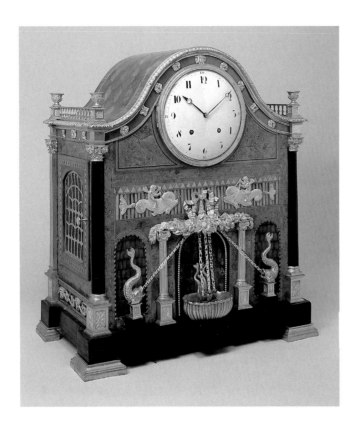

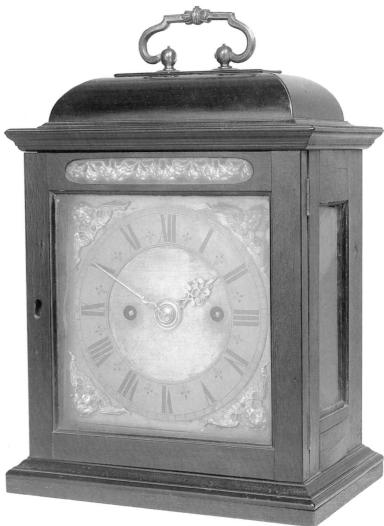

Austrian or Swiss Biedermeier automaton table clock
with organ
22¼ in. (57 cm.) high
Sold 16.10.85 in London for £16,200 ($22,793)

James II ebonized Roman striking bracket clock
By Joseph Knibb, London
12 in. (31 cm.) high
Sold 16.10.85 in London for £11,880 ($16,715)

Historical Royal presentation grande
sonnerie spring clock
By Thomas Tompion, London,
No. 278
*c.*1700
28 in. (71.1 cm.) high
Sold 26.11.85 in London for
£248,400 ($361,422)
Record auction price for an English
clock
Now on permanent loan to the
British Museum

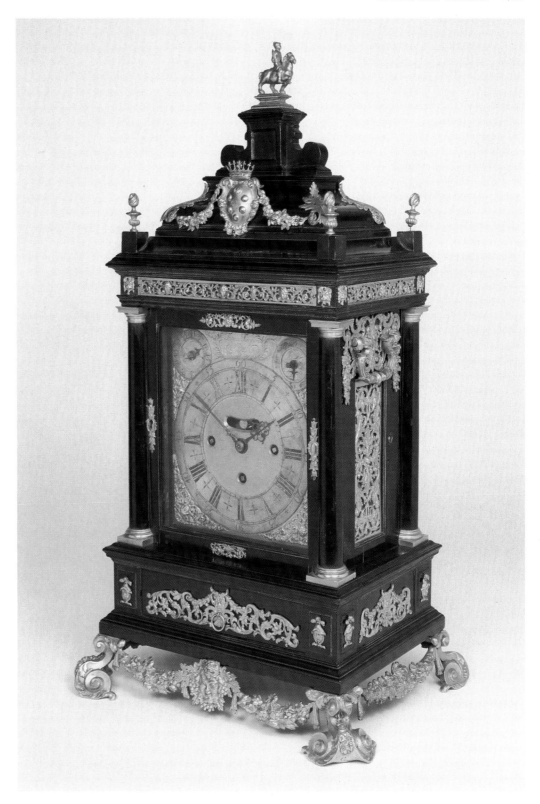

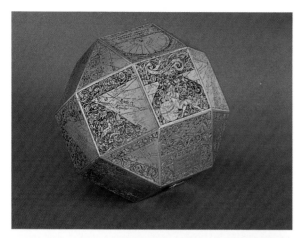

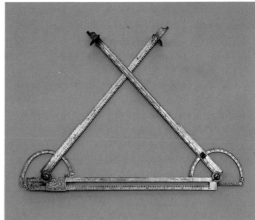

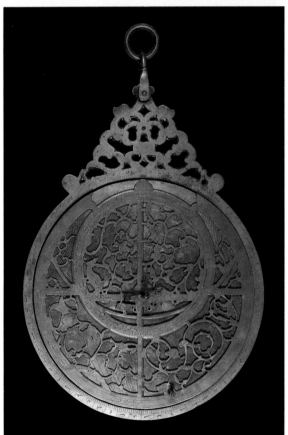

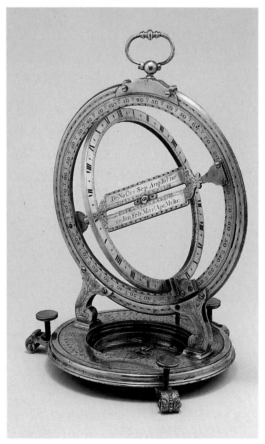

Far left:
Flemish gilt metal polyhedral
sundial
By Michael Coignet,
Antwerp
*c.*1590
5¾ in. (14.6 cm.) diameter
Sold 10.6.86 in London at
Christie's South Kensington
for £22,000 ($33,000)

Left:
French brass trigonometer
Signed *Philipus Danfrie, F.*
Late 16th century
14¾ in. (37.5 cm.) long, folded
Sold 17.10.85 in London at
Christie's South Kensington
for £35,000 ($49,298)

Lahori Indian brass astrolabe
Signed *Jamal al-Din ibn Muhammad Muqim ibn 'Isa ibn
Allahdad*
Dated 1666
9¾ in. (25 cm.) high
Sold 31.10.85 in New York for $26,400 (£18,340)
Now in the Science Museum, London

George II brass geared universal ring dial
Attributed to Thomas Heath, London
*c.*1725–50
14¼ in. (36 cm.) high
Sold 31.10.85 in New York for $26,400
(£18,340)

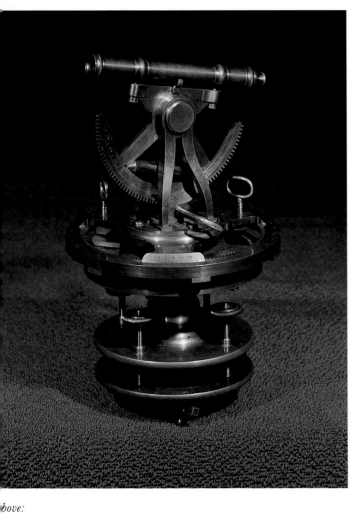

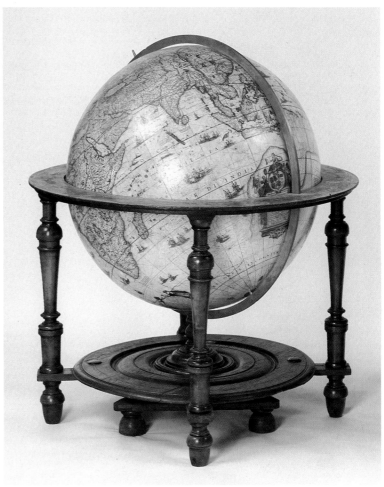

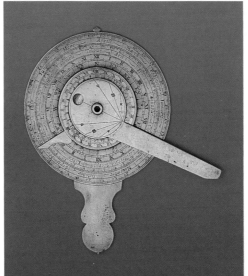

bove:
eorge II brass 'Cannon Barrel' theodolite
y J. Sisson, London
2 in. (30.5 cm.) high
old 12.12.85 in London
Christie's South Kensington for £15,000 ($21,278)

ight:
nglish brass nocturnal
earing monogram
1600
½ in. (8.9 cm.) diameter
old 17.10.85 in London
Christie's South Kensington for £10,000 ($14,085)

Above:
One of a pair of Dutch
terrestrial and celestial
globes
By Willem Janszoon
Blaeu
Dated 1622
26½ in. (67.7 cm.)
diameter
Sold 12.12.85 in
London for £48,600
($68,939)

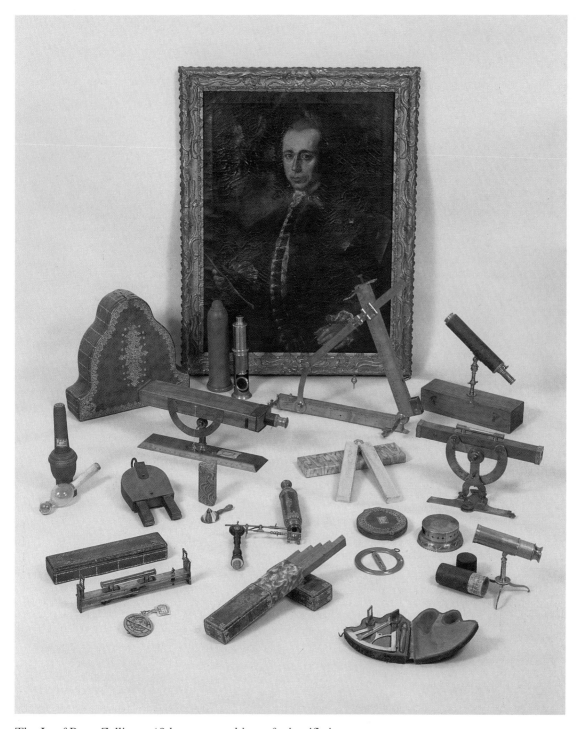

The Josef Peter Zallinger 18th century cabinet of scientific instruments
Mainly by Georg Friedrich Brander
Sold 17.4.86 in London at Christie's South Kensington for a total of £114,000 ($171,000)

Jewellery

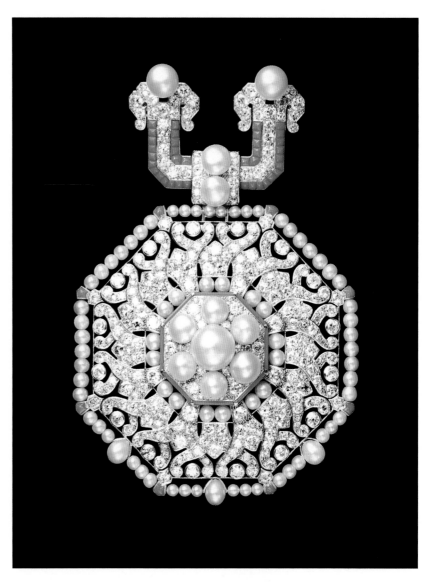

Art deco pearl, coral and diamond pendant brooch
Signed by Cartier
Sold 15.5.86 in Geneva for Sw.fr.154,000 (£55,000)

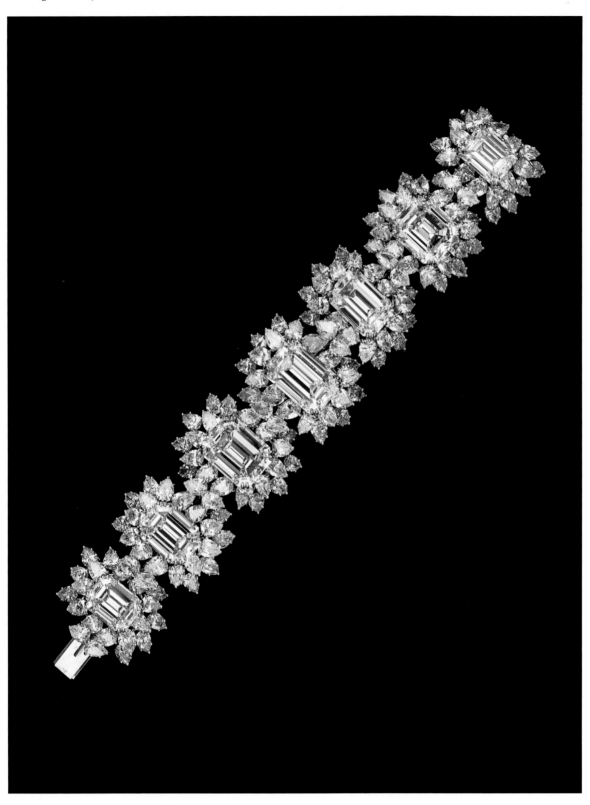

Diamond bracelet
composed of seven
rectangular diamonds
weighing a total of
92.20 carats
By Harry Winston
Five diamonds with
certificates by the
Gemological Institute of
America
Sold 14.11.85 in Geneva
for Sw.fr.2,915,000
(£946,428)

Diamond and fancy coloured
diamond necklace
Sold 22.10.85 in New York
for $528,000 (£367,330)
From the collection of
Mrs Madeleine Usher-Jones

Inset:
Fancy briolette diamond
pendant, the briolette of
60.80 carats
Sold 14.11.85 in Geneva for
Sw.fr.352,000 (£114,285)

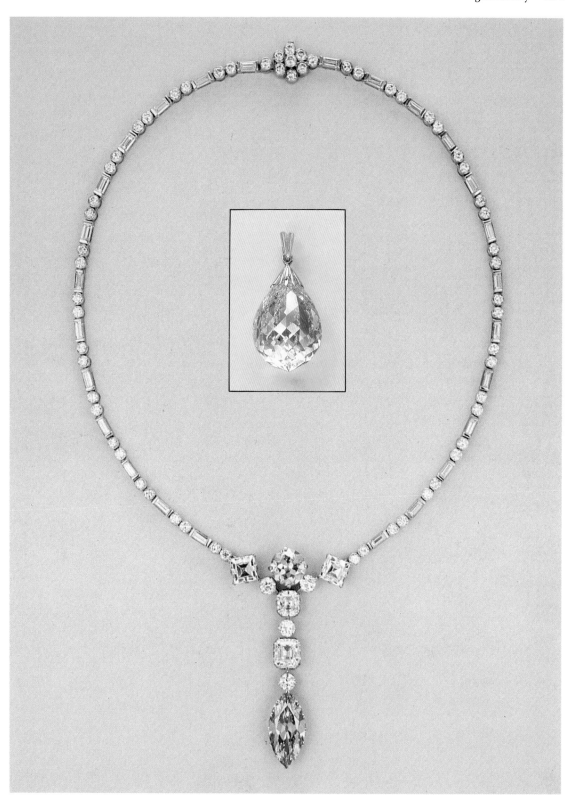

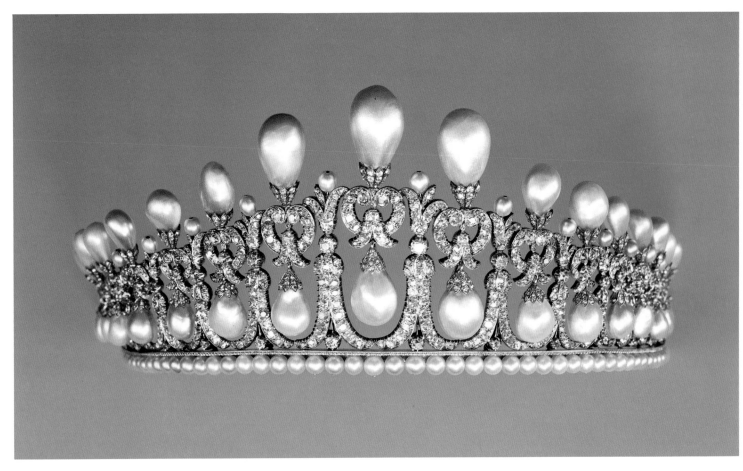

Antique pearl and diamond tiara
Sold 14.11.85 in Geneva for Sw.fr.462,000 (£150,000)

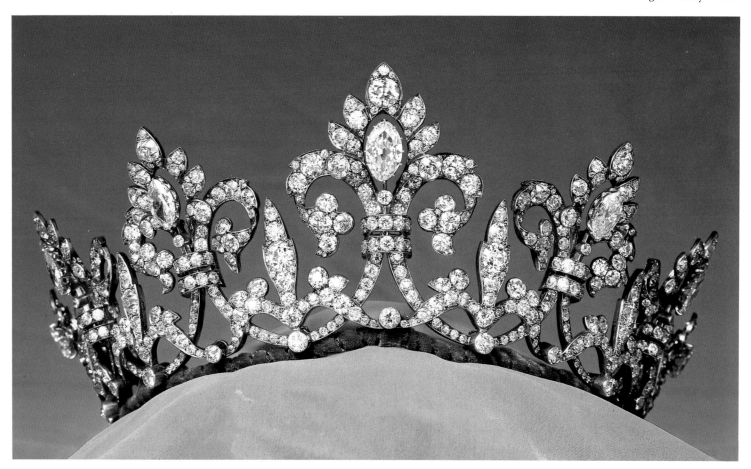

Diamond tiara, the 11 navette diamonds weighing a total of 39.79 carats
Sold 2.10.85 in London for £183,600 ($260,895)

Right:
Invisibly-set ruby ring
Signed by Van Cleef & Arpels
Sold 14.11.85 in Geneva for Sw.fr.22,000 (£7,143)

Right:
Invisibly-set sapphire ring
Signed by Van Cleef & Arpels
Sold 14.11.85 in Geneva for Sw.fr.20,900 (£6,786)

Far right:
Sapphire ring, the sapphire of 5.78 carats
With an expertise by Gübelin stating that the sapphire is
from Kashmir
Sold 14.11.85 in Geneva for Sw.fr.176,000 (£57,143)

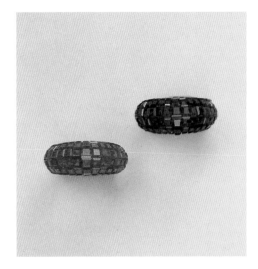
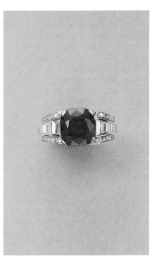

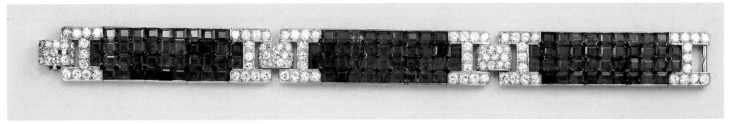

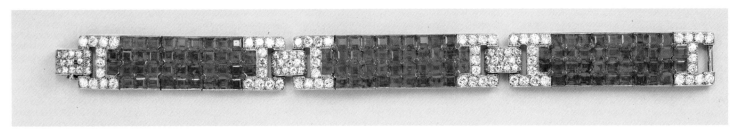

Above:
Sapphire and diamond bracelet
Signed by Cartier
Sold 14.11.85 in Geneva for Sw.fr.88,000 (£28,571)

Above:
Ruby and diamond bracelet
Signed by Cartier
Sold 14.11.85 in Geneva for Sw.fr.104,500 (£33,928)

Right:

THE KHEDIVE DIAMOND

Rectangular light yellow coloured diamond of 36.61 carats

Sold 15.5.86 in Geneva for Sw.fr.484,000 (£172,857)

The 'Khedive' derives its name from Ismail Pasha (1863–79), Viceroy or, from 1867, 'Khedive' of Egypt, who supposedly presented Empress Eugénie with this stone on the occasion of the opening of the Suez Canal in 1869. The actual offering of this important diamond is however not recorded by history and the 'Khedive' may therefore form part of a romantic tradition which surrounds so many notable diamonds of the world.

Far right:

Single stone diamond ring, the octagonal-cut diamond of 27.49 carats

With a gemological certificate stating that the diamond is colour D (colourless) and SI

Sold 15.4.86 in New York for $616,000 (£407,114)

From the estates of Dr and Mrs Jules C. Stein

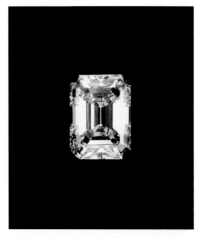
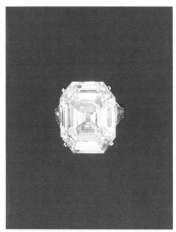

Right:

Pair of pendant diamond earrings, the pear-shaped diamonds of 11.66 and 12.28 carats

Sold 14.11.85 in Geneva for Sw.fr.418,000 (£135,714)

Far right:

Diamond ring, the navette-cut diamond of 24.88 carats

With a certificate from the Gemological Institute of America stating that the diamond is colour E and clarity VVS

Sold 14.11.85 in Geneva for Sw.fr.968,000 (£314,285)

By order of the estate of the late Sir Charles Clore

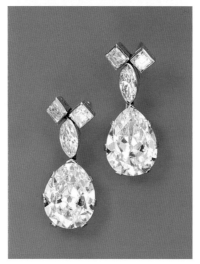
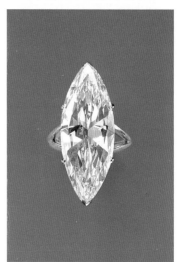

Right:

Sapphire and diamond ring, the sapphire of 38.46 carats

With an expertise by Gübelin stating that the sapphire is of Burmese origin

Sold 22.10.85 in New York for $418,000 (£290,803)

Far right:

Blue and white brilliant-cut diamond two-stone crossover ring, the blue diamond of 1.61 carats

Sold 11.6.86 in London for £32,400 ($49,896)

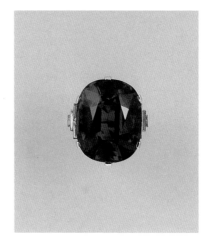
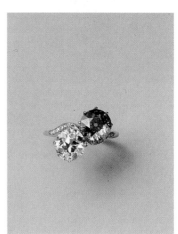

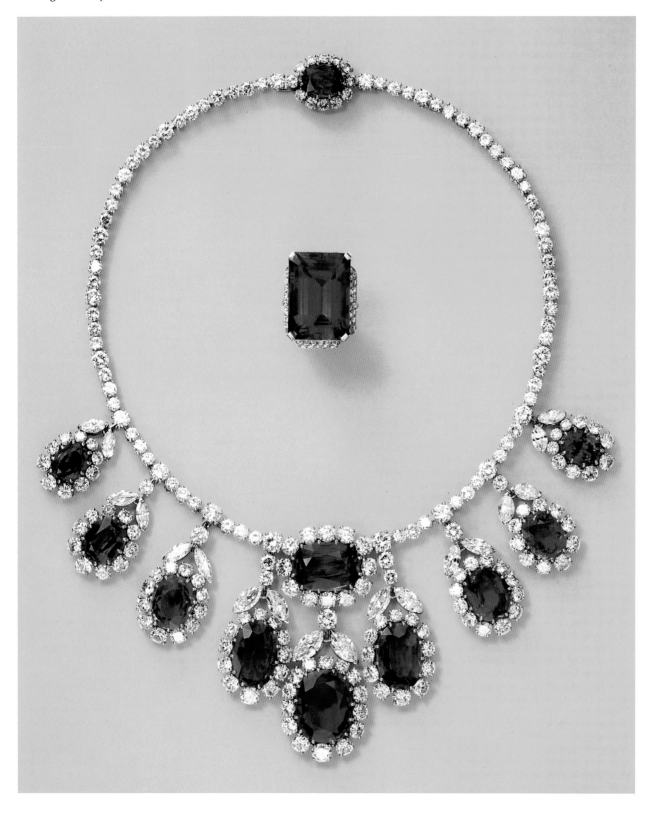

Cabochon sapphire and
diamond sautoir
Signed by Bulgari
Sold 14.11.85 in Geneva for
Sw.fr.220,000 (£71,428)

Opposite:
Sapphire and diamond
necklace
Sold 14.11.85 in Geneva for
Sw.fr.682,000 (£221,428)

Opposite inset:
Sapphire ring, the
rectangular sapphire of
50.80 carats
Sold 14.11.85 in Geneva for
Sw.fr.121,000 (£39,285)

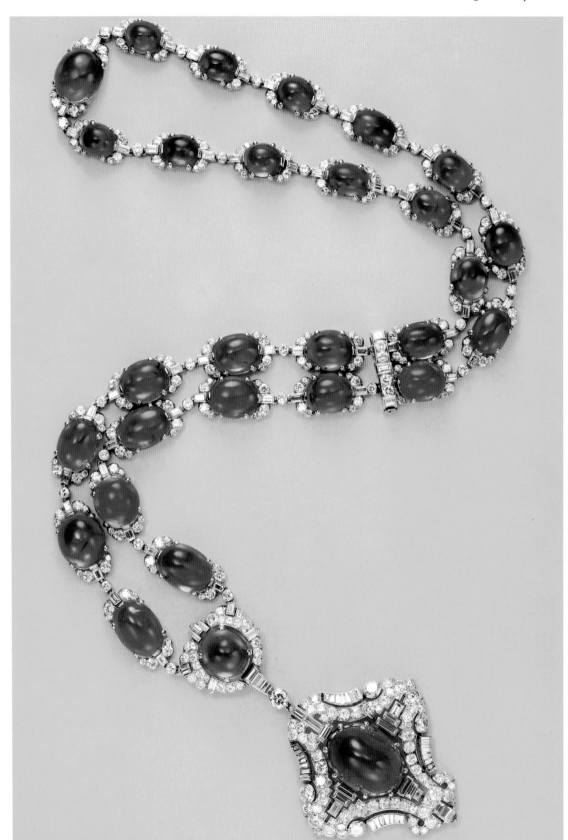

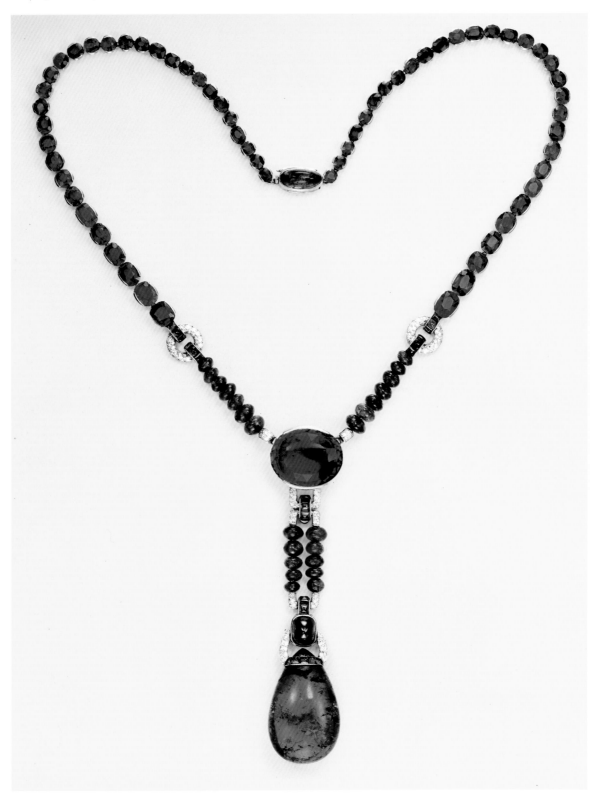

Art deco emerald,
sapphire and diamond
necklace
Signed by Cartier, made
in 1922
Sold 15.5.86 in Geneva
for Sw.fr.231,000
(£82,500)

Emerald and diamond
necklace
Sold 14.11.85 in
Geneva for
Sw.fr.1,650,000
(£535,714)

Inset:
Cut-cornered
rectangular emerald
and diamond ring,
the emerald of
22.69 carats
Sold 14.11.85 in
Geneva for
Sw.fr.418,000
(£135,714)

Right:
Pair of emerald and
diamond ear-
pendants, the pear-
shaped emeralds of
10.92 and 11.63 carats
Sold 14.11.85 in
Geneva for
Sw.fr.495,000
(£160,714)

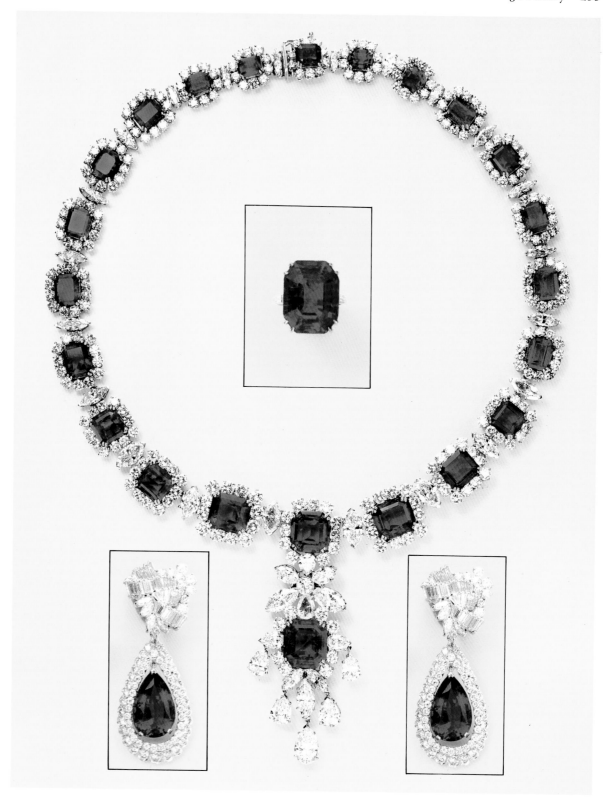

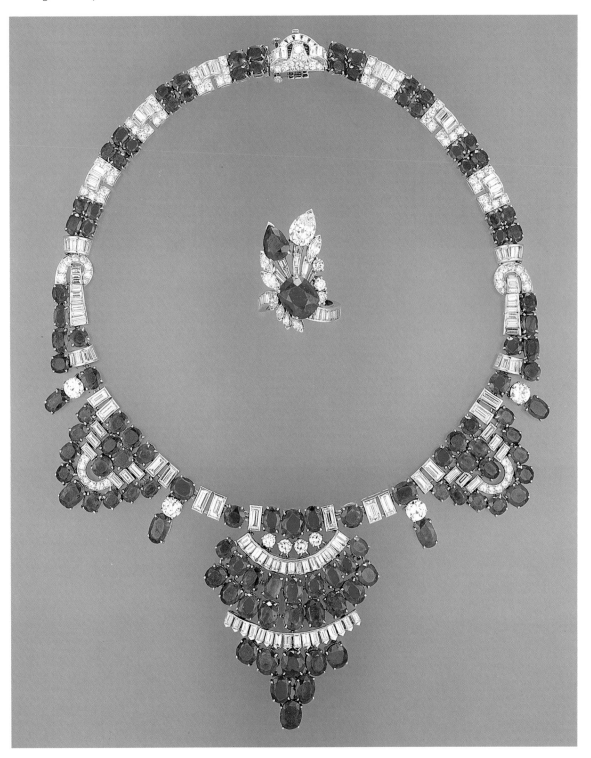

Ruby and diamond
necklace
Sold 15.4.86 in New York
for $132,000 (£87,239)
By order of the estate of
Jane Erdmann Whitney

Inset:
Ruby and diamond ring
Sold 15.4.86 in New York
for $143,000 (£94,509)
By order of the estate of
Jane Erdmann Whitney

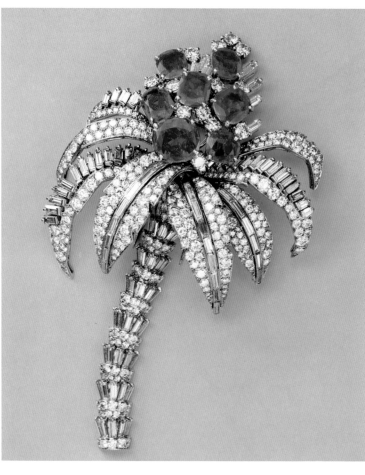

Ruby and diamond palm tree clip brooch
Signed by Cartier
Designed in 1957 by Georges Remy from an idea
by Jeanne Toussaint
With an expertise by Gübelin stating that the
rubies are from Burma
Sold 15.5.86 in Geneva for Sw.fr.770,000
(£275,000)

Ruby and diamond brooch
With an expertise by Gübelin stating that the rubies are
from Burma
Sold 15.5.86 in Geneva for Sw.fr.990,000 (£353,572)

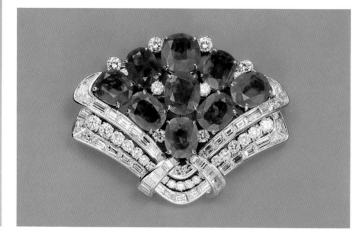

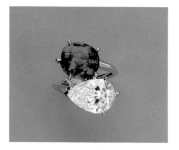

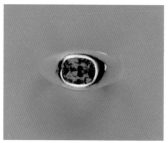

Ruby and diamond
crossover ring, the cushion-
shaped ruby of 5.65 carats
and the pear-shaped
diamond of 3.70 carats
With an expertise by
Gübelin stating that the
ruby is from Burma
Sold 15.5.86 in Geneva for
Sw.fr.253,000 (£90,358)

Ruby single-stone ring, the
ruby of 3.74 carats
With an expertise by
Gübelin stating that the
ruby is from Burma
Sold 15.5.86 in Geneva for
Sw.fr.154,000 (£55,000)

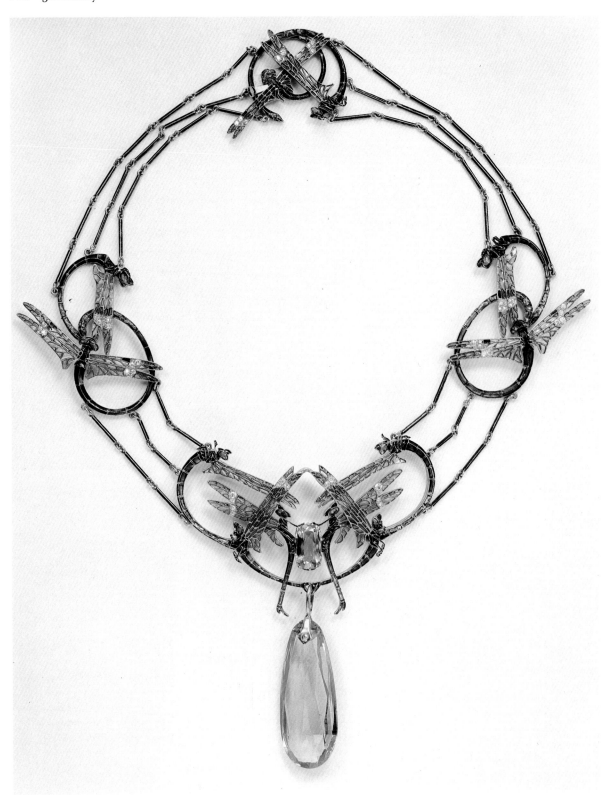

Art nouveau enamel,
aquamarine and
diamond necklace
Signed by Lalique
Sold 15.5.86 in
Geneva for
Sw.fr.231,000
(£82,500)

Art deco diamond and crystal bangle
Signed by Cartier
Sold 15.5.86 in Geneva for Sw.fr.71,500 (£25,536)

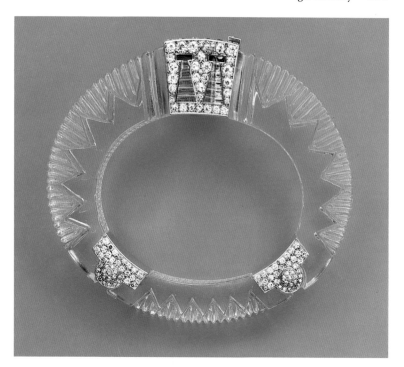

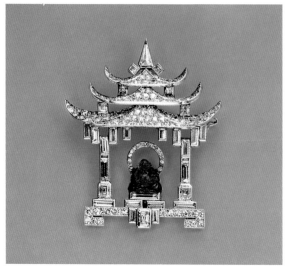

Art deco emerald and diamond brooch
Signed by Janesich
Sold 15.5.86 in Geneva for Sw.fr.27,500
(£9,822)

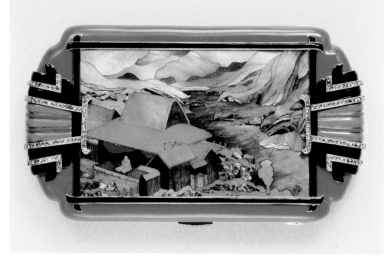

Art deco gem-set enamelled gold vanity case
The case signed by Linzeler-Marchak
The plaque signed by Vladimir Makovsky
Sold 15.5.86 in Geneva for Sw.fr.104,500 (£37,322)

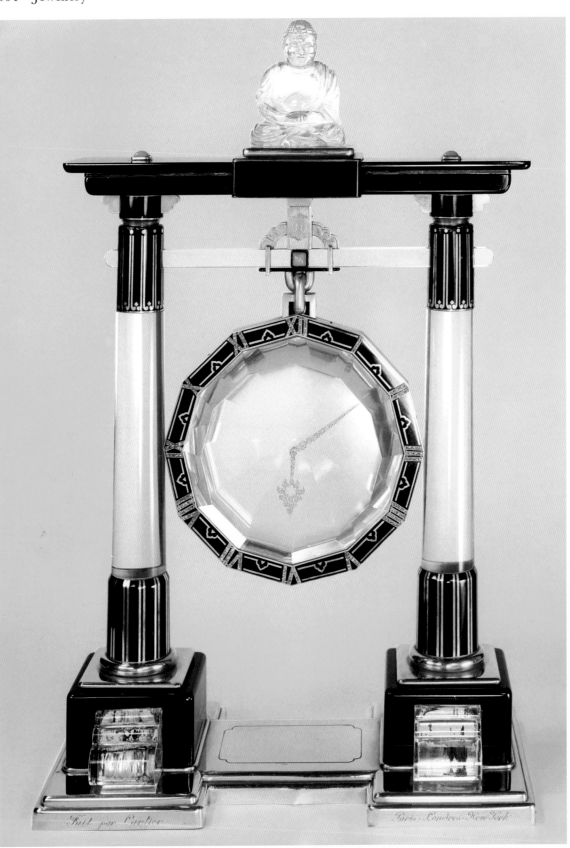

Rock crystal, onyx and agate Temple Gate mystery clock
Signed by Cartier, Paris
Sold 14.11.85 in Geneva for Sw.fr.825,000 (£267,857)
Between 1923 and 1925 Cartier's created six 'Portico' clocks which represent the quintessential solution to the problems which mystery clocks posed. In this series the dials are suspended from the roof where the mechanism is cleverly concealed in a minute part of the central section.
The present model dates from 1924.

Silver

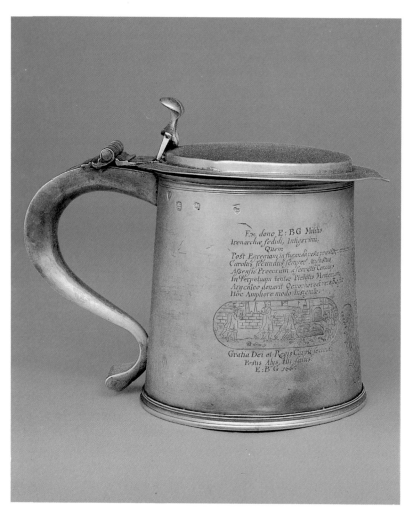

Charles II tankard and cover engraved with scenes of the Plague and
Fire of London
London, 1675
Maker's mark IN with mullet below
7³⁄₄ in. (19.8 cm.) high
Sold 27.11.85 in London for £59,400 ($86,991)

An Elizabethan Rarity

CHRISTOPHER HARTOP

One of the most fascinating aspects of the auction business is the opportunity, presented from time to time, to trace an object's previous appearances on the auction block. When the Elizabethan tankard illustrated opposite appeared recently from the collection of the late Mrs C.J. Devine of New York City, it was discovered to be no stranger to Christie's, having been sold twice before, both in times of war, in 1917 and 1942. On these two appearances, however, the tankard was accompanied by a replica made by Ambrose Stephenson in 1708. The present whereabouts of the replica is unknown.

The base of the Devine tankard is engraved 'A Legacy left M.M. by N.S. Minister deceased 1680', while the base of the replica was engraved 'The value of this left E.M. by Lady E.B. as a Legacy'. Both these inscriptions doubtless refer to members of the Morris family of Loddington, Leicestershire, the original vendors. John Morris of London, upholsterer, had purchased the Loddington estate in the 1670s. His son, Charles Morris, married Susanna, second daughter of Sir Edmund Bacon, Bt., of Redgrave, Suffolk, and the 'E.M.' engraved on the replica probably refers to Edmund Morris their son, who was MP for Leicestershire in 1722 and Sheriff of the county in 1746. 'Lady E.B.' is probably his maternal grandmother, the widow of Sir Edmund Bacon. The 'M.M.' engraved on the Devine tankard may well refer to another child of Charles and Susanna Morris.

Far more noteworthy, though, is the extremely unusual form of the tankards, and the fact that they are engraved with bands to simulate the staves and hoops of a barrel. A 1589 inventory of the Master's plate at Peterhouse, Cambridge, refers to similarly decorated tankards:

Item a tankard barred lipt and covered	v ounces	xxiiij s ij d
Item a white horn tankard with a cover, barres and lipt double gilt	vi ounces	xxi s

While the form of the Morris tankards owes its inspiration to stoneware and leather drinking vessels, the decoration is reminiscent of the wooden tankards that must have been the most common type of vessel during the 16th century. Obviously, hardly any have survived, but an example recently salvaged from the wreck of the *Mary Rose*, sunk off Portsmouth in 1544, not only shows the inspiration for the engraved bands and hoops on the Morris tankards, but also has an identical pointed cover with a distinctive long hinge held in place with a pin – a type of hinge that continued to be used for tankards until the 19th century.

From both ends of the social scale, the *Mary Rose* wooden tankard and the Devine silver example remain for us today as rare survivals of utilitarian articles that must once have been commonplace.

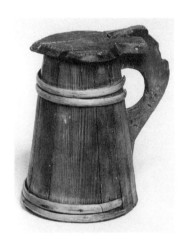

Tankard recently salvaged
from the wreck of the
Mary Rose, sunk off
Portsmouth in 1544.

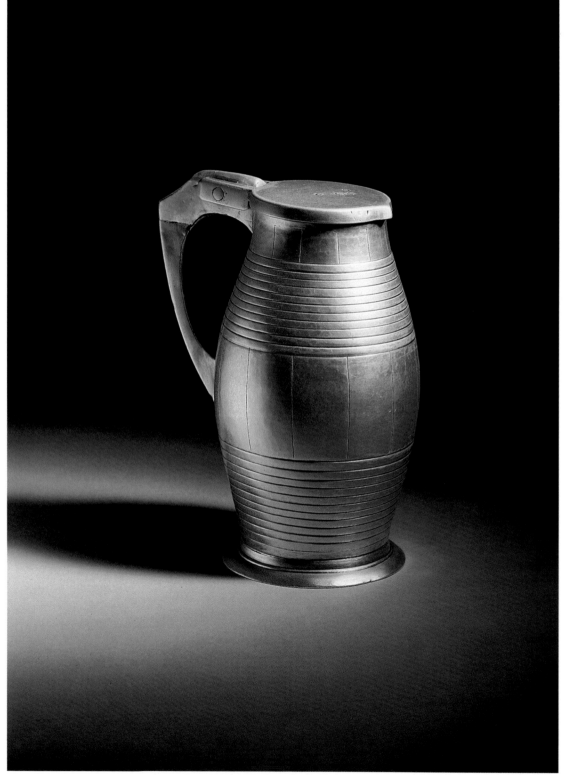

Elizabeth I tankard
London, 1597
Maker's mark TE in
monogram
7¼ in. (18.5 cm.) high
Sold 15.10.85 in New York
for $44,000 (£30,769)

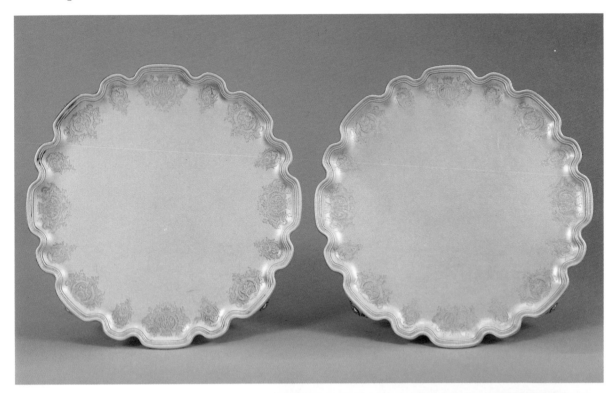

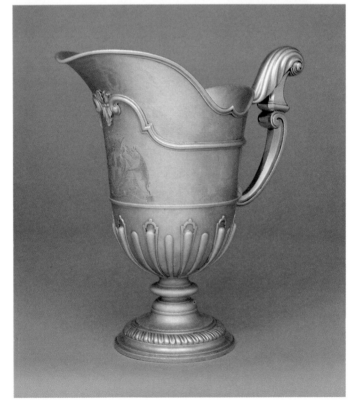

Above:
Pair of George II shaped-circular salvers
By David Willaume II
London, 1743
13¼ in. (33.9 cm.) diameter
Sold 9.7.86 in London for £56,160
($87,048)
Previously sold at Christie's 20.4.21 for
£274. 12s. 5d.

Right:
George II helmet-shaped ewer
By David Willaume II
London, 1742
10½ in. (26.8 cm.) high
Sold 9.7.86 in London for £45,360
($70,308)

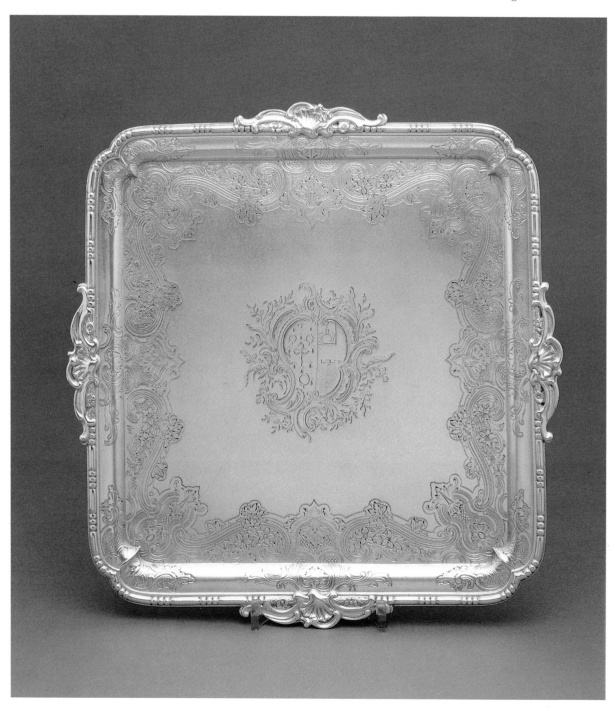

One of a pair of George II square salvers
By Paul de Lamerie
London, 1747
11½ in. (29 cm.) square
Sold 13.5.86 in Geneva for Sw.fr.198,000 (£70,967)

A Royal Puzzle

ANTHONY PHILLIPS

Detailed research into the history of an important piece of English silver often raises as many questions as it answers. Until it surfaced in Arizona in 1985, the whereabouts of this magnificent Queen Anne sideboard-dish by John Bache, London, 1702, had been unknown since its last public appearance in the historic J.P. Morgan sale in 1947. The dish is engraved in the centre with the arms of Robert Bertie, Earl of Lindsey (1660–1723), and with those of his first wife, Mary, daughter and heir of Sir Richard Wynn, 4th Baronet, in pretence. He succeeded his father as Earl of Lindsey and Hereditary Lord Great Chamberlain on 8 May 1701. Bishop Burnet described him as 'a fine gentleman, hath both wit and learning'. Dean Swift felt otherwise, for in his copy of Burnet's *Works*, he wrote in the margin, 'I never observed a grain of either'.

The dish itself raises a number of questions. The inclusion of lyres in the *repousse* band is an unusual feature, but it is found in the contemporary designs of Daniel Marot among others. Unfortunately, it has not as yet been possible to find the source of the designs for the ornament as a whole. The size and decoration of the dish suggest that it was a 'perk' of office presented to Lord Lindsey, who as Hereditary Lord Great Chamberlain had an important role in the coronation of Queen Anne on 23 April 1702. Indeed, research by Arthur Grimwade established that Lord Lindsey did indeed receive two such dishes and a ewer. The Earl of Exeter is also listed as being given a dish of similar weight for his part in the ceremony.

Until the discovery of the Lindsey dish it had been assumed that the Exeter coronation dish was possibly a sideboard-dish by Pierre Harache, London, 1702. However, there is at Burghley another dish with the maker's mark only of George Garthorne, also engraved with the Royal Arms. This dish was thought to date from *c.*1690 and to be later engraved with the arms and cypher of Queen Anne. However, as Arthur Grimwade has pointed out, the maker's mark is that used by Garthorne during the Britannia Standard period (i.e. after 1697). There seems no reason, then, to doubt that the Garthorne dish was made and engraved in 1702 for the coronation of Queen Anne, particularly as the Lindsey and Garthorne dishes are similar in size and weight, and *repousse* and chased with almost identical lyres, roses, thistles and scrolls.

While the Lindsey dish then helps to identify the Garthorne dish as being indeed the Exeter coronation dish, there are a number of anomalies concerning the Lindsey dish itself that are difficult to explain. Firstly, it is engraved with the Lindsey arms and not Royal Arms as to be expected. Secondly, it is fully hallmarked for 1702. Not only is it unusual for Royal dishes of this type to be fully hallmarked rather than unmarked or with maker's mark only, it is also odd that it is not by a Royal goldsmith and that it is marked with the 1702/3 date letter. As has been said, Queen Anne's coronation was held on 23 April and the 1702/3 date letter was implemented over a month later on 29 May. That there was some delay in Lord Lindsey receiving one of his perks of office is confirmed by a letter he wrote to William Cavendish, first Duke of Devonshire:

18 May 1702, Red Lyon Square
The Lords Commissioners for the Court of Claims having allowed my claim and not having as yet received the two towells with which Her Majesty washed her hands in Westminster Hall on the day of her coronation, I desire your Grace will be pleased to give order for the delivery of them to this bearer who is appointed by me to receive them.

It would seem likely that if he had not received the far more valuable dishes and ewer by this time he would have made reference to this fact.

Perhaps the most likely explanation for these various anomalies is that the present dish was a copy of the same size and weight ordered from Bache because either one of the originals was lost or stolen or Lindsey wanted another displaying his arms. Perhaps one day a document, or better still one of the original dishes, will come to light finally to explain the intriguing history of this remarkable piece of Queen Anne silver-gilt.

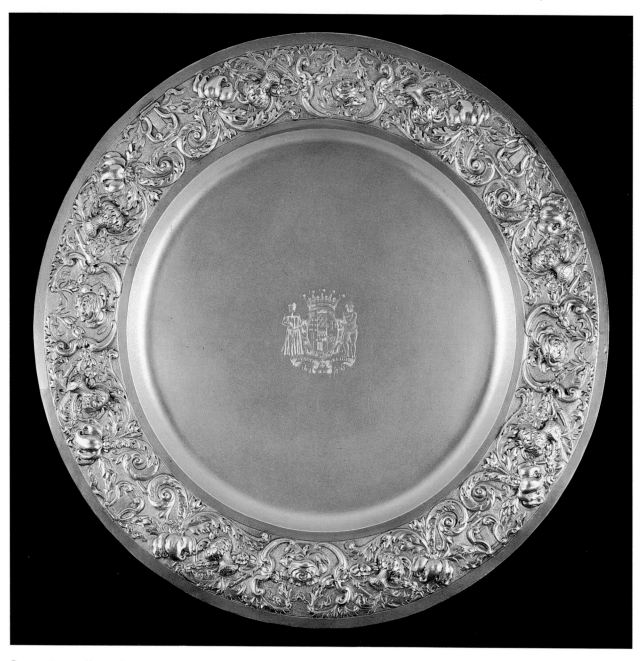

Queen Anne silver-gilt
sideboard-dish
By John Bache
London, 1702
Marked on the underside of rim, maker's mark struck twice
25 in. (64 cm.) diameter
Sold 15/16.10.85 in New
York for $90,200 (£64,018)

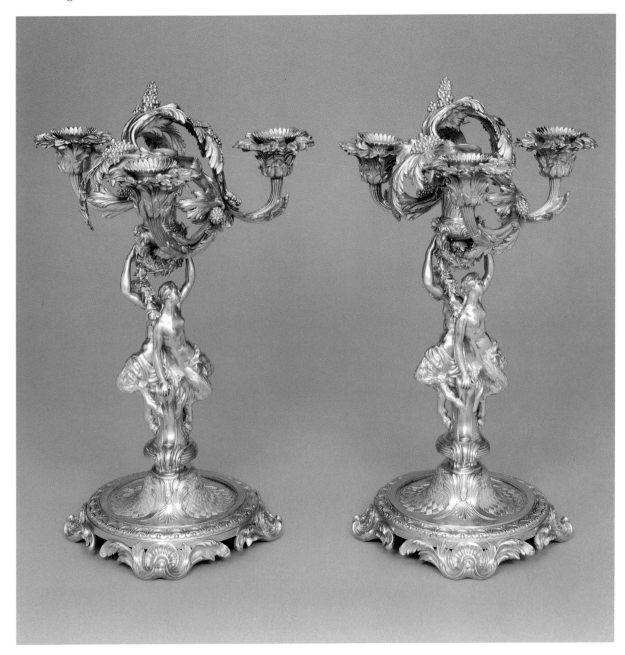

Pair of George III three-light candelabra
By Paul Storr
London, 1816
16¾ in. (42.6 cm.) high
Sold 19.3.86 in London for £91,800 ($135,090)

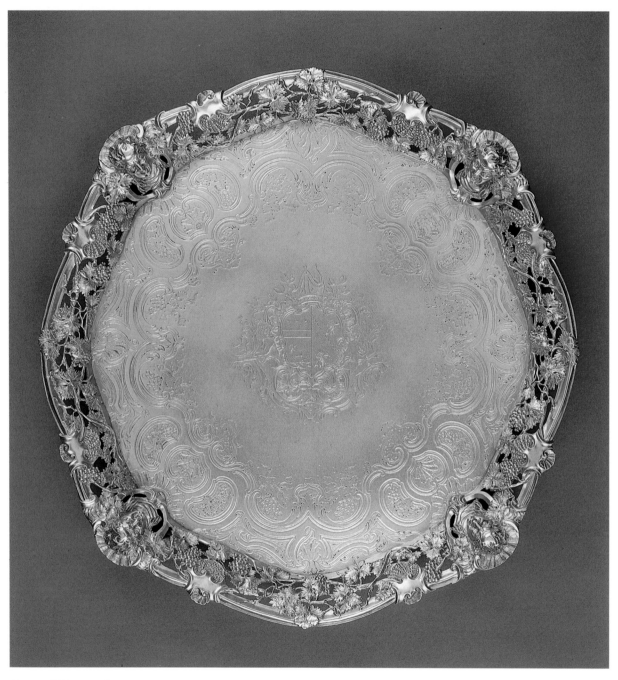

George II large salver
By Paul de Lamerie
London, 1745
18 in. (46 cm.) diameter
Sold 13.5.86 in Geneva for Sw.fr.308,000 (£110,394)

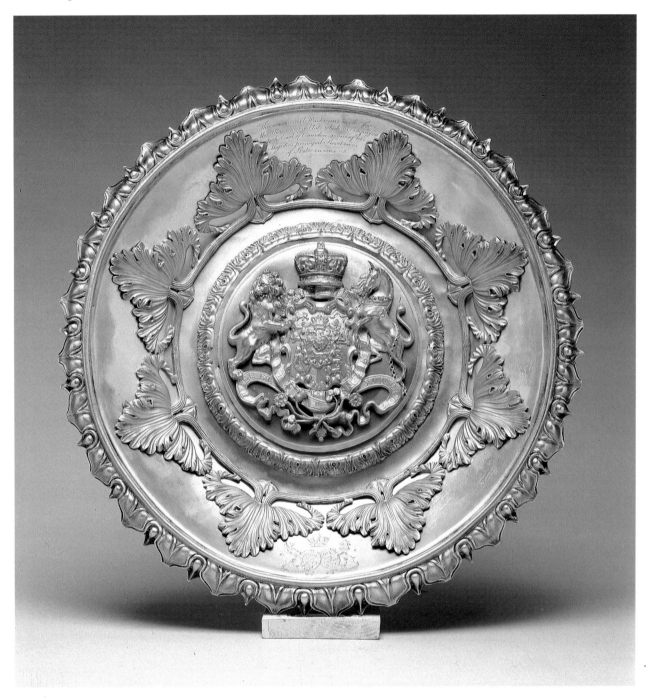

One of a pair of George III sideboard-dishes
By William Fountain
London, 1805
21½ in. (55 cm.) diameter
Sold 29.4.86 in New York for $93,500 (£60,597)
By order of the estate of Thomas J. Kelley

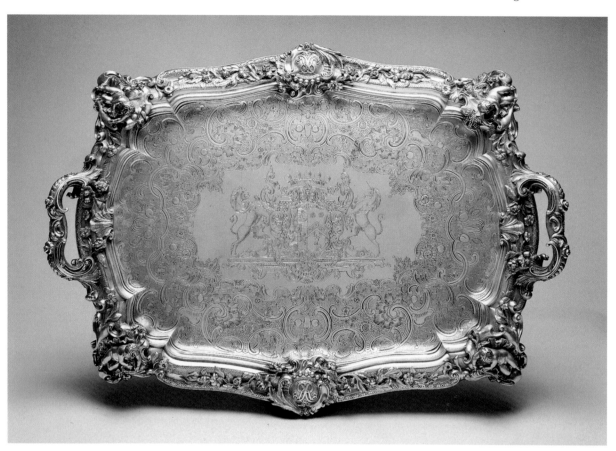

William IV tea-tray
By Robert Garrard
London, 1835
Stamped 'GARRARDS Panton Street, London'
32 in. (81 cm.) long
Sold 29.4.86 in New York for $46,200 (£29,942)

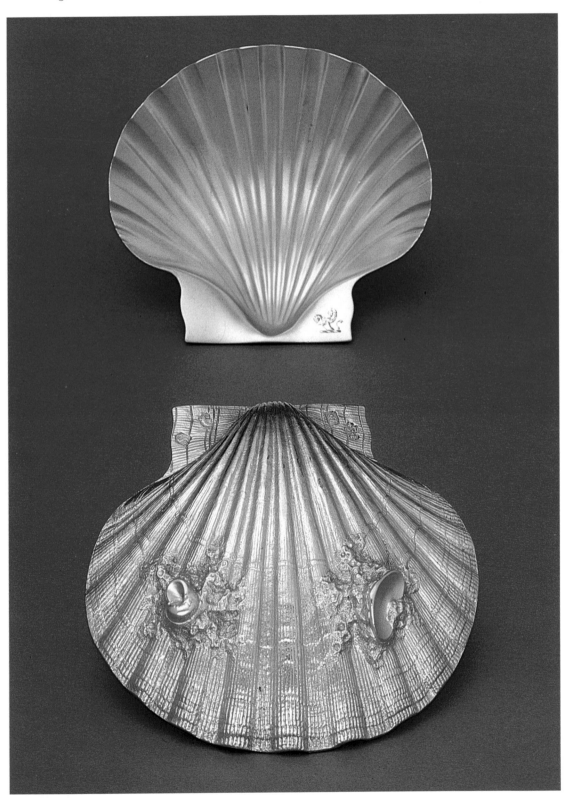

One of two pairs of George II
escallop shell dishes
By Paul de Lamerie
London, 1733
4¾ in. (12.5 cm.) wide
Sold 13.5.86 in Geneva for
Sw.fr.165,000 (£59,139)

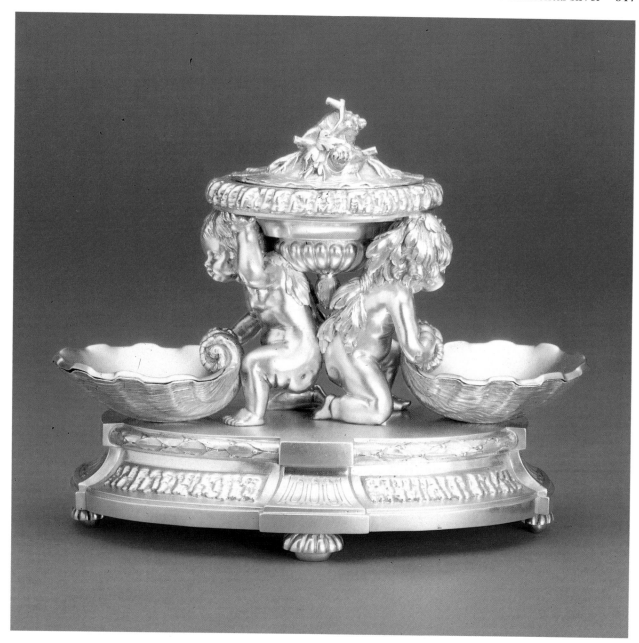

One of a pair of Louis XV double salt-cellars
By Robert-Joseph Auguste
Paris, 1768
With the charge of Jean-Jacques Prévost and the décharge of Julien Alaterre
8¾ in. (22 cm.) long; 7½ in. (19 cm.) high
Sold 13.5.86 in Geneva for Sw.fr.715,000 (£256,272)

Silver-gilt cup and cover on
circular foot
By Cornelius van Dijk
Delft, *c.*1730
9½ in. (24 cm.) high
Sold 22.10.85 in Amsterdam for
D.fl.92,800 (£21,582)

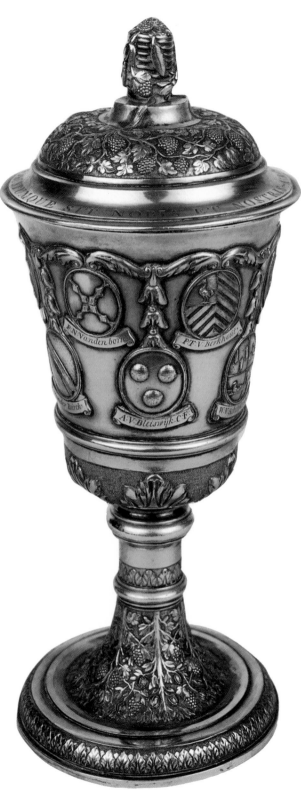

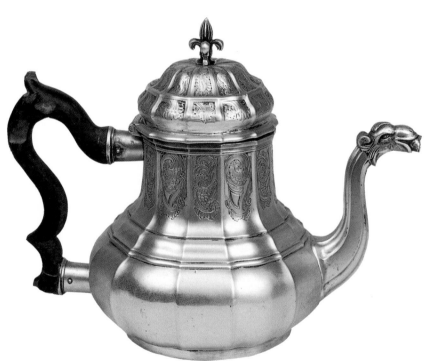

Circular pear-shaped teapot
By Guillaume Gaspar Velez
Liège, 1744
7 in. (18 cm.) high
Sold 4.6.86 in Amsterdam for
D.fl.52,200 (£13,736)

Documentary German
historicist silver-gilt
ceremonial horn
By Reinhold Vasters
Aachen, *c.*1875
Unmarked
30 in. (76 cm.) long
Sold 19.4.86 in New York for
$88,000 (£57,032)

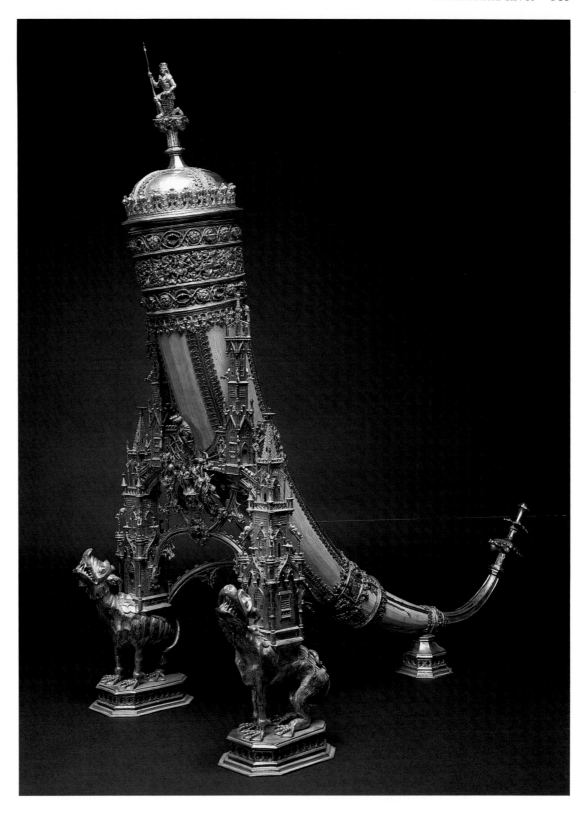

George I silver-gilt fifteen-sided salver
By Augustin Courtauld
London, 1723
11¼ in. (28.6 cm.) wide
Sold 28.11.85 in London for £30,240 ($44,287)
From the collection of the late Sir Charles Clore

Objects of Art and Vertu

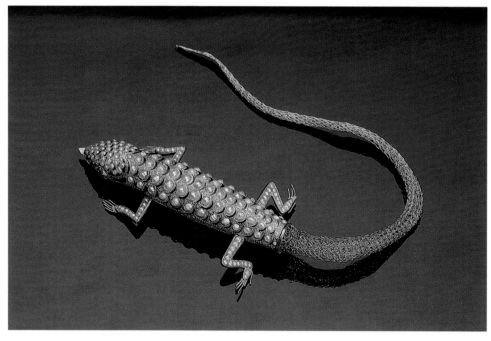

Swiss gold and pearl-set automaton in the form of a lizard
*c.*1815
7 ½ in. (19 cm.) long
Sold 14.5.86 in Geneva for Sw.fr.77,000 (£27,697)

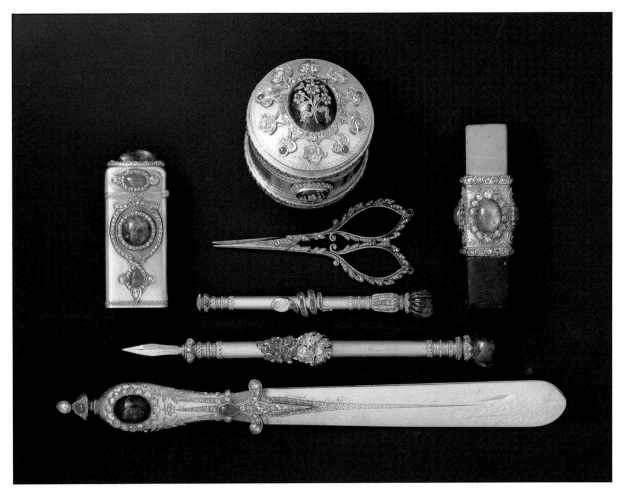

French elaborate jewelled gold desk-set
*c.*1840
Sold 19.3.86 in London for £28,080 ($41,320)
By order of the Executors of the late Major the Hon. Sir Francis Legh, K.C.V.O.

Viennese silver-gilt and
enamel centre-piece
Late 19th century
25 1/2 in. (65 cm.) high
Sold 9.7.86 in London for
£45,360 ($68,040)

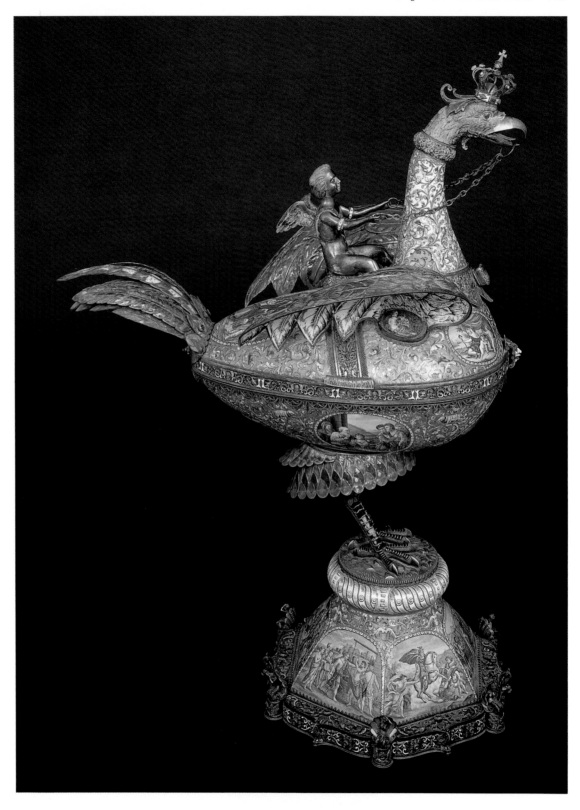

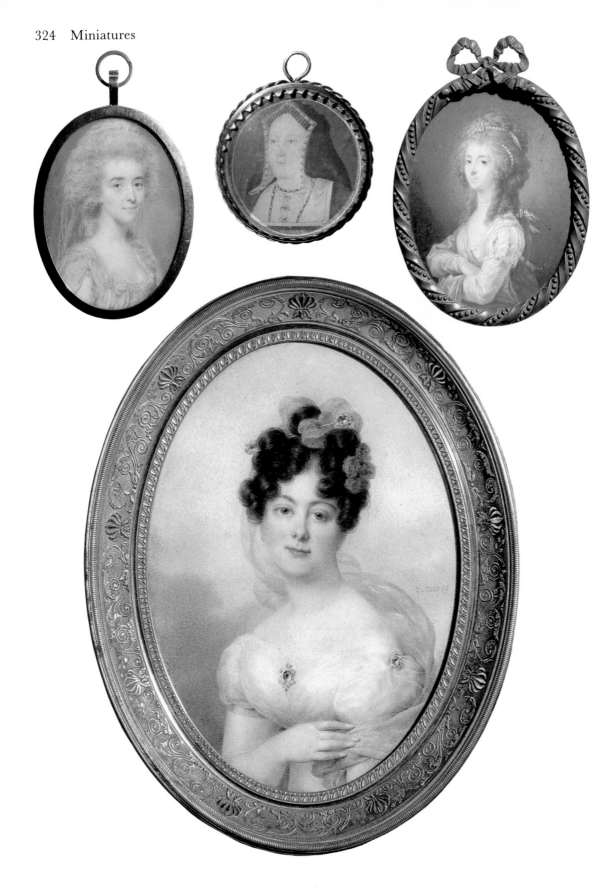

Far left:
JOHN SMART
A Lady
Signed with initials and dated 1786, I for India
Oval, 1⅞ in. (4.8 cm.) high
Sold 9.7.86 in London for £5,400 ($8,100)

Left centre:
LUCAS HORENBOUT
(HORNEBOLTE)
Catherine of Aragon
On vellum
1½ in. (3.9 cm.) diameter
Sold 9.7.86 in London for £10,800 ($16,200)

Above:
HEINRICH FRIEDRICH FÜGER
Christiane Lichnowsky (née Thun)
Oval, 3 in. (7.5 cm.) high
Sold 27.11.85 in London for £9,720 ($14,235)

Left:
JEAN BAPTISTE ISABEY
A Lady
Signed
On card
Oval, 5⅛ in. (13 cm.) high
Sold 9.7.86 in London for £6,696 ($10,044)
By order of the Trustees of the Harewood Charitable Trust

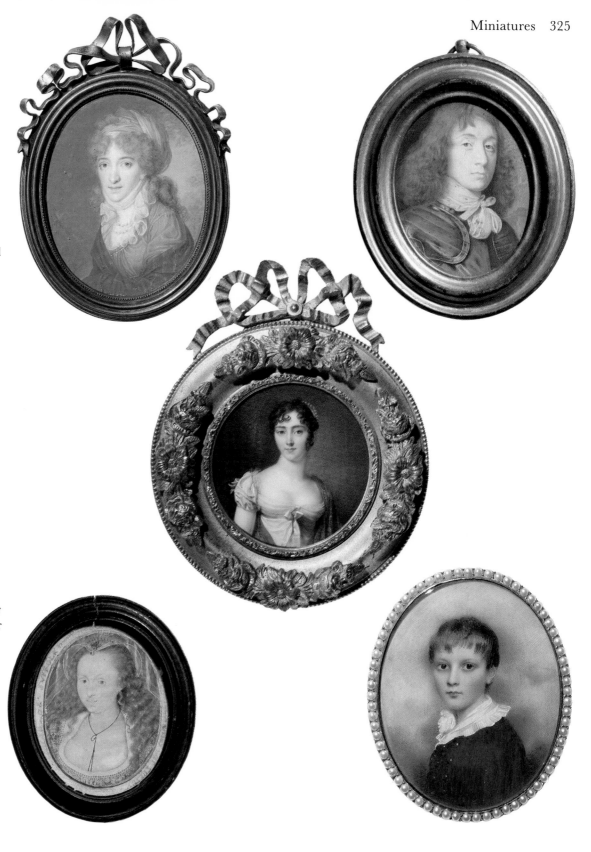

Right:
FRANZ GERHARD VON
KUEGELGEN
Empress Elizabeth Alexandria of Russia
Signed and dated 1799
Oval, 3 in. (7.5 cm.) high
Sold 9.7.86 in London for
£4,860 ($7,290)

Far right:
JOHN HOSKINS
A Gentleman
Signed with initials and dated 1657
On vellum
Oval, 2½ in. (6.4 cm.) high
Sold 27.11.85 in London for
£4,356 ($6,380)

Right centre:
JEAN BAPTISTE JACQUES
AUGUSTIN
Baroness George Axel Adelsward
Signed and dated Paris 1810
2½ in. (6.4 cm.) diameter
Sold 19.3.86 in London for
£5,400 ($7,947)

Right:
ISAAC OLIVER
A Lady called Elizabeth, Lady Willoughby D'Eresby
Vellum stuck to card which has been attached to a larger vellum oval, inscribed 'Catherine, Lady Willoughby of Eresby Dutchesse Dowager of Suffolk'
Oval, 2⅛ in. (5.4 cm.) high
Sold 27.11.85 in London for
£4,320 ($6,327)

Far right:
ANDREW PLIMER
Master James Parke
Oval, 3 in. (7.5 cm.) high
Sold 27.11.85 in London for
£4,356 ($6,380)

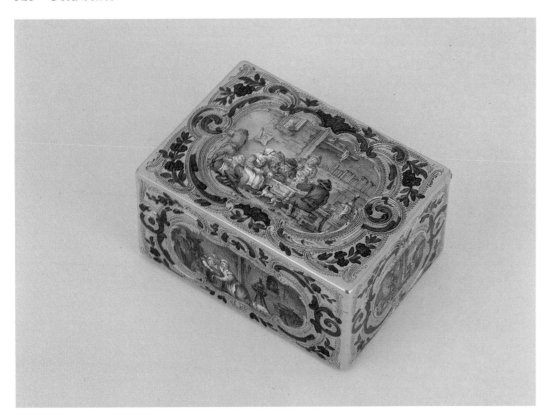

Louis XV gold and enamel
snuff-box
By Jean Formey, Paris, 1756–7,
with the charge and décharge of
Eloy Brichard, the enamel by
Mlle Duplessis
2⅞ in. (7.3 cm.) long
Sold 14.5.86 in Geneva for
Sw.fr.220,000 (£79,136)

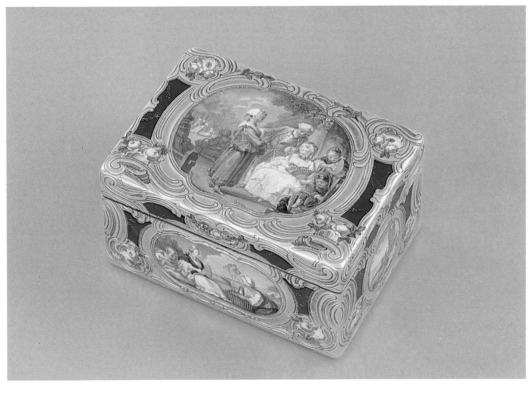

Louis XV snuff-box
By Jean Frémin, Paris, 1760–1,
with the charge and décharge of
Eloy Brichard and the
countermark of Jean-Jacques
Prévost, the enamel by Le Sueur
2¾ in. (7 cm.) long
Sold 12.11.85 in Geneva for
Sw.fr.352,000 (£115,409)

Louis XV gold and enamel
snuff-box
By Jean Moynat, Paris, 1749–50,
with the charge of Antoine
Leschaudel and the décharge of
Julien Berthe, the enamel
probably by Louis-François
Aubert
3 in. (7.6 cm.) long
Sold 12.11.85 in Geneva for
Sw.fr.286,000 (£93,770)

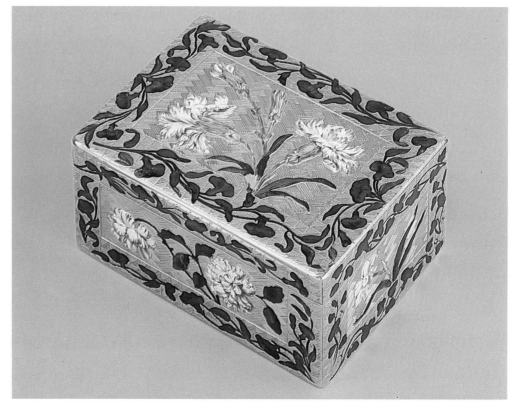

Louis XV gold and enamel
snuff-box
By Jean Moynat, Paris, 1745–6,
with the charge and décharge of
Antoine Leschaudel, the enamel
probably by Louis-François
Aubert
3 1/4 in. (8 cm.) long
Sold 12.11.85 in Geneva for
Sw.fr.220,000 (£72,131)
From the collection of the late
Baron Gustave de Rothschild

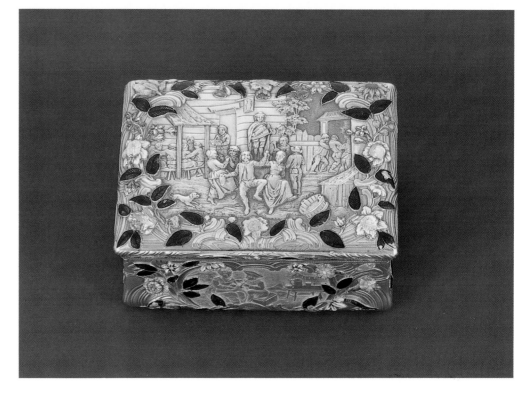

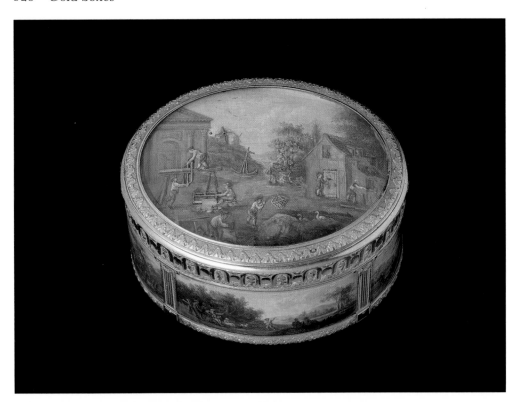

Louis XV gold automaton snuff-box
set with miniatures under glass
By Jean-François Garand, Paris,
1770–3, with the charge of Julien
Alaterre and the décharge of Jean-
Baptiste Fouache
3¼ in. (8 cm.) long
Sold 12.11.85 in Geneva for
Sw.fr.242,000 (£79,344)

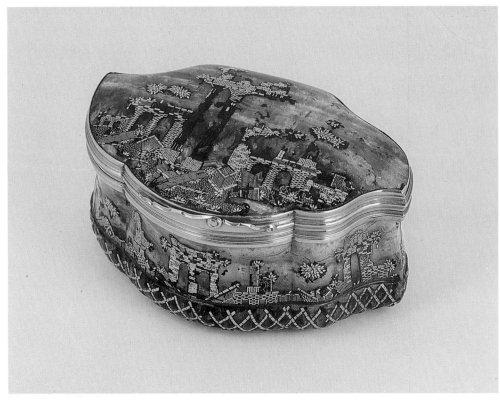

Frederick-Augustus III gold and
amethystine quartz snuff-box
Dresden, c.1750
4 in. (10 cm.) long
Sold 14.5.86 in Geneva for
Sw.fr.63,800 (£22,950)

George II gold snuff-box
By Francis Harache, London, 1746
2 ¾ in. (7 cm.) wide
Sold 14.5.86 in Geneva for
Sw.fr.12,000 (£4,317)

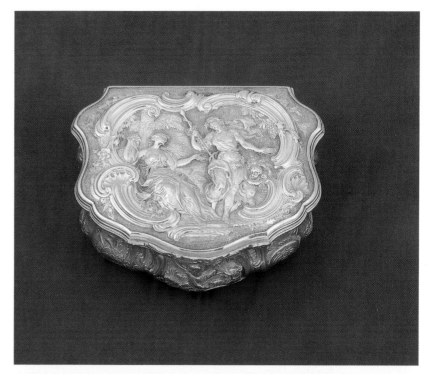

Charles II cylindrical gold
counter-case
*c.*1685
1 ⅜ in. (3.5 cm.)
Sold 19.3.86 in London for £8,640
($12,714)

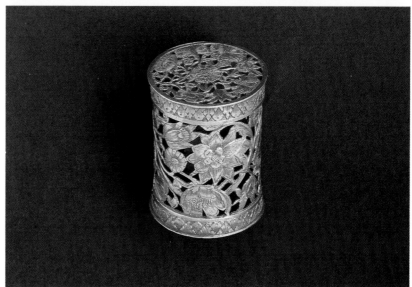

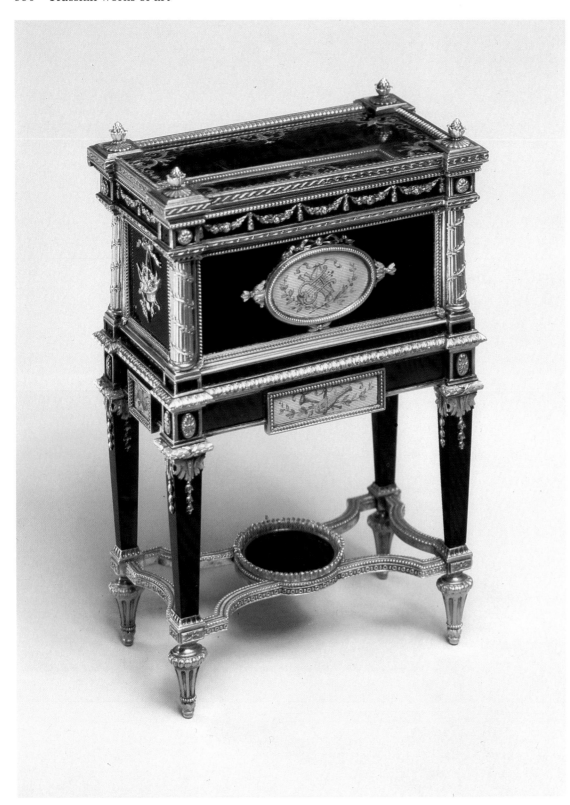

Guilloché enamel vari-colour gold mounted agate miniature replica of a Louis XVI *secretaire á abattant* Marked Fabergé, workmaster Michael Perchin, St. Petersburg, 1896–1908 5¼ in. (13.2 cm.) high Sold 13.11.85 in Geneva for Sw.fr.605,000 (£197,712) From the collection of the late Sir Charles Clore

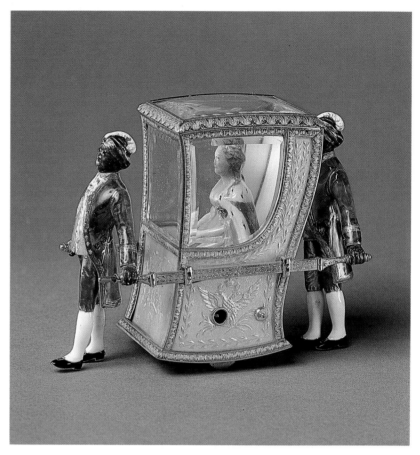

Jewelled, guilloché enamel two-colour gold automaton sedan chair with a
figure of Catherine the Great borne by two liveried servants
Marked Fabergé, workmaster Henrik Wigström, St. Petersburg,
1908–17
3¼ in. (8.1 cm.) long; 2¾ in. (7 cm.) high; 1¾ in. (4.1 cm.) diameter
Sold 13.11.85 in Geneva for Sw.fr.1,430,000 (£417,320)
From the collection of the late Sir Charles Clore

Hardstone figure of John Bull
Marked Fabergé, workmaster Henrik Wigström,
St. Petersburg, 1896–1908
4¾ in. (12 cm.) high
Sold 13.11.85 in Geneva for Sw.fr.154,000 (£50,326)
From the collection of the late Sir Charles Clore

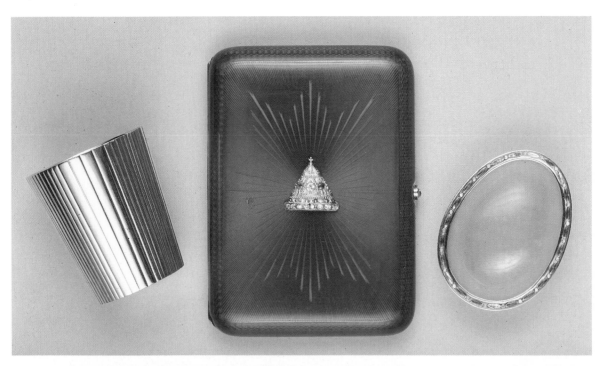

Far left:
Two-colour gold vodka bea
Marked with initials of Alf
Thielemann, St. Petersbur
*c.*1880
1⅞ in. (4.7 cm.) high
Sold 6.3.86 in London for
£3,024 ($4,365)

Centre:
Guilloché enamel cigarette-c
Marked Fabergé, workmas
August Hollming,
St. Petersburg, 1908–17
3¾ in. (9.5 cm.)
Sold 6.3.86 in London for
£10,800 ($15,590)

Left:
Enamel bowenite bowl
Marked with initials of
Michael Perchin,
St. Petersburg, *c.*1800
2⅛ in. (5.5 cm.) long
Sold 6.3.86 in London for
£2,592 ($3,742)

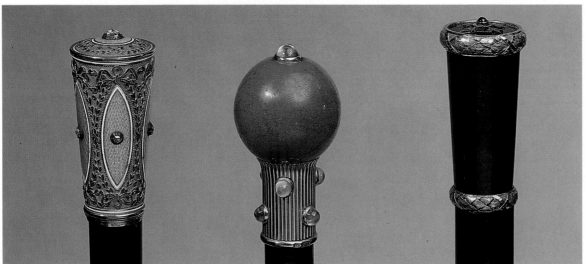

Guilloché enamel gold-mounted
walking-stick handle
Marked Fabergé, workmaster
Henrik Wigström,
St. Petersburg, *c.*1880
2¼ in. (5.5 cm.) long
Sold 13.11.85 in Geneva for
Sw.fr.28,000 (£9,150)

Jewelled, gold-mounted
purpurine walking-stick handle
By Fabergé, marked with initials
of Erik Kollin,
St. Petersburg, *c.*1880
2¼ in. (5.7 cm.) long
Sold 13.11.85 in Geneva for
Sw.fr.20,000 (£6,536)

Two-colour gold-mounted
nephrite walking-stick handle
2¼ in. (5.5 cm.) long
Sold 13.11.85 in Geneva for
Sw.fr.9,000 (£2,941)

All from the collection of the
late Sir Charles Clore

Right:
Hardstone rhinoceros
By Fabergé
2 1/2 in. (6.4 cm.) long
Sold 29.4.86 in New York for $3,300
(£2,139)

Right centre:
Guilloché enamel gold-mounted
desk-clock
By Fabergé, workmaster Henrik
Wigström, St. Petersburg,
1899–1908
4 1/8 in. (10.5 cm.) wide
Sold 29.4.86 in New York for
$19,800 (£12,832)

Far right:
Quatrefoil nephrite, diamond-set
and gold-mounted patch-box
Marked Fabergé, workmaster
Michael Perchin, St. Petersburg,
1896–1903, with English export
hallmarks
1 1/8 in. (2.8 cm.) diameter
Sold 29.4.86 in New York for
$15,400 (£9,980)

Silver bell-push in the form of a sow
Marked with Imperial Warrant of
Fabergé, Moscow, *c.*1905
4 in. (10 cm.) long
Sold 12.11.85 in Geneva for
Sw.fr.44,000 (£14,379)

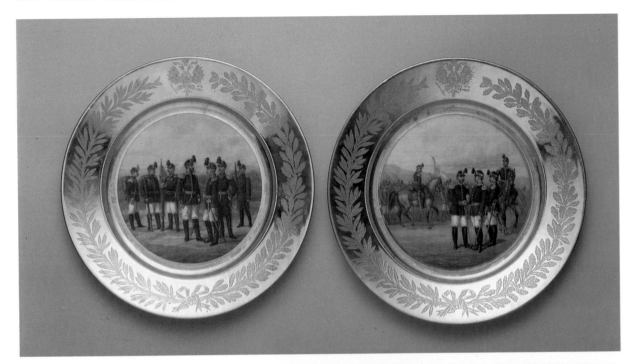

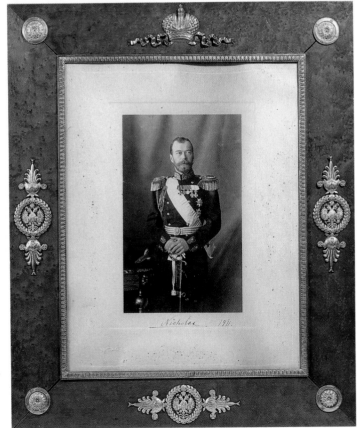

Above:
Two porcelain military plates
Painted after *Charlemagne* by Midin, by the
Imperial Porcelain Factory, Period of
Alexander III
Sold 6.3.86 in London for £4,536 ($6,547)

Right:
Silver-gilt mounted Karelian birchwood
photograph frame, containing an original
signed photograph of Tsar Nicholas II,
dated 1911 and stamped 'Boisonnas et
Eggler'
Marked Fabergé, workmaster Hjalmar
Armfeldt, St. Petersburg, 1908–17
16½ in. (42 cm.) high
Sold 14.5.86 in Geneva for Sw.fr.68,000
(£24,460)

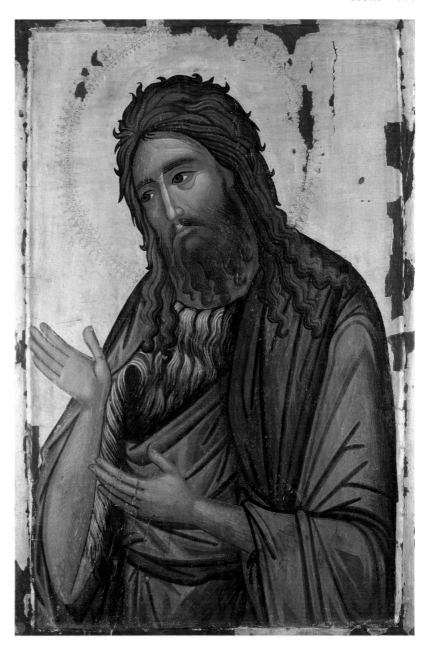

Cretan icon of St. John the Baptist from Deisis
16th century
Sold 29.10.85 in London for £8,100 ($11,534)

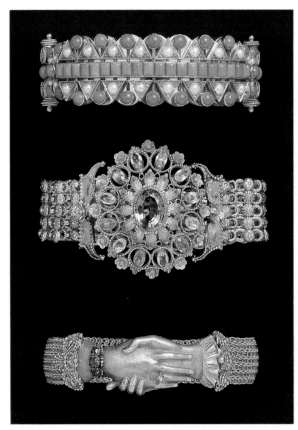

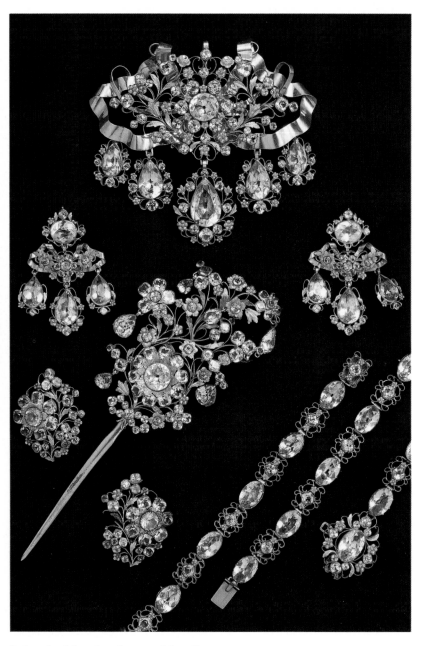

From top to bottom:
Gold bracelet
In fitted case with retailer's address 'Watherston & Son, 12 Pall Mall East'
Sold 24.7.86 in London for £2,808 ($4,212)
Watherston & Son were at the above address between 1864 and 1902

French gold bracelet
*c.*1830
6½ in. (16.5 cm.) long
Sold 24.7.86 in London for £756 ($1,134)

Regency gold bracelet
*c.*1830
7¼ in. (18.5 cm.) long
Sold 24.7.86 in London for £4,860 ($7,290)

Suite of gold and rock-crystal jewellery
*c.*1760
The brooch 3¾ in. (9.5 cm.) long
The bracelet 6¾ in. (17 cm.) long
Sold 24.7.86 in London for £14,040 ($21,060)

Jewelled gold and enamel
necklace
By Henry Wilson
*c.*1905
16½ in. (42 cm.) long
Sold 12.3.86 in London for
£8,640 ($12,727)

Jewelled gold and cloisonné
enamel pendant
By Henry Wilson
*c.*1908
5¼ in. (13.4 cm.) long
Sold 12.3.86 in London for
£17,280 ($25,454)

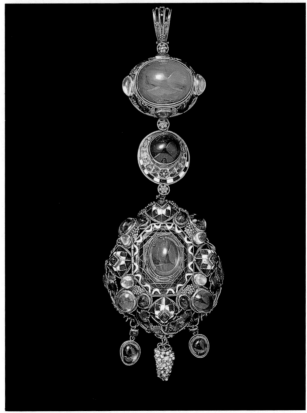

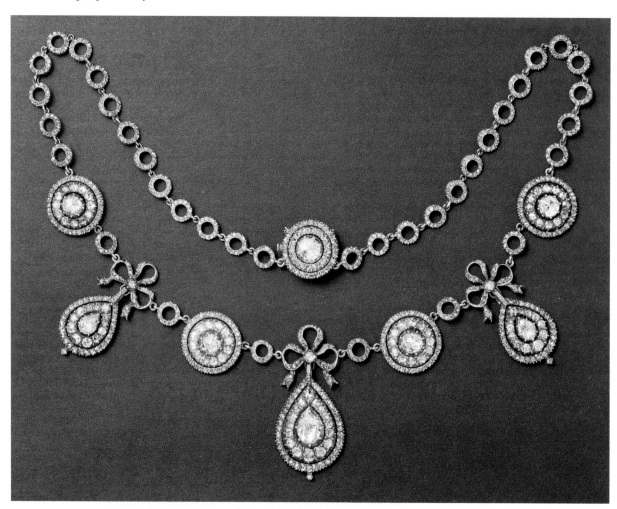

Rose-diamond necklace
Late 18th century
18 in. (45.8 cm.) long
Sold 24.7.86 in London for £10,260 ($15,390)

Works of Art

Mid-17th century Dutch terracotta relief of Mercury
From the workshop of Artus Quellinus the Elder
$25\frac{1}{2} \times 14\frac{1}{4}$ in. (64.5 × 36 cm.)
Sold 13.12.85 in London for £70,200 ($100,700)
By order of the Executors of the late Villiers David, Esq.

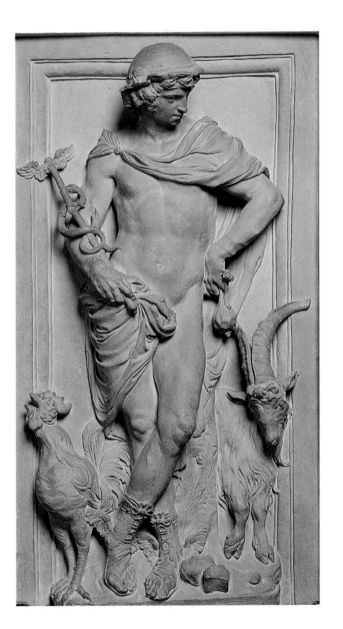

Sculpture, catching up with Painting

CHARLES AVERY

This year has seen dramatic confirmation of a trend that began to emerge at Christie's last season: the 'catching up' in price of important sculpture with equivalent paintings. It first manifested itself in the price of over £½ million that was paid for Roubiliac's marble portrait bust of *Lord Chesterfield* in April 1985; prior to then an English 18th century bust would have been regarded as expensive at a tenth of that figure. In December an equally interesting portrait of *Alexander Pope* by Rysbrack from the Athenaeum Club was negotiated to the National Portrait Gallery for over £400,000 ($600,000). Two huge Regency carved friezes from Marble Arch, with narratives from the Napoleonic Wars, and a Dutch 17th century terracotta relief of *Mercury* by Artus Quellinus the Elder also made substantial sums.

The July sale was quite exceptional in the quality and rarity of its contents. Distinguished provenances undoubtedly encouraged highly competitive bidding. From Alscot Park there was another brilliantly characterized bust by Rysbrack - all the more remarkable for being carved a century and a half after the death of its subject, William Shakespeare. It was in fine condition and fully documented in the family papers, which encouraged bidding up to £291,600 ($447,606).

The main component of the sale was from Wentworth Woodhouse in Yorkshire: a magnificent and historic series of marble sculptures purchased in Italy or commissioned in England by the 2nd Marquess of Rockingham, or by his nephew, the 4th Earl Fitzwilliam. The most spectacular, and one of the earliest, was a monumental group of *Samson and the Philistines* by Vincenzo Foggini, carved in Florence in 1749 and despatched to England on completion. Its dramatic subject was inspired by a model of Michelangelo, while its composition was derived from the famous marble group with two figures carved about 1560 by Giambologna.

More important from the point of view of the evolution of English sculpture was a series of four statues of classical goddesses carved by Joseph Nollekens at 'small life-size' during the 1770s. They are some of the rare 'poetical' works by which the sculptor – best remembered as a great portraitist – set great store. They were commissioned for the London house of the Fitzwilliams and it was discovered that three – *Venus*, *Minerva* and *Juno* – together with a classical statue restored as *Paris* (sold in the Antiquities sale of 16 July 1986, Lot 151), had formed a group of the 'Judgement of Paris'. A sculpturally more ambitious figure of *Diana*, running and turning to shoot her bow, was the last to be carved (1778) and must have been displayed separately. These four statues generated a grand total of over £400,000 ($650,000), again a staggering advance on any price paid hitherto for equivalent pieces.

The Fitzwilliams continued the tradition of acquiring major marble statues into the middle of the 19th century, with John Bell's *Eagle Slayer* (*c.*1840), Ludwig von Schwanthaler's *Danube* (1847) and Richard J. Wyatt's *Huntress* (1850). All fetched remarkable prices, the last unexpectedly equalling the *Diana* by Nollekens.

The other marble busts and statuettes from Wentworth Woodhouse also broke new ground in terms of value, as did similar pieces from other sources. Clearly fashion has swung in the direction of classic statuary, whether it be of antique inspiration or contemporary historical interest. Well-executed, ornamental sculpture of the 19th century is also in demand, as was indicated by the price paid in Monaco for an extraordinary group made by C.H.J. Cordier in coloured marbles, which showed a white and black child embracing – an allegory of the emancipation from slavery.

Also in Monaco, a unique pair of statuettes of *King Henri IV as Jupiter* and *Queen Marie de Medicis as Juno* by Barthelemy Prieur, the major discovery of the year in the field of bronzes, made Fr.fr.9,435,000 (£829,086). In a similar range was the *Hercules and Lichas* (sold in London), rarest out of a series of four 'Labours of Hercules', cast in bronze from models by Giambologna, early in the 17th century. The bronze is unique and is a model that was previously unknown.

Right:
Late 18th century English
marble statue of Minerva
By Joseph Nollekens
Signed and dated 'Nollekens
Ft: 1775'
56¾ in. (144 cm.) high
Sold 15.7.86 in London for
£108,000 ($165,780)

Far right:
Late 18th century English
marble statue of Juno
By Joseph Nollekens
Signed and dated 'Nollekens
Ft: 1776'
54¾ in. (139 cm.) high
Sold 15.7.86 in London for
£113,400 ($174,069)

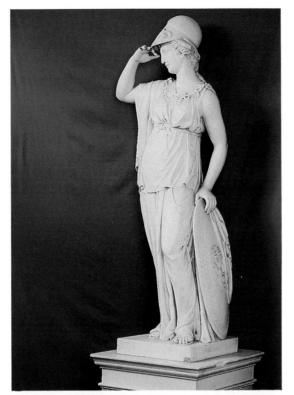

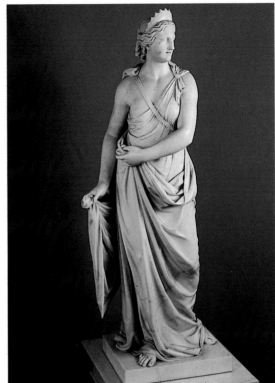

Right:
Late 18th century English
marble statue of Diana
By Joseph Nollekens
Signed and dated 'Nollekens
Ft: 1778'
48¾ in. (124 cm.) high
Sold 15.7.86 in London for
£91,800 ($140,913)

Far right:
Late 18th century English
marble statue of Venus
taking off her sandal
By Joseph Nollekens
Signed and dated 'Nollekens
Ft: 1773'
48¾ in. (124 cm.) high
Sold 15.7.86 in London for
£118,800 ($182,358)

All sold by order of the
Trustees of Olive, Countess
Fitzwilliam's Chattels
Settlement

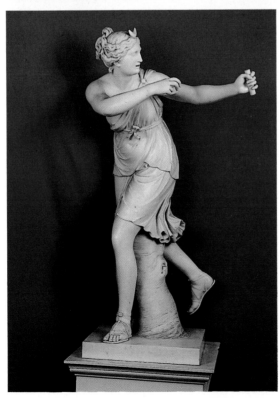

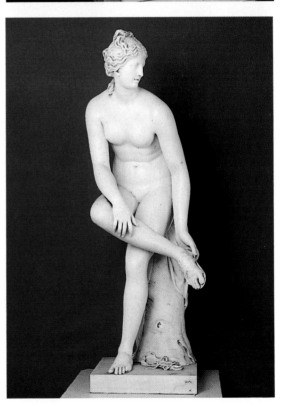

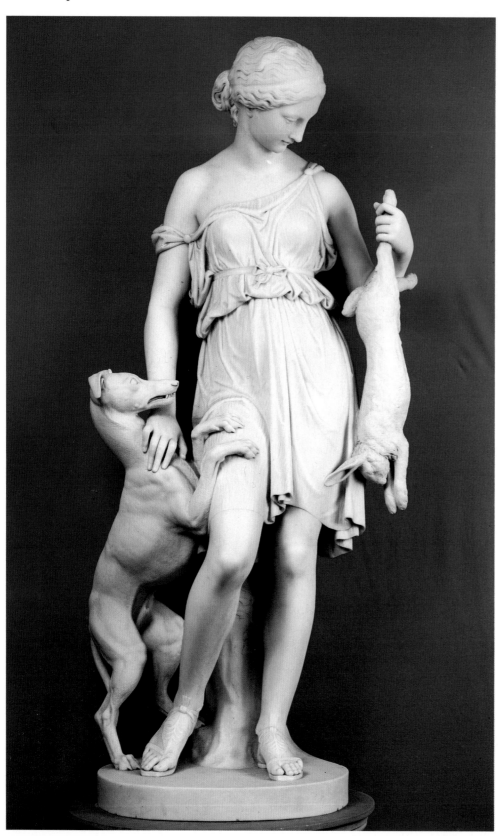

Mid-19th century English marble statue of a huntress with a leveret and greyhound
By Richard James Wyatt
Signed R.J. WYATT Fecit ROMAE
59 in. (150 cm.) high
Sold 15.7.86 in London for £91,800 ($137,700)
By order of the Trustees of Olive, Countess Fitzwilliam's Chattels Settlement

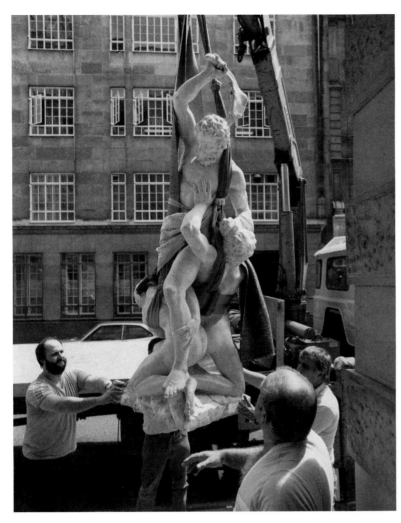

The Foggini *Samson and the Philistines* arriving at Christie's

Mid-18th century Florentine monumental marble group of Samson
and the Philistines
By Vincenzo Foggini
Signed VIN.VS FOGGINI/SCULPSIT FLO/RENTIAE/1749
92 in. (223 cm.) high
Sold 15.7.86 in London for £345,600 ($530,496)
By order of the Trustees of Olive, Countess Fitzwilliam's Chattels
Settlement

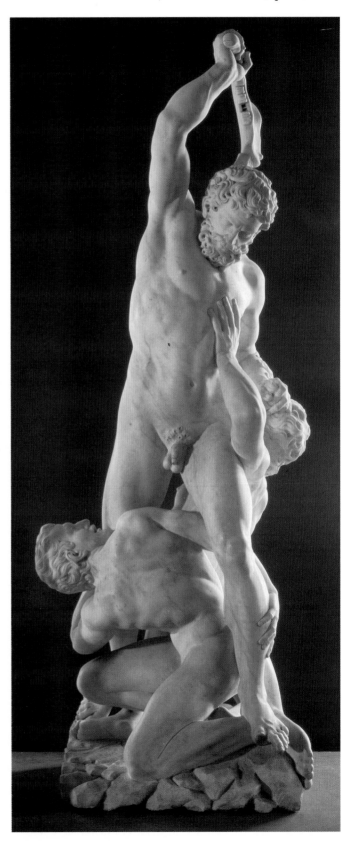

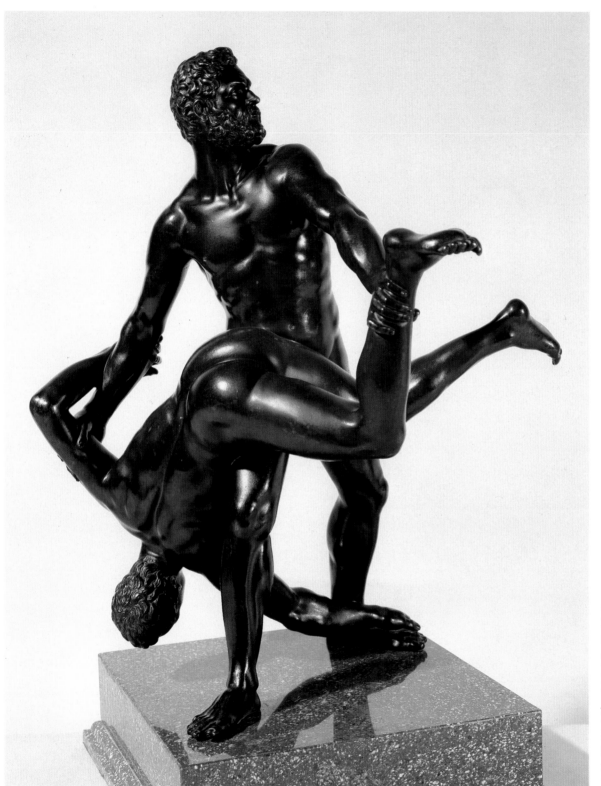

Late 16th or early
17th century Florentine
bronze group of
Hercules and Lichas
Cast from a model by
Giambologna
13½ in. (34.5 cm.) high
Sold 15.7.86 in London
for £259,200 ($397,872)

Opposite:
Pair of early 17th
century French bronze
statuettes of King
Henry IV and Queen
Marie de Medicis as
Jupiter and Juno
By Barthelemy Prieur
26½ in. (67 cm.) high
Sold 7.12.85 in Monaco
for F.fr.9,435,000
(£829,086)

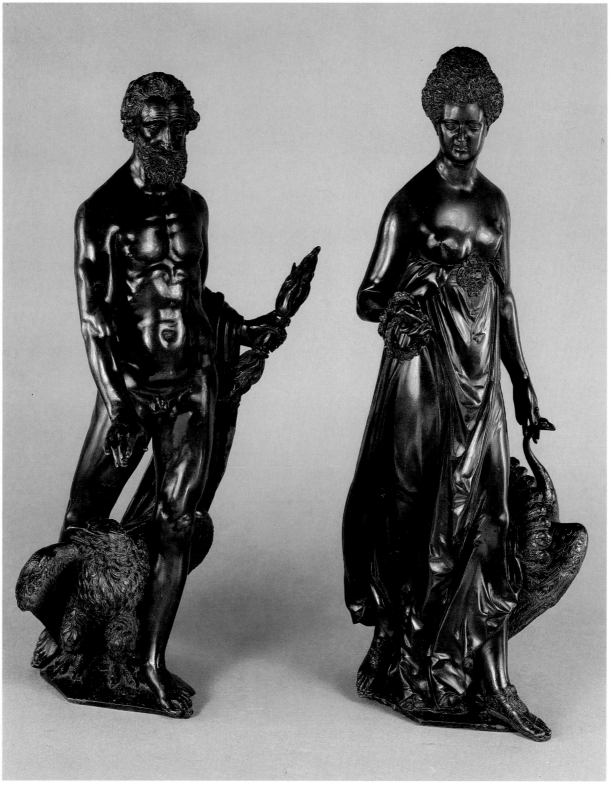

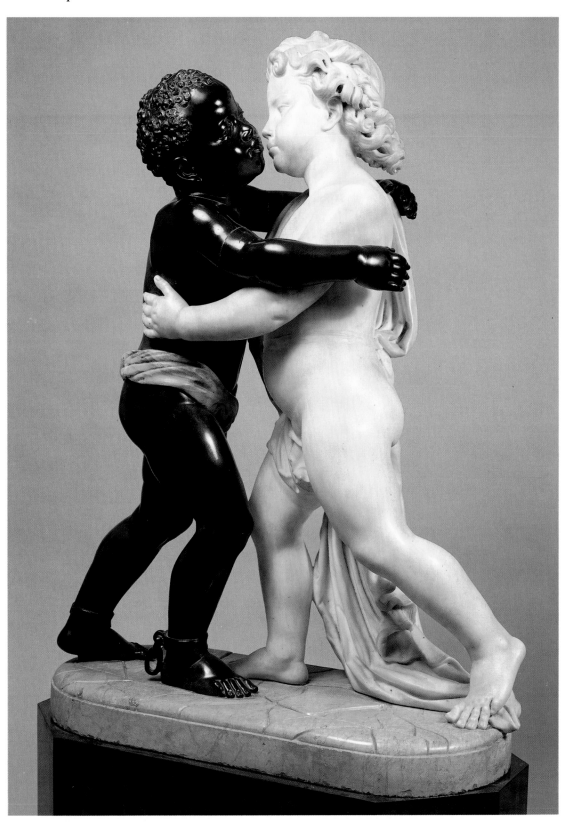

19th century French white, black and yellow marble group entitled *Aimez-vous les uns les autres*, showing a white child stepping forward to embrace a black slave boy
By Charles-Henri-Joseph Cordier
Signed and dated 1867
39¾ in. (101 cm.) high
Sold 7.12.85 in Monaco for F.fr.943,500 (£82,908)

Mid-18th century English marble bust of William Shakespeare (1564–1616)
By John Michael Rysbrack
Signed and dated on the back 'Michl. Rysbrack. Sculpt: 1760'
23 in. (58.5 cm.) high
Sold 15.7.86 in London for £291,600 ($447,606)
From the collection of Captain J.A.R. West
The bust was commissioned by the distinguished bibliophile and antiquarian James West, M.P., P.R.S., F.S.A. (1704–72) out of admiration for the *'Genius Loci'* – William Shakespeare. West's house, Alscot Park, was only a few miles from Stratford-on-Avon. He had admired Rysbrack's original terracotta bust, commissioned by Sir Edward Littleton (now missing), and ordered this marble version in 1758–9. It was delivered in 1763 and is one of Rysbrack's most brilliant portraits of deceased 'worthies'.

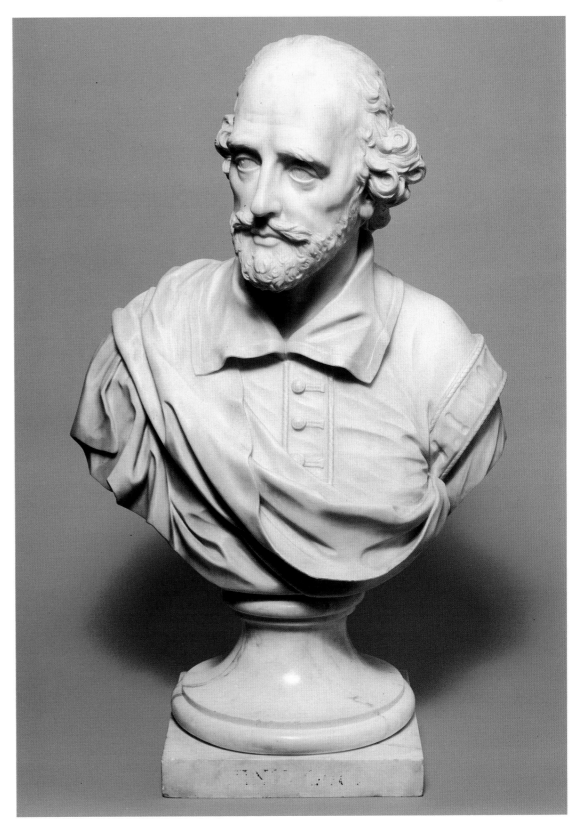

Sarah Bernhardt's Role as a Sculptress

JANE ABDY

Sarah Bernhardt always said she took up sculpture because she was bored. During the 1870s, her contract with the Comédie Française only required two performances a week, and Sarah was too vivacious and nervous to endure idleness (her other diversions were to include painting in oils, writing novels and plays, even cooking). What was at first an entertaining experiment became a lifelong hobby: Sarah had great talent as a modeller, and she continued to sculpt all her life. Of her works, some 50 can be documented; the whereabouts of 20 are known today, and photographs of another eight survive from old press cuttings; a pattern can be traced. The majority of her works are portrait busts, but she also made imaginative *objets de vertu*. The work which many will have seen, but few will suspect the authorship, is the huge statue of *Le Chant*, a particularly hefty angel with a lyre, which adorns the Casino at Monte Carlo and overlooks the sea.

Sarah was passionately interested in all forms of visual art. She designed her own dresses, which were then made up for her by the grandest couturiers. When she directed her own theatre company, she supervised the sets, the costumes and the jewellery for her productions, which were famous for the originality of their visual splendour. She was surrounded by a group of artist friends, Clairin, Louise Abbéma, Alfred Stevens, and Gustave Doré, all of whom encouraged her to paint. For sculpture, she chose two mentors, Mathieu Meusnier and Francheschi, who were established Salon artists, and responsible for much official marble in parks and town halls.

Sarah's first essays were small portraits in terracotta or plaster of family and friends. By 1874 she was brave enough to send a marble bust of Mlle B... G... to the Salon, and it was accepted. The following year she submitted a marble of her sister Regina, who had died of consumption a few months before. 'A lovelier face was never made by the hand of God', wrote Sarah, but admitted difficulty with her sister's expression; she looks like a sulky Vestal. Sarah was more succesful as a modeller than a carver; her plasters have a rhythm and vivacity (especially marked in her portraits of Clairin and Rostand), which become static when translated to marble.

Her success at the Salon inspired Sarah to buy a skeleton, and to take lessons in anatomy from her own physician, Dr Parrott. In 1876 she produced her most ambitious work, *Après la tempête*, which was inspired by Michelangelo's *Pièta*. It depicts a Breton fisherwoman of very visible bone structure cradling the body of her drowned grandson on her knee. This lugubrious work won Sarah an honourable mention at the Salon, and became her pride and joy. Gambart and Susse both vied for the casting rights, Gambart winning with the huge bid of 10,000 francs, and a number of bronze reductions of this work were produced.

Her sculpture received quite a favourable press, and was highly praised by William Powell Frith when he visited her Paris studio. Certain jealous detractors accused Sarah of harbouring a starving sculptor in her atelier to do the works, but there is no doubt that the sculptures are her own, though she may have had help with the marbles. All are boldly and proudly signed, at first in capital letters, and then in the nineties with her own distinctive signature.

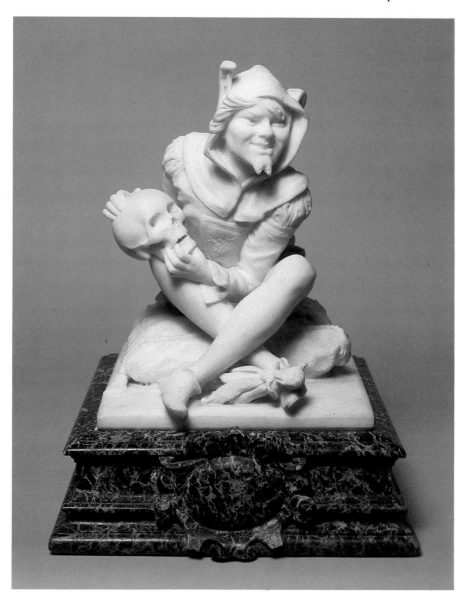

Late 19th century French marble statuette of a jester seated on a cushion, probably Yorick
By Sarah Bernhardt
Signed and dated 1877
17¼ in. (43.5 cm.) high
Sold 15.5.86 in London for £21,600 ($33,437)

Her sculpture also contributed to her earnings. She claimed to make 30,000 francs a year from her art – perhaps in a record year. She always needed money, she was immensely extravagant and very generous; she lived in a huge house, and entertained non-stop. Her view of money was straightforward: 'Quand je l'ai, je le dépense; quand je ne l'ai pas, je gagne'.

It must be said that Sarah loved her new role, and exploited it to the full. She rented a small studio near Montmartre, where she entertained friends and posed for a charming series of photographs by Melandri. These show her in the sculpting outfit she had designed for herself, a white satin trouser suit, with numerous lace frills at the neck, and, most inconveniently, on the cuffs. Pretty satin pumps with huge bows completed the outfit.

In 1879 the Comédie Française came to England for the first time. Sarah's fame as the star of the French stage had preceded her, and she had an overwhelming welcome. She profited from her visit by holding a small exhibition of 10 sculptures and 16 paintings at the gallery of Thomas Russell at 33 Piccadilly. Sarah served champagne to her guests and gatecrashers; 1,200 people, she said, visited the show. These included the Prince and Princess of Wales, who were both great fans, Prince Leopold, who bought a picture, and an admiring Mr Gladstone. In every way the exhibition was a success. The works sold well; Sarah said she asked 'modest prices', and quoted £160 for a small version of *Après la tempête*, but claimed Lady (Ethel) H... insisted on paying £400. When Sarah went to America in the following year she gave further exhibitions at the Union Club in New York and Philadelphia.

Her sculpture in the 1870s was competent, but derivative. In 1880 she modelled an extravagant self-portrait of herself holding an inkwell; she has the paws of a sphinx, the tail of a fish, and the wings of a bat. The masks of Comedy and Tragedy adorn each shoulder. Her expression recalls the words of Jules Lemaitre, who wrote, 'Mme Sarah Bernhardt has upon me the effect of a very strange person who returns from a great distance.' This bizarre work is Sarah's first venture in the Art Nouveau style, of which she was both the muse and the personification. At least six examples of this inkwell are known today, cast in bronze by the fashionable *fondeur* Thiebaut. Sarah kept one for herself, with her initials and her motto 'Quand même' sparkling in rose diamonds.

Sarah's life completely changed in 1880. She had founded her own company, made a triumphal tour of America, and embarked on a collaboration with Sardou which was to create the Art Nouveau style in the theatre. She was the first person to commission the fantastic jewellery of Lalique. For her own house, she bought Gallé vases and oriental works of art from the supreme *marchand* of japonisme, S. Bing, creator of 'La Maison de l'Art Nouveau'.

Every summer she went for two months to her house at Belle Ile, which overlooks the dramatic rocky Breton coast. She built studios for herself and Clairin. Belle Ile was the inspiration for some of her most individual sculptures. Reynaldo Hahn describes *Le Baiser de la mer*, in which a young girl is strangled by a giant crab. Three bronzes of fish, leaping and threshing, seem to have jumped straight from the sea. For herself she made a paper-knife in the form of seaweed. Most intriguing of all are her bronzes of sea plants, something rare and strange. Sponge-like growths lie on contorted stems, made more exotic by being cast in varying patinations like Japanese bronzes. Several of these were exhibited at the Exposition Universelle of 1900, which was the apotheosis of the Art Nouveau movement.

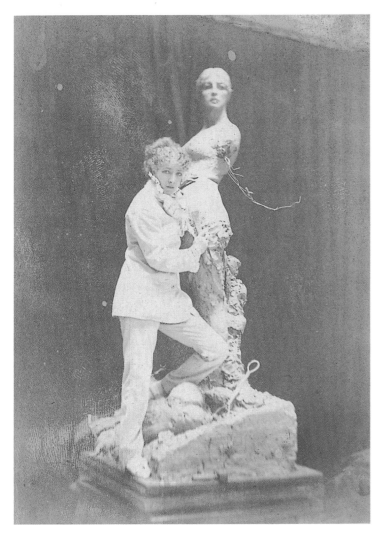

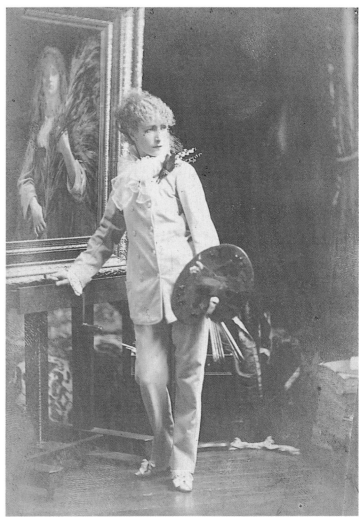

Sarah posing in her sculpting outfit as she works on her plaster group of Medea and her children, 1877

Sarah in her studio at 11 Boulevard de Clichy, in front of the painting she sold to Prince Leopold in London: *La Marchande des palmes*

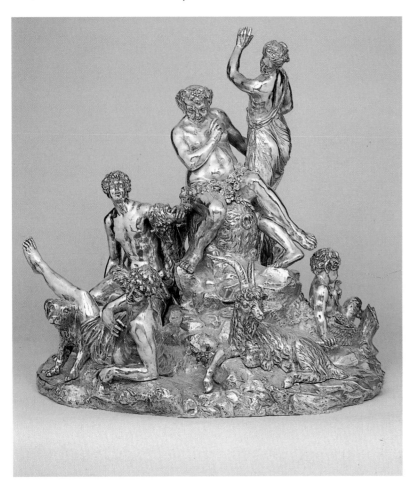

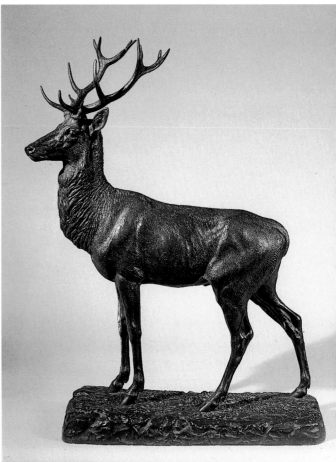

Mid-19th century silver centre-piece of the Triumph of Bacchus
Unmarked
24 in. (60 cm.) high
Sold 22.1.86 in London for £21,600 ($30,392)

Late 19th century French bronze model of a stag
Cast from a model by Isidore-Jules Bonheur
Dated ISIDORE BONHEUR 1893 and stamped PEYROL
$32 \times 26\frac{1}{2}$ in. (82 × 67 cm.)
Sold 15.5.86 in London for £7,560 ($11,703)

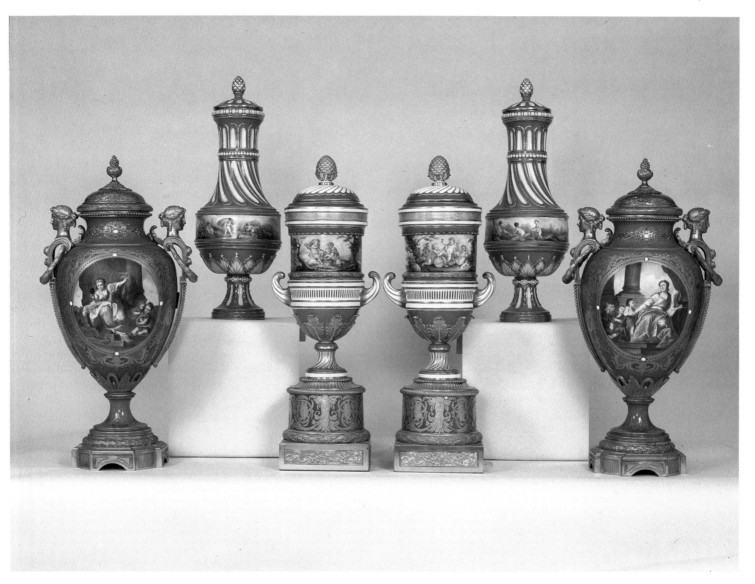

Above left and right:
Pair of mid-19th century Sèvres-pattern turquoise-ground jewelled and gilt bronze-mounted oviform vases and covers
25½ in. (64.5 cm.) high
Sold 15.5.86 in London for £4,860 ($7,436)

Above on raised step:
Pair of 19th century Sèvres-pattern turquoise-ground vases and covers
21¼ in. (54 cm.) high
Sold 15.5.86 in London for £1,404 ($2,149)

Above centre:
Pair of mid-19th century Sèvres-pattern gilt bronze-mounted two-handled vases, covers and fixed plinths
25 in. (63.5 cm.) high
Sold 15.5.86 in London for £4,860 ($7,436)

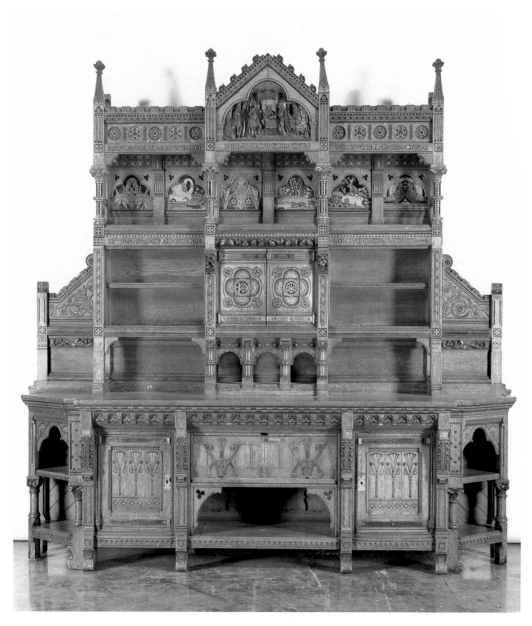

Mid-Victorian oak, fruitwood and marquetry breakfront side-cabinet
Designed by Bruce Talbert
112 in. (285 cm.) wide; 110 in. (279.5 cm.) high; 30 in. (76 cm.) deep
Sold 22.1.86 in London for £81,000 ($123,930)
Bruce Talbert was an influential Scottish mid-Victorian designer in the Gothic tradition. In 1868 he published *Gothic Forms Applied To Furniture*. The book enjoyed wide popularity largely on account of its secular decorative style and domestic emphasis on carvings of birds and animals, which contrasted favourably with the High Church associations of some previous Gothic furniture. Talbert's furniture varied from sober, plain pieces to the type of elaborate revivalist designs well shown by the above. The side-cabinet was made by Holland & Sons and exhibited in the Paris International Exhibition in 1867. When Talbert died in 1882 a cabinet-maker noted in his obituary that he was the 'creator of an epoch'.

Mid-Victorian parcel-gilt wood mirror from the Dining Room of Dorchester House, London
By Alfred Stevens
71 × 59¾ in. (180.5 × 151.8 cm.)
Sold 22.1.86 in London for £11,880 ($16,716)
The mirror is illustrated in a 1928 photograph taken for Hussey's article on Dorchester House. It flanked the entrance to the buffet on the north wall (east corner) of the Dining Room and dates from *c.*1860.
Dorchester House was built for R.S. Holford by Vulliamy along the lines of an Italianate palace, deriving its inspiration from the Villa Farnesina, Rome. In a letter of 31 March 1859, the art critic John Morris Moore wrote to Holford recommending Stevens as 'the only one who has studied with success upon the best models the principles of ornamentation'. Stevens received payments from December 1859 and Holford's letter of 19 May 1870 indicates that the woodcarving had been completed by the spring of 1865 (by June 1866 all the designs for the woodcarving had been paid for). Stevens died in 1875 before the completion of the scheme and, as Hussey remarks, 'the dining room that he was commissioned to decorate may only be a skeleton of his full conception for it; but at least it gives, if taken with the cartoons for the decoration of the ceiling now hung in the Tate Gallery, the most comprehensive basis for an estimate of his powers'.

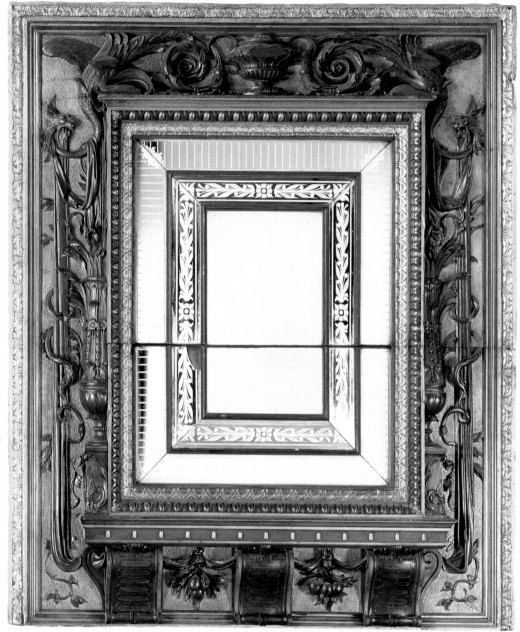

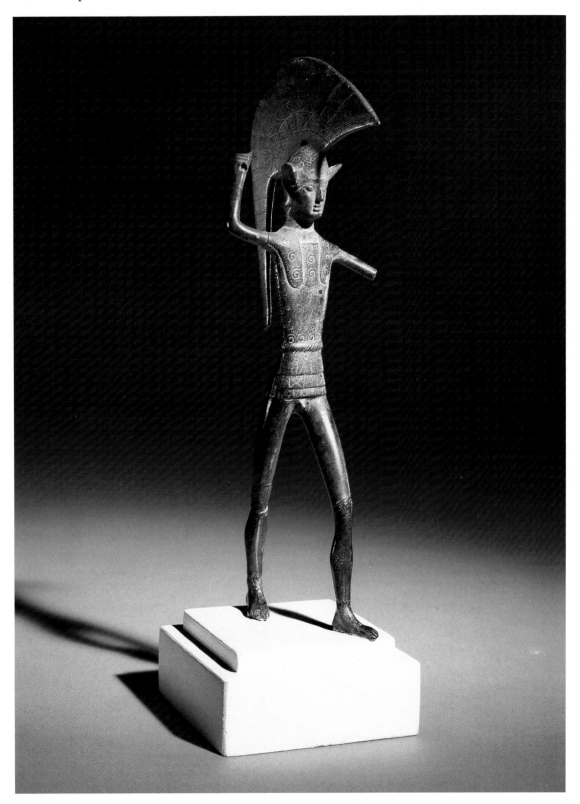

Etruscan bronze figure of a
striding warrior
5th century BC
9¾ in. (24.8 cm.) high
Sold 10.12.85 in London for
£91,800 ($132,147)

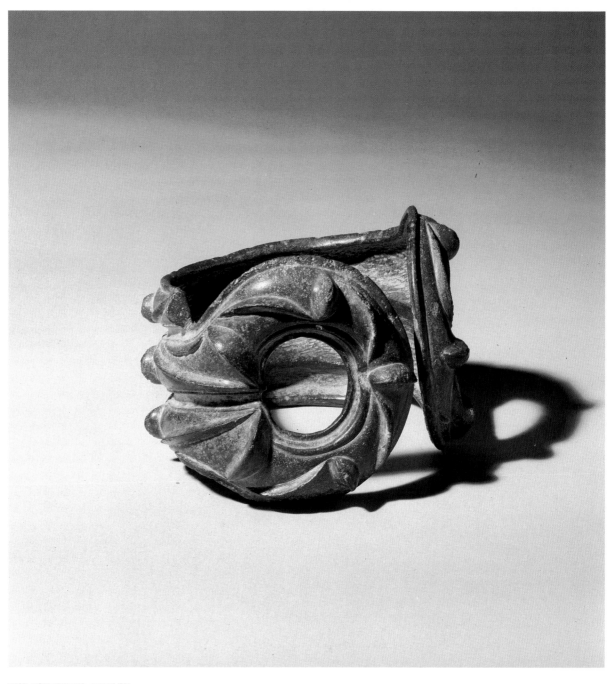

THE ACHAVRAIL ARMLET
Celtic massive bronze penannular armlet
1st–2nd century AD
$3\frac{1}{2}$ in. (9 cm.) high
Sold 16.7.86 in London for £75,600 ($113,400)
By order of The Sutherland Trust
Found at the turn of the century at Achavrail, eastern Scotland

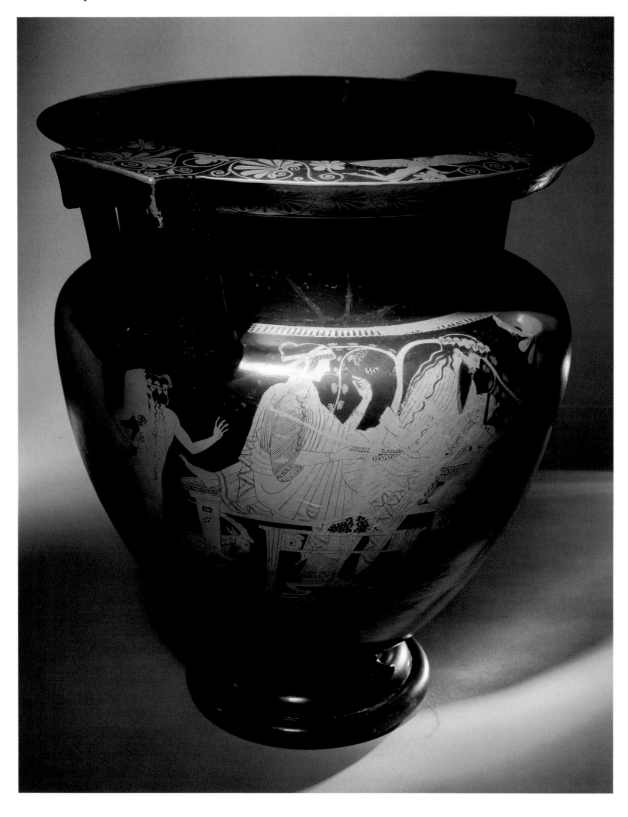

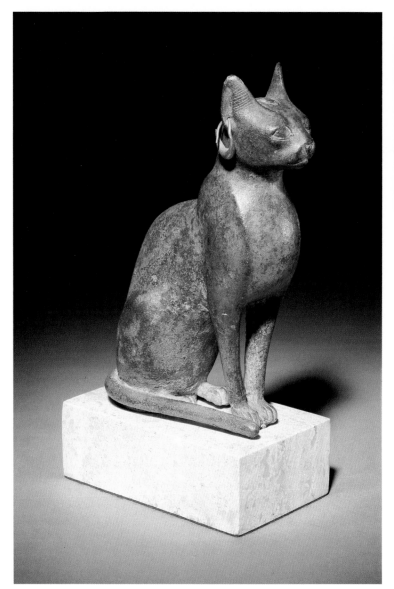

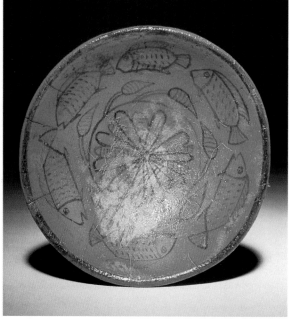

New Kingdom turquoise-glazed composition fish bowl
Dynasty XVIII
5¼ in. (13.3 cm.) diameter
Sold 16.7.86 in London for £19,440 ($29,160)

Bronze figure of a seated cat
*c.*6th–4th century BC
6 in. (15.2 cm.) high
Sold 16.7.86 in London for £10,800 ($16,200)

Opposite:
Attic psykter-column-krater
By the 'Troilos Painter'
Late Archaic, *c.*470 BC
20¾ in. (51.3 cm.) high; 17¾ in. (45.5 cm.) diameter
Sold 16.7.86 in London for £54,000 ($81,000)

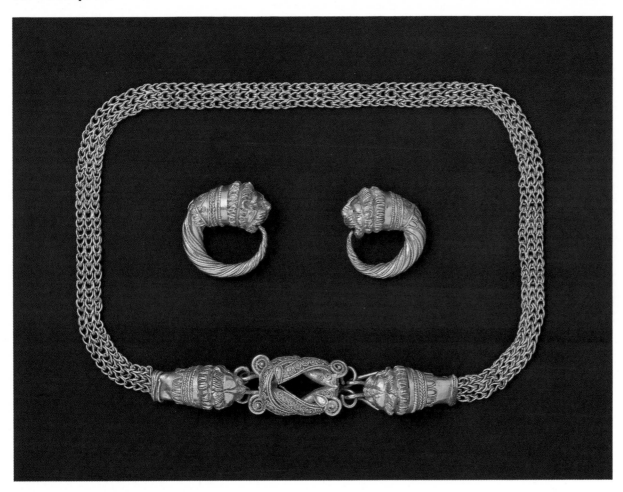

Hellenistic gold necklace and earrings
Late 4th or early 3rd century BC
Sold 16.7.86 in London for £28,080 ($42,120)

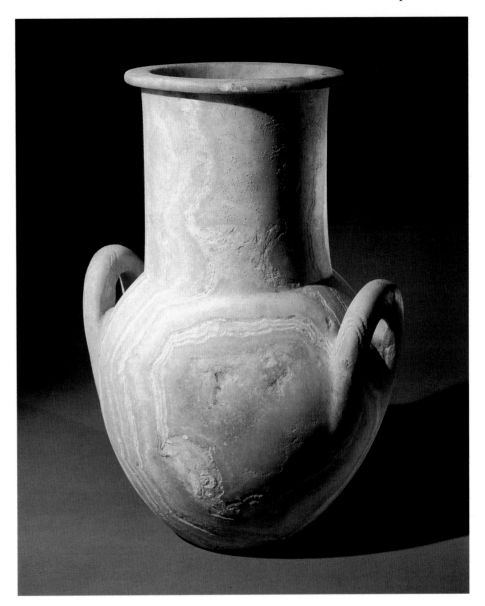

Alabaster amphora with spherical body
Dynasty XVIII, 1500–1300 BC
20³⁄₄ in. (52.7 cm.) high
Sold 16.7.86 in London for £25,920 ($38,880)

The Omai Relics

HERMIONE WATERFIELD

The native Omai was just a boy when the first Englishman set foot on Tahitian soil to plant the British flag and claim the island for King George III on 26 June 1767. The Englishman was Tobias Furneaux, 2nd Lieutenant on the *Dolphin*. Omai later became the first South Sea islander to visit the British Isles.

Omai's parents had been killed by men from Bora Bora who over-ran their land in Raiatea, so he was sent to live in Tahiti: he remembered Cook, Solander and Banks on their visit to Tahiti during the First Voyage, but to them he was just another native. When Tobias Furneaux returned as Captain of the *Adventure* on Cook's Second Voyage, Omai was on Huahine, an island between Tahiti and Raiatea, and he persuaded Furneaux to take him on board ship. They set sail on 7 September 1773 for Tonga (where they would have acquired the two clubs illustrated here), a visit that produced an amusing anecdote in Cook's Journals: 'it was astonishing to see with what eagerness every one catched at everything they saw, it even went so far as to become the ridicule of the Natives by offering pieces of sticks stones and what not to exchange, one waggish Boy took a piece of human excrement on the end of a stick and hild it out to every one of our people he met with'.

They sailed on to New Zealand, where the *Adventure* was parted from Cook's ship *Resolution* by a storm. Furneaux arrived in Queen Charlotte's Sound nearly a month after Cook and they had a horrible experience whilst refitting and provisioning for the onward voyage. Ten of the *Adventure*'s crew were killed and partially eaten by Maoris in Grass Cove. Furneaux decided to sail home eastwards and spent a month in Cape Town to refit and victual the ship (where Omai would have acquired the pair of slippers).

On arrival in England, 12 July 1794, Omai and his effects were taken to the Furneaux family home in Swilly just outside Plymouth. Lord Sandwich was Omai's sponsor but Joseph Banks considered him a rare prize, similar to an exotic plant, and had him to stay for many weeks.

Omai was a great success socially, making a good impression on King George III, to whom he was presented on two occasions. Whilst staying with Lord Sandwich at Hinchingbrooke the neighbours 'vied with each other in varying his diversions'. Omai had befriended James Burney, who was also on the *Adventure*, and we find amusing and sympathetic references to him in his sister Fanny's diaries: 'his manners are so extremely graceful, and he is so polite, attentive and easy, that you would have thought he came from some foreign court'.

The area about Plymouth was the home of a group of painters who have left portraits of Omai: the famous Reynolds painting now at Castle Howard; several drawings by Nathaniel Dance, one of which was engraved by Bartolozzi and dedicated to Lord Sandwich (a print was included in the sale); and a group with Solander and Banks by W. Parry. Tobias Furneaux was painted by his neighbour Northcote. Omai also inspired a number of poems and O'Keefe's play *Omai or a Trip Round the World*, with sets and costumes by de Loutherbourg. His return to the Society Islands provided Cook with the excuse to sail to Tahiti once more, and Omai left laden with gifts from the King, Lord Sandwich, Joseph Banks and other friends, and a suit of armour made specially for him by the Tower of London. On 26 June 1776 they reached Huahine where Cook built him a house, having purchased land for him from a chief. But Omai had died, apparently from natural causes, by the time Captain Bligh arrived on the *Bounty* two and a half years later.

Furneaux is commemorated in the antipodes by a group of islands off Australia named after him by Cook, by a memorial in Queen Charlotte's Sound, New Zealand, and also by several streets in Plymouth, England, as well as in Australia and New Zealand. The group of Omai relics was sent for sale by a descendant of Tobias's younger brother.

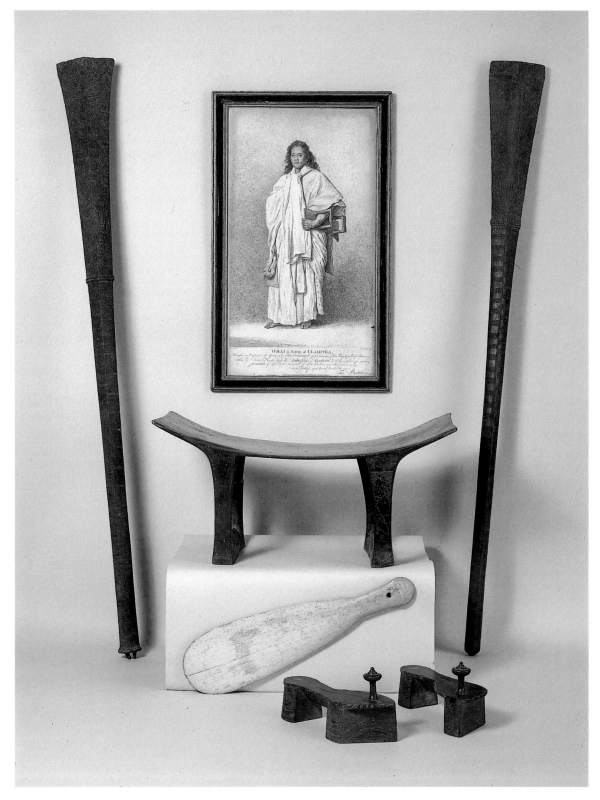

THE OMAI RELICS
Society Islands wood
seat, 21 1/2 in.
(55 cm.) wide
Bartolozzi print of Omai
after N. Dance
Two Tongan clubs, both
45 in. (115 cm.) long
Maori bone hand club,
17 in. (43 cm.) long
Pair of wooden shoes,
9 in. (23 cm.) long
Sold 23.6.86 in London
at Christie's South
Kensington for a total of
£95,700 ($148,335)

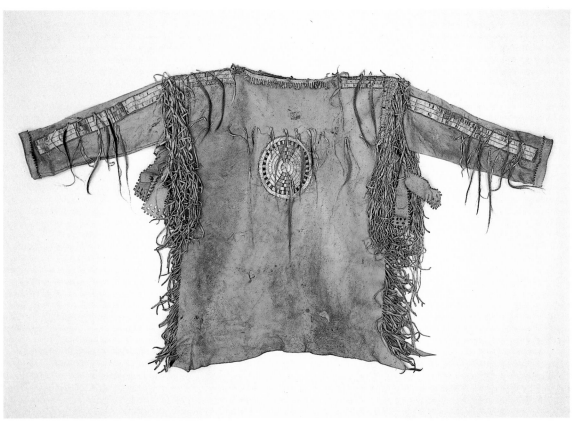

Quilled tanned skin shirt
*c.*1840
Sold 23.6.86 in London at
Christie's South
Kensington for £34,000
($52,700)
From the property of
Angus Macalister of
Glenbarr

Quilled buck-skin bow
case and rawhide quiver
*c.*1850
Sold 23.6.86 in London at
Christie's South
Kensington for £30,000
($45,000)
From the property of
Angus Macalister of
Glenbarr

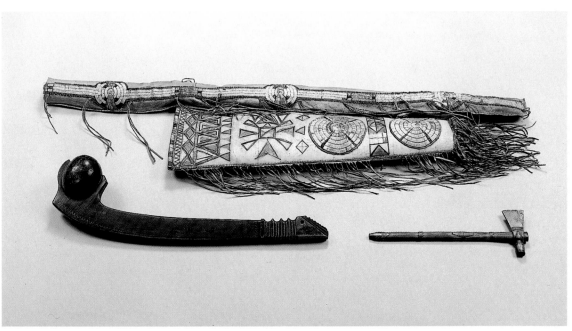

Wooden club
25 in. (64 cm.) long
Sold 23.6.86 in London at
Christie's South
Kensington for £35,000
($52,500)
Formerly 'the property of
great deservedly celebrated
Chief Logan, and with it
many have been
tomahawked'.

Ceramics and Glass

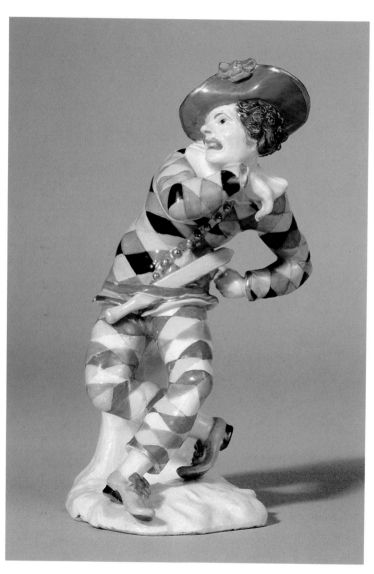

Meissen figure of Harlequin alarmed
Modelled by J.J. Kändler
*c.*1740
6¼ in. (16 cm.) high
Sold 9.6.86 in London for £41,040 ($61,930)
From the Nyffeler Collection

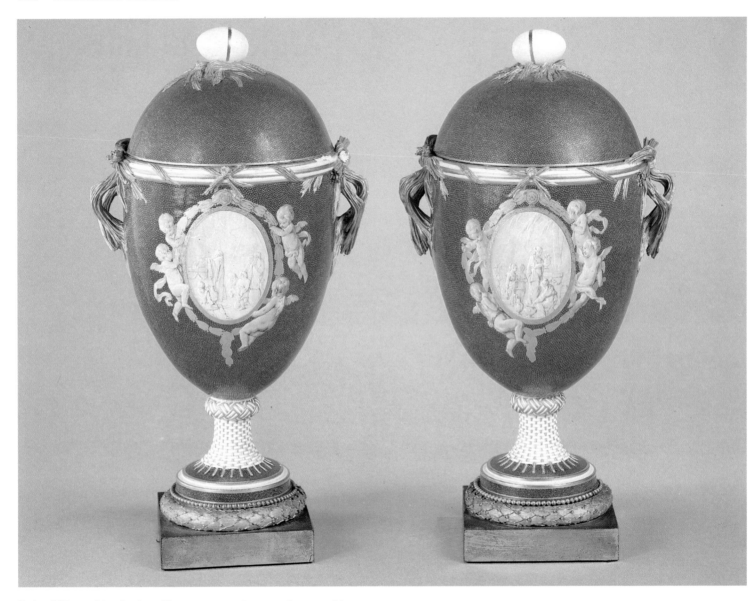

Pair of Sèvres bleu lapis oviform vases and covers *(vases oeufs)*
c. 1768–9
17¾ in. (45 cm.) high
Sold 6.12.85 in Monaco for F.fr.1,998,000 (£175,571)
From the collection of the late Sir Charles Clore
Now in the J. Paul Getty Museum, Malibu

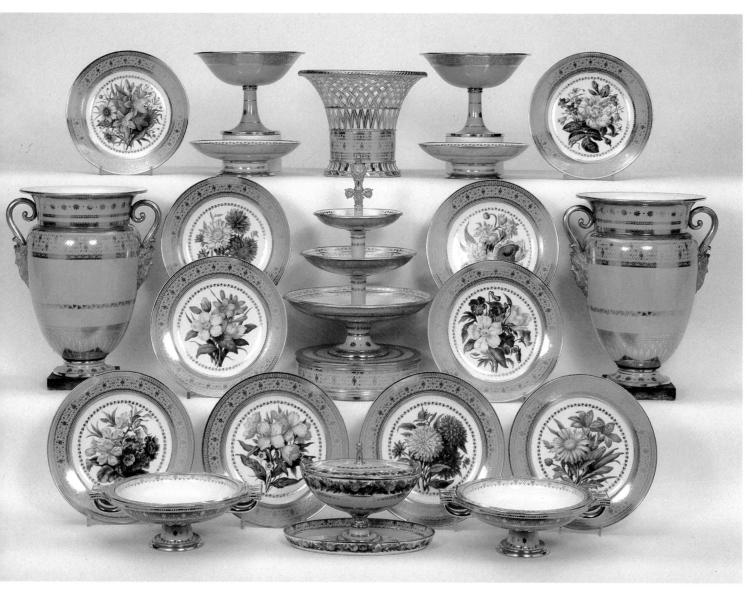

THE SALVANDY SERVICE
Sèvres (Louis Philippe) Royal presentation botanical dessert service comprising: two large wine coolers and liners (Glacières) with square ormolu feet; a flared basket (corbeille jasmin); four tiered tazzas (étagères); two sauce tureens, covers and fixed stands (sucriers cymbium et plateaux); four tall tazzas (compotiers coupe); two two-handled tazzas (compotiers étusques, 1825); four shallow tazzas (compotiers à larmier à pied); 60 plates
Date marks from 1835 and 1842
Painted by: Mme Charles, née Huard (in both her married and single states; at Sèvres, 1838–41); two plates by Mélanie Bonner (at Sèvres, 1834–54); Joséphine des Isnards (at Sèvres, 1835–48); one plate by Pierre-Jean-Victor Amable Langle; the sauce tureens by Jacques Sinsson (at Sèvres, 1795–1845)
Gilded by Jean Louis Moyes (1818–48)
Sold 30.6.86 in London for £237,600 ($356,400)
Record auction price for any lot of European porcelain

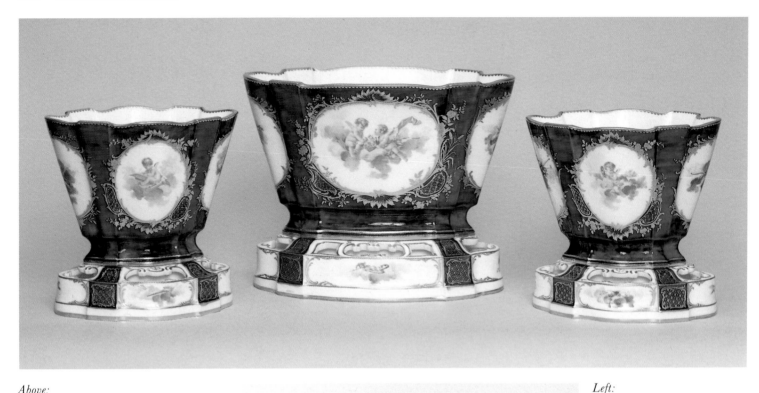

Above:
Garniture of three Vincennes bleu lapis vases Hollandais and stands
Blue interlaced L marks enclosing the date letter D for 1756 and painter's mark M for Morin
The centre vase 11¼ in. (28.5 cm.) wide
The two side vases 7¾ in. (19.5 cm.) wide
Sold 6.12.85 in Monaco for F.fr.721,500 (£63,400)
From the collection of the late Sir Charles Clore
The open book inscribed *Anacreon* occurs on several pieces of Sèvres of this period. They include a *cuvette à tombeau* in the Wallace Collection of 1757, a *vase Hollandais* formerly at Mentmore, a piece in the Maria Theresa service of 1757, and a *pot-à-fard* of 1762 at Harewood. In each case, the book forms part of decoration similar to that on the present lot.

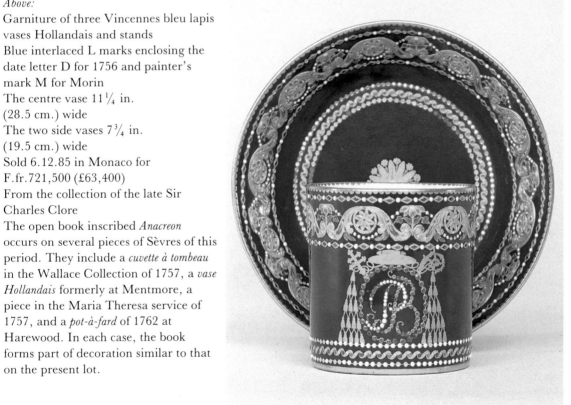

Left:
Jewelled Sèvres cylindrical cup and saucer
The cup with gilt interlaced L marks and painter's marks LG of Le Guay
*c.*1783
Sold 4.12.85 in London for £8,100 ($12,000)
Le Guay was one of the select group of artists at Sèvres capable of this quality of work in what was described as *émail et or*. The present lot would appear to have been made for an Italian client.

Sèvres bleu lapis vase grec à
festons, cover and stand
The stand with gilt interlaced
L mark
*c.*1764
21⅝ in. (55 cm.) high
Sold 6.12.85 in Monaco for
F.fr.499,500 (£43,892)
From the collection of the late
Sir Charles Clore
Previously sold at Christie's
on 9–17 May 1895 for
£493. 10s.

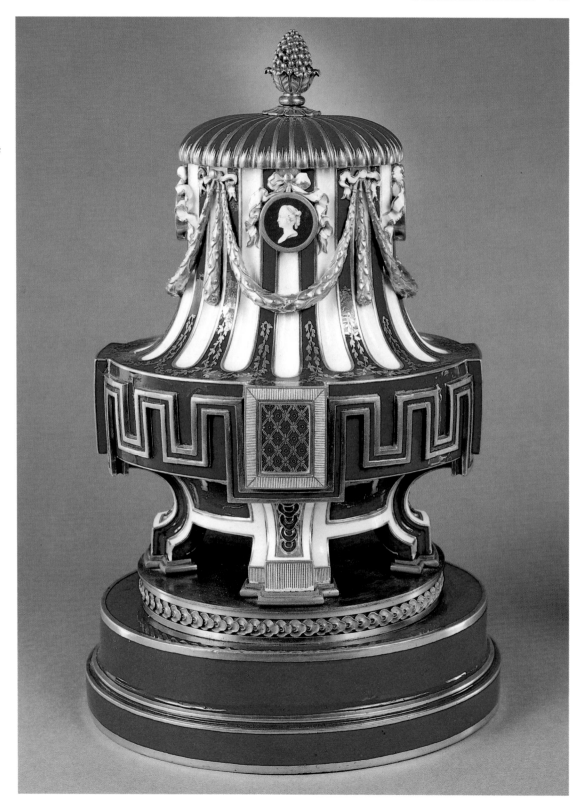

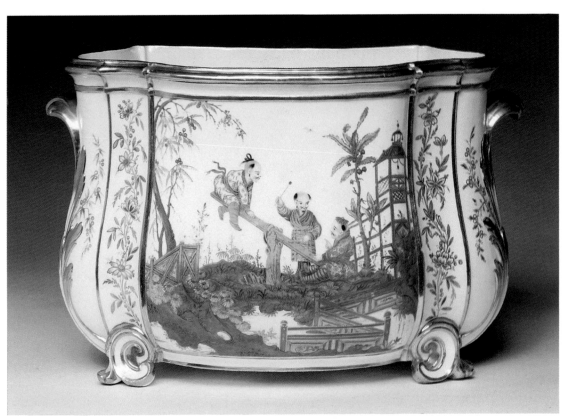

Left:
Sèvres (hard paste) cuvette
courteille
Crowned interlaced L mark
in blue
c. 1775
12¼ in. (31 cm.) wide
Sold 3.6.86 at West Dean for
£20,520 ($30,493)
From the Edward James
Collection

Below:
Sèvres pear-shaped ewer,
cover and oval basin (*pot à eau
ordinaire et jatte ovale*)
Blue interlaced L marks
enclosing the date letter P for
1768 and with the painter's
marks of Buteux aîné
The ewer 7½ in.
(19 cm.) high
The basin 11½ in.
(29.5 cm.) wide
Sold 3.3.86 in London for
£16,200 ($23,207)

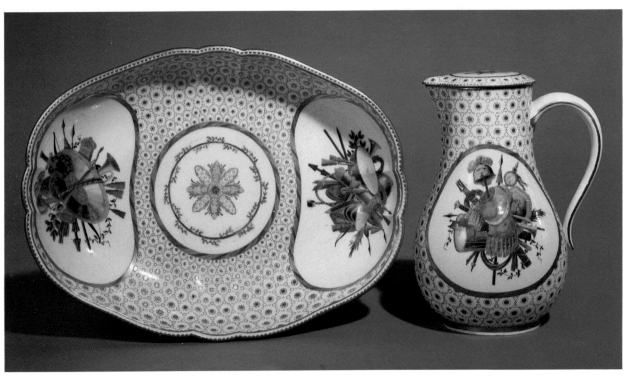

Capodimonte coffee-cup and
saucer
Stippled and coloured by
Giovanni Caselli with fruit in
landscape vignettes
Blue fleur-de-lys marks
*c.*1750
Sold 30.6.86 in London for
£8,640 ($12,960)

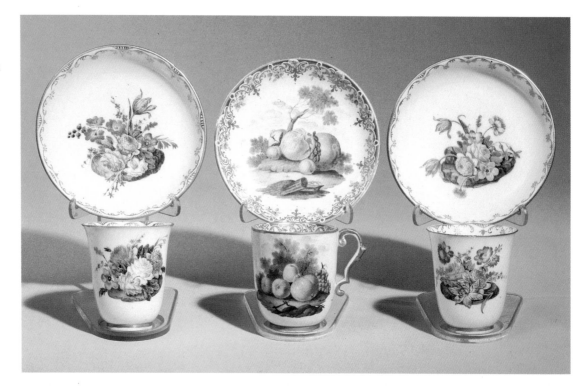

Pair of Naples Ferdinand IV
vases
*c.*1790
16½ in. (41.5 cm.) high
Sold 22.4.86 in Rome for
L.34,500,000 (£13,800)

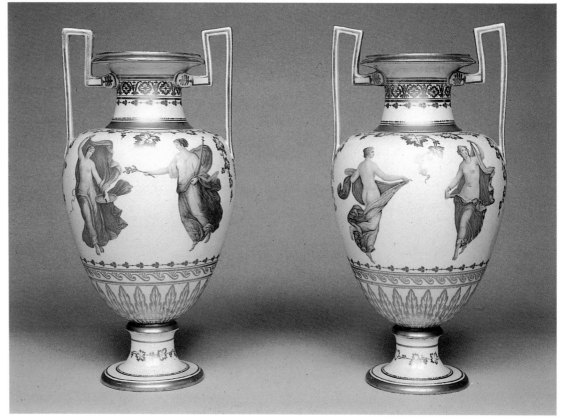

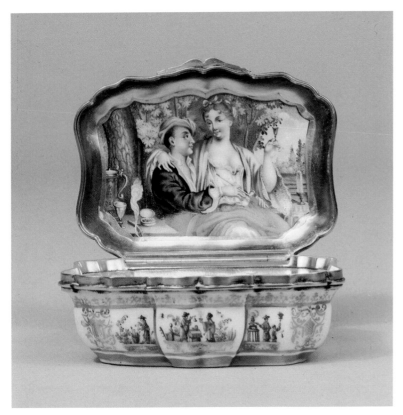

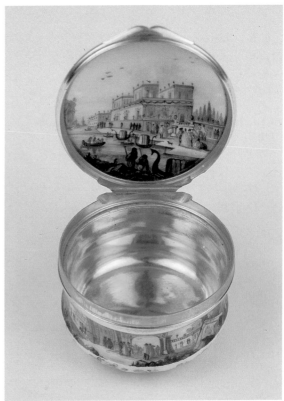

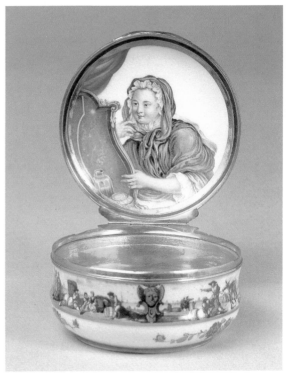

Above:
Meissen Chinoiserie shaped
rectangular gold-mounted snuff-
box and cover
Contemporary hinged reeded
mounts and shaped thumbpiece
*c.*1730
3¼ in. (8 cm.) wide
Sold 30.6.86 in London for
£19,440 ($29,160)
Derived from the engraving by
Bernard Picart dated 1705

Above right:
Meissen gold-mounted circular
bombé snuff-box and cover
Contemporary gold mounts
Amsterdam 1741 and with the
Master's mark of Louis Métayer
2¼ in. (5.5 cm.) diameter
Sold 11.11.85 in Geneva for
Sw.fr.66,000 (£21,710)
No comparable box with
Amsterdam mounts would
appear to be recorded

Right:
Meissen circular snuff-box and
cover
Painted by B.G. Haüer, with
contemporary hinged gold
mount with waved thumbpiece
1738–40
3 in. (7.5 cm.) diameter
Sold 7.10.85 in London for
£19,440 ($27,352)
From the collection of the late
Connal Wade Harris, Esq.

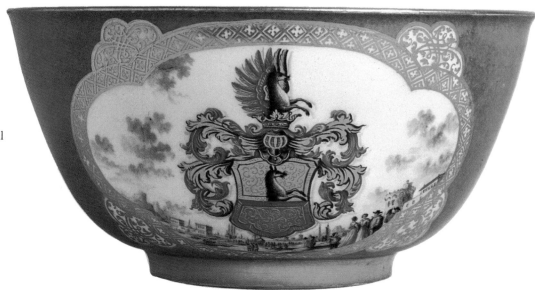

Meissen purple-ground armorial
circular slop bowl
By B.G. Haüer
Blue crossed swords mark
1735–40
6½ in. (16.5 cm.) diameter
Sold 11.11.85 in Geneva for
Sw.fr.33,000 (£10,855)
From the Weitnauer Collection
Previously sold at Christie's
24.3.69 for £2,520

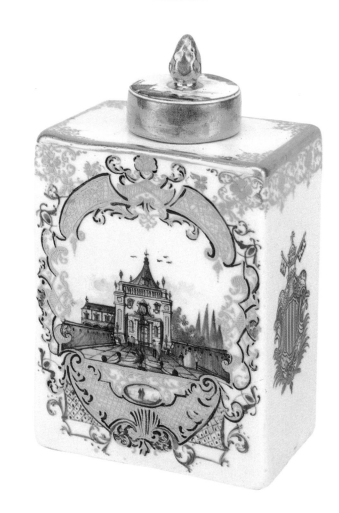

Meissen papal rectangular tea-
caddy and cylindrical cover from
the Benedict XIV service
c.1748
4¾ in. (12 cm.) high
Sold 11.11.85 in Geneva for
Sw.fr.60,500 (£11,901)
Previously sold at Christie's
2.12.74 for £1,785
From the service given by
Augustus III to Tommaso
Lambertini, Pope Benedict XIV,
in recognition of his help with the
building of the Neukirche in
Dresden

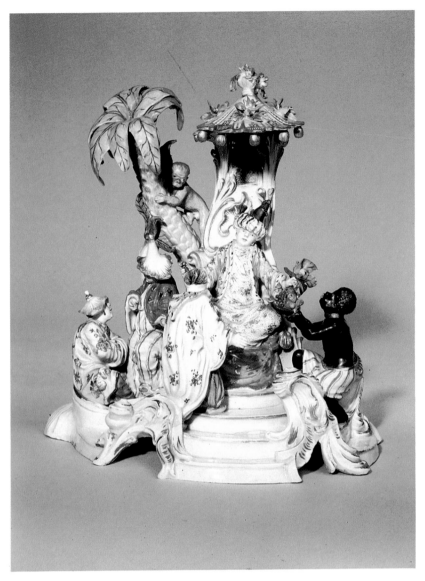

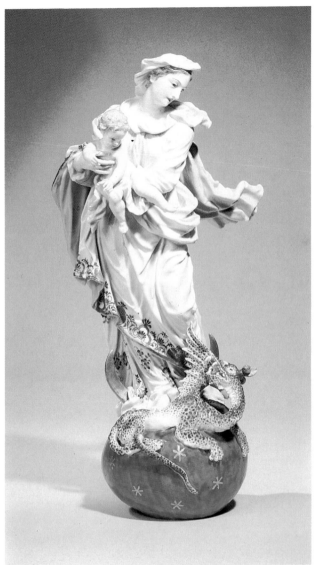

Höchst Chinoiserie group (*Der türkische Kaiser*)
Iron-red wheel mark
Before 1753
9½ in. (24 cm.) high
Sold 9.6.86 in London for £28,080 ($42,373)
Record auction price for a work from this factory
From the Nyffeler Collection

Meissen figure of the Madonna and Child
Modelled by Johann Joachim Kändler
*c.*1738
16½ in. (42 cm.) high
Sold 9.6.86 in London for £45,360 ($68,449)
From the Nyffeler Collection
This group is recorded in Kändler's Taxa for September
1738: '*Es stehet solches Bild auf einer Kugel, worauf ein Drache
liegt auf welchen sie tritt, hat auf dem linken Arm das
Christkindlein sitzen, welches mit einem Spiess den Drachen in
Rachen sticht, solchen zu erlegen. Sonsten ist erwähntes Bild mit
Gewändern gewöhnlicher massen bekleidet*'.
It is associated with the altar set supplied to the Dowager
Empress Amalia, mother-in-law of Augustus III.

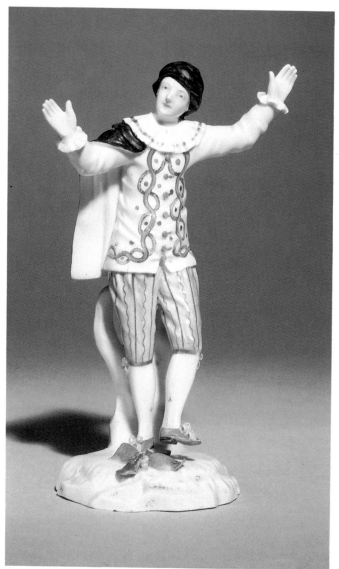

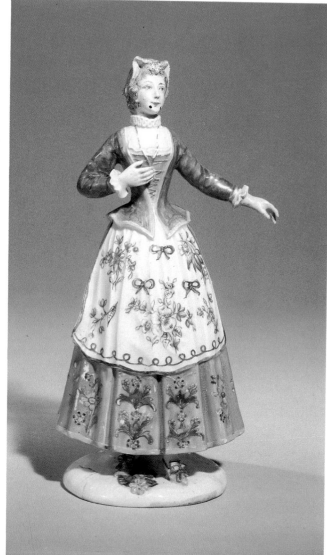

Fulda figure of Scaramouche
Modelled by Wenzel Neu from the *Commedia dell'Arte*
Blue cross mark
c. 1770
5¼ in. (13.5 cm.) high
Sold 3.3.86 in London for £20,520 ($29,395)
From the Meinertzhagen Collection
Now in the Hessiches Landesmuseum, Kassel
This figure would appear to be unrecorded in the literature
and sales of Fulda

Fürstenberg figure of Columbine
Modelled by Simon Feilner from the *Commedia dell'Arte*
c. 1753–4
7¾ in. (19.5 cm.) high
Sold 9.6.86 in London for £16,200 ($24,446)
From the Nyffeler Collection

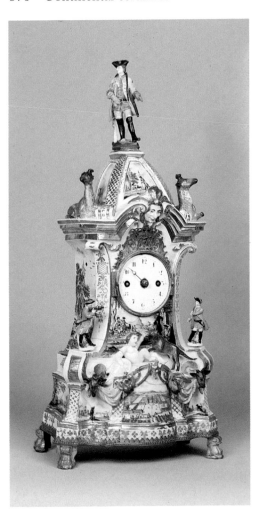

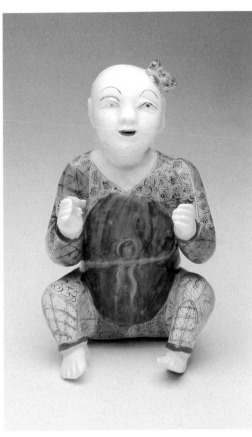

Far left:
Meissen Royal Jagd clock
The contemporary movement inscribed
on the reverse *Joh. Gottlieb*
Gravpner Dresden 149
Blue crossed swords mark at back
*c.*1733
19 in. (48 cm.) high
Sold 30.6.86 in London for £11,880
($17,820)
Now in the George R. Gardiner
Museum for Ceramic Art, Toronto
The crowned cypher would suggest that
this piece was made for Frederick
Augustus II between his succession to
the Electoral Throne of Saxony early in
1733 and his election to the Throne of
Poland as Augustus III later in the
same year.

Above left:
Meissen figure of a seated Chinese boy
Traces of blue mark
*c.*1730
5 in. (13 cm.) high
Sold 30.6.86 in London for £21,600
($32,400)
Now in the George R. Gardiner
Museum for Ceramic Art, Toronto
This model would appear to be
unrecorded in the literature on
Meissen. It is based upon a Chinese
K'ang Hsi original.

Left:
Pair of Chantilly two-handled
cylindrical cache pots
Puce hunting horn marks
*c.*1745
5¼ in. (13.5 cm.) high
Sold 30.6.86 in London for £17,280
($25,920)
Now in the George R. Gardiner
Museum for Ceramic Art, Toronto
The decoration on this lot is very close
to that occuring on Vincennes pieces of
this date. This would imply that either
the same decorator was active at both
factories or that they used the same
engraved sources of inspiration.

Fulda sporting group of a
huntsman and companion
Blue crowned FF mark
*c.*1780
6 in. (15.5 cm.) high
Sold 3.3.86 in London for
£32,400 ($46,413)
Record auction price for a
work from this factory
From the Meinhertzagen
Collection
Adapted from the engraving
Der Herbst by Johann Esaias
Nilson for the Prince Bishop
of Fulda

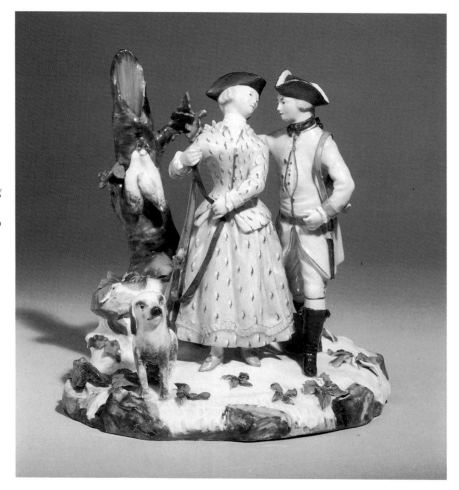

Pair of Zürich figures of a
huntsman and companion
Blue Z marks
*c.*1770
5½ in. (13.5 cm.) high
Sold 11.11.85 in Geneva for
Sw.fr.44,000 (£14,474)
Now in the Schweizerisches
Landesmuseum, Zürich

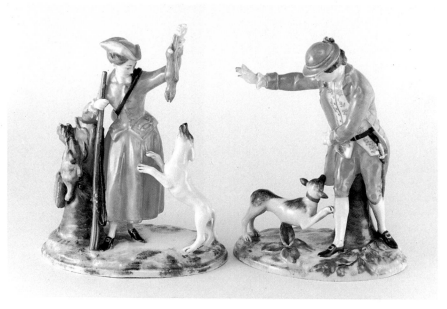

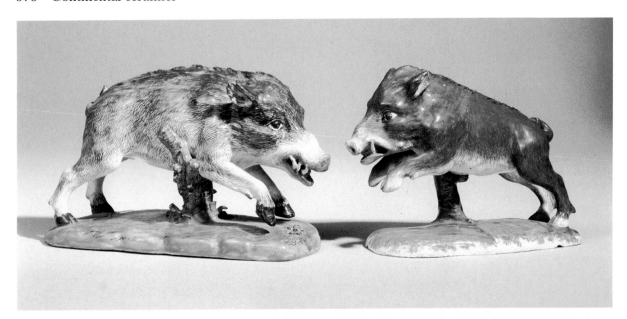

Strassburg faience figure of a running
boar
Modelled by J.W. Lanz
*c.*1750, Paul Hannong Period
8¼ in. (21 cm.) long
Sold 30.6.86 in London for £14,040
($21,060)

Strassburg faience figure of a leaping
boar
Modelled by J.W. Lanz
*c.*1750, Paul Hannong Period
6½ in. (16.5 cm.) long
Sold 30.6.86 in London for £11,880
($17,820)

Documentary Moustiers faience
mythological polychrome rectangular
plaque
Painted with Amphitrite rising from the
sea and with Neptune in his chariot
Inscribed in full 'J. Fouque' on the
reverse, Olerys factory
*c.*1740
8½ × 8 in. (21.5 × 20 cm.)
Sold 12.5.86 in Geneva for
Sw.fr.77,000 (£27,598)

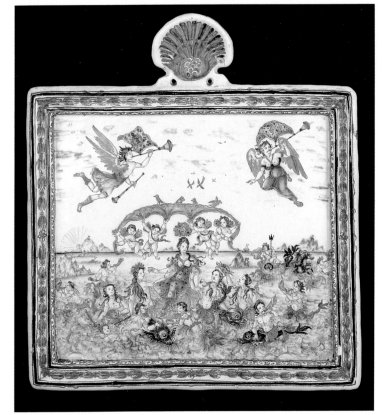

Right:
Pair of Staffordshire saltglaze
polychrome swans
*c.*1750
6½ in. (17 cm.) high
Sold 2.6.86 in London for
£48,600 ($71,588)

Below:

Left:
Whieldon-type lobed plate
*c.*1755
9¾ in. (24.5 cm.) diameter
Sold 29.1.86 in New York for
$1,210 (£860)

Lower left:
Whieldon-type figure of a
seated cat
*c.*1750
5¼ in. (14 cm.) high
Sold 29.1.86 in New York for
$3,190 (£2,266)

Centre:
Whieldon-type large melon
tureen and cover
*c.*1750
11¼ in. (28.5 cm.) wide
Sold 29.1.86 in New York for
$22,000 (£15,625)

Right:
Whieldon tortoiseshell glazed
pierced basket
*c.*1750
10¼ in. (26 cm.) diameter
Sold 29.1.86 in New York for
$7,700 (£5,469)

Lower right:
Whieldon-type apple teapot
*c.*1760
7½ in. (19 cm.) wide
Sold 29.1.86 in New York for
$7,480 (£5,312)

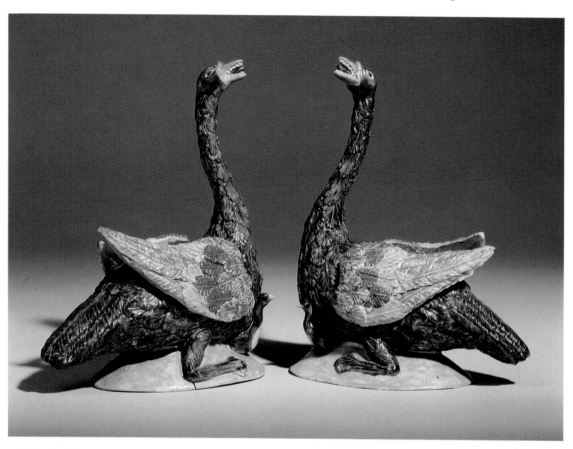

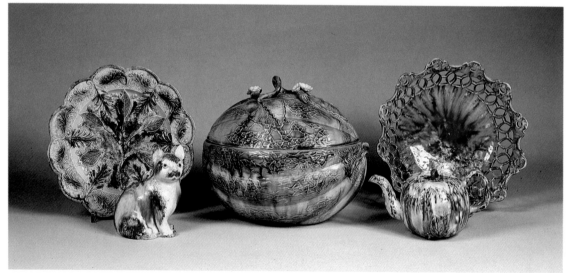

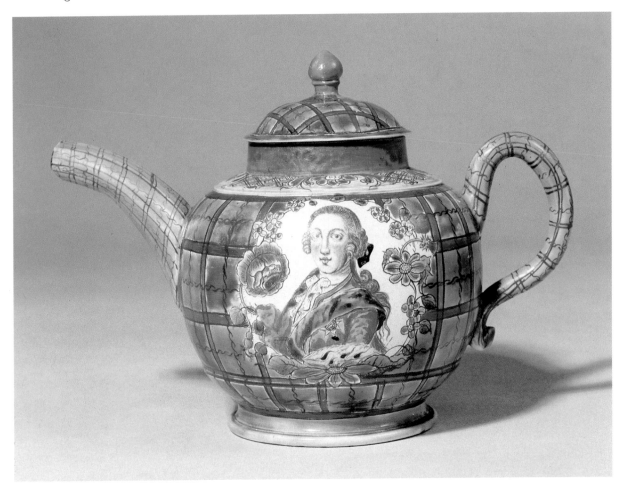

Staffordshire saltglaze tartan-ground royalist teapot and cover
c. 1750
5 ½ in. (14 cm.) high
Sold 14.10.85 in London for £10,800 ($15,201)

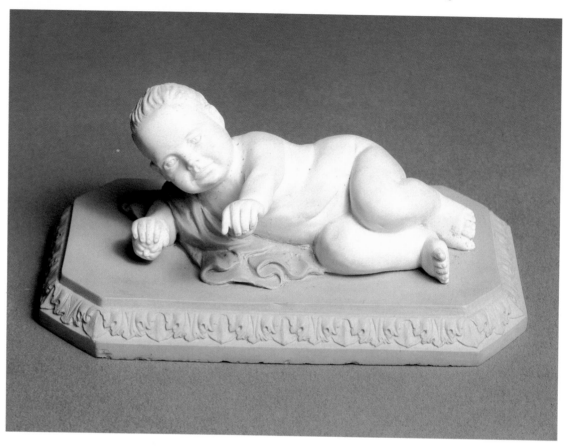

Wedgwood three colour jasper figure of a reclining
child
Modelled by William Hackwood after the Della
Robbia original
*c.*1785
5½ in. (14.3 cm.) long
Sold 10.2.86 in London for £10,800 ($15,142)

Wedgwood & Bentley caneware hare's head stirrup
cup
Impressed Wedgwood & Bentley mark
*c.*1775
7 in. (18.5 cm.) long
Sold 6.5.86 in New York at Christie's East for
$28,600 (£18,451)

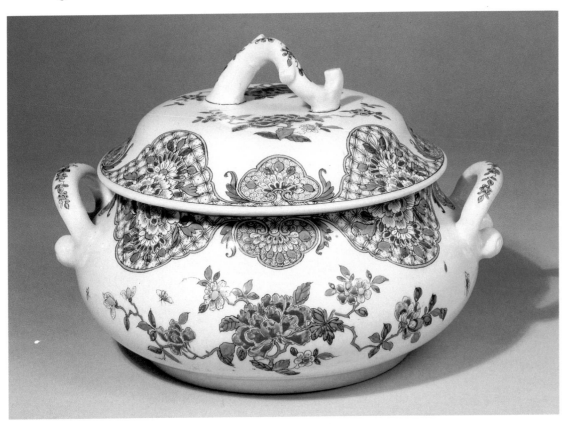

Bow circular tureen and cover
The unglazed base with incised R mark
c.1750
26 in. (66 cm.) wide
Sold 10.2.86 in London for £7,020 ($9,842)

Unrecorded documentary Bow dated blue and white ink-pot
Inscribed 'Made: at New Canton 1750'
3½ in. (9 cm.) diameter
Sold 10.2.86 in London for £10,800 ($15,142)

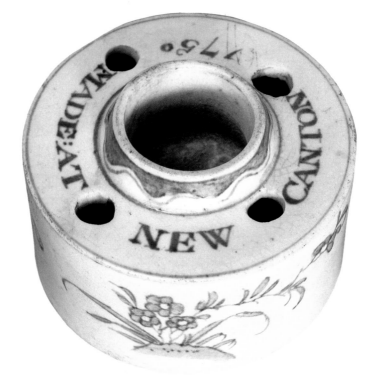

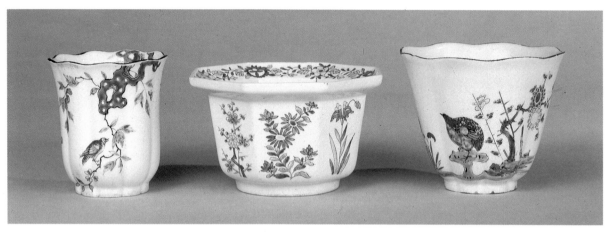

Left:
Chelsea lobed beaker
*c.*1750
2¾ in. (7 cm.) high
Sold 10.2.86 in London
for £7,560 ($10,655)

Centre:
Chelsea octagonal bowl
*c.*1752
4 in. (10.5 cm.) wide
Sold 10.2.86 in London
for £3,024 ($4,240)

Right:
Chelsea fluted flared
beaker
*c.*1750
3 in. (7.5 cm.) high
Sold 10.2.86 in London
for £2,592 ($3,634)

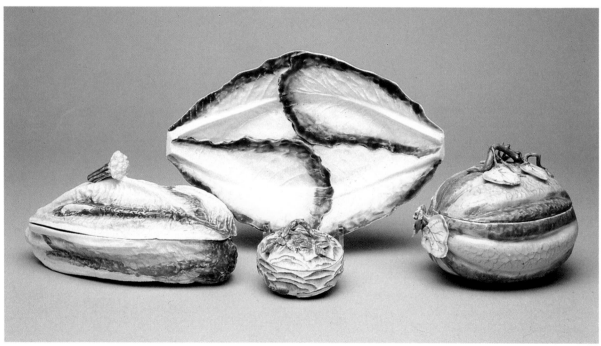

Left and centre:
Longton Hall cos-lettuce
tureen, cover and stand
*c.*1755
The stand 11½ in.
(29.5 cm.) wide
Sold 29.1.86 in New
York for $10,780 (£7,656)
In the advertisements of
1757 and 1758 for
Longton Hall Wares
various leaf shaped
articles are reported

Centre:
Longton Hall rose box
and cover
The cover impressed with
the letter l, the box with
painter's number 21 in
iron-red
*c.*1755
3¼ in. (8.3 cm.)
diameter
Sold 29.1.86 in New
York for $4,620 (£3,282)

Right:
Longton Hall melon
tureen and cover
*c.*1755
6 in. (15.5 cm.) wide
Sold 29.1.86 in New
York for $9,350 (£6,641)

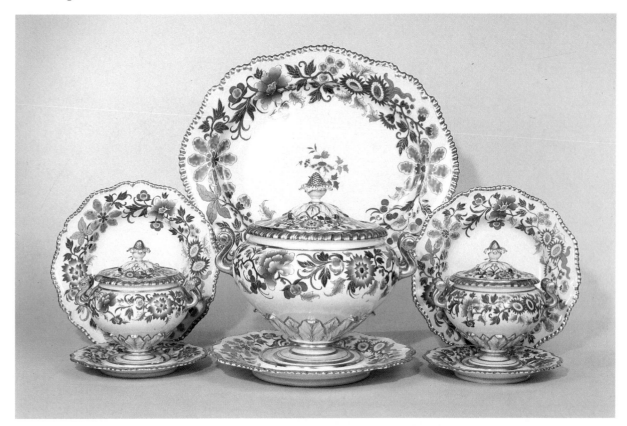

Above:
Worcester (Flight, Barr & Barr) dinner-service comprising: a circular two-handled soup-tureen, cover and stand; four sauce-tureens, covers and stands; two square salad-bowls; four rectangular vegetable-dishes and covers; two oval vegetable-dishes and covers; 24 shaped oval dishes in sizes; 20 soup-plates; 46 dinner-plates; 33 dessert-plates
c. 1815
Sold 14.10.85 in London for £34,560 ($48,643)

Right:
One from a set of 12 Rockingham dessert plates made by Royal Order
Dated 1832
9¼ in. (23.5 cm.) diameter
Sold 9.10.86 in New York for $30,800 (£21,852)
From the estate of Nathan Cummings
The arms are those of King William IV

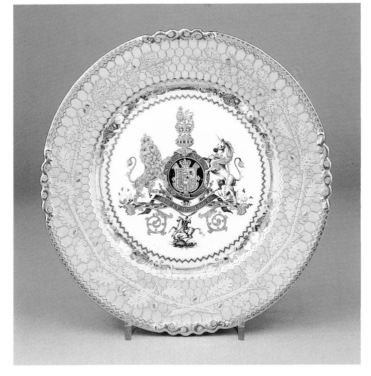

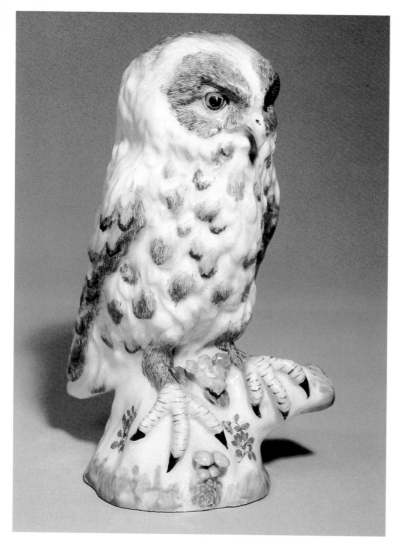

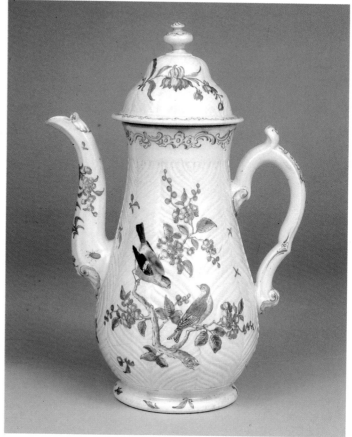

Bow owl
*c.*1758
7 ¾ in. (20 cm.) high
Sold 2.6.86 in London for £25,920 ($38,181)
By order of the Trustees of The Harewood Charitable Trust

Worcester herringbone-moulded baluster coffee-pot and
domed cover
Painted in the manner of James Rogers
*c.*1756
10 in. (25 cm.) high
Sold 2.6.86 in London for £5,184 ($7,636)

Caspar Lehmann

RACHEL RUSSELL

The adoption of the wheel in the decoration of glass was the major technical innovation of the early 17th century. This important step forward arose principally out of the hothouse atmosphere of the Imperial Court workshops of Prague where, under the patronage of Rudolph II, an extraordinary group of the most eminent artists and craftsmen of the day was gathered together. Prominent among them was Caspar Lehmann, a name which engenders excitement in the mind of the student of the history of glass, since it is he who is credited with being one of the earliest exponents of this new technique.

Caspar Lehmann (1563?–1622) is known to have shared apartments in Prague castle with the silversmith Paul van Vianen, the painter Hans von Aachen and the stone engraver Zacharias Peltzer, all of whom he would have met during his stay in Munich, where he served his apprenticeship as a hardstone-engraver until 1587/8. Lehmann received his first payment in Prague in 1588 and is recorded there as *Hoftrabant* in 1590, *Leibtrabant* in 1594, *Hartschier* in 1595–9, *Hofdiener* in 1600 and *Cammeredelsteinschneider Seiner Majestät* in 1601. Following his dismissal in disgrace from the court in Prague in 1606, he worked in Dresden at the court of Christian II as *Churfürstlicher sächsischer Kammersteinschneider* until his return to Prague in 1608 and it was in the following year that his famous glass engraving privilege was granted.

The attribution of the extant Lehmann works is based on his only signed example, the celebrated Prague beaker, dated 1605, with the three allegories of *Potestas*, *Nobilitas* and *Liberalitas*, and the rock-crystal covered goblet with Diana mentioned in account books of the Dresden court of 1606. The source of inspiration for much of his work, in particular his three portraits and the allegorical subjects, was the work of prominent contemporary artists or anonymous drawings by their associates which, in view of his close connections with the court, would have been readily available. In many cases he adapted or combined different elements in the one picture, a point which makes positive identification of the original hazardous.

Until the emergence of the group of five glass panels offered in our sale on 3 June (three of which are illustrated opposite), only 10 examples of glass including the Prague beaker are recorded with a firm attribution to the hand of Caspar Lehmann. With the exception of the beaker, these are all panels of roughly similar size, three engraved with portraits, three with allegorical subjects and three with the dates 1619 or 1620, these last more than likely of political significance. Of the panels illustrated, *Virtue triumphing over Evil*, as well as the example dated 1620, would seem to fall into this latter group, the iconography of which has perplexed researchers over many years. At such a turbulent period in European history, the court would have had its own point of view on contemporary events, now lost in the passage of time and devastating effects of the Thirty Years War immediately following.

The panel showing *Europa and the Bull*, perhaps taken from Ovid's *Metamorphoses* by Crispin de Passe, together with two further panels included in this sale, are perhaps those most closely associated with Lehmann's stay in Dresden, the initials CH being interpreted as those of Christian II of Saxony and his wife Hedwig, daughter of Frederick II of Denmark. Robert Charleston, in an unpublished paper on Lehmann read at the Corning Glass Museum Seminar in 1981, noted that in March 1608, whilst still in Dresden, Lehmann had been ordered payment for '5 engraved glasses, of which – the largest – is engraved with the Saxon and Danish arms'; this latter is now in the Kunst und Gewerbe Museum, Hamburg, another with the crowned CH initials is in the collection of the Victoria and Albert Museum. After a period of nearly 350 years, perhaps the present three panels finally complete this original group of five.

The discovery of this remarkable group of five glass panels, whose existence until this year was quite unknown, must be considered a major enrichment of our knowledge of the corpus of recorded works by this master.

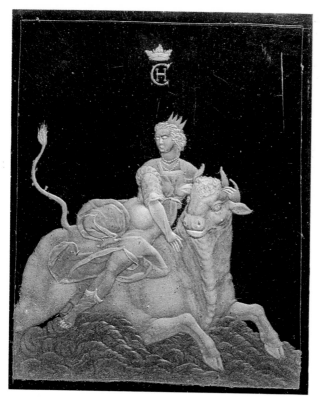

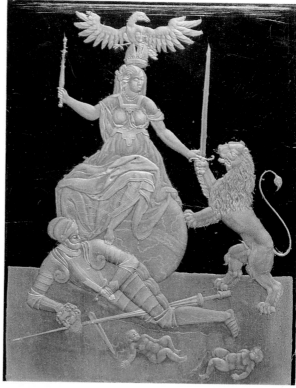

Above:
Rectangular glass panel, engraved with Europa and the Bull
By Caspar Lehmann
Dresden or Prague, 1606–11
9 × 7 in. (23 × 18.2 cm.)
Sold 3.6.86 in London for £27,000 ($40,500)

Above right:
Rectangular glass panel engraved with an allegory, perhaps representing
Virtue triumphing over Evil
By Caspar Lehmann
Prague, *c.* 1605
9 × 7 in. (23 × 19 cm.)
Sold 3.6.86 in London for £27,000 (£40,500)

Right:
Dated rectangular glass panel
By Caspar Lehmann
Prague, 1620
9 × 7 in. (23 × 18.5 cm.)
Sold 3.6.86 in London for £27,000 ($40,500)

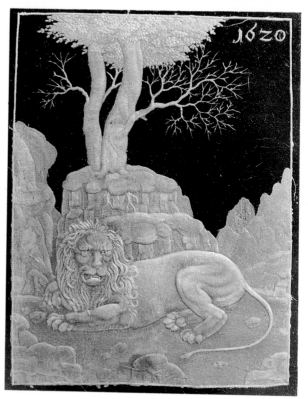

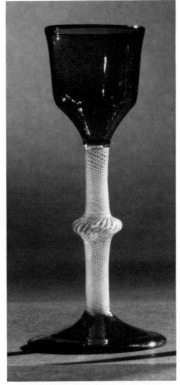

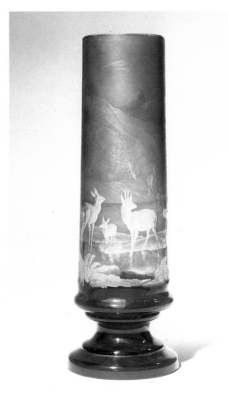

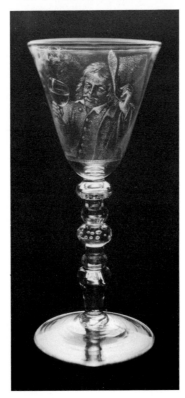

Above:
Dated facet-stemmed stipple-engraved wine-glass
By David Wolff
Inscribed on ribbon cartouches
Winter en Zomer/Verre en Naby/Dood en Leeven and above *Vriendshap*, the reverse inscribed on a zig-zag ribbon *Vereert aan't gezelschap der VVVVV door H.Stenfert, 1786*
The Hague, 1786
6½ in. (17.5 cm.) high
Sold 24.9.85 in Amsterdam for
D.fl.17,400 (£3,866)

Above right:
Two-coloured wine-glass
*c.*1760
6 in. (15 cm.) high
Sold 3.6.86 in London for £3,240
($4,815)

Above:
North Bohemian blue overlay vase
By Franz Zach
Signed on the bowl *F. ZACH*
Perhaps Garrach glasshouse, Neuwalt,
*c.*1860
11½ in. (30 cm.) high
Sold 3.6.86 in London for £4,860 ($7,290)

Left:
Stipple-engraved goblet
By Aart Schouman
Inscribed *Vreede en Vryheit* (Peace and Freedom), the bowl signed beneath the portrait *Aart Schouman, fecit, 1743*
1743
8 in. (21 cm.) high
Sold 24.9.85 in Amsterdam for D.fl.110,200
(£24,488)
Record auction price for a glass by the engraver

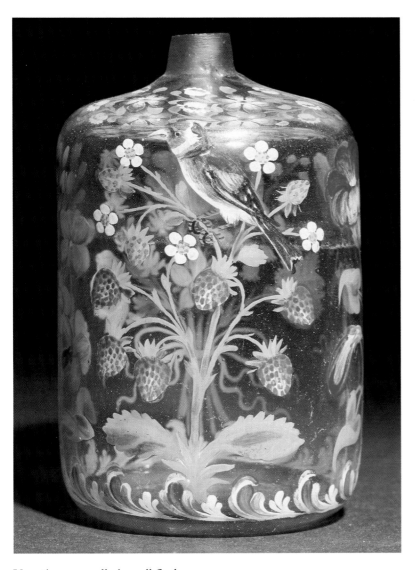

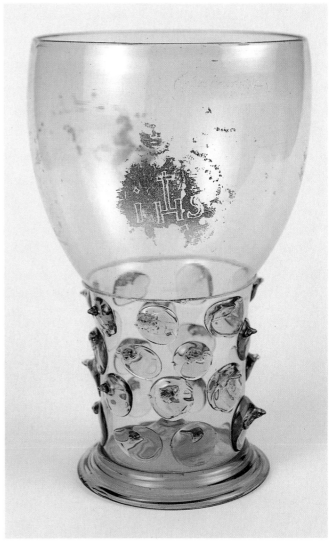

Venetian enamelled small flask
From the atelier of Osvaldo Brussa
Second quarter, 18th century
3½ in. (9 cm.) high
Sold 20.11.85 in London for £2,808 ($4,007)

Dutch large roemer of greenish-turquoise tint
Inscribed on the convex bowl in diamond-point *In
eerbaerheyt*, with traces of gilt decoration including the motto
IHS
Early 17th century
7 in. (18 cm.) high
Sold 24.9.85 in Amsterdam for D.fl.39,440 (£8,764)

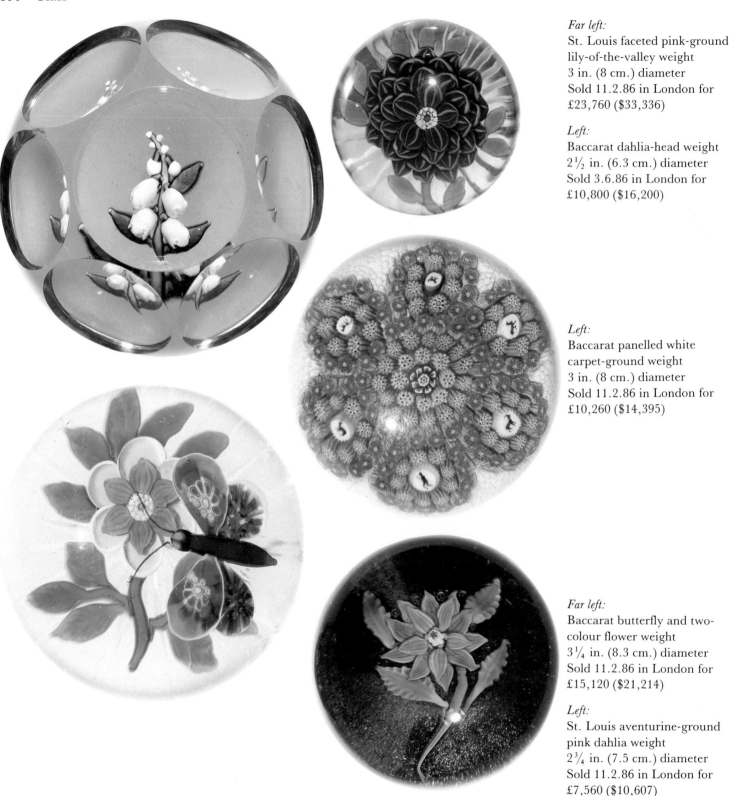

Far left:
St. Louis faceted pink-ground
lily-of-the-valley weight
3 in. (8 cm.) diameter
Sold 11.2.86 in London for
£23,760 ($33,336)

Left:
Baccarat dahlia-head weight
2½ in. (6.3 cm.) diameter
Sold 3.6.86 in London for
£10,800 ($16,200)

Left:
Baccarat panelled white
carpet-ground weight
3 in. (8 cm.) diameter
Sold 11.2.86 in London for
£10,260 ($14,395)

Far left:
Baccarat butterfly and two-
colour flower weight
3¼ in. (8.3 cm.) diameter
Sold 11.2.86 in London for
£15,120 ($21,214)

Left:
St. Louis aventurine-ground
pink dahlia weight
2¾ in. (7.5 cm.) diameter
Sold 11.2.86 in London for
£7,560 ($10,607)

Oriental Ceramics and Works of Art

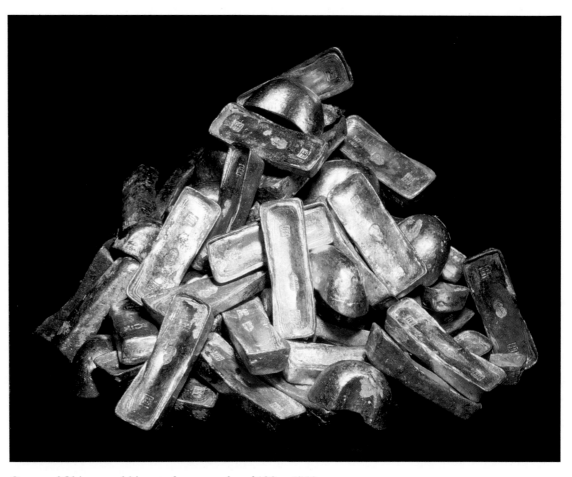

Group of Chinese gold ingots from a cache of 126, *c*.1750
18 shoe-shaped ingots $2\frac{1}{4}$ in. (5.5 cm.) wide
108 rectangular ingots $3\frac{1}{4}$ in. (8 cm.) wide
Sold 28.4.86 in Amsterdam for a total of D.fl.4,365,080 (£1,179,751)
From the Nanking Cargo

The Nanking Cargo

ANTHONY THORNCROFT

For Christie's, for the art market, for the world at large, 1986 will always be remembered as the year of Hatcher, for the dispersal, over five days at the Hilton Hotel in Amsterdam, of around 150,000 items of mid-18th century Chinese porcelain, plus 126 bars of gold, rescued from the depths of the South China Sea by 'Captain' Michael Hatcher.

The Hatcher story has everything. An ex-Barnardo boy from Yorkshire; precarious years spent as a tin salvager among the islands of Indonesia; the discovery in 1983 of a sunken junk which turned out to contain over 20,000 pieces of mid-17th century blue and white Chinese porcelain; the successful sale of the hoard through Christie's in Amsterdam; the return of Hatcher to the South China sea and the finding of a second, much larger, wreck.

The very size of 'Hatcher Two' caused Christie's some trepidation. Could the existing market possibly absorb such a vast quantity of Chinese porcelain? It seemed unlikely, especially as this was a cargo destined for the upper and emerging middle classes of northern Europe, with few exceptional items to excite the committed collector. Only by widening the demand and attracting the interest of new buyers could Christie's guarantee success. A major marketing campaign, perhaps the biggest ever mounted by an auction house, was set in train. A video was made of the excavation; a substantial hardback catalogue was produced in unprecedented quantities; the world's media was activated. In all, Christie's invested highly in the Hatcher auction, perhaps not unreasonably for the biggest single-owner sale of decorative arts ever held.

By a stroke of good fortune Dr Jorg of Groningen was able to identify the wreck from marks on some of the items – it was the *Geldermalsen*, a Dutch East Indiaman, which went down in 1751 near Java. With the names of the crew known, the evidence of the survivors, and a manifest of the contents, what had been just another wreck became living history.

The discovery of the fate of the crew helped stimulate public interest but did not reassure Christie's about the success of the sale. The main initial burden fell on Chinese specialists James Spencer and Colin Sheaf who had to catalogue it. How could they divide up the lots to ensure maximum demand? There were, for example, over 40,000 tea bowls and saucers. Obviously they would have to be gathered together in vast quantities but just how many in each lot? If the lots were too large it would deter the new buyers who were crucial for a happy outcome. Then there were the items encrusted with the detritus of two and a half centuries on the sea bed – would anyone want them? And what about the gold – should it be estimated at the current bullion price?

The logistics of the sale also caused worries. How would the team of eight auctioneers cope? Would the packed audience maintain its interest over so many days? How could the items be organized so that there were periodic bursts of excitement? To protect itself from over-enthusiasm Christie's placed a modest £3 million ($4.26 million) estimate on the sale.

It knew it had a hit on its hands by the size of the queues, 20,000 strong, for the previews – and by the 125,000 commission bids that were in the hands of the auctioneer by the opening

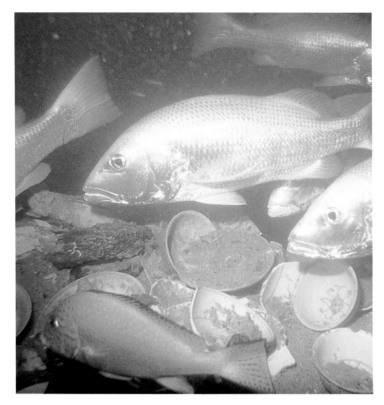

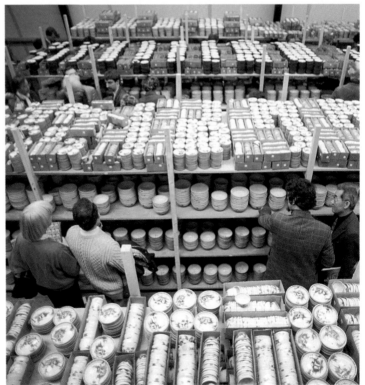

Above:
Porcelain scattered on the sea-bed

Above right:
Clients queuing to view the Nanking Cargo at Christie's in Amsterdam

Right:
The Nanking Cargo on view prior to the sale

Media attention at the sale

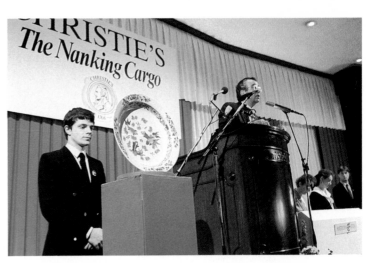

One of the fish dishes being sold for D.fl.104,400 (£28,216) by Harts Nystad, Chairman of Christie's Amsterdam

session. In the event the Hatcher sale became the major event of the season in Amsterdam and was a resounding success from the start. The two opening sessions were complete sell-outs, bringing in almost £1.4 million ($1.99 million) and with most items multiplying their forecasts five times. It set the pattern for the week and by Friday evening Christie's was contemplating a total of £10 million ($14.2 million).

The highlights were sprinkled throughout the week. The first came on the Monday evening when one of the gold bars, shaped like a shoe for good fortune and unknown before Hatcher's find, sold for £53,298 ($75,681); Christie's had given it a bullion value of around £2,000 ($2,840). So great was gold fever that night that the 125 ingots brought in over £1.15 million ($1.63 million).

The audience actually broke into applause the next day when auctioneer John Gloyne produced a record bid for a porcelain dinner service of £219,460 ($311,633) (overtaken at Christie's two months later when a Sèvres dinner service topped £237,000 ($336,540)). For Sheaf the most nail-biting day was the Friday when the thousand upon thousand of tea bowls and saucers came under his hammer. In the event the sales rush continued, with a typical lot of 48 sets making £6,270 ($8,903) as against an estimate of less than £1,000 ($1,420), for an average price of £130 ($184) while lots of a thousand sets sold for £31,351 ($44,518), or thereabouts, averaging £31 ($44) a set.

The other major surprise was the demand for pieces of porcelain, and the like, which were so encrusted with coral and the sediment of the sea-bed that they were almost indecipherable. One such object, which was once a cannon ball, sold for £7,567 ($10,745) as against a £400 ($568) estimate. It was bought by a French art collector who usually favours the sculptures of Henry Moore. She considered the bizarre shape provided the same stimulation to the imagination.

Sheaf later admitted that he had been over-conservative in cataloguing the tea bowls. In the event there was a tremendous demand for these, the cheapest Hatcher items, from the thousands of primed up potential buyers desperate for a memento from the sale. A set of tea bowl and

saucer in an average lot, which Sheaf estimated might sell for £12 ($17) actually made £48 ($68) in the auction room. The hunt for something from Hatcher was international – from Women's Institutes in Somerset to Harrods; from Australia to New York. Some London dealers, like Heirloom & Howard, Cohen & Pearce, and Bernheimer, invested up to £1 million ($1.42 million), mainly buying for clients but also for stock.

There were, of course, great worries as to whether this vast quantity of (mainly) blue and white would not undermine price levels in the Chinese export porcelain market. In the event it has split into two sectors – Hatcher items and non-Hatcher. There are some purist dealers who affect to look down on the Hatcher cargo, and few would claim it represents the height of the Chinese artistic genius. But for everyday domestic antiques it can hardly be bettered. With care, the items can even be used.

Some of the Hatcher porcelain from the auction will be released on to the market – through smart department stores and through dealers – slowly over the next few years. It should always command a price premium over comparable export porcelain of the period. Every item has been marked. Christie's itself expects to be selling pieces again and again in the future. In the end it was not a saleroom story but a human interest story, which gripped the imagination of thousands of people who had perhaps never considered buying at auction or owning antique porcelain.

The result pleased everyone. Hatcher had funds to improve his working yacht and increase his chances of finding another wreck – he went quickly back to the South China Sea to follow up a good prospect. Christie's enjoyed a flood of publicity, and ensured that its Amsterdam saleroom would in future be considered *the* place to sell works of art rescued from the sea. And thousands of people were happy to own a bit of Hatcher, some paying thousands for the privilege, some just a few pounds.

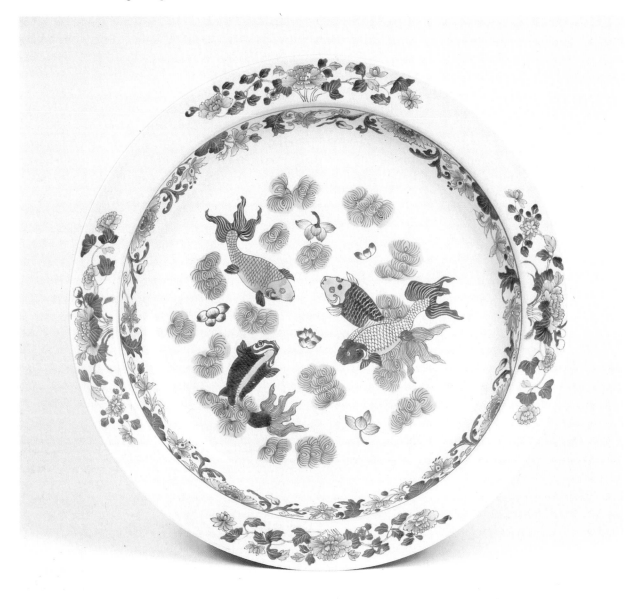

Blue and white deep dish
*c.*1750
17¾ in. (45 cm.) diameter
Sold 28.4.86 in Amsterdam for D.fl.104,400 (£28,217)
From the Nanking Cargo

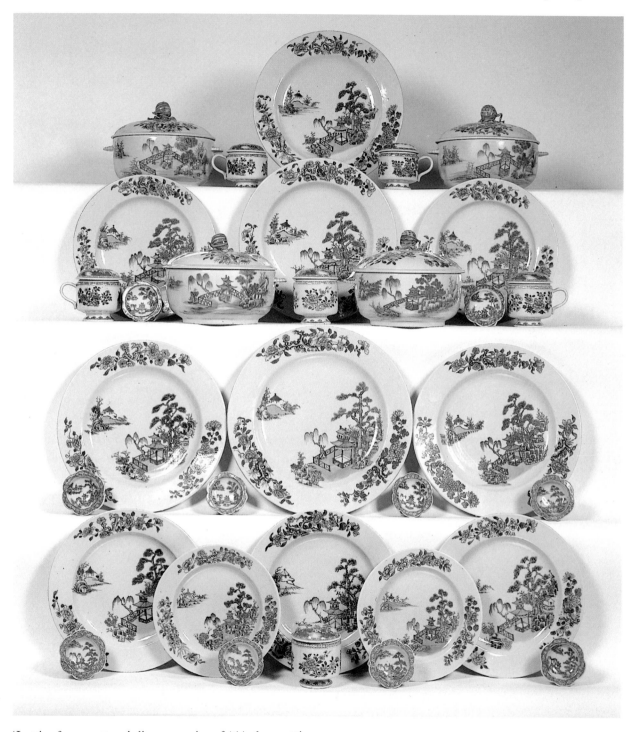

'Lattice fence pattern' dinner service of 144 place settings
*c.*1750
Sold 30.4.86 in Amsterdam for D.fl.812,000 (£219,460)
Record auction price for a Chinese porcelain dinner service
From the Nanking Cargo

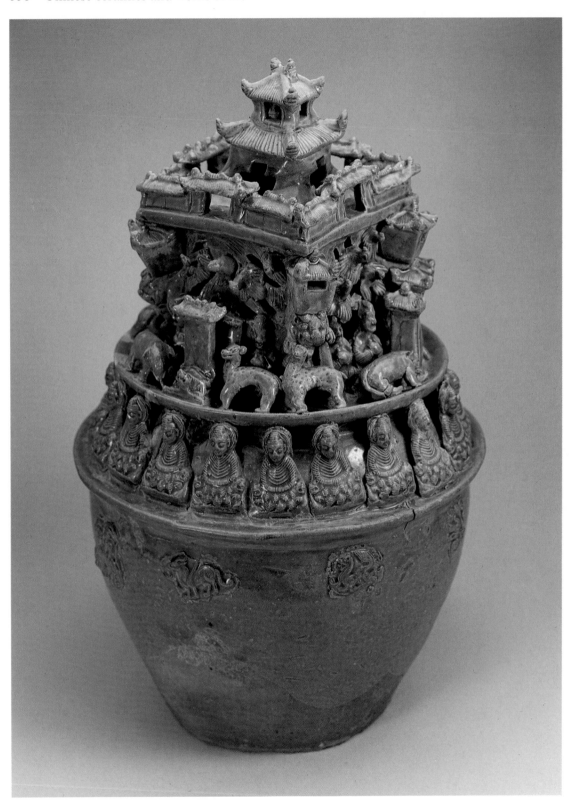

Yue Yao funerary vase
Six Dynasties
18 in. (45.5 cm.) high
Sold 16.6.86 in London for
£102,600 ($160,056)

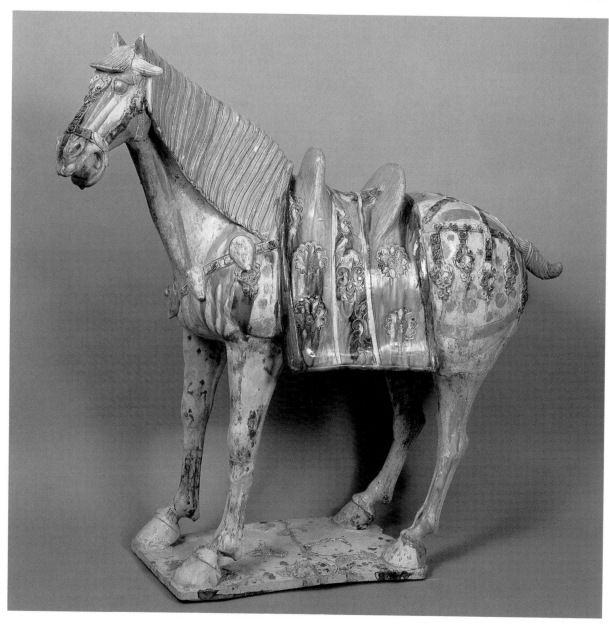

Sancai pottery figure of a caparisoned horse
Tang Dynasty
30¼ in. (77 cm.) high
Sold 9.12.85 in London for £237,600 ($346,420)

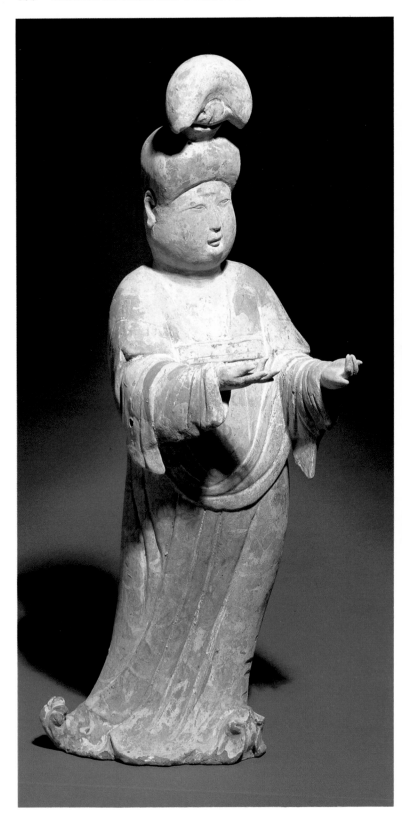

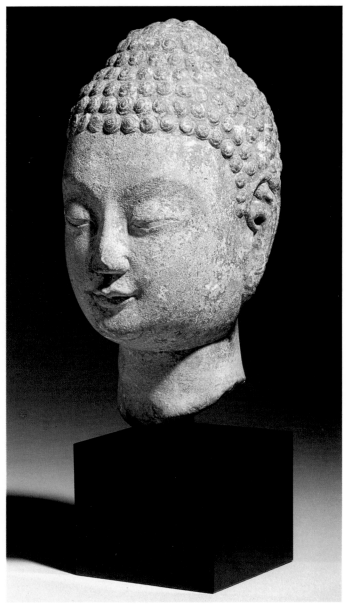

Above:
Small early limestone head of a youthful Buddha
Northern Qi/Sui Dynasty
*c.*570
9¼ in. (23.5 cm.) high
Sold 5.6.86 in New York for $49,500 (£33,045)

Left:
Painted red pottery figure of a court lady
Tang Dynasty
17½ in. (44.5 cm.) high
Sold 9.12.85 in London for £62,640 ($91,329)

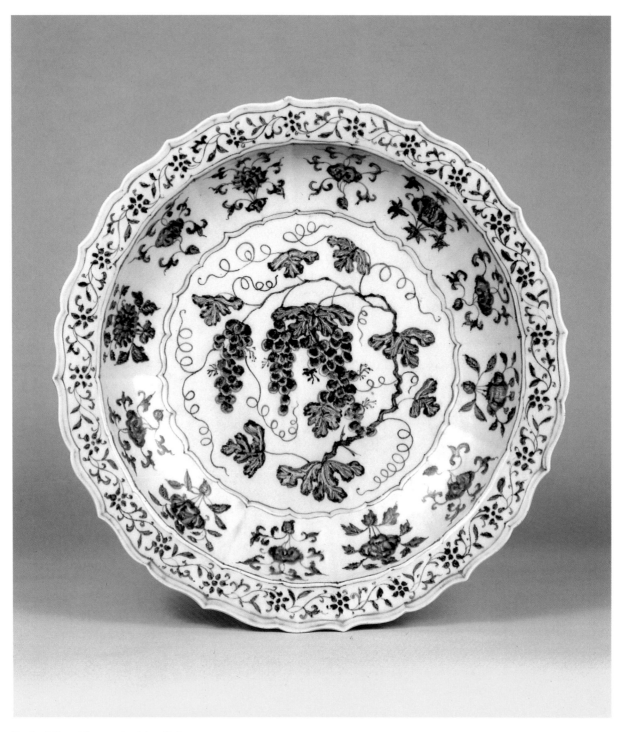

Early Ming blue and white dish
Yongle
17½ in. (44.5 cm.) diameter
Sold 9.12.85 in London for £105,840 ($154,315)

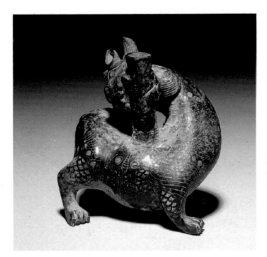

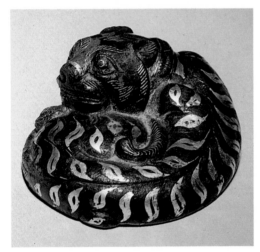

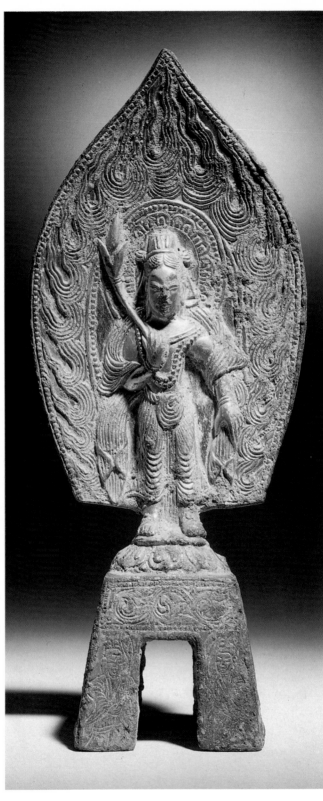

Northern Wei gilt-
bronze figure of a
Bodhisattva
Inscribed and dated
'Yanchang first year
second month' (AD 512)
7 in. (17.5 cm.) high
Sold 16.6.86 in
London for £32,400
($50,544)

Top:
Inlaid bronze joss-stick holder
Western Han Dynasty
3½ in. (9 cm.) high
Sold 5.6.86 in New York for $71,500 (£47,731)

Above:
Silver-inlaid bronze shroud weight modelled as
a recumbent tiger
Han Dynasty
Approx. 2¾ in. (7 cm.) wide
Sold 2.10.85 in New York for $71,500
(£50,317)

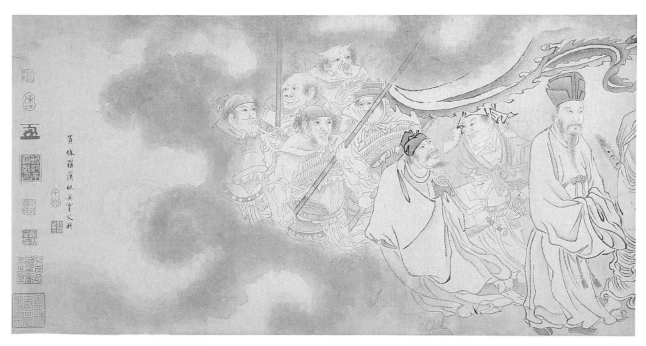

Above:
Qiu Ying (*c.*1495–1552)
Lohans (Arhats)
Handscroll, ink on
paper
13¾ × 198½ in.
(34 × 504 cm.)
Sold 3.12.85 in New
York for $165,000
(£111,336)

Right:
Mi Fu (1051–1107)
Calligraphy in *Xing Shu*
(Running Script):
*Treatise on Ten Different
Types of Chinese Paper*
Handscroll, ink on silk
12¾ × 85 in.
(32.5 × 216 cm.)
Sold 3.12.85 in New
York for $132,000
(£89,067)

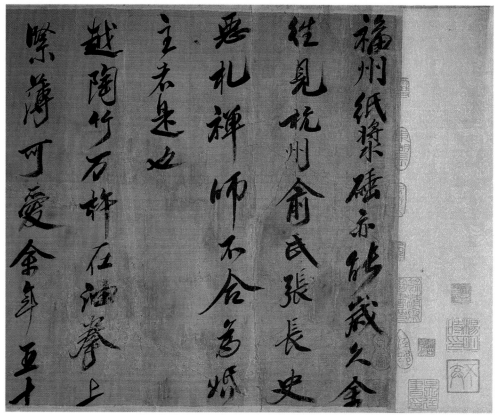

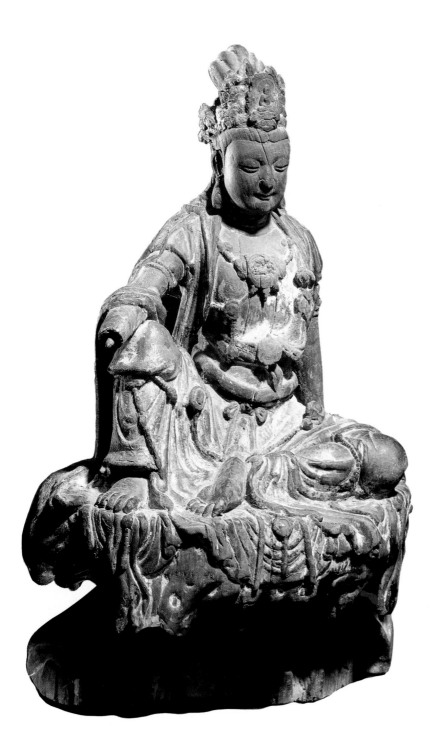

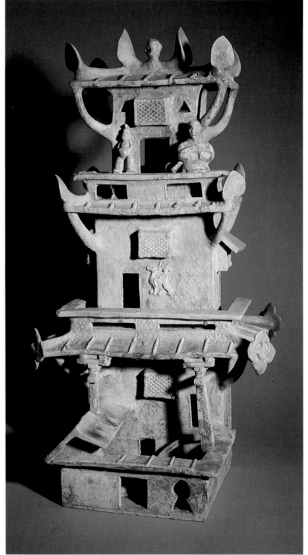

Above:
Green-glazed funerary model of a two-storeyed
watchtower
Han Dynasty
33 in. (84 cm.) high
Sold 1.12.85 in New York for $93,500 (£63,048)

Left:
Wood seated figure of Guanyin
Song Dynasty
*c.*12th century
23⅛ in. (59 cm.) high
Sold 5.6.86 in New York for $93,500 (£62,417)

Jade necklace of 59 beads
Approx. $\frac{1}{8}-\frac{1}{2}$ in.
(4–12.7 mm.) diameter
Sold 13.1.86 in Hong Kong
for HK$1,540,000 (£135,088)

Inset:
Jade pendant
Approx. $1\frac{3}{4} \times \frac{5}{8} \times \frac{1}{4}$ in.
(46 × 17 × 6 mm.)
Sold 3.1.86 in Hong Kong for
HK$418,000 (£36,667)

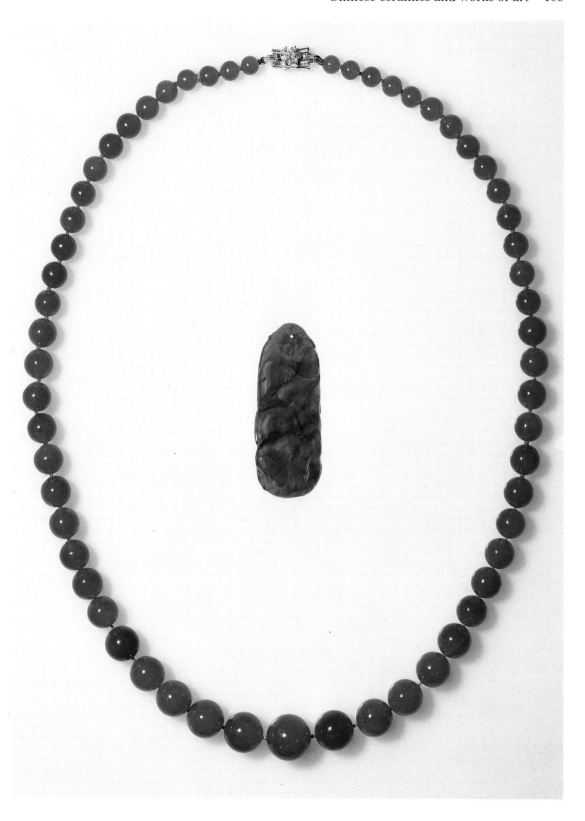

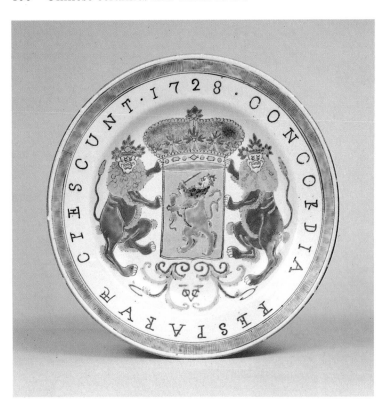

Famille rose plate with the arms of the Dutch East India Company
Yongzheng
9 in. (22.5 cm.) diameter
Sold 12.11.85 in London for £9,720 ($13,788)

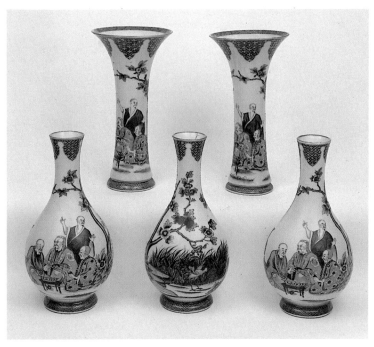

Blue and white garniture of three vases and covers and two beakers, with the *Doctor's Visit* painted after Cornelis Pronk
*c.*1736
11 in. (28 cm.) high
Sold 9.6.86 in Amsterdam for D.fl.110,200 (£29,000)

Famille rose standing figure
of a Dutch merchant
Qianlong
17¼ in. (42.5 cm.) high
Sold 7.7.86 in London for
£37,800 ($56,700)

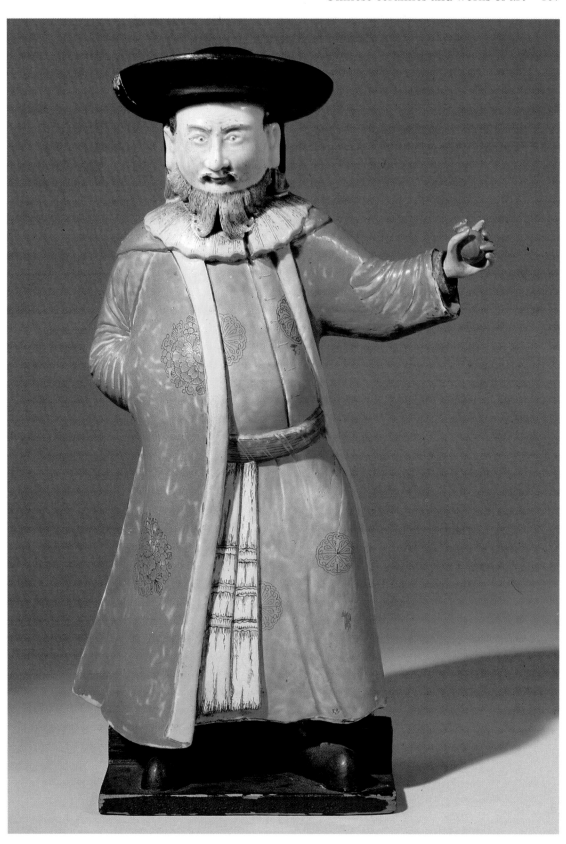

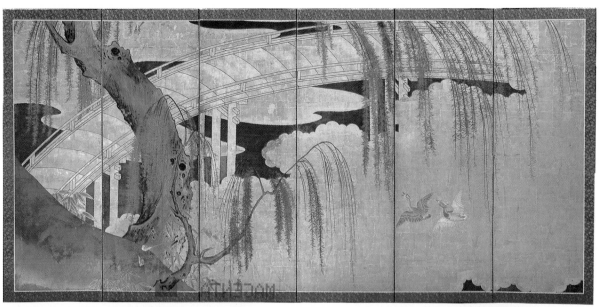

Left:
Six-leaf screen in sumi
Unsigned, late 17th
century
Each leaf approx.
$64\frac{1}{2} \times 24$ in.
(163 × 61 cm.)
Sold 18.11.85 in London
for £8,640 ($12,256)

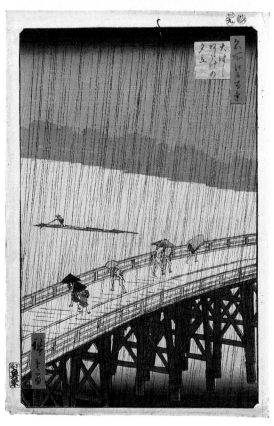

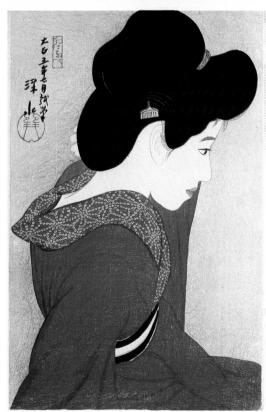

Far left:
HIROSHIGE
Oban tate-e
An album containing 98
prints from the series
Meisho Edo Hyakkei (One
Hundred Famous Views
of Edo), including
duplicates of
'Koumetzutsumi', all
signed, published by
Uoya Eikichi
Sold 4.3.86 in London
for £21,000 ($31,126)

Left:
SHINSUI
Oban tate-e
Taikyo (Facing the
Mirror), signed *shihitsu*
(drawn as an experiment
Shinsui, sealed *Ito*,
published by Watanabe
and dated Taisho 5
(1916) 5th month, signed
S. Watanabe and sealed
Watanabe
Sold 20.3.86 in New
York for $18,700
(£12,475)

RAKU-CHU RAKU-GAI
The Environs of the Itsukushima Shrine
Late 17th or early 18th century
One of a pair of six-panel screens, each panel 66½ × 24¼ in. (168.7 × 61.7 cm.)
Sold 20.3.86 in New York for $60,500 (£40,360)

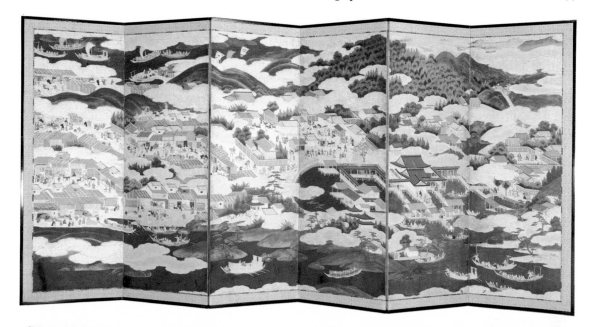

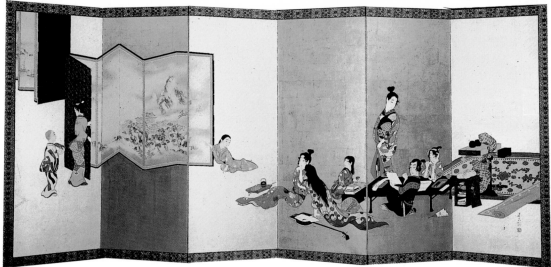

SHIBATA ZESHIN

The Four Elegant Pastimes – music, the game of Go, calligraphy and painting

One of a pair of six-panel screens, each panel 66¾ × 24¾ in. (169 × 63 cm.)

Ink and colour on gold paper, signed on the left screen *Ho ko-ei Zeshin* (Inspired by an older painting, Zeshin) with two seals *Reisai* and *Zeshin*, and on the right screen *Shibata Zeshin* with two seals *Reisai* and *Zeshin*

Sold 11.12.85 in New York for $143,000 (£100,245)

Record auction price for a pair of Japanese screens

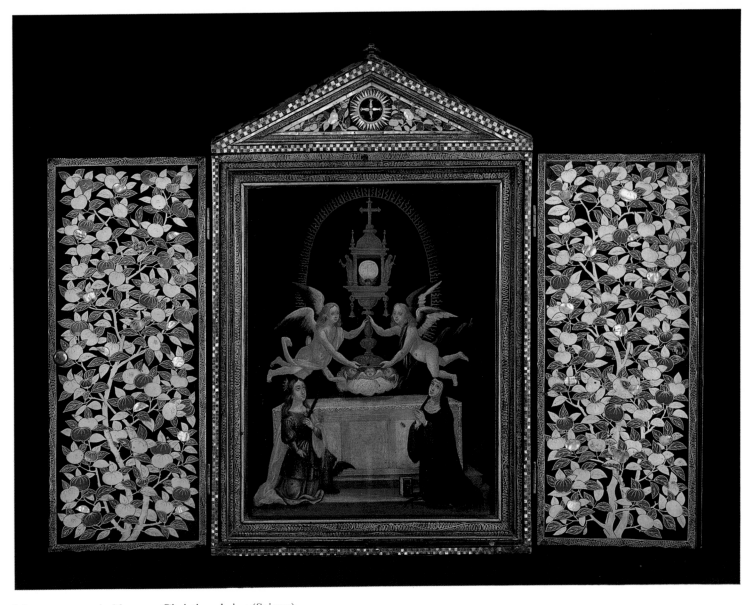

Momomaya period lacquer Christian shrine (Seigan)
*c.*1600
19½ in. (49.3 cm.) high; 13½ in. (34 cm.) wide; 1¾ in. (4.4 cm.) deep
Sold 19.11.85 in London for £70,200 ($100,070)
Originally in the possession of a Spanish family related to a former Governor of the Philipines, this shrine, although not the largest, is at once one of the most perfectly preserved and elegantly decorated examples to appear

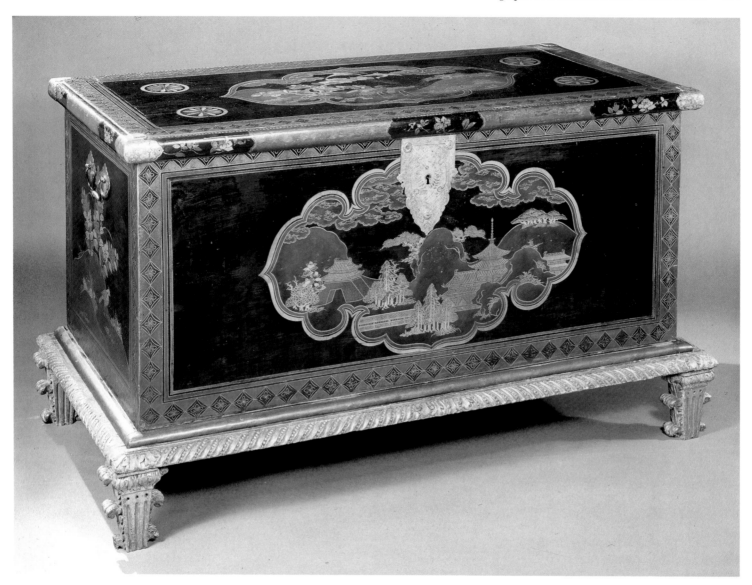

Black lacquer chest with hinged cover decorated in hiramakie
Early 17th century on 18th century giltwood stand
59½ in. (151 cm.) long; 28½ in. (72 cm.) high; 27 in. (68 cm.) deep
Sold 5.3.86 in London for £22,140 ($32,369)

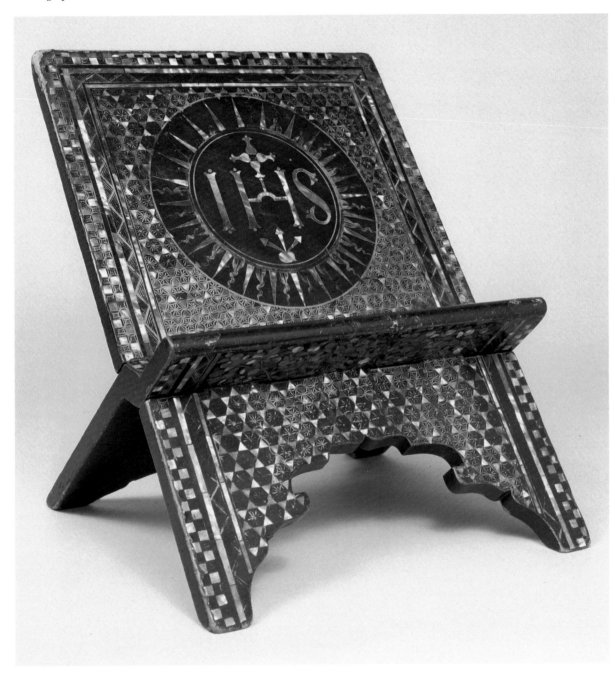

Momoyama period Christian folding lectern (Shokendai)
c. 1600
20 in. (50.5 cm.) high; 12 in. (31 cm.) wide
Sold 19.11.85 in London for £27,000 ($38,488)

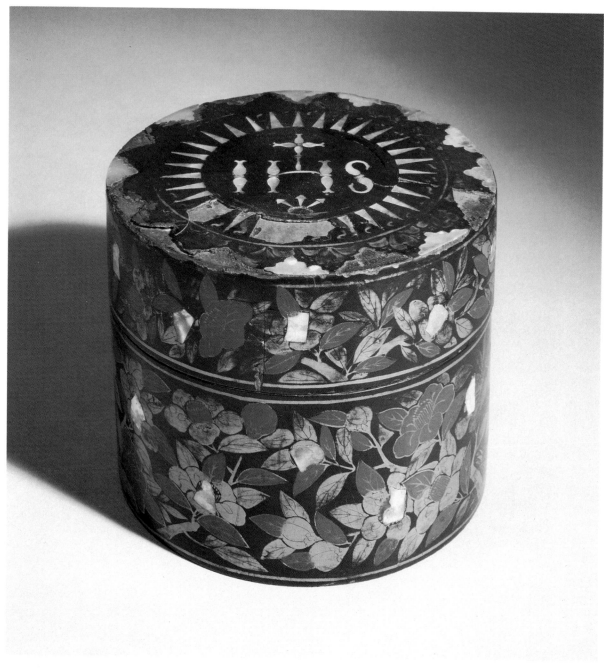

Momoyama period Christian host box or pyx (Seiheibako)
Late 16th century
3¾ in. (9.1 cm.) high; 4½ in. (11.5 cm.) diameter
Sold 19.11.85 in London for £19,440 ($27,712)
By order of the Trustees of Chiddingstone Castle, Kent
Host boxes are one of the rarest forms of Namban art, for their function and design was of such significance to the Christian community that they became an obvious target for destruction when the persecution began. Very few are known to have survived.

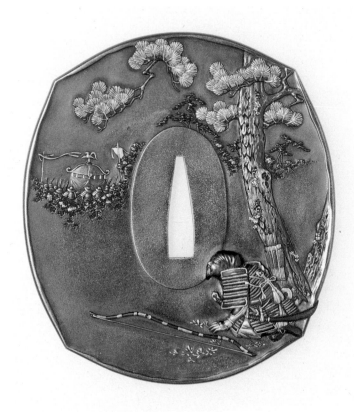

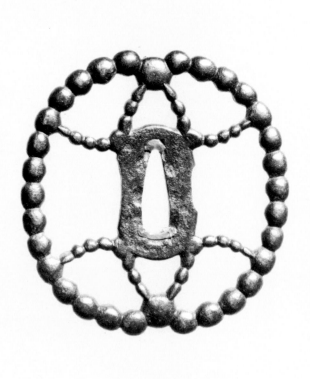

Bakumatsu period Kinko Tsuba by Higashiyama Motonobu of Tokyo, in hinoki box with descriptive hakogaki by Dr Kazutaro Torigoe
3¾ in. (9.3 cm.)
Sold 4.3.86 in London for £4,536 ($6,434)

Oval Iron Tsuba formed as a Buddhist rosary in marubori (juzu tsuba), with hinoki box and origami by Dr Kazutaro Torigoe dated August 1965
Unsigned, 17th century
3¾ in. (9.3 cm.)
Sold 4.3.86 in London for £14,040 ($20,232)
Record auction price for a Tsuba

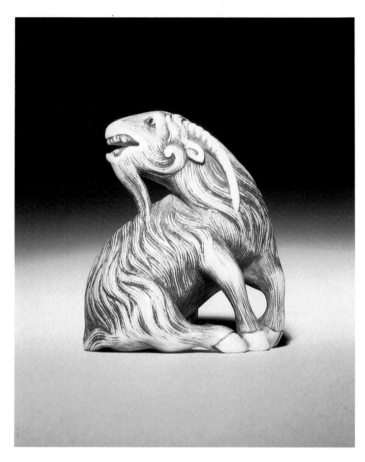

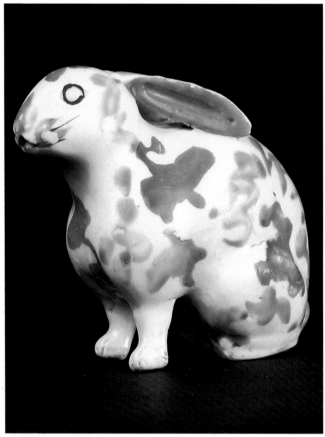

Ivory netsuke of a goat by Mitsuharu
Late 18th century
Sold 9.6.86 in London for £2,808 ($4,212)

Kakiemon Suiteki modelled as a seated hare
Late 17th century
3¾ in. (9.3 cm.) long
Sold 5.3.86 in London for £14,040 ($20,527)

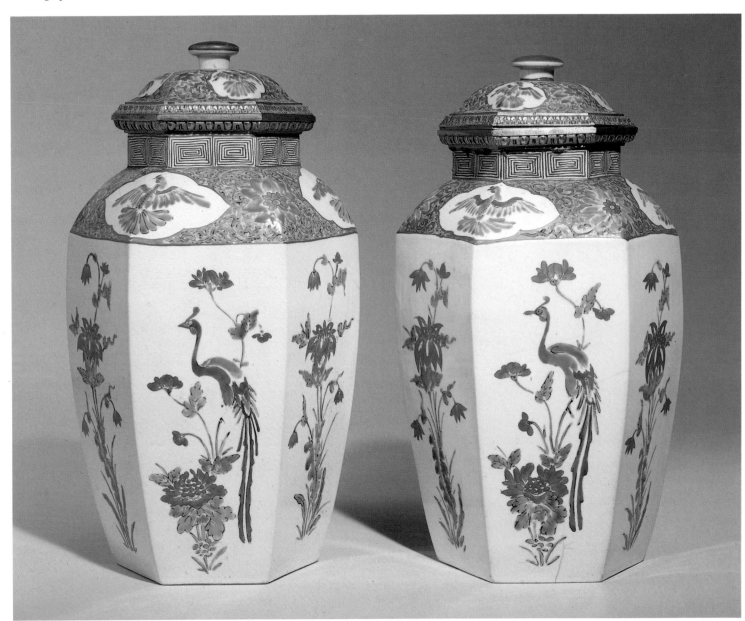

Pair of ormolu-mounted hexagonal jars and domed covers
Empo/Jokyo period (1673–87), the ormolu French, late 18th century
Both approx. 13 in. (33 cm.) high
Sold 9.6.86 in London for £37,800 ($56,700)

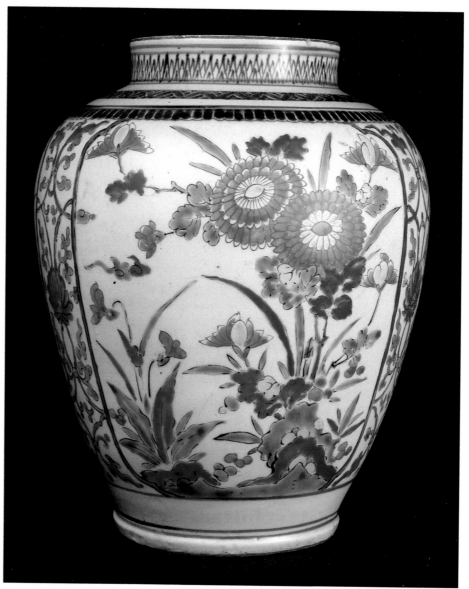

Arita 'Kakiemon' style oviform vase
*c.*1680
11 in. (27 cm.) high
Sold 5.3.86 in London for £36,720 ($53,685)

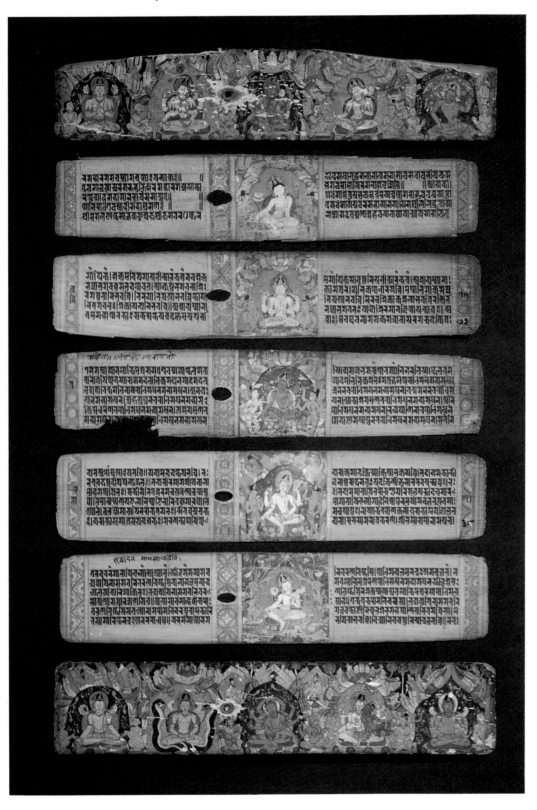

Nepalese Buddhist palm leaf
manuscript
13th century
11¾ (30 cm.) long
Sold 11.6.86 in London for
£20,520 ($31,600)

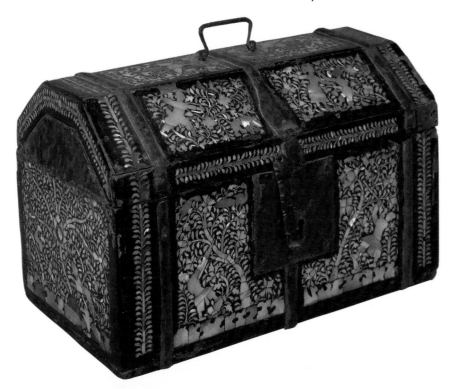

Indo-Portuguese mother-of-pearl
and tortoiseshell inlaid wooden
coffer
Early 17th century
13 in. (33 cm.) long
Sold 25.11.85 in London for
£10,800 ($15,752)

Singhalese ivory box
17th century
15½ in. (39.5 cm.) wide
Sold 25.11.85 in London for
£18,360 ($26,779)

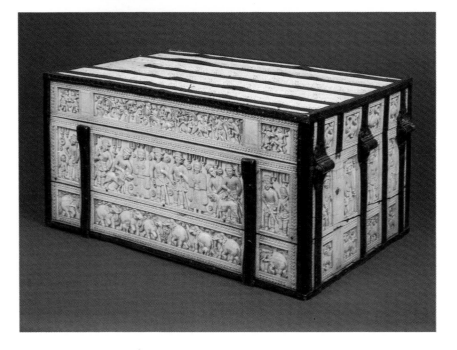

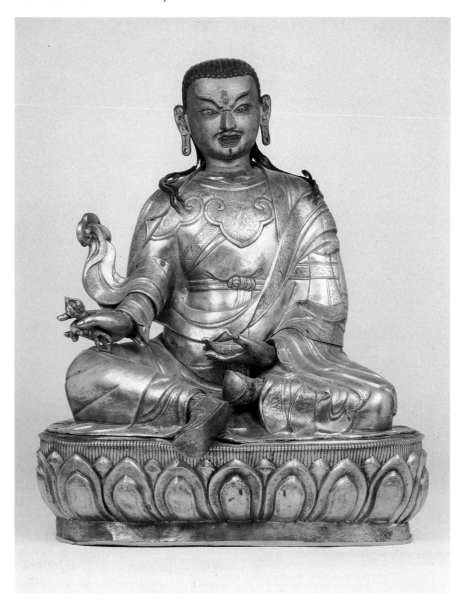

Tibetan gilt copper repousse figure of Padmasambhava (missing khatvanga)
Late 18th century
28 in. (71 cm.) high
Sold 25.11.85 in London for £4,860 ($7,089)

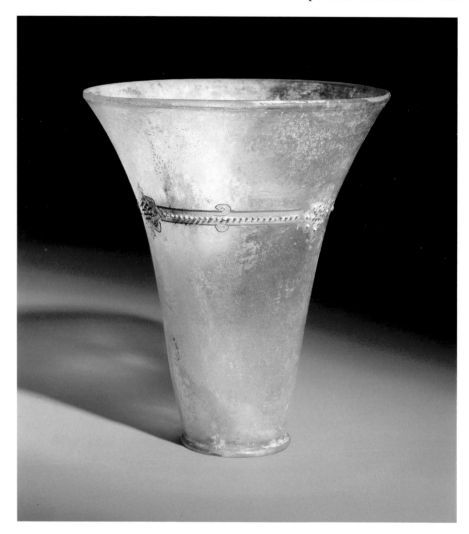

Syrian glass beaker
Raqqa group, *c.*1250
5½ in. (14 cm.) high
Sold 11.6.86 in London for £10,260 ($15,800)

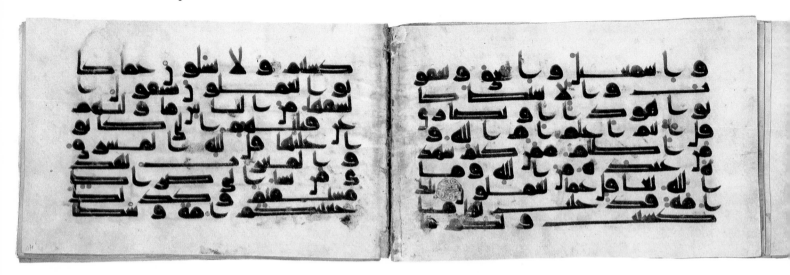

Qur'an section
Probably Kairouan, 9th century
Folio 4⅛ × 6⅝ in. (10.4 × 16.8 cm.)
Sold 25.11.85 in London for £27,000 ($39,380)

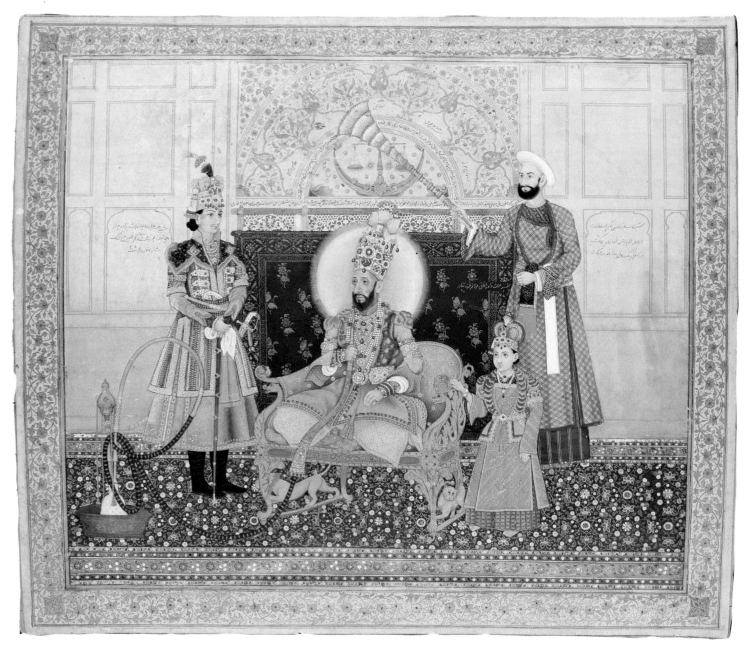

Emperor Bahadur Shah II Enthroned
Delhi, Rabi' I, AH1254 (May–June AD 1838)
Leaf 14¼ × 16½ in. (36.5 × 42 cm.)
Sold 11.6.86 in London for £17,280 ($26,612)
Emperor Bahadur Shah II ruled from 1837 to 1858, inheriting the throne at the age of 62. He was an able calligrapher and took a great interest in literature and music.

Qur'an

Persia, 11th or 12th century

Folio 7 × 4¾ in. (17.8 × 12.1 cm.)

Sold 11.6.86 in London for £16,200 ($24,948)

A highly important *Qur'an* in Eastern Kufic script, formerly in the Royal Mughal Library of Shah Jehan

Modern Decorative Arts

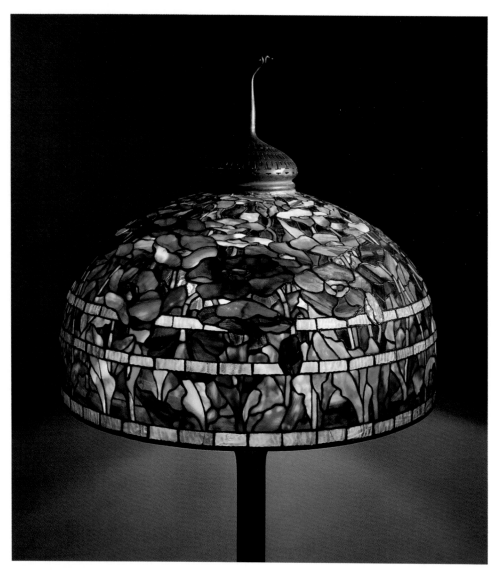

Oriental poppy leaded glass and bronze floor lamp
By Tiffany Studios
Impressed 'Tiffany Studios New York 1597'
The shade 26 in. (66 cm.) diameter; overall 79 in. (200 cm.) high
Sold 14.6.86 in New York for $75,000 (£50,000)

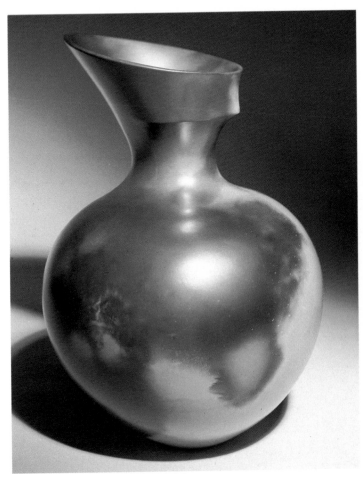

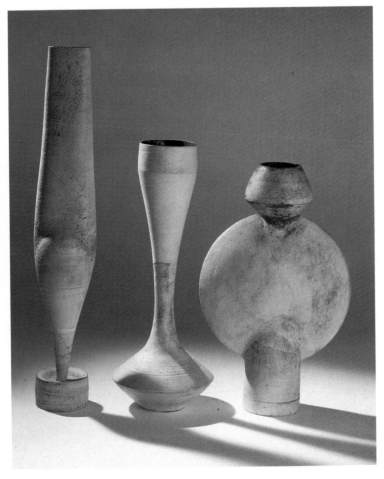

Handbuilt burnished and polished red clay vase
By Magdalene Anyango Namakhiya Odundo
Incised 'Odundo 1985'
13¾ in. (34.7 cm.) high
Sold 16.12.85 in London for £1,080 ($1,548)

Above left:
Stoneware flattened tapering tube-form with spherical belly
By Hans Coper
*c.*1968 impressed HC seal
14½ in. (36.9 cm.) high
Sold 18.12.85 in London for £10,260 ($14,672)

Above centre:
Tall slender stoneware vase
By Hans Coper
*c.*1970 impressed HC seal
11 in. (27.6 cm.) high
Sold 18.12.85 in London for £6,480 ($9,266)

Above right:
Stoneware composite bottle
By Hans Coper
*c.*1968 impressed HC seal
10 in. (25.5 cm.) high
Sold 18.12.85 in London for £7,020 ($10,038)

Split-Triangle
Glass sculpture in two
sections
By Colin Reid
Engraved 'Colin Reid
1985 R 140 A & B'
35½ in. (90 cm.) long
Sold 28.1.86 in London
for £3,780 ($5,254)

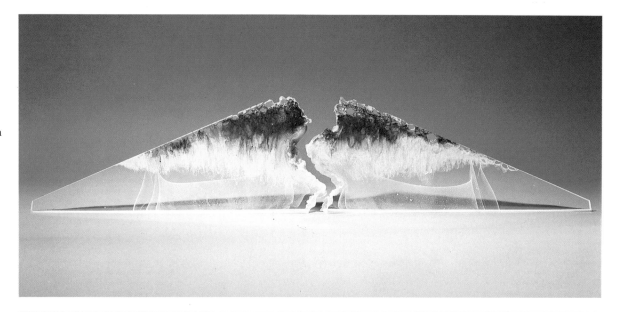

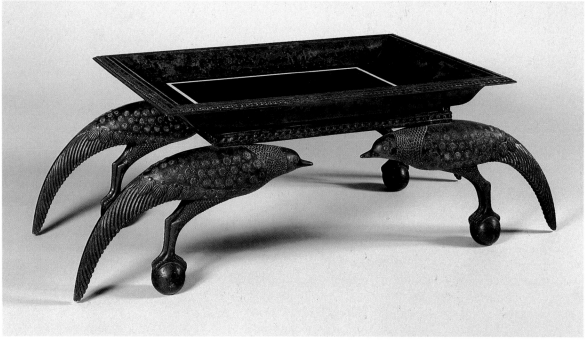

Bronze and marble table
By Armand J. Ratteau
*c.*1924
Unsigned
40 in. (101.6 cm.) wide; 19½ in. (49.4 cm.) deep; 13¾ in. (33.6 cm.) high
Sold 14.12.85 in New York for $48,400 (£33,740)
From the collection of Count Hubert O'Brien

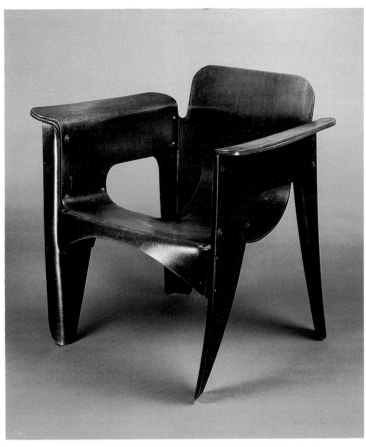

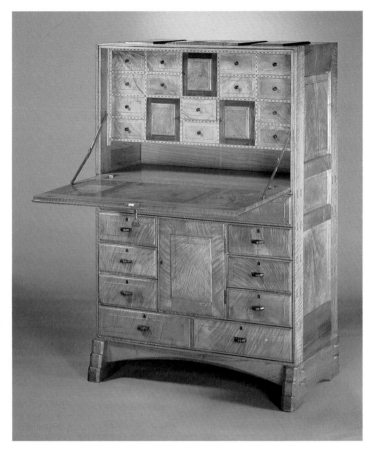

'Birza-chair'
By Gerrit Thomas Rietveld for the Birza Room, Amsterdam
Designed in 1927
24½ × 22 × 28 in. (62 × 55 × 71 cm.)
Sold 27.5.86 in Amsterdam for D.fl.127,600 (£33,579)
Record auction price for a piece of 20th century Dutch furniture
This is a unique piece, executed by A. van de Groenekan. He refused to produce another specimen because of the great difficulty he encountered in making the original. According to van de Groenekan's account, the fibre was softened in water and then modelled on a bench; nuts and bolts were added to hold the structure together. Difficulties arose because the fibre flattened out as it dried, instead of holding the shape into which it had been coaxed when wet.

Bureau
Designed by Ernest Gimson and executed by Sidney Barnsley
50½ in. (128.5 cm.) high; 33 in. (83.5 cm.) wide;
21 in. (53 cm.) deep
Sold 28.1.86 in London for £16,200 ($22,518)
In 1897 Ernest Gimson designed the White House, Clarendon Park, Leicester, for his half-brother Arthur; he also designed some of the furniture of which this bureau is a piece. It was purchased by the vendor's family along with other items of furniture in 1925 when they bought the White House.

Easy chair
By Gerrit Thomas Rietveld
for the Birza Room,
Amsterdam
Designed in 1924
28 × 24 × 33½ in.
(71 × 60 × 85 cm.)
Sold 27.5.86 in Amsterdam
for D.fl.110,200 (£29,000)
This chair was originally
designed for the Schröderhuis
and according to A. van de
Groenekan a maximum of
five of these chairs were
made, all of them executed by
him.

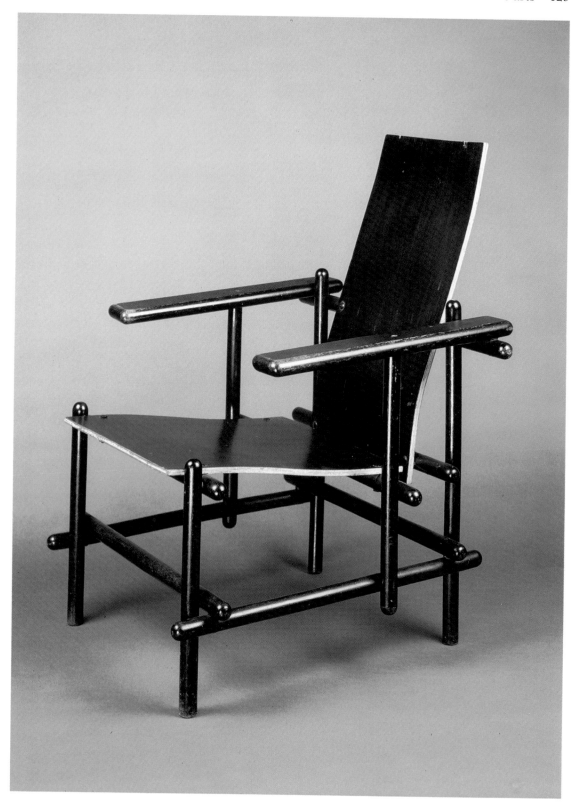

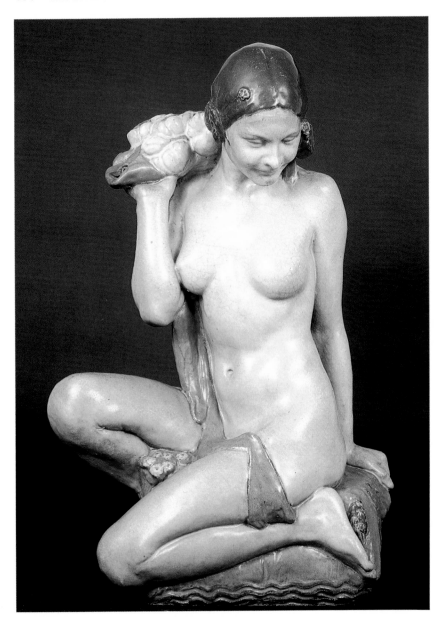

The Lily-Maid
Royal Doulton polychrome glazed stoneware fountain figure
Designed by Gilbert Bayes
24¼ in. (61.5 cm.) high
Sold 30.9.85 in London for £9,180 ($12,760)

Doulton and Co. faience baluster vase
Decorated by Florence Lewis
Painted marks 'Doulton and Co. London',
FL monogram
76 in. (193 cm.) high
Sold 18.4.86 in London for £31,320 ($47,293)
Although the precise history of this particular vase is not
known, it is very similar to a vase exhibited in 1893 at
the Chicago World's Fair, and now in the Museum of
Science and Industry in Chicago. The vase was
considered to be the crowning glory at the Doulton stand
in 1893, and a similar one was said to have been ordered
for the Gaekwar of Baroda at a staggering price of
$6,000. The glaze on the original vase when taken from
the kiln was found to be imperfect and a duplicate was
made. It is known from the records kept by Royal
Doulton that two versions of the vase were made, but not
clear whether the one intended for the Indian palace was
ever delivered there after the initial firing problems. It is
possible therefore that this vase was the one intended for
the Gaekwar of Baroda.
Florence Lewis was one of the Lambeth studio's most
highly acclaimed artists. John Sparkes, her art master,
introduced her to Henry Doulton around 1874 and said
of her, 'She has a remarkable power of design and a skill
in painting that is seldom surpassed. Her designs are of
flowers, foliage and birds and whether she is working out
a large design or a small tile her energy and power are
equally apparent.' Faience, Crown Lambeth and
Marqueterie were her preferred media and her work is
invariably first-rate. She left the Lambeth studios in
1897. She did, however, continue to do occasional
freelance work for Doulton, some of which was shown at
the Paris Exhibition of 1900.

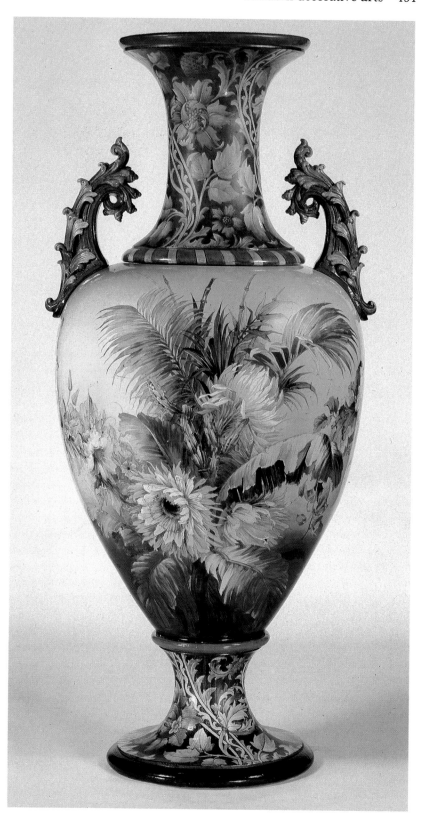

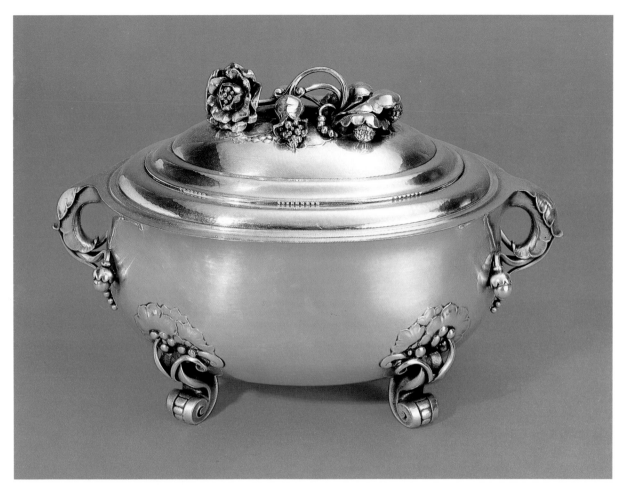

Tureen and cover
Designed by Georg Jensen
Stamped 'Georg Jensen 337B'
52 in. (132.5 cm.) wide
Sold 18.12.85 in London for £18,360 ($26,255)

Diana and *Acteon*, a pair of bronze mythological groups by Paul Howard Manship
One inscribed 'Paul Manship [?]1921' and 'C. Valsuani.Fondeur'; the other inscribed 'Paul Manship [?]1925' and 'C. Valsuani.Fondeur'
37¾ in. (96 cm.) high and 29 in. (73.3 cm.) high, excluding pedestals
Sold 6.12.85 in New York for $330,000 (£224,490)

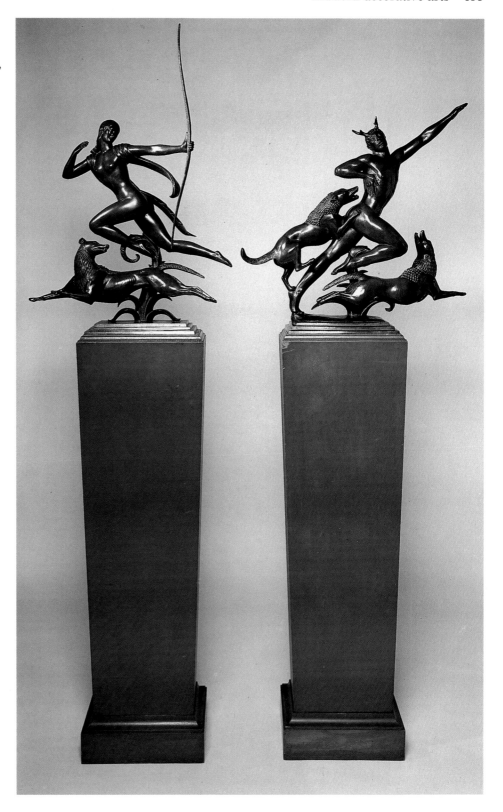

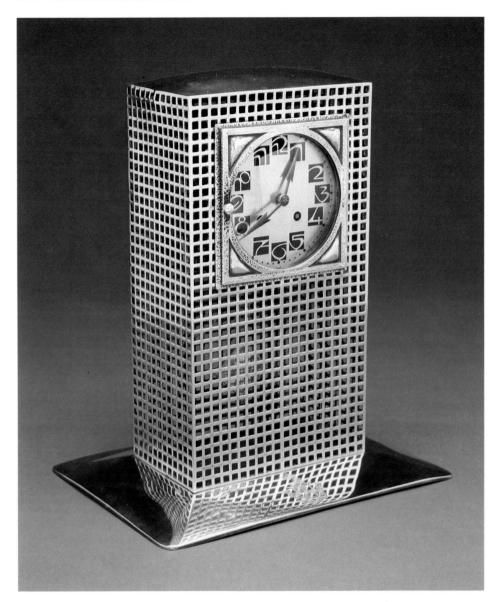

Silver table clock
Designed by Josef Hoffmann and executed by Alfred Meyer for the Wiener
Werkstätte
*c.*1906
11 in. (28 cm.) high
Sold 22.3.86 in New York for $60,500 (£40,388)

Opposite:
Le Jour et la nuit
Clear and frosted blue glass
clock
By René Lalique
14¾ in. (37.5 cm.) high
Sold 22.3.86 in New York for
$52,800 (£35,247)

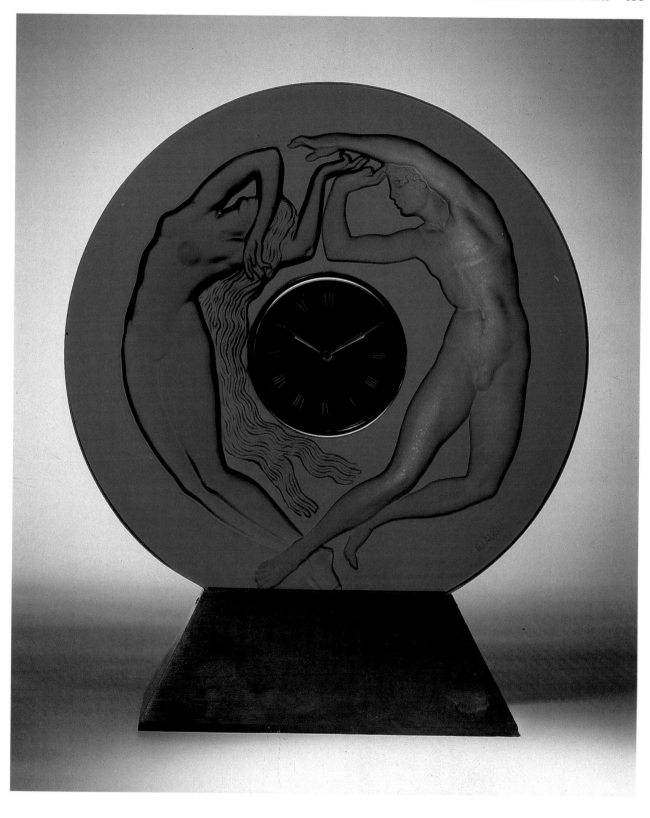

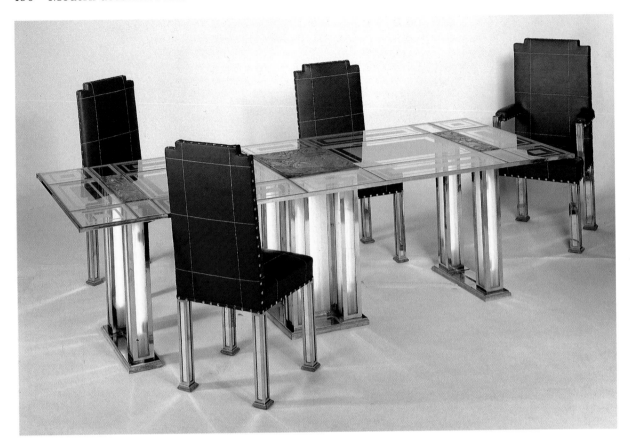

Set of six Asprey dining chairs and two armchairs
Sold 8.7.86 in London for £20,520 ($30,780)

Asprey glass and chromed metal dining table inlaid with Lalique panels
Moulded signature on panels 'R Lalique France'
108 in. (274 cm.) long; 42¼ in. (107.3 cm.) deep; 31¼ in. (79.5 cm.) high
Sold 8.7.86 in London for £86,400 ($129,600)
The table and the chairs were originally commissioned by an Indian Maharajah

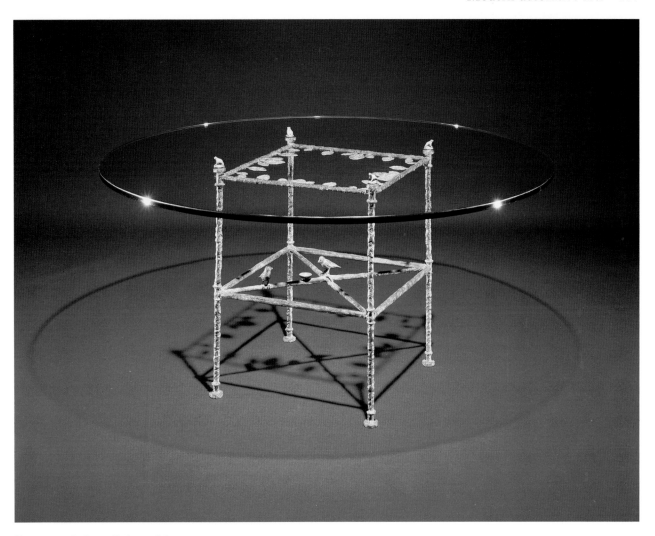

Bronze and glass dining table
By Diego Giacometti
Signed 'Diego'
60 in. (152.4 cm.) diameter; 29½ in. (74.9 cm.) high
Sold 14.6.86 in New York for $110.000 (£78,273)

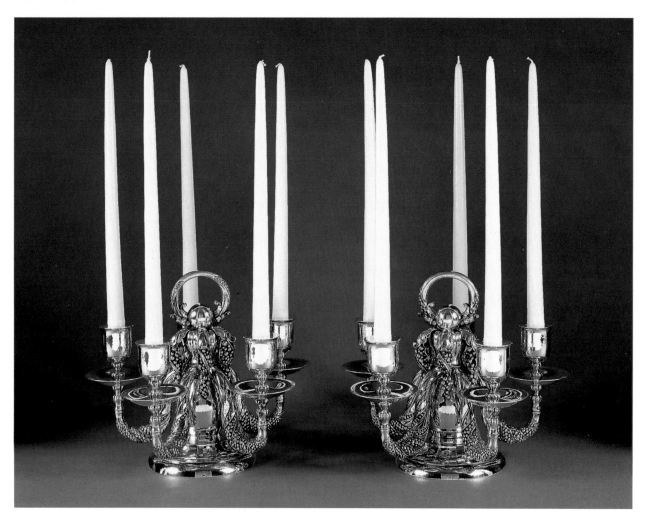

Pair of candelabra
Designed by Georg Jensen
Stamped marks 'Georg Jensen 383A'
10¾ in. (27 cm.) high
Sold 18.4.86 in London for £21,600 ($32,616)

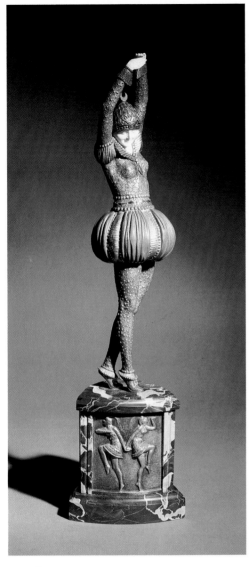

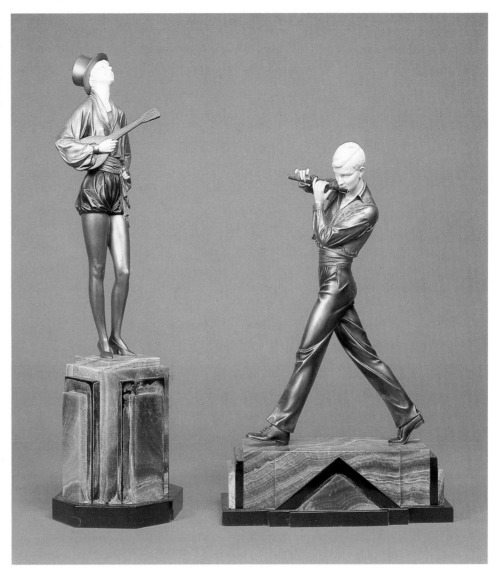

Bayadère
Bronze and ivory figure
Cast and carved from a model by
D.H. Chiparus
20¾ in. (52.5 cm.) high
Sold 18.4.86 in London for £10,260
($15,493)

Mandolin Player
Bronze and ivory figure
Cast and carved from a model by
Ferdinand Preiss
Signed 'F Preiss' in the marble
23¼ in. (59 cm.) high
Sold 8.7.86 in London for £20,520
($30,780)

Flute Player
Bronze and ivory figure
Cast and carved from a model by
Ferdinand Preiss
19 in. (48.5 cm.) high
Sold 8.7.86 in London for
£18,360 ($27,540)

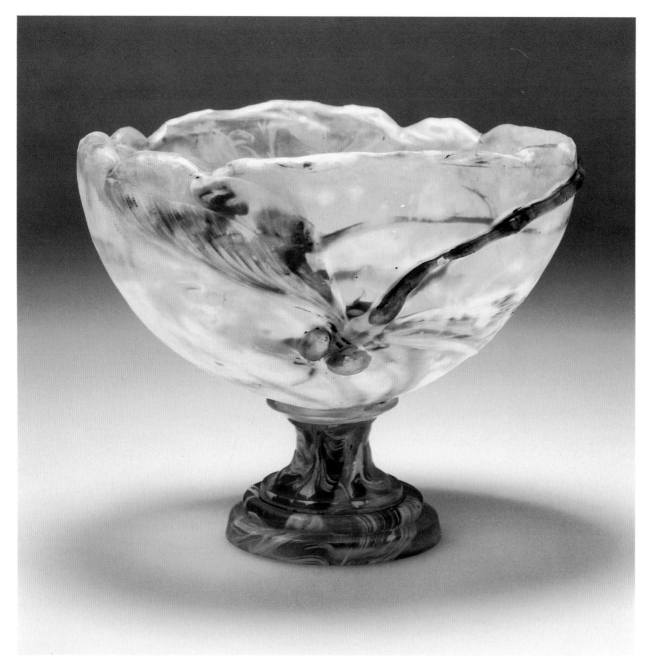

Marquetry intercalaire, engraved, applied and overlay glass coupe
By Gallé
5 1/4 in. (13.3 cm.) high; 6 5/8 in. (16.8 cm.) wide
Sold 10.11.85 in Geneva for Sw.fr.330,000 (£108,553)

Arms and Armour and Modern Sporting Guns

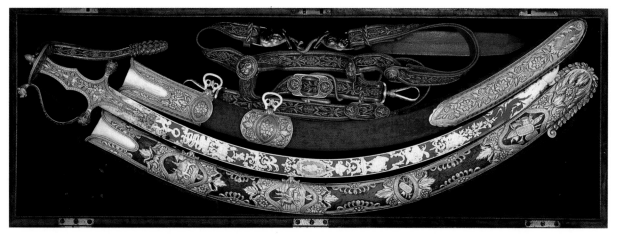

Silver-gilt mounted presentation sword, scabbards, and belt
By R. Johnston, 'Sword cutler & Belt Maker To His Majesty 68 St. James's Str.t London', the hilt with
London silver hallmarks for 1807, the belt with marks for 1808, both with maker's mark RJ
Blade 28½ in. (72.3 cm.)
Sold 30.4.86 in London for £23,760 ($36,591)
The inscription on the blade reads, 'This sword is Presented To Colonel Burne by The Officers of The 1st Batn
of the 36th Regt As A Particular Mark of Their Esteem'. Lieutenant-General Robert Burne (1755?–1825)
served with the 36th regiment from 1773 to 1811, and saw action in India, at Buenos Aires, and in the
Peninsula, whence he returned to England (due to ill-health) in 1812. The sword was presented in recognition
of his valour during the attack on Buenos Aires in July 1807, and at the time was valued at 120 gns.

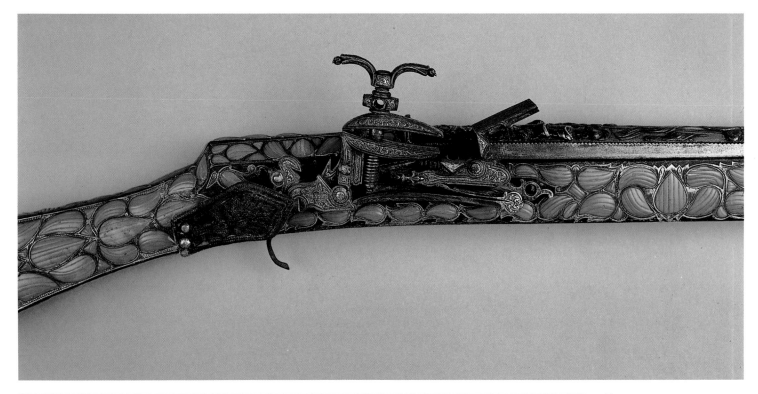

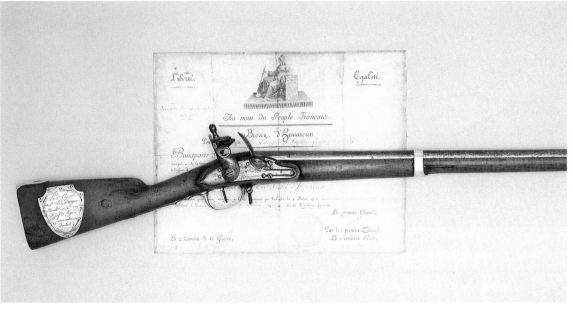

Above:
North-African toe-lock
presentation gun inlaid
with coral
Late 18th or early 19th
century
Barrel 52¾ in. (134 cm.)
Sold 5.9.85 in Amsterdam
for D.fl.104,400 (£23,728)

Silver-mounted flintlock *mousqueton d'honneur*
Signed 'Ent^se. Boutet' and stamped 'M^RE. N^LE. De Versailles', the silver plaque on the butt engraved
with presentation inscription 'Le 1^er Consul au C.en H.t Paugnion Carab.er au 25 rég. d'Inf.rie légère
pour actions d'éclat', French silver marks for 1798 to 1809, maker's mark of Jean Masson
Barrel 44¾ in. (113.6 cm.)
Sold 30.4.86 in London for £8,100 ($12,474)

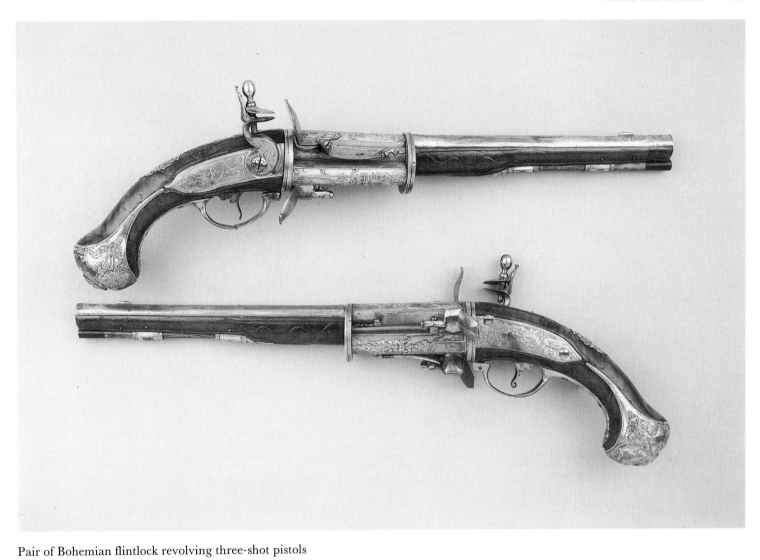

Pair of Bohemian flintlock revolving three-shot pistols
By Johann Adam Knod, Carlsbad
c. 1730–40
20½ in. (52 cm.)
Sold 21.5.86 in New York at Christie's East for $30,800 (£20,000)
From the estate of Dr Jack Strassman

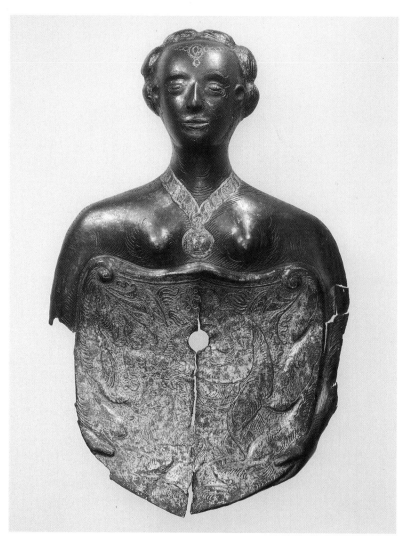

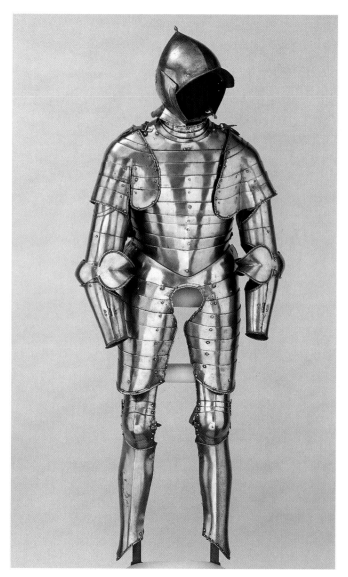

Escutcheon for a chanfron, made for a horse armour of the Emperor
Charles V
By Kolman Helmschmied, Augsburg
*c.*1515
6¾ in. (17.1 cm.) high
Sold 13.11.85 in London for £7,560 ($10,925)

German Armour of 'anime' construction
*c.*1540–50, probably Augsburg
Sold 13.11.85 in London for £15,120 ($21,388)

German princely sword
mounted in silver-gilt, and
engraved in the manner of
Heinrich Aldegrever of
Paderborn
Dated 1540
Blade 37¾ in. (95.8 cm.)
Sold 30.4.86 in London for
£43,200 ($66,528)
Formerly in the Dreger
Collection, sold by Fischer &
Kahlert, 2 August 1927, lot 75

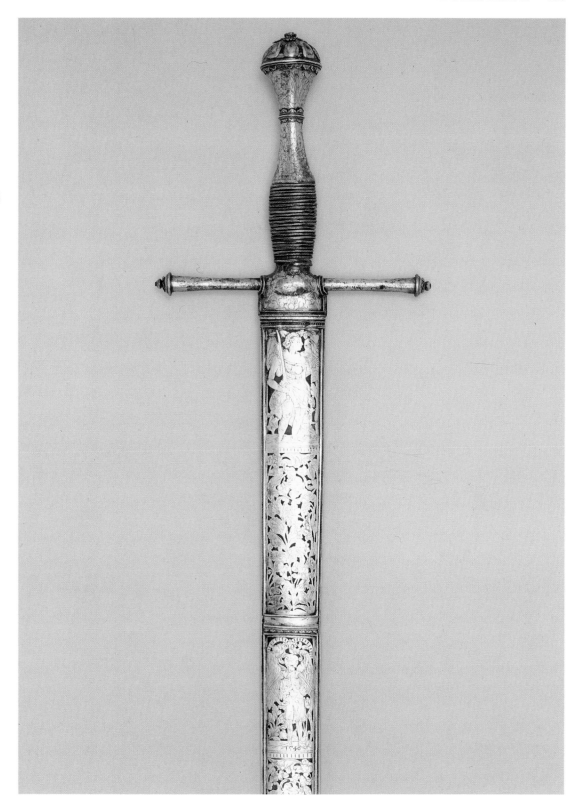

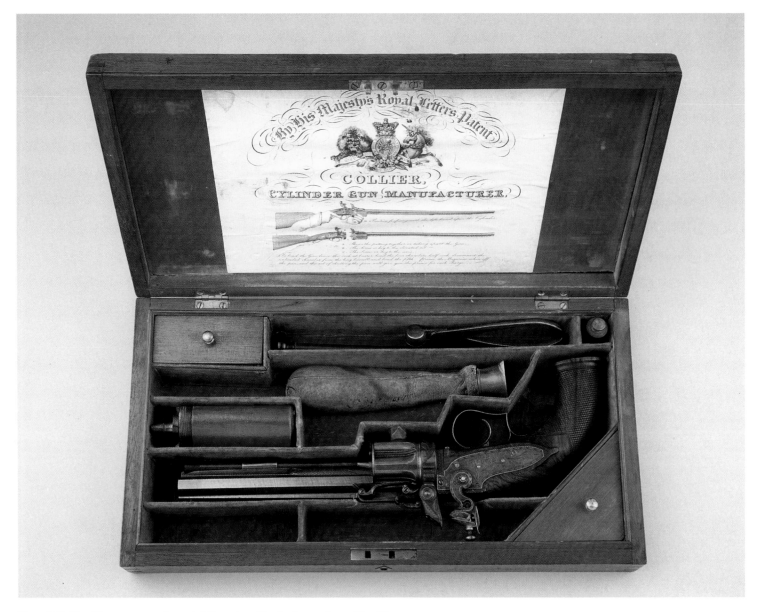

Cased Collier Patent second model five-shot flintlock revolver, No. 57
*c.*1824
14 in. (35.6 cm.)
Sold 21.5.86 in New York at Christie's East for $48,400 (£31,428)
From the estate of Dr Jack Strassman

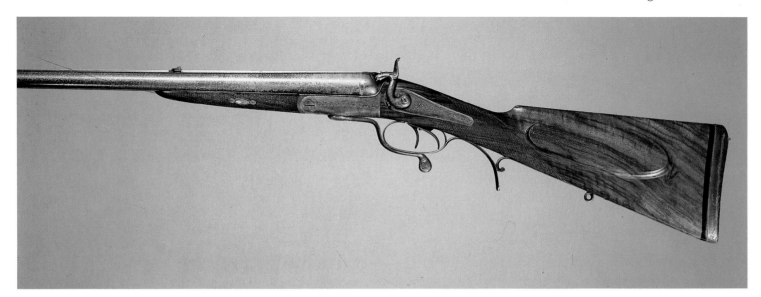

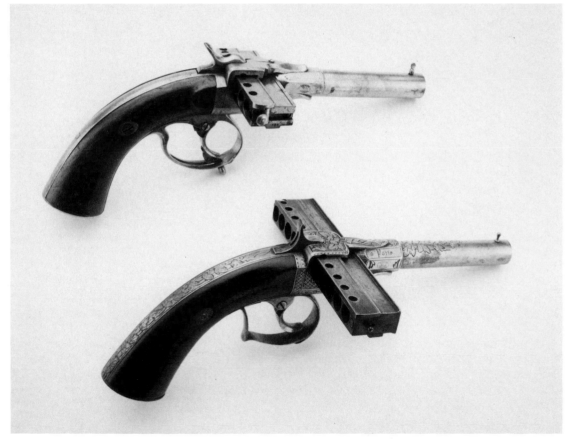

Above:
Hammer backlock rotary-
underlever .577 (2¾ in.
Black Powder) d.b. rifle
By J. Purdey, London
Built in 1877
Sold 13.11.85 in London for
£3,780 ($5,347)

Jarre 1859 Patent
'Harmonica' six-shot pin-fire
magazine-pistol
By Jarre et Cie, Paris
*c.*1865
Sold for $2,420 (£1,592)

Similar ten-shot pistol
By Lou Jarre, Paris
*c.*1865
Sold for $3,520 (£2,315)

Both sold 21.5.86 in New
York at Christie's East

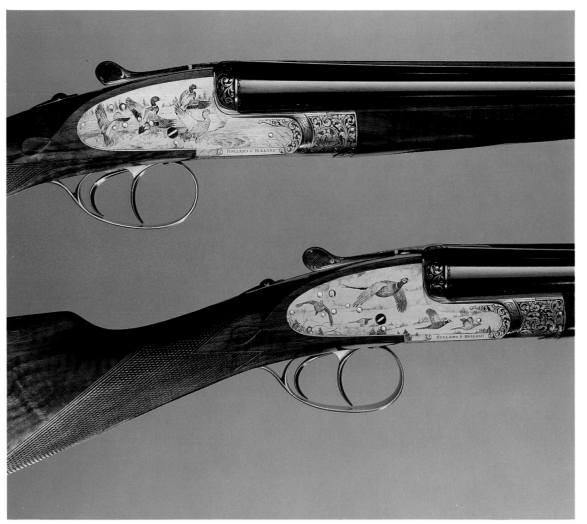

Pair of 'Model de luxe
Self-Opener' sidelock
ejector 20-bore (2¾ in.)
d.b. guns
By Holland & Holland,
London; specially
engraved by K.C. Hunt
Built c.1975
Sold 12.2.86 in London
for £34,560 ($48,886)
Record auction price for
a pair of modern sporting
shotguns

The market for modern sporting guns is remarkably healthy, though selective respecting condition. Seriously worn guns can prove difficult to sell, but demand for good examples of all types has gained strength. The positive aspect of this trend is demonstrated by the guns shown above. As they were of high quality and virtually as new, an exceptional price could be expected: what is not apparent, in the price quoted, is that it carried the addition of 15 per cent tax (V.A.T.), as the guns had been reimported for sale.

The sale of privately owned guns (on which tax is assumed to have been paid initially) is not normally subject to V.A.T., but it becomes so when the guns cross any E.E.C. frontier for sale. The logic and justice of this are dubious, but the effect is obvious. A surcharge of 15 per cent tax depresses bidding, as only a non-E.E.C. buyer can effectively recover the tax on export.

Other items were also handicapped in this way (e.g. the Purdey .375 rifle, p.450) and the prices achieved, despite this burden, indicate the market's strength.

Self-opening sidelock ejector 20-bore (2¾ in.) d.b. single-trigger gun
By J. Purdey, London
Built in 1959
Sold 25.3.86 in New York at Christie's East for $17,600 (£11,718)

'Premiere Easy-Opening' sidelock ejector 12-bore (2¾ in.) d.b. single-trigger gun
By Churchill, London
Built c.1971
Sold 25.3.86 in New York at Christie's East for $11,000 (£7,324)

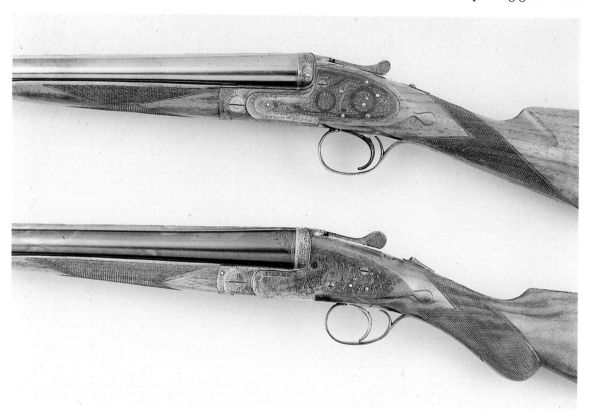

This season, group sales of modern and vintage firearms exceeded £1 million ($1.5 million) for the first time. In modern sporting guns, London's turnover is still five times that of New York, but the potential in America is enormous. The sheer abundance of sporting arms in the United States could create problems and we have to be particularly selective in accepting items for sale. This also benefits our clients, by enhancing the prestige of the sales and accelerating international recognition of a new market-place.

The market potential in collectable firearms is even greater in America, where most 19th century cartridge breech-loaders are accepted as antique. European firearms' laws are, generally, less generous in this respect, and in London most late 19th century firearms are classified as 'vintage', simply because they are not safely 'antique' in law. British legal restrictions on the market are partly offset by a smaller supply, and our gun sales at Christie's South Kensington are successful in handling the more modest sporting and collectable firearms, particularly pistols.

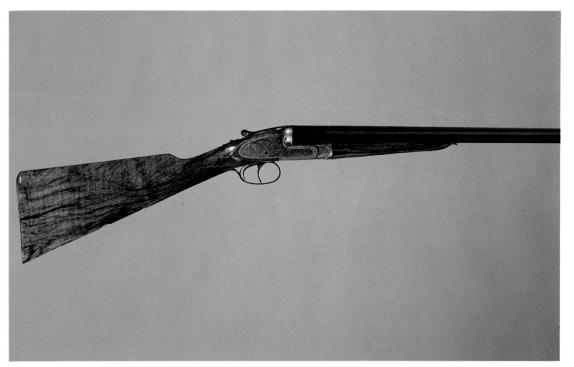

Pair of self-opening sidelock
ejector 12-bore ($2\frac{1}{2}$ in.)
d.b. guns
By J. Purdey, London
Built in 1920
Sold 2.7.86 in London for
£20,520 ($30,780)

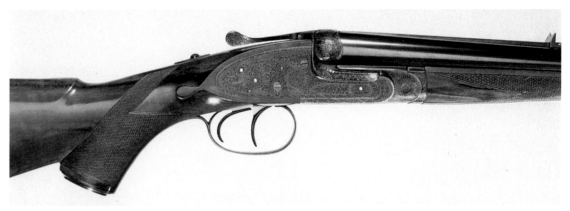

Self-opening sidelock ejector
.375 (Magnum Belted
Rimless) d.b. rifle
By J. Purdey, London
Built c. 1975
Sold 12.2.86 in London for
£18,360 ($25,970)
Record auction price for a
modern sporting double-
barrelled rifle

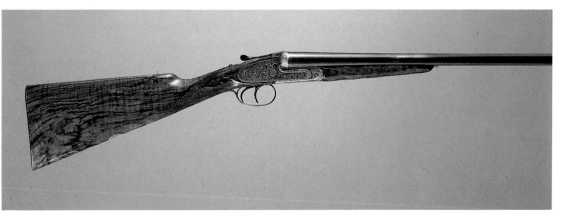

Pair of self-opening rounded-
bar sidelock ejector 16-bore
($2\frac{3}{4}$ in.) d.b. guns
By J. Purdey, London
Built in 1972
Sold 13.11.85 in London for
£15,120 ($21,388)

Set of three 'Model de luxe Self-Opener' sidelock ejector 12-bore (2¾ in.) d.b. guns
By Holland & Holland, London
Built *c.* 1976
Sold 12.2.86 in London for £34,560 ($51,910)

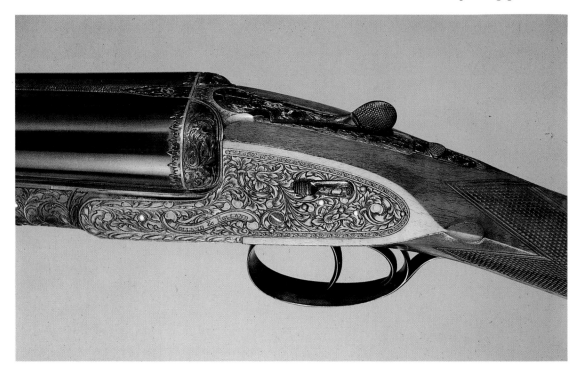

Pair of 'Modèle de luxe Self-Opener' sidelock ejector 12-bore (2¾ in.) d.b. guns, engraved with game scenes
By Holland & Holland, London
Built in 1968
Sold 13.11.85 in London for £17,280 ($24,443)

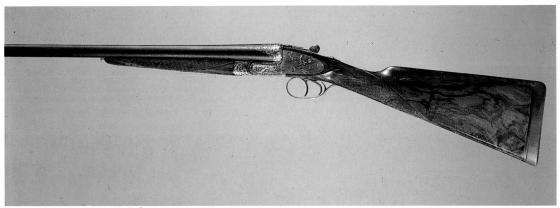

'Royal Self-Opener' sidelock ejector 20-bore (2¾ in.) d.b. gun
By Holland & Holland, London
Built in 1936
Sold 13.11.85 in London for £14,040 ($19,860)

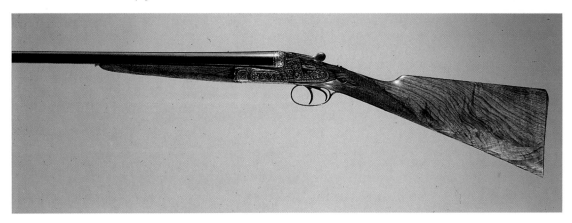

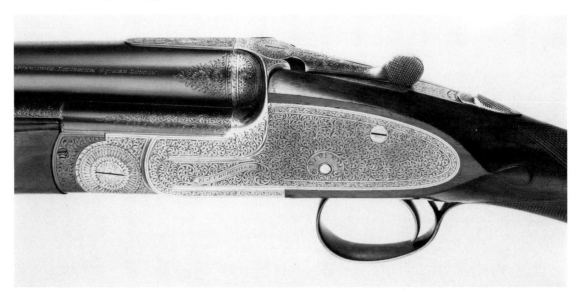

'Premiere XXV' under-and-over sidelock ejector 12-bore (2¾ in.) d.b. single-trigger gun
By E.J. Churchill, London
Built *c.*1937
Sold 2.7.86 in London for £7,560 ($11,340)

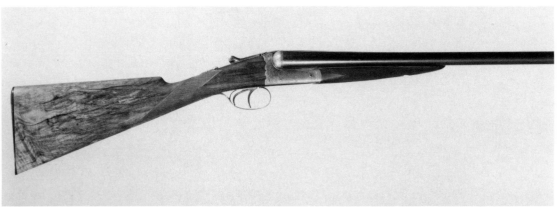

Pair of boxlock ejector 12-bore (2½ in.) d.b. guns
By Westley Richards, Birmingham
Built *c.*1937–41
Sold 13.11.85 in London for £5,400 ($7,639)

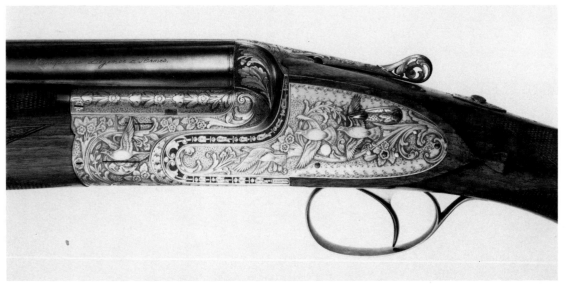

Belgian under-and-over sidelock ejector 12-bore (2¾ in.) d.b. single-trigger gun
By Manufacture Liègeoise d'Armes, Liège; engraved by J. Baerten
Built *c.*1975
Sold 2.7.86 in London for £4,752 ($7,128)

Stamps

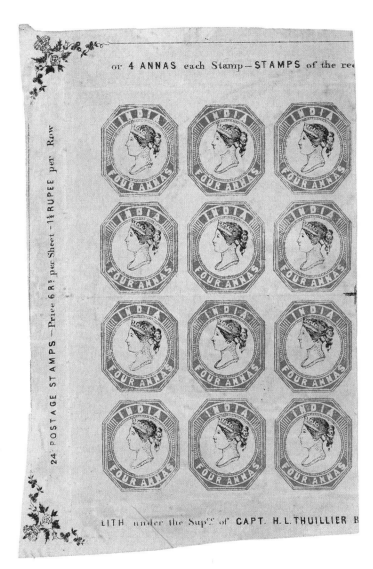

Half sheet of the India 1854 4 annas fourth printing
Sold 25.2.86 in London for £45,360 ($67,224)

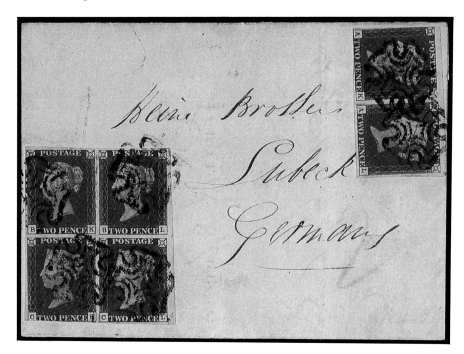

Great Britain 1841 from Newport to Lubeck with a block and a pair of the 2d. Sold 17.6.86 in London for £3,240 ($4,946)

Fifty sales were held during the season, of which 24 were held in London bringing £3,103,544, 12 in Bournemouth £1,407,297, nine in Zurich Sw.fr.3,087,520 (£1,055,773) and five in New York $1,786,941 (£1,230,424), bringing the total sales by auction to £6.8 million ($9.7 million). While there was a general improvement in the price of the exceptional essay, proof or cover that appealed to the specialist, the prices for ordinary stamps, even if of great rarity, tended to fall.

LONDON

In June the section of Pictorial envelopes realized £5,439 ($8,310), bringing the season's total for this category to £22,617 ($34,558). The two imprimatur 1840 1d. blacks from the Earl of Crawford's collection made £3,456 ($5,280) and £2,700 ($4,125) and the mint VR went for £1,188 ($1,815). The mint 1883 £5 orange at £1,296 ($1,980), the 1883–4 2s. 6d., 5s. and 10s. at £2,570 ($4,202) and a marginal block of the 1900 1s. with inverted watermark at £1,188 ($1,815) were notable. The six photographic essays of the first stamps of the reign of Queen Elizabeth II sold for £3,110 ($4,752).

There were 15 British Empire sales, commencing with Europe on 10 September, when a set of 19 Cyprus proofs for the 1934 pictorials at £9,720 ($12,650), the imperforate block of four Malta 1885 4d. at £12,960 ($16,867) and the set of 10 1925 Postage Dues at £7,560 ($9,839) were outstanding lots at outstanding prices. The star on the 21 September was the India 1854 4 annas with inverted head at £12,960 ($17,476) (illustrated).

Australia filled 22 October, when £126,000 ($180,243) was paid for collections of Australian Commonwealth formed by the late W.G. Richards, Barry Scott's British Solomon Islands, and part of the late J.R.W. Purves's Victoria. A set of 20 die proofs of the 1898–1909 pictorials made £12,960 ($18,539).

Joseph Hackmey's Grenada collection made £126,864 ($184,587) on 26 November, the top price being £4,320 ($6,285) for an 1877 envelope bearing a bisected and two whole 1d. plus

South West Africa 1931, a
complete set of 14 die proofs
in both languages
Sold 10.12.85 in London for
£6,048 ($8,706)

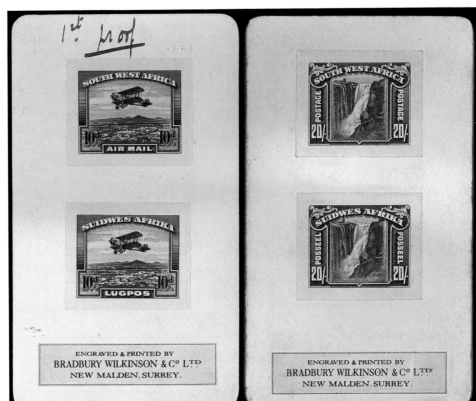

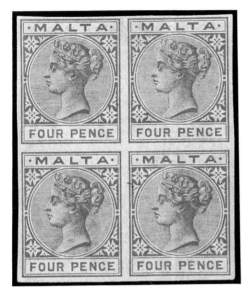

Malta 1885, a mint block of
the imperforate 4d.
Sold 10.9.85 in London for
£12,960 ($16,868)

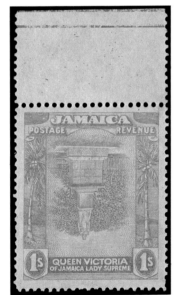

Jamaica 1921 1s. with
inverted centre
Sold 22.1.86 in London for
£13,500 ($18,995)

Jamaica 1921 Abolition of
Slavery 6d. essay
Sold 22.1.86 in London for
£10,800 ($15,196)

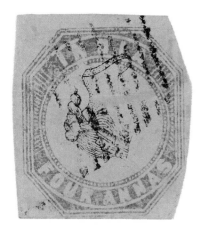

India 1854 4 annas first
printing, the finest known
example with inverted head
Sold 25.2.86 in London for
£41,040 ($60,822)

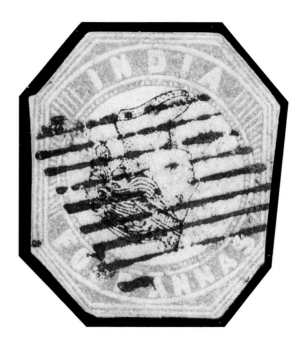

Cut-round example of the
same rarity discovered earlier
in the year, unnoticed in an
old collection sold in an
Austrian auction
Sold 24.9.85 in London for
£12,960 ($18,630)

a 6d. On the following day a collection of Nyasaland and Rhodesia brought £110,506 ($161,836), the set of 1905 Falls die proofs making £10,800 ($15,816).

1986 commenced with a valuable collection of Jamaica, of which the two star items are shown on the previous page. Falkland Islands had 31 Queen Victoria stamps overprinted SPECIMEN at £4,811 ($6,995), and an imperforate set of the 1935 Silver Jubilee perforated SPECIMEN made £3,240 ($4,710).

The Koh-i-Nor collection of India on 25 February made £387,645 ($574,489), and in addition to the two examples illustrated, two 1852 Scinde Dawk $\frac{1}{2}$ anna red brought £23,760 ($35,212), and among the many outstanding 1854 classics the block of 22 1 anna on cover at £13,500 ($20,007), the eight 4 annas second printing on cover and the unused marginal pair of the 4 annas die III/I, both selling for £18,360 ($27,209), were the best.

A two-day auction in March saw the sale of two collections of Malta, one formed by Leslie Wheeler. A 1761 cover brought £3,456 ($4,976), and three letters written by Lord Nelson went for £12,582 ($18,118). In April, a sale of Australian States had Lester Shepard's later New South Wales, John O. Griffiths' later South Australia and more of J.R.W. Purves's Victoria.

June saw a splendid sale of Rhodesia, including the Harry Birkhead collection, which brought £170,167 ($268,863). Three lots are illustrated; in addition, a pair of the Cape 4d. overprinted in 1896 with COMPANY omitted at £6,264 ($9,897), a double head plate proof of the 10d. at £4,320 ($6,825) and the rare 2s. at £4,590 ($7,252) were all excellent results. On 18 June the late James Collie's Basutoland and Graham Cooper's Sudan filled the day, and a sale of Southern Africa on 22 July contained exceptional Bechuanaland, Cape of Good Hope (with Mafeking Besieged), the Griqualand West formed by Dr G.H. Jonkers, as well as rarities of South Africa, Transvaal and Zululand.

Our unique Postal History Auctions held four sales over five days. In October the late Vernon Rowe's Devon and the late Charles Mackenzie Smith's Travelling Post Offices were featured.

British South Africa
Company: Rhodesia 1910
essay die proofs of the
bi-coloured ¹/₂ d. and 1d.
Sold 10.6.86 in London for
£8,640 ($12,986)

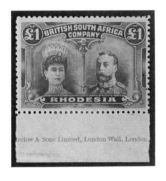

British South Africa
Company: Rhodesia 1910 £1
in the unissued scarlet and
mauve
Sold 10.6.86 in London for
£5,670 ($8,523)

British Bechuanaland 1d. on
1d., used in 1888 and
cancelled 'Tati
Bechuanaland' (which was in
Matabeleland)
Sold 10.6.86 in London for
£2,160 ($3,247)

In March there were collections of Anglo-Boer War and K.J.A. Smith's Nottingham. On 11 June, the second part of the Corsini correspondence realized £96,157 ($148,081). The 15 July sale included the Greenock and Ardrishaig Packets, and Airmails with pioneer Zeppelin flights. The turnover was £342,573 ($527,562).

For the first time in several years, a specialized overseas sale was held in London – a selection of rarities from the collection of Denmark and the Danish West Indies formed by the late F.T.K. Caroe. It realized £147,813 ($227,632).

Those countries with the largest turnover in the home market were Great Britain £679,64 ($1,073,843), India £479,369 ($757,403), Rhodesia £281,648 ($443,003) with Malta in fourth place at just under £200,000 ($316,000). The 15 British Empire sales made £2,084,000, bringing the total of the London sales to £3,103,544.

BOURNEMOUTH
These monthly sales increased in popularity and included over 30 philatelic estates such as the valuable collections of James Douglas, A.J. Gurney Jensen and Charles A. Mann. Over 10,000 lots were sold for a total of £1,407,297.

Japan 1872 20 sen with
missing petal
Sold 13.11.85 in Zurich for
Sw.fr.54,000 (£18,000)

Papal States 1867 insured letter to Reunion via
Lanslebourg, Marseilles, Alexandria and Suez
Sold 13.11.85 in Zurich for Sw.fr.9,562 (£3,187)

ZURICH

Three sales were held in November over two days, Europe realizing Sw.fr.779,030 (£254,584),
the top price being for a pair of the Danish 1852 2 R.B.S. on cover at Sw.fr.22,520 (£6,705);
the collection of Germania made Sw.fr.463,185 ($151,368). The Russian section was very
popular, whereas the Italian States realized only Sw.fr.163,884 (£53,356), a rather disappoin-
ting result. The best lots were the cover from Rome to Reunion (illustrated) and a combination
cover from Rome to Prince Tommaso Corsini at Sw.fr.17,437 (£5,698).

The Overseas sale made up for the Italian by realizing Sw.fr.530,415 (£173,338). The Asiatic
section proved very popular – the Waterlow proofs of China bringing Sw.fr.117,125 (£38,276).
The Japanese 1872 20 sen (illustrated) brought the highest price of the week. In comparison,
the Latin-America were patchy and only realized Sw.fr.88,768 (£29,010). The three sales made
a total of Sw.fr.1,405,560 (£459,333).

The six sales in May again started with Europe (Sw.fr.352,158/£123,564) the top price of
Sw.fr.15,187 (£5,328) being paid for the Netherlands 1856 entire to Constantinople bearing
a 10c. plus a pair and single 15c.

A small sale of Italian States realized Sw.fr.471,375 (£154,044) of which five lots fetched over
Sw.fr.15,000 (£4,901) each, including the bisected Sardinian 10c. lilac-brown bisected on cover
(illustrated).

The lovely collection of Greece formed by Terence Verschoyle brought Sw.fr.320,017
(£104,580), three of the rarities are illustrated. The slightly defective 40 lepta solferino fetched
148 times the £160 the owner paid one of our late partners in 1937. Norman Epstein's Russian
Airmails realized Sw.fr.83,089 (£27,154). An Asiatic sale brought Sw.fr.8,347 (£2,728) for an
imperforate pair of the 1897 Dowager 30c. on 40c. Among the few Japan, mint blocks of 50
1913 20s. and 50s. made Sw.fr.16,312 (£5,330).

Greece 1861 20 lep.
Sold for Sw.fr.19,125
(£6,710)

Greece 1862 10 lep. pale
salmon on greenish
Sold for Sw.fr.18,000
(£6,315)

Greece 1870 40 lep. solferino,
somewhat defective
Sold for Sw.fr.67,500
(£23,684)

All sold 6.5.86 in Zurich
From the Verschoyle
Collection

Denmark 1855 letter from
Copenhagen to Königsburg
bearing 1852 2 r.b.s. and a
strip of five 1855 4sk.
chestnut
Sold 26.11.85 in London for
£5,130 ($7,465)

The last session was Joseph Hackmey's collection of Ottoman Empire (Sw.fr.267,238/£87,332) from which three Turkish postcards fetched over Sw.fr.24,000 (£7,843), the best being an 1899 20 paras card from Medjil to Jaffa with the arrival date-stamp of the German post office, which made Sw.fr.11,250 (£3,676).

The six sales realized Sw.fr.1,681,960 (£596,440), bringing the total for the five days in Zurich to £1,187,744 ($1,722,223).

NEW YORK
Five auctions held at 502 Park Avenue made $1,786,921 (£1,230,424) spread over six days. The best prices in September were $2,100 (£1,448) for a mint strip of four of the U.S. 1908 10c. coil, and $5,280 (£3,641) for both the mint blocks of four of the 1930 Graf Zeppelin air-mail set and a splendid Confederate States 'Jefferson Davis' envelope bearing the 10c. blue.

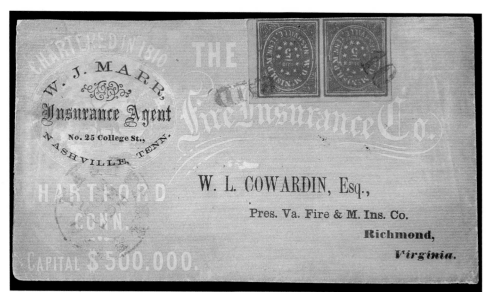

Confederate States 1861 pair of the Nashville 5c. violet-brown used on a Fire Insurance Co. envelope to Richmond, Virginia
Sold 19.3.86 in New York for $15,400 (£10,620)

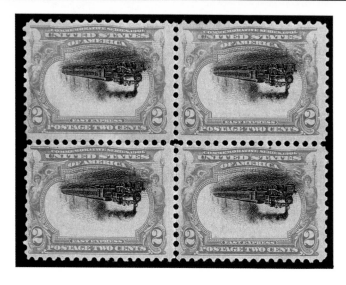

United States 1901 Pan American Exposition 2c. with the centre inverted, a rejoined block of four
Sold 18.3.86 in New York for $104,500 (£72,069)

The February auction included the collection of Canada formed by Carl Mangold, Jr., Clifford W. Schafer's Haiti and D. Scott Gallagher's illustrated envelopes. The charm of the last named was enormous and two of the Lucy Campbell pen-drawn envelopes used in England in 1871 brought $8,250 (£5,769). A pen and watercolour U.S. patriotic cover posted in 1861 from Antwerp to New York made $3,300 (£2,307). The best of the Canada was a mint block of four 1897 Jubilee $5 at $4,400 (£3,076).

There were two sales in March, the first including the reconstructed block of four of the Pan American 2c. with the centre inverted (illustrated). The second was the Tara collection of Confederate State stamps and covers. Illustrated above is one of the best of the fascinating postmasters provisionals. This collection realized $254,177 (£167,222). The April auction was strong in Canada and British Empire, the top price being $6,050 (£4,006) for the Kenya and Uganda 1922 £10 green and black.

Coins and Medals

The late Richard M. Stanley, grandson of Sir Henry M. Stanley, holding two medals that were part of the group of Awards and Royal Presentation pieces given to Sir Henry, which were sold on 25 March 1986 for a total of £188,751 ($283,504)

Sir Henry Morton Stanley (1841–1904)

RAYMOND SANCROFT-BAKER

There are few phrases that can be termed 'legendary', but one of them must be the words uttered by Henry M. Stanley, 'Dr Livingstone, I presume', as he greeted the intrepid African explorer in 1871. Yet, many people are unaware of Stanley's extraordinary life.

He was born on 28 January 1841 at Denbigh, North Wales, the illegitimate son of John Rowlands and Elizabeth Parry. He grew up in the care of his maternal grandfather, Moses Parry, and later in the notorious St Asaph workhouse. In 1858 he sailed as a cabin boy to New Orleans, where he met a benevolent merchant called Henry Morton Stanley, who gave him his name and announced his intention of providing for the young man, but unfortunately his benefactor died soon afterwards. For several years Stanley led a varied life. He became a soldier in the American Civil War and fought on both sides before volunteering for the U.S. Navy, where he distinguished himself under fire.

His experiences of war inspired him to write his first newspaper article and he later found work as a special correspondent covering the campaigns commanded by General Hancock against the Sioux, Kiowa and Comanche Indians in 1867. Later in the same year, Stanley was employed by J. Gordon Bennett of the *New York Herald* as a special correspondent in Abyssinia. He was in Madrid covering the Spanish disturbances when in 1869 Gordon Bennett summoned him to Paris and commissioned him 'to find Livingstone'.

Very little had been heard of Livingstone after he left for the interior of Africa in 1866 to try, amongst other things, to trace the source of the Nile. It was not until early 1871 that Stanley set off to trace him. They met on 10 November the same year and for four months travelled together.

David Livingstone died in 1873 and Stanley was a pall-bearer at his funeral in Westminster Abbey. He returned to Africa to continue Livingstone's exploratory work and travelled continuously during the years 1874–7. Then in 1879 he was invited by King Leopold of the Belgians to explore the Congo and this task occupied him for the next five years.

Stanley's last trip to Africa was for the relief of Emin Pasha, who was Governor of the Equatorial Province of Sudan. Mehmed Emin Pasha (1840–92) was a German, born Eduard Schnitzer, who graduated in medicine in Berlin and was then for nine years in Turkish government service. He adopted a Turkish name and in 1875 went to Khartoum to join General Charles Gordon as medical officer and in 1878 he became Governor of Equatoria. After a very gruelling expedition Stanley eventually rescued the reluctant Emin Pasha and his retinue. In 1870 he published an account of the journey under the title *In Darkest Africa*.

On 12 July 1890 Stanley married Dorothy Tennant at Westminster Abbey and they adopted a son, Denzil. Stanley sat in Parliament as a Liberal Unionist member for North Lambeth from 1895 to 1900. He was knighted in 1899 and died in 1904 at his home near Purbright, Surrey.

Royal Presentation Jewel,
reverse inscribed
'Presented to
Mr H.M. Stanley by
Victoria R.I. 1890'
Sold 22.3.86 in London
for £25,920 ($38,102)

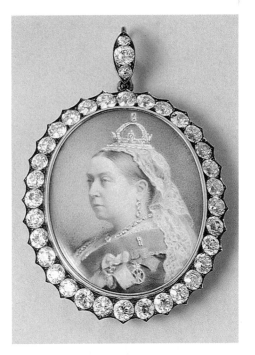

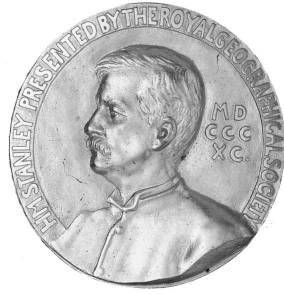

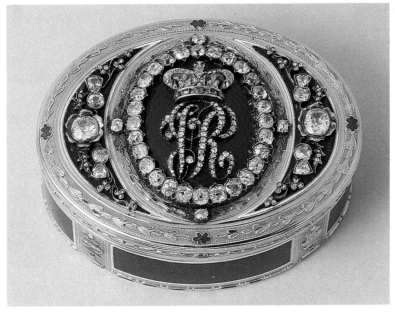

Gold and diamond-encrusted oval snuff-box presented to Henry
M, Stanley in 1872. Inscription on the inside cover reads:
'Presented by Her Majesty Queen Victoria to Henry M. Stanley
Esq.; in recognition of the prudence and zeal displayed by him in
opening communication with Dr Livingstone and thus relieving
the general anxiety in regard to the fate of that distinguished
traveller. London, August 17th 1872'
Sold 22.3.86 in London for £102,600 ($150,822)

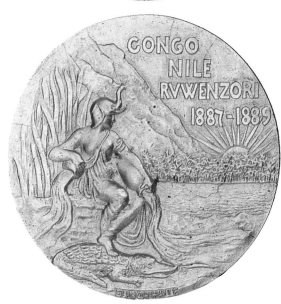

The Royal Geographical Society's Gold Medal
for 1890 awarded to Henry M. Stanley for his
heroic rescue of Emin Pasha
Sold 22.3.86 in London for £5,940 ($8,732)
This unique gold medal was cast by James Moore
at his Thames Ditton factory, using Welsh gold
given to the R.G.S. by Mr W. Pritchard Morgan

Galba
(AD 68–9), Aureus
£6,696 ($9,575)

Otho
(AD 69), Aureus
£25,920 ($37,065)

Vitellius
(AD 69), Aureus
£6,480 ($9,266)

Domitian
(AD 81–96), Aureus
£15,120 ($21,621)

L. Aelius
(AD 136–8), Aureus
£9,720 ($13,900)

Faustina I
(wife of Antoninus
Pius), Aureus
£3,888 ($5,560)

Commodus
(AD 172–7), Aureus
£4,536 ($6,486)

Pescennius Niger
(AD 193–4), Aureus
£23,760 ($33,976)

S. Severus, J.
Domna, Caracalla
and Geta Aureus
£14,040 ($20,077)

S. Severus, Caracalla
and Geta
Aureus
£8,100 ($11,583)

Licinius
(AD 317–24), Aureus
£12,960 ($18,532)

Decentius
(AD 351–3), Aureus
£3,240 ($4,653)

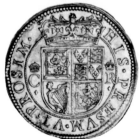

Scotland, Charles I
(1625–49)
Unit
£1,620 ($2,316)

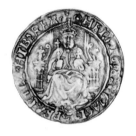
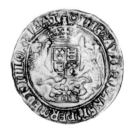

Henry VIII
(1509–47)
Half-sovereign
£486 ($694)

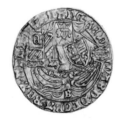
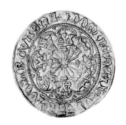

Edward IV, First
Reign (1461–70)
Half-ryal
£756 ($1,082)

France, Louis XIV
Double Louis d'Or,
1690
£3,240 ($4,633)

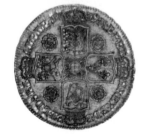

George II
Halfcrown, 1739
£702 ($1,004)

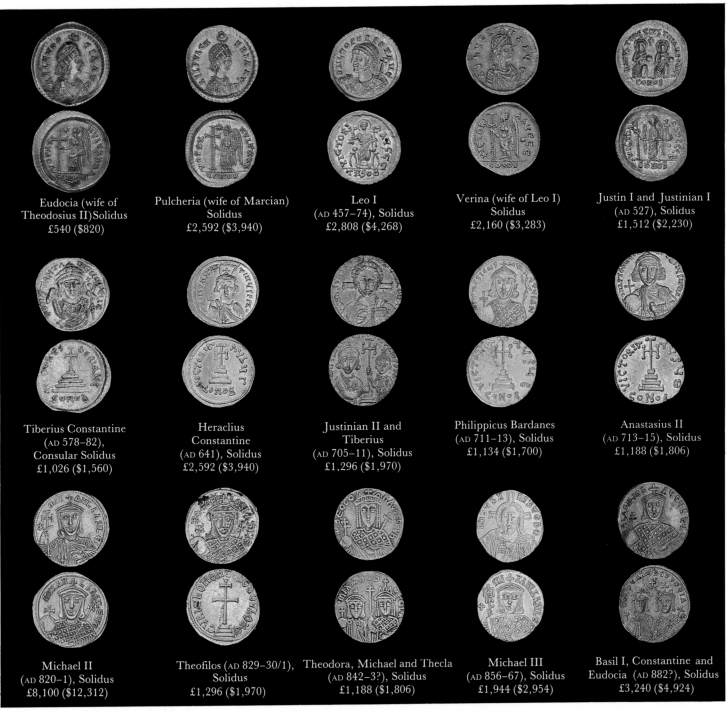

Eudocia (wife of
Theodosius II) Solidus
£540 ($820)

Pulcheria (wife of Marcian)
Solidus
£2,592 ($3,940)

Leo I
(AD 457–74), Solidus
£2,808 ($4,268)

Verina (wife of Leo I)
Solidus
£2,160 ($3,283)

Justin I and Justinian I
(AD 527), Solidus
£1,512 ($2,230)

Tiberius Constantine
(AD 578–82),
Consular Solidus
£1,026 ($1,560)

Heraclius
Constantine
(AD 641), Solidus
£2,592 ($3,940)

Justinian II and
Tiberius
(AD 705–11), Solidus
£1,296 ($1,970)

Philippicus Bardanes
(AD 711–13), Solidus
£1,134 ($1,700)

Anastasius II
(AD 713–15), Solidus
£1,188 ($1,806)

Michael II
(AD 820–1), Solidus
£8,100 ($12,312)

Theofilos (AD 829–30/1)
Solidus
£1,296 ($1,970)

Theodora, Michael and Thecla
(AD 842–3?), Solidus
£1,188 ($1,806)

Michael III
(AD 856–67), Solidus
£1,944 ($2,954)

Basil I, Constantine and
Eudocia (AD 882?), Solidus
£3,240 ($4,924)

The above twelve Byzantine coins were part of the collection formed by Hugh G. Goodacre (1865–1952), which sold on 22 April 1986 for a total of £153,257 ($232,108), with all 373 lots finding a new owner. Hugh Goodacre collected Byzantine coins at a time when they were distinctly unpopular, so much so that he, together with his friend Tommaso Bertelè, were almost the only serious collectors of these coins in Europe during the 1920s and 1930s.

Hugh Goodacre published many articles but is best remembered for his work *A Handbook of the Coinage of the Byzantine Empire*, published in three parts in 1928, 1931 and 1933; it was republished as one volume in 1957.

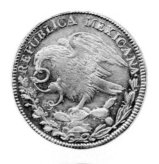
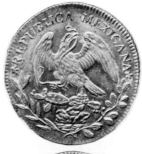
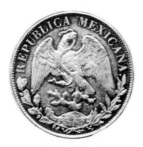

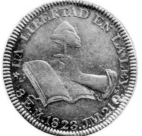
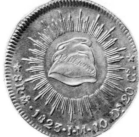
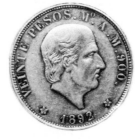

| Mexico
8-Escudos, 1823
$7,700 (£5,384) | Mexico
Pattern 8-Reales, 1823
$11,550 (£8,076) | Mexico
The 'Hidalgo' Pattern
20-Pesos, 1892
$33,000 (£23,076) | Mexico, Ferdinand VII
4-Escudos, 1812, Guadalajara
$37,000 (£28,461) |

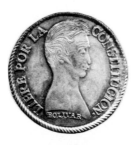
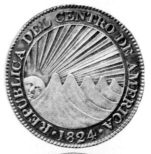
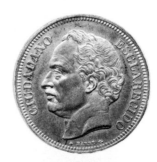

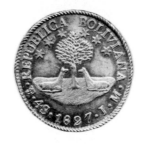
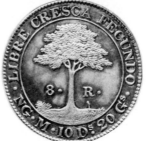

| Spain, Charles II
'Cob' 8-Escudos, 1673
$2,750 (£1,923) | Bolivia
Pattern 4-Sueldos, 1827
$5,200 (£3,636) | Guatemala
Pattern 8-Reales, 1824
$3,630 (£2,538) | Venezuela
10-Reales, 1863
$18,000 (£13,846) |

From the Norweb Collection of Mexican and South American coins
Sold 6/7.11.85 in Dallas, Texas

Sardinia, Filibert II
(1497–1504)
1-Ducat, undated
$31,900 (£22,307)

Japan, 20-Yen, 1897
$1,375 (£961)

South Africa, 1-Pond,
1902
$3,300 (£2,307)

2½-Dollars, 1796
$8,800 (£6,154)

5-Dollars, 1795
$6,600 (£4,615)

10-Dollars, 1795
$4,620 (£3,230)

Proof 2½-Dollars,
1895
$8,580 (£6,000)

Proof 3-Dollars,
1872
$7,480 (£5,230)

Proof 3-Dollars,
1887
$12,100 (£8,462)

Proof 20-Dollars, 1899
$12,100 (£8,462)

Mormon 5-Dollars, 1849
$3,740 (£2,615)

C. Bechtler, 5-Dollars,
Carolina
$2,750 (£1,923)

Panama-Pacific Exposition, 50-Dollars, 1915 S
$33,000 (£23,076)

U.S. Assay Office, 50-Dollars, 1852 $6,820 (£4,769)

All sold in New York

Ceylon, Oriental Banking Corporation
10-Rupees, 1881, Jaffna
£842 ($1,204), for two notes, 5 and 10-Rupees

Hong Kong, Asiatic Banking Corporation
100-Dollars
£1,620 ($2,316), for two notes, 50 and 100-Dollars

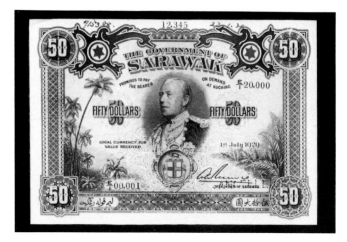

Sarawak, 50-Dollars, 1929, Kuching
£3,024 ($4,324), for set of five notes, 1, 5, 10, 25 and
50-Dollars

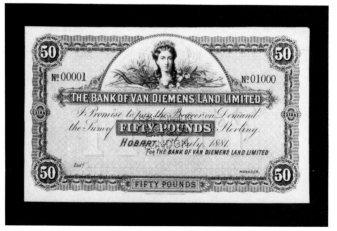

Australia, Bank of Van Diemens Land, 50-Pounds, 1881,
Hobart
£1,836 ($2,625), for set of five notes, 1, 5, 10, 20 and
50-Pounds

On 3 October 1985 a selection of specimen banknotes from the archives of the world-famous security printers Bradbury Wilkinson was offered for sale. The sale realized a total of £298,582 and was extremely popular, mainly because these attractive notes had never been offered for sale before and similar examples are difficult to acquire. Being archive specimens, many of the notes were annotated in ink with the date they were ordered and the number printed, which makes them appealing to collectors as it specifies the print-run. Bradbury Wilkinson established its reputation for first-class engraving during the latter half of the nineteenth century and has maintained that tradition to the present day. The artistic care and skill that is apparent in the engraved notes is perhaps explained by the fact that their top portrait engravers have often gone through 25 years of training. Many collectors have now had the opportunity to enhance their collection with these examples of fine workmanship.

Photographs

CLARENCE H. WHITE
Portrait of Alfred Stieglitz
Waxed platinum print
*c.*1906
Signed twice and dated 21 in pencil
on the tissue mount; signed by
Stieglitz in pencil on the verso
$9\frac{3}{4} \times 7\frac{1}{2}$ in. (25 × 19 cm.)
Sold 11.11.85 in New York for
$37,400 (£26,384)
Record auction price for a work by
the artist
The following is an excerpt from a
letter sent by the original owner of
this photograph to the current
owner: 'I attended the Clarence H.
White School of Photography in
1938–9. In the fall of 1940 I went
to work at the School as the
secretary-receptionist, and worked
there until March 1942. The White
School had moved to a large
building on West 74th St. just
before World War II started and,
very unfortunately, went bankrupt
and closed in 1942. Clarence White
Jr., the Director of the School, had
not been able to pay our salaries
the last month or two, and when
the School finally went out of
commission he offered each of the
staff their choice of one of his
father's prints, in lieu of the back
wages owed us. I chose the portrait
of Stieglitz, thinking it might have
value someday.'

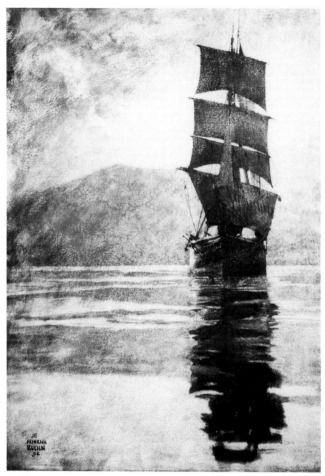

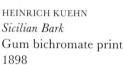

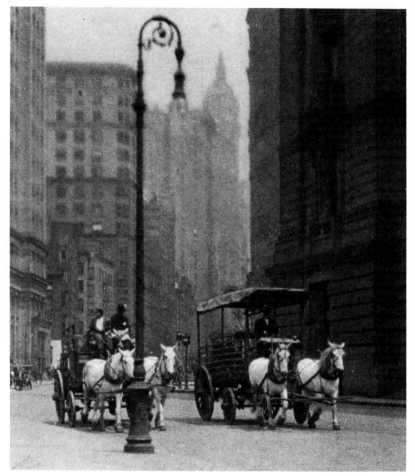

HEINRICH KUEHN
Sicilian Bark
Gum bichromate print
1898
Signed, dated and Trifolium insignia in ink on the recto;
notations in pencil on the verso
$30\frac{3}{8} \times 21\frac{1}{2}$ in. (77 × 44.3 cm.)
Sold 11.11.85 in New York for $10,120 (£7,140)
From 1897 to 1903, Kuehn and two other members of the
Linked Ring, Hans Watzek and Hugo Henneberg,
collaborated in experimentation with the gum bichromate
printing process. Their joint 'goal was (to create) a large
picture that could hold the wall like a painting and whose
broad areas of tone, purged of distracting detail, would
still be rich.' The association between the three men,
dubbed the Trifolium, prompted each of them to mark his
work with a clover-leaf design.

KARL STRUSS
Pictorial Views
An album containing 33 platinum prints
1909–11
Signed and dated in ink on the first leaf; 25 prints signed and dated, one
initialled and one dated in pencil on the recto; three dated in pencil on the
mount
Various sizes from $3\frac{1}{8} \times 1\frac{3}{4}$ in. (8 × 4.4 cm.) to $4\frac{1}{2} \times 3\frac{1}{2}$ in.
(11.6 × 9 cm.)
Sold 13.5.86 in New York for $30,800 (£19,618)
This personally designed album was presented as a love token in 1911 to
Amy Whittemore, a student of Clarence White's at Columbia University.
Three images are dated 1909, five are dated 1910 and 19 are dated 1911,
the majority of which are architectural scenes in New York.

MAXIME DU CAMP
Egypte, Nubie, Palestine et Syrie, dessins
A rare complete edition with 125 salt prints by Blanquart-Evrard from paper negatives by Du Camp
1852
Each approx. 6 × 8 in.
(15.3 × 20.3 cm.)
Sold 24.4.86 in London at Christie's South Kensington for £30,000 ($46,110)
Maxime Du Camp accompanied his friend Gustave Flaubert on a three-year expedition to Egypt, Nubia and the Holy Land, returning with 200 negatives, from which the above were selected for publication and printed at the Lille establishment of Louis-Desiré Blanquart-Evrard. Although several of the sites had been photographed previously, this was the first published work to include photographs of the Middle East, and the first comprehensive photographic documentation of a region and of its monuments. Among sites never previously photographed was that of the rock-cut temple of Ramses II at Abu-Simbel. In order to augment his own work, Du Camp included three views from daguerreotypes by Aimé Rochas – of Cairo, the Pyramids, and the interior of the temple at Medinet-Habu. Du Camp did not use photography again after his return, and his reputation as one of the pioneer photographers rests on this work, the first major French book to be illustrated with photographs.

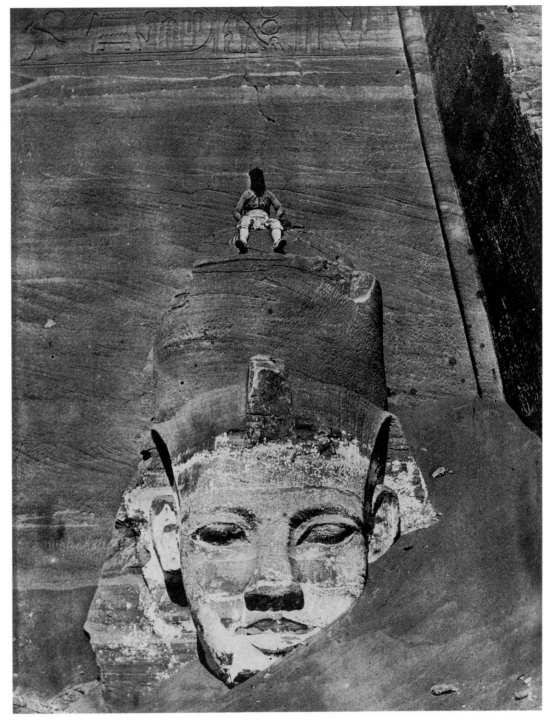

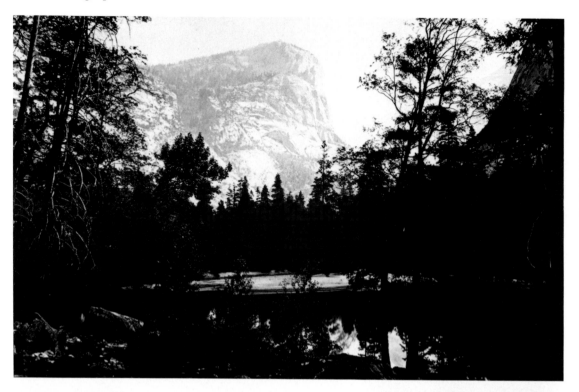

CARLETON E. WATKINS
Yo-Semite Valley: Photographic Views of the Falls and Valley of Yo-Semite in Mariposa County, California
An album containing 51 albumen prints
San Francisco, California, 1863
Each approx. $7\frac{1}{2} \times 11\frac{1}{2}$ in. (19×29.3 cm.)
Sold 11.11.85 in New York for $22,000 (£15,520)

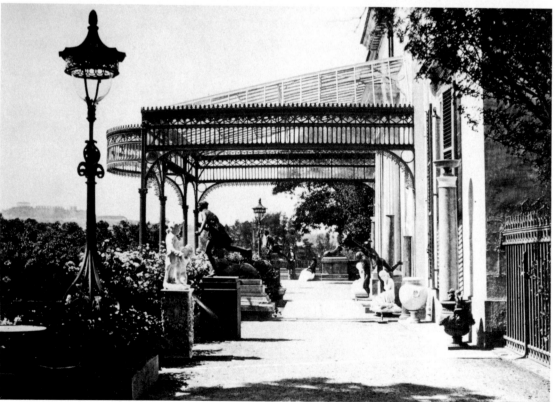

CHARLES MARVILLE AND ETIENNE CARJAT
Bagatelle jusqu'a 1870
1857–64
An album of 35 photographs comprising 34 albumen prints by Marville, 30 of these between $8\frac{1}{2} \times 14$ in. (21.6×35.6 cm.) and 11×15 in. (27.9×38.1 cm.), and one salt print by Carjat, oval, $8 \times 6\frac{1}{4}$ in. (20.3×15.9 cm.)
Sold 24.4.86 in London at Christie's South Kensington for £14,000 ($20,713)

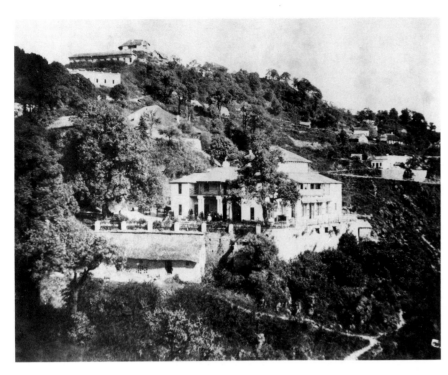

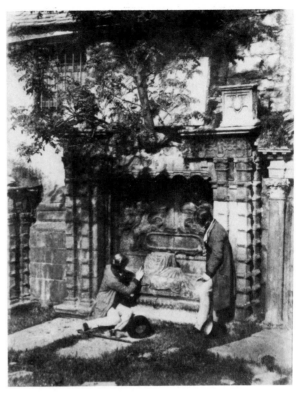

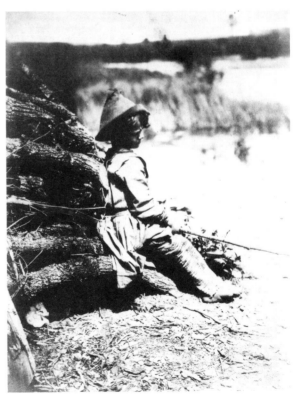

Above:

STANLEY TYTLER

In the Hills of Benares, India...taken immediately after the Mutiny
1858
Mammoth paper negative, 16½ × 20¾ in. (41.9 × 52.6 cm.), and
contemporary albumen positive print, 15¾ × 20¼ in. (40 × 51.4 cm.)
Sold 24.4.86 in London at Christie's South Kensington for £2,400 ($3,551)

Above right:

D.O. HILL AND R. ADAMSON

Tomb of the Family of Nasmyth, Grey Friars, Edinburgh
Calotype mounted on card with pencil title, photographer's credit and date
'Edinburgh 1844'
8 × 6 in. (20.3 × 15.3 cm.)
Sold 24.4.86 in London at Christie's South Kensington for £2,200 ($3,255)

Right:

SIDNEY RICHARD PERCY

Portraits and Genre Studies
c. 1850–7
Sold 24.4.86 in London at Christie's South Kensington for £1,700 ($2,516)

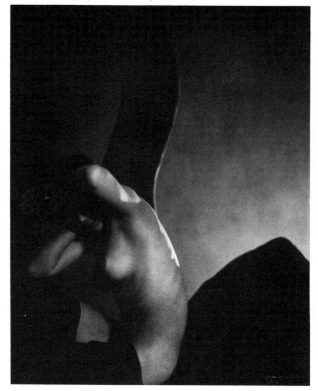

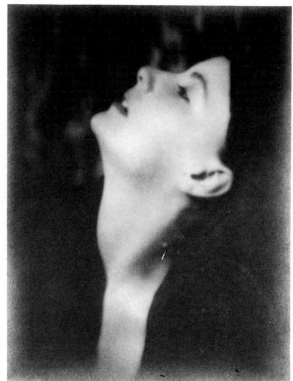

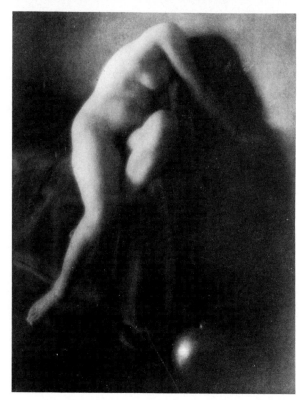

Above:
EDUARD STEICHEN
Steichen
Limited edition album
New York, Alfred Stieglitz, April 1906
Signed 'Alfred Stieglitz' and 'Eduard J. Steichen'
Sold 31.10.85 in London at Christie's South
Kensington for £2,000 ($2,879)

Above right:
ARNOLD GENTHE
Portrait of Greta Garbo
Gelatin silver print, 1925
Signed in pencil on the mount, framed
$13\frac{1}{4} \times 10\frac{1}{8}$ in. (33 × 25 cm.)
Sold 13.5.86 in New York for $8,250 (£5,296)

Right:
FRANTISEK DRTIKOL
Nude with Drape
Pigment print, 1926
Blindstamped on the recto; signed and dated in pencil
on the mount
$11\frac{3}{4} \times 9\frac{1}{4}$ in. (28.8 × 23.2 cm.)
Sold 11.11.85 in New York for $3,080 (£2,173)

Collectors' Sales

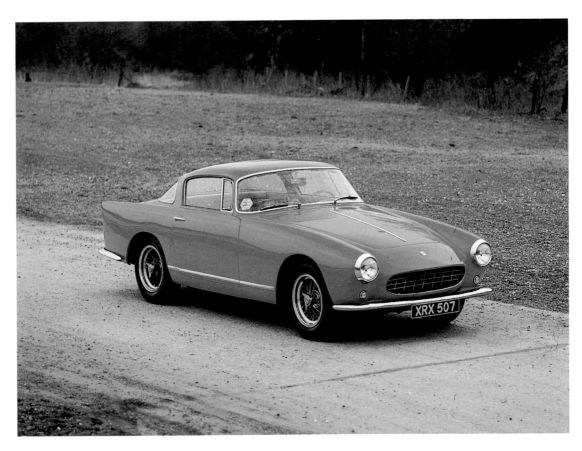

1956 Ferrari 250 GT
Two-seat Coupé
Coachwork by Boano
Sold 21.4.86 at Beaulieu for £32,400 ($49,216)

Fashion Plates and Books: The Reference Collection of Mrs Doris Langley Moore

SUSAN MAYOR

The new departure this season was the sale of the reference archive belonging to Mrs Langley Moore, the doyenne of costume historians, who founded the Museum of Costume in Bath. This was the first sale of a library devoted entirely to the study of fashion and not surprisingly it generated an enormous amount of interest in the press and saw heavy bidding from designers, the National Art Library and museums internationally, as well as booksellers, printsellers and costume collectors.

The top price, as predicted, was for Lucile's watercolour fashion designs for autumn 1904 and 1905, sold to the Victoria and Albert Museum for £4,400 ($6,664). Lucile (Lady Duff Gordon) was the first society woman to set up profitably in the couture, and for some years was the leading name in English dress design. These 107 designs had swatches of the elaborate materials and trimmings used and many were named: 'The elusive Joy of Youth, The Sweetness of Time, Oblivion, Unforgotten, The Tender Grace of a Day that is Dead'. As very few of Lucile's elaborate creations survive today this was an invaluable document.

Mrs Moore began collecting in the 1920s. The collection was therefore full of rarities, from the enchanting miniature frontispieces that appeared in ladies' pocket books and almanacks of the 1760s to 1790s to the marvellous huge plates of *Belle Epoque* in such magazines as *La Mode Artistique* of which 23 issues of March 1905 to February 1907 realized £1,300 ($1,969). As Mrs Moore pointed out in the foreword to the catalogue the former 'were so diminutive that few have survived, most of them probably having been given to children to glue into scrapbooks', and the latter 'were of cumbersome proportions and are thus missing from many archives'.

Work by all the great fashion artists appeared in this sale: Sulpice Guillaume Chevalier, called Paul Gavarni (1804–86); Lanté in the 1830s; the Colin sisters, Heloise Leloir (1820–74), Anais Toudouze (1822–99) and Laure Noel (1827–92); Anais's daughter Isobel also designed fashion plates; F.C. Compte-Calix in the 1850s; Gustave Janet in the 1870s; Jules David (d.1892), who 'spent about fifty years depicting the latest models in the most stylish and variegated manner, inventing scenes which in a more gracious world, would be part of everyday life'. David worked not only for the *Englishwoman's Domestic Magazine*, founded in 1852 by Mrs Beeton's husband, but for many other publications too. The other great artist of that period, Adolf Karol Sandoz, worked almost exclusively for *The Queen* from 1887 to 1898. He was a Ukrainian who had studied art in Paris and practised genre painting there. Fine examples of his work were fetching £20 ($31) a plate.

A fine but incomplete run of *Gazette du Bon Ton*, 9 issues of 1912–20, realized a staggering £3,200 ($4,847) – even odd plates by Georges Barbier were making £100 ($154) each. Another incomplete run of *Art, Goût, Beauté*, 13 issues of 1926–30, made £900 ($1,363). *The Journal of Design and Manufactures*, six volumes bound in three 1849–51, which was published in preparation for the Great Exhibition of 1851, realized £1,700 ($2,575). It contains numerous samples of early Victorian fabrics and wallpapers.

Six fashion plates for 1877, including *The Milliner and Dressmaker*, one plate by Jules David; and *The Queen, Supplement*, six coloured fashion plates by A. Sandoz for 1889
Sold 22.4.86 in London at Christie's South Kensington for £70 ($105) and £130 ($195) respectively

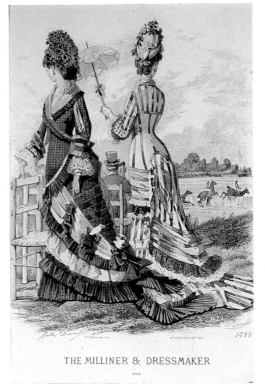

THE MILLINER & DRESSMAKER
AND

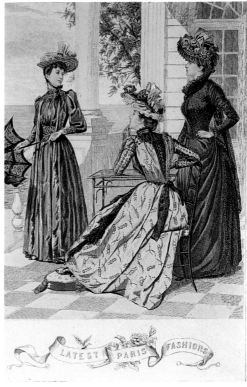

LATEST PARIS FASHIONS

Right:
Museé des Familles, one of 29 fashion plates by Laure Noël
Sold 22.4.86 in London at Christie's South Kensington for £95 ($142)

Far right:
Lucile's original designs in watercolour with samples of the materials and trimmings: 48 designs for autumn 1904; 69 designs for autumn 1905
Sold 22.4.86 in London at Christie's South Kensington for £4,400 ($6,600)

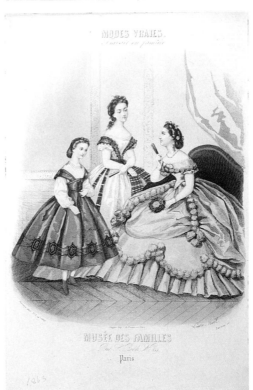

MUSÉE DES FAMILLES
Paris

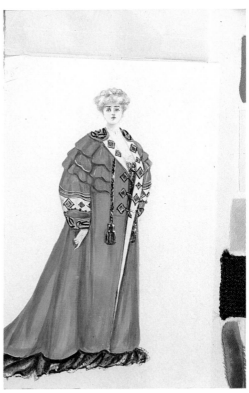

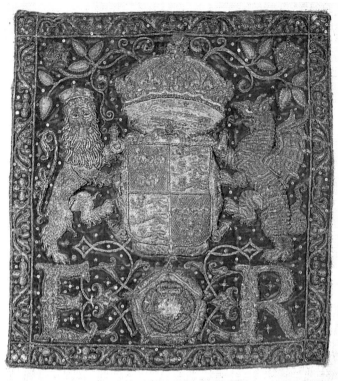

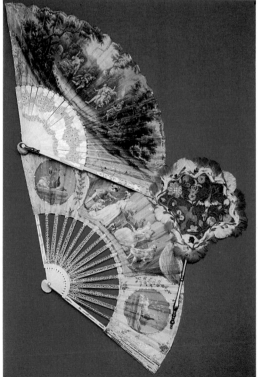

Above left:
Patchwork quilt
c. 1825
100 × 112 in. (254 × 283 cm.)
Sold 17.6.86 in London at Christie's South Kensington for £420 ($630)

Above:
Cover of a burse used to carry the Great Seal of the Realm
during the reign of H.M. Queen Elizabeth I
14½ × 13¼ in. (36.8 × 33.5 cm.)
Sold 11.3.86 in London at Christie's South Kensington for £12,000 ($17,340)

Left:
Fan
English, *c.* 1730
11 in. (28 cm.)
Sold 8.4.86 in London at Christie's South Kensington for £520 ($762)

Handscreen, probably made in South America
13 in. (33 cm.)
Sold 8.4.86 in London at Christie's South Kensington for £2,700 ($3,957)

Fan
French, *c.* 1775
11 in. (28 cm.)
Sold 8.4.86 in London at Christie's South Kensington for £500 ($729)

Right:
South Australia Militia
Lancers uniform
Sold 20.9.85 in London
at Christie's South
Kensington for £3,800
($5,092)

Right centre:
Uniform of Count
Alexander
Benckendorff, Imperial
Russian Ambassador to
the Court of St. James
By Herbert Johnson,
New Bond Street
Sold 20.9.85 in London
at Christie's South
Kensington for £1,700
($2,293)
Benckendorff was
accredited Ambassador
to the British court in
1903–17

Above far right:
King's Own Royal
Regiment of Norfolk
(Imperial) Yeomanry
set of uniforms in metal
trunk (bearing the
name Captain H.
Birbeck)
Sold 20.9.85 in London
at Christie's South
Kensington for £2,200
($2,967)

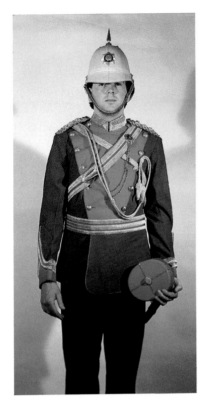

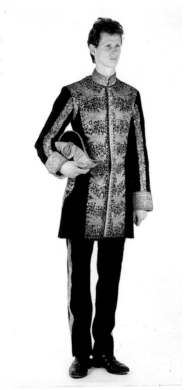

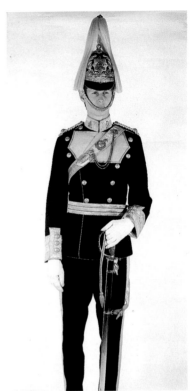

Right:
Helmet of Captain L.E.G. Oates,
6th (Inniskilling) Dragoons
Sold 20.9.85 in London at
Christie's South Kensington for
£2,200 ($2,967)

Far right:
Dragoon Guards (Princess
Charlotte of Wales's) officer's full
dress sabretache
c. 1837–55
Sold 20.9.85 in London at
Christie's South Kensington for
£1,700 ($2,287)

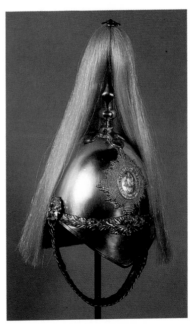

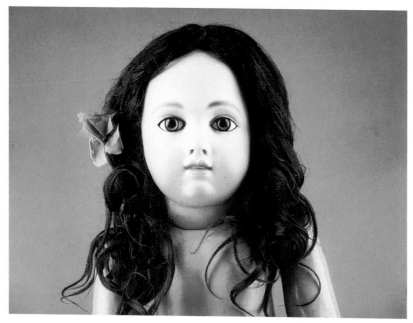

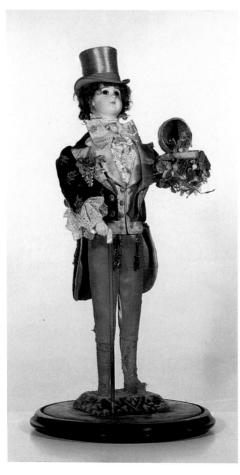

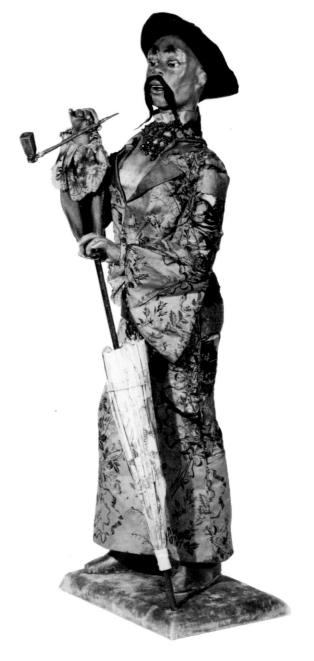

Above:
Large A.T. bisque-headed
bébé
Incised AIIT
25 in. (63.5 cm.) high
Sold 18.9.85 in New York
for $18,700 (£14,071)

Right:
Automaton doll magician
in glass dome
Marked *Deposé Jumeau*
24 in. (61 cm.) high
Sold 6.3.86 in London at
Christie's South
Kensington for £3,000
($4,331)

Far right:
Composition-headed
automaton modelled as a
standing Chinese man
French, 1880
30 in. (76 cm.) high
Sold 30.1.86 in London at
Christie's South
Kensington for £6,000
($8,397)

Two Steiff teddy bears, a bisque-headed doll and a Bing locomotive with Caledonian railway livery
Sold 6.3.86 in Glasgow for a total of £7,302 ($10,548)

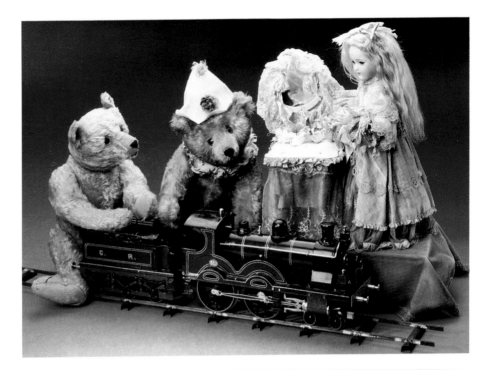

Selection of teddy bears from a collection of over 180 bears
Sold 13.12.85 in London at Christie's South Kensington for a total of £14,125 ($21,187)
This was the first sale solely devoted to teddy bears and soft toys

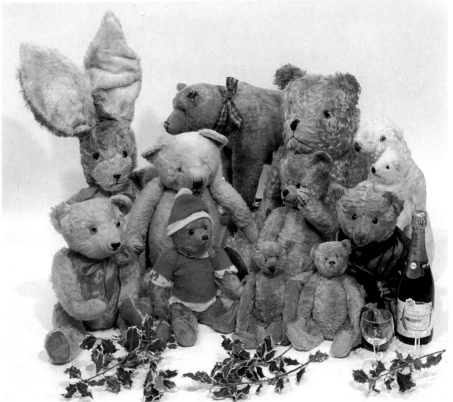

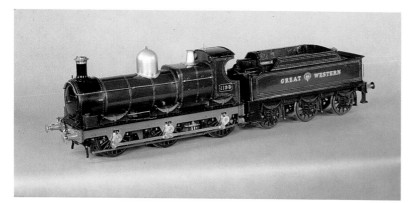

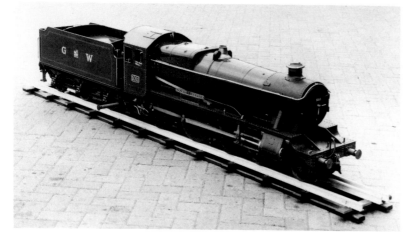

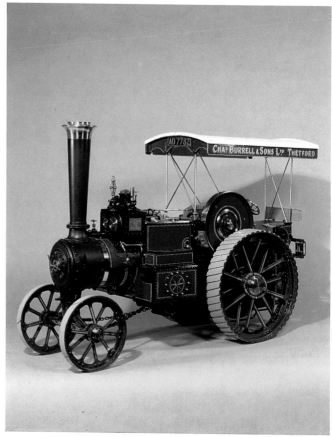

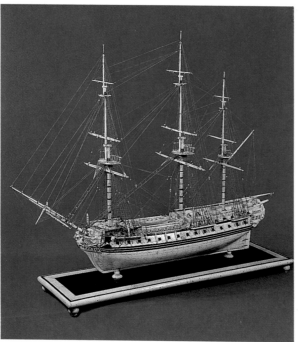

Top left:
5 in. gauge model of the G.W.R. *Armstrong*
13½ × 52 in. (34.5 × 132 cm.)
Sold 21.2.86 in London at Christie's South Kensington for
£6,000 ($8,625)

Above left:
7¼ in. gauge model of the G.W.R. *County of Chester*
21¾ × 101 in. (55.5 × 256.5 cm.)
Sold 27.9.85 in London at Christie's South Kensington for
£12,000 ($17,395)

Above:
2 in. model of the Burrell 5 n.h.p. 'Gold Medal' tractor
19¾ × 27 in. (50 × 69 cm.)
Sold 27.9.85 in London at Christie's South Kensington for
£7,500 ($10,872)

Left:
Model of a 52-gun Man-of-War
26½ × 36 in. (57.5 × 91.5 cm.)
Sold 21.2.86 in London at Christie's South Kensington for
£13,000 ($18,688)

Right:
Hessmobile, painted and lithographed 2 seater automobile, with hand-crank flywheel mechanism
German, *c.*1890
9 in. (22.8 cm.) long
Sold 29.5.86 in London at Christie's South Kensington for £3,000 ($4,500)

Far right:
Carette enamelled Mercedes two-seater open tourer, with clockwork mechanism
German, *c.*1907
10¼ in. (26 cm.) long
Sold 23.1.86 in London at Christie's South Kensington for £7,200 ($10,034)

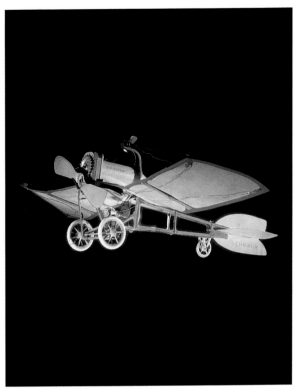

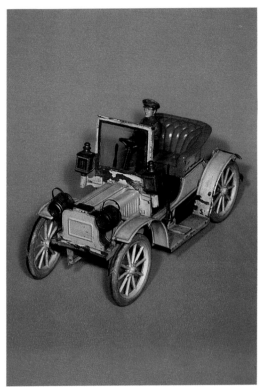

Columbia, painted metal model of a two funnel ship
By Bing, *c.*1904
26½ in. (67.8 cm.) long
Sold 12.9.85 in London at Christie's South Kensington for £3,600 ($4,673)

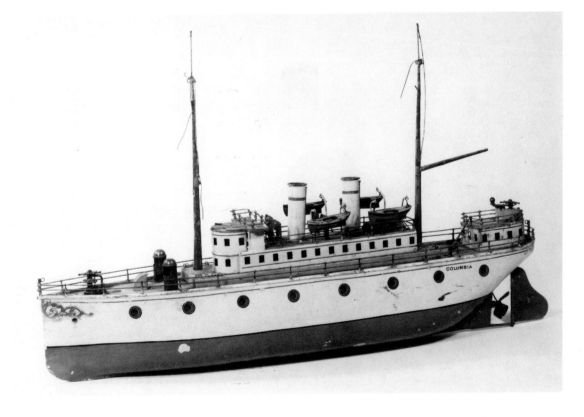

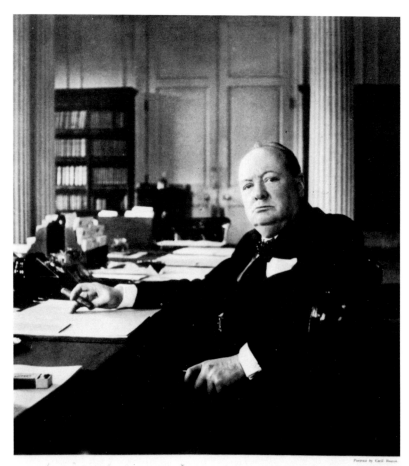

'THE MAN AT THE HELM'

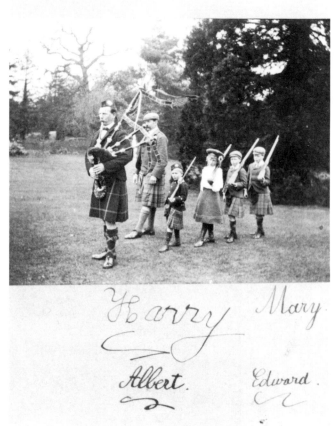

Charlie Chaplin bowler hat and cane
The hat initialled 'C.C.', with maker's label 'John B.
Stetson Company' of Philadelphia, and hat-seller's label
'McCue Bros. & Drummond, New York'
The 'bamboo' cane autographed 'Charles Chaplin, 1920'
Sold 17.7.86 in London at Christie's South Kensington for
£15,000 ($22,500)

Above left:
Winston Churchill: 'The Man at the Helm'
Signed on the mount 'Winston Churchill' and dated
'March 1941'; photographer's credit on mount 'Portrait by
Cecil Beaton'
8 × 7 in. (20 × 18 cm.)
Sold 13.2.86 in London at Christie's South Kensington for
£450 ($644)

Above:
Four eldest children of King George V and Queen Mary:
gelatin-silver print entitled *Drill Photograph at York Cottage,
1906*
Signed on mount by each of the subjects, Edward, Albert,
Mary and Harry
3 × 4 in. (7.6 × 10.2 cm.)
Sold 1.5.86 in London at Christie's South Kensington for
£380 ($583)

Right:
Quarter-plate tropical Una
Camera
By James A. Sinclair & Co.,
Ltd., London
Sold 24.4.86 in London at
Christie's South Kensington
for £1,100 ($1,690)

Far right:
Thornton-Pickard Type C
aerial camera, No. C192
Sold 24.4.86 in London at
Christie's South Kensington
for £1,700 ($2,613)

Right:
$3\frac{5}{8} \times 2\frac{3}{4}$ Dubroni No. 3
camera outfit
By A. Bourdin, Paris
Sold 24.4.86 in London at
Christie's South Kensington
for £4,000 ($6,148)

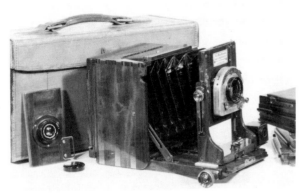

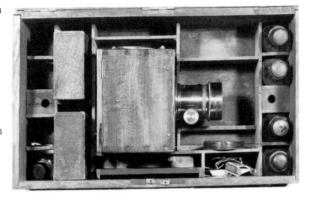

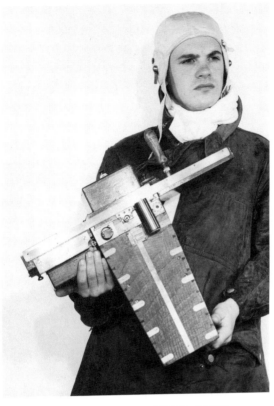

Right:
17.5 mm. Biokan
Combined Cinematograph
and Snapshot Camera,
Printer, Enlarger and
Projector, No. 187
By Alfred Darling,
Brighton
Sold 24.4.86 in London at
Christie's South
Kensington for £1,200
($1,845)

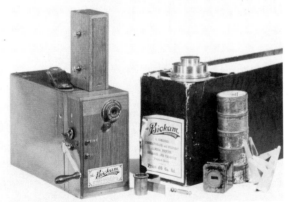

Right:
The British Journal Photographic Almanac, collection of
90 annuals
1871–1963
Sold 24.4.86 in London at Christie's South
Kensington for £2,800 ($4,304)

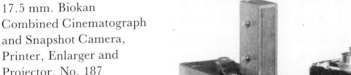

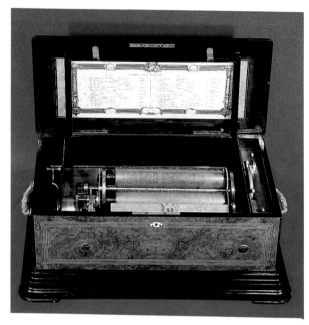

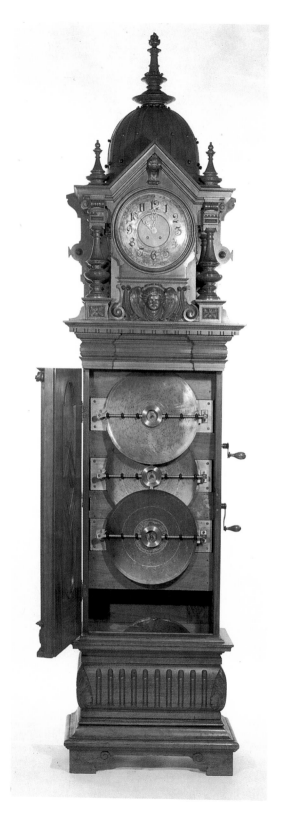

Above:
'Revolver' Mandoline Harp Piccolo Zither musical box
The tune-sheet marked 'J.M. & Co., Ste. Croix, No. 15520'
28 in. (71 cm.) wide
Sold 6.3.86 in London at Christie's South Kensington for £9,000 ($12,992)

Right:
Symphonion Eroica clock musical box with triple 'Sublime Harmony' comb
103 in. (262 cm.) high
Sold 6.3.86 in London at Christie's South Kensington for £9,500 ($13,713)

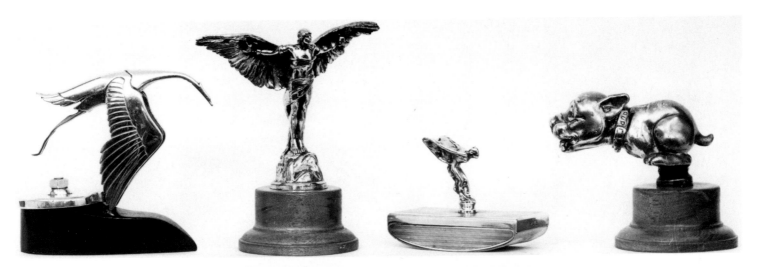

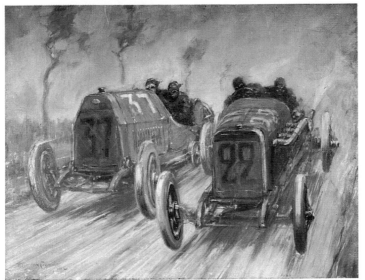

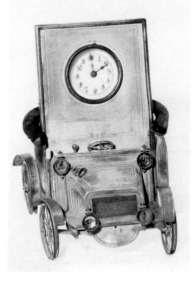

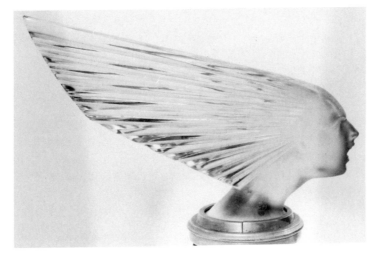

From left to right:
Chromium-plated Hispano-
Suiza stock
7 in. (18 cm.) long
Sold 10.4.86 in London at
Christie's South Kensington
for £300 ($438)

Nickel-plated bronze Farman
Icarus, *c.*1922
6 in. (15 cm.) high
Sold 10.4.86 in London at
Christie's South Kensington
for £350 ($511)

Rolls-Royce silver ink blotter
5½ in. (14 cm.) long
Sold 10.4.86 in London at
Christie's South Kensington
for £380 ($555)

Telcote Pup, Bonzo
6 in. (15 cm.) long
Sold 10.4.86 in London at
Christie's South Kensington
for £150 ($219)

Right:
Victoire (Spirit of the Wind)
Moulded 'R. Lalique'
10¼ in. (26 cm.) long
Sold 10.4.86 in London at
Christie's South Kensington
for £3,400 ($4,961)

Above left:
FREDERICK GORDON CROSBY
French Grand Prix, Dieppe 1912
Signed and dated 1912
18 × 24 in. (46 × 61 cm.)
Sold 10.4.86 in London at
Christie's South Kensington for
£7,000 ($10,213)

Above:
Chromium-plated timepiece
modelled as an Edwardian tourer
8½ in. (21.5 cm.) high
Sold 10.4.86 in London at
Christie's South Kensington for
£450 ($657)

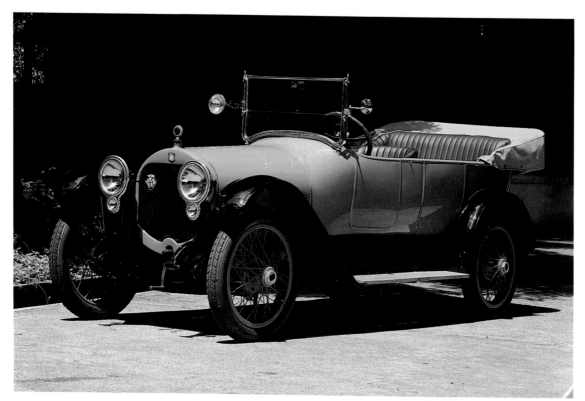

1917 Haynes Light 12
Model 41 Type T
Four-seat tourer
Sold 14.7.86 at Beaulieu
for £21,600 ($32,400)

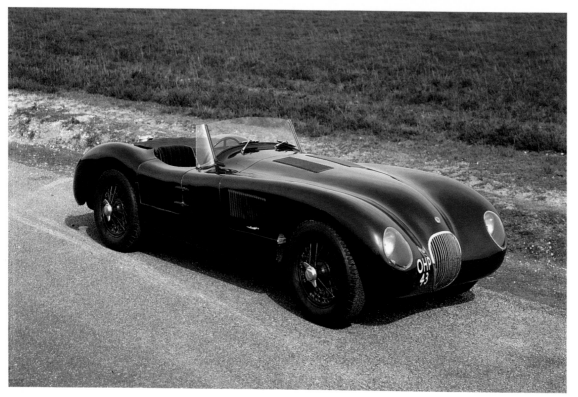

1953 Jaguar C-type Sports
Two-seater
Sold 14.7.86 at Beaulieu
for £108,000 ($162,000)

1957 BMW 503 V-8
Two-door four-seat
Cabriolet
Sold 14.7.86 at Beaulieu
for £22,680 ($34,020)

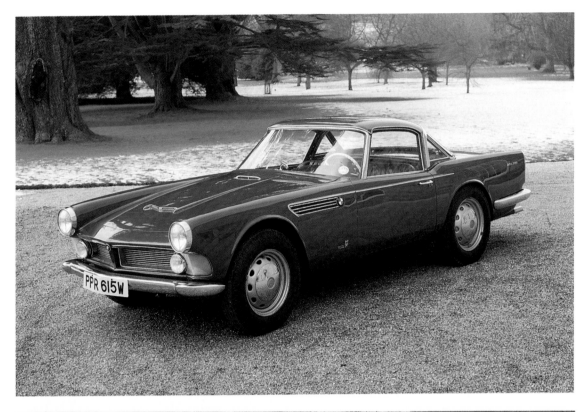

1958 BMW 507
Two-seat roadster with
detachable hardtop
Coachwork by Vignale
Sold 21.4.86 at Beaulieu
for £50,760 ($77,105)

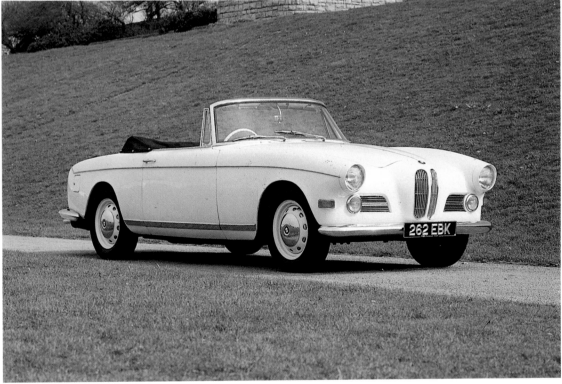

Animation and Comic Art

BETTY KRULIK

Christie's East began offering celluloids in American Paintings sales several years ago; from that inauspicious beginning, semi-annual auctions devoted to Animation and Comic Art developed. This area is now one in which Christie's is at the forefront and we hold world records for auction prices of painted celluloids as well as concept drawings and watercolours.

Since 1929, Walt Disney's animated films have enjoyed a worldwide audience of children and their parents, but only a very small group of foresighted collectors actively sought fine examples until recently, with most major collections only coming into their own in the last two decades. The idea of animation celluloids, background drawings and related works coming under the fine arts category emerged on a widespread scale only after the Whitney Museum of American Art held an enormous exhibition of these artworks in 1981.

The dispersal of the John O. Basmajian Collection of Animation Art by Christie's East in December 1984 attracted a very large group of bidders and finally, it seems, this field has sprouted into a fully-developed part of the art market. The Basmajian Collection brought together more than 300 prospective buyers who vied for the 379 lots, bringing many prices far above their anticipated levels. Prices ranged from a low of $262 (£202) for photocopies of model sheets showing favourite characters, to a world-record high of $20,900 (£16,077) for the celluloid showing the historic moment when Mickey Mouse swatted seven flies in one blow, a scene from *Brave Little Tailor*, an animated short of 1938.

This astounding record lasted only until the second sale of this type, held in December 1985, when a celluloid from *The Band Concert* of 1935 sold for $24,200 (£16,335). This extremely rare 'set-up' shot, full of exuberant animals playing band instruments on a gazebo, was the opening scene for Mickey's debut in a full-colour short-length film.

From our third sale, held on 21 June 1986, a fine collection of 151 drawings comprising the complete storyboard for *Mickey's Service Station* of 1935, the last of the black and white Mickey Mouse short films, was sold in 10 lots for a total price of $18,590 (£12,229). It is rare to encounter these developmental drawings; this one tells the story of 'The Trio' – Mickey Mouse, Donald Duck and Goofy – challenged by 'Mean Pete' to find a mysterious squeak in his car. *Mickey's Service Station* epitomizes the attention to detail and character development that is the genius of Walt Disney and his artists. Aside from developing the characters, the animators would draw all of the primary movements, representing every two to five frames of action. The drawings were traced on to the celluloid and coloured by the craftsmen. Drawings may be purchased from $50 (£33) for a depiction of one of the dwarfs from *Snow White and the Seven Dwarfs* to $950 (£625) for a 1938 *Betty Boop* mouth-action chart.

The skilled hands behind Walt Disney Studios' success ranged from the professional concept-artists to housewives who inked and coloured the celluloids. The material with which they worked for the most part, celluloid, is a petroleum product. The demand for petroleum during World War II prevented much animated film from being saved. The water-based gouache painted on the petroleum base was often washed off and the celluloid reused. For this reason, many images were destroyed and those available for purchase today are rare.

While celluloid is the most popular medium in the animation field, concept watercolours by Disney stylists such as Gustave Tenggren, Tyrus Wong, and Ferdinand Horvath have also created a great deal of excitement.

Mother Goose Goes to Hollywood, 1938
Katherine Hepburn as 'Little Bo Peep'
Gouache on full celluloid applied to a
watercolour background
$7\frac{1}{2} \times 8\frac{1}{2}$ in. (18 × 21.5 cm.)
Sold 21.6.86 in New York at Christie's East
for $1,650 (£1,100)

Alice in Wonderland, 1951
Alice, the Mad Hatter, the March Hare
and the Dormouse in the teapot having a
tea party
Gouache on partial celluloid applied to a
painted background
Inscribed 'to Imogen Coca, Best Wishes
Walt Disney'
$9\frac{1}{2} \times 14\frac{1}{2}$ in. (24 × 37 cm.)
Sold 21.6.86 in New York at Christie's East
for $11,550 (£7,598)

Brave Little Tailor, 1938
Mickey swatting seven flies in one blow
Gouache on celluloid applied to a Walt
Disney Productions watercolour
background
Production 2252
$8\frac{1}{8} \times 10\frac{5}{8}$ in. (20.5 × 26.8 cm.)
Sold 8.12.84 in New York at Christie's East
for $20,900 (£16,077)

The Band Concert, 1935
The band on stage, with Mickey as
bandleader
Gouache on two full celluloids applied to a
Walt Disney Productions watercolour
master background
9 × 11 in. (23 × 28 cm.)
Sold 4.12.85 in New York at Christie's East
for $24,200 (£16,335)
Record auction price for a celluloid
This marks the opening scene as all the
animals are introduced, while Mickey, as
bandleader, makes his debut in his first
colour cartoon short

Wine

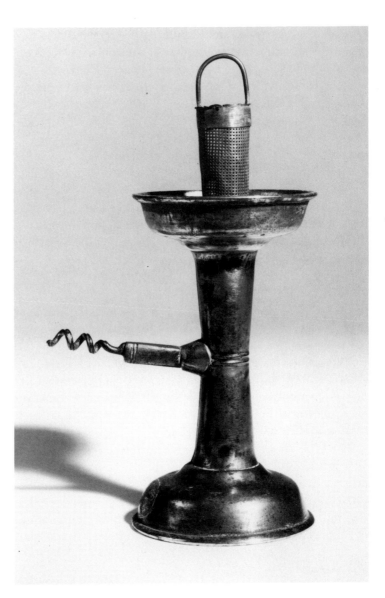

1843 William Darnby
corkscrew and wine strainer
Sold 5.12.85 in London for
£980 ($1,441)

A Wine for all Seasons

MICHAEL BROADBENT, M.W.

One of the great satisfactions of those who work in the wine department is the enormous range of wines and vintages we handle over the course of a season, not to mention the equally wide range of people we deal with: from great to lesser wines, and mortals. I think we can claim without contradiction that no other outlet lists and sells such a variety; the merest glance at the index of almost any of our Fine Wine catalogues will bear this out. And buyers come from far afield. For example, at our 12 June sale of Finest and Rarest we had clients from Australia, Mexico, Japan, Denmark, Norway, Switzerland, West Germany and France, in total more than the Americans who are commonly assumed to dominate such sales. The number of United Kingdom buyers just exceeded the grand total of overseas buyers.

Who buys wine? First and foremost, drinkers, restaurateurs, collectors, investors, wine merchants and brokers buying on behalf of, and selling on to, retailers of all descriptions. It is also not an exaggeration to say that many, if not most, of the New World's merchants and restaurateurs who offer prestigious rarities have, directly or indirectly, obtained them over the past 20 seasons via Christie's.

1966–86

Two centuries after James Christie's first sale, which included wine, the newly formed wine department held its first sale. Also in 1966, and coincidentally in its centenary year, W. & T. Restell, the City wine auctioneers, amalgamated with Christie's.

The 1966/7 season opened on 11 October with a sale of Fine Wines from Private Cellars. A total of 32 mainly specialized sales were conducted that first season, including, in May 1967, one of the most renowned of all, the Rosebery collection of pre-phylloxera claret and the biggest-ever offering of Bordeaux: over 24,000 cases for Alexis Lichine & Cie. The first season's sold total was £220,634 ($330,951).

The 20th season, just concluded, witnessed a sold total of Christie's wine sales worldwide, well in excess of £8 million ($12 million), of which over £5.5 million ($8.25 million) was sold at King Street. In comparison with big supermarket and brewery-controlled outlets, this sales total may not seem all that large, but in the context of fine vintage wines, the iceberg-tip of the market, it is substantial. To put Christie's efforts into perspective, our wine sale turnover is roughly double the estimated sold total of all other wine auctioneers combined.

THE MARKET

After quoting the above figures, it might be assumed that the market is buoyant. Buoyant, perhaps, but drifting. Looking back, the high point of sales, prices and percentage sold was in the New Year and spring of 1985. Prices in London were undoubtedly boosted by the general state of the economy and, in particular, by the strength of the dollar, which for a time was near parity with the pound. A year, a season, later, with stocks in merchants' hands, particularly

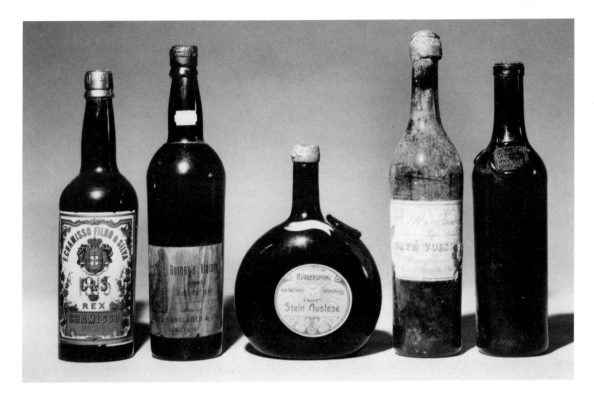

From left to right:
1815 Chamisso Port,
£150 ($223)
1887 Burnay's Port,
£130 ($193)
1897 Stein Auslese,
£820 ($1,214)
1868 Château Rauzan,
£210 ($311)
Pre-1860 Château Bel-Air,
Marquis d'Aligré,
£310 ($459)
All sold 5.12.85 in London

in America, at a very high level and with the rate of exchange roughly $1.50 to £1.00 sterling, demand and hence prices took a tumble.

Prices started to decline last summer and continued at a lower level through the autumn. Estimates were adjusted to reflect the trends, and a combination of lower sale prices with a lower percentage sold, resulted in a January to June sold total well under that of the same period last year. Happily, in July an extra sale and an average of £¼ million ($⅜ million) sold at each of the four sales improved the situation. Taking into account a busy autumn 1985, the 1985/6 figures show a distinct, if modest, increase over the outstanding record success of the 1984/5 season.

Prognostications? It is hard to say. Stocks are still high and there is a general feeling of uncertainty. We believe that the new season will see a continuation of the buyer's market, with prices more or less on an even keel. Selectivity will continue, buyers concentrating on the best wines and vintages.

HIGHLIGHTS OF THE SEASON

1787 Lafitte

Undoubtedly the major event of the wine season, of any season, anywhere, was the sale last December of the bottle of 1787 Château Lafitte *(sic)* engraved with the initials of Thomas Jefferson.

Before becoming President, Jefferson was for a time the American Minister (Ambassador) to France. This very civilized man absorbed all that was best in French culture and cultivated a deep interest in the finest wines. He visited Bordeaux in May 1787, and in 1791, following his return to America, he wrote directly to the leading châteaux proprietors to order wine for the President, George Washington, and himself: the best available for drinking, all to be bottled at the château and *etiquetté* with his initials and those of the President, so that the various

wines, which would have been shipped in chests of 25 or 50 bottles, could be readily identified and sorted out on arrival in Philadelphia.

How a stray batch found itself in Paris the records do not say, though it is known that Jefferson intended to return to France and had doubtless kept on his house. Roughly a dozen Jefferson wines were found in a bricked up cellar last year and acquired by a well-known German collector of old wines, Mr Hardy Rodenstock. Soon after their acquisition a bottle of the 1787 Yquem was opened at the château. Following that tasting, the bottle, cork, wax seal and wine were analysed in two German laboratories and confirmed to be of the period. A bottle of the 1784 Yquem was opened at a big tasting in Wiesbaden last October; it was well-nigh perfect. The 1787 Branne-Mouton was also opened and tasted earlier this year. The writer attended the latter two tastings and in both instances the wine was found to be absolutely remarkable and undoubtedly authentic.

One of the three known bottles of 1787 Lafitte, and the only one to be offered for sale, was featured in our 5 December 1985 Finest and Rarest and sold for the record auction price for any wine of £105,000 ($155,453). The purchaser was Christopher Forbes, and the bottle, flown back to the United States in one of the Forbes private jets, was immediately put on display in the Forbes Museum in New York.

Old vintages from the cellars of a major Bordeaux château
Probably the finest range of old vintages of claret and white Bordeaux ever to come on the market was sold in two tranches. The first was sold on 24 October 1985 and the second, and largest, on 12 June 1986.

It has always been standard practice for leading châteaux proprietors to exchange cases of wine. In theory this enables friendly rivals to compare vintages; in practice they are binned away and brought out, usually many years later, when out of courtesy and curiosity another proprietor happens to be a guest at some luncheon or dinner. Quite naturally, all châteaux proprietors will concentrate on their own wines so the result is that over a period of time wines of other châteaux are left relatively untouched, save for periodic checking and recorking.

The attractions of this sort of sale are that the buyer knows that the wine rested in the vendor's cellar from the time of its delivery shortly after bottling, and that it has remained undisturbed and carefully looked after ever since.

No fewer than 54 vintages, all of classed growths from 1847 to 1947, were shipped to London and sold. Of those vintages a remarkable 60 different châteaux were pre-1900 and 124 pre-1930. The total sold was over £260,000 ($390,000).

Other sales
Tattersalls, the renowned firm of auctioneers of thoroughbred horses, was, like Christie's, founded in 1766. On 1 May 1986 both firms broke new ground by adding a wine auction to a great day's racing at Newmarket. Christie's sale of Fine Wines took place in Tattersalls' famous sale ring in the morning. After lunch Christie's and their clients repaired to the racecourse for one of the great classic races of the season, the 1,000 Guineas. A good day out was had by all.

In 1985 the Lur Saluces family celebrated the 200th anniversary of their ownership of Château d'Yquem and to mark the occasion Christie's organized on 24 October a special commemorative sale. Twenty-six vintages, from 1889 to 1970 were entered for sale by several private vendors. The climax of the sale was the disposal of 100 dozen bottles of the renowned 1967 vintage for a total of £161,200 ($246,959).

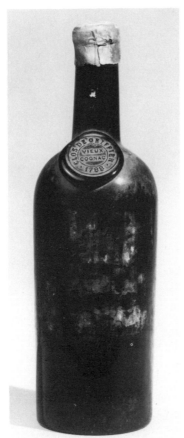

Far right:
1787 Ch. Lafitte (*sic*)
Sold 5.12.85 in London for
£105,000 ($155,453)

Right:
1788 Clos de Griffier cognac
Sold 12.6.86 in London for
£3,300 ($5,066)

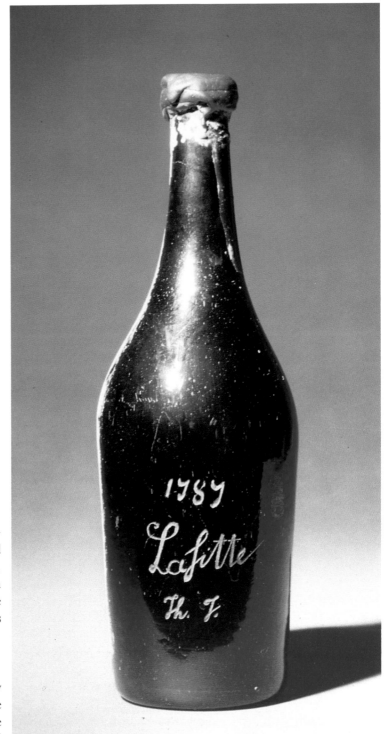

A month later, on 28 November, we featured two high-quality and rare types of wine: a magnificent range of old Almacenista sherries assembled by the firm of Emilio Lustau, and a magnificent century of Tokay, vintages ranging from 1864 to 1964, mainly from the historic cellars of the Hungarian Wine Trust. Both sales exceeded all expectations in the interest attracted and prices paid.

Other Christie sales in the United Kingdom
Christie's South Kensington have continued their monthly mixed sales of small private cellars and inexpensive trade stock. The sales are organized by their own in-house wine department, managed by Tony Thompson and conducted by Duncan McEuen. During 1985/6 16 sales were held. The total sold was well over £½ million ($¾ million).

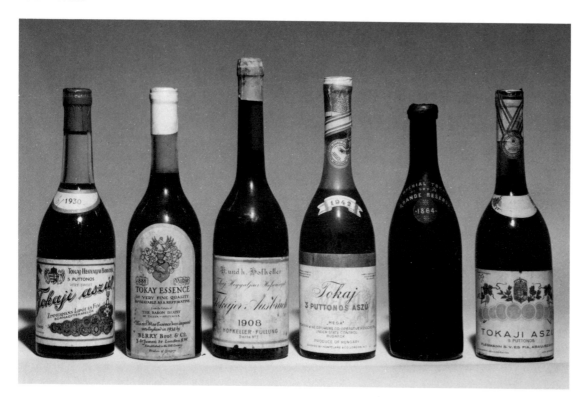

From left to right:
1930 Tokaji Aszú, 5 putts.,
£87 ($124) a half-litre
1888 Tokay Essence,
£360 ($512)
1908 Tokajer Ausbruch,
£88 ($126)
1942 Tokaji Aszú, 3 putts.,
£55 ($79)
1864 Imperial Tokay,
£115 ($164)
All sold 28.11.85 in London

Christie's wine sales in the City, nominally under the Christie's South Kensington banner, have invariably been well attended thanks to the convenient central venue, the Institute of Chartered Accountants Hall in Copthall Avenue, and the timing: a late morning tasting, followed by the lunchtime auction.

Our first sale in Scotland was held in Glasgow way back in 1969, but wine sales started in earnest, that is to say on a more regular basis, in 1984. Sales are held in association with Irvine Robertson Wines Ltd. and have been conducted at Prestonfield House, Edinburgh, and at Christie's/Edmistons, Glasgow. Two sales were held last season and the total sold was roughly £120,000 ($180,000).

Overseas wine sales
Our sales on the Continent of Europe have settled down to regular major events, each spring and autumn. Organized and conducted by the peripatetic Duncan McEuen, the two Fine and Rare wine sales in Geneva totalled just short of Sw.fr.1 million (£357,200), and in Amsterdam D.fl.1.6 million (£421,000).

Wine sales in Chicago are more frequent and have consolidated Christie's leading position in the United States in the Fine and Rare wine auction field. The market is healthy and the wine office there, headed by Michael Davis, operates like clockwork. With the active support of two senior members of the Christie's team in New York, Brian Cole and Fritz Hatton, both of whom, with the writer, conduct the sales, and a cooperative wine merchant, Schaefer's, who provides cellar space and other services, the past season has witnessed five sales and achieved a sold total of $1.5 million (£1 million).

Principal Prices 1985/6

Claret

1787 Ch. Lafitte (*sic*)	£105,000 ($154,350) per bottle (record auction price for any wine)
1847 Ch. Rauzan	£390 ($574) per bottle
1848 Ch. Margaux	£880 ($1,294) per bottle
1848 Ch. Haut-Brion	£1,150 ($1,691) per bottle
1870 Ch. Lafite	£3,600 ($5,292) per magnum
1870 Ch. Mouton-Rothschild	£1,350 ($1,985) per bottle
1900 Ch. Latour	£1,450 ($2,132) per magnum
1921 Ch. Cheval-Blanc	£1,150 ($1,691) per magnum
1929 Ch. Gruaud Larose	£1,200 ($1,764) per imperiale
Ch. Pétrus	£8,800 ($13,200) per dozen
1945 Ch. Lafite	£3,000 ($4,410) per bottle
1946 Ch. Mouton-Rothschild	£1,850 ($2,720) per bottle
1947 Ch. Cheval-Blanc	£7,600 ($11,172) per 6 magnums
1947 Ch. Pétrus	£8,200 ($12,300) per 6 magnums
1961 Ch. Pétrus	£1,200 ($1,764) per magnum
1961 Ch. Lafite	£2,500 ($3,675) per imperiale
1961 Ch. Palmer	£2,400 ($3,528) per dozen
1961 Ch. Mouton-Rothschild	£2,800 ($4,116) per 6 magnums
1966 Ch. Pétrus	£2,300 ($3,381) per dozen
1975 Ch. Pétrus	£1,550 ($2,279) per jeroboam
1982 Ch. Pétrus	£2,100 ($3,087) per dozen

White Bordeaux

1858 Ch. d'Yquem	£520 ($765) per bottle
1861 Ch. d'Yquem	£1,250 ($1,838) per bottle
1899 Ch. Lafite Blanc	£310 ($456) per bottle
1900 Ch. d'Yquem	£7,500 ($11,025) per dozen
1937 Ch. d'Yquem	£600 ($882) per magnum
1967 Ch. d'Yquem	£2,800 ($4,116) per dozen

Burgundy

1919 Richebourg (Rosenheim)	£300 ($441) per double-magnum
1959 Romanée-Conti	£280 ($412) per bottle
1959 La Tâche	£880 ($1,294) per double-magnum
1966 Romanée-Conti	£1,550 ($2,279) per double-magnum
1969 Romanée-Conti	£2,100 ($3,087) per dozen
1971 Romanée-Conti	£3,600 ($5,292) per 6 magnums

White Burgundy

1971 Le Montrachet (Laguiche)	£1,850 ($2,720) per dozen
1971 Le Montrachet (DRC)	£460 ($677) per bottle
1978 Chevalier-Montrachet (Leflaive)	£780 ($1,147) per dozen
1982 Montrachet (Ramonet)	£820 ($1,206) per dozen
1983 Montrachet (Laguiche)	£920 ($1,353) per dozen

Rhône

1959 Hermitage, La Chapelle	£920 ($1,353) per dozen
1961 Hermitage, La Chapelle	£105 ($155) per bottle
1971 Ch. Grillet	£620 ($912) per dozen

Alsace

1971 Gewürztraminer, Vendange Tardive (Hugel)	£400 ($588) per dozen

Hock

1727 Rüdesheimer Apostelwein	£500 ($735) per half-bottle

Australian

*c.*1880 Hunter Valley Shiraz	£270 ($397) per bottle

Champagne

1955 Dom Pérignon	£720 ($1,059) per dozen
1961 Dom Pérignon	£700 ($1,029) per dozen
1961 Krug	£620 ($912) per dozen
1962 Dom Pérignon	£740 ($1,088) per dozen

Tokay

1834 Essence	£320 ($471) per half-litre
1889 Essence	£330 ($486) per half-litre

Madeira

1792 Blandy's, bottled 1840	£800 ($1,176) per bottle
1795 Terrantez	£380 ($559) per bottle

Port

1904 Sandeman	£185 ($272) per magnum
1912 Cockburn	£1,280 ($1,882) per dozen
1924 Croft	£90 ($133) per magnum
1935 Cockburn	£1,350 ($1,985) per dozen
1945 Taylor	£1,500 ($2,205) per dozen

Cognac

1788 Clos de Griffier	£3,300 ($5,066) per bottle
1811 'Comet'	£1,150 ($1,691) per magnum
1812 Impériale	£700 ($1,176) per magnum

Other spirits

Pre-1939 Pernod, Extrait d'Absinthe	£700 ($1,176) per bottle

Corkscrews etc.

1843 William Darnby corkscrew and wine strainer	£980 ($1,441)

Christies International Plc
Chairman: J. A. Floyd

EUROPEAN SALEROOMS

Head Office
Christie, Manson & Woods Ltd.
8 King Street, St. James's
London SW1Y 6QT
Tel: (01) 839 9060
Telex: 916429
Facsimile (01) 839 1611
Chairman: The Hon. Charles Allsopp

South Kensington
Christie's South Kensington Ltd.
85 Old Brompton Road
London SW7 3JS
Tel: (01) 581 7611
Telex: 922061
Chairman: Anthony Coleridge

Scotland
Christie's & Edmiston's Ltd.
164-166 Bath Street
Glasgow
Tel: (041) 332 8134/7
Telex: 779901
Chairman: Sir Ilay Campbell, Bt.

Robson Lowe at Christie's
47 Duke Street
St. James's
London SW1Y 6QX
Tel: (01) 839 4034

39 Poole Hill
Bournemouth
Dorset
Tel: (0202) 292740

Italy
Christie's (International) S.A.
Palazzo Massimo Lancellotti
Piazza Navona 114
Rome 00186
Tel: (396) 654 1217
Telex: 611524
Maurizio Lodi-Fé

The Netherlands
Christie's Amsterdam B.V.
Cornelis Schuytstraat 57
1071 JG Amsterdam
Tel: (3120) 64 20 11
Telex: 15758
Cables: Christiart, Amsterdam
Harts Nystad
John Gloyne

Switzerland
Christie's (International) S.A.
8 place de la Taconnerie
1204 Geneva
Tel: (4122) 28 25 44
Telex: 423634
Cables: Chrisauction, Geneva
Facsimile (4122) 21 55 59
Hans Nadelhoffer
Thomas Milnes Gaskell
Maria Reinshagen
Georges de Bartha
Yves Oltramare
Graf Frans-Clemens
von Schoenborn-
Wiessentheid
Jocelyne Keller

UNITED STATES OF AMERICA SALEROOMS AND REPRESENTATIVES

**Christie, Manson & Woods
International, Inc.**
502 Park Avenue
New York, N.Y. 10022
Tel: (212) 546 1000
Telex: 620721
Cables: Chriswoods, New York
Facsimile: (212) 980 8163
President: Christopher Burge
Executive Vice Presidents: François
Curiel, Stephen S. Lash

Christie's East
219 East 67th Street
New York, N.Y. 10021
Tel: (212) 606 0400
Telex: 672-0346
President: J. Brian Cole

BEVERLY HILLS
Terry Stanfill
Russell Fogarty
Hillary Holland
342 North Rodeo Drive
Beverly Hills, Ca. 90210
Tel: (213) 275 5534
Telex: 6711872

BOSTON
Elizabeth M. Chapin
15 Traill Street
Cambridge, Mass. 02138
Tel: (617) 576 0400

CHICAGO
Frances Blair
Laura Gates
200 West Superior
Chicago, Illinois 60610
Tel: (312) 787 2765

DALLAS
Carolyn Foxworth
7047 Elmridge Drive
Dallas, Texas 75240
Tel: (214) 239 0098

PALM BEACH
Helen Cluett
251 Royal Palm Way
Palm Beach, Fla. 33480
Tel: (305) 833 6952

PHILADELPHIA
Paul Ingersoll
Francis Gowen
Molly Wood
P.O. Box 1112
Bryn Mawr, Pa. 19010
Tel: (215) 525 5493

SAN FRANCISCO
Ellanor Notides
3516 Sacramento St.
San Francisco, Ca. 94118
Tel: (415) 346 6633

WASHINGTON
David Ober
Nuala Pell
Joan Gardner
Box 185, Monkton, MD. 21111
Tel: (202) 333 7459

REPRESENTATIVES

Great Britain and Ireland

Christie's in the City
Simon Birch, Peter Arbuthnot
56/60 Gresham Street
London EC2V 7BB
Tel: (01) 588 4424

Highland
John Douglas-Menzies
Mounteagle, Fern, Ross-shire
Tel: (086283) 2866

Grampian
Lord Inverurie
The Stables, Keith Hall
Inverurie, Aberdeenshire
Tel: (0467) 24366

Perthshire
Sebastian Thewes
Strathgarry House
Killiecrankie by Pitlochry
Perthshire
Tel: (079681) 216

Argyll

Sir Ilay Campbell, Bt.
Cumlodden Estate Office
Crarae, Inveraray, Argyll
Tel: (0546) 86633

Edinburgh

Michael Clayton
5 Wemyss Place, Edinburgh
Tel: (031) 225 4756/7

Ayrshire

James Hunter Blair
Blairquhan, Maybole, Ayrshire
Tel: (06557) 239

Northumbria

Aidan Cuthbert
Eastfield House, Main Street
Corbridge, Northumberland
Tel: (043471) 3181

North-West

Victor Gubbins
Eden Lacy, Lazonby, Penrith, Cumbria
Tel: (076883) 8800

Yorkshire

Sir Nicholas Brooksbank, Bt.
Mrs Veronica Brook
46 Bootham, York
Tel: (0904) 30911

West Midlands

Michael Thompson
Stanley Hall, Bridgnorth, Shropshire
Tel: (07462) 61891

Midlands Office

The Hon. Lady Hastings
Mrs William Proby
The Stables, Milton Hall, Peterborough
Tel: (073121) 781

East Anglia

Iain Henderson Russell
Stuart Betts, M.C., F.G.A. *Consultant*
Old Bank of England Court
Queen Street, Norwich
Tel: (0603) 614546

Cotswolds

Viscount Ebrington
Rupert de Zoete *Consultant*
111 The Promenade, Cheltenham, Glos.
Tel: (0242) 518999

Hampshire & Wiltshire

Viscount Folkestone
The Estate Office, Longford Castle
Salisbury, Wiltshire
Tel: (0722) 332250

West Country

Richard de Pelet
Monmouth Lodge, Yenston
Templecombe, Somerset
Tel: (0963) 70518

South Dorset & Solent

Nigel Thimbleby
Wolfeton House, Dorchester, Dorset
Tel: (0305) 68748

And at:

Bournemouth

39 Poole Hill, Bournemouth, Dorset
Tel: (0202) 292740

Cornwall

Christopher Petherick
Tredeague, Porthpean
St. Austell, Cornwall
Tel: (0726) 64672

Devon

The Hon. George Lopes
Gnaton Estate Office
Yealmpton, Plymouth, Devon
Tel: (0752) 880636

South East

Robin Loder
Leonardslee Gardens
Lower Beeding, Nr. Horsham
West Sussex
Tel: (040376) 305

Kent

Christopher Proudfoot
The Old Rectory
Fawkham, Dartford, Kent
Tel: (04747) 2854

Ireland

Desmond Fitz-Gerald, Knight of Glin
Glin Castle, Glin, Co. Limerick
Private Residence:
52 Waterloo Road, Dublin 4
Tel: (0001) 68 05 85

Northern Ireland

John Lewis-Crosby
Marybrook House, Raleagh Road
Crossgar, Downpatrick, Co. Down
Tel: (0396) 830574

Channel Islands

Richard de la Hey
58 David Place, St. Helier, Jersey
Tel: (0534) 77582

Overseas

Argentina

Cesar Feldman *Consultant*
Libertad 1269, 1012 Buenos Aires
Tel: (541) 41 1616 or 42 2046
Cables: Tweba, Buenos Aires

Australia

Sue Hewitt
298 New South Head Road
Double Bay, Sydney, 2028
Tel: (612) 326 1422
Telex: 26343
Cables: Christiart Sydney

Austria

Dr. Johanna Schönburg-Hartenstein
Kohlmarkt 4, 1010 Vienna
Tel: (43222) 63 88 12

Belgium

Janine Duesberg
Christie, Manson & Woods (Belgium) Ltd.
33 Boulevard de Waterloo
1000 Brussels
Tel: (322) 512 8765 or 8830
Telex: 20380

Brazil

Maria-Thereza de Azevedo Sodre *Consultant*
Av. Rui Barbosa, 582
22250 Rio de Janeiro
Tel: (5521) 551 1467
Telex: 212 3323

Canada

Murray Mackay
Christie, Manson & Woods
International Inc.
94 Cumberland Street, Suite 416
Toronto, Ontario M5R 1A3
Tel: (416) 960 2063
Telex: 06-23907

Denmark

Birgitta Hillingso
Dronningen Tvaergade 10
1302 Copenhagen K
Tel: (451) 32 70 75
Telex: 21075

France

Princesse Jeanne-Marie de Broglie
Laurent Prevost-Marcilhacy
Christie's France SARL
17 rue de Lille, 75007 Paris
Tel: (331) 42 61 12 47
Telex: 213468

Hong Kong

Alice Yuan Piccus
3607 Edinburgh Tower
The Landmark
15 Queen's Road Central, Hong Kong
Tel: (852) 521 5396/7
Telex: 72014
Facsimile: (852) 527 1704

Israel

Christie's in Israel
2 Habima Square, Tel Aviv 64253
Tel: (9723) 202 930/204 727
Telex: 35770

Italy

Milan
Giorgina Venosta
Christie's (Italy) S.r.l.
9 via Borgogna, 20122 Milan
Tel: (392) 794 712
Telex: 316464

Turin
Sandro Perrone di San Martino
Corso Matteotti, 33, 10121 Turin
Tel: (3911) 548 819

Japan

Sachiko Hibiya
Ichibankan Bldg., B1
3-12, Ginza 5-chome
Tokyo 104
Tel: (813) 571 0668
Telex: 29879
Facsimile: (813) 571 5823

Mexico

P.O. Box 105-158
Mexico 11570
Tel: (525) 531 1686/1806

Monaco

Christine de Massy
Christie's Monaco S.A.M.
Park Palace
98000 Monte Carlo
Tel: (3393) 25 19 33
Telex: 489287

Norway

Ulla Solitair Hjort
Riddervoldsgt. 10b, Oslo 2
Tel: (472) 44 12 42

Portugal

Antonio M.G. Santos Mendonça
R. Conde de Almoster, 44, 1° Esq.
1500 Lisbon
Tel: (351) 78 63 83
Telex: 12839

South Africa

Johannesburg
Harriet Gilfillan,
P.O. Box 650852
Benmore
Sandton 2010
Tel: (2711) 783 0303

Cape Town
Juliet Lomberg
14 Hillwood Road
Claremont
7700 Cape

Spain

Casilda Fz-Villaverde y Silva
Valenzuela 7, Madrid 28014
Tel: (341) 232 66 27
Cables: Christiart, Madrid
Telex: 46481

Sweden

Lillemor Malmström
Artillerigatan 29
11445 Stockholm
Tel: (468) 620 131
Telex: 12916

Baroness Irma Silfverschiold
Klagerups Gard, 230 40 Bara
Tel: (4640) 44 03 60

Switzerland

Maria Reinshagen
Christie's (International) A.G.
Steinwiesplatz, 8032 Zürich
Tel: (411) 69 05 05
Telex: 56093

Venezuela

Alain Jathiere
Apartado 88061
1080 Caracas
Tel: (582) 962 1755
Telex: 24950

West Germany

Jörg-Michael Bertz
Inselstrasse 15
D-4000 Düsseldorf 30
Tel: (49211) 4982986

Christiane Gräfin zu Rantzau
Wentzelstrasse 21, D-2000 Hamburg 60
Tel: (4940) 279 0866

Charlotte Fürstin zu Hohenlohe-
Langenburg
Residenzstrasse 27, D-8000 Munich 2
Tel: (4989) 22 95 39

Monsieur Gérald Van der Kemp, President d'Honneur of Christie's Europe, is based in our Paris Office.

Index

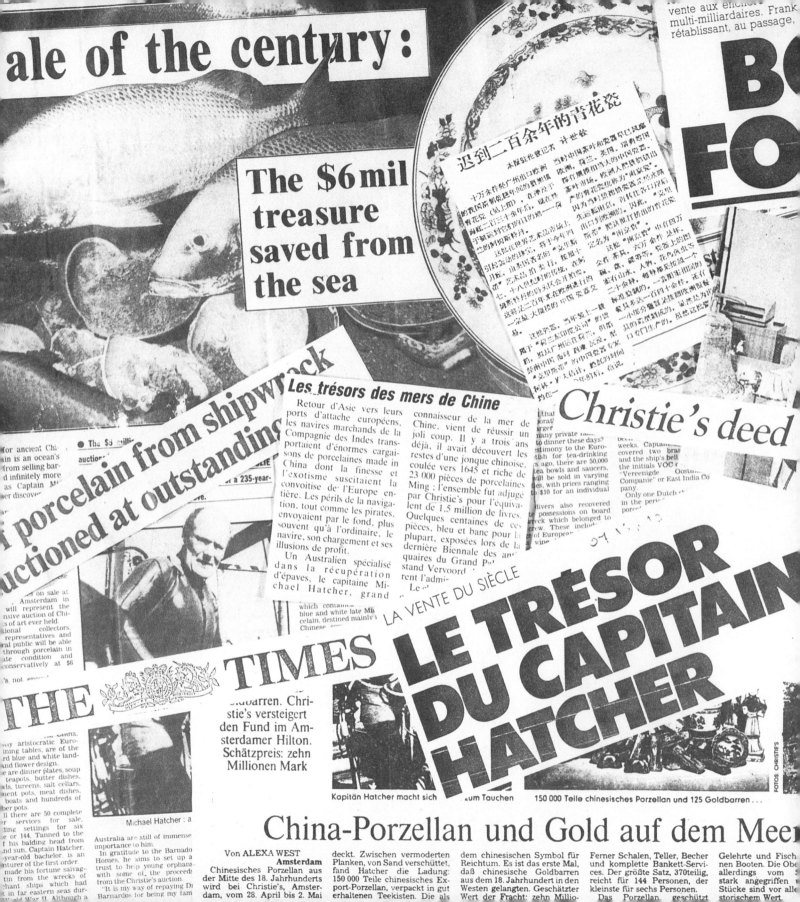